A HISTORY

THE ART OF WAR

THE MIDDLE AGES
FROM THE FOURTH TO THE
FOURTEENTH CENTURY

BY

CHARLES OMAN, M.A., F.S.A.

FELLOW OF ALL SOULS COLLEGE, OXFORD

WITH MAPS, PLANS, AND ILLUSTRATIONS

NEW YORK: G. P. PUTNAM'S SONS
LONDON: METHUEN & CO.
1898

PREFACE

THE present volume is intended to form the second of a series of four, in which I hope to give a general sketch of the history of the art of war from Greek and Roman times down to the beginning of the nineteenth century. The first volume will deal with classical antiquity; this, the second, covers the period between the downfall of the Roman Empire and the fourteenth century. In the third volume will be included the fifteenth, sixteenth, and seventeenth centuries. The fourth will treat of the military history of the eighteenth century and of the Revolutionary and Napoleonic wars down to Waterloo.

These volumes are concerned with the history of the art of war, and do not purport to give the complete military annals of the civilised world. Each section deals with the characteristic tactics, strategy, and military organisation of a period, and illustrates them by detailed accounts of typical campaigns and battles. There are also chapters dealing with the siegecraft and fortification, the arms and armour of each age.

The present volume should in strict logic have included two more books, dealing the one with the military history of Central and Eastern Europe in the fourteenth century (especially with the first rise of the Swiss and the Ottoman Turks), and the other with the invention of gunpowder and firearms. But the exigencies of space—the volume is already more than six hundred and sixty pages long—have compelled me to relegate these topics to the opening chapters of the third volume. It is fortunate that the influence of the discovery of gunpowder on

the wars of Western Europe was so insignificant during the fourteenth century that no serious harm comes from deferring the discussion of the subject.

I have endeavoured to avoid overburdening the volume with too voluminous foot-notes, but at the same time have given references for all statements which might seem to require justification or defence. In citing English chronicles my references are, where possible, to the Rolls Series editions; French chronicles are mainly quoted from Bouquet's magnificent *Scriptores Rerum Gallicarum et Francicarum*, German and Italian from the collections of Pertz and Muratori respectively.

Much valuable aid given to the author requires grateful acknowledgment. Most especially must I express my thanks to two helpers : to the compiler of the index—the fourth and the largest which has been constructed for books of mine by the same kindly hands—and to my friend Mr. C. H. Turner, Fellow of Magdalen College, who read the whole of the proofs, and furnished me with a great number of corrections and improvements.

I have also to acknowledge my indebtedness to Mr. T. A. Archer, who was good enough to go through with me the whole of Book V. (the Crusades) and also chapter vii. of Book III., wherein certain topics much disputed of late years are dealt with. I also owe some valuable hints to Professor York Powell and to the Rev. H. B. George of New College. The former, with his usual omniscience, indicated to me several lines of inquiry, from which I obtained valuable results. The latter will notice that in chapter ii. of Book VIII. I have adopted his theory of the formation of the English army at Crecy. Mr. F. Haverfield of Christ Church gave me some useful notes for the opening pages of the first chapter of Book I.

All the maps and plans have been constructed by myself from the best sources that I could procure. When possible, I walked over important battlefields, *e.g.* Crecy, Bouvines, Bannockburn, Evesham, in order to supplement the information

to be derived from maps by a personal acquaintance with the ground. The English plans are derived from the Ordnance Survey, the French from the maps of the État-Major, the Syrian from the admirable publications of the Palestine Exploration Society.

Of the seven plates illustrating armour, the first three are sketches taken from the original manuscripts ; the last four I owe to the kindness of Messrs. Parker of Oxford, who permitted me to reduce them from the blocks of one of their most valuable publications, Hewitt's *Ancient Armour*, a book from which I derived much useful information when dealing with the later Middle Ages.

OXFORD, *March* 1, 1898.

TABLE OF CONTENTS

BOOK I

THE TRANSITION FROM ROMAN TO MEDIÆVAL FORMS IN WAR, A.D. 235–552

BOOK II

THE EARLY MIDDLE AGES, A.D. 500–768

ix

BOOK III

FROM CHARLES THE GREAT TO THE BATTLE OF HASTINGS, A.D. 768-1066

BOOK IV

THE BYZANTINES, A.D. 579–1204

———

BOOK V

THE CRUSADES, A.D. 1097–1291

BOOK VI

WESTERN EUROPE—FROM THE BATTLE OF HASTINGS TO THE RISE OF THE LONGBOW

BOOK VII

ENGLAND AND SCOTLAND, A.D. 1296–1333— DEVELOPMENT OF THE LONGBOW

CHAPTER I.—ENGLAND AND SCOTLAND (1296–1328)

CHAPTER II.—ENGLAND AND SCOTLAND (1328–1333)—FIRST COMBINATION OF ARCHERY AND DISMOUNTED CAVALRY

BOOK VIII

THE LONGBOW BEYOND THE SEAS

CHAPTER I.—THE ARMIES OF EDWARD III.

CHAPTER II.—THE LONGBOW IN FRANCE: CRÉÇY

CHAPTER III.—POICTIERS, COCHEREL, AND AURAY

CHAPTER IV.—NAVARETTE AND ALJUBAROTTA

TABLE OF MAPS, PLANS, AND ILLUSTRATIONS

xv

BOOK I

THE TRANSITION FROM ROMAN TO MEDIÆVAL
FORMS IN WAR

THE ART OF WAR

THE MIDDLE AGES

CHAPTER I

THE LAST DAYS OF THE LEGION

A.D. 235–450

BETWEEN the middle of the third and the middle of the fifth century lies a period of transition in military history, an epoch of transformations as strange and as complete as those contemporary changes which turned into a new channel the course of political history and of civilisation in Europe. In war, as in all else, the institutions of the ancient world are seen to pass away, and a new order of things develops itself.

The most characteristic symptom of the tendencies of this period is the gradual disappearance of the Roman legion, that time-honoured organisation whose name is so intimately bound up with the story of Roman greatness. In A.D. 250 it was still the heavy-armed infantry of the empire which formed the core of battle, and was the hope and stay of the general. By A.D. 450 the cavalry was all in all, the foot-soldiery had fallen into disrepute, and the very name of legion was almost forgotten. It represented a form of military efficiency which had now completely vanished. That wonderful combination of strength and flexibility, so solid and yet so agile and easy to handle, had ceased to correspond to the needs of the time. The day of the sword and pilum had given place to that of the lance and bow. The typical Roman soldier was no longer the iron legionary, who, with shield fitted close to his left shoulder and

sword-hilt sunk low, cut his way through the thickest hedge of pikes, turned back the onset of the mailed horsemen of the East, and stood unmoved before the wildest rush of Celt or German. The old military organisation of Augustus and Trajan began to fall to pieces in the third century; in the fourth it was so weakened and transformed as to be hardly recognisable; by the end of the fifth it had disappeared.

The change in the character of the Roman army which ultimately substituted cavalry and light infantry for the solid strength of the ancient legion was mainly caused by the exigencies of border-warfare. From the time of Hadrian to that of Severus, the system of frontier-defence which the Roman Government adopted was to fix the limit of the empire at a great natural boundary, such as the Rhine, Danube, or Euphrates, and to place behind the boundary at suitable points large permanent camps, in which one or more legions were quartered. These garrisons were placed many scores or even hundreds of miles apart, and the long intervals between them were only filled by minor posts occupied by small bodies of auxiliary troops. Where natural obstacles, such as rivers or mountain-chains, were wanting, the frontier was not unfrequently marked out by long lines of entrenchments, like our own Northumbrian Wall, or the similar structure which stretches across South Germany. The stations were connected with each other by good military roads, and the alarm could be passed from one to another at the shortest notice by a system of beacons and mounted messengers. If the barbarous enemy across the frontier, German, Sarmatian, or Parthian, essayed a raid on Roman territory, he must first cross the obstacles and then cope with the garrisons of the local posts. These would be able to beat back any small plundering parties; but if they found the invaders too strong, they could at least endeavour to harass them, and to restrict the area of their ravages, till the nearest legion could march up from its great permanent camp.

This system worked well for more than a hundred years. But it had its weak points; there was a great want of a central reserve, in case the legions of any frontier should be unable to hold their ground against an attack of unusual strength. For the middle provinces of the empire were kept entirely denuded of troops, and new legions could not be improvised in a hurry from the unwarlike subjects of the empire, as they had once

been from the citizens of the early republic. Hence it came to pass that a disaster on one point of the border had to be repaired by drawing troops from another. This rather dangerous device could only be employed so long as the enemies of Rome were so obliging as to present themselves one by one, and to refrain from simultaneous onslaughts on far distant tracts of frontier. For more than two centuries the empire was fortunate enough to escape this contingency; its military system was never tried by the crucial test of an attack all along the line; in the times of stress Germany could lend troops to Britain, or Moesia reinforce the legions of Syria. Disasters were suffered from time to time which threw a province for a moment into hostile hands, but because they came singly they could always be repaired. The rebellion of Civilis shook the Roman hold on the Rhine frontier for a space; the defeat of Domitian's generals Sabinus and Fuscus let the Dacians into the interior of the Danube provinces; Marcus Aurelius once saw the Quadi at the gates of Aquileia. But reinforcements were brought up from frontiers where no war was in progress, and the incoming flood of invasion was at length stemmed.

In the third century there was a complete change in the face of affairs: the system of defence broke down, and the empire well-nigh collapsed under the stress. From the day of the murder of Alexander Severus (235 A.D.) to the moment at which Diocletian put down the last surviving rebel Caesar in the remotest corner of the West (297) the empire was subjected without a moment's respite to the double scourge of civil war and foreign invasion. In the space of sixty years no less than sixteen emperors and more than thirty would-be emperors fell by sword or dagger. While the arms of the legions were turned against each other, the opportunity of the enemies of the empire had arrived. All its frontiers simultaneously were beset by the outer barbarians, and the fabric reeled before the shock. For Rome's neighbours were growing more powerful just when Rome herself was weak and divided. The new and vigorous Persian kingdom had just replaced the decrepit Parthian power in the East (A.D. 226). The Germans were already commencing to form the confederacies which made their scattered tribes for the first time really formidable. The names of the Franks, Alamanni and Goths begin to appear along the Rhine and Danube.

So long as the frontier defence of the legions held firm, the

empire presented to its foes a hard shell and a soft kernel. The border was strongly held and difficult to pierce, but the rich *provinciae inermes* within were defenceless and ripe for plunder, if only the shell could be pierced. When the legions were withdrawn from the frontier to take part in civil war, and marched off time after time to enthrone some new usurper upon the Palatine, it was impossible to keep back any longer the pressure from without. The period 235–297 opens with a heavy and long-continued onslaught of the Quadi Carpi and Goths on the Middle and Lower Danube (236). It was beaten back by Maximinus I. and Philip for a few years; but in 249, while a vigorous civil war was distracting the Illyrian regions, the line of resistance was at last broken through. The Goths crossed Danube and Balkans, overran Moesia and Thrace, and scattered the Imperial troops before them. The Emperor Decius, having put down his rivals, hastened to meet them; but he, his son, and his whole army were cut to pieces in the disastrous battle of Forum Trebonii in the summer of 251. No Roman emperor had ever been slain before in battle with the barbarians; no Roman host of such strength had suffered defeat since the day of Cannae. It seemed for a moment as if the empire was fated to be cut in twain, or even as if some earlier Alaric were about to present himself before the gates of Rome.

For the next twenty years the Goths ranged almost unresisted over the middle provinces of the empire. The troops that should have been called in to resist them were occupied in civil wars in Italy, or were employed in defending other menaced frontiers. For, while the Gothic war was at its height, the Persian king Sapor overran Mesopotamia, defeated and took captive the Emperor Valerian, stormed Antioch, and ravaged Syria and Asia Minor (258–259). Favoured by these distractions, the Goths were able to carry all before them in the central provinces of the empire. Not only did they harry the whole Balkan peninsula as far as Athens and Dyrrachium, but daring bands of plunderers crossed the Hellespont and sacked Chalcedon, Alexandria Troas, Ephesus, and even the distant Trebizond. With a little more guidance and a single leader at their head, they might have made an end of the empire, for usurpers were rising in every province. Civil war had become endemic among the Romans; the Germans of the Rhine frontier were battering at the defences of Gaul and Rhaetia, and the

indolent and frivolous Gallienus, who still maintained his precarious seat on the Palatine, bade fair to be the Sardanapalus of Rome, and to see city and empire go down together in one universal conflagration of civil strife and foreign war. In the years 260–268 all seemed lost. But deliverers arose—the tough Illyrians, Claudius, Aurelian, and Probus, reconquered the West from rebel Caesars, cleared the Germans out of the Balkan peninsula, and won back the East from the Persians and the Palmyrenes. Soon after came Diocletian, the reorganiser and restorer, and with the reconquest of Britain (A.D. 297) the empire resumed its old external shape.

But the restoration was external only. In the sixty years of battle, murder, and plague which had elapsed since the extinction of the dynasty of Severus, the vital strength of the empire had been fatally sapped. Half the provinces lay waste; the other half had been drained dry of their resources. By twenty years of incessant labour Diocletian restored a superficial semblance of strength and order; his grinding taxation enabled him to put an end to the chronic bankruptcy of the Imperial exchequer, and to restore and regarrison the long broken-down military frontier of the Roman world.

But the sixty years of anarchy and disaster had left indelible marks on the composition and organisation of the Roman army. Though few of the old legions of Trajan and Severus seem to have disappeared,—most of their names are still found in the *Notitia*, a document a hundred years later than Diocletian,—yet they had apparently been much pulled about and disorganised, by being cut up and sent apart in detachments. Often the legionary eagle at headquarters must have been surrounded by a mere fraction of the corps, while detached cohorts were serving all about the world, drafted off under the pressure of necessity.[1] All sorts of cohorts and *alae* with new and often strange names had been raised The old broad division of the army into legions and *auxilia*, the former filled with Roman citizens, the latter with subjects of the empire who did not possess the citizenship, could no longer exist, for Caracalla in 212 had bestowed the franchise on all provincials. Thus the ancient distinction between the legionary

[1] So, at least, one would deduce from such facts as that the usurper Carausius in Britain strikes coins to celebrate the fidelity to himself of legions whose proper headquarters were in Germany or Moesia, *e.g.* IV. Flavia and XXX. Ulpia.

who was a Roman and the auxiliary who was not had vanished; the status of the one was now as good as that of the other.

Yet if auxiliary and legionary were now Romans alike, the non-citizen element had not disappeared from the army. In the days of anarchy the emperors had not been able to reject any military resources that came to hand. They had enlisted thousands of warriors from across the frontier, who were not subjects of the empire at all, and only served for pay and plunder. Broken German clans, Sarmatians, Arabs, Armenians, Persian renegades, Moors from inner Africa, were all welcomed in the time of stress and need. Corps formed of these foreigners now stood to the Roman army in much the same relation that the auxiliaries had once borne to the legions. Individuals among the mercenaries rose to high rank in the army; one of them, said to be the son of a Gothic father and an Alan mother, wore the purple for three short years under his adopted name of Gaius Julius Verus Maximinus. But it is needful to note that down to the beginning of the fourth century these foreign elements in the Roman army, though growing perilously large, were still entirely subsidiary to the native legions and cohorts. In the words of a fourth-century writer, they were still *praeliandi magis adminiculum quam principale subsidium.*[1]

But a tendency to increase the proportion of cavalry and light infantry, and to trust less and less to the legionary of the old type, grows more and more apparent as the fourth century commences. This is best shown by the fact that the name of "legion" itself no longer commands its old prominence in the empire. Instead of being considered superior to all other corps, and taking precedence of them, the legionaries began to be treated as what we should now call "troops of the line," and saw many new bodies, which were in name, but not in fact, parts of the Imperial guard, preferred to them. It was considered high promotion when Diocletian took two Moesian legions out of their old numerical place in the army list, rechristened them the Jovians and Herculians, and gave them under their new titles precedence over all their former comrades. By the end of the fourth century we learn from Vegetius that the legions had been so neglected and thrust back that it was difficult to keep their ranks filled: "the large majority of recruits insist on enlisting among the auxiliaries, where the discipline is less severe, where the work

[1] Vegetius, i, § 2.

is lighter, and where the rewards of good service come quicker and are bestowed with a more bountiful hand."[1]

In the Roman army as it was reorganised by Diocletian the legionary infantry no longer formed, as of old, the wholly preponderant part of the foot-soldiery of the empire, in spite of the fact that he and his colleagues raised a very considerable number of new legions. In the eastern half of the empire, where Diocletian himself presided, he seems to have added eleven new legions to the sixteen old ones which he found already existing. But the non-legionary part of the army was developed on an even larger scale. To the already existing auxiliary cohorts and *numeri* other bodies were added in huge numbers.[2] But they do not mainly belong to the frontier line of defence where the legions lay. The institution of the *Comitatenses* or movable Imperial army, as opposed to the *limitanei* or *ripenses*, the fixed garrison troops of the frontier, belongs undoubtedly to Diocletian's time. In this category were placed the flower of the new regiments. They were mainly composed of provincials from the Illyrian, Gallic, and Germanic provinces, though there was a considerable number of corps raised from the barbarians beyond the Rhine and Danube. Quartered almost entirely in the interior of the empire, they were to be used as a central reserve, free to be transferred to any point of the border that chanced to be in peril. To the *Comitatenses* raised by Diocletian numerous additions were made by Constantine, who drafted off many cohorts and fragments of legions from the frontier forces and added them to the movable army. These were the corps which later generations called the *Pseudo-comitatenses*, a curious name intended to show that they ranked somewhat lower than the old comitatensian troops, though they had been raised to a higher standing than the surviving limitary legions.

For some not fully known reason all the legions of the Comitatenses were kept at a strength of only a thousand strong, though those left on the border still retained their old complement of six thousand men. Thus, though there were seventy such

[1] Vegetius, ii. § 3.

[2] Of cohorts alone there were still fifteen existing when the *Notitia* was drawn up which bear the names of Diocletian or his colleagues Maximian and Constantius (*i.e.* Flavia, Valeria, Jovia, Herculea) in the regimental name. See Mommsen, *Hermes*, 1889. How many new cohorts were made which did not bear the Imperial name one cannot say. In the *Notitia* there were a hundred and five cohorts and forty-four *auxilia* in the frontier garrisons, over and above the legions.

legions at the end of the fourth century, they did not represent the enormous force which such a roll of names seems to imply.

But Diocletian not only raised the Comitatenses and gave them precedence over the old legions. He was the first to raise a huge Imperial guard, which stood as much above the Comitatenses as the latter did above the limitary troops. These were the *Palatini*, who practically superseded the old Praetorians, a body which Diocletian rightly distrusted, as having for the last century been far too much given to the making and unmaking of emperors. He confined the Praetorians to Rome, a place which neither he nor his colleagues often visited, and formed his new Imperial guard out of picked men who did not inherit the evil traditions of the old corps. How numerous the *Palatini* were at their creation we cannot say; but by the end of the century they appear in the *Notitia* as a very considerable body, comprising twenty-four "vexillations" of horse (regiments of five hundred each), and of foot twenty-five legions, each a thousand strong, with a hundred and eight *auxilia*, each probably five hundred strong. This was, no doubt, a very much stronger force than the original Palatine regiments raised by Diocletian. Each of his successors had added new units to it, as the names "Honorian," "Theodosian," etc., show. Constantine the Great is known to have raised the five *scholae* of horsemen who formed the actual life-guard of the prince, and followed his person whenever he went out to war. By the end of the century the Imperial guard mustered about twelve thousand horse and eighty thousand foot, all (or nearly all) cantoned round or within the eastern and western capitals of the empire.

Among the Palatini, as among the Comitatenses, there was a very strong barbarian element, and this element was on the increase all through the fourth century. As Mommsen remarks,[1] "each corps seems to have been valued more highly in proportion as it differed the more in nationality, organisation, and spirit from the old normal Roman legions," though those left on the body

Great as was the increase made by Diocletian and his colleagues in the number of the non-legionary infantry, the additions made to the cavalry were more striking still. An infinite number of new bodies of horsemen, *cunei, alae, vexillationes*, etc., were raised, alike for the limitary, the comitatensian, and the palatine armies. Germans, Moors, Persians are more numerous among

[1] *Hermes*, 1889.

them than the born subjects of the empire. The old legionary
cavalry wholly disappears,[1] and the commands of horse and
foot are entirely separated. Yet under Constantine and his
immediate successors the infantry still remained the more impor-
tant arm, though the cavalry was continually growing in relative
importance. When we read the pages of Ammianus Marcellinus,
we still feel that the Roman armies whose campaigns he relates
are the legitimate successors of the legions of Tiberius and Trajan,
though the names of the corps and the titles of the officers are
so greatly changed. In the last first-class victory which the
house of Constantine won over the barbarians—Julian's great
triumph over the South German tribes near Strassburg—it was
the infantry which bore off the honours of the day. The cavalry
were routed and driven off the field, but the foot-soldiery, though
their flank was uncovered, formed the *testudo*, beat off the
victorious German horse, and gained for their dispersed squadrons
the time to rally and retrieve the day. (357.)

Nevertheless, we find the cavalry continually growing in
relative numbers and importance. This is well marked by the
fact that when Constantine displaced the old *Praefectus
Praetorio* from his post as war-minister and commander-in-
chief under the emperor, he replaced him, not by a single
official, but by two—a *magister peditum* and a *magister equitum*.
By the time of the drawing up of the *Notitia*, the number of the
cavalry seems to have risen to about a third of that of the
infantry, whereas in the old Roman armies it had often been
but a tenth or a twelfth, and seldom rose to a sixth. The
figures of the *Notitia* show the results of the battle of Adrianople,
of whose military effects we have soon to speak. But long
before 379 the horse were high in numbers and importance.
The cause was twofold. The most obvious reason for the
change was that there was an increasing need for rapidly
moving troops. The Germans in the early fifth century
generally aimed at plunder, not at conquest. Comparatively
small bands of them slipped between the frontier posts, with
the object of eluding pursuit, gathering booty, and then making
their way homewards. It was as yet only occasionally that a
whole tribe, or confederation of tribes, cut itself loose from its
ancient seat, and marched with wife and child, flocks and herds
and waggons, to win new lands within the Roman border. To

[1] Apparently under Constantine, as there are faint traces of it under Diocletian.

hunt down and cut to pieces flitting bands of wary plunderers, the fully-armed legion or cohort was not a very efficient tool. The men marched with heavy loads, and were accompanied by a considerable baggage train ; hence they could not, as a rule, catch the invaders. Cavalry, or very lightly-equipped infantry, alone were suitable for the task ; the mailed legionaries were as ill-suited for it as were our own line-regiments to hunt down the Pindaris of the Deccan in the present century.

But there was another reason for the increase in the numbers of the cavalry arm. The ascendency of the Roman infantry over its enemies was no longer so marked as in earlier ages, and it therefore required to be more strongly supported by cavalry than had been necessary in the first or second century. The Germans of the days of the dynasty of Constantine were no longer the half-armed savages of earlier times, who "without helm or mail, with weak shields of wicker-work, and armed only with the javelin,"[1] tried to face the embattled front of the cohort. Three hundred years of close contact with the empire had taught them much. Thousands of their warriors had served as Roman mercenaries, and brought home the fruits of ex-perience. They had begun to employ defensive armour ; among the frontier tribes the chiefs and the chosen warriors of their comitatus were now well equipped with mail-shirt and helmet. The rank and file bore iron-bound bucklers, pikes, the short stabbing sword (scramasax), as well as the long cutting-sword (spatha), and among some races the deadly francisca, or battle-axe, which, whether thrown or wielded, would penetrate Roman armour and split the Roman shield. As weapons for hand-to-hand combat, these so far surpassed the old framea that the Imperial infantry found it no longer a light matter to defeat a German tribe. At the same time there is no doubt that the morale of the Roman army was no longer what it had once been ; the corps were less homogeneous ; the recruits bought by the composition - money of the landholding classes were often of bad material ; the proportion of auxiliaries drawn from beyond the frontier was too large. Nor can we doubt that the disasters of the third century had left their mark on the soldiery ; the ancient belief in the invincibility of the Roman Empire and the majesty of the Roman name could no longer be held so firmly. Though seldom wanting in courage, the troops of the fourth

[1] See Tacitus, Annals, ii. 14.

century had lost the self-reliance and cohesion of the old Roman infantry, and required far more careful handling on the part of their generals.

The end of this transitional period was sudden and dreadful. The battle of Adrianople was the most crushing defeat suffered by a Roman army since Cannae—a slaughter to which it is most aptly compared by Ammianus Marcellinus. The Emperor Valens, all his chief officers,[1] and forty thousand men were left upon the field; indeed the army of the East was almost annihilated, and was never again its old self.

The military importance of Adrianople was unmistakable; it was a victory of cavalry over infantry. The Imperial army had developed its attack on the great *laager* in which the Goths lay encamped, arrayed in the time-honoured formation of Roman hosts—with the legions and cohorts in the centre, and the squadrons on the wings. The fight was raging hotly all along the barricade of waggons, when suddenly a great body of horsemen charged in upon the Roman left. It was the main strength of the Gothic cavalry, which had been foraging at a distance; receiving news of the fight, it had ridden straight for the battlefield, and fell upon the exposed flank of the Imperial host, "like a thunderbolt which strikes on a mountain top, and dashes away all that stands in its path."[2]

There was a considerable number of squadrons guarding the Roman flank; but they were caught unawares: some were ridden down and trampled under foot, the rest fled disgracefully. Then the Gothic horsemen swept down on the infantry of the left wing, rolled it up, and drove it in upon the centre and reserve. So tremendous was their impact, that the legions and cohorts were pushed together in helpless confusion. Every attempt to stand firm failed, and in a few minutes left, centre, and reserve were one undistinguishable mass. Imperial guards, light troops, lancers, auxiliaries and legions of the line were wedged together in a press that grew closer every moment, for the Gothic infantry burst out from its line of waggons, and attacked from the front, the moment that it saw the Romans dashed into confusion by the attack from the flank. The cavalry on Valens' right wing saw that the day was lost, and

[1] The grand masters of the infantry and cavalry, the count of the palace, and thirty-five commanders of corps of horse or foot.

[2] Ammianus, xxi. 12.

rode off without another effort, followed in disorder by such of the infantry corps on that side of the field as were not too heavily engaged to be able to retire. Then the abandoned foot-soldiery of the main body realised the horror of their position: beset in flank and rear by the horsemen, and in front by the mass which had sallied forth from the Gothic *laager*, they were equally unable to deploy or to fly, and had to stand to be cut down. It was a sight such as had been seen once before at Cannae, and was to be seen once again, on a smaller scale, at Roosbeke. Men could not raise their arms to strike a blow, so closely were they packed; spears snapped right and left, their bearers being unable to lift them to a vertical position; many soldiers were stifled in the press. Into this quivering mass the Goths rode, plying lance and sword against the helpless enemy. It was not till two-thirds of the Roman army had fallen, that the thinning of the ranks and the approach of night enabled a few thousand men to break out, and follow the fugitives of the right wing in their flight southward. (378.)

Such was the battle of Adrianople, the first great victory won by that heavy cavalry which had now shown its ability to supplant the heavy infantry of Rome as the ruling power of war. During their sojourn on the steppes of South Russia, the Goths, first of all Teutonic races, had come to place their main reliance on their horsemen. Dwelling in the Ukraine, they had felt the influence of that land, ever the nurse of cavalry from the day of the Scythian to that of the Tartar and Cossack. They had come to consider it more honourable to fight on horse than on foot, and every chief was followed by his squadron of sworn companions. Driven against their will into conflict with the empire, whose protection they had originally sought as a shelter against the oncoming Huns, they found themselves face to face with the army that had so long held the barbarian world in check. The first fighting about Marcianopolis and Ad Salices in 377 was bloody, but inconclusive. Then, when Valens had gathered all the forces of the East for a decisive battle, the day of judgment arrived. The shock came, and, probably to his own surprise, the Goth found that his stout lance and his good steed would carry him through the serried ranks of the Imperial infantry. He had become the arbiter of war, the lineal ancestor of all the knights of the Middle Ages, the inaugurator of that ascendency of the horsemen which was to endure for a thousand years.

The battle of Adrianople had completely wrecked the army of the Eastern Empire: Valens had stripped the Persian frontier and the whole of Asia to draw together the great host which perished with him. His successor Theodosius, on whom devolved the task of reorganisation, had to restore the entire military system of his realm.[1] He appears to have appreciated to its full extent the meaning of the fight of Adrianople. Abandoning entirely the old Roman methods of war, he saw that cavalry must in future compose the more important half of the Imperial army. To provide himself with a sufficient force of horsemen, he was driven to a measure destined to sever all continuity between the military system of the fourth and that of the fifth century. After concluding a peace with the Goths so soon as he could bring them to reasonable terms, he began to enlist wholesale every Teutonic chief whom he could bribe to enter his service. The Gothic princes and their war-bands were not incorporated with the Imperial troops or put under Roman discipline:[2] they served as the personal retainers of the emperor, whose " men " they became by making to him the oath of faithful service, such as they were wont to give to their own kings. In return the princes received from the Caesar the *annonae foederaticae*, which they distributed among their horsemen. Thus began the ruinous experiment of trusting the safety of the empire to the *Foederati*, as the Gothic war-bands were now called:[3] for in their hands there lay the fate of the realm of Theodosius, since they formed by far the most efficient division of his army. From this moment the emperors had to rely for their own safety and for the maintenance of order in the Roman world, merely on the amount of loyalty which a constant stream of titles and honours could win from the commanders of the Foederati. No sufficient force of native troops was raised to keep the Germans in check, and the remnants of the old national

[1] I imagine that the enormous gaps in the numeration of the regiments of the Eastern army in the *Notitia* largely proceed from the extermination of whole corps at Adrianople. We find, for example, of Sarmatian horse only *Ala* VII. surviving, *Ala* I. *Armeniorum* is missing, and *equites tertii Parthii*, and nearly all the regiments of the Zabdiceni and Cordueni. Of course other causes must have extinguished many corps, but the slaughter at Adrianople was probably the chief one.

[2] See Jordanes, § 28.

[3] Hence they do not appear in the *Notitia*, though a few cohorts and alae of Goths incorporated in the regular army are there to be found.

army felt that they were relegated to a secondary place in the scheme of military organisation.

Only six years after Adrianople there were already forty thousand Gothic and other Teutonic horsemen serving under their own chiefs in the army of the East. It was on them that Theodosius relied when a few years later he marched to reconquer Gaul and Italy from the usurper Magnus Maximus. In the two battles at Siscia and Aemona, which settled the campaign of 387, he saw his confidence justified. On each occasion the Roman army of the West, those Gallic legions which had always been considered the best footmen in the world, were finally ridden down and crushed by the Teutonic cavalry, which followed the standard of the legitimate emperor. But the West loved not to obey the East : there was a quasi-national spirit of rage and resentment deep sunk in the breasts of the Gallic legions : in 392 they rose again, murdered the young Valentinian II., whom Theodosius had set over them, and tried their luck once more against the Eastern emperor and his hordes of Foederati. Under the nominal leadership of the imbecile Eugenius, but really guided by a hardy soldier of fortune named Arbogast, the Western armies faced Theodosius at the battle of the Frigidus. They were beaten after a struggle far more fierce than that of 387,[1] and again the chief part in their defeat was taken by the twenty thousand Gothic horsemen who formed the core of the host of Theodosius.

Henceforth the cavalry arm began to be as predominant in the West as in the East. If for a time the foot-soldiery of Gaul and Britain maintained some of their ancient importance, it was merely due to the fact that two Teutonic races which had not yet taken to horsemanship—the Franks and Saxons—were at once their most formidable adversaries and their favourite recruiting ground. For in the Western no less than in the Eastern realm the German mercenaries were for the future to be the preponderant element in the Imperial army : the native troops took a very secondary place. A glance down the lists of military officers of high rank during the fifth century shows an enormous numerical superiority of alien over Roman names. It is true that since Constantine's day there had always been a large

[1] So much more fierce, that the fortune of war ultimately leaned to Theodosius, owing to the treachery of some of Eugenius' officers rather than to the actual fighting.

sprinkling of half - Romanized barbarians among the corps commanders—the names of many of the generals in Ammianus tell their own tale.[1] But it is only from the time of Theodosius downwards that the alien names form the ever-increasing majority. For some three generations after his death it is hardly an exaggeration to say that the higher ranks in the army were almost entirely in the hands of the Germans—from the day of Stilicho to that of Aspar and Ricimer. Aëtius and Marcellinus were the only first-class generals with Roman names that we meet in the time: the rest are all aliens. It was but natural, for the Foederati were the most important part of the army, and they would not obey any leaders save their own chosen chiefs and princes.

In the well-known treatise of Vegetius, *De Re Militari*, is preserved a picture of the state of the Imperial army in the Western provinces, painted probably in the time of Valentinian II., and during his second reign in the West (388–392).[2] The book would be of far greater value to us, if only Vegetius had refrained from the attempt to describe things as they ought to be instead of things as they were. He is far more concerned with the ancient history of the Roman legion, and with its organisation, drill, and tactics in the days of its strength, than with the degenerate corps that bore the name in his own day. Instead of describing the army of A.D. 390, with its hordes of Foederati, and its small legions and numeri, each only a thousand strong, Vegetius persists in describing the army of the early empire, when all the legions were five or six thousand strong, and still formed the most important element in the Imperial host. Apparently it was his wish to induce the young Emperor Valentinian, for whose instruction he wrote, to restore the ancient discipline and organisation. Accordingly we continually find him describing the ideal and not the actual, as is proved by his frequent confessions that "this custom has long been extinct," or that "only part of these exercises are now wont to be used."

[1] *e.g.* Daglaif, Rhoemetalces, Hormisdas, Fullofaudes, Vadomar, Merobaudes Nevitta, Immo, Agila, Malarich.

[2] I am inclined to hold that the *De Re Militari* belongs to the time of Valentinian II., and not, as many good authorities think, to that of Valentinian III. In the days of the latter the whole military system had so far gone to pieces that it is incredible that even an archæologist like Vegetius should have described it in the terms which he uses. But in 388–392 it was still holding together.

2

Vegetius was a theoretical admirer of the old legion, and wholly destitute of any insight into the meaning of the change in military science which had taken place during the last hundred years. His explanation of the decadence of the Roman infantry is founded on a story that we can prove to be untrue. "From the days of the Republic," he writes, "down to the reign of the sainted Gratian, the Roman foot-soldiery bore helm, cuirass, and shield; but in Gratian's time regular drill and exercise were gradually abandoned through negligence and idleness. The soldier ceased to wear his armour habitually, and grew to find it heavy when the time came to assume it. Wherefore the men begged leave from the emperor first that they might abandon the use of the cuirass, and then that of the helm. So our soldiery went out with breast and head unprotected to meet the Goths, and perished beneath their missiles on countless battlefields. And after so many disasters, and the sack of so many great cities, no commander has yet been able to persuade them to resume the salutary protection of helmet and cuirass. So when our men, destitute of all defensive arms, are drawn up for battle, they think of flight more than of victory. For what can the footman armed with the bow, without helm or breastplate, and even unable to manage shield and bow at once, expect to do? . . . Thus, since they will not endure the toil of wearing the ancient armour, they must expose their naked bodies to wounds or death, or — what is worse — surrender, or betray the State by disgraceful flight. And the result is, that, rather than bear a necessary toil, they resign themselves to the dishonourable alternative of being slaughtered like sheep."[1]

Here Vegetius—always more of a rhetorician than a soldier —has inverted cause and effect in the strangest fashion. It was true that by his own day the Roman infantry had for the most part become light troops and abandoned their armour. It was true also that the change had begun about the time of Gratian, for that emperor was reigning in the West when the disaster of Adrianople destroyed the army of the East. But all else in the story is obviously absurd and untrue. The Imperial foot-soldiery were still wearing the full ancient panoply when it first met the Goths. Ammianus, a strictly contemporary writer, twice speaks of the defensive armour of the legions during his account of the

[1] Vegetius, i. § 20.

battle of Adrianople.[1] More than ten years later the anonymous writer on military equipment who dedicated his little work to the three Augusti—Theodosius, Arcadius, and Honorius—takes the breastplate for granted, when he gives some advice as to thick underclothing to be worn beneath it for campaigning in the winter or in cold and damp regions.[2] Ten years later, the Roman soldiery on the column of Arcadius were still represented in helm and cuirass.

It is of course ludicrous to suppose that, at a time when the cavalry were clothing themselves in more complete armour, the infantry were discarding it from mere sloth and feebleness. The real fact was that the ancient army of mailed legionaries had been tried in the battlefield and found wanting. In despair of resisting the Gothic horsemen any longer by the solidity of a line of heavy infantry, Roman military men had turned their attention to the greater use of missile weapons for the foot-soldiery, and to developing the numbers and efficiency of their own cavalry. The scientific combination of bow and lance against brave but disorderly swarms of horse was a fair device enough—as was to be shown a thousand years later on the fields of Falkirk and Creçy.

If the new tactics failed first against the Goths of Alaric and then against the Huns of Attila, their want of success must not be attributed to their own intrinsic faultiness. The armies of Honorius and Arcadius and their successors were generally beaten because they were composed partly of untrustworthy and greedy Teutonic Foederati, fighting for pay and plunder, not for loyalty, and partly of native troops discouraged and demoralised by being slighted and taught to consider themselves inferior to their barbarian comrades. In the hands of a Stilicho or an Aëtius the Imperial army could still do some good fighting. But it was more usually under the command of self-seeking mercenaries or incapable court favourites, and gradually sank from bad to worse all through the fifth century. The deterioration was inevitable: as the Teutonic auxiliaries grew more and more convinced of the weakness and impotence

[1] (1) The heat of the day, "Romanos attenuatos inedia sitique confectos, et *armorum gravantibus sarcinis*, exurebat." (2) The lines of infantry close, and "nostri occursantes gladiis obtruncant: mutuis ictibus *galeae perfringebantur et loricae*."

[2] Being dedicated to Theodosius and his two sons as joint Augusti, the work must have been written in the years 394–395.

of their masters, they became progressively greedier and more treacherous. As the native troops saw the empire falling deeper into the slough, they lost all self-respect and all hope of victory, and—as Vegetius complained—came to battle with their minds fixed on discovering the safest and easiest line of retreat.

In the reigns of Honorius and Arcadius the Roman army finally ceased to be a regular and organised body. The *Notitia Dignitatum*, a document drawn up during their joint reign, somewhere about 406, still shows us the old arrangements surviving. We find that many of the Flavian cohorts and numeri, and many even of the legions of the early empire are still surviving, though they are well-nigh swamped by the scores of new barbarian corps, with extraordinary, magniloquent, and sometimes grotesque[1] names,—Honoriani and Theodosiani and Valentiniani and Arcadiani, and so forth,—not to speak of regiments which more clearly betray their nationality—cohorts and alae of Chamavi or Juthungi, Franks, Alamanni, Taifalae, Goths, and Alans (406-409). But chaos may be said to have set in with the invasion of Alaric and the contemporary civil wars caused by the subsequent rebellions of Constantine in Britain (407-411), Maximus in Spain (411), and Jovinus and Sebastianus on the Rhine frontier (411-412).

It was in these evil days, while the imbecile Honorius was skulking behind the walls and marshes of Ravenna, that the final disorganisation of the Imperial forces took place, and most of the old native corps disappeared. It was not till the day of Alaric that Italy came to know thoroughly the Gothic horsemen whose efficiency Constantinople had already comprehended and had contrived for the moment to subsidise. But now the Goth became the terror of Rome, as he had previously been of the East. His lance and steed once more asserted their supremacy : the generalship of Stilicho, the trained infantry of the old Western army, light and heavy, the native and Foederate cavalry whose array flanked the legions, were insufficient to arrest the Gothic charge. The last chance of salvation vanished when Stilicho was murdered by his ungrateful master, and then the conquerors rode at their will through Italy and sacked the Imperial city herself. When they quitted the peninsula, it was

[1] *e.g.* Leones Seniores, Ursi Valentiniani, promoti braccati seniores, Mauri tonantes, etc.

by their own choice, for there were no troops left in the world who could have expelled them by force (A.D. 409).

The day of infantry indeed was now gone by in Southern Europe: they continued to exist, not as the core and strength of the army, but as a subsidiary force—used as light troops in the day of battle, or to garrison fortresses, or to penetrate woods or mountains where the horseman could not pierce his way. Roman and barbarian alike threw their vigour into the organisation of their cavalry.

This tendency was only emphasised by the appearance on the Imperial frontier of the Huns, a new race of horsemen, formidable by their numbers, their rapidity of movement, and the constant rain of arrows which they would pour in without allowing their enemy to close. In their tactics they were the prototypes of the hordes of Alp Arslan, of Genghiz, and of Tamerlane. The influence of the Huns on the Roman army was very marked: profiting by their example, the Roman trooper added the bow to his equipment; and in the fifth century the native force of the empire had come to resemble that of its old enemy the Parthian state of the first century, the choicer corps being composed of horsemen in mail armed with bow and lance. Mixed with these horse-archers fought squadrons of the Teutonic Foederati, armed with the lance alone. Such were the troops of Aëtius and Ricimer, the army which faced the Huns on the plain of Chalons.

That decisive battle was pre-eminently a cavalry engagement. On each side horse-archer and lancer faced horse-archer and lancer—Aëtius and his Romans leagued with Theodoric's Visigothic chivalry—Attila's hordes of Hunnish light horse backed by the steadier troops of his German subjects, the Ostrogoths, Gepidae, Heruli, Scyrri, and Rugians. The Frankish allies of Aëtius must have been the largest body of foot-soldiery on the field, but we hear nothing of their exploits in the battle.[1] The victory was won, not by superior tactics, but by sheer hard fighting, the decisive point having been the riding down of the native Huns by Theodoric's heavier Visigothic horsemen (A.D. 450). It was certainly not the troops of the empire who had the main credit of the day.

[1] Jordanes tells us, however, that the Franks had a bloody engagement with Attila's Gepidae on the night before the battle, in which fifteen thousand men fell on the two sides. There were no doubt many infantry in the host of Aëtius. In Attila's harangue before the battle Jordanes makes him bid the Huns despise the "testudines" of the Romans, *i.e.* their infantry formed in solid masses.

COMMENCEMENT OF THE SUPREMACY OF CAVALRY.
BELISARIUS AND THE GOTHS

A.D. 450–552

TO trace out in further detail the meaning of the wars of the fifth century is unnecessary. But it must be observed that, as the years of its middle course rolled on, a divergence began to be seen between the tendencies of the Eastern and the Western Empire. In the West the Foederati became the sole military force of any importance. One of their chiefs, the Suevian Ricimer, made and unmade emperors at his good pleasure for some twenty years. A little later, another, the Scyrrian adventurer Odoacer, broke through the old spell of the Roman name, dethroned the last emperor of the West, and ruled Italy as a Teutonic king, though he thought well to legalise his usurpation by begging the title of Patrician from Zeno, the emperor at Constantinople (476 A.D.).

In the East the decline of the native troops never reached the depth that it attained in the West, and the Foederati never became masters of the situation. That Byzantium did not fall a prey to a Ricimer or an Odoacer seems mainly to be due to the Emperor Leo I. (457–474), who took warning by contemporary events in Italy, and determined that—even at the cost of military efficiency—the native army must be kept up as a counterpoise to the Teutonic auxiliaries. He unscrupulously slew Aspar, the great German captain whose preponderance he dreaded, though he himself owed his throne to Aspar's services. At the same time he increased the proportion of Romans to Foederati in his hosts. His successor Zeno (474–491) continued this work, and made himself noteworthy as the first emperor who properly utilised the military virtues of the Isaurians—the rough and hardy pro-

vincials of the southern mountains of Asia Minor.[1] These wild highlanders had hitherto been looked upon as intractable and troublesome subjects. Zeno showed that their courage could be employed to defend instead of to plunder their more quiet neighbours. He dealt with them as William Pitt dealt with the Celts of the Scottish hills thirteen hundred years later—formed them into numerous regiments and taught them to become soldiers instead of mere cattle-lifters. Zeno also enlisted Armenians and other inhabitants of the Roman frontier of the East, and handed over to his successor an army in which the barbarian element was adequately counterpoised by the native troops. He had done another good service to the empire by inducing the Ostrogoths, the most formidable of his Teutonic auxiliaries, to migrate *en masse* to Italy. It would have been an evil day for the East if Theodoric, after routing so many of Zeno's generals and ravaging so many of his provinces, had determined to stay behind in the Balkan peninsula. But, moved by the emperor's suggestions and sent forth with his solemn sanction, the Ostrogoth led off his people to win a new home, and left Moesia and Macedonia ravaged and ruined indeed, but free of barbarian settlers (489).

Under the comparatively peaceful reigns of Zeno's successors, Anastasius and Justin (491–527), the Eastern Empire was able to recover a considerable measure of strength, both military and financial. A small pamphlet which has come down to us from this time shows us how entirely the strength of its army now lay in the cavalry arm. A certain Urbicius—a tactician of the closet, not a practical soldier—dedicates to the Emperor Anastasius " an original device to enable infantry to resist horsemen." Prefacing his remarks by a statement that a new theory of the defensive is needed to meet the conditions of the day, he proposes to resuscitate the ancient Macedonian phalanx. But the projecting barrier of pikes, which formed the essential feature of that body, is not to be composed of the weapons of the soldiery themselves. The men are to retain their equipment with the bow and javelin—for apparently the whole Roman infantry were by this time furnished with missile weapons. But each decury is to take with it a pack-horse loaded with short beams set with spear-blades. When the enemy comes in sight, the beams are to be hastily placed in line before the front of the corps, so as to

[1] Diocletian, however, had raised two Isaurian legions, which appear in the *Notitia*.

form a continuous barrier of *chevaux-de-frise*. If the ground is open, and attack may be expected from all sides, the infantry are to range themselves in a hollow square, covered on all sides by the spikes and beams. "The barbarians charging with their usual headlong impetuosity, the *chevaux-de-frise* will bring them to a sudden stop, then the constant rain of missiles from our men will strike down rank after rank before they can overturn the machines, and they will infallibly be routed, more especially if the corners of the square are strengthened with the *balistae*[1] which each corps carries with it."

The weak points of this rather childish device are at once obvious. It presupposes that the infantry will always have time to form square, and that every pack-horse's burden will be unloaded with equal celerity—for obviously a single break in the continuity of the line of obstacles would be fatal. Moreover, it condemns the troops using it to complete immobility; their square once formed, they cannot move, and must remain rooted to the spot as long as the enemy has a single unbroken squadron left. Moreover, if the barbarians under cover of a charge send parties of dismounted men to pull away a few of the *chevaux-de-frise*, it is practically certain that they must succeed at some point or other. At the best the device only aspires to preserve the troops who use it from being cut to pieces—it cannot enable them to take the offensive, and an army condemned to an eternal defensive can never deal a decisive blow.

As a matter of fact, the experiment was never tried, and the army of the East continued to depend for victory on its horsemen, native and Foederate. By a fortunate chance, the wars of the generation which followed that of Urbicius and his master Anastasius are described to us in great detail by a capable and observant eye-witness, Procopius. From him we learn all that we can wish to know about the East-Roman army—its disposition, organisation, and tactics during the second and third quarters of the sixth century.

The victorious hosts of Justinian, which reconquered for the empire Italy, Africa, and Southern Spain, were composed in about equal proportions of foreign auxiliaries serving under their own chiefs and of regular native troops. The Foederati were

[1] Large machines on the principle of the crossbow, each worked by several men and throwing a heavy bolt to three times the distance that a javelin carries, as Urbicius is careful to explain.

still mainly Teutonic—Gepidae, Heruli, and Lombards; but there
was a not inconsiderable intermixture of Huns and a certain
number of Armenians among them. The native corps were
partly surviving *numeri—χαταλόγοι* is Procopius' name for them
—of the old standing army;[1] but to these were added many new
bodies, raised for a particular service or emergency by officers to
whom the emperor gave a grant of permission to gather men.
This was something like the English mediæval system of com-
missions of array—still more like the seventeenth - century
arrangement by which a Wallenstein or a Mansfeld gathered
mercenaries under royal sanction, but by the attraction of his
own name.

Both among the Foederati and among the native corps the
cavalry were by far the more important arm. The mailed
cataphracti or cuirassiers of the Asiatic provinces win the special
admiration of Procopius. The paragraph in which he indicates
the superiority of the horse-archer of his own day over the
ancient infantry is so characteristic that it is worth reproducing.

"Men there are who call our modern soldiery 'mere bow-
men,' and can praise only the troops of old, 'the shielded
legionaries who fought hand to hand with the foe.' They lament
that our ancient warlike courage has disappeared in these days,
and thereby show themselves to be mere ignorant civilians.
They say that 'bowman' was from the earliest times a term of
contempt, not remembering that the archers of Homer's day—
for of them they are thinking—were light troops without horse,
lance, shield, or defensive armour, who came on foot to the battle
and skulked behind a comrade's shield or took cover behind a
stone. Such archers of course could neither defend themselves
adequately nor set upon the enemy with confidence: they were
mere furtive hoverers on the edge of battle. Moreover, they were
such weak and unskilled shooters that they only drew the bow-
string to the breast, so that the arrow flew aimlessly and pro-
bably did no harm.

"Now our horse-archers are very different men. They come
to the fight cuirassed and greaved to the knee. They bear bow
and sword, and for the most part a lance also, and a little shield
slung on the left shoulder, worked with a strap, not a handle.
They are splendid riders, can shoot while galloping at full speed,
and keep up the arrow-flight with equal ease whether they are

[1] We hear of numeri still, but no longer of legions—all of them had disappeared.

advancing or retreating. They draw the bow-cord not to the breast, but to the face, or even to the right ear, so that the missile flies so strongly as always to inflict a deadly wound, piercing both shield and cuirass with ease. Yet there are men who in antique prejudice despise our horse-archers, out of mere ignorance and folly. For it is clear and obvious that the grandest military results in the wars of our own day have been attained by the use of this very arm."[1]

The professional soldiers of the sixth century were, in fact, entirely satisfied with the system of cavalry tactics which they had adopted, and looked with a certain air of superiority on the infantry tactics of their Roman predecessors. They thought that a cavalry force could be almost self-sufficient, if to the native horse-archer were joined the heavier squadrons of the subsidised Foederati, Lombards, Heruli, or Gepidae, led by their own princes and armed with the lance. The one could act as light troops, the other as supports, so that the infantry would hardly be needed save for garrison duty or service in woods, mountains, or morasses where the horseman could not penetrate. There was a certain amount of justification for this belief; the hard-fought battle of Daras in the first Persian war was mainly won by the cavalry. The still more decisive victory of Tricameron, which made an end of the Vandal power in Africa, was fought and won by the horse alone; the infantry were a march behind, and only arrived in the evening when the battle was over.

Justinian's army and its achievements were not unworthy of the praise which Procopius lavishes upon it: its victories were its own, while its defeats were generally due to the wretched policy of the emperor, who persisted in dividing up the command among many hands — a system which secured military obedience at the cost of military efficiency. Justinian might, however, plead in his defence that the organisation of the army had become such that it constituted a standing menace to the central power. The system of the Teutonic *comitatus*, of the "war-band" surrounding a leader to whom the soldiers are bound by a personal tie, had become deeply ingrained in the Imperial forces. Always predominant among the Foederati, it had spread from them to the native army, owing to the system by which distinguished officers were now allowed to raise corps of their own for the Imperial service, instead of being merely

[1] *De Bello Persico,* I. i. 25-40.

promoted to the command of old existing units. In the sixth
century the monarch had always to dread that the loyalty of the
troops towards their immediate commanders, in whose name they
had been levied, might prevail over their higher duties. For
generals of note came to be surrounded by bands of retainers
of a very dangerous size and temper, when they were allowed to
take into their own bodyguard any soldier of the line who
distinguished himself in action. Belisarius and even the eunuch
Narses were surrounded by large bodies of these devoted com-
panions.[1] The personal followers of the former at the time of
his Gothic triumphs amounted to no less than seven thousand
veteran horsemen : it was no wonder that the Romans exclaimed
that "the household of a single man has overthrown the kingdom
of Theodoric."[2]

The existence of such corps of retainers rendered every
successful commander a possible Wallenstein—to use a name
of more modern significance. Thus the emperor, in his desire
to avert the predominance of any single officer, would join
several men of discordant views in the command of an army—
usually with disastrous consequences. This organisation of the
Imperial forces in "bands,"[3] bodies attached by personal ties
to their leaders, is the characteristic military form of the sixth
century. Its normal prevalence is shown by the contemporary
custom of speaking of each corps by the name of its command-
ing officer, and not by any official title. Nothing could be more
opposed than this usage to old Roman custom.[4]

How entirely the efficiency of Justinian's army depended on
the combination of heavy cavalry with the bow, can best be
shown by a short description of the three chief victories which
it won in East and West over its most important foes.

Earliest in date is the battle of Daras (530), in which
Belisarius won his first decisive victory. Daras was an
important frontier fortress which was threatened by a Persian
army of forty thousand men. Belisarius had gathered about
twenty-five thousand to prevent the siege being formed. He

[1] Procopius, *De Bello Gotthico*, III. i.

[2] Procopius calls them δορυφόροι and ὑπασπισται. The usual Latin word for them
was *Buccellarii*, from *Buccellum*, the ration-biscuit, meaning retainers fed by their lord.

[3] βάνδον is used by Procopius both for the standard of the regiment, and for the
regiment itself.

[4] *e.g.*, where Ammianus would still talk of the "cohors quarta Thracum," Pro-
copius would call them "that catalogue of Thracians which Bryes led."

put them in array close outside the city, so as to get easy protection if he were beaten. The centre, composed mainly of foot, was much drawn back and "refused"; the wings, composed of horse in equal strength, were thrown forward. To prevent a breach of continuity between centre and wings, a reserve of six hundred chosen Fœderate cavalry (Huns) was placed at each flank of the infantry, charged with the duty of supporting the cavalry wing to which it was nearest. Behind the infantry was the general and his personal bodyguard of cuirassiers. The whole front of the line was protected by a ditch, broken by many open passages left for the free exit or retreat of regiments moving forward and back. That it was not a very formidable obstacle is shown by the fact that both sides crossed it without difficulty more than once in the day. One flank of the whole line was covered by an isolated hill; that the other had any such protection we are not told.

The Persians came on in two lines—apparently, like the Romans, with horse on the flanks and foot in the centre; but this is not expressly stated, though we know that the hard fighting was all done by the former. The infantry were, as Belisarius remarked, "half-trained rustics, only good for trench work and long shooting." On the first day there was an indecisive skirmish, on the second a pitched battle.

When the Persians advanced, they came into contact with the Roman wings, but not with the "refused" centre, which was so far drawn back that only arrow-fire was here exchanged when the two cavalry divisions on the flanks were already heavily engaged. On the Roman left the Persians made some impression at first; but when they had pushed forward beyond the trench, they were charged in flank by the reserve of Hunnish cavalry from the left of the line of infantry. At the same time a small body of Herule Foederati, which had lain hid on the isolated hill, charged them in the rear. They broke and retreated, but did not disperse or leave the field. The Romans re-formed in their first position.

On the right meanwhile the Persian attack had been far more formidable; their commander had placed there the famous corps called the "Immortals" and the pick of his other horsemen. In the first charge they drove the Roman cavalry right back to the gates of Daras. But in so doing the victorious squadrons became separated from their own centre, which was now engaged

PLATE I.

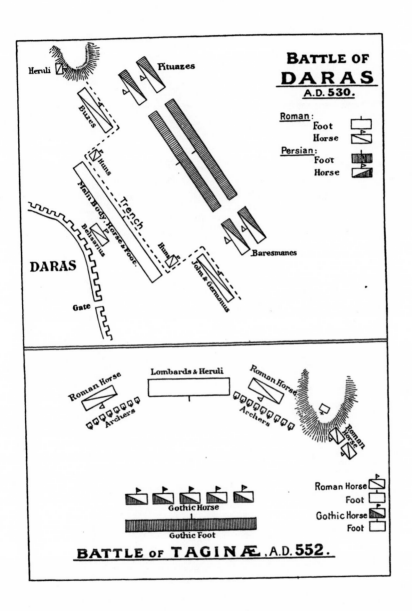

Battle of **DARAS** A.D. 530.

Roman: Foot, Horse. Persian: Foot, Horse.

Heruli. Pituazes. Buzes. Huns. Trench. Main Body, Horse & Foot. Belisarius. DARAS. Gate. Huns. John & Gemonius. Baresmanes.

Roman Horse. Lombards & Heruli. Roman Horse. Archers. Archers. Roman Horse. Roman Horse. Foot. Gothic Horse. Gothic Horse. Foot. Gothic Foot.

BATTLE OF TAGINÆ, A.D. 552.

in a duel of missiles with the Roman infantry behind the trench. Into the gap between the centre and the victorious wing Belisarius threw first the six hundred Huns who flanked his infantry on the right, then the similar body from the left, which he recalled the moment that the danger on that flank was ended. He himself with his bodyguard followed. Charged in flank and rear by these fresh troops, the Persian left wing fled away diagonally, in a direction which completely separated them from their own centre. Leaving the rallied right wing to pursue the fugitives, Belisarius now threw his Huns and body-guard against the exposed flank of the Persian centre. The infantry there stationed at once broke and fled, and suffered horrible slaughter. For the rest of the war the Persians never again would face the Roman host in the open for a pitched battle.

The main tactical point to be noticed in this fight is the deliberate purpose of Belisarius to keep his infantry out of the stress of the fight, and to throw all the burden of the day upon the horse. This was accomplished by " refusing " the centre and protecting it with the ditch, while the wings were thrown forward and so placed as to draw upon themselves the chief impact of the enemy. As the Persian had also strengthened his wings, all went as Belisarius desired, and the infantry in the centre hardly came to blows at all. If the hostile commander had adopted the opposite plan, that of reinforcing his centre and making his chief assault on the corresponding part of the Roman line, Belisarius would have been able to stop him by charging from the flank with his cavalry on to the Persians, when they had passed the level of his wings and had got into the hollow space in front of the " refused " line of infantry.

Of the two fights which settled the Vandal war we need say little; that of Ad Decimum was a mere "chance medley," fought without premeditation in a series of isolated combats. It is only noteworthy that the day was mainly won by the charge of the Hunnish light cavalry. The second and decisive battle, that of Tricameron, was a pure cavalry engagement. The infantry was a march to the rear when Belisarius found the Vandal host drawn out to oppose him. In spite of this, the great general resolved to fight at once; he placed his Foederate horse on one wing, his regular native regiments on the other, and his own bodyguard, the pick of the army and now several

thousand strong, in the centre. The front was covered by a small stream, which he hoped that the Vandals might be induced to cross, purposing to charge them just at the moment when they should be labouring through it. But King Geilamir would not take the offensive, and remained unmoved beyond the water. Belisarius sent several small detachments across the brook, to harass the hostile centre and induce it to charge and assault him. But the Vandals contented themselves with throwing out slightly larger bodies of horse, which drove the Romans back over the water, but refused to cross it in pursuit. Seeing the enemy grown so cautious, Belisarius concluded that they had lost their morale after their previous defeat at Ad Decimum, and might be dealt with summarily. Accordingly he bade his own centre cross the brook and advance for a serious attack. The Vandals thronged around it and gave the general's bodyguard very hard work for some minutes. But when all their attention was engrossed in the attempt to surround and destroy the Roman centre, Belisarius let loose his two wings and bade them cross the brook and do their best. Unprepared for a general assault all along the line, and apparently caught in flank while endeavouring to encompass the Imperial centre, the wings of the Vandal army broke at the first impact of the enemy. Their flight uncovered their comrades of the middle corps, who were nearly all cut to pieces, together with their commander Tzazo, the king's brother. Geilamir himself played a poor part, made no effort to rally his men, and escaped by the swiftness of his horse (535).

So ended the Vandal kingdom, wrecked in less than an hour of cavalry fighting. The lesson of the fight was simply that in a duel between two bodies of horse, the one which adopts a passive defensive, and receives the enemy's charge at a halt, will be scattered, in spite of a decided superiority in numbers. Geilamir's obvious duty was to charge the Roman centre while it was hampered in crossing the brook. He refused, allowed himself to be attacked, and lost the day. A similar example on a small scale was seen in the English heavy cavalry charge at Balaclava, thirteen hundred years later. There, too, the stronger force of cavalry chose to stand still to receive an attack: it bore up for some time against the frontal assault of the Scots Greys and Inniskillings, but broke at once and fled in disastrous confusion when its flanks were charged a

few minutes later by the Royals and 4th and 5th Dragoon
Guards.

The Gothic war, the greatest of the three struggles waged by
Justinian, was essentially a war of sieges and not of battles. In
the first half of it, indeed, down to Belisarius' capture of Ravenna,
there was no single general engagement between the Goths and
the Imperialists. The decisive event of this part of the struggle
was the long beleaguering of Rome, from which the Goths retired
foiled, partly because of their own unskilfulness in siegecraft,
partly because of the deadly fever of the Campagna, which had
thinned their ranks. But if the sieges were the chief events
in the struggle of A.D. 535–40, there were a good many skirmishes
and minor engagements which served to display the qualities and
tactics of the two armies. A glance cast round them shows that
on both sides the cavalry did almost all the fighting, and would
seem to have been the larger half of the host.[1] Infantry were, in
fact, so little used by Belisarius, that we read that during the
third year of the war[2] many of them procured themselves horses,
and learned to serve as light cavalry. On one occasion the com-
manders of the Isaurian archers, who formed the choicest part of
the foot-soldiery, came to the general complaining bitterly of
being kept out of the best of the fighting. Belisarius therefore
gave them a prominent part in his next sortie, more (we are told)
to conciliate such gallant soldiers, than because he thought it
wise to put them in the forefront of the battle. The result was
not happy for the infantry : they were shaken by the headlong
flight of a party of their own horse, who rode through their
ranks and put them into confusion. Then the Goths fell on
them and routed them : the two officers, Principius and Tarmutus,
who had counselled the sortie, were both slain while trying to
rally their broken troops.[3] The event of the fight only served
to confirm Belisarius in his belief in the absolute superiority of
cavalry.

The great general's own verdict on the military meaning of
the war has fortunately been preserved to us. On one occasion
during the siege of Rome,[4] some of his officers asked him how
he had dared to attack the Gothic power with such a small
army, and wished to know the causes of the confidence in his

[1] On one occasion we find a force composed of 4500 horse, and only 3000 foot.
[2] Procopius, *De Bell. Gott.* i. 28.
[3] *Ibid.* i. 29.
[4] *Ibid.* i. 27.

final success which he had always shown. Belisarius answered as reported by Procopius, who was himself present, in the following terms :—" In the first small skirmishes with the Goths, I was always on the look-out to discover what were the strong and weak points in their tactics, in order to accommodate my own to them, so as best to make up for my numerical inferiority. I found that the chief difference between them and us was that our own regular Roman horse and our Hunnish Foederati are all capital horse-bowmen, while the enemy has hardly any knowledge whatever of archery. For the Gothic knights use lance and sword alone, while their bowmen on foot are always drawn up to the rear under cover of the heavy squadrons. So their horse-men are no good till the battle comes to close quarters, and can easily be shot down while standing in battle array before the moment of contact arrives. Their foot-archers, on the other hand, will never dare to advance against cavalry, and so keep too far back." Hence there was no coherence between the two arms in the Gothic host ; the knights were always wanting to get to close quarters, while the bowmen preferred long shooting, and were nervously anxious not to be exposed to a cavalry charge. Thus it generally came to pass that the former, teased by the Roman arrows, were always making reckless and premature charges, while the latter, when they saw the horsemen beaten, absconded without thinking for a moment of retrieving the battle.

The clear-sightedness of Belisarius, and his complete appreciation of the weak point of the Gothic host, is best shown by a short account of the one great pitched battle which distinguished the war, though in that engagement the great general himself was not present. The fight of Taginae (552), which finally brought the struggle to an end, was won by the eunuch Narses, who, in spite of his training as a mere court chamberlain, showed military talents not inferior to Belisarius' own. His triumph was all the more striking because the Goths were now headed, not by the slow and incapable Witiges, with whom Belisarius had to deal, but by King Baduila, a gallant and experienced soldier, who had beaten the East-Romans in a score of minor fights, and thoroughly knew the tactics and methods of his adversaries.

Taginae lies just below the central watershed of the Apennines, near the modern Gubbio. The Goth had wished

to defend the mountain-line, but while he guarded the main pass, Narses slipped over by a side path, and appeared on the lower spurs of the western side of the range, at the head of the narrow valley down which runs the Chiascio, one of the affluents of the Tiber. Baduila arrived in time to seize the outlets of the valley, and to draw up his army so as to force Narses to fight, or else to make a perilous retreat back over a difficult pass, and in the face of a daring enemy. The scene of the battle was a small upland plain pressed in between the hills, with a breadth of perhaps two miles of ground suitable for the movement of cavalry. The two armies seem to have stretched across the level ground on an equal front, though the Imperialists had a considerable superiority in numbers. In front of the extreme left of Narses' position there was a small steep isolated hill which would have given good cover for an attack on that flank of his army. This he occupied with a small body of infantry; on the night before the battle the Gothic king tried to seize it, but the squadron of horse which he sent forward for that purpose could not make its way up the steep path which led to the summit of the mound, and was driven down with loss.

In accordance with Gothic custom, Baduila put all his confidence in his horsemen, who seem to have formed a good half of his host. They included all the flower of his nation, and were strengthened by many hundreds of German mercenaries who had, at one time and another, deserted the Imperial standards in order to serve under a leader in whom they recognised the last of the hero-kings of old. Baduila ranged his horsemen in the front line; the whole of his infantry, mostly archers, formed a second line in his rear. It was his purpose to carry all before him by a single charge there was to be no skirmishing or slow advance, but by a sudden unexpected onslaught he hoped to break through the Roman centre, where, as he could see with his own eyes, there appeared to be only infantry opposed to him. It was his object to get at the enemy as quickly as possible, in order to avoid the showers of arrows which were the strongest defence of the Imperialist troops. Delaying his attack all the morning, he suddenly hurled his whole army forward at the time of the midday meal, when he hoped to find Narses off his guard.

To meet the Gothic attack, the eunuch-general had adopted an order of battle which seems to have been of his own invention;

3

at any rate it had not been hitherto employed by any general in the wars of that age. He had composed his centre of the pick of his Foederate troops, eight or ten thousand Lombards, Gepidae, and Heruli, whom he had ordered to dismount from their horses and use their lances on foot. This employment of mailed horsemen as infantry recalls King Edward III.'s device at Creçy ; still more so does the rest of Narses' battle-array, for on each flank of the dismounted Foederati he had ranged his Roman foot-archers, four thousand on each wing ; they were slightly advanced in a curved half-moon, so that an enemy advancing against the centre would find himself in an empty space, half encircled by the bowmen and exposed to a rain of arrows from both sides. To protect the archers, the native Roman horse-soldiery, not dismounted, were arrayed immediately in their rear. Finally, on the left wing, where the isolated hill already described projected in front of the line, two detached bodies of cavalry were stationed, thrown out at an angle from the main line. The object of these was to deliver a side attack on the Gothic infantry, if it should advance close in the rear of its horse, and so expose itself to being rolled up from the flank.

The peculiarity of this formation was the combination of heavy masses of dismounted cavalry, armed with the lance and arrayed in close phalanx, with flanking bodies of archers. Infantry had so long given up any idea of resisting horse by a level front of spears, that Baduila seems to have had no idea of the strength of the tactics that were opposed to him. Even the historian who wrote the tale of the campaign ascribes a political and not a military purpose to Narses' order of battle. Procopius tells us that he distrusted the Lombards and Gepidae, thinking that they might retire, or even join the enemy, because of their sympathy and admiration for Baduila, and that he dismounted them to prevent their moving. But this very inadequate reason is evidently not the true one, for at Casilinum, the other great victory of the eunuch-general, a similar order was employed when there was no question of disloyalty among the Foederati.

At midday the Gothic king suddenly bade his horsemen charge ; they made for the hostile centre, leaving the wings of archers alone—a terrible mistake, much like that which the French knights committed at Creçy. For when they reached the centre of the semicircle formed by the Roman army, they

began to fall by hundreds beneath the converging fire from the
flanks. So disordered were the Gothic knights by their heavy
loss, and by the plunging and swerving of hundreds of wounded
or riderless horses in their ranks, that their charge slackened to
a very slow pace, and it was only after a long time, and with
great difficulty,[1] that they penetrated to the mass of dis-
mounted Foederati in the Roman centre. Having lost all the
advantage of a sudden impact, they did not break the line of
spears, and the battle resolved itself into a hand-to-hand fight
along a contracted front. Here the horsemen surged up and
down for several hours, vainly trying to make a gap, and being
shot down all the time by the volleys of arrows from the flanks.
Their own foot, who should have helped them by keeping the
Roman archers engaged, did not advance far enough to the
front, being apparently afraid to expose themselves to the risk
of a side-stroke from Narses' detached body of horse on the left
wing.

At last, at eventide, the Goths were thoroughly tired out,
and after one final effort the great mass of wearied and dis-
heartened horsemen gave back and began to retire. Narses at
once charged them with his Roman cavalry, who had as yet done
no work and were quite fresh. Then the Goths broke and fled,
and in their disorderly flight rode over their own infantry, who
in the confusion did not open their ranks to let the fugitives
through, but stood helpless and amazed.

So ended in complete success the first experiment in the
combination of pike and bow which modern history shows. It
is an interesting point of speculation to decide what would have
happened if Baduila had either commenced the battle with the
advance of his foot-archers supported by part of his horse, or
launched some of his cavalry at the Roman bowmen before
charging the dismounted men in the hostile centre. The whole
conduct of the battle on his side is so unworthy of his previous
fame, that we are tempted to accept the story told by Procopius,
that he was mortally wounded at the beginning of the great
charge, and that his men fought all the afternoon without a
leader. But the alternative tale which tells how he escaped
unhurt from the field, fled through the night, and was slain in a
chance medley by a small body of pursuing horsemen, has

[1] πολλῶν τε ἀνηκέστων κακῶν ἐς πεῖραν ἐλθόντες ὀψέ τε καὶ μόλις ἐς τῶν πολεμίων
ἀφίκοντο τὴν παράταξιν (Proc., De Bell. Gott. iv. 32).

generally been accepted by historians—perhaps merely because it presents more picturesque details.[1]

Narses had barely stamped out the last embers of the Gothic war, and received the surrender of the few fortresses which held out after the battles of Taginae and the Sarno, when he was called upon to encounter a new and altogether different race of antagonists. A great Frankish host, under the brothers Lothar and Buccelin, the generals of Theudebert of Austrasia, came pushing down into the peninsula, to prevent the Imperialists from enjoying the fruits of their victories. Unlike the Goths, the Franks were a nation of foot-soldiers armed with spear, sword, and axe: we shall deal with their methods of warfare in the next chapter. At Casilinum in Campania, not far from the battlefield of the Sarno where the Goths had made their last stand, Narses met and vanquished the eighty thousand men of Buccelin by a varied application of the same tactics which he had used against Baduila on the field of Taginae.

The Franks were wont to advance in a deep column or wedge, which was too solid to be easily broken by a flank attack: if assailed from the side during its advance, it halted, fronted to the exposed point, and beat off the assailants. Well acquainted with these tactics, Narses prepared a dreadful snare for the Franks. He ranged his foot-archers and other infantry in the centre, placed a chosen band of dismounted Foederati behind them, and arrayed his native Roman cavalry, all horse-archers, in two long wings. The Frankish column came rushing down on the centre, and scattered the front line of regular infantry and the second line of archers behind them without any great difficulty. It then came into contact with the Heruli and other Foederati who lay behind the light troops, and began to push them back. But at this moment Narses wheeled inwards both his wings of horse and threatened to charge the flanks of the advancing mass. The Franks were at once forced to halt, and made ready to receive the attack of the cavalry. But instead of letting his horsemen close, Narses halted them a hundred yards from the enemy, and bade them empty their quivers into the easy target of the great weltering mass of spearmen. The Franks could move neither to front nor flank, for fear of breaking their array and letting the horsemen into the gaps, hence they stood helpless, exposed to a shower of missiles

[1] Proc., *De Bell. Gott.* iv. 35.

PLATE II.

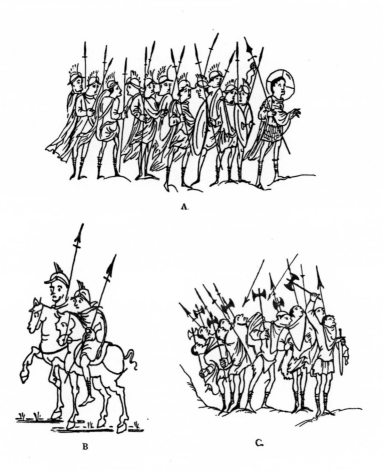

A.

B

C.

FRANKISH WARRIORS

to which they could make no reply. Their stubborn bravery kept them rooted to the spot for some hours, but at last they lost heart, and began to tail off to the rear, the one side on which they were not surrounded. Waiting till they were well shaken and lapsing into disorder, Narses ordered a general charge. His horsemen rode through and through the broken column, and made such a slaughter that it is said that only five of Buccelin's army got away from the field.

With this last victory of the Roman army of the East in Italy we may close the transition period in the history of the art of war. The old classical forms have long vanished, and with the appearance of the Franks on the field we feel that we have arrived at the beginning of the Middle Ages.

BOOK II

THE EARLY MIDDLE AGES
A.D. 500–768

CHAPTER I

THE VISIGOTHS, LOMBARDS, AND FRANKS

WHEN we leave the discussion of the military art of the later Romans, and pass on to investigate that of the Teutonic kingdoms which were built upon the ruins of the Western Empire, we are stepping from a region of comparative light into one of doubt and obscurity. If, in spite of our possessing military manuals like that of Vegetius, official statistics such as the *Notitia Dignitatum,* and histories written by able soldiers like Ammianus and Procopius, we still find difficult points in the Roman art of war, what can we expect when our sole literary material in Western Europe consists of garrulous or jejune chronicles written by Churchmen, a few fragments of ancient poems, and a dozen codes of Teutonic laws? To draw up from our fragmentary authorities an estimate of the strategical importance of the Persian campaigns of Heraclius is not easy; but to discover what were the particular military causes which settled the event of the day at Testry or the Guadelete, at Deorham or the Heavenfield, is absolutely impossible. We can for some centuries do little more than give the history of military institutions, arms, and armour, with an occasional side-light on tactics. Often the contemporary chronicles will be of less use to us than stray notices in national codes or songs, the quaint drawings of illuminated manuscripts, or the mouldering fragments found in the warrior's barrow.

It is fortunate that the general characteristics of the period render its military history very simple. By the sixth century the last survivals of Roman military skill had disappeared in the West. No traces remained of it but the clumsily-patched walls of the great cities. Of strategy there could be little in an age when men strove to win their ends by hard fighting rather than by skilful operations or the utilising of extraneous

41

advantages. Tactics were stereotyped by the national
organisations of the various peoples. The true interest of the
centuries of the early Middle Ages lies in the gradual evolution
of new forms of military efficiency, which end in the establish-
ment of a military caste as the chief power in war, and in the
decay among most races of the old system which made the
tribe arrayed in arms the normal fighting force. Intimately
connected with this change was an alteration in arms and
equipment, which transformed the outward appearance of war
in a manner not less complete. The period of transition may
be considered to end in the eleventh century, when the feudal
knight had established his superiority over all descriptions of
troops pitted against him, from the Magyar horse-bowmen of
the East to the Danish axemen of the North. The fight of
Hastings, the last notable attempt of unaided infantry to with-
stand cavalry in Western Europe for two hundred years, serves
to mark the termination of the epoch.

The Teutonic kingdoms which were founded in the fifth
century within the limits of the Western Empire were some of
them established by races accustomed to fight on horseback,
some by races accustomed to fight on foot. All the tribes
which had their original habitat in the plains beyond the
Danube and north of the Euxine seem to have learned horse-
manship: such were the Goths, both Eastern and Western,
the Lombards, Gepidae, and Heruli. The races, on the other
hand, which had started from the marshes of the Lower
Rhine or the moors of North Germany and Scandinavia, were
essentially foot-soldiery; the Franks, Saxons, Angles, and
Northmen were none of them accustomed to fight on horseback.
The sharp division between these two groups of peoples is all
the more curious because many tribes in each group had been
in close contact with the Romans for several centuries; and it
might have been expected that all would have learned a similar
lesson from the empire. Such, however, was not the case: the
Franks of the fifth century, though their ancestors the Chamavi
and Chatti had been for four hundred years serving the Romans
as auxiliaries when they were not fighting them as enemies,
seem singularly uninfluenced by their mighty neighbours; while
the Goths under similar conditions had profoundly modified
their armament and customs. In the days of the breaking-up
of the Western Empire the Franks seem no more advanced

than races like the Saxons and Angles, whose relations with
Rome had begun late and continued comparatively slight. To
a certain extent this must have come from the fact that the
emperors had been wont to encourage each band of auxiliaries
to keep to its own national arms and equipment. In the fourth
and fifth centuries, as Mommsen observes, each Teutonic corps
of mercenaries seems to have been valued more, in proportion
as it had assimilated itself less to the Roman model. In spite
of this, it is astonishing to find the Franks of Chlodovech still
destitute of all body-armour and wholly unaccustomed to fight
on horseback. Our surprise is only the greater when we find
that the Imperial host had actually included an ala or two of
Frankish cavalry[1] in the year 400. Evidently the Roman
teaching had taken no hold on the bulk of the race, and its
methods of fighting had remained unaltered.

(I.) The Visigoths, 500–711.

We have already spoken of the Goths, and their pre-
ponderant use of cavalry in war. We have seen the Visigoths
of Theodoric charging the Huns on the Catalaunian plain, and
the Ostrogoths of Baduila fretting away their strength against
the horse-archers of Narses. The latter race disappear from
the stage of history in 553, but their Western kindred survived
and kept the same warlike customs down to the eighth century.
Considered as a military power, the Visigoths were not strong;
they generally failed in their contests with the foot-soldiery of
the Franks, and they were shattered with shameful ease by the
Saracens of Tarik and Musa. It would seem, however, that we
must ascribe their weakness to political rather than to purely
military causes. From the first they were too few to hold
firmly the enormous realm that they had conquered. The
Suevi could brave them for several generations in the
Galician hills: the weak chain of Imperial garrisons which
Justinian had established along the southern coast of the
Peninsula was able to hold out against them for seventy years.
The Visigoths of the sixth and still more of the seventh century
appear to have consisted of a not very numerous aristocracy of

[1] *e.g.* one cantoned in Egypt and another in Mesopotamia occur in the *Notitia*.
What is more curious still is that there occurs in the province of Phoenicia an "ala
Saxonum"; so that even the Saxons had been formed into cavalry. (Not. Or.
Thebais, 31–53 ; Mesopotamia, 31–33 ; and Phoenicia, 32–37).

nobles, surrounded by war-bands of their personal retainers, *buccellarii* or *clientes*, without any solid national body below them. The original army of Alaric and Ataulf had been small, and the Gothic conquerors could not recruit their numbers by amalgamating frankly with the Spanish provincials, owing to the fatal bar of religion. Reccared's conversion to orthodoxy (589) seems to have come too late to save the race from perishing for want of numbers. From the military point of view, the masses of provincials counted for little or nothing; though they seem from the first to have been made liable to service in the host, they were unwilling and inefficient auxiliaries.[1] Amalgamation between them and their masters began so late that it was not quite complete even at the time of the Saracen conquest in 711. The ruin of the kingdom was the want of a solid middle class of free Goths. For lack of it the strength and core of the Visigothic armies consisted of the counts and the horsemen of their personal retinues, the oath-bound *clientes* or *buccellarii* who had made themselves the "men" of the nobles. This body showed all the faults of feudal armies of a later age, for the spirit of loyalty was wanting. The old royal house died out with the slaughter of Amalric in 531, and none of the later kings succeeded in founding a permanent dynasty. The throne passed rapidly from usurper to usurper, and each great man might covet it, and hope some day to snatch at it by the aid of his war-band. The provincials passed helplessly from hand to hand without asserting any will of their own: the later kings utterly failed in their effort to build up a strong royal power based on the friendship of the Church and the support of the masses. Towards the end of the seventh century there seems to survive no free middle class at all; apparently a process like that which occurred in England after the Danish invasions had driven the small freemen to "commend themselves" to the local magnates and become their clients.

The Spanish nobles were at the first, like the English thegnhood, an aristocracy of service, not of blood. The original host of Ataulf which conquered Spain was Visigothic in name, but in reality a mixed multitude of Teutons of all sorts. The Visigothic nucleus which Alaric had originally commanded in Epirus was quite small; it only swelled to a great army by the

[1] We hear of the Arverni, all provincials without doubt, serving by themselves, and under a native leader, in the Visigoth host that fought at Vouglé as early as 507.

junction of adventurers of all sorts, especially that of the thirty
thousand Foederati in Italy who joined the invader after the
murder of Stilicho. Hence in this heterogeneous mass there was
no generally recognised noble blood, such as was to be found
among more compact nationalities, like the Lombards, Bavarians,
or Saxons. The only original distinction came from being
promoted to official command by the king. But the men who
had once been given the appointment of "count" or "duke"
grew wealthy, acquired lands, and accumulated clients. Their
descendants in a few generations formed a true nobility based
on wealth and local influence. The majority of the provincial
governors were drawn from their ranks, and they resented in a
body the attempts of strong-handed kings to supersede their
class in office by the preferment of obscure but loyal members
of the royal *comitatus*. Chindaswinth (641–652) and Wamba
(672–680) tamed them for a short time, but the moment that
the sceptre passed to weaker hands, the aristocracy asserted
itself again. At the moment when the monarchy fell in 711, it
had become wholly feudalised: the nobles and bishops were
the real masters of the realm.

The stream of Spanish annals is such a scanty one that we
learn very little about the details of the interminable civil wars
of the sixth and seventh centuries. Towards the end of the
latter the chronicles fail altogether, and the Egicas and
Rodericks of the last days of the realm are mere names to us.
It is certain, however, that by the end of the seventh century
the Visigothic kings were at their wits' end to keep up the
numbers of their army; a notable law of Wamba gives the
best proof of it. He orders that "every man who is to go forth
in our host, duke or count or castellan, Goth or Roman, freeman
or freedman, or holder on a servile tenure of royal domain-land,
shall bring with him to the expedition a tenth part of his slaves
armed with weapons of war."[1] Nothing but the utter want of
a middle class of warlike small proprietors could account for
this desperate expedient being tried. A similar deduction may
be made from the fact that another law of Wamba orders even
clerical landholders to come to the host with their armed slaves.
Of the organisation of the army we know only that the counts
led the levies of their own districts, each of which corresponded
as a rule to an ancient Roman *civitas*. Under the counts were

[1] *Lex Visigothorum*, ix. 2, 9.

thiufads or thousand-men, and *centenarii* or hundred-men, whose duty was to collect the host each in his own locality. In time of peace the count and thousand-man were judges and governors, like an English ealdorman; in time of war they took the field at the head of the whole levy *en masse*, Gothic or Roman, of their district. Spanish armies, therefore, were often very numerous, but they were disorderly, undisciplined, and generally very half-hearted in their service. The masses of provincials cared nothing for their ephemeral kings, and thought much more of propitiating their local despots, the counts. Hence rebellious nobles could generally rely on the service—slack and unwilling though it might be—of the inhabitants of their government. By the seventh century the majority of these inhabitants had become the "men." of their rulers, who thus reached such a pitch of greatness that we find them called, even in state documents, *tyranni*,[1] as if they were independent princes.

The Gothic nobles and their war-bands fought on horseback, "gaudent equorum praepeti cursu," as Isidore of Seville wrote in 615;[2] though, when necessary, they would dismount. Their great weapon was the lance; their bodies were covered with harness of ring-mail or scale-armour, and their heads by crested helms, probably of the same shape as those worn by their neighbours the Franks. They bore round shields, swords, and daggers (*semispatha*, *scrama*). The mace and axe were not unknown to them; the use of the latter they had learned from the Franks, and they therefore called it *francisca*. That defensive armour was fairly common may be deduced from the fact that King Erwig (680) ordered that even of the slaves whom the bishops and nobles led to the host, some should wear a mail-shirt, though the majority were only expected to come with shield, spear, sword, *scraina*, or bow and sling.[3] The word employed

[1] *e.g.* in some of Wamba's rescripts.

[2] The passages on weapons in Isidore of Seville's *Etymologicon* are so pedantic, and so stuffed with quotations from Virgil and Lucan, that we might be tempted at first to dismiss them as wholly useless repetitions of Roman usage. But this would be unjust to the author, who shows that he is not wholly neglectful of the things of his own day by making notes on the *scrama-semispatha*, and adding a mention of the "secures quas et Hispani ab usu Francorum per derivationem franciscas vocant." It is to be noted also that he has no account of the old Roman breast and back harness of plate under *lorica*, and only catalogues the mail-shirt of rings and the *lorica squamea* of scales. See *Etym.* xviii. § 11, 13, 18.

[3] *Lex Visigothorum*, ix. § 9.

for the mail-shirt is *zaba*, the same which Maurice and Leo use for the armour of the Byzantine cavalry-soldier, and not *brunia* (*byrnie*), the common term of the Franks, Saxons, and other Teutonic tribes of the North.

The provincial levies, as opposed to the counts and their *clientes*, were great masses of unarmoured infantry, like the old English *fyrd*, armed with rude and miscellaneous weapons, and serving much against their will. There was little or no infusion of Gothic blood amongst them, and their service was perfunctory unwilling, and inefficient.

The Visigoths seem to have had a greater skill in the poliorcetic art than many of their Teutonic kinsmen. Probably it was picked up from the East-Romans during the long sieges of the haven-towns of South Spain during the reigns of Reccared, Sisibut, and Swinthila, when for a whole generation (580–620) the main political object of the kings was to recover the ports of Andalusia and Algarve, which the folly of Athanagild had betrayed to the generals of Justinian. We find that the Visigoths were acquainted with the *funda* and *balista*, which threw respectively stone balls and darts, that they used the ram (*aries*), and aided its work with the *pluteus* (shelter-hurdle) and the *musculus* for digging into the foundations of walls. In the one siege of which we have considerable details, that in which Wamba took Nismes in 673, the ram, the stone-throwing machine, and fire-arrows are described as in use.[1]

The end of the Visigoths as a military power was sudden and disgraceful. How far the immediate cause of the loss of the battle of the Guadelete was disloyalty on the part of the counts, or slackness on the part of their subjects in the provincial levies, or a deficiency of properly-equipped fighting men, we cannot tell. The details of the fatal day are lost; nor have we sufficient notices of any Spanish wars of the previous century to enable us to construct a full account of the tactics of the Visigothic army.

(II.) The Lombards, 568–774.

Concerning the Lombards, the last of the Teutonic races whose strength lay in their horsemen, we have far more knowledge. They were in much more direct touch with the Eastern

[1] See Archbishop Julian's *Life of Wamba*, the last really detailed piece of Visigothic history which survives.

Empire than any of their brethren during the sixth, seventh, and eighth centuries, so that we have a certain amount of information bearing on them from Byzantine sources. Their early legends have been preserved by the excellent Paul the Deacon, who also furnishes us with a sketch of their later annals, abounding in those picturesque tales which, though they may not be accurate history, are invaluable as giving the manners and customs of the race. In addition we can draw on the information contained in the code of laws drawn up by Rothari (643) and the supplements appended by his successors. Like all the races that have ever dwelt by the Middle Danube, they were essentially a race of horsemen. The primitive folk-tales recorded by Paul show it very clearly; on their first actual appearance on the stage of history it is equally manifest. Procopius records how they sent to Narses two thousand five hundred horsemen of noble birth, and three thousand of lesser race who were the attendants and squires of the others. If they dismounted at Taginae to stand the Gothic charge, it was by Narses' order; the old general had resolved to make his centre solid by placing there his steadiest auxiliaries.[1] A little later, when they invade Italy on their own account, we read of every king and duke and hero fighting with lance and war-horse at the head of his men. One interesting passage in Paul gives us the armament of the Lombard knight—helm and mail-shirt, and even greaves, which last many Western races had not adopted even three centuries later.[2] In another, we read of the great lance (*contus*), so strong that a Lombard champion, who had pierced a Byzantine horseman through the body, actually lifted him from his saddle and bore him aloft wriggling on the weapon's point.[3] The other great Lombard weapon was the broadsword (*spatha*), which seems to have been worn at all times,[4] not merely when the warrior was equipped for war. On one occasion only do we hear of a hero fighting with a club, and then only because his lance was not to hand.[5] Though acquainted with the bow,[6] they do not seem to have used either it or the javelin to any extent

[1] Not, we need hardly repeat, because he wished to prevent troops of doubtful loyalty from leaving the field.

[2] "Loricam suam, galeam, atque ocreas tradidit diacono, et caetera arma." (Paul. v. 40).

[3] *Ibid.* v. 10.

[4] In Paul. vi. § 51 it is worn at the king's council board; in vi. § 38 at a feast.

[5] *Ibid.* vi. § 52. [6] *Ibid.* v. § 33.

in war.　It was always on lance and war-horse that they placed
their reliance, like the Goths, who had held the plains of
Northern Italy before them.　It was always on horseback that
their plundering bands crossed the Alps to ravage Provence and
Dauphiné, faced the Bavarians on the Upper Adige, or pursued
the Slovenes of Carinthia when they dared to molest the borders
of Friuli.　From a passage in the *Tactica* of Leo the Wise we know
that, when hard pressed and surrounded, the Lombard knights
would turn their horses loose, and fight back to back in a solid
mass, with spears levelled outwards.[1]　It must have been only
in dire extremity that they would do so.　Paul the Deacon
tells in one characteristic passage relating to a Lombard defeat,
how Argait the Schultheiss was slain with many of his men
because he must needs spur his horse up an almost inaccessible
slope to attack the plundering bands of the Carinthian Slavs.
His duke Ferdulf had taunted him with the words, " Arga
[slothful] is your name and your nature too."　To vindicate his
courage, Argait and his horsemen charged up the steep slope and
were destroyed by the great stones which the Slavs rolled down
on them, whereas, if they had dismounted and turned the
position, they were " men many and brave enough to have
destroyed thousands of such foes."[2]

　　It is perhaps worth noting that the horse appears more fre-
quently in the Lombard laws than in those of any other Teutonic
people.　There are countless clauses relating to horse-stealing,
to horse-breeding, to the valuation of horses, to assaults such as
throwing a man off his horse (*meerworphin*), to accidents caused
by the kick of a horse, to the buying and selling of horses.　A
war-horse with its trapping was valued as high as one hundred
solidi, twice the value of the life of a household slave, and two-
thirds of that of a free Lombard of low degree.[3]　The king's
breed of chargers was highly esteemed, and the gift of one of
them to a retainer or a high official was a great mark of favour.

　　The Lombards, unlike the Franks, Visigoths, and Saxons,
were not a collection of war-bands, nor a mixed multitude of
diverse races,[4] but a compact national body moving down *en
masse* with wives and children, flocks and herds, to occupy the

[1] Leo Sapiens, *Tactica*, xviii. § 81.　　　　[2] Paul. vi. § 24.
[3] See Laws of Rothari and Luitprand, *passim*.
[4] Though there were many Saxons and broken men of small tribes with Alboin
(Paul. ii. § 26, iii. § 5), yet the great majority were Lombards.

4

well-nigh depopulated plain of Northern Italy. But there was a disintegrating force among them; this was the want of a permanent royal house. Even before the conquest of Italy by Alboin, their dynasty, according to their own legends, had changed several times. Alboin was only the second of his race who had reigned over them. When he died heirless, and his immediate successor, Cleph, was slain only a year later, the nation could not agree on the choice of a king, and lived for ten years without one. But they did not cease to advance and to conquer, though they were only led by the "dukes" (*heretogas* or *ealdormen*, as the Anglo-Saxons would have called them), who were the heads of the various *faras* or families which made up the nation. Under these princes the Lombards broke up into tribal groups: some entered Gaul to ravage Burgundy; others pushed down the peninsula of Italy, and established the duchies of Spoleto and Benevento. It was only the pressure of a Frankish invasion, aided by the Byzantines, that drove them into combination again, and forced them to crown Authari as their king. The kingdom thus restored was never so strong as it should have been; the dukes of Spoleto were in practice, if not in name, independent of it, and those of Benevento hardly acknowledged its supremacy at all. It was only Luitprand (712–744), who reigned but shortly before the Frankish conquest of Italy, that welded the Lombards north of Benevento into a compact state.

The warlike organisation of the race, as was the case in all the Teutonic kingdoms, was the same which served for civil government. The Lombard realm was divided up into duchies; there are said to have been thirty-six, and the men of each district rode to war under their duke. These chiefs were generally of the old noble blood of the race, *eorl-kin*, as the English would have called them. Chance has preserved the names of some of these old noble families, the houses of Caupus and Harodos, Beleo, Anawas, and Hildebohrt. As the realm grew stronger, the king sometimes replaced a rebellious duke by an officer more directly dependent on himself, a *gastaldus*; those who had borne this title at first seem to have been the governors of cities in the royal domain,[1] and the guardians of the royal domains within the duchies. There appears to have been a large middle class of Lombard race, the thing that was so

[1] Domus Nostrae Civitates, *Codex Dipl. Long.* ii. 334.

much lacking among the Visigoths of Spain. All Lombards small and great were *exercitiales* (or *arimanni*), bound to turn out at the monarch's call to war, like the English *fyrd*. Many, both noble and simple, had made themselves the king's "men," by the oath of personal devotion. They were called *gaisindi*,[1] a word corresponding of course to the Anglo-Saxon *gesith*, and, like the *gesith*, rode in their lord's train, and had their place in his hall. The chief of these military retainers were the *marpahis* or constable, the *scilpor* or shield-bearer, and the banner-bearer of the king. The dukes in a similar way kept smaller bands of *gaisindi*, but they were never able to make henchmen of the whole of the freemen resident in their duchies, as did the counts of Visigothic Spain. The number of the Lombards of middle fortune was too great to allow of such a usurpation taking place, and the king's *gastaldus* and *schultheiss* (reeve, as the English would have called him) were present in each duchy, to keep its ruler in check, and afford protection to any freemen whom he might strive to oppress.[2]

Having dealt with Goth and Lombard, we may now turn to the Teutonic kingdoms of the North, where infantry and not horsemen were the main power in war.

(III.) The Franks, 500-768.

The Frankish tribes whom Chlodovech had united by the power of his strong arm, and who under his guidance overran the valleys of the Seine and Loire, were among the least civilised of the Teutonic races. In spite of their long contact with the empire, they were (as we have already had occasion to mention) still mere wild and savage heathen when they began the conquest of Northern Gaul. The Franks, as pictured to us by Sidonius Apollinaris, Procopius, Agathias, and Gregory of Tours, still bore a great resemblance to their Sigambrian or Chamavian ancestors whom Tacitus described more than three centuries earlier. The words in which Sidonius paints them in 460 are practically identical with those which Agathias used more than a century later, so that even the conquest of Southern Gaul seems to have made little difference in their military

[1] Paul translates *gaisind* by *satelles*, vi. 38.

[2] See the Law of Rothari, 23: "Si dux exercitialem suum molestavit injuste, gastaldus eum solatiet, quousque veritatem suam inveniat," etc.

customs. The poetical bishop of Auvergne speaks of their unarmoured bodies girt with a belt alone, their javelins, the shields which they ply with such adroitness, and the axes which, unlike other nations, they use as missiles, not as weapons for close combat. He mentions their dense array and their rapid rush, "for they close so swiftly with the foe, that they seem to fly even faster than their own darts." Agathias is more detailed, but he is evidently describing a race in exactly the same stage. "The arms of the Franks," he says, "are very rude; they wear neither mail-shirt nor greaves, and their legs are only protected by strips of linen or leather. They have hardly any horsemen, but their foot-soldiery are bold and well practised in war. They bear swords and shields, but never use the sling or bow. Their missiles are axes and barbed javelins (ἄγγωνες). These last are not very long, they can be used either to cast or to stab. The iron of the head runs so far down the stave that very little of the wood remains unprotected. In battle they hurl these javelins, and if they strike an enemy the barbs are so firmly fixed in his body that it is impossible for him to draw the weapon out. If it strikes a shield, it is impossible for the enemy to get rid of it by cutting off its head, for the iron runs too far down the shaft. At this moment the Frank rushes in, places his foot on the butt as it trails on the ground, and so, pulling the shield downwards, cleaves his uncovered adversary through the head, or pierces his breast with a second spear."[1]

The *francisca* or casting axe was even more typically a Frankish weapon than the barbed *angon*. Numerous specimens have been found in Merovingian graves;[2] it was a single-bladed axe with a heavy head, composed of a long blade curved on its outer face, and deeply hollowed in the interior. It was carefully weighted, so that it could be used, like the American tomahawk, for casting purposes, even better than for close combat. The skill with which the Franks discharged the weapon just before closing with the hostile line was extraordinary, and its effectiveness made it the favourite national weapon. A shield, sword, and dagger completed the arms of the warrior: the first-named was of a broad oval shape, and had a large iron boss and an iron rim; the sword was a two-edged cut-and-thrust weapon,

[1] Agathias.
[2] One was in the first Frankish monument to which a definite date can be given, Childeric's tomb at Tournay (481).

ranging from thirty to thirty-six inches in length ; the dagger
(*scramasax, semispatha*) was a broad thrusting blade of some
eighteen inches.

For some two centuries on from the time of Chlodovech,
these were the arms of the Frankish foot-soldiery ; they seem to
have borrowed nothing from their Roman predecessors. It is
true indeed that some of the Gaulish levies who served the
Merovings continued for a space to wear the ancient equipment
of the troops of the empire. Such, at least, is the statement of
Procopius, an author whose words are never to be lightly treated :,
he says that many of the Gaulish cities, having surrendered
themselves on favourable terms to the Frankish conqueror, were
still in his own day sending their contingents to the host under
their ancient banners, and wearing the full Roman array, even[1]
down to the heavy-nailed military sandals. There is nothing
incredible in this statement ; it is certain that from a very early
stage of the conquest of Gaul the Frankish kings strengthened
their armies from the ranks of the provincials, an experiment
which was far easier for them than for Lombard or Visigoth,
because they were not divided from their subjects by the fatal
bar of Arianism.[2] But it is quite clear that the conquerors
did not adopt the arms of the conquered, and that the survival
of the Roman garb and weapons among the Gauls disappeared
in the sixth century. Just as we find Gallo-Romans adopting
Frankish names by the end of that age, so we find them
assimilating Frankish military customs. The tendency among
the masses is towards the barbarising of the provincial, not to-
wards the civilising of the Teuton. All through the Merovingian
times, and indeed down to the time of Charles the Great him-
self, the Frankish armies were mainly great disorderly masses
of unarmoured infantry, fighting in dense column formation.

It is among the highest classes alone that the effect on the
invaders of their contact with the lingering civilisation of Gaul
is to be seen—in things military as in all other things. The
epigram which the Gothic sage made concerning his own
tribesmen and the conquered provincials was true of the Franks

[1] καὶ σημεῖα τὰ σφέτερα ἐπαγομένοι οὕτω ἐς μάχην καθίστανται, καὶ σχῆμα τῶν
Ῥωμαίων ἔν τε τοῖς ἄλλοις ἅπασι καὶ ἐν τοῖς ὑποδήμασι διασώζουσιν (*De Bell. Gott.* i. 12).

[2] As Fustel de Coulanges points out, even Chlodovech himself seems to have had
Gauls in his army, especially a certain Aurelianus, whom he made ruler of Melun
(*M. F.* 495).

also: "The poor Roman tends to assimilate himself to the German, and the wealthy German tends to assimilate himself to the Roman."[1] While the masses in Gaul forgot the old military habits of the empire, and degenerated into disorderly tribal hordes, the kings and great nobles among the Franks borrowed something from the externals of the vanishing civilisation. Just as they appropriated relics of Roman state and show in things civil, so in certain military matters they did not remain entirely uninfluenced by the Roman practice. In the sixth and seventh centuries we find among them the feeble beginnings both of the use of cavalry and of the employment of armour, commencing around the person of the king, and gradually spreading downwards.

Of the employment of horsemen among them the first mention is in Procopius,[2] who says that King Theudebert, while invading Italy in 539 with a hundred thousand men at his back, had a few horsemen whom he kept about his person. They were armed with the lance, but nothing is said of their wearing armour; probably it was still very rare among them, and only used by kings, dukes, and counts. It is remarkable that on the whole there is very little mention of defensive arms in Gregory of Tours, though he describes countless battle scenes. Even chiefs engaging in single combat before their followers do not always seem to have been provided with them.[3] But from the middle of the sixth century onwards armour seems gradually to grow usual among great men, and then among all the wealthier classes. Bishop Sagittarius in 574 is blamed for taking the field "armed not with the sign of the heavenly cross, but with the secular cuirass and helm."[4] Count Leudastes shocks the good Bishop of Tours by entering his house in helm and breastplate, a quiver swinging at his waist, and a lance in his hand.[5] The henchman of Duke Guntram wears a breastplate, and is drowned by its weight in a ditch (A.D. 583).[6] The usurper Gundovald Ballomer is saved by his body armour from the stroke of a javelin (A.D. 585).[7] In the Saxon war of 626 we read of both Clothar II. and his son Dagobert wearing

[1] " Romanus miser imitatur Gothum, et Gothus utilis imitatur Romanum."

[2] De Bell. Gott. ii. 25.

[3] So I gather from the account of the single combat of Guntram and Dracolenus in Gregory, v.

[4] Gregory, iv. § 18.

[5] Ibid. v. § 48.

[6] Ibid. vi. § 26.

[7] Ibid. vii. § 38.

helm and breastplate (A.D. 626).[1] The *brunia*, which com-
posed the body armour, was no doubt usually the mail-shirt of
rings which we find among all Teutonic races in the Middle
Ages. But scale armour·sewn on to a leather foundation was
also known ; it was sometimes of the fish-scale shape, sometimes
square-scaled. In either case it was fixed so that each row of
scales overhung the one below it, and protected the upper ends
of it, where the thread fastened it to the leather. There seems
to have been no survival beyond the fifth century of the old
Roman *lorica* of plate ; perhaps Western armourers were not
capable of forging it ; but even at Byzantium, where the power
to make it was not wanting, this form of cuirass disappeared :
probably it was inconvenient for the horse-bowman, and was
dropped when he became the chief factor in war in the East,
that the more pliant mail-shirt might take its place.

The Frankish headpiece was of a peculiar form, very dis-
similar both to the usual shapes of the Roman helmet and to the
pointed Byzantine casque with its little tuft. The typical form
among the Franks was a morion-shaped, round-topped head-
piece, peaked and open in front, but rounded and falling low at
the back, so as to cover the nape of the neck. It was furnished
with a comb or crest, which may have been composed either
of thin metal or of leather. This very peculiar helm bears
more likeness to a sixteenth-century morion than to any shape
among the numerous headpieces of the Middle Ages. Its
prototype, however, was undoubtedly one of the less common
late Roman types, not the old classical helmet, which we see
on the head of Honorius or Justinian, but one more like that
worn by certain classes of gladiators, and occasionally represented
on coins of the fifth and sixth centuries. [See Plate No. II.]

Some German writers have doubted the existence of the
crested Frankish helm, such as appears in hundreds of
Carlovingian and pre-Carlovingian representations of military
figures.[2] They allege these drawings to be the mere slavish
copies of old Roman pictures, taken from fourth or fifth
century manuscripts. There was, no doubt, an immense
amount of such copying done, but that the crested helm never
existed is incredible. The Franks brought no headpiece of their
own into Gaul ; they had fought bareheaded when they dwelt

[1] *Vita Dagoberti*, § 13.
[2] As, for example, those from the Utrecht Psalter on Plate II.

on the moors of Toxandria. But they found the late Roman helm in full use in their new realm, and there can be no doubt that their kings and nobles borrowed it from their subjects. From the first, as we have seen, the Franks used their provincial vassals as auxiliaries in the field. The Roman condottieri, like Count Aurelianus, who served under Chlodovech I., no doubt wore the crested headpiece; so did the Gallic contingents, whom Procopius describes as serving "with the old Roman uniform and standards," in the army of Theudebert in 539.[1] We cannot suppose that when the Gallo-Roman Bishop Sagittarius equipped himself in a helm in 574, to fight the Lombards, he put on some newly-invented Frankish headpiece.[2] Undoubtedly the old crested helm of the late Roman period was perpetuated among the leading men of the Gallic provincials, and was taken directly from them by the Franks. It only gave way to simpler forms of a more pointed shape in the ninth century. No doubt, however, this costly metal helm was always rare; when headpieces became more common, cheaper productions, such as the leather caps of a plain round shape, which the MSS. of the eighth and ninth centuries often display, were more usual. But the helm which the eighth-century Lex Ripuaria values at six solidi[3]—half the price of a mail-shirt—must have been no leather makeshift, but an elaborate piece of metal-work, to be worth such a great price.[4]

The Frankish shield, it may be added, was usually round and very convex. It was made of wood bound at the edges with iron, and possessed a prominent boss, which was sometimes spiked. It was only when the use of the horse in war became common, that the round shield became kite-shaped. Before the ninth century the circular shape was almost universal.

The use of the horse in battle seems to extend itself in exactly the same proportion as that of body armour, spreading downward through the sixth and seventh centuries, till, by the close of the Merovingian age, it has become usual among the upper classes; the counts and dukes with their immediate

[1] See p. 53. [2] See p. 54.

[3] The *brunia* is mentioned in the early Ripuarian law, and valued at twelve solidi, the helm at six, the sword at seven (*Lex Rip.* xxxvi. § 11). It is more surprising to find *bainbergae* (greaves) mentioned, and valued at six solidi.

[4] See illustration on Plate II.: the Utrecht Psalter is late, but its drawings are copied from Merovingian originals.

retinues were habitually fighting on horseback by the end of the seventh century, though when pressed or surrounded they would still dismount and fight on foot like their ancestors. The first single combat on horseback related to us is that of Guntram and Dracolenus in 578. Early instances of the appearance of a considerable body of cavalry are found in the army of Count Firminus in 567,[1] and that of Duke Leudigisl in 584;[2] but the first mention of a regular cavalry charge which settled a battle is in the Saxon war of Chlothar II. in 626. The king, irritated by the cries of the enemy, who from the other side of the Weser kept pelting him with taunts and insults, "put spurs to his horse and crossed the stream, all the Franks following him and swimming through the water, though it was full of fierce whirlpools." Chlothar engaged Bertwald, the Saxon leader, before his men could come up with him; "then all the Frankish horsemen, who were still far behind their lord, shouted, "Stand firm, O king, against thy adversary!" Chlothar's hands were wearied, "for he wore a breastplate, and the water which had soaked all his garments rendered them very heavy," but he slew Bertwald before his men reached him, and then together they made a vast slaughter of the Saxons.[3]

That, as a rule, the proportion of horsemen in a Merovingian army, even in the seventh century, was very small, can be gathered from many pieces of evidence. The battle picture which Fredegarius gives of the victory of Zülpich in 612, when Theuderich of Burgundy beat his brother of Austrasia, may serve as a fair example, because the writer specifies it as the most bloody and obstinate combat on a large scale which had been seen in human memory. It appears that the fighting was all on foot, for "so great was the press when the hostile masses [*phalanges*] met and strove against each other, that the bodies of the slain could not fall to the ground, but the dead stood upright wedged among the living."[4] Obviously this could only

[1] Gregory, iv. § 30. In this case the horses are only mentioned as lost by their riders after a defeat; does this mean that they had dismounted to fight? They are described as swimming the Rhone on their backs.

[2] *Ibid.* vii. § 35.

[3] *Vita Dagoberti*, § 13.

[4] "Tanta strages ab utroque exercitu facta est, ubi phalangae ingressae certamine contra se praeliabant, ut cadavera occisorum undique non habuerint ubi inclines jacerint, sed stabant mortui inter ceterorum cadavera stricti, quasi viventes" (Fredegarius, 38).

have happened in an infantry fight. Still more interesting is the account of the array of the Franks a hundred years later, at the all-important battle of Poictiers, where Charles Martel turned back the advancing flood of Saracen horsemen who had swept so easily over the débris of the Visigothic monarchy. "The men of the North," says the chronicler, "stood as motionless as a wall;[1] they were like a belt of ice frozen together, and not to be dissolved, as they slew the Arabs with the sword. The Austrasians, vast of limb, and iron of hand, hewed on bravely in the thick of the fight; it was they who found and cut down the Saracen king." Obviously, therefore, at Poictiers the Franks fought, as they had done two hundred years before, at Casilinum, in one solid mass,[2] without breaking rank or attempting to manœuvre. Their victory was won by the purely defensive tactics of the infantry square; the fanatical Arabs, dashing against them time after time, were shattered to pieces, and at last fled under shelter of the night. But there was no pursuit, for Charles had determined not to allow his men to stir a step from the line to chase the broken foe. Probably he was right, for an undisciplined army cannot advance against cavalry without danger, and the Arabs, even when repulsed, were too agile and brave to be allowed the chance of penetrating into the mass. We must conclude, therefore, that the Frankish chiefs and nobles had all dismounted and fought on foot in the "wall of ice" which they opposed to the fiery onslaught of the Moslem horsemen. Such tactics were, no doubt, exceptional by the eighth century, and adopted only against an enemy all-powerful in horsemen. Against armies of Saxons, or Frisians, or Bavarians, composed wholly or almost wholly of foot-soldiery, the Franks would employ their proportion of mounted men to advantage. We have already seen King Chlothar, a hundred years before Poictiers, lead a charge against a Saxon host at the head of his cavalry. Perhaps a less able general than Charles Martel would have tried the experiment against the Arabs, and courted disaster thereby. For a few thousand Frankish knights could have

[1] "Gentes septentrionales ut paries immobiles permanentes, et sicut zona rigoris glacialiter adstricti gladio Arabes enecant. Gens Austriae mole membrorum praevalida et ferrea manu per ardua pectorabiliter ferientes regem inventum exanimant" (Isidorus Pacensis).
[2] See p. 63.

done nothing against the swarms of invaders, while the infantry, destitute of the backing of mailed men of high rank and practised skill, might have been ridden down.

Nothing could have been more primitive than the military organisation of the Merovingian era. The count or duke who was the civil governor of the *civitas* was also its military head. When he received the king's command, he ordered a levy *en masse* of the whole free population, Roman, it would appear, no less than Frankish. From this summons, it seems that no one had legal exemption save by the special favour of the king. In practice, however, we gather that it cannot have been usual to take more than one man from each free household.[1] That the "ban" did not fall on full-blooded Franks alone, or on landholding men alone, is obvious from the enormous numbers put in the field. The levy of the county of Bourges alone was fifteen thousand men,[2] and, as Fustel de Coulanges remarks, it is incredible that in such a district, at a time when large estates were common, there should have been fifteen thousand families holding their land straight from the king. The fine for failing to obey the ban was enormous: by the Ripuarian law it was sixty solidi for free Franks, thirty for Romans, freedmen, or vassals of the Church.[3] At a time when a cow was worth only one, and a horse six solidi, such a sum was absolutely crushing for the poor man, and very serious even to the rich.

There is as yet no trace of anything feudal in the Merovingian armies. The Franks in Gaul appear, as far as can be ascertained from our sources, to have had no ancient nobility of blood, such as was to be found among the eorl-kin of England, the Edilings of continental Saxony, and the Lombard ducal families. The Franks, like the Visigoths, seem to have known no other nobility than that of service. Chlodovech had made a systematic slaughter of all the ruling families of the small Frankish states which he annexed; apparently he succeeded in exterminating them. Among all his subjects none seems to have had any claim to stand above the rest except by the royal favour. The court officials and provincial counts and dukes of the early Merovings were drawn from all classes, even from the

[1] Such would be the deduction from the document quoted by Fustel de Coulanges, *Monarchie Franque*, p. 293, where a son is allowed to volunteer for a campaign in his father's place.

[2] Gregory of Tours, vi. § 31. [3] *Lex Rip.* lxv. § 2.

ranks of the Gaulish provincials. Great officers of state with
Roman names are found early in the sixth century ; by the end
of it, the highest places of all were open to them. One Gallo-
Roman, Eunius Mummolus, was King Guntram's commander-in-
chief ; a few years later, another, Protadius, was Mayor of Bur-
gundy, and first subject of the crown. The Frankish king, like all
Teutonic sovereigns, had his own " men " bound to him by oath ;
they were called *antrustions*, and corresponded to the English
gesith, the Lombard *gaisind*, and the Gothic *saio*. But they do
not appear to have been a very numerous body, certainly not
one large enough to form the chief element of importance in the
host, though there were enough of them, no doubt, to furnish
the king with a bodyguard. The Frankish tariff of weregilds
shows that the *antrustions* were drawn from all classes. In each
rank of life their valuation was very much higher than that of
persons not included in the royal *comitatus*. Both the Salic and the
Ripuarian laws value a free Frank at two hundred solidi, but a
freeman " in the king's trust " at six hundred. That there were
also Gauls and *letes* (freedmen) among the *antrustions*, is shown by
two clauses of the Salic law, which fine " anyone who, at the head
of an armed band, has broken into the house of a freeman in
the king's trust and slain him, eighteen hundred solidi ; and
anyone who has broken into the house of a Roman or a lete in
the king's trust and slain him, nine hundred solidi." [1] From the
ranks of the *antrustions* were drawn the counts and dukes who
headed the Frankish provincial levies in the field.

It seems clear that these officials had very imperfect control
over the men whom they led out to war. Being mere royal
nominees, without any necessary local connection with the
district which they ruled, their personal influence was often
small. When the counts, with their subordinates in the ad-
ministrative government, the *vicarii* and *centenarii*, took the field,
it was at the head of masses of untrained men. There was
neither pay nor even food provided for the army, the men being
supposed to bring their own rations with them—even down to
the time of Charles the Great. Hence it was no marvel that
bad discipline, and a tendency to plunder everywhere and any-

[1] *Lex Sal.* xlii. (ed. Hessels) : "Si quis collecto contubernio hominem ingenuum in
domo sua occiderit, si in truste dominica fuit ille qui occisus est, solidos MDCCC
culpabilis judicetur : solidos DCCCC si quis Romanum vel litum in truste dominica
occiderit."

where, were the distinguishing features of a Merovingian army.
Having exhausted its own scanty food supply, the host would
turn to marauding even in friendly territory: the commanders
were quite unable to keep their men from molesting their
fellow-subjects, for hunger knows no laws. When in a hostile
country, they lived by open rapine, eating up the land as they
passed; if therefore a long siege or a check in the field confined
them for some time to the same spot, they soon harried it bare,
and were then reduced to starvation. Gregory of Tours and
Paul the Deacon show one great host in Lombardy reduced to
such straits that the men sold their very clothes and arms to buy
bread.[1] Time after time large armies melted away, not because
they had been defeated, but merely because the men would not
stand to their colours when privations began. To this cause,
more than to any other, is to be ascribed the fact that after the
first rush of the Franks had carried them over Gaul, they failed
to extend their frontiers to any appreciable extent for more than
two hundred years.

The other great disease of Merovingian hosts was want of
discipline. Unless the king himself were in the field, there was
the gravest danger that the contingents of the various provinces
would fail to obey their commander-in-chief. One count
thought himself as good as another, and the local levies might
have some respect for their own magistrate, but cared nothing
for the man who ruled a neighbouring province. The Merovings
sometimes tried to secure obedience by creating dukes for the
frontier regions, and giving them authority over several counts
and their districts, so as to secure uniformity of action against
the enemy. But there was no proper hierarchy either of civil or
of military functionaries ever established, nor was subordination
of man to man really understood. The generals of King Gun-
tram answered to their master when he rebuked them for a
disgraceful defeat at the hands of the Visigoths:[2] " What were
we to do? no one fears his king, no one fears his duke, no one
respects his count; and if perchance any of us tries to improve
this state of affairs, and to assert his authority, forthwith a
sedition breaks out in the army, and mutiny swells up." This
is almost the same language used by the Byzantine emperor,
Leo the Wise, when, three hundred years later, he describes the
Franks of his own day.

[1] Gregory of Tours, x. § 3. [2] *Ibid.* ix. § 31.

Even the kings themselves often found that the hereditary respect of their people for the royal blood was insufficient to secure obedience. Chlothar I. in 555 wished to make peace with the Saxons, when they offered him tribute and submission. But his army thought themselves sure of victory, and yearned after the plunder that had been promised them. They forced Chlothar to send away the Saxon envoys and to fight.[1] As might have been expected, the disorderly host was well beaten. An example of the opposite form of indiscipline was seen in 612, when the armies of Theuderich II. and Theudebert II.—one of the numerous pairs of unnatural brothers who disgrace the annals of the Merovings—were in presence. When Theuderich bade his men advance, they broke their ranks, slew the Mayor Protadius in the king's very tent, because he tried to urge them on, and forced their unwilling master to make peace with the Austrasians. It is marvellous that this phenomenon did not take place more often; so worthless were the Merovings, and so futile their pretexts for war with each other, that one can only wonder at the docility of the subjects who let themselves be butchered in such a cause.

[1] Gregory, iv. § 8.

CHAPTER II

THE ANGLO-SAXONS

IN their weapons and their manner of fighting, the bands of Angles, Jutes, and Saxons who overran Britain were more nearly similar to the Franks than to the German tribes who wandered south. In blood and language, however, they were more akin to the Lombards than to the Franks; but two or three hundred years spent by the Danube had changed the Lombard warriors and their military customs, till they had grown very unlike their old neighbours on the Elbe from whom they had parted in the third or fourth century. The Angles and Saxons, even more than the Franks, were in the sixth century a nation of foot-soldiery, rarely provided with any defensive armour save a light shield. They had been in comparatively slight contact with the empire, though they had made occasional piratical descents on the east coast of Britain even before the year 300, and though one "ala Saxonum" appears among the barbarian auxiliaries of the *Notitia*.[1]

The arms and appearance of the war-bands which followed Hengist or Cerdic across the North Sea can best be gathered from the evidence of the countless Anglo-Saxon graves which have been excavated of late years. We must trust the Fairford or Ossengal cemeteries rather than the literary evidence of Bede or the *Beowulf*, which are excellent for the seventh and eighth centuries, but cannot be relied upon for the fifth and sixth. Arms and armour had been profoundly modified in the interval.

It is doubtful whether even the chiefs of the first English war-bands wore any defensive armour. Probably they, like their *gesiths*, used to go out to war in their tunics, with undefended head and breast, and bearing the broad shield of linden tree

[1] It is most curious to find these Saxons acting as cavalry, and stationed so far east as Phoenicia. (See p. 43.)

alone. This was a round convex target like that of the Franks,
bound with iron at the rim, and furnished with a large projecting
iron boss. Often it seems to have been strengthened by a cover-
ing of stout leather.

Of the offensive arms of the old English the spear was the
most prominent: they were in this respect still in the stage
which Tacitus had described four centuries back. The most
usual form of the weapon had a lozenge-shaped head, ranging
from ten up to eighteen or even twenty inches in length. Barbed,
leaf-shaped, and triangular spear-heads are occasionally found,
but all of them are far less common than the lozenge-headed
type. The shaft was usually ash, fastened to the head by rivets :
it seems to have averaged about six feet in length. The sword
appears to have been a less universally employed weapon than
the spear ; the usual form of it was broad, double-edged, and
acutely pointed. It had very short cross-pieces, which only
projected slightly beyond the blade, and a very small pommel.
In length it varied from two and a half to three feet. As an
alternative for the sword the old English often used in early
times the broad two-edged dagger eighteen inches long, re-
sembling the scramasax of the Franks, which they called *seax*,
and associated with the Saxon name. The axe, the typical
weapon of the Frank, was rare in England, but the few specimens
that have been found are generally of the Frankish type, *i.e.* they
are light missile weapons with a curved blade, more of the type
of the tomahawk than of the heavy two-handed Danish axe of
a later day.

The organisation of the English conquerors of Britain differed
from that of the other Teutonic invaders of the empire in
several ways. They were not a single race following its
hereditary king like the Ostrogoths, nor were they, like the
Franks, a mass of small, closely-related tribes welded together
and dominated by the autocratic will of the chief who had united
them. They were not of such heterogeneous race as the so-
called Visigothic conquerors of Spain, nor, on the other hand, so
homogeneous as the Lombards of Italy. The Ostrogoths and
Lombards were nations on the march ; the Franks and Visigoths
were at least the subjects of one king. But the old English were
merely isolated war-bands who had cast themselves ashore at
different spots on the long coast-line of Britain, and fought each
for its own hand. They were but fragments of nations whose

larger part still remained in their ancient seats.[1] Their chiefs
were not the old heads of the entire race, but mere *heretogas*,
leaders in time of war, whose authority had no ancient sanction.
No continental Teutonic State started under such beginnings:
the nearest parallel that we can point out is the time when the
Lombards, after the death of King Cleph, abode for ten years
without a king, and pushed their fortunes under thirty inde-
pendent dukes. But this condition of things lasted but a few
years in Lombardy, and was soon ended by the outward pres-
sure from Frank and East-Roman. In Britain it was more than
four hundred years before the Danish peril led to a similar
result.

The old English kingdoms, therefore, were the small districts
carved out by isolated chiefs and their war-bands. They were
won after desperate struggles with the Romano-Britons, who did
not submit and stave off slaughter like their equals in Gaul or
Spain, but fought valiantly against the scattered troops of the
invaders. If a mighty host commanded by one great king like
Alaric or Theodoric had thrown itself upon Britain in the fifth
century, the provincials would certainly have submitted: they
would have saved their lives, and probably have imposed their
tongue and their religion upon the conquerors within a few
generations. But instead of one Theodoric there came to
Britain a dozen Hengists and Idas, each with a small following.
The Romano-Britons were often able to hold the invaders back
for a space, sometimes to entirely beat them off. Even after the
Saxons had gained a firm footing on the southern coast, they
were unable to advance far inland for two generations. Hence
it came to pass that in its early stages the conquest was not a
matter of submission under terms, such as always happened on
the Continent, but a slow hunting of the Romano-Britons towards
the West and North.[2] In the first stage of the conquest, there-
fore, the English kingdoms were almost wholly Teutonic, and the
survival of the Celtic element small; yet it is certain that some
men of the old race still remained on the soil as *laets* and many
more as slaves. The realm of Kent or Sussex or Essex would
be composed of a *heretoga* who had become permanent and
adopted the title of king, of his personal oath-bound followers

[1] At least this was the case with Jute and Saxon : the majority of the Angles did,
in all probability, cross the seas.

[2] This, one must certainly imply from Bede i. 15, and from Nennius.

5

or gesiths, and of other freemen, some of noble blood (*eorls*), some of simple blood (*ceorls*). Below them were the non-Teutonic element—a few laets and many more slaves. The kingdom of Kent as it appears in the laws of King Aethelbert (A.D. 600) still preserves the character of the days of the first conquest. Having attained its full limits in a few years, and being cut off from further expansion into Celtic Britain, its condition has become stereotyped. In such a State the army consisted of the whole free population, and was a homogeneous Teutonic body, very unlike a contemporary Visigothic or Frankish host. The simple freemen (ceorls) have a very important position in the State : they possess slaves of their own (laws 16, 25) ; the fine for violating their domicile is half that paid for violating an " eorl's tun " in the same way [1] (laws 13, 15); to put one of them in bonds is a high crime and misdemeanour (law 24). Laets of various standing exist, but evidently the free Teuton is the backbone of the community. The king's dependants are but slightly mentioned, nor does the word *gesith* occur in the code, though it is found in the additions made to the Kentish law by Wihtraed [2] ninety years later.

But the later and larger English kingdoms were of a somewhat different cast. The picture of Wessex which we get in Ini's Code, a production of about the year 700, gives us a less simple and a less Teutonic realm than that of Aethelbert. [3] Even before the coming of Augustine and the introduction of Christianity, the English had begun to admit the Romano-Britons to terms. [4] · After a victorious campaign the cities were still sacked and burned, but the Celtic country-folk were no longer reduced to slavery or at the best to laethood, but were granted an independent, though an inferior, status as freemen. The laws of Ini speak of Welsh subjects of the king owning a half-hide or even a whole hide of land. [5] They even serve in his retinue : the horse-wealh who rides on his errands is specially mentioned, [6]

[1] So too for misdoings with a ceorl's slave the fine is half of that for meddling with an eorl's (laws 14, 16).

[2] Wihtraed's laws, § 5.

[3] It has been lately suggested that Ini's Code is connected with the settlement of newly-won British land rather than with the ordering of the whole of Wessex.

[4] See, for example, Bede's account of the heathen Aethelfrith, "who conquered more territory from the Britons, either making them payers of tribute, or driving them out, than any other king or 'tribune' of the English " (i. 34).

[5] Law 32. [6] Law 33.

and King Cynewulf had a Welshman among his gesiths.[1] We
are reminded at once of the Frankish king and his Gallo-Roman
antrustions on the other side of the Channel.[2] But something
more is to be noted in the Wessex of 700. Society seems to be
growing more feudal, and the nobility of service is already assert-
ing itself over the old eorl-blood. We find not merely slaves
and Welshmen, but English ceorls under a *hlaford* or lord,
to whom they owe suit and service. If they try to shirk their
duty to him, heavy fines are imposed on them.[3] We are
tempted to infer that a large proportion of ceorls were now
either the vassals of lords or the tribute-paying tenants on royal
demesne land.[4] The king has *geneats* or landholding tenants,
who are so rich that they are *twelve-hynde* and own estates
even so large as sixty hides.[5] But the most important thing to
notice is that the king's *comitatus* seems to have superseded the
old eorl-kin as the aristocracy of the land. The " gesithcund man
owning land " is the most important person of whom the code
takes cognisance after king and ealdorman. Probably the
greater part of the old noble families had already commended
themselves to the sovereign, and entered the ranks of his sworn
companions. The actual name of the thegn only once appears
instead of that of gesith, but the thegnhood itself is evidently in
existence. There still exist, however, certain members of the
comitatus who have not yet become proprietors of the soil. The
" gesithcund men not owning land "—inferior members of the
war-band who got but bed and board and weed and war-horse
from the king—are valued at double a ceorl's price.

One clause (law 54) in the code is very important as giving
the first indication of the fact that armour is growing common.
A man weighed down by a great fine, it says, may pay part of it
by surrendering his byrnie [mail-shirt] and sword at a valuation.
Comparing this with the almost contemporary law of the

[1] A.S. Chronicle, A.D. 755 ; but the event related occurred in 784.
[2] See p. 60.
[3] Law 39. [4] Laws 59, 67, " paying gafol," rent or tribute, to him.
[5] Law 19.

Ripuarian Franks, we note that Ini says nothing about the helm and the *bainbergæ*, whose price is settled under similar circumstances by the continental code.[1] Apparently, therefore, the byrnie was much more common than the helm in A.D. 700.

From whence did the old English learn the use of their mail-shirt? Possibly it was already known to them ere they left Saxony and Jutland, though few but kings can have possessed it at that early time. Conceivably it may have been borrowed from the Welsh. If we can be sure that the Gododin poems are fair reproductions of early originals, and were not wholly rewritten, with new surrouhdings, five hundred years later, we must hold that the use of armour no less than that of the war-horse survived for some time in Britain as a legacy from the Romans. A poem that claims a sixth-century origin speaks of the "loricated legions" of the half-mythical Arthur:[2] another praises at length the battle-steeds of Geraint, "whose hoofs were red with the blood of those who fell in the thick of the battle." Helm and corslet are mentioned almost as regularly as shield and spear.[3] There is no antecedent improbability in believing that such legacies from their old masters lingered on among the Celts of Britain, as they certainly did among the Celts of Gaul. Perhaps the Cymry taught the use of mail to the Englishmen, as the Gallo-Roman taught it to the Frank. If so, the use of these remnants of the old civilisation must have been mainly confined to Eastern Britain. The wilder tribes of Wales, as we find them in the later centuries, were neither wearers of armour nor combatants on horseback. The loss of the plain-land of Loegria and the gradual decay of all culture among the mountains of the West, may account for the disappearance of the war-horse, and even for that of the mail.

But, on the whole, it is more probable that the byrnie came to England from the Franks rather than from the Celts. The invaders seemed to have borrowed nothing save half a dozen words of daily speech from the tribes whom they drove westward.

[1] See p. 56. [2] *Ancient Books of Wales*, Taliessin, xv.

[3] Take as examples Gododin, 14 (Battle of Cattraeth): "With his blade he would in iron affliction pierce many a steel-clad commander." Or *ibid.* 38: "From Edyrn arrayed in golden armour, three loricated hosts, three kings wearing golden torques." *Ibid.* 96: "When Caranmael put on the corslet of Kyndylan and pushed forward his ashen spear." Or Taliessin, 14: "Wrath and tribulation as the blades gleam on the glittering helms."

It is noticeable, too, that mail begins to grow common in England almost at the same moment when we saw it coming into ordinary use on the other side of the Channel.

The Saxon helm, however, was certainly not borrowed from the Franks. Though the crested helm of late-Roman type, such as Merovingian warriors wore, is not unknown in English illustrated MSS., yet the national headpiece was the boar-helm mentioned so frequently in the *Beowulf*. A single specimen of it has been preserved—that dug up at Benty Grange in Derbyshire by Mr. Bateman. This headpiece was composed of an iron framework filled up with plates of horn secured by silver rivets. On its summit was an iron boar with bronze eyes.[1] Another form of helm was destitute of the boar ornament, and consisted merely of a framework of bronze overlaid with leather and topped by a circular knob and ring. Such was the specimen dug up on Leckhampton Hill above Cheltenham in 1844. It is probable that the composite headpiece of iron blended with horn or leather is the early form of the Saxon helm, but that by the seventh or eighth century the whole structure was solid metal. This at least we should gather from the *Beowulf*, where " the white helm with its decoration of silver forged by the metal-smith, surrounded by costly chains,"[2] the " defence wrought with the image of the boar, furnished with cheek guards, decked with gold, bright and hardened in the fire,"[3] must surely refer to polished metal, not to the less showy and less efficient helmet of composite material. Unfortunately, in Christian times burial in full armour ceased, so that the later helms are only preserved to us in literary descriptions or in illuminated manuscripts. Many seem to have been plain conical headpieces, quite unlike the classical shapes ; others, again, resemble the crested Frankish helm of which we have already spoken.

Both head armour and body armour appear so perpetually in the *Beowulf* that we should be tempted to believe that they must have been universal in eighth-century England. But in fact the writer of the epic is using the poet's licence in making his heroes so rich and splendid. Just as Homer paints Achilles wearing arms of impossible beauty and artistic decoration, so the author of the *Beowulf* lavishes on his warriors a wealth that the real monarchs of the eighth century were far from owning.

[1] *Collectanea Antiqua*, vol. ii. [2] *Beo.* 1450.
[3] *Beo.* 350.

Helm and byrnie were still confined to princes and ealdormen and great thegns.

Unmolested for several centuries in their new island home, and waging war only on each other or on the constantly receding Celt, the English retained the old Teutonic war customs long after their continental neighbours had begun to modify them. They never learned, like the Franks, to fight on horseback; though their chiefs rode as far as the battlefield, they dismounted for the battle. Even in the eleventh century they still were so unaccustomed to act as cavalry that they failed as lamentably when they essayed it[1] as did Swiatoslaf's Russians before Dorostolon. One isolated passage in the *Beowulf* speaks of a king's war-horse "which never failed in the front when the slain were falling."[2] But we have no other indication of the use of the charger in the actual battle; perhaps the poet may have been taking the same licence as Homer when he makes Greek kings fight from the chariot, or perchance he is under some continental influence. It is at any rate certain that—in spite of some pictures in English MS. copied from foreign originals, —the horse was normally used for locomotion, but not for the charge.

Nor had the old English learned much of the art of fortification: they allowed even the mighty Roman walls of London and Chester to moulder away. At best they stockaded strong positions. The Anglo-Saxon Chronicle tells us that Bamborough, the Bernician capital, was first strengthened with a hedge,[3] and later by a regular wall; but the evidence is late, and Bede tells us that when in 651 Penda the Mercian beset it, he strove to burn his way in by heaping combustibles against the defences— a fact which seems to suggest that they were still wooden.[4] The plan, we read, must have succeeded but for the miraculous wind raised by the prayers of St. Aidan, which turned back the flames into the besiegers' faces. If an actual stone wall was built across the narrow isthmus of the rock of Bamborough, it was a very unusually solid piece of work for old English engineers to take in hand.

[1] A.S. Chronicle, Year 1055.

[2] "Then Hrothgar bade bring eight steeds within the enclosure with rich cheek-trappings, on one of them was girt a saddle wrought with gold and bright treasures— the war-seat of Halfdan's son when he would enter on the sword-play: never did it fail in the front when the slain were falling" (*Beo.* 1036–42).

[3] A.S. Chronicle under A.D. 547. [4] Bede, iii. 16.

Hence it came that the wars of the English in the sixth, seventh, and eighth centuries were so spasmodic and inconsequent. Edwin or Penda or Offa took the field at the head of a comparatively small force of well-armed *gesiths*, backed by the rude and half-armed levies of the countryside. The strength of their kingdoms could be mustered for a single battle or a short campaign; but even if victory was won, there was no means of holding down the conquered foe. The king of the vanquished tribe might for the nonce own himself his conqueror's man and contract to pay him tribute, but there was nothing to prevent him from rebelling the moment that he felt strong enough. To make the conquest permanent, one of two things was needed—colonisation of the district that had been subdued, or the establishment of garrisons in fortified places within it. But the English were never wont to colonise the lands of their own kinsmen, though they would settle readily enough on Welsh soil. Fortifications they were not wont to build, and garrisons could not be found when there was no permanent military force. No great warrior king arose to modify the primitive warlike customs of the English till the days of Alfred and Edward the Elder. Hence all the battles and conquests of a Penda or an Offa were of little avail: when the conqueror died, his empire died with him, and each subject State resumed its autonomy.

The Anglo-Saxon battle was a simple thing enough. There is no mention of sleight or cunning in tactics: the armies faced each other on some convenient hillside, ranged in the "shield-wall,"[1] *i.e.* in close line, but not so closely packed that spears could not be lightly hurled or swords swung. The king would take the centre, with his banner[2] flying above his head, and his well-armed gesiths around him. On each side the levies of the shires would stand. After hurling their spears at each other (the bow was little used in war), the hosts would close and "hack and hew at each other over the war-linden," *i.e.* over the lines of shields, till one side or the other gave way. When victory was achieved, the conqueror thought rather of

[1] The "Bord-weall" is of course merely a poetical expression for the wall-like line of shielded men. It has nothing to do with locking shields after the manner of the Roman *testudo*, with which it has been compared. Warriors in *Beowulf* 2980 hew each other's helms to pieces "over the shield-wall."

[2] The banner is mentioned both in Bede (King Edwin's) and in *Beowulf* 2506.

plundering the richest valleys in his adversary's realm than of seizing the strategical points in it. Systematic conquest — as we have already observed — never came within the scope of the invader's thoughts: at the best he would make the vanquished his tributaries.

BOOK III

FROM CHARLES THE GREAT TO THE BATTLE
OF HASTINGS
A.D. 768–1066

CHAPTER I

CHARLES THE GREAT AND THE EARLY CAROLINGIANS
(A.D. 768–850)

THE accession of Charles the Great serves to mark the commencement of a new epoch in the art of war, as in most other spheres of human activity in Western Europe. In our second book we had to describe the military customs of Frank and Goth, Lombard and Saxon, in separate sections. The conquests of Charles combined all the kingdoms of the Teutonic West into a single State, with the exception of England and the obscure Visigothic survival in the Asturias. Races which had hitherto been in but slight contact with each other are for the future subjected to the same influences, placed under the same masters, and guided towards the same political ends. The rescripts of Charles were received with the same obedience at Pavia and Paderborn, at Barcelona and Regensburg. For the first time since the fall of the West-Roman Empire the same organisation was imposed on all the peoples from the Ebro to the Danube. The homogeneity which his long reign imposed upon all the provinces of Western Europe was never entirely lost, even when his dynasty had disappeared and his realm had fallen asunder into half a dozen independent States. In the history of the art of war this fact is as clear as in that of law, literature, or art. In spite of all national divergences, there is for the future a certain obvious similarity in the development of all the Western peoples.

We have pointed out that under the later Merovings and the great Mayors of the Palace the Franks were showing a decided tendency towards the adoption of armour and the development of cavalry service. It is under Charles the Great that this tendency receives a definite sanction from the royal authority,

and, ceasing to be voluntary, becomes a matter of law and compulsion. At the same time an endeavour is made to render the old Frankish levy *en masse* more efficient, by making definite provision for its sustenance and by enforcing discipline. Most important of all is the introduction of a system under which the universal liability to service remains, but the individuals on whom the *hereban* falls are made to combine into small groups, each bound to furnish one well-armed man to the host; so that a single efficient warrior is substituted for two, three, or six ill-equipped peasants.

The reasons which led to the reforms of the great Charles are not hard to seek. Under the later Merovings the Franks were barely able to maintain their own borders: their usual foes were the Saxon, Frisian, and Bavarian: expeditions against Spain and Italy had almost ceased. This period of decay and unending civil wars was brought to a sudden close by the onslaughts of the Saracens in 725–732: Charles Martel had fortunately come to the front just in time to save the State. The next forty years were a period of aggressive wars against the Saracen, the Lombard, and the Saxon. Both Saracens and Lombards were horse-soldiery, and we cannot doubt that in the wars with King Aistulf and the Emirs of Spain the Franks were led to develop their cavalry in order to cope with their enemies. They obtained such marked success against each of their adversaries, that we cannot doubt that their mounted men were growing more numerous and more efficient than they had been in the seventh century.

But Charles the Great undertook offensive wars on a much larger scale than Pepin and Charles Martel. His armies went so far afield, and the regions which he subdued were so broad, that the old Frankish levy *en masse* would have been far too slow and clumsy a weapon for him. An army of Neustrian and Austrasian infantry could hardly have hunted the Avars on the plains of the Theiss and the Middle Danube. The Frankish realm had been so vastly enlarged that it extended, not as of old from Utrecht to Toulouse, but from Hamburg to Barcelona. To keep this mighty empire in obedience a more quickly-moving force was required; hence Charles did his best to increase the number of his horse-soldiery. It was also incumbent on him to raise the proportion of mailed men in his host: against the well-armoured Lombard and Saracen, and later against the

horse-bowmen of the Avars, troops serving without helm and byrnie were at a great disadvantage.

The first ordinance bearing on military matters in the Capitularies of Charles the Great is one showing his anxiety to keep as much armour as possible within the realm. In 779 he orders that no merchant shall dare to export byrnies from the realm. This order was repeated again and again in later years, in the *Capitula Minora*, cap. 7,[1] and again in the Aachen Capitulary of 805 ; the trade in arms with the Wends and Avars is especially denounced in the last-named document.[2] Any merchant caught conveying a mail-shirt outside the realm is sentenced to the forfeiture of all his property.

In the first half of his reign Charles issued a good deal of military legislation for his newly-conquered Lombard subjects. He imposed upon them the Frankish regulations on military service, which made the fine for neglecting the king's "ban" sixty solidi,—the old Ripuarian valuation of the offence,—and the penalty for desertion in the field, "which the Franks call *heresliscs*," death, or at least to be placed at the king's mercy both for life and property.[3] It is interesting to find in the Lombardic Capitulary of 786 that the Lombards who are to swear obedience to the royal mandates are defined as cavalry one and all, being described as "those of the countryside, or men of the counts, bishops, and abbots, or tenants on royal demesne, or on Church property, all who hold fiefs, or serve as vassals under a lord, all those who come to the host with horse and arms, shield, lance, sword, and dagger."[4] The possession of this mass of Lombard horsemen was of the greatest importance to Charles in his wars with the Avars. Nearly all the fighting against these wild horse-bowmen was done by the Lombards, under Pepin, the king's son, whom he had made his vicegerent in Italy. It was a Lombard host which in 790 pushed forward into the heart of Pannonia, beat the Avars in the open field, and stormed their camp. The slow-moving Austrasians meanwhile had only wasted the Avaric borders as far as the Raab. A few years later it was again the Lombard horsemen who practically made an end of the Avaric power : under Pepin and Eric Duke of Friuli they captured the great "Ring," or royal encampment of the Chagan, hard by the Theiss, and sent its spoils, the

[1] *Cap. Min.* § 7 : " Ut bauga et bruniae non dentur negociatoribus."
[2] *Cap. Aquisg.* § 7. [3] *Cap. Ticinense*, § 3. [4] *Cap. Langobardiae* of 786, § 7.

accumulation of two centuries of plunder, to deck the halls of
Aachen. The Avars never raised their heads again, and fell
into decrepitude. If he had led only Frankish infantry levies,
Charles would never have been able to subdue this race of nomad
horsemen : the numerous Lombard knights, however, could both
pursue them and ride them down when caught. It is interesting
to note how the strong domineering spirit of the great king
inspired his new subjects to undertake and carry out an adven-
ture which their own kings had never been able to achieve, for
the Avar raids had been a scourge to Friuli and Lombardic
" Austria " for two centuries, and no remedy had been found
against them.

The chief military ordinances of Charles the Great are
five rescripts dating from the later years of his reign—the
Capitulare de Exercitu Promovendo of 803, the *Capitulare
Aquisgranense* of 805, the later edicts issued from the same city
in 807 and 813, and the *Capitulare Bononiense* of 811. All these
deserve careful study.

The first of them, the edict of 803, is directed towards the
substitution of a smaller but better-armed force for the old
general levy. It ordains that the great vassals must take to the
field as many as possible of the retainers whom they have
enfeoffed on their land (*homines casati*). A count may leave
behind only two of his men to guard his wife, and two more
to discharge his official functions. A bishop may leave only
two altogether.[1] Secondly, a new arrangement is made as to
the field service of all Franks holding land. Everyone who
owns four *mansi*,[2] or over, must march himself under his lord,
if his lord is serving on the expedition,—under his local count
if the lord be busy elsewhere. To every man who owns
three *mansi* there shall be added another who has but one, and
these two shall settle between them for the service of one man
properly equipped : if the wealthier goes himself, the poorer
shall pay one-fourth of his equipment; if the poorer goes, the
wealthier shall be responsible for three-fourths. Similarly, all
men owning two *mansi* are to be arranged in pairs : one is to
march, the other to provide half the equipment. And so, again,
holders of one *mansus* are to be arranged in groups of four : one
will go forth, the other three will each be responsible for one-

[1] *Cap. de Exercitu Promovendo*, § 4.
[2] Cf. the English enactment about the man with five hides or over, on p. 109.

fourth of his equipment.[1] The local counts are charged to see
that all men holding a *mansus* or more are placed in one of these
groups: those found unenrolled are to be heavily fined for
shirking the ban.[2] Thus we see that the service of the ill-
armed poor is lightened, and that of the well-armed rich strictly
enforced. The general result would be a decrease in numbers,
but a rise in average personal efficiency, in the host of the
realm.

The *Capitulare Aquisgranense* of 805 is intended to supple-
ment the ordinance of 803. It orders that every man having
twelve *mansi* must come to the host in a mail-shirt: anyone
who has such armour and fails to bring it to the host is to forfeit
both the byrnie and any *beneficium* that he may hold from
the king.[3] The fine for neglecting the ban, or failing to be
enrolled in one of the contributary groups established in 803, is
to be half a man's substance;—three pounds of gold for anyone
holding land or chattels to the value of six pounds, thirty
solidi for a man owning three pounds, and so forth.[4] The
prohibition against selling arms outside the realm is re-enforced,
and it is enacted that no man shall carry weapons within his
own district in time of peace: "if a slave is found with a spear,
it shall be broken over his back."[5]

The bulk of the army consisting of men owning less than
twelve *mansi*, it is obvious that the minority only were as yet
furnished with armour. All the men of the contributory groups
are evidently infantry armed with shield and spear alone.

Much more notable than the Capitulary of 805 is that of 807.
This carries the duty of providing warriors down to men holding
even less than the one *mansus* which was laid down as the base
of service in 803. For the future three owners of that limit, in-
stead of four, are to furnish a man for the host, while six holders
of half a *mansus*, or possessors of ten solidi in chattels, are to
contribute to equip one of themselves.[6] Two separate clauses
deal with the service of the Saxons and Frisians. The former,
all apparently treated as belonging to the poorest class, *i.e.* being
all infantry, are to send one man in six for an expedition against
the Saracens or Avars, one man in three against the Slavs of
Bohemia; but if the Wends and Sorbs, their immediate neigh-
bours, are in arms, then the whole levy is to take the field.

[1] *Cap. de Exerc. Promov.* § 1. [2] *Ibid.* § 2. [3] *Cap. Aquisg.* 805, § 6.
[4] *Ibid.* § 19. [5] *Ibid.* § 5. [6] *Ibid.* 807, § 2.

The ordinance for the Frisians is quite different. The counts'
all holders of a royal "beneficium," and all who serve on horse-
back (*caballarii omnes*), are to march out whenever the ban is
proclaimed ; of the commons (*pauperiores*) every six men are to
join in equipping one warrior for the host. There is unfortunately
no statement of the limits of the class which served as mounted
men ; we should have been glad to learn its character. Not
improbably it may have consisted of the holders of twelve
mansi, and the personal retainers of the great vassals and
officials.

For the inner discipline of the host the *Capitulare Bononiense*
(811) is very important. We learn from it that those who
arrived late at the muster were punished by being compelled to
abstain from wine and flesh for just so many days as they had
fallen behind the appointed time.[1] Anyone found drunk in
camp was to be deprived of wine till the campaign was ended.[2]
Every holder of a "beneficium" who deserted his comrades in
the hour of need, either from cowardice or from private feud,
was to forfeit his holding to the crown.[3] The provision of food
which each man was to bring to the host is defined as being
three months' rations ; it consisted, as we learn from a later
document, of flour, bacon, and wine.[4] The three months were to
count from the border, with certain relaxations in favour of
those coming from afar. Thus anyone coming from beyond the
Rhine may count his three months commencing at the Loire,
and anyone coming from beyond the Loire may count his three
months from the Rhine. On the other hand, a dweller beyond
the Rhine going east may only count from the Elbe, and
a dweller beyond the Loire going south may only count from
the Pyrenees.[5] The *Capitulare Bononiense* is very clear on the
necessity for providing as many fully-armed men as possible : it
enacts that if any bishop or abbot finds that he has more byrnies
in store than he has to contribute men to the host, he must not
let them lie idle, but at once inform the king of their existence.[6]
It also lays great stress on the necessity of all retainers follow-
ing the host even when their lord is not present : if he neglects

[1] *Cap. Bon.* § 3. [2] *Ibid.* § 6. [3] *Ibid.* § 5.
[4] *Cap. Aquisg.* 813, § 10. Cf. also the curious story about Charles and the
drunken guards in the Monk of St. Gall, book ii.
[5] *Cap. Bon.* § 8.
[6] *Ibid.* cap. 10. I presume that the king would either buy them at a valuation,
or provide other men to wear them.

to forward them to the local count, he must pay the fine that they have incurred by slighting the *hereban*.[1]

The section on rations in the *Capitulare Bononiense* can be supplemented by a clause of the edict *De Villis Dominicis*, which lays down the rule that cars such as follow the host should each be able to contain twelve bushels of corn, or twelve small barrels of wine, and that each car should be furnished with a leather cover pierced with eyelet holes, and capable of being turned into a pontoon by being sewed together and stuffed (with hay?). Each cart was to carry a lance, a shield, a bow and quiver—presumably to equip the driver in time of need.[2]

Last of the military decrees of Charles the Great comes the *Capitulare Aquisgranense* of 813, which contains several important notices. It provides that the count, when his men are mustered, must see that each has a lance, a shield, a bow, two bowstrings and twelve arrows. No one is for the future to appear carrying a club alone; the most poorly-armed men must at least have a bow. The stress laid on the bow in this document and in the *Capitulare de Villis Dominicis* is important. The weapon was practically new to the Franks, and the attempt to make it universal was probably due to experience in war against the Avars,[3] the only neighbours of the empire who made much use of the weapon. Another clause provides that all the " men " (obviously the household men) of counts, bishops, and abbots must have both helm and mail-shirt. We get from section 10 of this document a glimpse at the existence of a military train : on the royal cars are to be pickaxes, hatchets, iron-shod stakes, pavises, rams, and slings (obviously machines, not merely hand-slings). The king's marshals are to provide stones suitable for casting from these *fundibuli*.

On all these documents the best commentary is the summons which calls Fulrad, Abbot of Altaich, to the royal host in 806. It is worth quoting at length. " You shall come to Stasfurt by the Weser on May 20," writes the king, " with your ' men ' prepared to go on warlike service to any part of our realm that we may point out ; that is, you shall come with arms and gear and all warlike equipment of clothing and victuals. Every horseman shall have shield, lance, sword, dagger, a bow and a

[1] *Cap. Bon.* caps. 7, 9. [2] *Cap. de Villis Dominicis*, § 64.

[3] Rather the Avars than the Byzantines, I should imagine, as the contact with the latter had been comparatively small, while the Avar wars were very long.

6

quiver. On your carts you shall have ready spades, axes, picks, and iron-pointed stakes, and all other things needed for the host. The rations shall be for three months, the clothing must be able to hold out for six. On your way you shall do no damage to our subjects, and touch nothing but water, wood, and grass. Your men shall march along with the carts and the horses,[1] and not leave them till you reach the muster-place, so that they may not scatter to do mischief. See that there be no neglect, as you prize our good grace."

This is a summons to a tenant-in-chief (the phrase is already to be found in Carolingian documents) to come forth with his retainers for general service. It is noteworthy that all Fulrad's followers are expected to appear on horseback; there is no mention of any foot-soldiery, or directions as to their equipment. It is not definitely stated that all the abbot's horsemen are to appear in mail; the summons being dated before the laws of 807 and 813, it naturally contains no such order. Any of Fulrad's men who had twelve *mansi* would have been bound to serve in a byrnie by the edict of 805, but compulsion is not yet put upon the rest. The command to bring the bow is to be compared with the contemporary attempt to make the infantry adopt the same weapon. In neither case did the experiment succeed. The very large quantity of provisions and the heavy entrenching tools must have made the waggon train very cumbersome. It was evidently contemplated that the camp might have to be fortified, in order to protect the mass of baggage; it is for this purpose that the iron-shod stakes and the spades are required. Charles is also, as the last clause of the summons shows, very anxious to avoid the cardinal vice of the old Merovingian hosts—the plundering of the districts through which the troops had to march before reaching the frontier. Hence the very heavy load of rations which Fulrad is directed to bring with him. If the train made the army slow to assemble and slow to move, it at any rate enabled it to carry on operations even in a hostile or a devastated district for several months, long after the date at which a Merovingian expedition would have commenced to starve and then to disband.

When all the royal commands were carried out under the

[1] Reading *caballis* instead of *caballariis*, which last does not make good sense. The only way of giving it a rational meaning would be to suppose that Fulrad had other followers beside his horsemen, which does not appear.

royal eye,—and Charles was ubiquitous,—it is obvious that the host of the early ninth century must have been a very different weapon from the tumultuary hordes of the Merovings. Its efficiency is best shown by the great king's conquests, and the fact that when made they were retained. Charles was untiring: if one campaign did not bring him to the desired end, he recommenced his work in the next spring. In a specially difficult conquest, such as that of Saxony, he even wintered in the hostile districts, to prevent the rebels from having any opportunity of rallying in his absence. In 785–786, for example, he not only built forts and cut roads, but conducted repeated raids against the surviving insurgents even in the depth of mid-winter.

But perhaps the most important of all Charles' innovations is his systematic use of fortified posts. When a district had done homage and given hostages and tribute, he did not evacuate it as his predecessors would have done, and leave it free to revolt again at the first opportunity. He selected a suitable position,—a hill by a riverside was his favourite choice,—and there erected a palisaded and ditched " burg," in which he left a garrison. Each post was connected with the next, and with its base on the old frontier, by a road. Charles and his officers at last acquired a very considerable skill in the laying out of entrenchments; it was unfortunate for the empire that his successors neglected the art, till a long series of Danish invasions compelled them to learn it again. Probably the most ambitious work of entrenchment which was undertaken in his reign was the great circumvallation round Barcelona, which was constructed in 800 by the king's son Lewis and the levies of Aquitaine and Septimania. The army lay around the town for the whole winter of 800–801, hutted and girt by a double trench and palisade, to guard against sorties from within and diversions from without. The works were so efficient that the Moorish garrison, after a gallant resistance, was starved out and forced to surrender. The *burgs* of Charles were indeed a very successful expedient: it was seldom that they were taken; that of Eresburg only fell by treachery in 776, though that of Karlstadt seems to have been fairly stormed by the desperate assault of the Saxons (778). The use of these fortifications was a new lesson in the art of war for Western Europe; the Teutonic nations hitherto had never even fortified their own camps, much less had they thought of employing the spade and iron stake for the holding down of conquered lands.

Hence it came to pass that Charles made permanent conquests where his predecessors had merely executed raids and imposed tribute. So well chosen were the sites of his posts that many of them have remained the centres of political life in the districts where they were established down to our own day. Such were Magdeburg, Paderborn, Bremen.

There are many points in the Carolingian armies on which we crave information that Einhard and his fellows do not vouchsafe to afford us. Of the proportion of infantry to cavalry and of unarmed to mailed men in the hosts of Charles we are unfortunately unable to give any statistics. That, owing to his continuous legislation on the topic, the mailed riders must have been a much more numerous part of the army in 814 than in 770, is all that we can say. One interesting passage in a chronicle relating to the Saxon war of 782 seems to show that at least in some expeditions a very considerable part of a Frankish host must have been composed of horsemen. The Counts Geilo and Adalgis, marching against the rebels, find that Count Theuderich with another detachment is converging on the enemy from a different base. Eager that they should have the sole credit of the victory which they supposed to be in their hands, they bade their men snatch up their arms, "and hastened on as if they were about to pursue a beaten army, not to fight an intact one, *each as fast as his horse would go*,[1] so that they came all in disorder against the Saxons, who stood ranged in front of their camp." The reckless attack was beaten off, and four counts, two *missi dominici*, and more than twenty other persons of account, fell "with many of their men, who chose to follow them to the death rather than to survive them." If these words do not imply that the whole of Geilo's and Adalgis' forces were cavalry, they must at least mean that so large a proportion of them were horsed that the counts hoped to win without the aid of their infantry, which in such a mad onslaught must have been left miles behind.[2] The latter, in all probability, is the real meaning of the passage, and the desperate courage of the Frankish horsemen is to be accounted for by the fact that they were the henchmen and enfeoffed retainers (*homines casati*) of the counts, whom they

[1] " Prout quemque velocitas equi sui tulerat, unus quisque eorum summa festinatione contendit " (*Ann. Einh.* 782).

[2] The army had been raised in Thuringia and among the Franconian districts, where we should expect to find more foot than horse.

refused to desert even in the hour of certain death. Probably
the infantry were left so far behind that they never came into
the fight.

Of the order of Frankish hosts in battle, *i.e.* whether the horse
stood on the wings or in front of the foot-soldiery, we are equally
unable to speak with certainty. Whether there was any larger
unit in the assembled army than the count and his local follow-
ing we are never informed. That the host marched in divisions
with a rearguard and vanguard may be deduced from the
account of the disaster of Roncesvalles, where the rear ("ii qui
novissimi agminis incedentes, praecedentes subsidio tuebantur"[1])
were so far from the main body that they were cut to pieces
before their comrades could return to help them. A march in
parallel columns over open country can probably be traced in one
of the Avaric campaigns of 791 and the Saxon campaign of 804.

Perhaps the most scientific disposition of forces recorded in
all the wars of Charles occurs in a campaign at which he was not
himself present—the invasion of Catalonia in 800–801. On this
occasion his son Lewis, who held the command, while under-
taking the siege of Barcelona with one-third of his forces, placed
another third, under William Count of Toulouse, some leagues
west of the town to act as a covering army, while he himself
with the remainder took post nearer his base of operations in
Roussillon, ready to aid either of the other fractions that might
require his help. The Caliph of Cordova advanced from
Saragossa, but found the covering army so strongly posted that
he turned aside, and invaded the Asturias instead of entering
Catalonia. When he had retired, the covering force joined the
besieging force in building the trenches and winter camp, which
we have already had occasion to describe.

The best description of the appearance of one of the hosts of
Charles is unfortunately not that of a contemporary, though the
writer is careful to state that he had been in communication with
old men who remembered the emperor and had served in his
campaigns. This author is the Monk of St. Gall, who wrote
some sixty years after Charles' death, and dedicated his work to
Charles the Fat, the unworthy great-grandson of the conqueror.
He is describing the Frankish host as it approached Pavia in
the Italian campaign of 773. Borrowing his words, as has been
suggested, from some lost poem contemporary with Charles,

[1] Einhard, § 9.

he describes King Desiderius and his henchman Ogier the Dane watching the long column of the invading army draw near. As each body comes into sight, the king asks whether his rival and the main host have not now appeared. Ogier replies again and again that Charles is not yet at hand—the numerous warriors that have passed by are but his vanguard. At last the plain grows dark with a still mightier column than any that have yet drawn near. "Then appeared the iron king, crowned with his iron helm,[1] with sleeves of iron mail on his arms, his broad breast protected by an iron byrnie, an iron lance in his left hand, his right free to grasp his unconquered sword. His thighs were guarded with iron mail, though other men are wont to leave them unprotected that they may spring the more lightly on their steeds. And his legs, like those of all his host, were protected by iron greaves. His shield was plain iron, without device or colour. And round him and before and behind him rode all his men, armed as nearly like him as they could fashion themselves ; so iron filled the fields and the ways, and the sun's rays were in every quarter reflected from iron. 'Iron, iron everywhere,' cried in their dismay the terrified citizens of Pavia."[2]

The interest in this description of ninth-century armour is that we learn that the short byrnie, not reaching below the hips, was usual not only in the day of the great emperor, but in that of his great-grandson, Charles the Fat, to whom the Chronicle of St. Gall was dedicated. Greaves (ocreae, bainbergae) were evidently in full use when the description was written, but the thighs were generally unprotected. That the sleeve is spoken of apart from the byrnie as if it was a separate piece of armour is notable. The description is borne out by a passage in the will of Count Eberhard of Fréjus, who in 837 leaves a helm with a hauberk, a byrnie, one sleeve, and two greaves. Probably the sleeve (manica) was only needed for the right arm, the left being guarded by the shield.

The reign of Lewis the Pious (814-40) is as poor in military legislation as that of his father had been rich—a fact that might perhaps have been expected when the character of the two emperors is taken into consideration. By far the larger part of Lewis' capitularies deal with matters ecclesiastical. That the

[1] Does "ferrea cristatus galea" imply that the helmet was a crested one, like those in contemporary Frankish drawings in MSS. ?

[2] Monachus Sangallensis, ii. § 26.

organisation introduced by Charles was to some extent kept up may be deduced from an edict of Lewis and his son Lothar, dated 828, which orders the counts to inquire accurately whether all the smaller landholders are properly enrolled in contributary groups for service in the host, such as had been instituted in 803.[1] Another document issued by Lothar at Pavia in 832 for his sub-kingdom in Italy, recapitulates the prohibition against selling mail outside the kingdom, and restates the old regulation that the holder of twelve *mansi* must come to the host wearing a byrnie.

The time of Lewis being one in which the central power was rapidly growing weaker, and the independence of the local counts growing more marked, we cannot doubt that the mailed and horsed retainers of these notables must have been continually growing in numbers and importance as compared with the unarmoured infantry of the local levies. The perpetual civil wars which occupied the later years of Lewis' reign are so full of sudden desertions and inexplicable changes from side to side on the part of large bodies of troops, that we see that the self-interest of the counts has become of more importance than the general loyalty of their subjects. Docile obedience to the royal ban has been replaced by the most open treason. Owing to the emperor's foolish liberality to his sons, the realm had four rulers at once, and ambitious nobles could cloak their private schemes by pretending to adhere to one or other of the rebellious young kings. When the will of the local ruler became of more import-ance than that of the nominal head of the empire, the day of feudalism was beginning to draw nigh. Already in the time of Charles the Great we find the counts accused of pressing hardly upon the smaller freemen, exacting from them illegal impositions and services—misdemeanours against which the capitularies declaim again and again. Under weak rulers like Lewis and his sons the evil was perpetually growing worse. At the same time, the other characteristic sign of feudalism, in its social as opposed to its political aspect—the commendation of an ever-growing proportion of the smaller landholding classes to their greater neighbours—was steadily going forward. Probably the heavy burden of military service on distant frontiers, which Charles had imposed on his subjects, was not one of the least of the causes of the decay of the free peasantry. The duty which had been comparatively light in the lesser realm of the Mero-

[1] See *Cap. Papiense*, 832, § 15.

vings was immeasurably increased by the vast extension towards the Elbe and Danube.

But the tendencies towards feudalism in the State, with the corresponding tendency towards the depreciation of the national levies of foot-soldiery, would have been comparatively slow in its progress if it had not been suddenly strengthened by new influences from without. The transformation of Western Europe from the military point of view was to a very large extent the direct result of the incursions of the Northmen. The lesser troubles caused by the Magyars on the eastern frontier and the Saracens in Italy were co-operating causes, but not to be compared in importance with the effect of the raids of the Scandinavians.

CHAPTER II

THE VIKINGS (800-900)

HOSTILE relations between the peoples of the North and the Frankish kingdom had begun three centuries before, on the day when Theudebert of Ripuaria slew Hygelac the Dane, the brother of the hero Beowulf, on the Frisian shore (515). But it was seldom that Frank and Dane had met; the barrier of independent Saxons interposed between the two races had always kept them apart. Down to the time of Charles the Great the Scandinavian peoples were mainly engaged in obscure wars with each other. They are seldom heard of in the North Sea. But at last the Frankish power, with its wealth, its commerce, and its Christian propaganda, swept over Saxony and moved on its boundaries to the Eider. It was within a very few years of Charles' first conquest of Saxony that the Vikings (*Wickings*, men of the shallow fiords that face the Cattegat and Skager Rack) made their first appearance on the scene as serious disturbers of the peace of Western Europe. Perhaps the first seeds of trouble were sown when Witikind the Saxon fled before the sword of the Franks and took refuge in Jutland; we need not doubt that he told his Danish hosts terrible tales of the relentless might, the systematic and irresistible advance of the iron king of the Franks. The danger was now at their doors—the fate of Saxony might soon be that of Denmark. The kings of the southern Danes gave shelter to Witikind, but they sent fair words to Charles and did their best to turn away his wrath. Yet, when Witikind yielded and was baptized in 785, they must have felt that their own turn to face the oncoming storm had now arrived. But for the next few years the great Avaric war, the repeated local risings in parts of Saxony, and the troubles of Italy kept the Franks employed elsewhere. The first offensive strokes in the long struggle of Frank and

Norseman were struck by the latter. Strangely enough, the earliest recorded Danish raids were not aimed against the realm of Charles the Great, but at more distant lands. The isolated piracy of the "three ships from Herethaland" which burned Wareham in Dorsetshire in 789[1] is the first note of the appearance of the Scandinavians on the offensive. Four and five years later two small fleets burned the rich abbeys of Lindisfarne and Wearmouth on the Northumbrian coast. In 795 the Danes appeared so far west as Ireland, and destroyed the monasteries of Rechru on Dublin Bay. It was only in 799, ten years after the descent on Wareham, that the first recorded raids of the Vikings on Frankish territory are noted. In that summer they are said to have landed and made havoc both in Frisia and in Aquitaine: the ever-watchful Charles was soon on the spot, and ordered a fleet to be built to guard the narrow seas and the coast of Neustria. But the only serious trouble which the empire suffered from the Danes was a daring invasion of Frisia by the warlike king Godfred in 810. With two hundred ships in his train, Godfred overran the Frisian Isles and extorted from their inhabitants a large tribute. He spoke in his hour of triumph of visiting the emperor at Aachen, but one of his own men murdered him not long after, and his nephew and successor Hemming at once made peace with the Franks and sailed home; the Danes were not destined to see Aachen till seventy-six years later. The peace which Hemming promised was ill kept, and several small raids on the northern coast of the empire are recorded between 810 and 814. But these were all trifling matters. It was not till the reign of Lewis the Pious that the Viking raids began to grow serious. During the later years of Charles, the favourite sphere of activity of the Vikings was Ireland, where, from 807 onward, they were making sad havoc of the whole coast-line, and harrying one by one the rich monasteries which lay along its bays and islands.

During their first tentative raids the Scandinavians had not yet learned their own strength, nor were they such practised marauders as they afterwards became. It is strange enough, however, to see how suddenly they asserted themselves as a new military power. At first they were sailing in unknown seas,

[1] If that is the exact date : perchance the event was a few years later, for, though the A.S. Chronicle enters the fact under 789, it says merely that it was "in King Beortric's days" that the Vikings came to Wareham.

and their ships were but long, light, undecked vessels, that seemed unfitted to face the wild Atlantic. That such craft, less than twenty years after their first appearance in the North Sea, should be risking their slight frames in rounding the rocky shores of Donegal and Kerry, is the most astounding proof of the wonderful seamanship of the Vikings. The boats were essentially rowing, not sailing vessels; their masts could be and often were unshipped; they were only used when the wind set fair. For their propulsion the Viking ships relied on their oars, from ten to sixteen a side, though a larger number was employed when boat-building had become more scientific, in the tenth and eleventh centuries: even a second tier of oars seems to have been occasionally used in these later times. The prows and sterns were both high and curved. The former were often fashioned into the dragon-shaped figure-heads which are so famous in the sagas. There was no helm, but the ship was steered by a long oar lashed near the stern, as is a Shetland *sixern* of to-day. The early Viking vessels probably carried from sixty to a hundred men—only the larger constructions of the tenth century could contain as many as two hundred.

The Danes, Swedes, and Norsemen of the year 800 were in a state of society very much resembling that in which their Anglian and Saxon kinsmen had come to Britain three hundred years before. The raiders were not compact tribal bodies, but war-bands of adventurers enlisted under the banner of some noted leader, who was, as often as not, a mere warrior of renown, not a member of one of the old royal houses. There are few examples in the early Viking age of hosts commanded by the national king, though the first notable raid—that which King Godfred led to Frisia in 810—was an exception to this rule. The so-called sea-king was a mere war-chief, who might relapse into obscurity when the expedition was over—

"Solo rex verbo, sociis tamen imperitabat,"

as Abbo wrote, describing the leader who beleaguered Paris in 886.

The first Viking adventurers must have been no better armed than the English raiders of the fifth century. If their chiefs had a few helms and byrnies, spoils of war or merchandise of the south,[1] the main body must have been wholly unmailed.

[1] Finds in Sweden of the pre-Viking period have included fragments of byrnies and iron helms (Montelius).

After gold and silver, helms and mail-shirts were the form of plunder which the raiders most yearned for. This did not endure for long: in less than two generations the Northmen had armed themselves from the spoils of their enemies, and their own smiths too had begun to essay the armourer's art. So essential was mail to the professional Viking, whose hand was against every man, whose sole occupation was war, that by 850 or 900 it was the rule, and not the exception, in their hosts. Their body armour seems to have been exactly of the Frankish model; the helm, however, was pointed and often furnished with a nasal, unlike the old semi-classical shape which had prevailed among the Franks down to the ninth century.[1] The shield was at first round, like those of most of the other Teutonic races; it was only in the tenth century that it took the kite-shape familiar to us in the Bayeux Tapestry and other contemporary works of art. Shields were often painted red or some other bright hue, and, hung on the bulwarks of the war-ship when the warriors were at sea, produced lines of brilliant colouring along the gunwale.

The Danes used for offensive weapons spear, sword, and axe. Their swords seem at first to have been of the comparatively short, leaf-shaped kind, without a cross-guard, and very small in the grip, which are habitually found in Northern excavations. Later, they took to the longer and broader *spatha* of the Franks. The axe was the more characteristic national weapon; it was not the light missile tomahawk (*francisca*) which the Franks had been wont to employ in the sixth century, but a very heavy weapon, with a single broad blade welded on a handle five feet long. For proper use it required both hands: wielded by muscular and practised arms, it would cleave shield and helm in the same blow, strike off heads and limbs, and fell a horse without difficulty. Both sword and axe-head were occasionally marked with runes, as the sagas tell; and specimens so adorned are to be found in most of the Northern museums. The javelins of the Scandinavians do not seem to have differed in any essential point from those of the Franks and Angles. The bow they were accustomed to use more than any of the nations with whom they fought, for the English had never taken to it kindly, and the edicts of Charles the Great had not succeeded in making it popular on the Continent. Even the most noted warriors of the

[1] The helm with nasal, however, was probably known to the Franks in the ninth century; it was most likely the "helmum *cum directo*" of the Ripuarian Code.

North were proud of their skill with the arrow; it was held an honourable weapon by them, while among their enemies it was the mark of the poorest military classes. Readers of the sagas will remember the marksmanship of Olaf Tryggeveson and his henchman Einar, and the celebrated shot with which King Magnus slew Earl Hugh the Proud on Menai Strait.

It was only some time after their appearance in western waters that the Vikings acquired a complete ascendency over the peoples of the older Teutonic realms. They were at first cautious, attempting no ravage deep in the land, but absconding after the plunder of some one seaboard town or abbey. The Franks, Irish, and English seem to have been more angered than terrified by the first raids, and several times caught and destroyed considerable bodies of the invaders.[1] But the fleets grew larger, the raiders more daring and better armed, their knowledge of the strong and weak spots of the line of defence more perfect. About forty years after the first plunderings in England, and thirty after the first assault on the Franks, Western Europe began to awake to the fact that the Northmen were beginning to be no mere pest and nuisance, but a serious danger to Christendom. The landmarks of this period are the first serious invasion of the interior of Ireland by a great host under Thorgils (832), the plunder of the rich haven of Dorstadt and the famous cathedral city of Utrecht among the Franks (834), and the erection of the first fortified Viking camp in England on the isle of Thanet in 851. The invaders were beginning to grow so numerous and so daring that it was obvious that some new measures must be taken if their progress was to be checked.

Among the faction-ridden tribes of Ireland it was hopeless to look for union or skilfully-combined resistance. More might have been hoped from the English and the Franks. But the contemporary political situation of neither of those peoples was favourable. In England there was no central authority: King Egbert, to whom the other princes of the Heptarchy had done homage, was really supreme in Wessex alone. He had no power to protect Northumbria or even Mercia: if he kept the bounds of his own realm, it was all that he could accomplish. His victory at Hingston Down over the combined bands of the Vikings and the Corn-Welsh was a considerable success (838),

[1] *e.g.* the Northumbrians destroyed in 794 the band that had sacked Wearmouth. In 811 the Irish defeated a host in Ulster, and in 812 another in Connaught.

but it did not and could not save the north or the east from plunder. When Egbert died and his weaker son Aethelwulf succeeded him, the supremacy of Wessex became purely nominal: only once in his reign did Aethelwulf lead an army beyond his boundary to help one of the other English States (853). He was, in fact, a worthy and a well-meaning king, but there was no touch of genius in him. Though he fought conscientiously enough against the Vikings whenever they appeared, and was more than once victorious, yet the fortunes of England were steadily failing all through his reign. London and Canterbury were both sacked in 850, and though Aethelwulf destroyed at Ockley in Surrey the band that had wrought these ravages, yet three years later another host came down on Wessex, and, most ominous step of all, fortified themselves so strongly in the isle of Sheppey, behind the marshy channel of the Swale, that they could not be dislodged.[1] This was the second wintering of the Danes in Britain. Meanwhile, if Wessex was faring ill, Mercia and Northumbria were in a far worse case: both realms were ravaged from end to end, and there remained hardly a town or a monastery unburnt within their borders. Yet this was but the beginning of evils : the period of settlement had not yet succeeded to the period of sporadic ravages.

The Frankish Empire should have borne the brunt of the contest with the Northman. But its condition was in some ways even more unpromising than that of England. In the latter country the tendency was still towards union : Wessex had just permanently absorbed Kent and Sussex ; Mercia had almost succeeded in doing the same to East Anglia, and had quite amalgamated with herself the former sub-kingdoms of the Hwiccas and Lindiswaras.[2] But in the realm of Lewis the Pious the spirit of the times was making for disintegration rather than for union. The old separatist tendencies of Aquitaine and Bavaria, and the dislike of the Lombards for the Frankish yoke, had disguised themselves in new shapes, and taken the form of rebellions in favour of the ungrateful sons to whom Lewis had distributed the government of those provinces. However much

[1] The first was the wintering in Thanet narrated in A.S. Chronicle *sub anno* 851.

[2] From Offa's murder of King Ethelbert in 792, onward to 825, East Anglia seems to have been subject to Mercia : the defeat of the latter by the King of Wessex brought about that rising of the East Anglians in which two kings of Mercia, first Beornwulf, then Ludica, perished.

the foolish tenderness of the emperor and the unfilial ambition of his children may have supplied the formal cause of disruption, its essential cause was the desire for independence on the part of the subject nationalities. In all the realm the Austrasians were the only people who consistently stood up for the cause of union and imperialism. The civil wars of the sons of Lewis had begun in 830, and for some time the ever-thickening Viking raids seemed to the statesmen of the empire tiresome diversions, distracting them for the moment from the all-important questions whether Lewis should subdue his children or lose his throne, and whether his youngest son Charles should or should not obtain the kingly crown along with his brothers. Lewis died in 840, after having seen the Danes cut deep into Frisia and push daring raids up the Meuse and the Loire. After his disappearance from the scene the civil wars only became more constant and more chaotic: the bloody battle of Fontenay (541) where the might of Austrasia was for ever broken, settled the fate of the empire. It was to split up permanently into independent national kingdoms, and never again was one sovereign will to sway all the military force of the West, from Hamburg to Barcelona, for a common end.[1]

Now, from some points of view it might appear quite probable that three or four compact national kingdoms would be better able to cope with the Vikings than the vast but somewhat unwieldy empire of Charles the Great. But the dynastic interests of the Carolingian house were still too strong to allow real national States to develop themselves. Each king was snatching at his brother's or cousin's provinces, in a vague hope of reconstituting the empire for his own benefit. It was not till the male line of the eldest son of Lewis the Pious died out in Italy (875), and that of his second son in Germany (911), that those intermittent projects of reunion died out. As long as they lasted they were wholly evil: while Charles the Bald was getting himself crowned at Metz or Rome, while Wido was overrunning Burgundy, or Carloman and Arnulf devastating the Lombard plain, the Dane and Saracen and Magyar were tearing their realms to pieces behind their backs. Kings immersed in Imperial politics could not find time to discharge the simple duty of superintending the local defence of their own coast and

[1] Charles the Fat, though king of Germany, West Francia, and Lombardy, never ruled in the Burgundies, so the above statement is literally correct.

border. It was not unnatural, therefore, that the years from 840 to 900 were the very darkest that Christendom had known since the first formation of the Teutonic kingdoms in the fifth century. No sign of better days is to be seen till Alfred's expulsion of the Danes from Wessex (878), Count Odo's successful defence of Paris in 885–886, and King Arnulf's great victory at Louvain (891).

We must now investigate the tactics of the Northmen, and the various expedients which their English and Frankish adversaries employed against them. By the middle of the ninth century the invaders had increased into a formidable multitude; their expeditions had been so fortunate that the whole manhood of Scandinavia had thrown itself into the Viking career. The Northmen were now members of old war-bands contending with farmers fresh from the plough—veteran soldiers pitted against raw militiamen. They were far better provided with arms than their adversaries: the helm and byrnie seem to have become universal among them, while the English *fyrd* and the Frankish local levies were still mainly composed of unarmoured men. Only the thegnhood on this side of the Channel, and the counts and their retainers on the other, were sufficiently well equipped to be able to face the invaders man to man. With anything like equal numbers the Vikings were always able to hold their own. But when the whole country-side had been raised, and the men of many shires or countships came swarming up against the raiders, they had to beware lest they might be crushed by numbers. It was only when a fleet of very exceptional strength had come together that the Northmen could dare to disregard their opponents, and offer them battle in the open field. Fighting was, after all, not so much their object as plunder, and, when the landsfolk mustered in over-whelming force, the invaders took to their ships again and sailed off to renew their ravages in some yet intact province. They soon learned, moreover, to secure for themselves the power of rapid locomotion on land: when they came to shore they would sweep together all the horses of the neighbourhood, and move themselves and their plunder on horseback across the land. To fight as cavalry they did not intend; it was only for purposes of swift marching that they collected the horses. The first mention of this practice in England comes in the year 866, when "a great heathen army came to the land of the East

Angles, and there was the army a-horsed."[1] Curiously enough, it is in the same year that we first hear of the Danes in the Frankish realm[2] trying the same device. Their base of operations, however, was of course their fleet, and such excursions always ended in a swift return to the boats. It was only when a waterway was not available that the raiders dared to cut themselves adrift from their vessels. As a rule, their method was to work up some great stream, sacking the towns and abbeys on each shore of it; when they got to the point where it was no longer navigable, or where a fortified city stretching across both banks made further progress impossible, they would moor their ships or draw them ashore. They would then protect them with a stockade, leave part of their force as a garrison to guard it, and undertake circular raids with the rest. On the approach of a superior force they were accustomed in their earlier days to hurry back to their vessels, drop down stream, and escape to sea. But as they grew more daring they began to fortify points of vantage, and hold out in them till the hostile army disbanded for lack of provisions, or was dispersed by the advent of winter. These strongholds were generally islands. The bands who afflicted Neustria made their habitual refuge the isle of Oiselle [Oscellus] in the Seine, ten miles above Rouen. Here they stood sieges at the hands of Charles the Bald in 858 and 861. But on one occasion at least they dared to fortify themselves farther up the stream, at the place called Fossa Givaldi, near Bougival, which seems to have been a peninsula girt round with marsh rather than an island. In England they used Thanet, and also Sheppey, for the same purpose. On one famous occasion (871) they chose the tongue of land at Reading between the Thames and Kennet for their stronghold. At the Loire mouth they used the isle of Noirmoutier ; at the Rhone mouth the isle of La Camargue was their refuge. Walcheren was in a similar way their base for attacks on Flanders and Austrasia. The great host which pushed up the Rhine in 863 defied the combination of the Austrasians of Lothar II. and the Saxons of Lewis the German by holding an island in the river near Neuss, from which they only retired at their own good time. Against an enemy not provided with ships of war these island posts were almost impregnable.

[1] A.S. Chronicle, 866.

[2] *Annales Bertinenses*, p. 84 : "Nortmanni circiter quadringenti de Ligeri *cum caballis* egressi, commixti Britonibus Cenomannis civitatem [Le Mans] adeunt."

7

Even when the Danish fortifications were not pitched in an inaccessible island, it was but seldom that the landsfolk were able to break through the stakes and foss, manned by the line of well-armoured axemen. The failures of Charles the Bald at Givald's Foss (852), of Charles the Fat at Ashloh (882), of Ethelred of Wessex at Reading (871), are well-known examples of the danger of besetting a Danish camp. All the more credit, therefore, is due to the few Christian kings who succeeded in storming one of those formidable strongholds. King Arnulf's capture of the great camp of Louvain in 891 was probably the most brilliant achievement of this kind recorded in the ninth century. The host of Northmen had harried all Austrasia and routed the local levies at the battle of the Geule. At the news of this defeat the German king came flying from the eastern frontier, and found the enemy stockaded in a place where the Dyle forms a loop, with a ditch scooped in the marsh from bank to bank, and a high rampart behind it. Undeterred by the formidable barrier, Arnulf dismounted, bade all his counts and mounted warriors do the like, and with drawn sword waded through the marsh and began to hew down the palisade. His men pressed in so fiercely behind him that after a bitter struggle the shield-wall of the Danes gave way, and the whole mass of Vikings were driven pell-mell into the flooded Dyle, where they perished by thousands. Such a blow was worth many victories in the open field, for it made the Danes doubt their own power of resisting behind entrenchments in the inland. No really dangerous Viking host ever essayed to strike deep into the German kingdom after this defeat. For this reason the storming of the Louvain camp deserves perhaps an even higher place in military history than our own Alfred's victory at Ethandun thirteen years before. For the great king of Wessex, though he had beaten the Danes in the open, did not storm their camp at Chippenham. The stronghold only yielded on terms, and terms that, considering the relative positions of Alfred and Guthrum at the moment, must be considered very favourable to the Danes.

When the Danes were surprised at a distance from their camp and forced to fight without protection, they would draw themselves up in the best position they could find, on a steep hillside, as at Ashdown (871) or Ethandun (878), or behind a

stream ; they formed their shield-wall,[1] and fought the matter out to the end. On many occasions, when broken in the open by the charge of the Frankish horse, they would retire behind the nearest cover,—a .village, as at Saucourt (881); a church, as at Brisarthe (866); a large building, as in the fight in Frisia in 873, —and there hold out till they either beat off the enemy, were themselves cut to pieces, or at nightfall were able to abscond.

Nothing shows better the stubbornness of the Danes than the way in which they often by a desperate rally repaired a lost battle. At the great fight in front of York in 868 they were thoroughly beaten by Osbert and Aella, and forced back on the town, but, rallying among the houses, they drove out the Northumbrians, and finally slew both kings and won the day. So, too, at Wilton in 872 they had been seriously repulsed by Alfred, and had gone back for some distance, when at last, seeing the Wessex men losing their order in the excitement of victory, they rallied and redeemed the day.[2] The same had almost happened at Saucourt, where nothing but the praiseworthy efforts of King Lewis in restoring order among his men prevented a success being turned into a disaster by the last desperate effort of the Vikings. At the battle by Chartres in 911 they had been thoroughly defeated, and had lost six thousand men, yet, when their beaten but undaunted host was assaulted by the newly-arrived horsemen of the Count of Poictiers, they turned on him, drove him off, and actually stormed his camp, ending a day of failure by a success at nightfall. It was hard to say that a Viking host was really disposed of till its last banner had been cast down and its last man slain.

The Northmen seldom appeared as the assailants in the open field—like the English in the Hundred Years' War, they preferred to stand on the defensive. Indeed, foot-soldiery fighting an enemy whose force grew year by year to be more entirely composed of cavalry were almost compelled to adopt such tactics. If they did attack, it was generally by a surprise, as at the battle on the Geule (891). On this occasion the Austrasian levies, marching in disorder to find the Northmen, whom they believed to be

[1] The shield-wall (testudo, as Asser pedantically calls it) is of course not a wedged mass like the Roman testudo, but only a line of shielded warriors.

[2] I cannot see in either of these battles, as related in Asser and the authorities who copied him, any trace of the "feigned flight" which some have detected. The Danes seem to have been honestly driven back, and then to have rallied.

flying, were suddenly set upon by the invaders, who had advanced to meet them instead of waiting to be attacked. The Franks, being entirely out of array, were easily scattered.

We must now turn to a consideration of the methods by which the Franks and English endeavoured to beat off the Vikings, at first with poor success. The one patent fact which the kings of the house of Charles the Great and the house of Egbert had to face was that the half-armed local levies of the *fyrd* or the *ban* were insufficient to cope with the invaders. The Frankish counts and the English ealdormen made many a gallant attempt to beat off the raiders: sometimes they were successful, but much more frequently they suffered a disastrous defeat. The Vikings were too well-armed, too wary, too experienced in every shift of war, to be adequately faced by the raw militia opposed to them. Some more efficient body of troops had to be improvised to meet them, some system of defence devised to keep them from overrunning the open country. Down to the ninth century the Frankish towns, unless they had old Roman walls, were not provided with any systematic protection; the English were even more exposed, for such of them as had the Roman circumvallation had allowed it to moulder away ever since the first conquest,[1] while those which had arisen since Roman days had never been fortified at all.

[1] York, for example, the greatest centre of Northern Britain in Roman days, was in 867, in the words of Asser (*sub ann.* 867) imperfectly protected, for "non enim tunc illa civitas firmos et stabilitos muros eo tempore habebat"; therefore the Northumbrians were able "murum frangere" by a rush—to hew down a palisade, I suppose. Canterbury seems to have had walls rather early, however.

CHAPTER III

THE VIKINGS TURNED BACK (A.D. 900–1000)—THE FEUDAL HORSEMAN AND THE FEUDAL CASTLE—THE THEGN AND THE BURH

THE military history, therefore, of the ninth century shows two all-important movements directly caused by the need of repelling the Danes. The first is the substitution of a professional class of fighting men for the general local levies; the second is the development of a system of regular and systematic fortification of the most important points in the realm. The combination of the two movements gives us the feudalism of the later Middle Ages. Though both are felt equally in the English and the Frankish kingdoms, they take somewhat different shapes on the two sides of the Channel. The English thegn of the tenth century is not quite the same as the Frankish vassal; the English burh is by no means identical with the continental castle.

The primary need of the Christian realms of the West was a large body of courageous and well-armed fighting men, capable of meeting the Northman man to man. Fortifications are good things in their way, but they need trustworthy garrisons. The most elaborate entrenchments serve no end— as King Lewis of West Frankland found in 881—if those set to defend them have not their heart in the business. His great castle at Etrun was quite useless because none of his nobles would undertake to hold the post of danger.[1]

Now for the purpose of repelling the Vikings, the national levy with its great tardily-moving masses of foot-soldiery had been tried and found wanting. It was too slow, too ill-armed,

[1] *Annales Bertinenses*, 881 : "Quod magis ad munimentum paganorum quam ad auxilium Christianorum factum fuit, quia ipse rex Hludovicus invenire non potuit cui illud castellum ad custodiendum committere posset."

too untrained. The Danes if in small numbers took to their
boats or their horses and slipped away; if in strong force they
put the local levies to rout. The only other military body in
the realm was the magnates and their retainers. We have
already seen that by the year 800 both the Frankish and the
English realms possessed an aristocracy, originally dependent
on the kings, and wholly official in character—a "nobility of
service," to use the phrase that we have already had so many
occasions to employ. On the Continent it now included not
only actual holders of countships or great offices about the
court, but large numbers of persons, both lay and clerical, who
held "beneficia," feudal grants of land, from the king. Each of
these counts and *vassi* of various sorts had his bands of personal
followers, landed or unlanded, *homines casati*, or sub-tenants
with holdings of various size. The vassal-class was steadily
growing: a family which had once held office and received
grants of "beneficia" did not drop back into the ranks of the
ordinary freemen. The class, too, was already tending to
encroach on its poorer neighbours; the counts were using their
official position, the holders of "beneficia" their less legal but
equally efficient powers of bringing pressure to bear on the
smaller men. Above all, the Church was extending its
boundaries on every side so rapidly, that, as early as 831, Lothar,
the son of Lewis the Pious, began special legislation against the
handing over of land to the "dead hand." When the hideous
distress caused by the Danish invasions came to aid the already
existing tendency towards feudalisation, the result was easy to
foresee. By the end of the tenth century the vast majority of
the smaller freemen had passed under the control of their
greater neighbours, either by voluntary commendation, or as the
result of deliberate encroachment.

Nor were the Danish invasions less powerful in hastening
the development of the other side of feudalism, the establishment
of the counts and dukes as hereditary local potentates, who
practically could no longer be displaced by the crown. There
was an obvious convenience during the time of trouble in letting
the son succeed to the father's government; none would know
so well as he the needs and capacities of the district in which
he had been brought up. Moreover, there was danger, in those
days of incessant dynastic war, in the attempt to remove a
powerful noble from his father's post; he might at once transfer

his allegiance to some other member of the Carolingian house. Charles the Bald and his short-lived successors habitually bought respite from the peril of the moment by letting the son succeed to his progenitor's office. In the next generation, the counties of West Francia had become hereditary fiefs, in which the right of succession was looked upon as fixed and absolute. In every one of the great vassal States of the later middle age, we find that the commencement of succession within the family starts from the years between the fatal battle of Fontenay and the deposition of Charles the Fat. The first ruler in the county of Toulouse who passed on his lands to his son, dates from 852; in Flanders, the date is 862; in Poitou, 867; in Anjou, 870; in Gascony, 872; in Burgundy, 877; in Auvergne, 886. In East Francia, the development was not so rapid; among the newly-conquered German tribes, the Saxons and Frisians, there still survived great masses of small freemen. But the tribal dukes, whom Charles the Great had such difficulty in clearing away, begin to reappear again before the end of the ninth century. They start with Liudolf (died 866), the first *Dux Saxonum* of the new kind, who passed on his government to his son Bruno, a great fighting man, who fell by the hands of the Danes in the disaster on the Lüneburg Heath in 880. By forty years after his time, Bavaria, Lotharingia, Thuringia, Suabia, have once more got dukes, and there were hereditary counts in Hennegau, Rhaetia, and many other smaller districts. In Lombardy the same phenomenon crops up at about the same time, and Ivrea, Friuli, Modena, Spoleto, appear as hereditary States.

Now, as we have already seen, the Frankish counts and vassals were accustomed to serve on horseback, and were expected to bring their retainers to the host mounted like themselves, even before the death of Charles the Great. The development of feudalism, therefore, meant the development of cavalry; we can place the dismissal of the infantry of the local levies into obscurity and contempt, and the entire supersession of them by the feudal horsemen, between the death of Charles the Great and the end of the century. Two short quotations from chroniclers, dating the one from 820, the other from 891, show how complete was the change. In the former year Bera Count of Barcelona was challenged to a judicial duel by Sanila, another noble of the Catalonian March. They

fought, as the chronicler remarks, " equestri praelio quia uterque Gothus esset." [1] Coming from the old Visigothic stock of Septimania, it was natural for them to fight on horseback ; but obviously this did not yet seem the most natural thing to a Frank. How different from this is the note of the Monk of Fulda, who states that Arnulf, when attacking the camp of Louvain in 891, doubted for a moment whether he should bid his knights dismount, " quia Francis pedetemptim certare inusitatum est," [2] because it is not usual for the Frankish nobles to fight on foot.

We may therefore conclude that, during the last seventy years of the ninth century, the infantry were always growing less and the cavalry more, just as the freemen were disappearing and the vassals growing ever more numerous. Already, by the middle of the century, the cavalry were the most important arm ; in Nithard's account of the manœuvres of his patron Charles the Bald before and after Fontenay, the language used leads us to think that most of the young king's followers must have been mounted. Thirty years later, when this same king invaded Austrasia to snatch territory from his nephew Lewis, he is made to exclaim that " his army was so great that their horses would drink up the Rhine, so that he might go over dry-shod." [3]

The definite date at which we may set the permanent depression of the infantry force in West Francia, is in 866. From this year dates the celebrated clause in the Edict of Pitres, in which Charles orders that every Frank who has a horse, or is rich enough to have one, must come mounted to the host. His words are that, " pagenses Franci qui caballos habent aut habere possunt cum suis comitibus in hostem pergant," [4] and no one in future is to spoil a man liable to service of his horse under any pretence. The phrase *pagenses Franci* is evidently intended to cover the surviving freeholders due for service under the count. The " men " of the *seniores* were already obliged to come horsed, by much older edicts.

After the recognition of the all-importance of cavalry in the Edict of Pitres, we are not surprised to find that, twenty-five years later, King Odo, calling out the forces of Aquitaine against his rival, Charles the Simple, found himself at the head of ten thousand horse and six thousand foot. The chronicler Richer,

[1] *Vita Hludovici*, § 33. [2] *Ann. Fuld.* 891.
[3] *Ann. Fuld.* 876. [4] Edict of Pitres, 2. 26.

who tells of this levy, calls the cavalry *milites*, as opposed to the foot-soldiery, *pedites*.[1] This is the first indication of the use of the word *miles*, the warrior *par excellence*, for the mounted soldier. A few years before, it would have been applied to all fighting men ; we now see it starting on its way to become the designation of the *knight* of the later Middle Ages. By the time that the tenth century has arrived, the infantry in West Francia seem wholly to have disappeared ; in such battles as the bloody field of Soissons, where King Robert was slain, both armies, without exception, seem to have been composed of mounted men.

It is easy to understand the military meaning of the change ; it was not merely that the impetus of the mailed horseman alone could break the Danish shield-wall. Almost more important was the fact that the cavalry only could keep up with the swiftly-moving Viking, when he had purveyed himself a horse, and was ranging over the countryside at his wicked will. The local count who could put a few hundred mailed horsemen of approved valour in the field, men bound to him by every tie of discipline and obedience, and practised in arms, was a far more formidable foe to the invader than ten thousand men of the *ban*. Even if he could not check the raiders in open fight, he could hang about their path, cut off their stragglers, fall upon them when they scattered to plunder village or manor, intercept them at every defensible ford or defile, where the few can block the passage of the many, or circumvent them by cross roads which the native must know better than the stranger. The moment that the Frankish cavalry had reached its full development, the career of the Viking was terribly circumscribed. At last, his only method of dealing with it was to learn to fight on horseback himself ;[2] the art was acquired too late to influence the general course of history in Western Europe, but by the end of the tenth century the Norman horse was equal to any in Christendom. In the eleventh it was the flower of the chivalry of the first Crusade.

The other expedient which the Franks used against the

[1] " Odo congregari praecepit milites peditesque : quibus collectis in decem millibus equitum peditum vero sex millibus erat," etc. (Richer, § 81).

[2] The first mention of Danes *fighting* on horseback seems to be at the battle of Montfaucon (888). Abbo distinctly mentions that their horse and foot were separated, and fought Odo apart. At Soissons (923) the Norman contingent in the army of Charles the Simple all fight on horseback.

Northmen was the systematic and elaborate fortification of points of vantage. The deliberate adoption of this policy is laid down in the same Edict of Pitres (866), which we have already had to quote for its importance in the development of cavalry. But the actual scheme had been begun as early as 862. It had occurred to Charles the Bald that the Danish fleets might be kept from running up the rivers by erecting at favourable spots fortified bridges, through which they would be unable to force their way up stream. Pitres, some miles higher up the Seine than the Viking stronghold on the isle of Oiselle, was the chief point which he pitched upon. Here he began to build a great bridge with *têtes-du-pont* at either end; it took some years to complete, and the Danes still dashed through its unfinished centre when they chose. He therefore constructed another less ambitious bridge higher up, at Trilbardou, and by means of it blocked the return of the raiders. After trying to break through in vain, Weland, the Northmen's chief, gave up his prisoners and plunder, on condition of being allowed to drop down stream under the bridge unmolested.[1] The great structure at Pitres was finished in 866, and smaller ones at Auvers and Charenton-le-Pont were erected to guard the Oise and Marne, as additional precautions. Most important of all, Charles made the island-city of Paris throw bridges across to the northern and southern banks of the Seine. These structures were destined to have more influence on the future of the Viking invasions than any of the new buildings down stream. For the weak point of the plan was that the new bridges required garrisons, and that a permanent force to hold them was hard to find. A city like Paris could find men to man its own defences, but isolated fortifications, like those at Pitres, required special bodies of troops, which were not always at hand. Apparently, they were broken through during the civil wars at the end of the reign of Charles. At any rate, we find the West Franks in 885 devoting all their attention to building, as a substitute for them, a new fortification at Pontoise. When the Danes came up the Seine for the great siege of Paris, they had first to destroy this obstruction. It made a creditable resistance, but, getting no succour from without, was compelled to surrender.[2] Then, pushing up to Paris, the invaders began the eleven months' beleaguering of the place. Paris had been more than once in

[1] *Annales Bertinenses*, 862. [2] *Annals of St. Vedast*, 885.

Viking hands before Charles the Bald fortified it,[1] but now its new defences enabled it to make a very different resistance. Its gallant defenders, Odo and Bishop Gozelin, held it against every attack, though the Emperor Charles the Fat gave them little or no help. It is true that the Danes ultimately succeeded in getting up the river, by laboriously dragging their vessels across the flat shore round the southern bridge-head.[2] But they could not take the place, and were at last glad enough to receive a bribe and depart, leaving Paris free [886]. This successful defence was almost as great a landmark in the history of West Francia as the victory of Ethandun in England, or that of Louvain in Austrasia.

The Danish ravages in Germany are of little importance after the year 900; in the Western realm they continued much later, but were never so threatening again as they had been in the years before 886. For the future, the Frankish victories are almost as numerous as those of the Northmen. The fights of Montfaucon (888), Montpensier (892), and Chartres (911), are all worthy of notice. They show that the Franks were now no longer wont to shirk the ordeal of battle, as they had been thirty years before, but fought whenever they had the chance. As often as not they beat back the invader, and kept the land free for a space from his ravages. But it was the new fortifications, even more than the battles, that saved France from utter ruin. When every town had surrounded itself with a ring-wall, and endeavoured to block its river with a fortified bridge-head, the Danes found their sphere of operations much limited. They wanted plunder, not year-long sieges with doubtful success at the end ; a gallant resistance like that of Paris in 886, or Sens in 887, not only saved the particular town that was holding out, but was of indirect benefit to every other place that might have to stand a siege hereafter, since it lessened the self-confidence of the Danes, and forced them to contemplate the possibilities of similar failures in the future. There was little gain in harrying the open country ; not only had it been plundered already by fifty previous raids, but now the peasantry flocked into fortified places with all that was worth carrying away. The refuges and strongholds were now numerous enough to afford shelter to the

[1] It had been plundered in 845 and 856.
[2] *Metz Annals*, 888, and Abbo. See pp. 141–6 for a detailed narrative of the siege.

whole countryside ; for during several generations, bishops, counts, abbots, and great vassals were hard at work, fortifying every point of vantage. Not only great towns but small were soon wall-girt, and private castles supplemented them as points of resistance. A good deal of this work was only woodwork or palisading,[1] not solid stone ; but if properly held, it yet served its purpose.

It was the increasing difficulty and barren results of their raids in France which led the Danes of Rolf in 911 to come to the same bargain with Charles the Simple which the Danes of Guthrum had made with Alfred of Wessex in 878. When the king offered them a great *Danelagh* (as the English would have called it), reaching from the river of Epte to the Western Sea, Rolf and his followers accepted the bargain, and agreed to draw together, settle down, and make a peace with the Franks. Contrary to what might have been expected, the settlement was on the whole a success from the point of view of Charles the Simple. Gradually all the other Danish bands, leaving the Loire and the Garonne mouths, gathered in to settle along with Rolf's men. Like Guthrum in England, Rolf in Normandy was a more faithful vassal than might have been expected, and even sent his bands on several occasions to help the king against native rebels. It was only when Charles had fallen into the deadly snare of Count Herebert of Vermandois that the Normans were turned loose again on the land (928). The Franks proved now well able to defend themselves, and King Rodolf cut to pieces at the battle of Limoges (929) the host that tried to open once again the old route of the raiders into Aquitaine. From the time of William Longsword onward, the Normans appear no longer as heathen invaders from without, but as unruly vassals within. By the year 1000 they may for most purposes be regarded as assimilated to their neighbours, and Normandy is but the most important fief of the French crown.

We must now turn back to the Danish invaders of England and see how Alfred and his descendants faced the problem which Charles the Bald endeavoured to solve by the aid of cavalry, walled towns, and fortified bridge-heads. England had

[1] For some account of the palisaded mounds of the continental nobles see Book VI. chapter vii. The famous tower at the bridge-head round which so much fighting raged during the great siege of Paris was only woodwork (see Abbo, I).

no force of horsemen when the Viking raids began ; Ecgbert's
army was in this respect wholly unlike that of Charles the
Great. There was no question of reinforcing the cavalry arm
in England, for no such force existed. But in other respects
we find the Frankish methods reflected, with some variations,
on this side of the Channel. If Wessex had no mailed horse-
men to serve as models for the reorganisation of the whole host,
she had heavily-armed foot-soldiery. The "gesithcund man
holding land," as Ini would have called him, the "thegn," as
the laws of Alfred name him, was practically equivalent to the
vassus or holder of a *beneficium* of the Continent. As among
the Franks the tendency of the ninth century was to drive all
men into the feudal hierarchy,—the more important freeholders
becoming vassals, the less important serfs,—so in England the
middle classes tend to be divided in a similar way. The richer
ceorls are absorbed into the thegnhood, the poorer sink into
subjection to their greater neighbours. In the laws of Alfred
it is easy to detect the fact that the free middle class is far less
prominent than it had been even in the time of the laws of Ini.[1]
There were already "hlafords" and dependants in the day of
the elder code ; by the day of the later they must have been
the most important part of the population. How the change
came about may be gathered from the two important but
anonymous documents of the early tenth century, the one
dealing with Weregelds, the other with "The People's Ranks
and Laws," printed on pp. 79–81 of Thorpe's *Early English Laws*.
In the Weregeld document the first draft states that "if a ceorl
thrive so that he have a helm and a coat-of-mail and a sword
ornamented with gold, but have not five hides of land to the
king's *utware*, he is nevertheless a ceorl. But if his son and
son's son so thrive that they have so much land afterwards,
the offspring shall be of 'gesithcund' race, and the weregeld
2000 thrymsas."[2] The second draft, however, alters this into
"if the ceorl acquire so much that he have a coat-of-mail and a
helm and an overgilded sword, though he have not that land
[five hides] *he is sithcund*, etc. etc."[3] These two passages are
to be compared with the third in the "Ranks and Laws"
document, which states that "the ceorl who throve so that he

[1] See Alfred's Laws, 1 and 37, particularly the latter.
[2] Weregeld Document, 9, 10, 11.
[3] Weregeld Document, 2nd version, 9, 10, 11.

had fully five hides of his own land, church and kitchen, bell-house and burhgeat, place and duty in the king's hall, was henceforth of thegn-right worthy."[1] So was, it will be remembered, "the merchant who fared thrice over sea at his own expense."[2]

The obvious meaning of these passages is that all holders of five hides and upwards who were not already in the thegnhood were now absorbed into it, and became charged with its duties as well as its privileges. Nay, even more, the ceorl who is fully armed, though he have not the full five hides, is apparently allowed to come into the gesithcund class, if the second version of the Weregeld document is to be trusted. This is obviously an endeavour to increase the thegnhood by encouraging all ceorls to arm themselves as well as possible, and so obtain the right to enter it. A similar object is served by allowing the merchant to qualify for the same promotion.

The chief charge of the thegnhood was, of course, the duty of following the host in full mail whenever the king took the field. At all costs it was intended to raise the proportion of well-armed men in the army to a maximum. It is worth noting that we find, in the "Ranks and Laws" document, sub-tenants holding under a "hlaford" who have reached the assessment of wealth necessary to qualify for gesithcund rank: though not directly sworn to the king, they are yet reckoned part of the thegnhood, being called "medial thegns."[3]

This new military force, therefore, which was produced by incorporating all men of wealth and energy among the ceorls in the enlarged thegnhood, was the main weapon with which Alfred and his descendants faced the Danes. The great national levy of the fyrd, though it still retained its miscellaneous armament and its comparative inefficiency, was made somewhat more useful by being divided into two halves, each of which was to take the field in turn while the other tilled the countryside.[4] It served but as the shaft of the weapon of which the thegnhood formed the iron barb.

Alfred did not neglect to follow the example of Charles the Bald in the matter of building strongholds. Though the English fortifications were as a rule mere palisades,—the art of building

[1] Ranks and Laws, § 2. [2] Ranks and Laws, § 6.
[3] A phrase to be found in Canute's Heriot-law, Leges C. § 72.
[4] A.S. Chronicle, 894.

in England being far behind that of the Continent,—they seem
to have been very effective in checking ravages. In a few cases
solid masonry seems to have been used—for example, in patching
up the Roman wall of London, which Alfred "*honorifice restaur-
avit*[1] in 887. Alfred's warlike daughter Ethelflaed followed his
example in this respect at Chester in 907, where her rude repairs
can still be discerned among the Roman masonry. Canterbury,
too, had walls very early. But it was mainly by stake and foss
in concentric rings, enclosing water-girt mounds, that Alfred and
his children protected their frontier. Edward the Elder worked
against the Danelagh with such strongholds in a most systematic
way. His first line of *burhs* was to guard his own border, but
gradually he and his sister Ethelflaed pushed forward a second
line of forts of offensive purpose. These ἐπιτειχίσματα, as a Greek
would have called them, were built opposite every Danish town,
and furnished with garrisons to contain the sallies of the inhabit-
ants and hold down the neighbourhood. Hardly one fell in
twenty years of war, so ineffectual were the siege operations of
the Danes.

It would seem that the system by which the burhs were
maintained was somewhat like that which Henry the Fowler[2]
established in Germany a few years after Edward had begun his
system of fortification. To each burh was allotted a certain
number of hides of the surrounding region, and all the thegns
resident in that district were responsible for the defence of the
stronghold. Each of them was bound to keep within the palisade
of the burh a house, which he must either inhabit himself, or fill
with a trustworthy representative able to bear arms in his stead.
Thus the original inhabitants of the burhs were a race of warriors,
though in later years, when the land settled down into quiet, and
town houses grew to be valuable property, the thegn might let
his tenement to a merchant or craftsman whose primary occupa-
tions were not warlike. But in the early ninth century the burh-
men were essentially military in their pursuits. It would seem
that the cnihten-gilds, as we find them at Cambridge, London,
and elsewhere, were the original association of the settlers, who,
coming in from all sides to hold reconquered land, had no
common local tradition, and had to start new bonds of unity
among themselves.[3]

[1] Asser, 887. [2] See p. 120.
[3] All these suggestions I get from Professor Maitland's invaluable *Domesday Book*

One of Alfred's devices of fortification deserves a special note, as being exactly copied from a feat of Charles the Bald. In 896 a great Viking host had ascended the river Lea with all their vessels. The king, choosing a place near the point where the Lea runs into the Thames, rapidly erected two burhs on each side of the river, and then joined them so effectually—whether by floating booms or bridgework, we are not told—that the Danes were sealed up in the river, and, being unable to return to the Thames, had ultimately to abandon their fleet, and retire overland, leaving the Londoners to bring the ships in triumph back to their city.[1] This is perfect reproduction of the doings of the Frankish king on the Marne in 862,[2] and it cannot be doubted that Alfred had remembered the device, and deliberately copied it when the opportunity came to him.

Far better, however, than any mere fortification of the inland was the third great plan which Alfred adopted for bringing his Danish wars to a successful conclusion. He began to build a strong fleet, able to contend at sea with the Vikings. In the very first years of his reign he had seen that this was the one really effective way of keeping the coast secure. As early as 876, long before the peace of Wedmore, he gathered a few ships and chased off a small raiding squadron.[3] After he had gained some leisure by the peace with Guthrum, he kept continually enlarging this force; by 885 he had apparently some dozens of ships afloat, though not enough to cope with the main Viking fleets.[4] Later, as the Chronicle tells us, he built " long ships that were full nigh twice as long as others ; some had sixty oars, some more ; they were both swifter and steadier, and also higher than others, and they were shaped neither as the Frisian nor as the Danish vessels, but as it seemed to himself that they might be most useful." The first successful doings of the new squadron are recorded under the year 897. The nucleus of a well-built fleet was perhaps the most precious legacy of all that Alfred left to England ; his son steadily increased it. In 911

and Beyond. The " Burgal Hidage " which he gives in full, seems to belong to a period early in Edward's reign, when the reconquest of Mercia and Essex was just commencing. It has very full details of the division of all the shires south of Thames into districts depending upon burhs, but becomes incomplete as we advance into the regions which were beginning to be reconquered from the old enemy. There the system was but just being built up.

[1] A.S. Chronicle, 896. [2] See p. 106.
[3] A.S. Chronicle, 876. [4] A.S. Chronicle, 885.

Edward was able to send out some hundred ships to guard the coast of Kent; twenty years later the navy was so large and so well practised, that Æthelstan, Alfred's grandson, was able to coast up the whole eastern shore of Britain unresisted, to invade the domains of Constantine, King of the Scots.[1] The Danes of Northumbria were in rebellion at the time, but they were evidently unable to launch any squadron large enough to molest his armament.

Among the Franks, then, mailed cavalry and systematic fortification, among the English, mailed infantry, well-built burhs, and a fleet, ultimately succeeded in curbing the raids of the Northmen. It must not be forgotten, however, that to a certain extent this triumph of the defensive over the offensive was due to a change of conditions among the invaders themselves. The success of the first Vikings was very largely due to the fact that they were a mere army, with no homes or treasures of their own to defend; their wives and children and stored property were all over seas in inaccessible Scandinavia, and they had no base to defend save their fleet. Their sons, however, who had rooted themselves down to a greater or less extent on the Seine or the Humber, were in a very different case. The moment that they began to make permanent encampments on this side of the North Sea, they commenced to lose some of their advantages. When they brought over their families, and began to till the land in an English or a Frankish Danelagh, they completely forfeited their strategical superiority. A Dane of Normandy or the " Five Boroughs " had to protect his own homestead as well as to endeavour to harry Neustria or Wessex. An enemy who has towns to be burned, and cattle to be lifted, is much more easily to be dealt with than a mere marauder who has nothing to lose, and whose base of operations is the sea. In the tenth century the tables were completely turned between Englishman and Dane. Contrast with the dismal records of the years 840–880 the following extract from the Anglo-Saxon Chronicle, covering the fifth year of Edward the Elder :—

" A.D. DCCCCV.—In this year the " army " in East Anglia [*i.e.* the Danes of Eoric, Guthrum's son] harried Mercia till they came to Cricklade, and then went over Thames, and took about Braden forest all that they could carry off, and then went home. Then went after them King Edward, as speedily as he could

[1] A.S. Chronicle, 933.

8

gather his men, and harried all their lands between the Dikes and Ouse, as far north as the Fens."

The retaliatory raid now followed an invasion as surely as effect follows cause, and Eoric and hundreds of his warriors were slain in the mere attempt to cut off Edward's last retreating column, when the English wheeled round to return to Wessex, after burning out every Danish farm in the East Midlands. It is easy to understand the kind of reasoning that nineteen years later caused all the English Northmen to take King Edward "to father and lord," after he had gradually subdued East Anglia and the "Five Boroughs" [924].

The later Danish wars in the time of Ethelred the Redeless and Sweyn Forkbeard are no true continuation of the struggles of Alfred and Edward a hundred years before. The later invaders came for political conquest, not for plunder or land ; they were in their ends more akin to William the Bastard than to Ingwar and Guthrum. If Cnut conquered England, it was not the individual superiority of his warriors that made him king. Dane and Englishman were now armed alike, and fought with the same weapons and in the same array. Ethelred fell because his realm was in an advanced stage of feudal decomposition, due to the mistaken policy of Edgar in cutting up England into great Ealdormanries, whose rulers had grown too independent, and failed to help each other in the hour of need. Instead of the king heading the united thegnhood of England, backed by the fyrd, we find great provincial satraps each at the head of his local levy, maintaining a spasmodic resistance without mutual aid. The fall of the Saxon house was due to the repudiation of Ethelred by his own subjects, who disowned him and took Sweyn and Cnut as their masters.

The rule of Cnut was notable in England not merely for his temporary suppression of the danger of feudal disintegration, by the rough method of summarily slaying the turbulent earls Uhtred and Eadric, but for the introduction of a new military element into the kingdom. He retained with him, when he dismissed the rest of his host to their Danish homes, a small standing army of picked mercenaries, his "huscarles," or military household. To the number of several thousands, they constantly followed the king, and formed the nucleus of any force that he had to raise. They had a considerable advantage over the thegnhood, as they had not to be called in from distant estates,

but were always ready under the king's hand for any sudden need. The institution survived the extinction of Cnut's house ; Edward the Confessor and Harold Godwineson ·maintained under arms this body of picked men. They were the core of the hosts which smote Griffith the Welshman and Macbeth the Scot.[1] Their glorious end was to fall to the last man fighting round the Dragon banner of Wessex, on the fatal field of Senlac.

The influence of the Danes had marked itself in English warfare not only by causing the reorganisation of the military force of the realm, and by precipitating the growth of feudalism, but by certain novelties of equipment. It seems to have been from the Vikings that the English got the kite-shaped shield which superseded the round buckler in the tenth century. Still more notable was the adoption of the Danish axe, a heavy two-handed weapon utterly different from the light casting-axes of the early English. By the time of Edward the Confessor it seems to have been as common as the sword among the English thegnhood. At. Hastings it was the characteristic weapon of Harold's host. In the far East it was so peculiar to the English and Danes of the Byzantine Caesar's Varangian Guard, that they are habitually described by their employers as the Πελεκυφόροι.

[1] In the battle against Macbeth there were slain " Osbern and Siward the Younger, and some of Earl Siward's huscarles, and also many of the king's, on the day of the Seven Sleepers " (A.S. Chronicle, 1054).

CHAPTER IV

THE MAGYARS (A.D. 896-973)

THOUGH the most formidable, the Vikings were by no means the only dangerous enemies of Christendom in the evil days of the ninth and tenth centuries. While the raids of the Scandinavians were still terrifying the Franks and the English, other enemies were thundering at the gates of the southern and the eastern realms. With the Saracens who so afflicted Italy in the days of Lewis II. and Berengar we need not much concern ourselves. They are the same Cretan and African Moslems with whom the Byzantine fought, and their methods of war are described in the chapters in which we deal with the wars of the Eastern Empire. The more formidable invaders of Germany require a longer notice.

The Magyars first came upon the horizon of the Western Empire in 862, when the first of their bands which pushed across Hungary made a transient irruption into the Bavarian Ostmark. But they did not make a permanent appearance on the Imperial frontier till 896, just when the worst of the Danish inroads were ended in East Francia. King Arnulf had asked their aid in 892 against his enemies, the Slavs of Moravia,[1] and apparently the easy success which they won over these tribes tempted the Magyars to move westward. They had just been defeated by their neighbours the Patzinaks, and, being driven out of their previous homes on the Bug and Dnieper, came flooding through the passes of the Carpathians into the valleys of the Theiss and Danube. The Avars had long sunk into nothingness, and the Slavs who had succeeded them on the Middle Danube seem to have been perfectly helpless before the invaders. So the kingdom of " Hungary " came into existence in a single year, with little fighting or opposition.

[1] *Ann. Fuld.* 892.

The new neighbours of the East Franks were a people of horse-bowmen, ever in the saddle, and entirely given up to war and plunder. They were formidable on account of their swift movements, their proneness to stratagems and surprises, their wariness on the march, and their horrible greed and cruelty. As the chronicler Regino observed, "no man could stand against them if their strength and their perseverance were as great as their audacity."[1] But they were incapable of besieging a walled town, or of standing firm in the shock of hand-to-hand fighting. Their tactics in the West, as in the East, were to hover round the enemy in successive swarms and overwhelm him with flights of missiles. When charged by the heavy Frankish horse, they fled, still pouring their arrows behind them.

The Magyars had been established for no more than three years in their new abode, when they turned to plunder their Christian neighbours. The poor spoil to be won from the Slavs did not content them, and they were well acquainted with the comparative wealth of the Franks and Lombards. The ambassadors whom they sent to King Arnulf are said, indeed, to have been mere spies, whose real object was to learn the routes into the empire.[2] But their great irruption into Venetia in 899, followed by an almost equally destructive raid into Bavaria in 900, was a complete surprise to the Christians, who had never suffered a serious invasion from the East since Charles the Great had crushed the Avars ninety years back.

The moment which the Magyars chose for their invasion was an unhappy one for Italy and Germany. In the former country King Berengar was but lately freed from his first rival, Lambert of Spoleto, and was just about to start on his contest with a second pretender, Lewis of Provence (900–901). He was also much distracted by Saracen raids on Latium and Tuscany. In the German kingdom Lewis the Child wore the crown—he was a boy of no more than seven years old, the first minor who had worn the Carolingian crown. No strong regent governed for him, and the great vassals who had of late established themselves in the new duchies were about to plunge into a series of bloody and useless civil wars.

The extraordinary successes which the Magyars obtained

[1] Regino, 889, i. 600.

[2] "Missos illorum sub dolo ad Baioarias pacem optando, regionem illam ad explorandum transmiserunt" (*Ann. Fuld.* 900).

during the first thirty years of the tenth century were far more the result of their enemies' divisions and ill-governance than of their own strength. The marvellous swiftness of their incursions made it hard to catch them; but if the eastern frontier of Germany and the passes of the Venetian Alps had been properly guarded by the systematic fortification of the chief strategical points, and if the mounted levies of all the frontier districts had been taught to act in unison, they could have been held back. Neither in Italy nor in Germany were these measures taken: the perpetual civil wars of the period 900–918 prevented any common action against the enemy. The fortification of Ennsburg (901) to protect the eastern frontier of Bavaria was an isolated and a wholly insufficient precaution, but the only one which the reign of Lewis the Child can show. Only once was a general levy of all Germany called out against the Magyars (910), and then it fought in three separate divisions many miles apart. The main body, with which was the young king himself, was routed near Augsburg by one of the usual "Turkish stratagems" so well known to the Byzantines. While half the Magyars offered battle, and turned to fly after a trifling resistance, the rest of their horde lay hid in ambush till the German horse swept by them in the disorder of victory. Then, pouring out on the flank and rear of King Lewis's men, while their comrades wheeled and charged the front, they won a great victory.[1]

Pitched battles, however, were rare in the Hungarian wars, for the raiders were more set on plunder than fighting. Nor had they any bases (like the Danish ship-camps) to which they were accustomed to return with their booty, and in which they could be brought to bay. Carrying off only what could be borne on pack-horses, they swept across the open country like a whirlwind, and were often gone before the ban had time to assemble. Ekkehard, describing the devastation of the lands by the Lake of Constanz in 926, gives us a good picture of a Magyar raid. "They went," he writes, "not in one mass, but in small bands, because there was no Christian army in the field, spoiling the farms and villages and setting fire to them when they had spoiled them: they always caught the inhabitants unprepared by the swiftness of their appearance. Often a hundred of them or less

[1] A fair description of this fight is in Luitprand, *Antapodosis*, ii. §§ 3, 4, much loaded unfortunately with Virgilian quotations.

would come suddenly galloping out of a wood on to the prey:
only the smoke and the nightly sky red with flames showed
where each of their troops had been."[1]

It was their rapid movement, far swifter even than that of
the Danes, which alone made the Magyars formidable. The
wide sweeps which some of their expeditions made far exceed
in length any Viking raid. The most formidable of all were
those of 924, 926, and 954. In the former they swept through
Bavaria and Swabia, crossed the Rhine, ravaged Elsass and
Lorraine, penetrated into Champagne, turned eastward again
from the Ardennes, and returned across Franconia to the Danube.
In the second raid—a still more astonishing feat of horseman-
ship—they passed the Venetian Alps, swept over Lombardy
(taking Pavia on their way), and then endeavoured to cross the
Pennine Alps into Burgundy. Checked in the passes by Rodolf of
Little Burgundy and Hugh Count of Vienne, they turned south,
and, taking a more unguarded route, burst into Provence and
Septimania. On their return journey Rodolf and Hugh cut off
many of them, but the bulk seem to have got safely back to
the Danube.[2] But the expedition of 954 was the most dreadful,
as it was the last, of all the great Magyar raids. In that year
the invaders wasted first Bavaria, then Franconia: they crossed
the Rhine near Worms. Then the rebel Duke Conrad wickedly
made a pact with them, and sent them guides to lead them to
the lands of his private enemy, Reginald Duke of Lower Lorraine.
After harrying that duchy as far as Maestricht, they turned south,
and suddenly descended the Meuse into France, where no one
was expecting them. After burning every open village in the
territories of Laon, Rheims, and Chalons, they swooped down on
Burgundy. Here they met considerable resistance, but, forcing
their way through the Burgundians, they dropped down into Italy,
apparently by the Great St. Bernard, and finally hurried across
Lombardy and over the Carnic Alps back to their own land.
It was fortunate for Christian Europe that the Lechfeld victory
was to fall into the next year, and that the wings of the Magyar
vultures were to be for ever clipped by Otto the Great (955).[3]

The remedies against the Hungarian raids were obviously the
same that were required against the Danish,—swift cavalry to
chase the raider, and fortified places to afford shelter for the

[1] Ekkehard, c. 52. [2] *Flodoard Ann.* 924.
[3] For this raid see Witikind, iii. § 30, and *Cont. Regino*, 954.

population of the countryside, and place their wealth out of the raiders' reach. Unfortunately for Germany, its eastern frontier was almost destitute of strong towns, and the Saxons and Thuringians (as also the Bavarians to a lesser degree) were, of all the Teutonic races, the least educated in cavalry tactics. The Saxons, indeed, were still for the most part foot-soldiery.

It was not till the advent of Henry the Fowler (or Henry the Builder, as contemporaries more wisely called him) that any check was set to the Magyars by either of the necessary expedients. Henry from his first accession showed himself a far more powerful prince than his unfortunate predecessors, Conrad of Franconia and Lewis the Child; but it was not till he had been five years on the throne that he found leisure to devise a system of defence against the invaders. Having in 924 concluded a truce with them, on the ignominious terms of paying a large "Magyargeld" (if we may coin the word by analogy from "Danegeld"), he set to work to garnish the frontier with new fortresses. In Saxony and Thuringia he made every ninth man of the *agrarii milites—i.e.* all men in the countryside liable to the *ban* in time of need—remove into a walled place. He set the whole population to work day and night to build these strongholds, and to construct houses inside them: these being finished, he settled that each ninth man should dwell therein, and take care of the eight neighbouring houses which his companions were to occupy in time of war, while the eight were to pay the indweller in return one-third of the net products of their lands.[1] All the legal and festal meetings of the district were to take place inside these new fortified places, so as to induce the population to haunt them as much as possible. Among these foundations were Merseburg, Quedlinburg, Goslar, Nordhausen, Grona, and Pöhlde. Henry also compelled the abbeys to wall themselves in, and repaired the fortifications of the older centres of population which dated back to the *burgs* of Charles the Great. At first the new strongholds were little more than thinly-inhabited places of refuge, but ere long most of them became real towns. The founding of Merseburg, the easternmost and the most exposed bulwark of Saxony, deserves a special notice. Henry peopled it by sparing the life of every "strong thief" that he caught, on condition that he should go to dwell at Merseburg and receive a

[1] All this is told very elaborately in Witikind, i. 35.

grant of land in its environs. Strangely enough, this "legio collecta a latronibus," as the chronicler calls them,[1] did very well in their new settlement, and, like Romulus' robber band, made their city the centre of a strong community in a very few years.

Henry also devoted his years of peace to inducing the Saxons and Thuringians to learn the art of fighting on horseback. We are unfortunately without information as to the means he employed—whether he compelled the royal vassals alone to serve mounted, or whether he also put pressure on the freeholders who still abounded between the Elbe and Weser. We only know that when the next Magyar raid came, in 933, it found North Germany for the first time possessed of "milites equestri praelio probatos,"[2] as well as of a formidable range of new fortresses.

The result was most satisfactory. When the invaders threw themselves on Thuringia, their smaller bands were cut to pieces by the local forces, who were now able to follow them at equal speed. Their main army was attacked by Henry himself, who had called up the cavalry of the neighbouring Franconian and Bavarian lands to join the Saxons and Thuringians. By showing only a small force, the levy of Thuringia alone, "cum raro milite armato," i.e. with few mail-clad men, he enticed them to attack him. But when the whole German host suddenly displayed itself and charged, the Magyars broke and fled without staying to fight. A few were caught and slain, a good many were drowned in the Unstrut (which lay behind them), but the majority got off in safety and returned to Hungary. Such was the battle at Riade, which modern historians have generally called the battle of Merseburg, though it seems really to have been fought nearer to Erfurt than to the other city.

Three years later Henry the Builder died, and was succeeded by his still more famous son, Otto the Great. It may seem strange that under such an able ruler the Magyar raids should still have continued for more than twenty years after the day on which his father had shown the true way of salvation. A closer consideration of the facts shows that they are not so surprising as they appear. The inroads after 933 are, with two exceptions, by no means so formidable as those of the earlier years of the century. These two really important invasions were carried out, the one before Otto was firmly seated upon his throne, the

[1] Witikind, ii. 3. [2] *Ibid.* ii. 38.

other in the midst of a great civil war, and with the traitorous co-operation of the rebels. For the greater part of the early years of his reign (936–955) the realm was fairly free from raids, if we except a continual bickering along the Bavarian frontier, in which the Germans were more often victorious than unsuccessful. The change in the spirit of the times since the battle of Riade is sufficiently shown by the fact that the Bavarians are found entering Hungary and wasting it as far as the Theiss in 950, instead of waiting helplessly to see their own lands plundered, as they had been wont to do thirty years before.[1] Saxony, safe behind its new line of fortresses, seems to have held its own without difficulty.[2]

The great Magyar invasions of 954 and 955 were a last rally of the plundering hordes, conscious that their prey was escaping them, and determined to try one more bold stroke before it was too late. The chroniclers record the fact that they had put every available horseman into the field, and that no such host had ever been seen before.[3] We may compare the Hungarian army that marched on Augsburg in 955 to the Turkish army that marched on Vienna in 1683—it was the last desperate effort of a power conscious that its superiority was slipping from it.

Nevertheless, King Otto had every right to be proud of his victory on the Lechfeld on St. Lawrence's Day. His realm was still disturbed with the last throes of the great rebellion which he had put down in the previous year, and, as there were dangerous movements still working among the Slavs of the Lower Elbe and on the Lotharingian frontier, he had not been able to call out the full levy of his kingdom. There were hardly any Saxons, Thuringians, or Lotharingians, and very few Franconians with him. His army was composed of the cavalry of Bavaria and Swabia, with a thousand Franconians, and the same number of his Slavonic vassals the Bohemians, under their prince Boleslav. Hearing that Augsburg was besieged, and that its garrison was in great danger, Otto marched rapidly to its rescue, without waiting for further reinforcements. He divided his army into eight corps, *legiones* as Witikind calls them, each entirely com-

[1] Witikind, ii. § 36.

[2] The Magyars' raid into Saxony in 938 was most disastrous to themselves (Witikind, ii. § 14).

[3] Gerh. v. Oudalr. § 12.

posed of cavalry, and each mustering about one thousand men. Three "legions" were Bavarian, two Swabian, one Franconian, one Bohemian ; the eighth was composed of the king's personal following and of picked men from the other divisions ; it was somewhat larger than the rest. The army was small compared with that which had accompanied Otto on his invasion of France in 946, when (as he boasted) "thirty-two legions had followed him, every man wearing a straw hat,"—for in the summer heat the Germans had marched unopposed through Champagne with their helms at their saddlebows, and the peaceful headgear of straw shading their brows.[1]

On hearing of the king's approach, the Hungarians hastily raised the siege of Augsburg, and drew themselves up on the broad and level Lechfeld, a region very well adapted for the practice of their usual Parthian tactics. Otto, however, moved to meet them through broken ground which was unsuitable for their manœuvres, and then camped by the side of the Lech. He drew up his army in a single line of corps, his own chosen band in the centre, on its right the three Bavarian " legions " and that of the Franconians, on his left the two Swabian divisions. The Bohemians, whether because their loyalty was doubted or because they were considered less solid troops, were placed behind, in charge of the baggage. They were a camp-guard, not a reserve.

The Magyars soon came in sight—a confused weltering mass of hundreds of small troops ; the German chronicles say that they were a hundred thousand strong, and, however exaggerated the figure may be, they no doubt many times outnumbered Otto's host. They had crossed the Lech far sooner than had been expected. Their first manœuvre was characteristic : while some of them threatened the German front, a great body slipped off to the left, apparently unseen, and suddenly fell upon Otto's camp. The Bohemians left there on guard were routed after a short struggle. The Magyars then suddenly changed their direction, and charged in upon the rear of the two Swabian corps of the king's left wing. Taken by surprise by this attack from an unexpected quarter, the Swabians were defeated, and driven towards the German centre : Otto then sent the Franconian corps from his right wing to aid them. Led by Duke Conrad, a

[1] Witikind, iii. § 2. The straw hat was a specially Saxon head-dress for summer wear. See the passage from Rather of Verona, quoted in Pertz's edition of Witikind, p. 451.

lately pardoned rebel who had to win back his reputation for loyalty, the Franconian horse charged with such a fierce shock that the Magyars were completely routed, and fled in disorder to join their main body. Otto meanwhile, with his own division and the Bavarians, had been watching and containing the rest of the Magyars. When he saw the horde which had turned his flank crushed by Conrad, he hastily rearranged the disordered left wing, and ordered a general charge of his whole line.[1]

The Magyars, dismayed by the disaster which had befallen their detached corps, made a poor resistance. They were indeed wholly incapable of standing up to the Germans man to man : their horses were smaller, and very few of them wore any defensive armour.[2] After letting fly a few volleys of arrows, they wheeled off and fled. Many were overtaken and slain, for their horses were fatigued by the first fight ; more were drowned in the Lech, for its farther bank was steep, and they could not readily climb the slippery slope ; they had easily descended it as they attacked, but found it almost impossible to mount on their retreat.

Otto's host had suffered severely in the first fight, but lost few men in the second ; Duke Conrad, however, who had loosened his hauberk to take the air, received a Parthian shaft in his throat at the very moment of victory, and was left dead on the field. On the same evening the Magyar camp was taken and plundered. For the next two days the army pursued the flying foe, many of whom were cut off as they fled by the Bavarian peasantry. Three great chiefs who fell into Otto's hands were incontinently hung.

So ended, as Witikind remarks, the greatest victory which Christendom had won over the heathen for two hundred years ; he was thinking, no doubt, of Poictiers [723] as the last fight that could fairly be compared with the Lechfeld.[3] It is only fair, however, to remember that Henry the Builder's success at Riade, though less showy and less complete, was far more truly the turning-point of the history of the Magyar invasions than the battle of the Lechfeld. Since 933 Germany had found the raiders much less formidable than before, and the invasion of 955

[1] Thietmar is apparently wrong in making the battle last two days ; in Witikind the whole of the fighting takes place on St. Lawrence's Day, August 10.

[2] " Maxima enim ex parte nudos illos armis omnibus cognovimus," says Otto in the speech which Witikind puts into his mouth (iii. § 46).

[3] Wit. iii. 49.

was a desperate final rally. Just as in the history of the Otto-
man assaults on Christian Europe we place the real moment of
greatest danger during the siege of Vienna in 1529, not during
that in 1683, so the most threatening time of the Magyar attack
was undoubtedly in 933, when they had never yet received a
check of importance, and not in 955, when they had already been
met and turned back many times by Otto and Otto's generals.

The danger, at any rate, was now wholly past. That it ever
had grown great was owing to the anarchy of the reigns of
Lewis the Child and Conrad the Franconian. In less than a
generation after the Lechfeld the rôles of German and Magyar
were wholly changed: the Christian is always advancing and the
pagan recoiling. Otto, too, was able to cut a new " march " out
of the Pannonian lands which the Magyars had devastated and
occupied in his grandfather's time. This was the new Bavarian
Ostmark (973), destined to be famous under the name of Austria
for many a future generation.

CHAPTER V

ARMS AND ARMOUR (800–1100)

WE have seen that down to the time of Charles the Great
there had been comparatively little alteration in the
character of arms and armour since the days of the first founda-
tion of the Teutonic kingdoms in the fifth century. In the ninth
century, however, we find a gradual change coming over the outer
appearance of the warriors of Christendom. Not only do a
much greater proportion of them wear defensive arms, but the
arms themselves begin to change in appearance. All the altera-
tions are in the direction of securing greater protection for the
wearer. The short byrnie reaching to the hips and the open
Frankish helm seem to have been regarded as insufficient against
the Danish axe and the Magyar arrow.

One of the first changes consists in the adoption of the
hauberk ("hals-berge," or neck-protection) for the defence of the
throat, neck, and sides of the face. The earliest form of it was
simply a thick leather covering hiding the ears and neck, and
probably was fastened to the rim of the helm, like the camail of
modern Sikh or Persian headpieces. In this primitive shape it
is merely an appendage of the helm; and when Count Eberhard
of Fréjus records in his will (837) a *helmum cum halsberga*,
we must think of it as meaning no more than this. Representa-
tions of such hauberks may be seen in the St. Denis chessmen
figured by Viollet-le-Duc in his *Mobilier Français*,[1] or the
warriors in the Stuttgart Psalter. The next form was more
complete: the material of the hauberk was changed to fine chain-
mail, and it was fitted more tightly to the head and brought
forward to cover the chin and neck. In this shape it was
probably formed into a coif or hood, the part covered by the
helmet being now leather, and the mail beginning where the

[1] Vol. v. p. 67. But their date is much later than Viollet supposed.

headpiece no longer protected the skull. The lower edge of
the hauberk was sometimes tucked under the upper edge of the
byrnie and sometimes hung above it, for the two had not yet
become one garment.

This was the universal wear of well-armed warriors in the
tenth and eleventh centuries. The poorer men had only the
short mail-shirt, the richer supplemented it by the hauberk. We
find clear traces of its use in incidents such as that at the battle
of Soissons in 923, where King Robert, to make himself known,
"pulled out his long beard from under its covering,"[1] that the
enemy might see it. So, too, Duke Conrad at the Lechfeld
received a mortal arrow-wound in the throat, because, overcome
by the heat, he had loosened his hauberk to take the air in
the moment of victory.[2]

The next step in the development of this piece of armour
was that it was joined to the mail-shirt so as to form a single
garment, like an Esquimaux skin-coat. But this did not occur
till the end of the eleventh or beginning of the twelfth century.
Most of the warriors of the Bayeux Tapestry wear mail-shirts not
joined to their hauberks, for in several representations of byrnies
not in actual use we see that they have no hoods. When in the
twelfth century hauberk and byrnie became one, the name of the
former was often used to cover the whole suit—a fact which has
caused much confusion to those who, knowing the term in this
late use, have not seen that it was at first a mere cheek-guard
hanging from the helm.

The helm itself changed entirely in shape in the ninth century.
The open crested Frankish helmet with its peak disappears, and
is superseded by a crestless conical headpiece. The latter shape
is better for turning off sword or axe blows, but it is probable
that it came in not merely for that reason, but because it could
be worn more easily with the hauberk. The older crested helm
stood out too far from the face and was too open to go well with
the new appendage. Probably, too, it did not fit so tightly to the
head, so that if worn above a hauberk of the later shape it would
be more likely to be knocked off than the new conical helm.
After the ninth century we never find the old crested Frankish

[1] "*Barbam obvelatam detegit*, seseque esse monstrat" (Richer, i. 46). The other,
reading "*barbam lorica extraxit*," presupposes a *lorica* covering the chin, *i.e.* furnished
with a complete mail coif, which does not seem to have yet existed in 923.
[2] Witikind, iii. 47.

shape in real use, though it still occurs occasionally in illustrated manuscripts, copied from originals of an earlier time with too great fidelity.

In the tenth century the conical helm receives a new addition in the shape of the nasal, a projecting iron bar to guard the nose from down-cuts which had been turned by the headpiece. The device had been known earlier,[1] but only became really common after 950. It prevailed from that date till the second half of the twelfth century, when it was superseded by the " pot-helm " covering the whole face, such as that seen on the great seal of Richard I.

Not only headgear and throatgear began to change in the ninth century, but also the mail-shirt itself. It had hitherto reached to the hips alone, but now began to lengthen itself towards the knees. Horsemen fighting foot-soldiery armed with heavy striking weapons (like the Vikings), are specially liable to receive cuts at and just above the knee. It was no doubt to guard against this danger that the byrnie grew longer and longer till it touched the calves. To make riding possible, it had to be split at back and front, for a space of some thirty inches or two feet from its lower edge. This divided shirt when drawn by an incapable artist gives the impression of a pair of mail breeches, but such garments were not common till much later.

The sleeves of the byrnie were still wide and short in the tenth century, and far into the eleventh, so that the lower arm had no protection. How wide they were about 923 may be gathered from the fact that King Robert was killed at Soissons by a lance which went up his sleeve, and then bore downwards into his side and through his liver.[2]

From this short sketch it can easily be seen that the warrior of 1050, with conical helm and nasal, hauberk covering his ears and throat, and long mail-shirt reaching below the knee, was entirely different in appearance from the Carolingian fighting man, who still preserved a certain resemblance to the late-Roman soldier. He was also, it must be owned, more effectively armed, if less sightly to look upon. The covering of ring-mail was not yet growing so heavy as to incommode or fatigue the wearer.

To complete the contrast, we must add that by 1050 the kite-shaped shield had wholly superseded the round shield for cavalry, though the latter was still often used by the despised foot-soldiery. A large round shield is a great encumbrance to a

[1] *Helmum cum directo* occurs in the Ripuarian Laws. [2] Richer, i. 46.

rider,[1] who can only wield it with his upper arm, since his hand
is busy with the reins: while a small round shield gives poor
protection against arrows and javelins, though when used by a
skilled warrior it is effective enough against sword or lance.
The kite-shaped shield, on the other hand, has the advantage of
covering the greater part of the body without swelling to the
unnecessary breadth of the round shield, or hindering the outlook
on the left side to the same extent. Thus its advantages were
just those which led the Romans, twelve hundred years earlier,
to substitute the oblong *scutum* for the round Argolic shield.
The last people to preserve the circular targe were those of the
Scandinavians who did not settle in the South. As late as 1171
the Danes who fought Strongbow's Normans at Dublin had the
round red shield which their ancestors had carried three hundred
years before.[2]

Offensive arms did not alter their shape nearly so much as
defensive during the years 800–1100. The double-handed axe,
as we have already seen, was introduced by the Danes, and
adopted by the English and in a lesser degree by other races.
The missile taper-axe did not, however, entirely disappear: it is
mentioned in a charter of Cnut's, and appears again in William
of Poictiers' description of the battle of Hastings, as hurled by
the English at the oncoming Normans.[3] The sword grew
decidedly longer, and had by 1050 received a rounded point
instead of a sharp one, so that it was wholly a cutting weapon.
The horseman's lance was not yet of any great length; at
Hastings the Norman knights used it to cast as well as to thrust.
In some countries the bow was in fairly common use, though it
was always the short-bow, not the formidable six-foot weapon of
the fourteenth century. The Scandinavian peoples, the South-
Welsh, and the races in touch with Byzantium seem to have used
it most. The Danish blood of the Normans accounts for the
large proportion of archers whom they employed at Hastings.
Neither the Germans, the English, nor the French seem to have
taken to it kindly. Abbot Ebolus, the defender of Paris in 886,
is the only notable archer among these peoples who occurs to my

[1] Unless it is made of very light stuff, wicker or cane, for example, such as those
of the Turks of the eleventh and twelfth centuries. But the Western shield was a
heavy solid affair of wood and leather.

[2] Giraldus Camb., *Exp. Hib.* i. § 21: "Clipeis quoque rotundis et rubris, ferro
circulariter munitis."

[3] W. P. 201.

9

memory.[1] At the end of the period which we are now discussing, the crossbow had already been added to the longbow as an infantry arm. But by 1100 it was only just beginning to assert the ascendency which it was to enjoy in the twelfth and still more in the thirteenth century.

[1] See Abbo, *Bell. Par.* ii. 405, for his lucky shot at a Danish pilot. He was also a good marksman with a balista (*ibid.* i. 110).

CHAPTER VI

SIEGECRAFT—A.D. 800–1100

THERE is on the whole a greater continuity in the history of siegecraft and siege-machines through the whole Middle Ages down to the invention of gunpowder, than in the history of any other province of the military art. When we read the account of Witiges' siege of Rome in 537, of the beleaguering of Gundovald Ballomer in Comminges in 585, of Wamba's capture of Nismes in 673, of the Northman Siegfried's siege of Paris in 885–886, of the operations of the Crusaders against Jerusalem in 1099, we are struck with the astonishing similarity of the proceedings of men so far apart in age and in nationality. To take, for example, the first and the last of these five sieges— we find Witiges and Godfrey of Bouillon relying on exactly the same methods. When the rude expedients of striving to fill the town-ditch and swarm up the wall on ladders do not avail, the besieger in each case falls back on two main resources. The one is that of breaching the fortress with rams, the other that of clearing the ramparts of their defenders not only by the missiles discharged by engines placed close at the foot of the wall, but by the concentrated volleys of men posted in high movable towers brought up close to the fortifications, so as to overtop them and to allow them to be swept by arrows from above. If Witiges failed and Godfrey succeeded, it was mainly because the Goth never succeeded in getting his towers right up to the walls, while the Crusader gradually filled the ditch with débris, and finally pushed his engines into such close contact with the town that he could throw his bridges down on the rampart, and cross them at the head of his knights.

All through the Dark Ages there were two great weapons of offence in siegecraft, the ram and the bore. The former worked by gradually battering to pieces the point of the wall on which

it was set to play: it shook the whole structure till the mortar gave way and the ramparts crumbled into a breach. The bore (*terebrus*), on the other hand, consisted of a massive pole furnished with a sharp iron point: it was intended to work piecemeal, picking out or breaking up the individual stones till it produced a round hole in the tower or the front of curtain which it assailed.

The ram was often a vast bulk, the largest tree of the countryside, fitted with an enormous head, and requiring forty or sixty men to swing it. It was slung by ropes or chains from two solid perpendicular beams, drawn back by the workers as far as the chains allowed, and then released to dash itself against the wall. As the besiegers could not hope to live close under the ramparts, beneath the deadly hail of stones and shafts which the defenders poured upon them, it was necessary to cover the ram with a shelter. Accordingly it was provided with a large penthouse which usually ran upon wheels or rollers, though sometimes it seems to have been carried forward by main force, and set down again and again as the ram moved on. The sides of the penthouse were usually made of hides, or of hurdles covered with hides, to make the structure as light and portable as could be managed. The roof, however, had to be more solid, as the defenders were wont to pour on it liquid combustibles, such as pitch or boiling oil. If the assailant made it very strong, with solid beams covered by raw hides, tiles, or earth to keep off the burning liquid, the only resource of the defenders was to drop heavy stones upon it or to destroy it by a sortie.

But even if the penthouse could not be harmed, the ram itself might be disabled: a favourite device—descending, like the engine to which it was opposed, from Roman times—was to let fall on its head, while it struck the wall, heavy forked beams, which caught it, held it firm, and prevented it from being drawn back. We shall see this plan tried in the Viking siege of Paris. A less effective palliative was to hang from the wall, over the point on which the ram was playing, thick mattress-like sheets of sacking filled with straw, or broad and thick beams. The ram spent its strength on these without progressing in its attempt to make a breach. Both beams and sacking are heard of in the great siege of Jerusalem in 1099, and both ultimately proved more harmful to the besieged than to the assailant.

It is confusing to find the ram and its penthouse spoken of in chronicles under names which hide the true nature of their

work.　Such are *cancer* and *testudo*, both employed as synonyms for this machine, but both referring properly not to the ram but to the penthouse, whose rounded upper surface suggested the comparison to the two creatures.

The bore (*teretrus, terebrus, terebro*) worked less ostentatiously and less effectively than the ram ; it required an immense amount of labour before it could make its hole, and was exposed no less than the ram to the dangers from above.　It had, however, the not inconsiderable advantage of being much lighter and easier to transport.　Moreover, it did not require the enormous number of men to work it which the ram demanded.　It was, of course, always covered with a penthouse on a smaller scale than that required for the battering engine, but constructed on the same lines.

The bore and its shelter appear under many names in the chronicles.　It is sometimes called *musculus*, the mouse,[1] because its object was to gnaw a round hole in the lower courses of the rampart.　At other times it is called a " cat," because it clawed its way into walls.　A third and very usual name was the " hog " or " sow " (*scrofa, sus*),[2] applied either because of the resemblance of the round-topped penthouse to a hog's back, or because it worked with its tusks like a boar.　The word *vulpes* is less commonly used for it :[3] in this case, as in that of *musculus*, the allusion is to the capacity of the engine for making neat round holes in the surface that it attacked.

Like the later Romans, the men of the Dark Ages sometimes supplemented the ram and the bore by the device of mines. Before the invention of gunpowder these were invariably worked on a single plan.　The besieger removed as much earth as he could carry away from beneath some exposed corner of the fortifications, and shored up the hole with beams.　He then filled the space between the beams with straw and brushwood, and set fire to it.　When the supports were consumed, the wall crumbled downwards into the hole, and a breach was produced.　Early writers often call the mine a " furnace," the general effect of the lighted mine breathing out smoke and sparks from its orifice

[1] As in Abbo, i. 99.

[2] Many readers will remember the joke of Black Agnes of Dunbar when she had smashed the penthouse and saw its occupants scampering away from beneath: " Behold, the English sow has farrowed."

[3] Albert of Aix uses it in his account of the siege of Nicæa, 1097.

reminding them of the oven of everyday life. Mines were of course very effective against places built on soft soil: the diggers could work undisturbed by the storm of stones and darts from above, which made the use of the ram and bore so dangerous. On the other hand, they were entirely useless against fortresses built on high ground or upon a foundation of solid rock. The best device which the besieged could employ against mining was to countermine, and then attack the diggers below ground, drive them back, and fill up the hole they had excavated. If, however, the besieger had commenced his mine at a considerable distance from the wall, and carefully hidden the mouth of it, so that its exact locality and direction could not be easily discerned, he had a very fair chance of success. For an early example of the mine in use on this side of the Channel we may turn to William the Norman's capture of Exeter in 1067.[1]

The ram, the bore, and the mine were the main resources of the poliorcetic art during our period, but we must mention one or two engines of lesser importance. Scaling ladders are the simplest of all the besieger's tools, and the most useless against a competent defence ; nevertheless a town not unfrequently fell before an unexpected *coup-de-main* or a night attack in which the assailant had no more than ladders to help him. A still more primitive method was that of heaping up earth fascines or rubbish of any kind against the lowest part of a hostile wall, and endeavouring to clamber in over them. Rome itself fell before this rude expedient in 896, when King Arnulf bade his Germans lay against the foot of the ramparts their heavy saddles and the packs of their beasts of burden, and actually succeeded in entering the Eternal City by scrambling up the heap.[2]

The movable tower, as distinguished from the mere penthouse destined to shelter a ram, appears at the end and the beginning of our period, but seems to be absent during its central years. Witiges, as we have already had occasion to mention,[3] employed it in vain against Rome in 537. But we do not find it emerging again till the eleventh century. Probably it passed out of use during the days when fortification was neglected, and had to be revived when the feudal castle had been produced by the influence of the Viking and Magyar. It was, at any rate, in

[1] See Orderic, iv. p. 510: " Per plurimos dies obnixe satagit . . . murum subtus suffodere."

[2] Luitprand, *Antapodosis*, § 27. [3] See p. 131.

full employment before the beginning of the Crusades, being known to William the Conqueror and other competent generals of his age.[1] The most famous examples of its success, however, are to be found in the great campaigns of the East, starting from the capture of Jerusalem in 1099. The tower had a double use: men posted on its top and armed with missiles overlooked the defenders of a rampart and shot them down from above, so as to clear the way for an assault. But it was also quite usual to fit the tower with a drawbridge, which at a propitious moment was let down on to the walls and served as a path for a column of stormers. The tower had all the disadvantages which we have already seen to be inherent to the penthouse. It was even heavier to move than that machine: it was equally combustible, and it was stopped by the slightest ditch, since it could not advance over uneven ground. Even if the besiegers filled the ditch with débris, and produced a level at the foot of the walls, the great weight of the tower often made it sink into the newly-turned earth, and when once stuck fast it could not be moved again. We may add that its size and height made it the easiest of marks for mangonels and petraries. Not unfrequently we hear of towers battered to pieces by the mere missiles of the besieged. William of Tyre remarks that those from which the Crusaders stormed Jerusalem only just served their purpose: they were so damaged at the moment of the assault that the chiefs were on the point of ordering them to be rolled back, and of abandoning the attempt to use them.[2]

Among the minor tools of early siegecraft the many devices of twisted hurdle-work deserve mention. These mantlets (*plutei, crates, hourdis*) were mainly used to shelter the advancing assailants. They were composed of stakes wattled together with osiers or other branches, and were generally covered with a coating of hide. Sometimes a whole storming party would advance against the walls carrying the mantlets over their heads.[3] At other times they were used to protect the smaller siege engines, which had not penthouses of their own. Sometimes they were arranged in rows, so as to form a covered way to enable men to enter the penthouses with safety, or to get close

[1] See Guy of Amiens, l. 699. Ansgar the Staller explains to the Londoners that "Cernitis oppressos valido certamine muros, Molis et erectae transcendit machina turres."

[2] William of Tyre, viii. [3] See Abbo, i. 220.

to the foot of the walls. When set in this fashion, they are often called by the old Roman names of *testudo* or *vinea*. War-bands who had been long in the field, like the Vikings or the Crusaders, came to have a great confidence in these light defences, and grew skilled in the rapid making of them. When the Crusading armies sat down in front of a Syrian town, we often find the whole force turning to the construction of a large stock of mantlets before beginning any serious attack on the place. They made the leaguer so much less wasteful of life that the time spent on making them was not thrown away.

The engines for throwing missiles employed in sieges were the same for assailant and defender. They may be divided according to the method which they employed for propulsion, and the missiles which they threw.

There were in the Middle Ages three chief methods of producing the propelling power required to launch a stone or javelin. Only two of them, however, seem to have been used in the earlier centuries with which we are now dealing. These were *torsion* and *tension*. The third and later device was the employment of the counterpoise. By torsion is meant the twisting of ropes and cords whose sudden release discharged the missile. By tension we mean the mere stretching of the cord, in the same fashion used to draw the ordinary bow. Both classes were directly borrowed from the later Romans. The elaborate details for the construction of machines given by Vitruvius, and later writers like Vegetius, Procopius, and Ammianus, explain to us the originals of most of the machines which were at a later time employed in the Teutonic kingdoms of Western Europe. At Constantinople they continued to be made with the old perfection all through the Dark Ages: in the lands west of the Adriatic they were small and rude copies of the Roman originals.

Of the machines working by torsion the best type was the mangon, which played the part of heavy siege-artillery. It consisted of two stout posts joined by a double or quadruple set of ropes. If a beam is placed between the two sets of ropes, and drawn back so as to twist them in opposite directions, a very considerable force is generated. It is utilised either by making a spoon-shaped hole in the end of the beam or by attaching a sling to it; the engineer then places a missile, *e.g.* a rock or a ball of lead or stone, in the spoon or sling, and then suddenly releases the beam.

The ropes, untwisting themselves in a moment, cast the rock or ball with a high elliptic trajectory. The machine is difficult to aim, as everything depends on the exact amount of torsion applied. A wet or dry day, for example, considerably affects the ropes. But for shooting at large easy marks the mangon was effective; it was specially good for what we may call "bombarding" work, *i.e.* the casting of missiles at large into a walled city or an entrenched position. The machine is called by the name "mangon" as early as 886, where Abbo uses the word in his account of the siege of Paris.[1] But it is probably identical with the machine called by the simpler name of sling (*fundus, fundibula*), which (as we have already had occasion to mention) was in use at a much earlier date. Such no doubt were the "slings" which were carried by the military train of Charles the Great.[2] The mangon is the legitimate descendant of the Roman *onager* or *scorpio* described by Ammianus[3] and Procopius.[4]

The second class of machines throwing missiles were those worked by tension, of which we may take the *balista* as the type. The balista is a magnified crossbow, as will be seen from the very clear description of it given by Procopius, when he is describing the engines used by Belisarius to defend the walls of Rome in 537. "These machines," he says, "have the general shape of a bow; but in the middle there is a hollow piece of horn loosely fixed to the bow, and lying over a straight iron stock. When wishing to let fly at the enemy, you pull back the short strong cord which joins the arms of the bow, and place in the horn a bolt, four times as thick as an ordinary arrow, but only half its length.[5] The bolt is not feathered like an arrow, but furnished with wooden projections exactly reproducing the shape of the feathers. Men standing on each side of the balista draw back the cord with little devices [*i.e.* winches]; when they let it go, the horn rushes forward and discharges the bolt, which strikes with a force equal to at least two arrows, for it breaks stone and pierces trees."

In this description Procopius omits only two points: he neglects to specify what were the "devices" for pulling back

[1] Abbo, i. 364. [2] See p. 81.
[3] Ammianus, xix. § 7, and xxiii. § 4. [4] Procopius, *De Bell. Gott.* i. 21.
[5] But it threw javelins as well as bolts, and these evidently of great length. See the passage below from Abbo, about Abbot Ebolus.

the cord, calling them merely μηχαναί; we know, however, from Ammianus, that they were little winches or windlasses which were wound round and round in order to bring back the cord. He also omits to state that the cord was usually of twisted gut, and that when tightened it was caught in grooves or notches cut in the iron or wooden stock to which the two arms of the balista were fixed. The machine was then aimed, by directing the point of the stock at the object which the engineer wished to strike, and, when good aim had been taken, the cord was loosed, and sped the missile on its way.[1] Vegetius, who is far shorter on the subject than Procopius, remarks that the longer the arms of the balista, the harder was the stroke of the missile which it projected.[2] The bolts thrown by it must have been formidable things: at the siege of Rome by Witiges, Procopius saw a mailed Gothic chief, who was struck by a balista-bolt while mounted in a tree, hang for a long time on the missile, which, after piercing him, had stuck deep into the wood. But it cast not only bolts, but long javelins. At the siege of Paris, Abbo tells us how Abbot Ebolus launched from a balista a lucky shaft which went through several Danes, who fell dead pierced by the same missile. The abbot, thinking of fowls broached on a spit, bade their friends "pick them up and take them to the kitchen."[3]

The balista was, of course, a weapon capable of much more accurate shooting than the mangon, for its javelins could be propelled point-blank, and were not hurled with a great curve like the rocks thrown from the other machine; it might, perhaps, be aimed like a modern gun. Hence it was valuable for accurate shooting at small marks, while the mangon was more fitted for battering at large ones. The special use of it by besiegers was to pick off the defenders on the front of wall which was being attacked. The besieged, on the other hand, would employ it to play on those of their assailants who were exposing themselves, especially at men who were out of range of ordinary arrows or javelins. We shall see that in Abbo's description of the siege of Paris, the engineers who were

[1] Procopius must be read closely with Ammianus here: each supplements the other. Ammianus does not speak clearly of the horns of the bow. Procopius omits the winches and notches.

[2] Vegetius, iv. § 22: "Quanto prolixiora brachiola habet, tanto spicula longius mittit."

[3] Abbo, i. 110.

directing the construction of the Danish rams were slain by a long shot from a balista while their machines were still very far from the walls.

The machines of the ninth century, it must also be remembered, were of very inferior workmanship to their proto-types of the fourth. It is probable that much which was iron in Ammianus' day was wooden in that of Abbo. We doubt whether the Frankish smiths could make arms for the balista from iron ; most probably both the arms and the stock were wooden in the days of the siege of Paris.

There is no doubt that the balista was the parent of the crossbow of later centuries. The Romans had possessed some sort of weapon of this kind, but it had so passed out of memory that the Byzantines of the eleventh century, who preserved so many other Roman engines, had no knowledge of it.[1] In the West, on the other hand, it was known and in full use before the time of the Crusades. William the Norman had "balistantes" no less than "sagittarii" at Hastings, as Guy of Amiens is careful to inform us. Nor were the earliest crusaders without crossbowmen, though they did not at first understand how to employ them properly against the Turks. The description of the crusader's arbalest by Anna Comnena is well worth giving, as it shows an exact correspondence in miniature to the great balista described by Procopius, with the exception that, owing to the smallness of the weapon, it can be bent by the force of the body, and does not need a windlass at the side. "That hitherto unknown engine, the Tzaggra," she says, "is not a bow held in the left hand and bent by the right, but can only be spanned by the bearer stooping and placing both feet against it, while he strains at the cord with the full force of both arms. In the middle it has a semicircular groove of the length of a long arrow, which reaches down to the middle of its stock ; the missiles, which are of many and various kinds, are placed in the groove, and propelled through it by the released cord. They pierce wood and metal easily, and sometimes wholly imbed themselves in a wall, or any such obstacle, when they have struck it."[2] Who was the genius who first conceived the idea of making a small hand-balista which could be carried and worked by a single soldier, we are unable to say, nor can we be sure of

[1] It was, says Anna Comnena, τοῖς Ἕλλησι παντελῶς ἀγνοούμενον (x. 8).

[2] *Ibid.* x. 8.

the exact date of its appearance—probably this revival of the old Roman manubalista dates back to that darkest of dark ages, the end of the tenth century.

Of the Trebuchet and other engines working by the use of heavy counterpoises we shall delay to speak till we reach the twelfth century. It is by no means clear when they were first introduced, but apparently they were still unknown in the centuries (800–1100) with which we are now dealing.

Much confusion is caused to the readers of chronicles by the fact that the writers of the early centuries of the Middle Ages use many names for describing the same weapons. All siege-artillery was either of the type of the mangon, *i.e.* relying on torsion, or on that of the balista, *i.e.* relying on tension. But they are called indifferently "slings," "catapults," "petraries," "machines," "engines," "tormenta," with the most exasperating vagueness and inaccuracy, by authors who, being for the most part clergy and not military men, did not fully understand the principles of the devices which they were describing. Moreover, confusion is often caused by the fact that by slight adaptations or changes of shape, the "mangon," whose proper work was the casting of rocks, might be made to hurl javelins, and the balista, whose speciality lay in the accurate propelling of shafts, might be induced to hurl stones.

The best way to gain some idea of the characteristics of a siege during the Dark Ages, is to investigate the details of a typical case. Unfortunately, there are very few chroniclers who give us really good descriptions of such operations. On the whole, we have a better account of the great siege of Paris in 885–886 than of any other leaguer between the days of Justinian and the Crusades. Abbo's long poem on the subject is couched in the vilest Latin, and abounds in the most excruciating false quantities, but it is very detailed, and on the whole very clear. As every device of siegecraft known to the Dark Ages was employed by assailants and defenders, it is well worth while to give a short sketch of the incidents of those eventful eleven months.

We have already mentioned that Paris in the autumn of 885 consisted of the old island-city, with the new fortifications added by Charles the Bald, namely, two bridges crossing the two branches of the Seine, which encircled old Paris, and furnished with two bridge-heads. The northern one lay some-

where about the spot where the tower of the Châtelet afterwards
stood. The southern one must have been somewhere near the
modern Place St. Michel. The bridges were wooden structures,
whose central supports were laid on great piles of stones cast
into the Seine. The bridge-heads were stone towers, but the
northern one was not completed at the moment when the
Danes appeared, having only attained a half or a third of its
destined height. The town was in charge of Odo, count of
the surrounding district, and of its bishop Gozelin. It was
garrisoned by picked men from neighbouring parts of Neustria
as well as by its own citizens; among the chief defenders were
Count Ragenar, Robert (afterwards king) the brother of Count
Odo, and Ebolus, Abbot of St. Germain des Prés.

After capturing Pontoise, the Danes appeared in front of
Paris on November 25, 885. They wished to proceed up the
Seine, which was blocked by the two bridges, and sent to offer
terms to Odo and Gozelin, promising to do the city no harm if
their vessels were allowed to pass under the bridges without
molestation. The count and bishop replied in very proper
terms: the Emperor Charles, they said, had placed Paris in
their hands to serve as a bulwark for the rest of Neustria, and
they would be betraying their master if they saved the town
but handed over the bulk of the kingdom to fire and sword.
Siegfried, the Viking commander, returned them the answer
that, as they refused terms, he would take their city by force,
or, if force failed, at least reduce it by famine.

The Vikings at once landed, and made a vigorous attempt
to storm the unfinished northern bridge-head. It failed, but the
defenders were so struck by the weakness of the tower, that
they spent the night in raising it to the full size which it had
been intended to attain, by a hasty superstructure of beams
and planks. Next morning the Danes found it built up to more
than twice the height which it had shown on the previous day.

Seeing that the bridge-head could no longer be stormed, the
besiegers resolved to have recourse to the old Roman device of
sapping its foundation by means of the "bore" or "pick."[1]
Preparing mantlets (*musculi*), they laid them against the foot
of the tower, and commenced to pull out stone by stone under
cover of these protections. The defenders replied by pouring
boiling oil and burning pitch upon the mantlets, which set them

[1] "Qui (Daci) vero cupiunt murum succidere musclis" (Abbo, i. 99).

on fire, and so scorched the men working under cover of them that they were fain to jump into the river.

The next device of the Danes was an attempt to turn the use of fire against the defenders. They made a mine under the tower, probably filling it with combustibles and setting the mass on fire according to the usual practice.[1] When the mine fell in, a breach appeared in the base of the bridge-head. The Vikings tried to enter it, but failed, being overwhelmed by all sorts of heavy projectiles dropped on them from above. They then laid combustibles against the door of the tower, to burn it open; but a high wind blew the smoke and flame backward, so that the gate stood firm. Meanwhile the defenders brought up to the tower, and to the parts of the wall of the island-city which looked out on the tower, many "catapults," *i.e.* machines of the *balista* type casting bolts and darts. These made such havoc among the Vikings that they finally retired to their ships with the loss of three hundred men (November 27).

Convinced that the place was not to be taken by a *coup-de-main*, the besiegers sent out their bands to ravage the neighbourhood, and collect a vast store of corn and cattle. They fortified a camp near the church of St. Germain l'Auxerrois, with a foss and stakes, and settled down to beleaguer the city in full form. Their artificers took some time in preparing three great rams, each covered by a penthouse of solid wood furnished with sixteen wheels. The penthouses could hold sixty men apiece for the working of the rams. When, however, the machines were wheeled towards the walls, the besieged overwhelmed them with a hail of missiles, and the two artificers who had designed them are said to have been both slain by one javelin from a balista. This disaster to their engineers seems to have delayed the bringing of the rams into action for some days.[2]

January was now far advanced, and the siege had lasted two months. The Vikings, by no means at the end of their resources, resolved to try new methods. They prepared a great number of very heavy mantlets (*plutei*, or *crates*, as Abbo calls them), made of wicker-work, covered with thick coatings of newly-flayed hides. The main body of the besiegers attempted to approach the tower under cover of these mantlets, each of which was capable of concealing from four to six men. Meanwhile two smaller parties embarked on their ships and rowed

[1] Abbo, i. 133–137. [2] *Ibid.* i. 213–215.

up to the bridge, which they tried to climb by mooring their vessels against its supports.

The assailants on land, having reached the bridge-head under shelter of the *plutei*, began to fill up the ditch which surrounded it. They cast into it clods of earth, boughs, straw, brushwood, rubbish of all sorts, and (when they grew excited at their failure) their store-cattle, and even the bodies of the unfortunate prisoners whom they had captured in their raids round the neighbourhood. Meanwhile the besiegers poured a constant hail of missiles upon them, and slew great numbers; but while their attention was thus occupied, the Danes repaired and brought up the three rams which they had been unable to utilise at their last assault. The rams were set to batter at three points of the bridge-head, and began to work considerable damage among the stones and mortar.

The besieged now put in use a very ancient device, which had been regularly employed against the ram in Roman times, letting down large beams with forked teeth, which caught the ramheads and gripped them, so that they could no longer be pulled backwards to deliver their stroke. They had also constructed a number of mangons.[1] The heavy rocks which these machines cast broke down the thick mantlets whenever they struck them, and crushed all those sheltered beneath. After three days of assault, the Danes had lost so heavily that they withdrew from the walls under cover of the darkness, taking away such of their mantlets as were intact, but leaving two of their three rams abandoned and disabled as prizes for the Franks.

While these unsuccessful attempts were being made upon the bridge-head, a very exciting struggle had been carried on around the bridge. The Vikings first tried to take it by assault; when beaten off, they had recourse to other measures. Filling three ships with straw and firewood, they set them alight, and towed them up-stream by ropes from the northern bank, intending to get them under the bridge, and so set it on fire and break the connection between the island and the bridge-head. Luckily for the besieged, the three vessels all went aground upon the heaps of stones on which the wooden pillars of the bridge were laid, and there burned themselves out, or

[1] Abbo, 364: "Machina conficiunt longis lignis geminatis, mangana quae proprio vulgi libitu vocitantur."

were sunk by rocks hurled on them from above. The bridge suffered no harm, and the double assault by land and water had completely failed. (January 29–February 1, 886.)

Four days later, however, an unfortunate accident did for the Danes what they had been unable to accomplish by their own hands. Heavy rains swelled the Seine and Marne, and the furious current which they engendered carried away part of the northern bridge on the night of the 5th–6th of February. To add to the misfortune, there were at the moment only twelve warriors keeping guard in the tower at the bridge-head. Seeing that the garrison could not be succoured from the city till the bridge was restored, the Vikings made a sudden and violent attack on the now isolated tower. They rolled up a cart of straw against its gate, and set fire to it ; the defenders were too few to keep them off, while the discharges which the catapults on the city walls directed against the stormers were distant and not effective—the smoke, we are told, lay about the tower, and the citizens could not see what was going on. The timber superstructure of the bridge-head soon caught fire, and the handful of defenders were forced to evacuate it and take refuge on the fragment of broken bridge which adhered to the tower. The Danes offered to spare their lives, professing admiration for their gallant defence, but no sooner had they laid down their arms than the treacherous barbarians massacred them one and all, and flung their bodies into the river. They then proceeded to throw down the stone foundation of the unfortunate bridge-head. After this success, we should have expected that the Vikings would have made every effort to get some of their vessels up-stream through the broken bridge, and then would have attempted general assaults on the island-city. But they did nothing of the kind : whether it was that provisions were running short and required replenishing, or that they were simply tired of siege operations, they sent the greater part of their forces off to ravage the land towards the Loire. Their entrenchments looked so deserted that the defenders thought that all had departed, and Abbot Ebolus led a sortie to seize and burn the camp. The vigour with which it was repelled showed that there were still several thousand Danes lying in front of the city.

While the siege was thus languishing, Henry Duke of Saxony appeared on the heights above Montmartre with rein-

forcements sent by the emperor. The Danes retired into their
camp and took up the defensive, so that the duke was able to
communicate without hindrance with the city, and to throw into
it a large convoy of provisions. The besieged took advantage
of the respite to restore the bridge, and apparently also to
roughly reconstruct the ruined bridge-head.[1] But the siege was
not yet raised: after an unsuccessful attempt to storm the en-
trenchments of the Vikings, Henry drew off again, and left Paris
to its own resources (March 886). The besiegers were, however,
sufficiently impressed by the appearance of the relieving force
to transfer their camp from the northern to the southern bank of
the Seine, so as to put the river between themselves and any
force coming from the north. Siegfried, the most important of
the Danish leaders, recommended the raising of the siege, as it
was known that the Emperor Charles was calling together a
large army to carry out the enterprise in which Duke Henry
had failed. The majority refused, however, to follow his advice,
and resolved instead to deliver a general assault on the city
before the emperor should arrive. Early in April they simul-
taneously attacked the two bridge-heads, the bridges, and the
island itself, running their boats aground on the narrow shore
at the foot of its fortifications and trying to scale them. They
had no success at any point, and a few days later Siegfried,
followed by a considerable part of the host, took his departure,
after receiving sixty pounds of silver—quite a moderate sum—
from the besieged, who hoped that he would induce the whole
horde to follow him.

The majority, however, headed by a chief named Sinric,
utterly refused to abandon the siege. They were perhaps
encouraged to persist by the fact that pestilence had broken
out in the crowded city with the return of the warm weather;
among its victims was Bishop Gozelin, one of the two chief
heroes of the defence. The siege, however, had assumed a
very curious aspect: the Danes being now mainly concentrated
on the south bank of the river,—though they kept a corps of
observation opposite the northern bridge-head,—the besieged
could communicate in an intermittent way with the open

[1] This is nowhere stated by Abbo, but how could Henry have sent the flocks and
herds into Paris without a bridge? Moreover, the "tower," *i.e.* the bridge-head,
begins again to appear early in the second book of Abbo's poem, and is securely held
by the besieged.

10

country. Sometimes they sent out boats up-stream, sometimes
they ran the blockade in and out of the northern bridge-head.
The fighting died down into skirmishes for egress and ingress
by this route, till in May the Danes tried, without warning or
ostentatious preparations, an attempt at escalade. Three
hundred of them suddenly ran their boats ashore at the foot of
the island wall, and swarmed up it with ladders. The head of
the column got within the enceinte at the first rush, but the
defenders, running together from all quarters, were able to
repulse them before their main body could come to their aid.

In the end of June or the beginning of July, Count Odo,
who had slipped out of the city to communicate with the emperor
and gather reinforcements, appeared on Montmartre with three
thousand men. The Danish corps of observation on the northern
bank tried to intercept him, but he cut his way through them
and re-entered the city with his followers. Soon after the van
of the great army which the emperor had collected from all the
Austrasian and West-German lands came in sight of the city.
Charles the Fat tarried behind at Rheims himself, but sent
Henry of Saxony forward to clear the way to Paris. Less
fortunate than at his first attempt to communicate with the city,
the duke fell into a hidden ditch which the Danes had con-
structed in front of their camp, and there perished. The
emperor still holding aloof, the Danes tried one more general
assault. This time they brought up many more engines than
before, and tried to clear the walls of their defenders by incessant
volleys of stones, javelins, and leaden balls cast from a thousand
machines. They then attempted at one and the same moment
to escalade the bridges and the island-wall from boats, and to
burn the northern bridge-head by heaping combustibles against
it. At every point they were repelled after a desperate struggle,
though it seemed at one instant as if they would destroy the
rough wooden fort which had been reconstructed to cover the
northern bridge. At the last moment, when the garrison had
actually been driven out by the smoke, the fire suddenly died
down before the enemy had entered, and the Franks were able
to rush back and reoccupy the much-disputed work.

This assault was the last crisis of the siege, which ended very
shortly after, not by the driving away of the Danes by the large
army which had now been gathered against them, but by a dis-
graceful treaty. Charles the Fat, instead of attempting to storm

the Danish camp, offered the Vikings a ransom of seven hundred pounds of silver and free permission to pass over into Burgundy, if they would but raise the siege. They accepted his pusillanimous offer, received the money, and passed southward till they came to Sens, which city they beleaguered in vain for six months. Thus, Paris was not relieved by the valour of its garrison, but by the cowardice of its monarch. Nevertheless, its gallant defence had no small effect on men's minds. Seeing the Danes foiled, and the city untaken after so many desperate attacks, all the people of Neustria were encouraged to resist for the future.

Two main points of interest strike the reader who studies the details of this great leaguer. The first is the extraordinary skill in the technique of siegecraft which the Danes had attained after sixty years of raiding in the empire. The second, contrasting strangely with the first, is the fact that they completely failed to appreciate the necessity of cutting off the communication of the city with the outer world. A much shorter term of months must have reduced Paris to surrender if only the assailants had properly taken in hand the isolation of the fortress.

Turning to the first point, we are amazed to see most of the tools and engines known to Vegetius and Procopius in full employment among the wild seamen of the North. The ram, the machines for hurling missiles, the penthouse, the *plutei* and *crates*, the mine, the use of fire, are all thoroughly understood by the Vikings. Obviously, they must have picked them up from their enemies during the interminable series of raids and sieges which had begun in the later years of Lewis the Pious. The Franks are by 885 not a whit more skilled in poliorcetics than their adversaries.

On the other hand, the general strategy of the siege was wholly faulty. No proper arrangement of a permanent covering force was made: any considerable body of relieving troops which presented itself was able to force its way into Paris. The succours under Henry of Saxony and Count Odo had to face some severe fighting in order to pass through the Danish blockade, but they were neither compelled to engage in a pitched battle, nor to force lines of circumvallation. During the first half of the siege the Vikings seem to have neglected the southern bank of the Seine ; during the second half—when they had moved their camp to St. Germain des Prés—the

northern bank seems to have been left without sufficient guard. All through the long months of the leaguer the defenders were able to communicate with their kinsmen of the outer world, either by boat on the Upper Seine or by running the gauntlet between the outposts of the besiegers. Reinforcements and food were thrown into the fortress again and again. The Danes should have blocked the river above the city by a boom, or built boats upon it to keep the water-way closed. They should also have been prepared to risk a general engagement with any relieving force, and not have sent mere detachments against it. Their position, to compare modern things with ancient, much reminds us of that of the English and French before Sebastopol in 1855. A siege may drag on for ever if the assailant only attacks one side of a fortress, and leaves the other in free communication with the open country. The Vikings had the additional difficulty of having only very narrow fronts—the two bridge-heads—to attack. The river prevented them from making any really dangerous assaults on the island, whose walls they could not properly breach by siege-artillery placed on the mainland. Hence we may fairly say that only famine could have been relied upon as a certain method of reducing the place, and that the new methods of fortification introduced by Charles the Bald thoroughly justified themselves, and proved impregnable against any mere attack by main force, even when it used the best siegecraft of the day.

CHAPTER VII

THE LAST STRUGGLES OF INFANTRY—THE BATTLES OF HASTINGS (A.D. 1066) AND DYRRHACHIUM (A.D. 1081)

AS the last great example of the endeavour to use the old infantry tactics of the Teutonic races against the now fully-developed cavalry of feudalism, we have to describe the battle of Hastings, a field which has been fought over by modern critics almost as fiercely as by the armies of Harold and William.

About the political and military antecedents of the engagement we have no occasion to speak. Suffice it to say that on September 25, 1066, Harold Godwineson had defeated and slain Harold Hardrada and Tostig at Stamford Bridge, after a bloody struggle, whose details are entirely lost, though we know that both hosts had fought the matter out to the end in the old fashion of Dane and Englishman, all meeting face to face on foot, and "hewing at each other across the war-linden," till the invaders were well-nigh annihilated. On September 28, William of Normandy and his army came ashore at Pevensey, unhindered by the English fleet, which after long waiting had finally been driven from the Channel by want of provisions,[1] and had sailed back to London three weeks before. The Normans began at once to waste the land, and, since the king and the field army were far away in the north, they met with little resistance. Only at Romney, as we are told, did the landsfolk stand to their arms and beat off the raiders.[2]

Meanwhile, the news of William's landing was rapidly brought to Harold at York, and reached him—if we may trust Henry of Huntingdon—at the very moment when he was celebrating by a banquet his great victory over the Northmen.[3]

[1] Florence of Worcester. A.S. Chronicle, 1066. [2] William of Poictiers, 139.
[3] But, according to Guy of Amiens (156), he was returning with his trophies from the north when the messenger met him.

The king received the message on October 1 or October 2: he immediately hurried southward to London with all the speed that he could make. The victorious army of Stamford Bridge was with him, and the Northumbrian levies of Eadwine and Morcar were directed to follow as fast as they were able. Harold reached London on the 7th or 8th of October, and stayed there a few days to gather in the fyrd of the neighbouring shires of the South Midlands. On the 11th he marched forth from the city to face Duke William, though his army was still incomplete. The slack or treacherous earls of the North had not yet brought up their contingents, and the men of the Western shires had not been granted time enough to reach the mustering place. But Harold's heart had been stirred by the reports of the cruel ravaging of Kent and Sussex by the Normans,[1] and he was resolved to put his cause to the arbitrament of battle as quickly as possible, though the delay of a few days would perhaps have doubled his army.[2] A rapid march of two days brought him to the outskirts of the Andredsweald, within touch of the district on which William had for the last fortnight been exercising his cruelty.

Harold took up his position at the point where the road from London to Hastings first leaves the woods, and comes forth into the open land of the coast. The chosen ground was the lonely hill above the marshy bottom of Senlac,[3] a place far from all human habitations, and marked to the chronicler only by "the hoar apple tree" on its ridge, just as Ashdown had been marked two centuries before by its aged thorn.[4]

The Senlac position consists of a hill about a mile long and 150 yards broad, joined to the main bulk of the Wealden Hills by a sort of narrow isthmus with steep descents on either side.

[1] William of Poictiers, 201.

[2] Or even tripled it, says Florence of Worcester. The A.S. Chronicle is more vague, but to the same effect.

[3] This name is only used by Orderic Vitalis (501 A), among the many chroniclers who describe the battle. But it is substantiated by local documents of a later date; and since *Santlache* occurs as the name of a tract of abbey land in the Chronicle of the Foundation of Battle Abbey, there is no reason to doubt that it was the genuine name of the valley. It is easy to understand that the majority of the writers who narrate the fight had not heard of this local name, and followed the popular voice in naming the fight after the town of Hastings, which, though eight miles away, was the nearest place of importance.

[4] Asser, p. 23.

The road from London to Hastings crosses the isthmus, bisects the hill at its highest point, and then sinks down into the valley, to climb again the opposite ridge of Telham Hill. The latter is considerably the higher of the two, reaching 441 feet above the sea level, while Harold's hill is but 260 at its summit. The English hill has a fairly gentle slope towards the south, the side which looked towards the enemy, but on the north the fall on either side of the isthmus is so steep as to be almost precipitous. The summit of the position, where it is crossed by the road, is the highest point. Here it was that King Harold fixed his two banners, the Dragon of Wessex, and his own standard of the Fighting Man.

The position was very probably one that had served before for some army of an older century, for we learn from the best authorities that there lay about it, especially on its rear, ancient banks and ditches,[1] in some places scarped to a precipitous slope. Perhaps it may have been the camp of some part of Alfred's army in 893–894, when, posted in the east end of the Andredsweald, between the Danish fleet which had come ashore at Lymne and the other host which had camped at Middleton, he endeavoured from his central position to restrain their ravages in Kent and Sussex.[2] No place indeed could have been more suited for a force observing newly-landed foes. It covers the only road from London which then pierced the Andredsweald, and was so close to its edge that the defenders could seek shelter in the impenetrable woods if they wished to avoid a battle.[3]

The hill above the Senlac bottom, therefore, being the obvious

[1] "Crescentes herbae *antiquum aggerem* tegebant" (Orderic Vitalis, 501 D). "Praerupti vallis et *frequentum fossarum* opportunitas" (William of Poictiers, 203 D). Of these one *agger* was in the *rear* of the English position, and was used against the Normans in the last moments of the battle. But there was a *fovea magna* in *front* of the English line, according to Henry of Huntingdon, 763 C: "Fugientes [Normanii] ad quandam magnam foveam dolose tectam devenerunt, ubi multus eorum numerus oppressus est." This *fovea* was well down the slope, and outside the English position. I think these "frequent ditches" and "ancient earthworks" in an uninhabited place can mean nothing but the remains of an ancient camp. Both Mr. Archer and Mr. George pointed this out to me when we were talking over the details of the battle.

[2] A.S. Chronicle, 893–894, copied in Ethelweard, Florence, and Henry of Huntingdon. Alfred "encamped as near to them as he might for the wood-fastnesses and the water-fastnesses, so that he might reach either army, in case it should seek to ravage the open land."

[3] "Mons silvae vicinus erat, vicinaque vallis, et non cultus ager asperitate sui" (Guy of Amiens, 365, 366).

position to take for an army whose tactics compelled it to stand upon the defensive, Harold determined to offer battle there. We need not believe the authorities who tell us that the king had been thinking of delivering a night attack upon the Normans, if he should chance to find them scattered abroad on their plundering, or keeping an inefficient look-out.[1] It was most unlikely that he should dream of groping in the dark through eight miles of rolling downs, to assault a camp whose position and arrangements must have been unknown to him. His army had marched hard from London, had apparently only reached Senlac at nightfall, and must have been tired out. Moreover, Harold knew William's capacities as a general, and could not have thought it likely that he would be caught unprepared. It must have seemed to him a much more possible event that the Norman might refuse to attack the strong Senlac position, and offer battle in the open and nearer the sea. It was probably in anticipation of some such chance that Harold ordered his fleet, which had run back into the mouth of the Thames in very poor order some four weeks back, to refit itself and sail round the North Foreland, to threaten the Norman vessels now drawn ashore under the cover of a wooden castle at Hastings.[2] He can scarcely have thought it likely that William would retire over seas on the news of his approach,[3] so the bringing up of the fleet must have been intended either to cut off the Norman retreat in the event of a great English victory on land, or to so molest the invader's stranded vessels that he would be forced to return to the shore in order to defend them.

Harold took one further precaution. He had served a campaign in the Norman ranks a few years before, on the occasion of his involuntary visit to Ponthieu, and he thoroughly knew the Norman tactics. The danger to the English lay, first, in the rush of the duke's horse; secondly, in the long shooting of the duke's archers. To guard against both these perils Harold

[1] William of Poictiers, 201 B.

[2] *Ibid.* 201 A. I cannot see why Professor Freeman and other writers have doubted this statement. The fleet, or some large part of it, must still have been at London in October.

[3] Yet a good authority, William of Poictiers, says that Robert Fitz-Wymara, a Norman resident in England, sent messengers to the duke to warn him that Harold was approaching with such a large army that he had better put to sea and return to Normandy. William, we are told, scornfully declined the advice.

directed his men to build a fence of crossed woodwork [1] from the brushwood in the forest which lay close at their backs. It was an old Danish device, used two hundred years before, to

[1] Here we come to the most vexed point in this most interesting fight. Neither William of Poictiers, Guy of Amiens, Baldric, Henry of Huntingdon, nor any of the early minor sources of information, distinctly mention this wicker-work. Can we trust Wace, who gives an elaborate description of it before the battle and alludes to it during the course of the engagement? Wace is an authority of later date than the others, and wrote some ninety years after the battle. He occasionally makes strange errors in his narrative (though the earlier writers, it must be remembered, do the same) and sometimes is guilty of anachronisms, though on the whole he comparatively seldom clashes with earlier writers in such a way as to show himself absolutely wrong.

Is it likely that Wace, in describing the struggle which was to his audience *the* battle *par excellence* of the last age, would make such a strange error as to describe what was really a fight on an open hill as an attack on a position which had been entrenched, even though the entrenching was but slight? On the whole, Wace's general narrative is so fairly consistent with the earlier sources, that I cannot believe that he made this great blunder. If it had been the common and ordinary thing for armies to stockade themselves about 1150-60, though an uncommon thing in 1066, we might have thought that Wace was committing a mere anachronism. But it was no more unusual at one date than at the other, and I do not see what should have induced him to bring the wattled barrier into his narrative, unless it existed in the tale of the fight as it had been told him by his father and others who had talked with the victors of the great battle. In our own day popular tradition is a comparatively feeble thing : the written word has everywhere supplanted the oral tale : but in the twelfth century the people's memory was a far more trustworthy thing. I cannot think that Wace, writing for the grandchildren of the men of Senlac, would have ventured to change so entirely the character of the engagement.

We can trace in the *Roman de Rou* the author's knowledge of several of our existing authorities, *e.g.* of William of Poictiers, Guy of Amiens, and William of Jumièges. If he had thought the existence of the breastworks inconsistent with their tale, it seems unlikely that he would have inserted it, for he does not give us the idea of an irresponsible inventor of facts, but of one who conscientiously uses the *data* that come to him, though he may have to adapt them a little to make them assume a fitting place in his story.

I conclude, then, that Wace, possibly from some lost chronicle or poem, possibly only from popular oral tradition, knew of the existence of Harold's wattled breastworks, and mentioned them. His words must imply some kind of wooden barricade—

> "Fait orent devant els escuz
> De fenestres et d'altres fuz
> Devant els les orent levez
> Comme cleies joinz e serrez
> Fait en orent devant closture,
> Ni laissierent nule jointure." (7815-20.)

The reading *fenestres* is, as Professor York Powell pointed out to me, possibly a scribe's blunder for *fresnes tressés* : if so, the passage translates thus—

"They made in front of them shields of wattled ash and of other woods, they raised them in front of themselves like hurdles joined and set close : they left no opening in them but made them into an enclosure." The other main passages referring to the breastwork are, "d'escuz et d'ais s'avironoent," and "ne doterent pel ne fosse," in line 8499.

stockade a force against an overwhelming onset of cavalry by means of breastworks and a ditch. The material for the wattled hurdles, *crates* or *plutei*, as the writers of the time called them, was plentiful and close at hand. They were intended perhaps more as a cover against missiles than as a solid protection against the horsemen, for they can have been but hastily-constructed things, put together in a few hours by wearied men. In all probability they were no more than four feet high. They were set along a slight ditch, perhaps a remnant of the ancient camp which probably lay on the Senlac hill, perhaps a work of the army itself. The ditch, and the mound made of the earth cast up from it and crowned by the breastworks, constituted no impregnable fortress, but a slight earthwork, not wholly impassable to horsemen. We must not think either of a six-foot trench or of massive palisading behind it: such a structure would have required far more time and exertion than the English had to spare. The entrenchment, according to Wace, was triple, *i.e.* consisted of a centre and two wings, with intervals left between them.[1]

Close behind the breastwork, and ready to hurl javelins or strike with hand-weapons across it, was ranged the English host in one great solid mass.[2] Although the Northumbrian and West-country levies were still missing, the army must have numbered many thousands, for the fyrd of south and central England was present in full force, and stirred to great wrath by the ravages of the Normans. It is impossible to guess at the strength of the host: the figures of the chroniclers, which sometimes swell up to hundreds of thousands, are wholly useless. As the position was about a mile long, and the space required by a single warrior swinging his axe or hurling his javelin was some three feet, the front rank must have been some seventeen hundred or two thousand strong. The hill was completely covered by the English, whose spear-shafts appeared to the Normans like a wood,[3] so that they cannot have been a mere thin line: if they were ten or twelve deep, the total must have

[1] "Closre le fist de boen fossé, de treis parz laissa treis entrées" (*R. de R.* 12106). *Fossé* is the technical word for a military trench, and quite distinct from *fosse* (feminine), a ditch.

[2] *Cuneus*, which here, as in most other places, means merely a body in deep order or column as opposed to line, and does not in the least imply a wedge-shaped array.

[3] Guy of Amiens: "Spissum nemus Angligenarum," 421, "silvaque densa prius rarior efficitur," 428.

reached some twenty - five thousand men. Of these the smaller part must have been composed of the fully - armed warriors, the king's housecarles, the thegnhood, and the heavily-equipped soldiery, of whom one had to be furnished by every five hides of land. The rudely-armed levies of the fyrd must have constituted the great bulk of the army: they bore, as the Bayeux Tapestry shows, the most miscellaneous arms—swords, javelins, clubs, axes, a few bows, and probably even rude instruments of husbandry turned to warlike uses. Their only defensive armour was the round or kite-shaped shield: body and head were clothed only in the tunic and cap of everyday wear.

In their battle array we know that the well-armed house-carles—perhaps two thousand or three thousand strong—were grouped in the centre around the king and the royal standard. The fyrd, divided no doubt according to its shires, was ranged on either flank. Presumably the thegns and other fully-armed men formed its front ranks, while the peasantry stood behind and backed them up, though at first only able to hurl their weapons at the advancing foe over the heads of their more fully-equipped fellows.

We must now turn to the Normans. Duke William had undertaken his expedition not as the mere feudal head of the barons of Normandy, but rather as the managing director of a great joint-stock company for the conquest of England, in which not only his own subjects, but hundreds of adventurers, poor and rich, from all parts of Western Europe had taken shares. At the assembly of Lillebonne the Norman baronage had refused in their corporate capacity to undertake the vindication of their duke's claims on England. But all, or nearly all, of them had consented to serve under him as volunteers, bringing not merely their usual feudal contingent, but as many men as they could get together. In return they were to receive the spoils of the island kingdom if the enterprise went well. On similar terms William had accepted offers of help from all quarters: knights and sergeants flocked in, ready, "some for land and some for pence," to back his claim. It seems that, though the native Normans were the core of the invading army, yet the strangers considerably outnumbered them on the muster-rolls. Great nobles like Eustace Count of Boulogne, the Breton Count Alan Fergant,[1] and Haimer of Thouars were ready to risk their lives

[1] Cousin of the reigning sovereign in Brittany.

and resources on the chance of an ample profit. French, Bretons, Flemings, Angevins, knights from the more distant regions of Aquitaine and Lotharingia, even—if Guy of Amiens speaks truly—stray fighting men from among the Norman conquerors of Naples and Sicily, joined the host.[1]

Many months had been spent in the building of a fleet at the mouth of the Dive. Its numbers, exaggerated to absurd figures by many chroniclers, may probably have reached the six hundred and ninety-six vessels given to the duke by the most moderate estimate.[2] What was the total of the warriors which it carried is as uncertain as its own numbers. If any analogies may be drawn from contemporary hosts, the cavalry must have formed a very heavy proportion of the whole. In continental armies the foot-soldiery were so despised that an experienced general devoted all his attention to increasing the numbers of his horse. If we guess that there may have been ten thousand or twelve thousand mounted men, and fifteen thousand or twenty thousand foot-soldiers, we are going as far as probability carries us, and must confess that our estimate is wholly arbitrary. The most modest figure given by the chroniclers is sixty thousand fighting men;[3] but, considering their utter inability to realise the meaning of high numbers, we are dealing liberally with them if we allow half that estimate.

After landing at Pevensey on September 28, William had moved to Hastings and built a wooden castle there for the protection of his fleet. It was then in his power to have marched on London unopposed, for Harold was only starting on his march from York. But the duke had resolved to fight near his base, and spent the fortnight which was at his disposal in the systematic harrying of Kent and Sussex. When his scouts told him that Harold was at hand, and had pitched his camp by Senlac hill, he saw that his purpose was attained: he would be able to fight at his own chosen moment, and at only a few miles' distance from his ships. At daybreak on the morning of October 14, William

[1] Guy of Amiens, line 259.

[2] Wace, the latest authority, gives the most reasonable figures. If the vessels had carried as many men as Viking boats, they might have had sixty thousand men on board; but the horses must have taken up half the room, if there were, say, ten thousand of them.

[3] William of Poictiers, 199, where the duke says that he would "go on even if he had only ten thousand men as good as the sixty thousand whom he actually commanded."

bade his host get in array, and marched over the eight miles of rolling ground which separate Hastings and Senlac. When they reached the summit of the hill at Telham, the English position came in sight, on the opposite hill, not much more than a mile away.

On seeing the hour of conflict at hand, the duke and his knights drew on their mail-shirts, which, to avoid fatigue, they had not yet assumed, and the host was arrayed in battle order. The form which William had chosen was that of three parallel corps, each containing infantry and cavalry. The centre was composed of the native contingents of Normandy; the left mainly of Bretons and men from Maine and Anjou; the right of French and Flemings.[1] But there seem to have been some Normans in the flanking divisions also.[2] The duke himself, as was natural, took command in the centre, the wings fell respectively to the Breton Count Alan Fergant and to Eustace of Boulogne: with the latter was associated Roger of Montgomery, a great Norman baron.

In each division there were three lines: the first was composed of bowmen mixed with arbalesters: the second was composed of foot-soldiery armed not with missile weapons but with pike and sword. Most of them seem to have worn mail-shirts,[3] unlike the infantry of the English fyrd. In the rear was the really important section of the army, the mailed knights. We may presume that William intended to harass and thin the English masses with his archery, to seriously attack them with his heavy infantry, who might perhaps succeed in breaking the breastworks and engaging the enemy hand to hand; but evidently the crushing blow was to be given by the great force of horsemen who formed the third line of each division.

The Normans deployed on the slopes of Telham, and then began their advance over the rough valley which separated them from the English position.

When they came within range, the archery opened upon the

[1] Guy of Amiens, 413 :
" Sed laevam Galli, dextram petiere Britanni,
Dux cum Normannis dimicat in medio."
This means that the French attacked Harold's left, not that they formed William's left.

[2] Robert of Beaumont, a Norman, led a thousand men in the right wing (William of Poictiers, 202 c).

[3] " Pedites firmiores et loricati," as William of Poictiers expresses it.

English, and not without effect;[1] at first there must have been little reply to the showers of arrows, since Harold had but very few bowmen in his ranks. The breastworks, moreover, can have given but a partial protection, though they no doubt served their purpose to some extent. When, however, the Normans advanced farther up the slope, they were received with a furious discharge of missiles of every kind, javelins, lances, taper-axes, and even—if William of Poictiers is to be trusted—rude weapons more appropriate to the neolithic age than to the eleventh century, great stones bound to wooden handles and launched in the same manner that was used for the casting-axe.[2] The archers were apparently swept back by the storm of missiles, but the heavy armed foot pushed up to the front of the English line and got to hand-to-hand fighting with Harold's men.[3] They could, however, make not the least impression on the defenders, and were perhaps already recoiling when William ordered up his cavalry.[4] The horsemen rode up the slope already strewn with corpses, and dashed into the fight. Foremost among them was a minstrel named Taillefer, who galloped forward cheering on his comrades, and playing like a *jougleur* with his sword, which he kept casting into the air and then catching again. He burst right through the breastwork and into the English line, where he was slain after cutting down several opponents.[5] Behind him came the whole Norman knighthood, chanting their battle-song, and pressing their horses up the slope as hard as they could ride. The foot-soldiery dropped back—through the

[1] Baldric, v. 407: "Spicula torquentur, multi stantes moriuntur."

[2] "Lignis imposita saxa" (W. P. 201 D). They seem to be represented by the club-like weapons thrown by some of the English in the Bayeux Tapestry.

[3] "Festinant parmis galeati jungere parmas, erectis hastis hostis uterque furit" (Guy of Amiens, 383); *i.e.* the heavy-armed men (*galeati*) met shield to shield with the English, and both sides fought furiously with their lances.

[4] "Interea, dubio dum pendent proelia marte," Taillefer and the cavalry came forward.

[5] One would have doubted the romantic episode of Taillefer if it did not occur in such a good authority as Guy of Amiens. Several later writers give details also. Guy writes (390–400)—

> " Interea dubio dum pendent proelia marte
> Eminet et telis mortis amara lues
> Histrio, cor audax nimium quem nobilitavit,
> Agmina praecedens innumerosa ducis
> Hortatur Gallos verbis et territat Anglos
> Alte projiciens ludit et ense suo,
> Incisor—Ferri mimus cognomine dictus," etc.

intervals between the three divisions, as we may suppose—and the
duke's cavalry dashed against the long front of the breastworks,
which in many places they must have swept down by their mere
impetus.[1] Into the English mass, however, they could not break :
there was a fearful crash, and a wild interchange of blows, but
the line did not yield at any point. Nay, more, the assailants
were ere long abashed by the fierce resistance that they met ;
the English axes cut through shield and mail, lopping off limbs
and felling even horses to the ground.[2] Never had the
continental horsemen met such infantry before. After a space
the Bretons and Angevins of the left wing felt their hearts fail,
and recoiled down the hill in wild disorder, the horsemen
sweeping away the foot-soldiery who had rallied behind them.
All along the line the onset wavered, and the greater part of the
host gave back,[3] though the centre and right did not fly in wild
disorder like the Bretons. A rumour ran along the front that the
duke had fallen, and William had to bare his head and to ride
down the ranks, crying that he lived, and would yet win the day,
before he could check the retreat of his warriors. His brother
Odo aided him to rally the waverers, and the greater part of the
host was soon restored to order.

As it chanced, the rout of the Norman left wing was destined
to bring nothing but profit to William. A great mass of the
shire-levies on the English right, when they saw the Bretons
flying, came pouring after them down the hill. They had
forgotten that their sole chance of victory lay in keeping their
front firm till the whole strength of the assailants should be
exhausted. It was mad to pursue when two-thirds of the hostile
army was intact, and its spirit still unbroken. Seeing the
tumultuous crowd rushing after the flying Bretons, William
wheeled his centre and threw it upon the flank of the pursuers.
Caught in disorder, with their ranks broken and scattered, the
rash peasantry were ridden down in a few moments. Their
light shields, swords, and javelins availed them nothing against
the rush of the Norman horse, and the whole horde, to the

[1] For a description of the effect of a furious rush of cavalry on a stout abattis see
Kincaid's description of Waterloo. He and his battalion had erected a breastwork
across the road by La Haye Sainte. It was *completely swept away* by two squadrons
of horse who charged through it. (Kincaid's *Rifle Brigade*, chap. xx.)

[2] " Pugnae instrumenta facile per scuta et alia tegmina viam inveniunt " (W. P.
133).

[3] " Fere cuncta ducis acies cedit " (William of Poictiers, 133).

number of several thousands, were cut to pieces.[1] The great
bulk of the English host, however, had not followed the routed
Bretons, and the duke saw that his day's work was but begun
Forming up his disordered squadrons, he ordered a second
general attack on the line. Then followed an encounter even
more fierce than the first. The breastworks were probably
swept away from end to end, and the ditch filled with débris
and the bodies of men and horses ere it slackened. The fortune
of the Normans was somewhat better in this than in the earlier
struggle : one or two temporary breaches were made in the
English mass,[2] probably in the places where it had been
weakened by the rash onset of the shire-levies an hour before.
Gyrth and Leofwine, Harold's two brothers, fell in the forefront
of the fight, the former by William's own hand, if we may trust
one good contemporary authority.[3] Yet, on the whole, the duke
had got little profit by his assault : the English had suffered
severe loss, but their long line of shields and axes still crowned
the slope, and their cries of "Out! out!" and "Holy Cross!"
still rang forth in undaunted tones.

A sudden inspiration then came to William, suggested by
the disaster which had befallen the English right in the first
conflict. He determined to try the expedient of a feigned flight,
a stratagem not unknown to Bretons and Normans of earlier
ages. By his orders a considerable portion of the assailants[4]
suddenly wheeled about and retired in seeming disorder. The
English thought, with more excuse on this occasion than on the
last, that the enemy was indeed routed, and for the second time
a great body of them broke the line and rushed after the retreat-
ing squadrons. When they were well on their way down the
slope, William repeated his former procedure. The intact portion
of his host fell upon the flank of the pursuers, while those who
had simulated flight faced about and attacked them in front.
The result was again a foregone conclusion : the disordered men
of the fyrd were hewn to pieces, and few or none of them

[1] "Exardentes Normanni et circumvenientes, millia aliquot insecuta se
momento deleverunt, ut ne unus quidem superesset" (William of Poictiers, 133).

[2] William of Poictiers, 202 : "Patuerunt tamen in eos viae incisae per diversas
partes fortissimorum militum ferro." This is before the feigned flight.

[3] Guy of Amiens.

[4] We cannot say what portion, or what proportion. The *Brevis Relatio* says
that it was a "cuneus Normannorum fere usque ad mille equites," and that they were
"ex altera parte" from the duke. But does this mean the right or the left wing ?

escaped back to their comrades on the height. But the slaughter in this period of the fight did not fall wholly on the English ; a part of the Norman troops who had carried out the false flight suffered some loss by falling into a deep ditch,—perhaps the remains of old entrenchments, perhaps the " rhine " which drained the Senlac bottom,—and were there smothered or trodden down by the comrades who rode over them.[1] But the loss at this point must have been insignificant compared with that of the English.

Harold's host was now much thinned and somewhat shaken, but, in spite of the disasters which had befallen them, they drew together their thinned ranks, and continued the fight. The struggle was still destined to endure for many hours, for the most daring onsets of the Norman chivalry could not yet burst into the serried mass around the standards. The bands which had been cut to pieces were mere shire-levies, and the well-armed housecarles had refused to break their ranks, and still formed a solid core for the remainder of the host.

The fourth act of the battle consisted of a series of vigorous assaults by the duke's horsemen, alternating with volleys of arrows poured in during the intervals between the charges. The Saxon mass was subjected to exactly the same trial which befell the British squares in the battle of Waterloo—incessant charges by a gallant cavalry mixed with a destructive hail of missiles. Nothing could be more maddening than such an ordeal to the infantry-soldier, rooted to the spot by the necessities of his formation. The situation was frightful : the ranks were filled with wounded men unable to retire to the rear through the dense mass of their comrades,[2] unable even to sink to the ground for the hideous press. The breastworks had been swept away : shields and mail had been riven : the supply of missile spears had given out : the English could but stand passive, waiting for the night or for the utter exhaustion of the enemy. The cavalry onsets must have been almost a relief compared with the desperate waiting between the acts, while the arrow-shower kept beating in on the thinning host. We have indications that, in spite of

[1] William or Malmesbury says that it was a *jossatum* (*i.e.* a trench) which the English avoided because they knew it. It is perhaps the same as Henry of Huntingdon's " iovea magna " (762 c).

[2] " Leviter sauciatos non permittit evadere sed comprimendo necat sociorum densitas " (William of Poictiers, 202 D).

the disasters of the noon, some of the English made yet a third
sally to beat off the archery.[1] Individuals, worked to frenzy by
the weary standing still, seem to have occasionally burst out of
the line to swing axe or sword freely in the open and meet a
certain death.[2] But the mass held firm—"a strange manner of
battle," says William of Poictiers,[3] "where the one side works by
constant motion and ceaseless charges, while the other can but
endure passively as it stands fixed to the sod. The Norman
arrow and sword worked on: in the English ranks the only
movement was the dropping of the dead:[4] the living stood
motionless." Desperate as was their plight, the English still held
out till evening; though William himself led charge after charge
against them, and had three horses killed beneath him, they
could not be scattered while their king still survived and their
standards still stood upright. It was finally the arrow rather
than the sword that settled the day:[5] the duke is said to have
bade his archers shoot not point-blank, but with a high tra-
jectory, so that the shafts fell all over the English host, and
not merely on its front ranks.[6] One of these chance shafts
struck Harold in the eye and gave him a mortal wound. The
arrow-shower, combined with the news of the king's fall, at last
broke up the English host: after a hundred ineffective charges,
a band of Norman knights burst into the midst of the mass,
hewed Harold to pieces as he lay wounded at the foot of his
banners, and cut down both the Dragon of Wessex and the
Fighting Man.

The remnant of the English were now at last constrained to
give ground: the few thousands—it may rather have been the
few hundreds—who still clung to the crest of the bloodstained

[1] William of Poictiers, 202 D, says that there were *two* sallies of the English
provoked by Norman feigned flights, in addition to that which followed the first real
flight of the Bretons. "*Bis* eo dolo simili eventu usi sunt Normanni."

[2] This is indicated only by Wace, but is eminently probable in itself.

[3] William of Poictiers, 202 D : "Fit deindi insoliti generis pugna," etc.

[4] "Mortui plus, dum cadunt, quam vivi movere videntur" (*ibid.*).

[5] That the arrow-shower alternated with the charges is obvious. The archers
could not shoot while the knights blocked the way. That the arrow was largely used
is proved by William of Poictiers: "*Sagittant* et perfodiunt Normanni." This
must have been done alternately and not simultaneously. Wace well describes the
dismay caused by the rain of shafts falling from above (13287).

[6] Henry of Huntingdon, 763 C. I see no reason to doubt his statement of Harold's
end, corroborated by Wace and William of Malmesbury. The narrative of the
slaughter and mangling of Harold by the four Norman knights, described by Guy of
Amiens, does not really conflict with it.

hill turned their backs to the foe and sought shelter in the friendly forest in their rear. Some fled on foot through the trees, some seized the horses of the thegns and housecarles from the camp and rode off upon them. But even in their retreat they took some vengeance on the conquerors. The Normans, following in disorder, swept down the steep slope at the back of the hill, scarped like a glacis and impassable for horsemen,—the back defence, as we have conjectured, of some ancient camp of other days.[1] Many of the knights, in the confused evening light, plunged down this trap, lost their footing, and lay floundering, man and horse, in the ravine at the bottom. Turning back, the last of the English swept down on them and cut them to pieces before resuming their flight. The Normans thought for a moment that succours had arrived to join the English—and, indeed, Edwin and Morcar's Northern levies were long overdue. The duke himself had to rally them, and to silence the faint-hearted counsels of Eustace of Boulogne, who bade him draw back when the victory was won. When the Normans came on more cautiously, following, no doubt, the line of the isthmus and not plunging down the slopes, the last of the English melted away into the forest and disappeared. The hard day's work was done.

The stationary tactics of the phalanx of axemen had failed decisively before William's combination of archers and cavalry, in spite of the fact that the ground had been favourable to the defensive. The exhibition of desperate courage on the part of the English had only served to increase the number of the slain. Of all the chiefs of the army, only Ansgar the Staller and Leofric, Abbot of Bourne, are recorded to have escaped, and both of them were dangerously wounded. The king and his brothers, the stubborn housecarles, and the whole thegnhood of Southern England had perished on the field. The English loss was never calculated; practically it amounted to the entire army. Nor is it possible to guess that of the Normans: one chronicle gives twelve thousand,[2]—the figure is possible, but the authority is not a good or a trustworthy one for English history. But whatever was the relative slaughter on the two sides, the lesson of the battle was unmistakable. The best of infantry, armed only with weapons

[1] William of Poictiers, 203 D: "Frequentes fossae et praeruptus vallis." "Antiquus agger" (Ord. 501 D).

[2] *Annales Altahenses majores, sub anno* 1066.

for close fight and destitute of cavalry support, were absolutely helpless before a capable general who knew how to combine the horseman and the archer. The knights, if unsupported by the bowmen, might have surged for ever against the impregnable breastworks. The archers, unsupported by the knights, could easily have been driven off the field by a general charge. United by the skilful hand of William, they were invincible.

Yet once more—on a field far away from its native land—did the weapon of the Anglo-Danes dispute the victory with the Norman lance and bow. Fifteen years after Harold's defeat, another body of English axemen—some of them may well have fought at Senlac—were advancing against the army of a Norman prince. They were the Varangian Guard—the famous Πελεκυ-φόροι—of the Emperor Alexius Comnenus. That prince was engaged in an attempt to raise the siege of Dyrrhachium, then invested by Robert Guiscard. The Norman army was already drawn out in front of its lines while the troops of Alexius were only slowly arriving on the field. Among the foremost of the emperor's corps were the Varangians, who rode to the battle-spot, like the thegns of the West, but sent their horses to the rear when they drew near the enemy. Alexius had entrusted to their commander a body of light horse armed with the bow, bidding him to send these first against the enemy, and only to charge when the cavalry should have harassed and disturbed Robert's ranks. But Nampites, the Varangian leader, neglected these orders. When they approached the Norman line, the English were carried away by their reckless ardour. Before the Greek army was fully arrayed,[1] and long before the emperor had designed to attack, they moved forward in a solid column against the left wing of the Normans. They fell upon the division commanded by the Count of Bari, and drove it, horse and foot, into the sea. But their success disordered their ranks, and Guiscard was enabled, since the main body of the Byzantine host had not yet approached, to send fresh forces against them. A vigorous cavalry charge cut off the greater part of the English: the remainder collected on a little mound by the seashore, surmounted by a deserted chapel. Here they were surrounded by the Normans, and a scene much like that of Senlac, but on a smaller scale, was enacted. After the horse-

[1] They, ἱκανον ἀπέστησαν δι᾽ ἀπειρίαν ὀξύτερον βεβαδικότες, were a considerable distance from the rest of the army (Anna Comnena, book iv. § 6).

men and the archers had combined to destroy the majority of
the Varangians, the survivors held out obstinately within the
chapel. At last Robert sent for fascines and other woodwork
from his camp, heaped them round the building, and set fire to
the mass. The English sallied out, to be slain one by one,
or perished in the flames. Not a man escaped: the whole corps
suffered destruction as a consequence of their misplaced eager-
ness to open the fight.[1] Such was the fate of the last important
attempt made by infantry to face the feudal array of the eleventh
century. We shall find, it is true, some instances in the twelfth
century of cavalry being withstood by dismounted troops. But
these were not true infantry, but knights who had sent their
horses to the rear in a supreme moment of peril, and stood firm
to fight out the battle to the end. Well-nigh three centuries
were to elapse before real foot-soldiery, unaided by the cavalry
arm, made another serious attempt to stand up in the open
against the mailed horseman.[2] The supremacy of the feudal
horseman was finally established.

[1] Anna Comnena calls the leader of the Varangians " Nampites." This does not
seem to be a true Teutonic name. A military correspondent suggests to me that it
may possibly represent a nickname—"Niemecz" or "Nemety"=the German—
bestowed on the English chief by Slavonic fellow-soldiers in the Imperial host.

[2] I except, of course, attempts such as that of the Danish Ostmen at the battle of
Dublin to withstand Miles Cogan's men (see p. 403). This was a fight on a small
scale in an obscure corner of Europe ; the Scandinavians neglected the cavalry arm
even later than the English. Other cases could be quoted.

BOOK IV

THE BYZANTINES

A.D. 579–1204

CHAPTER I

HISTORICAL DEVELOPMENT OF THE BYZANTINE ARMY

I N our first chapter we traced the military history of the
Eastern Empire down to the reign of Justinian, the last
date at which it is possible to discern any continuity of character
between the ancient Roman army and the troops which had
replaced it. For, less than thirty years after the death of the
conqueror of the Goths and Vandals, a complete reorganisation
was carried out, and the last remnants of the old system dis-
appeared. It was replaced by a new one whose nomenclature,
tactical units, and methods were as unlike those of Justinian's
day, as the "Palatine" and "Limitary" *numeri* of Constantine
were to the legions of Trajan or Augustus Caesar. This new
system was destined to survive the shocks of five hundred years
with small change: for all practical purposes the arrangements
of the end of the sixth century lasted down to the end of the
eleventh. Then only did they vanish, dashed to pieces by the
great disaster of Manzikert (1071) even as the old Roman army
had been dashed to pieces by that of Adrianople seven hundred
years before.

Alike in composition and in organisation, the army which
for those five hundred years held back the Slav and the Saracen
from the frontier of the Eastern Empire differed from the troops
whose traditions it inherited. Yet in one respect at least it
resembled the old Roman host: it was in its day the most
efficient military body in the world. The men of the lower
empire have received scant justice at the hands of modern
historians: their manifest faults have thrown the stronger
points of their character into the shade, and "Byzantinism" is
accepted as a synonym for effete incapacity both in peace and
in war. Much might be written in general vindication of their
age, but never is it easier to produce a strong defence than
when their military skill and prowess are called in question.

"The vices of Byzantine armies," says Gibbon, "were inherent, their victories accidental."[1] So far is this sweeping condemnation from the truth, that it would be far more correct to call their defeats accidental, their successes normal. Bad generalship, insufficient numbers, the unforeseen chances of war, not the worthlessness of the troops, were the usual sources of disaster in the campaigns of the Eastern emperors. The causes of the excellence and efficiency of the Byzantine armies are not hard to discover. In courage they were equal to their enemies; in discipline, organisation, and armament far superior. Above all, they possessed not only the traditions of Roman strategy, but a complete system of tactics, carefully elaborated to suit the requirements of the age.

For centuries war was studied as an art in the East, while in the West it remained merely a matter of hard fighting. The young Frankish noble deemed his military education complete when he could sit his charger firmly and handle lance and shield with skill. The Byzantine patrician, while no less exercised in arms,[2] added theory to empiric knowledge, by the study of the works of Maurice, of Leo, of Nicephorus Phocas, and of other authors whose books survive in name alone. The results of the opposite views taken by the two divisions of Europe are what might have been expected. The men of the West, though they regarded war as the most important occupation of life, invariably found themselves at a loss when opposed by an enemy with whose tactics they were not acquainted. The generals of the East, on the other hand, made it their boast that they knew how to face and conquer Slav or Turk, Frank or Saracen, by employing in each case the tactical means best adapted to meet their opponents' method of warfare.

The Byzantine army of the seventh and following centuries may be said to owe its peculiar form to a reorganisation which it went through in the last quarter of the sixth century, some twenty-five years after the death of Justinian. The details of that reorganisation are preserved for us in the *Strategicon*,[3] an invaluable work, which shows us precisely when and by whom

[1] Vol. ii, p. 382.

[2] Nothing better attests the military spirit of the Eastern aristocracy than their duels; cf. the cases of Prusianus and others.

[3] A work difficult to procure, for its MSS. are very rare, and its only printed edition is that of Upsala, dated 1664, a book only to be found in a few public libraries.

the change was carried out. East - Roman writers of a later
age often erroneously attributed these alterations to the
celebrated warrior-prince Heraclius, the conqueror of Persia
and the recoverer of the True Cross. In reality, the army
with which Heraclius won his battles had already been re-
organised by his worthy but unfortunate predecessor, the
Emperor Maurice, whose troubled reign filled the years 582–
602. It is under his name that the *Strategicon* appears, and by
his hands that it was compiled. There seems no reason what-
ever to doubt the attribution of the *Strategicon* to the Emperor
Maurice. A careful inspection of the chronological data which
are supplied by the book itself shows that it cannot have been
written before 570 or after 600. The Persian king is alluded
to as the chief enemy of the empire, but he is not represented
as a masterful and oppressive neighbour, as would have been
the case in any book written after the Persian invasions of 605–
6–7–8. On the other hand, the Slavs and Avars are declared to
be the hostile powers on the Danube, no mention being made
of Gepidae or Lombards: therefore the latter tribes must have
already vanished from its banks ; *i.e.* the writer is dealing with a
period after 568. But from the fact that all the fighting with
Slavs and Antae is supposed to take place in the close neighbour-
hood of the Danube, and for the most part not on Roman soil,
but beyond the river, we can fairly decide that the great Slavonic
raids of 581–585, which reached as far as Thessalonica and
Thermopylae, cannot yet have begun. The date 570–580 is
rendered still more likely by the fact that the writer does not
speak with the tone and authority of an emperor. He merely
" wishes to turn to the public' use the certain amount of military
experience which has come in his way,"[1] and gives advice rather
than commands. A comparison of the preamble of Maurice's book
with that of Leo's *Tactica*, a work written by a reigning prince,
shows such a complete difference of tone that we feel sure that
Maurice was as yet only a rising general when he penned his
work. He ascended the throne in 582, so the *Strategicon*
may fairly be placed a year or two earlier. We should imagine
that the work was written nearer to 580 than to 570, from the
fact that an appreciable space of years seems to separate the
writer from the times of Justinian, who only died in 565. For
he alludes to the army as having been for some time in a con-

[1] *Strategicon*, i.

dition, of decay, and as forgetting its old triumphs; such a complaint could hardly have been made when the victories of Taginae and Casilinum (553-555) were still fresh in men's memories. The decline began in the last few years of Justinian's time, when (as Agathias tells us) "the emperor having entered on the last stage of his life seemed to weary of his labours, and preferred to create discord among his foes or to mollify them with gifts, instead of trusting to arms and facing the dangers of war. So he allowed his troops to decline in numbers because he did not expect to require their services, and the ministers who collected his taxes and maintained his armies were affected with the same indifference." [1] The decay which began under Justinian spread deeper during the thirteen years' reign of his successor the haughty and incapable Justin II. (565-578), and may well have reached the disastrous stage described by Maurice in the latter days of that prince.

But we may venture to determine even more exactly the date of the *Strategicon*. When the Emperor Tiberius Constantinus succeeded Justin II. (578) he carried out a thorough reorganisation of the army, deputing the care of details to two distinguished officers, Justinian, the son of Germanus, and Maurice himself. These two colleagues "set right that which was wrong, and made orderly that which was chaotic, and, in short, reduced everything to a state of efficiency." [2] We may therefore conclude with reasonable certainty that the *Strategicon* was then issued by Maurice to serve as the official handbook of the reorganised host of the Eastern Empire. In that case it may be ascribed to the year 579, a date which exactly suits all the internal indications of time of which we have already spoken. It would seem that the commissioners made many sweeping changes in the army, for the troops which Maurice describes are arrayed and named very differently from those of which Procopius had drawn a picture thirty years before. It is true that the mailed horse-archer, the καβαλλάριος or κοντάτος, [3] as he is now called, still remains the great power in war, and the stay and hope of the Imperial host. But a completely new system of organisation has been introduced both among cavalry and infantry. Under Justinian there was no permanent unit in the army larger than the single regiment, the corps which Procopius

[1] Agathias, book v. 14. [2] Theophanes, *sub anno* 6074.
[3] *i.e.* lancer, from κόντος, the long cavalry spear.

calls a κατάλογος, so translating the word *numerus,* which was still its official title. Maurice recognises this body, which he calls an ἀριθμός (*i.e.* numerus), or more frequently a τάγμα or βάνδον, as the base of military organisation; but he speaks of the numeri as being formed into larger bodies,—brigades and divisions as we should call them. Six, seven, or eight numeri are to form a μοῖρα of two thousand to three thousand men, the equivalent of a brigade, and three μοῖραι are to be united into a μέρος,[1] or division of six thousand or eight thousand men. He adds that the numerus should be not less than three hundred or more than four hundred strong, and that moirai should be formed of an irregular number of numeri, in order that the enemy should not be able to calculate the exact force opposed to them by merely counting the number of standards in the line of battle. Napoleon, it will be remembered, laid down a similar rule as to his army corps, always taking care that they should not be of exactly similar force.

A numerus, or "band," or τάγμα of three to four hundred strong, is now commanded by an officer called *comes* or *tribunus.* It is interesting to see how the importance of these names has shrunk—in the fourth century there were only about a dozen "counts" in the whole empire, and each had ruled a whole frontier and commanded many cohorts. A tribune in a similar manner had once been the commander of a whole legion of six thousand men. Now, however, the two words are used as homonyms, and applied to a simple colonel. The brigadier in command of seven or eight bands is now called a μοιράρχος, or, as a Latin equivalent, a *dux* (δοὺξ), though the *duces* of the fourth century had in precedence and power taken rank below *comites.*

There is no sign yet in Maurice that the brigading together of the numeri or "bands" was permanently fixed. He rather implies that the commander of an army will make it his first duty to so combine them when war is declared. In this the army of 580 differs from that of the next century, in which, as we shall see, a permanent localisation of the regiments and the constitution of what may be called fixed army corps comes into being.

The most important change which we trace in the general organisation of the army by Maurice is the elimination of that system, somewhat resembling the Teutonic *comitatus,* which

[1] Also called a δρούγγος, a Teutonic name connected with our own word *throng.*

had crept from among the Foederati into the ranks of the regular Roman army. The loyalty of the soldier was secured to the emperor rather than to his immediate superior, by making the appointment of all officers above the rank of centurion the care of the central government. The commander of an army or division had thus no longer in his hands the power and patronage which had made him dangerous. The men found themselves under the orders of delegates of the emperor, not of quasi-independent authorities surrounded by enormous bands of personal retainers. Thus the soldier no longer regarded himself as the follower of his immediate commander, but merely as a unit in the military establishment of the empire.

This reform was rendered all the more easy by the fact that the barbarian element in the Imperial army was decidedly on the decrease. The rapid fall in the revenues of the State which had set in towards the end of Justinian's reign, and which continued to make itself felt more and more under his successors, had apparently resulted in a great diminution in the number of Teutonic mercenaries serving in the Roman army. It was a case, to quote a modern proverb, of "*Point d'argent, point de Suisse.*" For the foreigner was a more expensive and a more independent personage than the native soldier, and vanished when his pay ceased to appear. To the same end contributed the fact that of the Lombards, Heruli, and Gepidae, the nations who had formed the majority of Justinian's Foederati, one nation had removed to other seats, while the others had vanished from the scene. At last the number of the foreign corps had sunk to such a low ebb that there was no military danger incurred in assimilating their organisation to that of the rest of the army. The barbarian element, as we find it in Maurice's book, appears under the names of Foederati, Optimati, and Buccellarii. The former seem to represent the old bands of Teutonic auxiliaries serving under their own chiefs; they are apparently spoken of as invariably consisting of heavy-armed horse. A casual notice in Theophanes informs us that the Emperor Tiberius Constantinus found it so hard to keep up their numbers, that he bought all the Teutonic slaves he could find for sale in and outside the empire, freed them, and enrolled them as soldiers. The total number of Foederati was thus brought up to fifteen thousand, and it was precisely Maurice who was put in command of them,

with the title of "Count of the Foederati." The "Optimati" seem to have been the pick of the Foederati: they were chosen bands of Teutonic volunteers of such personal importance that each was attended by one or more military retainers, called *Armati*, just as a mediæval knight was followed by his squires.[1] The Buccellarii, whose name and status has caused much needless trouble to commentators both in Byzantine and modern times, were another select portion of the Foederati, who were regarded as the emperor's personal following — they had no doubt done him homage and regarded themselves as part of his "comitatus"; practically they were the barbarian element in the Imperial Guard, the body which corresponded to the old "Batavian cohorts" of the first century. The institution, as we have already had occasion to mention, was of German origin: we find in the laws of the Visigoths *saio* and *buccellarius* used as synonyms for the oath-bound military dependant whom the Angle or Saxon would have called a *gesith*. But it had early been adopted by the Romans: great captains like Aëtius and Belisarius had their buccellarii just like a Gothic king.

The Teutonic element had thus become comparatively small in the Imperial army: such as it was, it consisted of the scanty remains of broken tribes such as the Heruli, Ostrogoths, and Gepidae, and of stray Lombards who had fled from their king —like the Droctulf of whom we have considerable notice in Maurice's time. There were also a few "Scythians," *i.e.* remnants of the Huns, and Avar refugees who had deserted their lord the Great Chagan, a habit to which, as we learn from the *Strategicon*, they were very prone.

Nothing can be more characteristic of the transitional state of the organisation of the East-Roman army in the day of Maurice than the extraordinary mixture of Roman, Greek, and Teutonic words in its terminology. Latin was still the official language of the empire, and all the drill commands in the *Strategicon* are still couched in it; but we may note that the Latin is already in a very debased stage, showing signs of losing or confusing its case endings.[2] Upon the substratum of

[1] Procopius mentions a custom which throws light on this. Audoin, the Lombard king, lent Justinian in 551 for the Gothic war "two thousand noble horsemen and three thousand five hundred more of meaner rank, who acted as the followers and attendants of the others" (*De Bell. Gott.* iv.).

[2] Compare the story of the "Torna fratre" cry, passed down the line of march in the Slavonic campaign of 587, preserved by Theophanes.

old Roman survivals we find a layer of Teutonic words intro-
duced by the Foederati of the fourth and fifth centuries—such
as *bandon* for a company of soldiers, *drungus* (cf. throng) for a
larger body :[1] *burgus, coccoura, betza,* and *phulcus,* and similar
words. Finally, we meet with many Greek words, some of
them literal translations of Roman terms—for example, ἀριθμός
for numerus,—some of them borrowed from the old Macedonian
military system by officers of classical tastes,[2] some newly
invented.[3]

The whole official language of the empire was, in fact, still in
a state of flux ; the same thing had often two or three names,
one drawn from each tongue. Maurice calls the regiment in-
differently βάνδον, τάγμα, or ἀριθμός, and the brigadier μοιράρχος,
δρουγγάριος, or *dux.* On the whole, however, the Latin holds its
own ; we still find it used for scores of things which in Leo's
Tactica, a work of three hundred years later, have only
Greek names. A very large proportion of the native troops were
still Latin-speaking, all those, in fact, raised in Thrace, Moesia,
and the inner parts of the Balkan peninsula. It was not till
these provinces were overrun by the Slavs, a few years after the
Strategicon was written, that the ancient Roman tongue became
practically a dead language in the Eastern realm. Maurice
seldom or never thinks it worth while to give the Greek
rendering of a Latin technical phrase, while his successor Leo
invariably translates such terms.

One very important military reform which Maurice advocates
deserves especial notice, and serves as a notable sign of the
times. It appears that he was most anxious to break down the
barrier which had been imposed in the fourth century between
the class which paid taxes and that which filled the ranks of
the army. The foreign auxiliaries who had formed such a large
proportion of the army of Justinian were no longer so easily to
be procured, and the tendency to raise more and more native
corps being so strong, Maurice wished to make the empire self-
supporting in military matters, and to recruit the army entirely
from within. "We wish," he writes, "that every young Roman
of free condition should learn the use of the bow, and be con-

[1] This curious word is first found in Vegetius, who employs it only for the
confused throngs of a barbarian host.

[2] *e.g.* διφαλαγγία, ὑπασπιστής, οὐραγός, λόχαγος.

[3] *e.g.* μοῖρα and μέρος as technical military expressions.

stantly provided with that weapon and with two javelins."
Once accustomed to arms, he thought that the provincial would
more easily be induced to enlist. If, however, this was intended
to be the first step towards the introduction of universal military
service, the design was not carried out. Three hundred years
later we find Leo echoing the same words:[1] "The bow is the
easiest of weapons to make, and one of the most effective. We
therefore wish that those who dwell in castle, countryside, or
town, in short, every one of our subjects, should have a bow
of his own. Or if this be impossible, let every household keep a
bow and forty arrows, and let practice be made with them in
shooting both in the open and in broken ground and in defiles
and woods. For if there come a sudden incursion of enemies
into the bowels of the land, men using archery from rocky
ground or in defiles or in forest paths can do the invader much
harm ; for the enemy dislikes having to keep sending out
detachments to drive them off, and will dread to scatter far
abroad after plunder, so that much territory can thus be kept
unharmed, since the enemy will not desire to be engaging in a
perpetual archery-skirmish."

It is unfortunate that we have no definite information as to
the extent to which this plan for creating a kind of *landstürm*
apt for guerilla warfare was carried out. That in many districts
of the empire little or nothing came of it we know only too
well. We hear continually of provinces that failed to defend
themselves when they were not furnished with a regular garrison.
On the other hand, there seems to have been some obligation
to provide men for military service incumbent on the themes.
We learn, for example, from a casual reference in Constantine
Porphyrogenitus' *De Administrando Imperio* that in the time
of his own father-in-law Romanus, "when the emperor wished
to raise Peloponnesian troops for an expedition against the
Lombards, in the days when John the Protospathiarius ruled that
theme, the Peloponnesians offered to give a thousand saddled and
bridled horses and a contribution of one centenar of gold instead
of the levy, and, the offer being accepted, paid it with alacrity.
The Archbishop of Corinth was assessed at four horses, the
Archbishop of Patras at four, the bishops at two horses each,
all protospathiarii resident in the theme at three horses each,
spathiarii at one horse, the richer monasteries at two each, the

[1] *Tact.* xx. § 84.

poorer at a horse for each pair; while each man liable to serve personally gave five gold bezants, save very poor men, who were allowed to give two and a half each; so the composition was easily raised."[1] The unwarlike Greek themes might make such offers, and pay what the Western Europeans of a later age would have called a "scutage," but the more martial Asiatic and Northern themes certainly did not. In many of these border districts, especially in the later centuries of Byzantine history, we frequently find the local population turning out in arms.[2] The men of the Armeno - Cappadocian frontier evidently relied very largely upon themselves for defence. Indeed, there seem to be traces of a semi-feudal military tenure of land in the districts in that region, especially in those reconquered from the Saracen in the tenth and eleventh centuries. Here military settlers were allowed to establish themselves on condition of holding their land by the sword.[3] The very curious and interesting poem of *Digenes Akritas*,[4] which gives the life of a border baron on the Cappadocian frontier in the tenth century, shows us a population of warlike castle-dwelling chiefs surrounded by subject villages of their retainers, and waging a continual war of raids with their Saracen neighbours of Cilicia and Mesopotamia. They depended on their own strong arms, and not on the regular garrisons of the themes whose border they inhabited. In Leo's *Tactica* we learn from the chapter that deals with sieges that the government relied on the services of the citizens whenever a frontier town was besieged, and that they were distributed to definite posts in the defence. Only if any of them were suspected of disaffection does the emperor recommend that they should be refused leave to serve by themselves, and distributed among the regular companies forming part of the garrison. The most definite mentions of a generally established militia in the Asiatic themes are the statements in Cedrenus and Zonaras that Constantine IX. in 1044 was so unwise as to relieve the provinces of the eastern border of their obligation to keep up local levies to supplement the Imperial garrison. They had hitherto been exempted from certain taxes in consideration of

[1] Const. Porph., *De Adm. Imp.* cap. 51.

[2] There seems to have been militia even in the theme of Hellas in 1040, when we read of the people of Thebes taking arms against the Slav rebels (Cedrenus, 747).

[3] The holdings were called κτήματα στρατιωτίκα : they were hereditary, as long as the military service was paid duly.

[4] Edited by Sathas and Legrand, Paris, 1875.

this service. Now they were ordered to disband the militia and in future send money to the central treasury.[1]

If universal military service never came into use in the Eastern Empire, yet Maurice had at least a portion of his desire fulfilled. From his time onward the rank and file of the Imperial forces were raised almost entirely within the realm, and most of the nations contained within its limits, the Greeks alone excepted, furnished a considerable number of soldiers. The Armenians, Cappadocians, and Isaurians of Asia Minor, and the Thracians in Europe, were considered the best material by the recruiting officer.

The next great landmark in the military history of the empire after the issue of the *Strategicon* is the fearful storm which passed over it in the Persian and Saracen invasions of the years 604–656. Tiberius Constantinus and Maurice were fairly lucky in their campaigns, beat back the Persians, and carried incursions into the land of the Transdanubian Slavs. But Maurice was unpopular with the army—perhaps his cutting down of the power and importance of the great officers, no less than his strict discipline and economy, irritated them. He perished the victim of a mutiny, and the brutal and imbecile Phocas, who succeeded him, involved the empire in the last and the most disastrous of its Persian wars. The whole East, from the Euphrates to the Hellespont, was overrun by King Chosroes, while at the same time the Slavs and the Chagan of the Avars moved forward into the European provinces. The empire seemed on the brink of destruction, and was only saved by the heroic six years' campaign of Heraclius (622–628). But hardly had the Persian war ended, and the old frontier of the empire been restored, when the still more fatal Saracen invasion began (633). In his old age Heraclius saw Egypt and Syria permanently severed from the empire, and had to reorganise a new military frontier for his diminished realm along the line of the Taurus.

There was no peace with the Saracen till 659, and for twenty-six years the whole force of Eastern Rome was concentrated along its Asiatic border, struggling desperately with the oncoming flood of Saracen fanaticism. Either during this long war, or more probably at its end, when Constans II.[2] sat on the throne, a new military organisation of the highest importance was imposed

[1] Cedrenus, 790 ; Zonaras, ii. 260.

[2] Or Constantine IV., as he should more properly be named.

on the army and the empire. The old boundaries of the provinces had been wiped out during the Persian and Saracen invasions, and all the civil administration was out of gear. The burden of administration in a time of perpetual martial law had fallen upon the shoulders of the generals. Recognising this fact, Constans II. or his son Constantine made a new division of the lands which still remained unconquered on both sides of the Bosphorus, using the military organisation of the moment as the basis of civil as well as of military districts. The forces serving in Asia Minor at this time consisted—(1) of the troops of the old "diocese" of *Oriens, i.e.* Syria, now called in Greek 'Ανατολικοί; (2) of the troops of the borders of Mesopotamia and Armenia, who were generally known as 'Αρμηνιακοί; (3) of the soldiers of Thrace, brought over into Asia during the stress of the struggle, and known as *Thracesians*; (4) of the surviving Foederati, now known as the *Optimati*; (5) of the native and foreign halves of the Imperial Guard, known respectively as the *Obsequium* and the *Buccellarii.* During or at the end of the war these troops were cantoned in various parts of Asia Minor in separate bodies or army corps, for the long-continued struggle had rendered permanent their brigading.[1]

The new provincial arrangement of the middle of the seventh century consisted in making these army-corps districts, adopted first of all only for convenience in the subsistence or mobilisation of the troops, into permanent civil divisions. The commander of the army corps became also the governor of the district and the head of the administration; the "bands" and "moirai" were permanently fixed down to the posts where they found themselves. The new geographical divisions and the army corps both received the appellation of Themes, θέματα. Their proper names were drawn from the titles of the troops quartered in each, and were therefore Anatolicon, Armeniacon, Thracesion, Optimaton, Buccellarion, Obsequium (ὀψίκιον). These were the original "themes" of Asia; shortly afterwards there was added to them one whose character was similar, but whose origin was probably naval rather than military; this was the Cibyrrhæot theme, a narrow district reaching along the southern coast of Asia Minor from Caria to Isauria, and comprising only the land between the mountains and the sea.

[1] I owe the original hint for these paragraphs to Professor Bury's excellent chapters on the Themes in his *History of the Later Roman Empire.*

PLATE III.

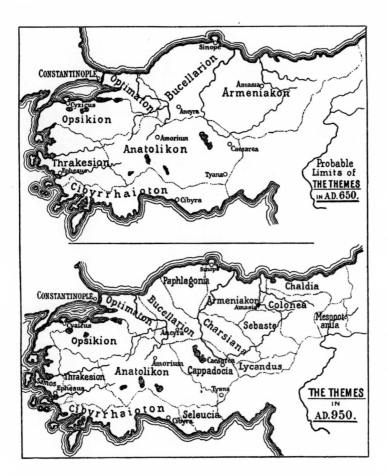

THE "THEMES" OF THE EASTERN EMPIRE IN 650 AND 950

Cibyra was a small place, and why it gave its name to the theme was a constant puzzle to later Byzantine authorities. Constantine Porphyrogenitus, in his work on the Themes, says that the name was bestowed in mockery. This is of course absurd : it is perhaps lawful to conjecture that at the moment when the new provincial divisions were made, Cibyra was the chief station of the Imperial fleet which guarded the southern shore of Asia Minor and the passage into the Aegean. The district to which it gave its name was purely maritime, and the isolated coast-plains of which it was composed only communicated with each other by sea. It was probably, therefore, the special domain of the fleet, and if there was any regular cavalry army corps allotted to it, the " bands " told off to protect it from incursions of the Saracen were probably at the disposition of the admiral of the Cibyrrhæot squadron. This, at least, is made likely by the evidence of a passage in Leo's *Tactica*, which bids the general of the Anatolic theme, when his own theme is attacked by land, to send word to the commander of the Cibyrrhæot fleet, that the latter may land forces in the rear of the Saracens and devastate Cilicia.[1] By the time of Constantine Porphyrogenitus, Optimaton, probably on account of its vicinity to the capital, had no longer any military establishment, and was ruled by a Domesticus, not a general.

Such being the " themes " of Asia, we find that those of Europe were inferior in number—the provinces of the Balkan peninsula had been so entirely devastated and overrun by the Slavs in the time of Heraclius, that the whole inland had passed out of Roman hands. There were probably only three themes south of the Danube—Thrace, Thessalonica, and Hellas ; to these the other Western possessions of the empire add three more—Sicily, Africa, and the surviving dominions in the empire in Italy. These last, however, were always called not a theme, but the Exarchate of Ravenna. Later emperors in the eighth and ninth centuries subdivided the provinces both of East and West, till the whole number of themes finally rose to more than thirty.

Maurice's *Strategicon* is, of course, too early to give the themes and the complement of garrison allowed to each. But if

[1] ὅταν δὲ διὰ τῆς γῆς ἐκστρατεύειν μέλλωσι οἱ Κίλικες βάρβαροι, μηνύῃς τῷ Κιβυραιώτῃ τοῦ πλωΐμου στρατηγῷ, καὶ μετὰ τῶν ὑπ' αὐτὸν δρομώνων εἰσπιπτέτω κατὰ τῶν Ταρσέων καὶ Ἀδανείων χωρίων (Leo, *Tactica*, cap. xviii. § 139).

we may follow the *Tactica* of Leo the Wise, written some two
hundred and fifty years after the theme-system was invented,
the strategos of a theme might usually expect to find himself at
the head of some eight thousand, or ten thousand, or twelve
thousand men, as he is spoken of as commanding two or three
"turmarchs" (or "merarchs," as Maurice would have called them
at an earlier date), the turma running from three thousand up to
five thousand strong. It does not seem, however, to have been
possible for the strategos of a province to mobilise and move
outside of his own district the whole of the troops at his
disposition. Most of the infantry, it seems, were left behind for
garrison duty, and Leo calculates that the average theme should
furnish about four thousand or six thousand picked cavalry, and
not more, when called upon for aid by its neighbours. Nicephorus
Phocas, in his handbook for commanders of frontier themes,
gives five thousand as the total. But this mobilised division was
to consist of troops of the best quality only ; all recruits, weak
and disabled men, and untrained or weakly horses being left
behind at the depôts, so that each "turma" would take the field
rather short in numbers, but very compact and fit for hard
service. In one passage, Leo says that the "bands" of the
turma would not muster more than about two hundred and fifty-
six men for this active service.

Just as "theme" meant both the district and its garrison, so
was it with the smaller divisions, each theme being divided up
into districts garrisoned by a "meros" or "turma." So we find
such expressions as that "Cappadocia was a turma of the
Anatolic theme," or that "Cephallenia was a turma of the
theme of Langobardia." Some casual notices in Constantine
Porphyrogenitus's *De Administrando Imperio* show us how the
districts were occasionally revised and made into new units.
We read, for example, that, owing to the creation of the new
theme of Charsiana in the days of Constantine's father, Leo, the
author of the *Tactica*, a large rearrangement was made on
the eastern border. "Charsiana," he says, "was once a 'turma'
of Armeniacon, but when the religious Emperor Leo made it a
theme, then the bands forming the garrisons of Bareta, Balbadon,
Aspona, and Acarcus were transferred from the Buccellarian
theme into the theme of Cappadocia ; and at the same time the
garrisons of Eudocias, St. Agapetus, and Aphrazia were trans-
ferred from the Anatolic theme into the Cappadocian theme.

These seven bands, four originally Buccellarian and three Ana-
tolic, made a new Cappadocian turma, called Commata. At the
same time the Buccellarian theme gave up the bands stationed
at Myriocephalon, Hagios Stauros, and Verinopolis to the theme
of Charsiana, these, with other two from the Armeniac theme,
namely the garrisons of Talbia and Connodromus, forming a
new Charsianian 'turma,' called Saniana. The theme of
Cappadocia also gave over to the Charsianian theme the whole
turmarchy of Casa, and the garrisons of Caesarea and Nyssa."[1]
Thus the Charsianian theme was composed of fragments from
the Buccellarian, Armeniac, and Cappadocian army corps, while
Cappadocia was compensated for the large slice taken out of it
by acquiring seven bands from Buccellarion and Anatolicon.
The net result was probably to leave the Buccellarian theme
composed of two turmae instead of three, and Armeniacon and
Anatolicon slightly weakened. All these being now interior
themes, separated from the Saracen frontier by Cappadocia and
Charsiana, they could afford to suffer a reduction of their
garrisons.

By the time that Leo's *Tactica* and his son Constantine's
work on the governance of the empire were written, there were
some new units of frontier administration in existence which
were smaller than themes, and were purely military in character,
not including any large district, or conferring on their governors
any civil jurisdiction over an extensive region. Such a district
was called a "Clissura," a corruption of the Roman *clausura*.
It consisted of an important mountain pass with a fortress and
garrison, and was entrusted to a "clissurarch," whose duties one
may compare to those of the "comes littoris Saxonici" of the
fourth century. Some of these "clissuras" comprehended
several passes and a considerable number of garrisons, so that
Constantine doubts in one or two cases whether they ought not
to be raised to the dignity of themes. The command of a
clissura was a splendid opportunity for a young and rising
military officer, as he had an excellent chance of making a name
by repelling the raids of Slav or Saracen, and thus might
ultimately rise to the command of a theme.

[1] Constantine Porph., *De Adm. Imp.* 50.

CHAPTER II

ARMS AND ORGANISATION OF THE BYZANTINE ARMY

THE extraordinary permanence of all Byzantine institutions is well illustrated by the fact that the arms and organisation which Maurice sets forth in his *Strategicon* in 578 are repeated almost unchanged in the *Tactica* of his successor Leo the Wise, written somewhere about the year 900. In particular, the chapters of Leo which deal with armour, discipline, and the rules of marching and camping are little more than a reëdition of the similar parts of his predecessor's book. It would not be fair, however, to the author of the *Tactica* to let it be supposed that he was a slavish copyist. Though a mere amateur in military matters,—he reigned for more than twenty years without going out in person to a single campaign,—Leo was an intelligent compiler and observer. In many chapters of his work the *Strategicon* is largely rewritten and brought up to date. The reader is distinctly prepossessed in favour of Leo by the frank and handsome acknowledgment which he makes of the merits and services of his general, Nicephorus Phocas, whose successful tactics and new military devices are cited again and again with admiration. The best parts of his book are the chapters on organisation, recruiting, the services of transport and supply, and the methods required for dealing with the various barbarian neighbours of the empire. These are the points on which an intelligent war-minister in the capital could attain full knowledge. The weakest chapter, on the other hand,—as is perhaps natural,—is that which deals with strategy ; its sections are arranged in rather a chaotic manner, and form rather a bundle of precepts than a logical system. Characteristic, too, of the author's want of aggressive energy, and of the defensive system which he made his policy, is the lack of direction for campaigns of invasion in an enemy's country. Leo contemplates raids on hostile soil, but

184

not permanent conquests ; his main end is the preservation of his own territory rather than the conquest of his neighbour's. After reading the book, it is easy to see why the frontiers of the empire stood still during his reign, though the times were very favourable for aggression both to East and West. Another weak point is his neglect to support precept by example ; his directions would be much the clearer if he would supplement them by definite historical cases in which they had led to success. But this he does very rarely ; half a dozen instances drawn from the campaigns of Phocas, two from the campaign of Basil I. round Germanicia, a misquoted incident of the Avaric wars of Justin II. drawn from Maurice's *Strategicon*,[1] and a few notes from ancient Greek and Roman history, are all that can be cited. The reader is forced to collect for himself the data which must have led Leo to arrive at his various conclusions.

The strength of the East-Roman army in the time of Leo no less than in the time of Maurice lay in its divisions of heavy cavalry. The infantry is altogether a subsidiary force, and the author contemplates whole campaigns taking place without its being brought into action. It seems, in fact, destined rather for the defence of frontier fortresses and defiles, for the garrisoning of important centres, and for expeditions on a small scale in mountainous regions, than for taking the field along with the horse.

The καβαλλάριος or heavy trooper wore, both in the time of Maurice and that of Leo, a steel cap surmounted with a small tuft, and a long mail-shirt reaching from the neck to the thighs.[2] He was also protected with gauntlets and steel shoes. The horses of the officers and of the men in the front rank were furnished with steel frontlets and poitrails ; all had solid well-stuffed saddles and large iron stirrups—an invention which had cropped up since the fifth century without our being able to say from whom it had its origin. The trooper was furnished with a light

[1] Maurice speaks of a surprise in the campaign near Heraclea which Leo stupidly misrenders into a campaign of the Emperor Heraclius ! He might have remembered that Maurice could not possibly have quoted campaigns which took place twenty years after his death.

[2] Leo concedes that if mail-shirts are not always procurable in sufficient numbers, it may sometimes be necessary to make shift with scale armour of horn (such as the ancient Sarmatians wear on Trajan's Column), or even with buff-coats of strong leather strengthened with thin steel plates.

linen surcoat to wear over his armour in hot weather, and with a large woollen cloak for cold or rainy weather, which was strapped to his saddle when not in use. His arms were a broadsword (σπάθιον), a dagger (παραμήριον), a horseman's bow and quiver, and a long lance (κοντάριον) fitted with a thong towards its butt, and ornamented with a little bannerole. Some men seem to have carried an axe at the saddle-bow in addition to the sword. The tuft of the helmet, the lance-pennon, and the surcoat were all of a fixed colour for each band, so that the army may be said to have worn a regular uniform, like its predecessors of Roman times, and unlike any Western army that took the field before the sixteenth century.

Byzantine military pictures of a really satisfactory kind, in which the armour is not affected by the artist having copied older classical drawings, are not common. It is therefore worth while to insert here two plates from an eleventh-century MS., the Psalter of Theodore of Caesarea, in the British Museum, where the warriors portrayed are evidently armed exactly as was the contemporary East-Roman soldier. The MS. being dated 1066, the soldiery represented in it must wear the same dress and equipment as the unfortunate army that perished at Manzikert in 1071. It will be noted that the horsemen do not in all ways correspond to Leo's description of the cavalry of the year 900. Their mail-shirts are shorter than we should have expected, and the tuft on the helms is wanting, unless indeed the very small ball on the top of the headpiece of the front horseman in IV. A and of the right-hand foot-soldier in V. C represents it. These balls, however, look more like small metal knobs. It will be noted that all the mounted men wear mail-shirts with tunics below them, and high boots. Their lower arms are unprotected, but the upper arm of most of them is guarded by the characteristic *brassard* of narrow metal plates which is seen in most Byzantine military figures. The horse-archer in IV. B does not wear this defence, but apparently a sleeveless mail-shirt : the brassards would have been a hindrance in drawing the bow. Most of the helms are pointed ; only the horseman in V. C has a plain round-topped steel cap. The shields are all round and of moderate size. Several of the cavaliers show their military cloaks flying behind them. The arms used are lance, bow, axe, and mace. The last two are to be seen in the group of horsemen besieging the castle in IV. B. The horses seem to have light

PLATE IV.

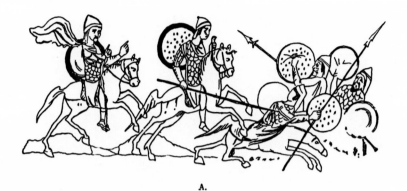

A.

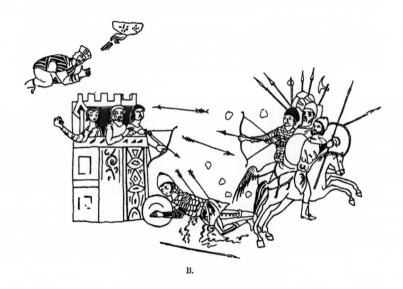

B.

BYZANTINE ARMOUR A.D. 1066

[From the Psalter of Theodore of Caesarea]

trappings: there is no trace of the frontlets or poitrails of which Leo speaks in his *Tactica*.

In some of the provinces, where the use of the bow was not generally popular, Leo recommends that recruits should be given two light darts and a shield, until they have been trained to the practice of archery. This was to be done by giving them small and weak bows, which were to be progressively changed for larger and stronger ones as the young soldier grew more adroit. When skilled in his new weapon, he would have to abandon the shield, whose employment was incompatible with the free use of both hands required in shooting.

The Byzantine cavalry-soldier was, like the Roman of the old republic, a person of some substance and standing. In his chapter on the raising of troops, Leo writes: "The strategos must pick from the inhabitants of his theme men who are neither too young nor too old, but are robust, courageous, and provided with means, so that, whether they are in garrison or on an expedition, they may be free from care as to their homes, having those left behind who may till their fields for them. And in order that the household may not suffer from the master being on service, we decree that the farms of soldiers shall be free from all exactions except the land-tax. For we are determined that our comrades (for so we call every man who serves bravely in behalf of our own Imperial authority and the Holy Roman Empire) shall never be ruined by fiscal oppression in their absence." [1]

The rank and file were recruited partly from military settlers holding στρατιωτίκα κτήματα, but mainly from the ranks of the small free farmers. Their officers, especially those of the higher ranks, were drawn from the best families of the Byzantine aristocracy. "Nothing prevents us," says Leo, "from finding a sufficient supply of men of wealth and also of courage and high birth to officer our army. Their nobility makes them respected by the soldiery, while their wealth enables them to win the greatest popularity among their troops by the occasional and judicious gift of small creature-comforts." [2] A true military spirit existed among the noble families of the Eastern Empire; houses like those of Skleros and Phocas,[3] of Bryennius, Kerkuas, and Comnenus, are

[1] *Tactica*, iv. § 1. [2] *Tactica*, iv. § 3.
[3] The family of Phocas is the most distinguished of the whole Byzantine aristocracy. It supplied two centuries of notable soldiers, starting from Nicephorus

found furnishing generation after generation of officers to the Imperial army. The patrician left luxury and intrigue behind him when he passed through the gates of Constantinople, and became in the field a keen professional soldier.

The whole of the officers and many of the troopers being men of substance, they brought with them to the campaign a considerable number of servants and boys—some bondsmen, others free hired attendants. Leo highly approves of this custom, remarking that when the corps had no camp-followers many soldiers had to be told off to menial duties and the care of baggage animals, thus thinning the ranks of the fighting men. He recommends that the poorer troopers be encouraged to keep one attendant for every four or five of them, and if possible a pack-horse to carry such of their baggage as they could not easily strap to their own saddles. These non-combatants and baggage animals formed a considerable impediment to the rapid movement of a cavalry corps, but it was believed that in the end they justified their existence by keeping the men in good physical condition. For when moving in the desert countries on the frontier, where food for men and fodder for horses were hard to gather, the troops had largely to depend for subsistence on their camp-followers, just as an English army in India does at the present day.

Leo does not give such complete details about the arming and organisation of the infantry "bands," as about those of the cavalry. The foot-soldiery were divided into light and heavy armed. The former, as in the times of Justinian and Belisarius, were nearly all archers; a few provinces where archery was not practised supplied javelin-men instead. The typical bowman is described by the *Tactica* as wearing a tunic reaching to the knees, and large broad-toed nailed boots. He carried a quiver with forty arrows, and a small round buckler slung at his back, and an axe at his belt for hand-to-hand fighting. As many as possible were to be provided with a light mail-shirt: there is no mention made of helmets, which apparently were not worn by the archers. Leo only recommends that they shall cut their hair short, and makes no suggestion about a covering for it.

The heavy-armed foot - soldier, still called *scutatus* as in

Phocas, who drove the Saracens from Calabria in 884–887, including the victorious emperor of the same name, 963–969, and the famous rebel Bardas Phocas, who died in 989.

PLATE V.

A.

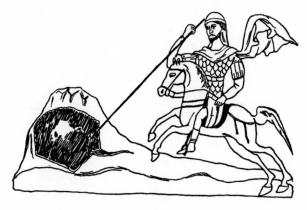

B.

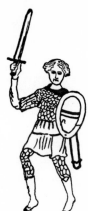

C.

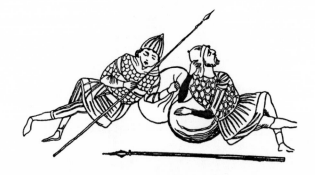

BYZANTINE ARMOUR A.D. 1066

[From the Psalter of Theodore of Caesarea]

the days of Justinian, wore a pointed steel helmet with a tuft, a mail-shirt, and sometimes gauntlets and greaves. He carried a large round shield, a lance, a sword, and an axe with a cutting blade at one side and a spike at the other. The shield and helmet-tuft were of a uniform colour for each band.

In Plate V. will be seen three characteristic figures of foot-soldiers of the year 1066, taken (like the horsemen described on p. 186) from the Psalter of Theodore of Caesarea. They wear short mail-shirts above their tunics, and two of the three also show the characteristic Byzantine brassard on their upper arms. The third (the left-hand sleeper in V. C) has a short mail sleeve to his mail-shirt and no brassard. The headdress differs in each figure: one wears a pointed helm, one a round-topped helm of classical appearance with a knob at its summit; the third has no headpiece at all. It will be noted that the helmless man wears mail breeches, unlike any of the other soldiers, horse or foot, on our plates. One of the two sleepers evidently wears leather breeches: both have high boots. The spears are long, the sword short and broad. Two of the shields are circular, in accordance with Leo's description; the third is oval, and bears a device of two coloured bars. Two of the men wear short cloaks fastened round their necks; the third is apparently without this garment.

The infantry, like the cavalry, were followed by a considerable train of baggage and camp-followers. For every sixteen men [1] there was to be provided a cart to carry biscuit, etc., and a supply of arrows, as well as a second cart carrying a hand-mill, an axe, a saw, a chopper, a sieve, a mallet, two spades, two pickaxes, a large wicker basket, a cooking-pot, and other tools and utensils for camp use. In addition to the carts there was to be a pack-horse, so that when the infantry were forced to leave the waggon-train behind, for forced marches or other such purposes, the horses might be able to carry eight or ten days' biscuit with them for immediate use. The two carts and the pack-horse required at least two camp-followers to drive them, so that every "band" was followed by a considerable body of non-combatants. It will be noted that the contents of the second cart gave every "century" twenty spades and

[1] The "decury," in spite of its name, was sixteen men strong, and not ten. Thus a century would be about a hundred and sixty men, and three centuries would go to the "band," making it about four hundred and eighty strong.

twenty picks for entrenching purposes ; for the Byzantine camp, like the ancient Roman, was carefully fortified to guard against surprises.

A corps of engineers (Μίνσωρες (*sic*) or even Μινσοράτορες) always marched with the vanguard, and, when the evening halting-place was settled, marked out with stakes and ropes, not only the general outline of the camp, but the station of each corps. When the main body had come up, the carts and pack-horses, called *en masse* "Tuldum" (τὸ ροῦλδον), were placed in the centre of the enclosure, while the infantry bands drew a ditch and bank along the line of the Mensores' ropes, each regiment doing a fixed amount of the digging. Meanwhile, a thick chain of pickets was kept far out from the camp, and the men not engaged in entrenching were kept close to their arms, so that a surprise was almost impossible, unless the pickets displayed gross negligence. The carts were often ranged laager-fashion within the ditch, so as to make a second line of defence. If the army was not close to the enemy, the majority of the infantry bands camped outside the fosse, and only the cavalry within it. But when close to the hostile forces, the whole of the corps both of horse and foot were placed inside; the infantry taking the outer posts and the cavalry the inner ones. The object of this arrangement was, of course, to prevent the cavalry from being harassed by night attacks, against which they are far more helpless than infantry, as they have to saddle their horses before they are of any use.

So perfect was the organisation of the Byzantine army that it contained not only engineers and military train, but even an ambulance corps.[1] To each "band" was attached a doctor and surgeon (θεραπευταί, ιατροί), and six or eight bearers (*deputati* or σκρίβωνες), whose duty it was to pick up and attend to the wounded. The deputati were provided with horses furnished with a sort of side-saddle with two stirrups on the same side, for carrying the wounded, as well as with a large flask of water.[2] The value attached to the lives of the soldiery is well shown by the fact that the deputati were entitled to receive a *nomisma*,[3] or bezant, for every dangerously wounded man whom they brought off the field.[4]

We may now pass on to the tactics of the Byzantine army.

[1] Leo, *Tactica Const.* iv. § 6.
[2] *Tactica Const.* xii. § 53.
[3] About twelve shillings, or a trifle more.
[4] *Tactica Const.* xii. § 51.

The first point to observe is that normally the heavy cavalry form the most important part of the army. Infantry only take the first place in expeditions among hills and passes where cavalry are obviously useless. In the ordinary operations of war both arms may frequently be found acting together, but it is just as usual for cavalry to be working alone, without any infantry supports. This partly comes from the inferior reputation of the infantry, but still more from the fact that both in Europe and in Asia the Byzantines had very frequently to deal with enemies like the Turks (Magyars), Patzinaks, and Saracens, whose whole force consisted of horsemen. When such tribes made an incursion into the empire, the infantry could not hope to keep up with them. It was quite a normal thing, when the news of a Turkish or Saracen raid arrived, for the strategos of the invaded theme to send off all his infantry to occupy passes in the hills, or fords on great rivers, so as to block the enemy's retreat; he would then start with his cavalry alone to hunt down the raiders. This fact is deducible from Leo's *Tactica*, but is still more explicitly stated in the excellent pamphlet on the defence of the Asiatic border which stands under the name of the Emperor Nicephorus Phocas.[1]

When infantry and cavalry acted together, as would be the case against an enemy mainly composed of foot-soldiery, *e.g.* the Slavs or the Franks, or against a regular invasion of Saracens as opposed to a mere raid, the usual tactical arrangement of the Byzantines was to place the infantry in the centre, with cavalry on the wings and in reserve behind the line. The infantry "band" was drawn up sixteen, eight, or occasionally four deep, with the *scutati* in the centre and the archers and javelin-men on the flanks. If expecting to be charged by cavalry, or to be assailed by a heavy column of hostile foot, the light troops retired to the rear of the *scutati* and took refuge behind them, just as a thousand years later the musketeers of the sixteenth and seventeenth centuries used to take cover behind their pikemen. The "band" was taught to fight either in single or in double line (διφαλαγγία): to take this latter formation the

[1] Niceph. Phoc. iii. § 1. The strategos is at once, on receiving news of a raid, to collect his horse and τὸ πεζικὸν ἅπαν ἐπισυνάγειν ἐπὶ τὴν ὁδὸν καθ' ἣν ὁρμήσουσιν οἱ πολέμιοι ἐξελθεῖν. The retreating enemy, heavy with plunder, could be intercepted easily in the passes by the foot-soldiery, and could be crushed between them and the pursuing cavalry.

rear ranks (four or eight, according as the band was eight or
sixteen deep in its previous formation) stood still, while the
front ranks moved forward and then halted.[1] In a defensive
battle, the infantry centre of the host was usually drawn up close
to the camp, and protected in the rear by the ditch and waggon-
laager manned by the camp-guard.[2] When, however, the army
had moved out far from its camp to take the offensive, the
infantry were formed in two lines. This formation might be
made either by drawing up a certain number of the battalions
of each brigade (*i.e.* bands of each *drungus*) in second line, or
by forming each band into the above-mentioned διφαλαγγία,
with an interval of three hundred yards between its front and
its rear half-band. The army was never drawn out in a single
line without reserves ; that order of battle was discouraged by
all Byzantine writers on matters tactical. It was only used as
a last resort when there was a desperate need to produce at all
costs a line equal in length to the enemy's.

 Byzantine infantry were accustomed to charge in column
sixteen deep ; the bowmen and javelin - men having retired
behind the *scutati*, the latter received the command to close up
the ranks (πύκνωσόν), and drew close together, the front rank
locking their shields together, while the second and rear ranks
held their shields aloft over their heads, after the manner of the
ancient Roman *testudo*. The bowmen in the rear kept up such
a discharge as they best could over their comrades' heads. On
getting within a few paces of the enemy, the *scutati* hurled their
spears, as did the ancient Romans their *pila*, and then fell to
work with sword and axe. It was with these short weapons,
not with the spear, that they were expected to win the day.
Thus a Byzantine infantry division (turma) when charging
would be composed of a number of small columns, with
moderate intervals between them, each composed of from some
two hundred and fifty to four hundred men.[3] The strength of
the division might be anything between two thousand[4] and
six thousand strong, and the number of battalions (bands) in it

[1] *Tactica*, vii. § 76. [2] *Tactica*, vii. § 73, 4.

[3] An interesting but casual notice in one of the doubtful chapters of the
Tactica (No. xxxiv.) says that in the Thrakesian theme the bandon was supposed to
be three hundred and twenty strong ; in the theme of Charsiana it was three hundred
and eighty ; in some of the Western themes as much as four hundred.

[4] Constantine Porphyrogenitus, quoted above on pp. 182, 183, mentions the
turma of Saniana as only five bands strong.

might vary from five to twenty. It was a standing principle
that the divisions should be of unequal sizes, that the enemy
might not be able to calculate the exact force opposed to him
by merely counting the number of divisional standards in the
line. Whether strong or weak, the division advanced in two
lines, of which the first was called the *cursores*[1] or fighting line,
the second the *defensores*[2] or reserve line.[8]

Byzantine infantry would always be covered on the wings by
cavalry when offering battle on any ground where horsemen
could be used. They were not, therefore, obliged to take any
care of their flanks. On the other hand, their rear might possibly
be threatened by hostile cavalry sweeping completely round the
wings of the army. In this case the bands forming the line of
defensores would front to the rear. Or if there was need to keep
watch both before and behind, the individual band would take
the formation we have described above under the name of
διφαλαγγία, and the rear half-band, eight deep, would receive the
order "right about face" (ὑποστρέψατε) and front to the rear,
while the other half-band still kept its original position.

When fighting in hilly country, or in passes and other ground
where cavalry could not be used, the infantry band drew itself
up with the *scutati* in the middle, and the light troops thrown
forward on either flank, so as to form a kind of crescent-shaped
array. This was especially used for the defence of defiles, when
the heavy-armed men posted themselves across the path, and
the archers and javelin-men endeavoured to line the approaches
to the spot where their comrades were posted, so as to
secure a flanking fire on any enemy endeavouring to force the
road. In forest defiles Leo advises that more reliance should be
placed on the javelin-men, who work best at short ranges : in
rocky defiles, where there was a longer view and a better aim, the
archers would have the preference.[4]

Cavalry tactics had been carried to a far greater degree of
elaboration than infantry tactics by the East-Roman army.
The horsemen were, as we have already seen, the preponderant

[1] κούρσωρες. [2] διφένσορες.

[8] I infer, though it is nowhere explicitly stated, that the reserve line in a division
or brigade was formed, as a rule, from complete bands, and not from the rear half-
bands of the battalions in the front line, because Leo says, in *Tactica*, vii. § 45, that
a brigadier or divisional general is to tell off his bands into *defensores* and *cursores*, and
to be careful that each band gets a fair share of each sort of work.

[4] Leo, *Tactica*, ix. § 78.

13

arm, and they often in a mixed force equalled or even exceeded the foot in numbers.[1] When they were in a large majority, Leo advises that the whole front line should be formed from them, and the infantry placed in the rear in reserve. This was the order adopted by Nicephorus Phocas in his celebrated victory in front of the walls of Tarsus (A.D. 965).[2] Often infantry were altogether wanting, and the whole army was composed of cavalry. Both Leo's *Tactica* and the Παραδρομὴ Πολέμου ascribed to Nicephorus Phocas are very full of directions for this case, and the most elaborate instructions for the marshalling of a cavalry host are given by both. They are well worth recording, as representing the most characteristic development of the Byzantine art of war.

The main principle of the battle-tactics of the Imperial cavalry was that the whole force must be divided into (1) a fighting line, (2) a supporting line, (3) a small reserve behind the second line, (4) detachments out on the wings, destined some to turn the enemy's flank, some to protect that of their own main body. As to the numerical proportions of these four parts of the host, the front line should average somewhat more than a third—say three-eighths—of the whole; the supporting line about a third of the whole;[3] the reserve about a tenth; the flanking detachments about a fifth.

As an illustration of such an array Leo gives a practical example. He supposes that the strategos of an eastern frontier theme has pursued a large Saracen raiding force and brought it to bay. Having left behind all weak men and horses, all recruits, and certain necessary detachments, the general has with him two weak divisions (*turmae*), each composed of two brigades (*drungi*) of five regiments (*banda*) each. The individual band has been weeded down to two hundred or two hundred and fifty men, but contains only picked troopers. The total of the host is only about four thousand six hundred men, though

[1] John Zimisces in his expedition against the Russians had thirteen thousand horse and fifteen thousand foot (Leo Diaconus, viii. 4).

[2] The centre was formed of πανσιδήροι ἱππόται, behind whom were the infantry, the wings of cavalry also (Leo Diaconus, iv. 3).

[3] Τὸ τρίτον ποσόν, says Leo, when laying down his general rule in *Const.* xii. § 29. But in the practical example which he gives, the supporting line is only thirteen hundred strong out of four thousand six hundred. In a small army, apparently, the flanking detachments would be a trifle stronger in proportion than in a large one.

the two turmae, if present with their whole effective, would amount to at least six thousand five hundred or seven thousand.

1. The front rank is to be composed of three bodies each five hundred strong, *i.e.* each composed of two bands of two hundred and fifty men. It is drawn up with the smallest possible intervals between the bands, so as to present a practically continuous front. The senior divisional general (*turmarch*), the second in command of the whole force, leads the line:[1] he takes his post in its centre, surrounded by his standard-bearer, orderlies, and trumpeters. Each of the six bands sends out to skirmish one-third of its men, all archers: the remainder are halted till the time for charging comes.

2. The second line is composed of four bands, *i.e.* one thousand men. They are not drawn up in continuous line, as are their comrades in the front, but in four separate bodies a bowshot apart. The three intervals between the bands are to serve for the passage of the fighting line to the rear in case it should be routed. The commander-in-chief, with a bodyguard of a hundred men and the great battle-flag, takes his position in the middle of the second line, but is not fixed there; he may transfer himself to any point where he is needed.[2] To give an appearance of solidity to the line, a few horsemen—three hundred are enough—are drawn up two deep in each of the intervals between the four bands[3] (G G G *in plan*).

3. Behind the second line, not to its rear, but on its flanks,[4] are placed two bands of two hundred and fifty men each as a last reserve.

4. On the flank of the fighting line, thrown somewhat forward, (D) to the right is placed a weak band (two hundred men), destined to endeavour to turn the enemy's left flank when the clash of battle comes; they are called the ὑπερκεράσται. On the left (E) lies a corresponding band of two hundred men, who are charged with the duty of preventing any such attempt on the part of the enemy; they are called the πλαγιοφύλακες. It will be noted that armies are expected to make the outflanking movement from their own right: this comes from the wish to get in on the enemy's left side, against his weaponless left arm.

[1] xii. 77. [2] xii. 90. [3] xviii. § 147.
[4] xii. § 30. This point, noted in the general directions for drawing up a cavalry array, is not repeated in *Const.* xviii., where the above-named plan for ordering four thousand men is to be found.

5. Far out from the whole line of battle, to right and left, are to be placed two bodies, each of two small bands (or four hundred men) called the ἐνέδροι or liers-in-wait (F F). They are intended to make a long circular march, hide themselves in woods and hollows or behind hills, and come in suddenly and unexpectedly upon the flank or rear of the enemy.

Thus the whole battle order works out into

Front line	6	"bands" =	1500 men.
Second line	4	"bands" =	1000 men.
Third line	2	"bands" =	500 men.
Ὑπερκεράσται	1	"band" =	200 men.
Πλαγιοφύλακες	1	"band" =	200 men.
Ἐνέδροι	4	"bands" =	800 men.
General's escort.	½	"band" =	100 men.
To fill the intervals in the second line		1½	"bands" =	300 men.
		20	"bands" =	4600 men.

I presume that the first turma or division supplied the ten bands of the front line and the ἐνέδροι, while the second turma furnished the second and third lines and the other small detachments. But this is not definitely stated.

The bands are drawn up eight or ten deep, though Leo grants that this formation is too heavy. With an ideally perfect body of men. he thinks that four deep would be the best formation;[1] but for practical work with an ordinary regiment he regards eight deep as the least that a general should allow, and ten deep as the safest and most solid array.

This order of battle is deserving of all praise. It provides for that succession of shocks which is the key to victory in a cavalry combat: as many as five different attacks would be made on the enemy before all the impetus of the Byzantine force had been exhausted. The intervals of the second line give full opportunity for the first line to retire when beaten, without causing disorder behind. Finally, the charge of the reserve and the detached troops would be made, not on the enemy's centre, which would be covered by the second line even if the first were broken, but on his flank, his most exposed and vulnerable point. Modern experience has led to the adoption of very similar arrangements in our own day.

The only point which seems of doubtful value is the arrangement of the small detached bodies of men two deep in the

[1] xii. § 40.

PLATE VI

**A BYZANTINE CAVALRY FORCE OF TWO 'TURMAE'
IN LINE OF BATTLE.**

Enemy's Line of Battle

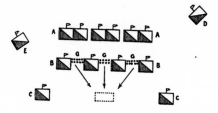

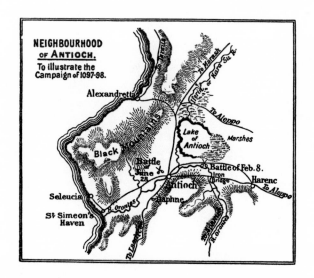

NEIGHBOURHOOD
OF ANTIOCH.
To illustrate the
Campaign of 1097-98.

intervals of the second line. Leo intends them to deceive the enemy's eye, and to give an impression of continuity and solidity to the array.[1] If the front line is broken, they are to retire, leave the intervals open, and draw up in the rear of the second line, and between the two bands of the third line. There they are to serve as a rallying point for the broken troops from the front, who will form up on each side of them. But in practical work this retiring to the rear at the moment when the remnants of the shattered first line were tumbling in upon them would be a very hazardous experiment. There would be a great chance that, instead of the fugitives rallying upon the support, the support would be carried away by the fugitives, and all go off the field in disorder. Only the steadiest and coolest troops could be trusted to carry out the manœuvre. Still, as we shall see from the battles which we are about to describe as instances of Byzantine cavalry tactics, the troops of the empire were quite capable of rallying and returning to the charge.

[1] xii. 31.

CHAPTER III

STRATEGY AND TACTICS OF THE BYZANTINE ARMY

WE have already had occasion to observe that the chapters on organisation, arms, and tactics in the military writers of the East-Roman Empire are always more satisfactory than those which deal with strategy. Gibbon, with his usual sweeping contempt, remarks that such works seem to aim at teaching how to avoid defeat rather than how to achieve victory. There is a certain amount of truth in the sneer, for the main lines of Byzantine strategy during the greater part of the history of the empire are somewhat one-sided. They are almost entirely defensive in their scope, and pay little attention to the offensive. In this respect they do but reflect the general condition and needs of those who used them. From 600 to 800, and again from 1050 to 1453, the rulers of Constantinople were making a strenuous fight for existence, and not aiming at offensive operations beyond their own borders. Between Heraclius' Persian campaigns (622–28) and Nicephorus Phocas' conquest of Cilicia (964), the East-Roman generals never were able to contemplate an invasion on a large scale into hostile territory. The tactical offensive they might often take, but it was always with the object of preserving or recovering their own lands, not with that of annexing those of their neighbours. Summed up shortly, the whole military history of these centuries consists in a struggle to preserve Asia Minor from the Saracen, the Balkan peninsula from Slav, Bulgarian, and Turk,[1] and the Italian themes from Lombard and Frank. Of these struggles the first was far the most engrossing : when once the pressure was taken off the Eastern

[1] *i.e.* Avar, Magyar, Patzinak : perhaps one ought to include the Bulgarian also under this name. At least the Byzantine writers often place him in that category. See Leo, *Tactica*, xviii.

frontier, owing to the incipient decay of the Abbasside Caliphate in the middle of the ninth century, the East-Romans suddenly appear once more as a conquering and aggressive power. Cilicia, North Syria, and Armenia are overrun, the Balkan peninsula is reconquered up to the Danube, a vigorous attempt is made to win back Sicily. Our military text-books, however, belong almost entirely to the defensive period:[1] an edition of Leo's *Tactica* brought up to date by Basil II. would be invaluable; but unfortunately it does not exist.

The fact that the main aim of Byzantine strategy was to protect the empire rather than to attack its enemies accounts for its main limitations. But it does not explain the whole of the differences between the military feeling of East and West during the early Middle Ages. Of the spirit of chivalry there was not a spark in the Byzantine, though there was a great deal of professional pride, and a not inconsiderable infusion of religious enthusiasm. The East-Roman officer was proud of his courage, strength, and skill; he looked upon himself as charged with the high task of saving Christendom from pagan and Saracen, and of preserving the old civilisation of the empire from the barbarian. But he was equally remote from the haughty contempt for sleights and tricks which had inspired the ancient Romans, and from the chivalrous ideals which grew to be at once the strength and the weakness of the Teutonic West.[2] Courage was considered at Constantinople as one of the requisites necessary for obtaining success, not as the sole and paramount virtue of the warrior. The generals of the East considered a campaign brought to a successful issue without a great battle as the cheapest and most satisfactory consummation in war.[3] They considered it absurd to expend stores, money, and the valuable lives of veteran soldiers in achieving by force an end that could equally well be obtained by skill. They would have felt far higher admiration for such feats as Marl-

[1] The Παραδρομὴ Πολέμου, which bears Nicephorus Phocas' name, is written by an officer who had seen the rise of the new offensive tactics, but does not know whither they are about to lead. He is one of the old school, though privileged to see the turning of the tide, and proud to recognise the changed conditions of war in his own old age.

[2] I suppose that Baduila the Ostrogoth, that loyal Christian knight, merciful to foes, true to his word, guided in all things by his conscience and his love of justice, is the first chivalrous figure in modern history. Yet he failed before Byzantine fraud and courage combined.

[3] Leo, *Const.* xx. § 12.

borough's forcing of the lines of Brabant in 1706, with the loss of only sixty men, or for Wellington's manœuvring the French out of the Douro valley in 1813, than for bloody fights of the type of Malplaquet or Talavera. They had no respect for the warlike ardour which makes men eager to plunge into the fray: it was to them rather the characteristic of the brainless barbarian, and an attribute fatal to anyone who made any pretensions to generalship. They had a strong predilection for stratagems, ambushes, and simulated retreats. For the officer who fought without having first secured all the advantages for his own side they had the greatest contempt. Nor must we blame them too much for such views: fighting with comparatively small and highly-trained armies against enormous hordes of fanatical Saracens or savage Turks and Slavs, they were bound to make skill supply the want of numbers. A succession of emperors or generalissimos of the headstrong, reckless type that was common in the West would have wrecked the Eastern realm in fifty years. The two men who more than any others brought ruin on the empire were two gallant swashbucklers who never could keep out of a fray, whether it were opportune or inopportune,—Romanus Diogenes, the vanquished of Manzikert and the loser of all Asia Minor, and Manuel Comnenus, the crowned knight-errant who wasted the last resources of his realm on unnecessary victories in Hungary and Armenia.

But it must be confessed that there often appear in Byzantine military history incidents that show something more than a mere contempt for rashness and blundering courage. Modern generals have not always been straightforward and honourable in their observance of the customs of war.[1] But they do not as a rule proceed to glory in their ingenuity and commit it to paper as a precedent for the future. There is ample evidence, not only from the records of chroniclers, but from the chapters of Leo's *Tactica*, that the East-Romans felt no proper sense of shame for some of their over-ingenious stratagems in war. It is with a kind of intellectual pride in his own cleverness that the Imperial author advises that if negotiations with a neighbour are going on, and

[1] Napoleon certainly committed breaches of the laws of war as odious as any of which the Byzantines ever were guilty. None of them ever surpassed those masterpieces of treachery and lying,—the seizure of the Vienna bridges in 1805 under pretence of an armistice, and the occupation of the Spanish fortresses in 1808.

it is intended to break them off, the softest words should be reserved to the last day but one, and then a sudden expedition be launched against the enemy, who has been lulled into a belief in the certainty of peace. He is quite ready to send bribes into the hostile camp. He recommends two ancient tricks that were already a thousand years old in his own day. The first is that of addressing treasonable letters to officers in the enemy's camp, and contriving that they shall fall into the hands of the commander-in-chief, in order that he may be made suspicious of his lieutenants. The second is that of letting intelligence ooze out to the effect that some important person in the hostile country is secretly friendly, and adding plausibility to the rumour by sparing his houses and estates when raids are going on.[1] Leo is not above raising the spirits of his own soldiers before a battle by inventing and publishing accounts of imaginary victories in another corner of the seat of war. A trick too well known in later as well as in Byzantine times is that of sending *parlementaires* to the enemy on some trivial excuse, without any real object except that of spying out the numbers and intentions of the hostile forces. These and similar things have been tried in modern times, but they are not now recommended in official guides to the art of war published under Imperial sanction.[2] It is only fair to say that the same chapter which contains most of them (*Const.* xx.) is full of excellent matter, to the effect that no plighted treaty or armistice must be broken, no ambassador or parlementaire harmed, no female captive mishandled, no slaughter of non-combatants allowed, no cruel or ignominious terms imposed on a brave enemy. A few precepts of the rather futile immorality of those which we have instanced above must not be allowed to blind us to the real merits of the strategical system into which they have been inserted. The art of war as it was understood at Constantinople in the tenth century was the only system of real merit existing in the world ; no Western nation could have afforded such a training to its officers till the sixteenth, or we may even say the seventeenth century. If some of its

[1] A device as old as the Punic Wars ! Hannibal tried it against Fabius.

[2] The most " Byzantine" piece of writing that I can recall in a modern campaign is Kutusoff's cynical despatch to the Emperor of Russia, avowing the trick which he had played off on Murat a few days before Austerlitz. " In alleging the conclusion of an armistice," he wrote, " I had nothing in view but to gain time, and thereby obtain the means of removing to a distance from the enemy, and so saving my corps." Many men might have carried out the fraud : few would have openly boasted of it.

precepts leaned a little too much towards the side of fraud, it may be pleaded that at any rate its methods were more humane than those prevailing in any other part of the world at the time.

But we are at present engaged in investigating the efficacy and not the morality of the military customs of the Byzantines. A survey of the main lines of the strategy and tactics of their armies must be our next task.

The generals of the new Rome made it their boast that they knew how to face and conquer the various enemies of the empire in East and West, by employing against each the tactical means best adapted to meet their opponents' method of warfare. The *Strategicon* of Maurice gives an account of the Persian, Avar, and Lombard and the methods to be used against them: Leo, three hundred years later, substitutes for these earlier foes the Frank and Saracen, the Slav and Turk. His chapter dealing with them (*Const.* xviii.) is more detailed and more interesting than the corresponding passage in his predecessor's work, and deserves reproduction, alike as showing the diversity of the tasks set before a Byzantine general, and the practical manner in which they were taken in hand. They serve, indeed, as a key to the whole art of war as it was understood at Constantinople.

"The Franks and Lombards," says Leo, "are bold and daring to excess, though the latter are no longer all that they once were: they regard the smallest movement to the rear as a disgrace, and they will fight whenever you offer them battle. When their knights are hard put to it in a cavalry fight, they will turn their horses loose, dismount, and stand back to back against very superior numbers rather than fly. So formidable is the charge of the Frankish chivalry with their broadsword, lance, and shield, that it is best to decline a pitched battle with them till you have put all the chances on your own side. You should take advantage of their indiscipline and disorder; whether fighting on foot or on horseback, they charge in dense, unwieldy masses, which cannot manœuvre, because they have neither organisation nor drill. Tribes and families stand together, or the sworn war-bands of chiefs, but there is nothing to compare to our own orderly division into battalions and brigades. Hence they readily fall into confusion if suddenly attacked in flank and rear—a thing easy to accomplish, as they are utterly careless and neglect the use of pickets and vedettes and the proper surveying of the countryside.

They encamp, too, confusedly and without fortifying themselves, so that they can be easily cut up by a night attack. Nothing succeeds better against them than a feigned flight, which draws them into an ambush; for they follow hastily, and invariably fall into the snare. But perhaps the best tactics of all are to protract the campaign, and lead them into hills and desolate tracts, for they take no care about their commissariat, and when their stores run low their vigour melts away. They are impatient of hunger and thirst, and after a few days of privation desert their standards and steal away home as best they can. For they are destitute of all respect for their commanders,—one noble thinks himself as good as another,—and they will deliberately disobey orders when they grow discontented. Nor are their chiefs above the temptation of taking bribes; a moderate sum of money will frustrate one of their expeditions. On the whole, therefore, it is easier and less costly to wear out a Frankish army by skirmishes, protracted operations in desolate districts, and the cutting off of its supplies, than to attempt to destroy it at a single blow."

The chapters (xviii. 80–101) of which these directions are an abstract have two points of interest. They present us with a picture of a Western army of the ninth or tenth century, the exact period of the development of feudal cavalry, drawn by the critical hand of an enemy. They also show the characteristic strength and weakness of Byzantine military science. On the one hand, we see that Leo's precepts are practical and efficacious ; on the other, we see that they are based upon the supposition that the Imperial troops will normally act upon the defensive, a limitation which must materially impair their efficiency. Byzantine statesmen had long given up any idea of attempting the reconquest of Italy; they aimed at nothing more than retaining their hold on the "Calabrian" and "Langobardic" themes. Hence come the caution and want of enterprise, the proneness to sleights and stratagems, displayed in Leo's chapters, characteristics which lead the Frankish writers into stigmatising the East-Romans as treacherous and cowardly. To win by ambushes, night attacks, and surprises, seemed despicable to the Frankish mind. These, nevertheless, were the tactics by which the Eastern emperors succeeded in maintaining their Italian provinces for four hundred years against every attack of Lombard duke or Frankish emperor.

The method which is recommended by Leo for resisting the "Turks" (by which name he denotes the Magyars and the Patzinaks who dwelt north of the Euxine[1]) is different in every respect from that directed against the nations of the West. The Turkish hordes consisted of innumerable bands of light horsemen who carried javelin and scimitar, but relied most of all on their arrows for victory. They were "given to ambushes and stratagems of every sort," and were noted for the care with which they conducted their scouting and posted their vedettes. In battle they advanced not in one mass, but in small scattered bands, which swept along the enemy's front and around his flanks, pouring in flights of arrows, and executing partial charges if they saw a good opportunity. On a fair open field, however, they could be ridden down by the Byzantine heavy cavalry, who are therefore recommended to close with them at once, and not to exchange arrows from a distance. Steady infantry also they could not break, and foot-archers were their special dread, since the bow of the infantry-soldier is larger and carries farther than that of the horseman; thus they were liable to have their horses shot under them, and when dismounted were almost helpless, the nomad of the steppes having never been accustomed to fight on foot. The general who had to contend with the Turks, therefore, should endeavour to get to close quarters at once, and fight them at the earliest opportunity. But he should be careful about his flanks, and cover his rear if possible by a river, marsh, or defile. He should place his infantry in the front line, with cavalry on the flanks, and never let the two arms be separated. Heedless pursuit by the cavalry was especially to be avoided,[2] for the Turks were prompt at rallying, and would turn and rend pursuers who followed in disorder. But a proper mixture of energy and caution would certainly suffice to defeat a Turkish host, because in the actual clash of battle they were man for man inferior to the Imperial *Cataphracti*. These chapters would have been the salvation of four generations of Western Crusaders if their chiefs had but been able to read them. Well-nigh every disaster which the Crusaders suffered came from disobeying some

[1] Apparently also the Bulgarians (xviii. §§ 42–44), as he speaks of them as a Scythian race very like the Turks, and again, of their "differing little or not at all from each other in their way of life and their methods of war."

[2] Never let the *cursores* get more than three or four bowshots from the *defensores*, is Leo's general rule.

one of Leo's precepts—from falling into ambushes, or pursuing too heedlessly, or allowing the infantry and cavalry to become separated, or fighting in a position with no cover for rear or flanks. The Byzantines, on the other hand, made on the whole a very successful fight against the horse-archers who overwhelmed so many Western armies. It is true that one huge disaster, the defeat of Manzikert, brought on by the rashness of Romanus IV., was perhaps the most fatal blow that the empire ever received. But, with this and a few other exceptions, the East-Roman armies gave a good account of themselves when dealing with the Turk. Alexius Comnenus, though not a genius, was always able to defeat the Patzinaks ; his son and grandson reconquered from the Seljouks half Asia Minor, and, even after the Latin conquest of 1204, Lascaris and Vatatzes held them back. It was not the horse-archers of the older Turkish tribes, but the disciplined janissaries of the Ottomans that were destined to give the *coup de grâce* to the Eastern Empire.

The third group of nations with which Leo deals are the Slavonic tribes—Servians, Slovenes, and Croatians, who inhabited the north-western parts of the Balkan peninsula. The space devoted to them is much less than that spent on each of the other categories of the enemies of the empire. Leo remarks that since their conversion to Christianity in the reign of his father Basil, and the treaty in 869 which had made the Dalmatian and Bosnian Slavs, in name at least, vassals of the empire, they had given no trouble. They were a nation of foot-soldiers, and only formidable when they kept to the mountains, where their archers and javelin-men, posted in inaccessible positions, could annoy the invader from a distance, or their spearmen make sudden assaults on the flank or rear of his marching columns. Such attacks could be frustrated by proper vigilance, while, if surprised in the plains when engaged in a plundering expedition, they could be easily ridden down and cut to pieces by the Imperial cavalry, since they had no idea of discipline and no defensive arms save their large round shields. Leo gives no description of the Russians, though they were already beginning to plague the themes along the Euxine coast.[1] Had he devoted a chapter to them, we should be the richer by some interesting details of their early military customs. Sixty years later, when

[1] Their first expedition had been in 865, and there was one in Leo's own reign in 907.

they fought John Zimisces, they had adopted the armour and tactics of their Varangian chiefs, and resembled the Northmen rather than the Slavs of the South, fighting with shirts of mail, long kite-shaped shields, and battle-axes, and arraying themselves in well-ordered columns, which could often beat off cavalry. It took the most strenuous efforts of the gallant Zimisces and his chosen horse-guards to break into these stubborn masses, and the battle of Dorostolon was one of the hardest fought and perhaps the most creditable of all the victories of the Byzantine armies (971).

The longest and most interesting paragraphs in Leo's Eighteenth "Constitution" are reserved for the Saracens, and his description of them can be amplified by details from the very interesting Περὶ Παραδρομῆς Πολέμου, a work written about 980 by a trusted officer of Nicephorus Phocas, who desired to preserve his late master's precepts and practice in a literary shape. The little book is practically a manual for the governors of themes on the eastern border, giving all the methods to be employed in repelling Saracen raids, and all the precautions necessary for the execution of retaliatory invasions of Saracen territory. It is especially valuable because, unlike the *Tactica* of Leo, it gives lavish historical illustrations and examples, and does not confine itself to precept.

To deal with the Saracen, the most formidable enemy of the empire, the greatest care and skill were required. "Of all barbarous nations," says Leo, "they are the best advised and most prudent in their military operations." The commander who has to meet with them will need all his tactical and strategical ability, the troops must be well disciplined and courageous, if the "barbarous and blaspheming Saracen" is to be driven back in rout through the "clissuras" of Taurus.

The Arabs whom Khaled and Amru had led in the seventh century to the conquest of Syria and Egypt had owed their victory neither to the superiority of their arms nor to the excellence of their organisation. The fanatical courage of the fatalist had enabled them to face better-armed and better-disciplined troops, as it nerved the Soudanese ten years ago to face the breechloaders of our own infantry. We, who remember the furious rush that once broke a British square, cannot wonder that the troops of Heraclius, armed only with pike and sword, were swept away before the wild hordes of the early Caliphs.

It is greatly to the credit of the East-Roman troops and the house of Heraclius that Asia Minor did not suffer the same fate as Persia and Spain. But when the first flush of fanaticism had passed by, and the Saracens had settled down in their new homes, they did not disdain to learn a lesson from the nations they had defeated. Accordingly, the Byzantine army served as a model for the forces of the Caliphs. " They have copied the Romans," says Leo, " in most of their military practices,[1] both in arms and in strategy." Like the Imperial generals, they placed their confidence in their mailed lancers : they were no longer the naked hordes of the sixth century, but wore helms, shirts of chain-mail, and greaves. But the Saracen and his charger were alike at a disadvantage in the onset : horse for horse and man for man the Byzantines were heavier, and could ride the Orientals down when the final shock came.

By the tenth century the Saracens had an art of war of their own. Some of their military works have survived, though none, it appears, date back to the times contemporary with Leo. They had advanced very considerably in poliorcetics and forti- fication ; they had learned how to lay out and entrench their camps, and how to place pickets and vedettes. But they never raised a large standing army, or fully learned the merits of drill and organisation. The royal bodyguards were their only regular troops ; the rest of the army consisted of the war-bands of chiefs, miscellaneous bands of mercenary adventurers, or the general levies of tribes and districts.

Two things rendered the Saracens of the tenth century dangerous foes,—their numbers and their extraordinary powers of locomotion. When an inroad into Asia Minor was on foot, the powers of fanaticism and greed united to draw together every unquiet spirit from Egypt to Khorassan. The wild horsemen of the East poured out in myriads from the gates of Tarsus and Adana to harry the rich uplands of the Anatolic, Armeniac, and Cappadocian themes. " They are no regular host, but a mixed multitude of volunteers ; the rich man serves from pride of race, the poor man from hope of plunder. They say that God, ' who scattereth the armies of those that delight in war,' is pleased by their expeditions, and has promised victory to them. Those who stay at home, both men and women, aid in arming their poorer neighbours, and think that they are performing a

[1] *Tactica*, xviii. § 120.

good work thereby. So mere untrained plunderers and experienced warriors ride side by side in their hosts."[1]

Once clear of the passes of Taurus, the great horde of Saracen horsemen cut itself loose from its communications, and rode far and wide through Cappadocia and Phrygia, burning the open towns, harrying the countryside, and lading their beasts of burden with the plunder of a region which was in those days one of the richest in the world. It was only exceptionally that the invaders were aiming at serious conquests and halted to besiege a fortified town. The memory of the awful failures of the two great hosts that perished before Constantinople in 673 and 718 seems to have been deep impressed in the minds of the Mohammedan rulers and generals. The two last attempts at getting a footing beyond the Taurus were those of Haroun-al-Raschid in 806, and of Al-Motassem in 838. Each, after taking one considerable town, found such a long and difficult task before him that he gave up his project and retired. The armies of their successors, even when counted by scores of thousands, were aiming at nothing more than vast plundering raids.

When the Saracens had passed the defiles of Taurus, they pushed on for some days at an almost incredible speed, for their baggage was all laid on camels or sumpter beasts, and their foot-soldiery were either provided with horses of some sort or taken up on the cruppers of the cavalry.[2] They made for the district that they had marked out for plunder, and trusted to arrive in such haste that the natives would not have had time to gather in their property and take shelter within walled towns.

Now was the time for the Byzantine general to show his mettle. If he was a competent commander, he would have had regular outposts, relieved every ten or fifteen days, to watch the passes. The moment that these were driven in, they would take

[1] Leo here adds, xviii. § 129: "And would that we Christians did the same. For if all of us, both soldiers and those who have not yet borne arms, could agree to strengthen our hearts and go forth together, if every man armed himself, and the people gave their money to equip such a host, and their prayers to help it, then marching against that race which blasphemes our Lord and God, Christ, the King of all, we should obtain victory. For the Roman armies being increased manifold, and furnished liberally with all weapons of war, and abounding in military skill, and having heaven as their aid, could not fail to crush the barbarous and blaspheming Saracen." This surely is the spirit of the Crusader, appearing two hundred years before its time.

[2] Τοὺς δὲ πεζοὺς αὐτῶν φέρουσιν ἢ ἐφ' ἵππων ἰδίων ὀχουμένους, ἢ ὄπισθεν τῶν καβαλλαρίων καθημένους (xviii. § 115).

the tidings to the chief town of the theme, and to the nearest commanders of bands and turmae. While the main body of the cavalry of the theme concentrated under the strategos at a central point, it would be the duty of the turmarch into whose district the raid had come, to collect the nearest two or three bands in haste, and to hang on to the skirts of the invading force at all costs. For even a small observing force compels the invaders to move cautiously, and to abstain from letting their men straggle for plunder. Meanwhile, all the disposable foot-soldiery of the theme would be hurried off to seize the mouths of the passes by which the enemy would probably return. These were not so numerous but that a competent officer might make some provision for obstructing them all.[1]

To ascertain the enemy's route and probable designs, the commander of the theme must spare no pains. The turmarch charged with following the raiders ought to be sending him continual messages; but in addition, says Leo, "never turn away freeman or slave, by day or night, though you be sleeping or eating or bathing, if he says that he has news for you." Success is almost certain if continual touch with the enemy is kept up; the most disastrous consequences may follow if he is lost. When the strategos has concentrated all or most of his regiments, he makes with all speed for the district which the raiders are reported to have reached. If they are in comparatively small numbers, he must endeavour to fight them at once. If they are too strong for him, he must obstruct their way by all means which do not expose him to an open defeat. If there are fords or defiles on their path, he must defend them as long as possible; he must block up wells and obstruct the roads with trenches. Above all, he must endeavour either to cut off all raiding parties that leave the enemy's camp, or—if these are too strong—to adopt the opposite course, and storm the camp in their absence. By such devices he may either worry them into returning, or else detain them long enough to allow of the arrival of the mobilised troops of two or three neighbouring themes. When a sufficient force has accumulated, open battle can be tried. But these Saracen invasions in force ("Warden-Raids," if we may borrow a phrase from the similar expeditions of our own

[1] All this is from Nicephorus' Περὶ Παραδρομῆς Πολέμου, cap. i. § 1. The chapter is really excellent; it might be used on the Indian north-west frontier to-day, so practical is it.

Borderers) were of comparatively unfrequent occurrence, and it was not often necessary to " set all the rest of the themes of the East marching," each with its picked corps of four thousand or four thousand five hundred cavalry. If needed, however, Leo states that thirty thousand cavalry of the best quality could be collected in a moderate space of time. A most perfect instance of such a concentration had taken place in A.D. 863 (though Leo does not mention it[1]), when a great Saracen army under Omar, the Emir of Malatia, had been completely surrounded and absolutely exterminated by the skilful and simultaneous appearance of no less than ten contingents, each representing a theme.[2]

The more typical Saracen inroad, however, was on a smaller scale, and only included the warriors of Cilicia and Northern Syria, assisted by casual adventurers from the inner Mohammedan regions. To meet them the Byzantine commander would have no more than the four or five thousand horsemen of his own theme. When he came up with them, they would probably turn and offer him battle: nor was their onset to be despised. Though unequal, man for man, to their adversaries, the Saracens were usually in superior numbers, and always came on with great confidence. " They are very bold when they expect to win : they keep firm in their ranks, and stand up gallantly against the most impetuous attacks. When they think that the enemy's vigour is relaxing, they all charge together in a desperate effort." If this, however, failed, a rout generally followed, " for they say that all misfortunes come from God, and if they are once well beaten, they take it as a sign of divine wrath, and altogether lose heart." Their line once broken, they have not discipline enough to restore it, and a general *sauve qui peut* follows. Hence a Mussulman army, when routed, could be pursued *à l'outrance*,[3] and the old military maxim, *Vince sed ne nimis vincas*, was a caution which the Byzantine officers could disregard.

In the actual engagement with the Saracen foe, the tactics

[1] Perhaps because the reigning emperor was Michael III., whom Basil I. (Leo's father) had murdered.

[2] Having sacked Amisus and ravaged Paphlagonia and Galatia, Omar found his way home blocked by the contingents of the Anatolic, Obsequian, and Cappadocian themes; at the same time those of the Buccellarian, Paphlagonian, Armeniac, and Colonean themes encompassed him on the north ; and that of the Thracesian theme, strengthened by European troops of the Macedonian and Thracian themes, closed in on the west. The Saracens were absolutely exterminated.

[3] Nic. Phoc. xxiv. § 10.

recommended were those of the double line, with flank-guards, reserve, and outlying detachments to turn the enemy, which we have described in the section dealing with the organisation of the Byzantine army. The Saracens were accustomed to array themselves in one very deep line, which Leo calls a solid oblong (τετράγωνον καὶ ἐπιμήκη παράταξιν). Their cavalry were practically the sole force that gave trouble, the foot being a mere rabble of plunderers, which would never stand. Their only useful infantry were composed of Ethiopian archers, but these, being wholly destitute of defensive armour, could never face the Byzantine footmen. In battle the single heavy line of the Orientals must under ordinary circumstances give way before the successive charges of the three Byzantine lines. The generals of the East had already discovered the great precept which modern military science has claimed as its own, that " in a cavalry combat the side which holds back the last reserve must win." They were equally masters of the fact that this last reserve should be thrown in on the flank rather than on the front of the enemy. It was not, therefore, without reason that the author of the Παραδρομή exclaims that "the commander who has five or six thousand of our heavy cavalry and the help of God needs nothing more." [1]

It would sometimes, however, happen that the Saracens were not caught on their outward way, and that the forces of the Byzantine general only closed in on them as they were retreating.[2] Loaded with booty, the raiders would be constrained to move far more slowly than on their advance; their camps, too, would be filled with captured herds and flocks, laden waggons, and troops of prisoners. In this case Nicephorus Phocas recommended a night attack, to be delivered by infantry or dismounted cavalry. "Send three infantry bands, ranged a bowshot apart, to charge into each flank of their camp," says the emperor, "assail the front a little later with your main body of foot, and leave the rear, where lies the road to their own land, unattacked. In all probability the enemy will instinctively get to horse, and fly by the only way that seems to lead to safety, leaving their plunder behind them." [3]

[1] Nic. Phoc. Preface, § 15.

[2] Nic. Phoc. xvii. § 15.

[3] εἰ δὲ συμβῇ λυθῆναι τὴν παράταξιν, δι᾽ ἑαυτῶν ἀσύστατοι καὶ ἀνεπίστροφοι γενόμενοι μόνῳ τῷ σωθῆναι ἐλαύνουσιν (xviii. 116).

But success was most certain of all if the invaders could be caught while retreating through the passes of Taurus. If the infantry of the theme had succeeded in reaching the defiles and posting themselves there before the retreating enemy arrived, while at the same time the pursuing cavalry pressed them in the rear, the Saracens were lost. Wedged in the narrow road, with their line of march mixed with countless waggons and sumpter-beasts laden with spoil, they were quite helpless. They could be shot down by the archers, and would not stand for a moment when they saw their horses, "the Pharii whom they esteem above all other things," struck by arrows from a distance; for the Saracen, when not actually engaged in close combat, would do anything to save his horse from harm.[1]

The most noted instance of a victory of this kind was that won in 963 by Leo Phocas, brother of Nicephorus, over the hosts of Seïf-ed-dauleh ben Hamdan, Emir of Aleppo. Though he had with him only the forces of his own theme of Charsiana,[2] Leo captured or slew the whole of the Saracen army, recovered much plunder, liberated many thousands of Christian prisoners, and bore off in triumph the standard and the silver camp equipment of the emir. Mohammedan historians confess the greatness of the disaster, though they reduce the number of their slain to three or four thousand.[3] Seïf-ed-dauleh himself escaped with three hundred men only, by climbing an almost impracticable precipice. His ruin is ascribed by Abulfeda to the fact that he had dared to return to Cilicia by the same pass, that of Maghar-Alcohl, by which he had entered into the Roman territory. It is interesting to find the very methods which Leo describes in 900 used sixty years after with perfect success—a sufficient proof that the emperor was not altogether undeserving of his name of "the Wise."

Many other points of interest may be gathered from the chapters of Leo and of Nicephorus Phocas. Cold and rainy weather, we learn, was distasteful to the Oriental invader; at times when it prevailed he did not display his ordinary firmness and daring, and could be attacked with great advantage. Much might also be done to check his progress by delivering a vigorous counter-attack into Cilicia or Northern Syria, the moment that the Saracen was reported to have passed north into Cappadocia

[1] Leo, xviii. § 135. [2] Nic. Phoc. Preface, § 15.
[3] Jemaleddin, p. 134; Abulfeda, ii. 469.

or Charsiana. On hearing of such a retaliatory expedition, the Moslems would often return home to defend their own borders.[1] This destructive practice was very frequently adopted, and the sight of two enemies each ravaging the other's territory without attempting to defend his own was only too familiar to the inhabitants of the borderlands of Christianity and Islam. Incursions by sea supplemented the forays by land. "When the Saracens of Cilicia have gone off by the passes, to harry the county north of Taurus," says Leo, "the commander of the Cibyrrhæot theme should immediately go on shipboard with all available forces, and ravage their coast. If, on the other hand, the Cilicians have sailed off to attempt the shore districts of the Imperial provinces, the clissurarchs of Taurus can lay waste the territories of Tarsus and Adana without danger."

All through the tenth century the Saracens were growing less and less formidable foes, owing to the gradual dropping off of the outlying provinces of the empire of the Abbassides, who by the end of the period were masters of little more than the Euphrates valley, and were dominated even in their own palace by their Turkish guards. The Byzantine realm, on the other hand, under the steady and careful ministers who served the Macedonian dynasty, was at its very strongest. For a hundred and fifty years after the accession of Basil I., the empire was always advancing eastward, and new themes were continually being formed from the reconquered territory. There is a great difference of tone between the language which Leo, writing about 900, and the author of the Παραδρομή, writing about 980, use concerning the Saracen enemy. To the former they are still the most formidable foes of the empire ; the latter opens his preface with the words : "To write a treatise on frontier operations may seem at the present day no longer very necessary, at least for the East, since Christ, the one true God, has in our day broken and blunted the power of the sons of Ishmael, and cut short their raiding. . . . But I write nevertheless, thinking that my experience may be useful, because I was an eye-witness of the commencement of our successes and of the application of the principles which led to them. Through the use of these principles I have seen small armies accomplish

[1] The author of the Παραδρομή speaks of this device, quoting it as a good piece of counsel given by Leo, and gives as example an occasion when the siege of Misthea was raised by means of a retaliatory raid against Adana (xx.).

great feats. What once, when the Saracens of the border were strong, seemed impossible to a whole Roman army, has been of late carried out by a single good general with the forces of a single theme. By the use of these principles I have seen a force, though too small to face the enemy in open fight, yet defeat his purpose, and preserve our borders unravaged. The system was first, as far as I know, utilised in modern times by Bardas Caesar,[1] who foiled the Saracens of the Tarsiot border not once but ten thousand times, and erected countless trophies over them. Constantine Meleïnos, strategos for many years in Cappadocia, won magnificent successes by using these principles.[2] But Nicephorus Phocas, that prince of immortal memory, accomplished by their use feats that defy description and enumeration. He it was who bade me write down the system, for the use of future generations. And this I do with the more readiness because it can be applied not only to the eastern border, but to the western, as I (who have served most of my time on the latter) can state from my own experience."

By the end of the tenth century the Byzantines were habitually taking the offensive against the Saracens, and, instead of seeing Cappadocia or Phrygia ravaged, were themselves pushing their incursions almost to the gates of Damascus and Bagdad. The conquest of Cilicia by Nicephorus Phocas was but the first of a series of advances which promised ultimately to restore to the empire the frontier that it had held in the days of Justinian. Antioch was conquered, the Emirs of Aleppo and Tripoli were made tributary, and kept in that position for sixty years. Even after the death of Basil II., the greatest soldier of the Eastern realm, the Imperial borders continued to advance eastward: Edessa was captured in 1032, and a new theme was established in Mesopotamia. The whole of Armenia was annexed in 1045, and Constantine IX. might have boasted that his provinces extended farther to the East than those of any of his predecessors since Trajan.

[1] This, I suppose, was the unfortunate Bardas Caesar who was murdered by his nephew Michael III. in 866. There had been some great victories in his day, notably that over Omar (see p. 210), and he is said to have devoted much attention to military affairs, but it is surprising to find him given such a marked place by the author of the Παραδρομή. Did his exploits inspire the sections on border warfare in Leo's Tactica?

[2] There were several good generals of this name. I suppose this to be the one who ruled Cappadocia about 960 A.D.

But at the moment when the East - Roman boundaries reached their largest extent, the new foe was at hand who was to deal the fatal blow from which the empire was never wholly to recover. The disastrous day of Manzikert (1071) is really the turning-point in the history of the great East - Roman realm.

CHAPTER IV

DECLINE OF THE BYZANTINE ARMY—1071–1204

THOUGH the internal condition and administration of the empire had been steadily deteriorating since the death of Basil II. (1024), it cannot be said that its army showed any decline till the very day of Manzikert. Indeed, as we have already seen, the Imperial frontier continued to advance down to the moment of that disaster, and the first advance of the Seljouks was met without wavering. For some years the Turks had no higher aim than to win booty by sudden inroads into Asia Minor. Of their raiding bands some were turned back, and some cut to pieces; but their numbers were so great that the line of defence could not be held everywhere, and on different occasions Caesarea, Iconium, and Chonae fell into their hands. No lodgment, however, was made in the empire, and the fact that the decisive battle was fought so far east as Manzikert, in farther Armenia, hard by the Lake of Van, shows that the hold of the government on its frontier provinces was not yet shaken.

The Seljouks of Alp Arslan were in tactics just like the Turks whom Leo the Wise had described a century and a half before. They only differed from the Patzinaks and other Western tribes of the same blood by their enormously superior numbers. No such formidable invasion had befallen the empire since the days of Leo the Isaurian, and to meet it there sat on the Byzantine throne a gallant hot-headed soldier with a doubtful title and many secret enemies. Romanus Diogenes had been lately raised to the purple by his marriage with Eudocia, the widow of Constantine XI., and reigned as colleague and guardian of her young son Michael. He knew that he was envied and hated by many of his equals, who had aspired to fill the same place: hence he was nervously anxious to justify his elevation by military success, as his great predecessors, Nicephorus Phocas

and John Zimisces, had done. He was in the field for almost
the whole of the three uneasy years for which he reigned (1068–
71); and if energy and ceaseless movement could have driven off
the Seljouks, he must have been successful. But he was a bad
general, easily distracted from his aims, and too quick and rash
in all his actions.

In the spring of 1071 Romanus collected a very large army,
at least sixty thousand strong, and betook himself to the extreme
eastern corner of his dominions, with the intention of meeting
the Turks at the very frontier, and recovering the fortresses of
Akhlat and Manzikert, which had fallen into their hands. He
had retaken the latter place, and the former was being besieged
by a detached division of his army, when the main host of the
Seljouks came upon the scene. It was a great horde of horse-
archers, more than a hundred thousand strong, and full of confid-
ence in its victorious Sultan. The tactics which Romanus should
have employed were those laid down in Leo's manual—to beware
of ambushes and surprises, never to fight with uncovered flanks
or rear, to use infantry as much as possible, and never to allow the
army to get separated or broken up. Romanus violated all
these precepts. His first brush with the enemy was a disaster
on a small scale, caused by pure heedlessness. When a small
body of Turkish cavalry came forward to reconnoitre the Imperial
camp, it was furiously charged by a rash officer named Basilakes,
who commanded the theme of Theodosiopolis: he drove it
before him till he lost sight of his master, and fell into an ambush,
where he and all his men were killed or captured. A division
which Romanus sent to support them found nothing but the
bodies of the slain.

With this warning before him, the emperor should have acted
with all caution: perhaps, indeed, he intended to do so till his
rashness ran away with him. He drew up his host in front of
his camp with great care. The right wing was composed of the
cavalry from the easternmost themes—Cappadocia, Armeniacon,
Charsiana, and the rest, under Alyattes, strategos of the Cap-
padocian theme. The left wing, under Niçephorus Bryennius,
was formed of the drafts of the European themes. In the centre
was the emperor, with his guards and the regiments of the
metropolitan provinces. A very strong rear line, composed of the
mercenary cavalry (which included a regiment of Germans and
also some Normans from Italy) and the levies of the nobles of

the eastern frontier,[1] was placed under Andronicus Ducas, a kinsman of the late Emperor Constantine. He was unfortunately, though a good officer, a secret enemy of Romanus.

Alp Arslan had been so moved by the news of the size and splendour of the army which was moving against him, that on the morning after the skirmish in which Basilakes had been captured, he sent an embassy offering peace on the terms of *uti possidetis*. He would withdraw and undertake to make no further invasions of the empire. Romanus was probably right in refusing to negotiate, for Turkish promises could not be trusted. He told the ambassadors that the first condition of peace must be that the Sultan should evacuate his camp, retire, and allow it to be occupied by the Imperial forces. Alp Arslan would not consent to sacrifice his prestige, and the armies were soon in collision. The Turks, after their usual manner, made no attempt to close, or to deliver a general attack on the Imperial host. Large bodies of horse-archers hovered about and plied their bows against various points of the line. The Byzantine cavalry made such reply as they could, but, their skirmishers being outnumbered, suffered severely in the interchange of arrows, and many horses were disabled. Both the emperor and his troops grew angry at the protraction of this long random fight, and in the afternoon Romanus gave orders for the whole line to advance. He was, however, sufficiently master of himself to see that the distances were observed, and that the reserve division kept its place accurately, so as to prevent any attack from the rear. For some hours the host drove the Turks before them, inflicting, however, little loss, as the enemy refused to make a stand anywhere; they even passed over the site of the Sultan's camp, which had been evacuated and emptied of all its contents some hours before. As the dusk came on, Romanus halted: his men were tired and thirsty, and he had left his camp insufficiently garrisoned, so that he was anxious to return to it, lest it might be surprised in his absence. Accordingly, he gave orders to face about and retire. Then began the disasters of the day: the order to retreat was not executed with the same precision in all the divisions of the host; those on the flanks received it late, did not understand its cause, and, when they wheeled about, did not keep their dressing with the centre. Gaps began to appear between several

[1] These are, I suppose, the ἑταῖροι and τὸ ἀρχοντικόν of which Bryennius speaks in his account of the battle.

of the corps. The Turks, according to their custom, commenced
to close in again when the army commenced its retreat. They
molested the retiring columns so much that Romanus at last
gave orders to face about again and beat them off. The whole
front line carried out this order, but the reserve under Andronicus
did not: out of deliberate malice, as most of the authorities allege,
this treacherous commander refused to halt, and marched back
rapidly to the camp, observing that the day was lost, and the
emperor should fight out his own battle. To lose the rear line,
and to be left without any protection against circling move-
ments on the flanks, was fatal. The Turks began to steal round
the wings and to molest the fighting line from behind: they
particularly concentrated attention on the right wing, which,
trying to face both ways, fell into disorder in the twilight, and
at last broke up and fled. The victors at once fell on the flank
and rear of the centre, where the emperor made a gallant defence,
charged repeatedly both to flank and rear, and held his own.
But the European troops in the left wing had got divided from
the centre, and, after fighting a separate battle of their own, gave
way, and were driven off the field. Thus left isolated, Romanus
encouraged his men to stand their ground, and held out till
dark, when the Turks broke into his column and made a dread-
ful slaughter. The emperor's own horse was killed beneath him ;
he was wounded and taken prisoner, with many of his chief
officers : the whole centre was cut to pieces, and not a man of it
escaped.

Thus Romanus Diogenes, like Crassus of old, paid the penalty
for attacking a swarm of horse-archers in a open rolling country,
where he had cover neither for his flanks nor for his rear. It is
only fair to say that he would have in all probability brought
home his army without any overwhelming loss but for the abomin-
able misconduct of Andronicus Ducas. When encompassed by
the Turks on the open plain, he was not nearly so helpless as the
Romans had been at Carrhae : his force, being all cavalry, was
capable of fairly rapid movement, and a sufficiently large propor-
tion of the men were armed with the bow to enable him to make
some reply to the Turkish arrows. Still, by his inconsiderate
pursuit of the enemy he had placed himself in a radically false
position : it is useless for heavy troops to pursue swarms of light
horse, unless they are able to drive them against some obstacle—
a river or a defile, which prevents farther flight. In this case the

Turks could retire *ad infinitum*, while the Byzantines, continually moving farther from their camp and their stores, were at last brought to a standstill by mere fatigue. Their retreat was bound to be dangerous ; that it was disastrous was the fault of Ducas, not of his master. We shall see in our chapter on the Crusades that the details of Manzikert show a striking similarity to those of several later battles in which the chivalry of the West had to face the same Turkish tactics.

The empire had suffered other defeats as bloody as that of Manzikert, but none had such disastrous results. The captivity of Romanus Diogenes threw the nominal control of the realm into the hands of his ward, Michael Ducas, who, though he was only just reaching manhood, displayed the character of a pedant and a miser. His reign of seven years was one chaotic series of civil wars: half a dozen generals in corners of the empire assumed the purple ; and Romanus, after his delivery from prison, tried to reclaim his crown. Meanwhile, the Seljouks flooded the plateau of Asia Minor, almost unopposed by the remnants of the Imperial army, who were wholly taken up in the civil strife. No man of commanding talents arose to stem the tide, and ere long the horse-bowmen of Malekshah, the son of Alp Arslan, were seen by the Ægean and even by the Propontis. The Turkish invasion was a scourge far heavier than that of the Saracens. While the latter, when bent on permanent conquest, offered the tribute as alternative to the " Koran or the sword," the Seljouks were mere savages who slew for the pleasure of slaying. They were barbarous nomads, who had no use for towns or vineyards or arable land. They preferred a desert in which they could wander at large with their flocks and herds. Never, probably, even in the thick of the Teutonic invasions of the fifth century, was so much harm done in ten short years as in Asia Minor during the period 1071–1081. By the end of the latter year the flourishing themes which had been for so long the core of the East-Roman realm had been reduced to mere wastes. Thirty years after Manzikert, when the armies of the Crusaders marched from Nicæa to Tarsus, right across the ancient heart of the empire, they nearly perished of starvation in a land of briars and ruins.

It seemed for a time quite probable that the fall of Constantinople might put the crown to the misfortunes of the empire, for the would-be Caesars who were contending for the throne left the Seljouks alone. Both Michael VII. and his foe, the usurper

Nicephorus Botaniates, actually bought the aid of Turkish auxiliaries by formally surrendering whole provinces. In 1080 the barbarians even seized Nicæa, thus obtaining a footing on the Propontis, and almost within sight of the gates of the capital.

In this chaos the old Byzantine army practically disappeared. The regiments which had fallen at Manzikert might in time have been replaced, had the Asiatic themes still remained in the hands of the empire. But within ten years after the fall of Romanus IV. those provinces had become desolate wastes : the great recruiting-ground of the Imperial army had been destroyed, and the damage done was irreparable. So wholly had the army of the East been cut off, that in 1078 Michael Ducas, by collecting all the scattered and disbanded survivors of the old corps from the Asiatic side of the Bosphorus, and supplementing them with recruits, only obtained a division of ten thousand men, the so-called "Immortals," with whom the future emperor, Alexius Comnenus, made his first great campaign.[1] Yet, only ten years before, the Asiatic provinces had shown twenty-one themes, or a standing army of at least a hundred and twenty thousand men.

The European themes were, no doubt, not so thoroughly disorganised ; we find some of their old corps surviving into the time of the Comneni. But even here great havoc was made by the ten years of endemic civil war, from 1071–1081, and by the revolts of the Servians and Bulgarians.

After Manzikert, indeed, we find foreign mercenaries always forming both a larger and a more important part of the Imperial host than in the flourishing days of the Macedonian dynasty. Franks, Lombards, Russians, Patzinaks, Turks, were enlisted in permanent corps, or hired from their princes as temporary auxiliaries. It is no longer the old Byzantine army which we find serving under Alexius Comnenus and his successors, but a mass of barbarian adventurers, such as the army of Justinian had been five hundred years before. The old tactics, however, still survived : the generals were the same if the troops were changed. A concrete example may be quoted to show the old methods still prevailing.

In A.D. 1079 Nicephorus Botaniates, who sat on a most

[1] Ὁ βασιλεὺς Μιχαὴλ ἰδὼν τὸ τῆς Ἐῴας στράτευμα ἅπαν ἤδη ἐκλελοιπὸς, ὡς ὑποχείριον τῶν Τούρκων γενόμενον, ἐφρόντισε ὡς οἷον τε στράτευμα καταστῆσαι νεόλεκτον, καὶ δή τινας τῶν ἐκ τῆς Ἀσίας διασπαρέντων καὶ ἐπὶ μισθῷ δουλευόντων συλλέγων, θώρακάς τε ἐνέδυε καὶ θυρεοὺς ἐδίδου, etc. etc. (Nic. Bry. iv. § 4).

uneasy throne at Constantinople, sent against the rebel Nicephorus Bryennius his general Alexius Comnenus, whom he had lately made "Domestic of the Scholae," *i.e.* commander of the Imperial Guard. Nearly all the European provinces had fallen away to Bryennius, and as Asia had been overrun by the Turks as far as Nicæa and the Propontis, the ruler of Constantinople was not able to put into the field so large an army as the insurgents.

The armies, both wholly composed of cavalry, met at Calavryta, hard by the river Halmyrus. Comnenus, as the weaker of the two, waited to be attacked, and chose a position with a comparatively narrow front, apparently where a road crossed the slope of a hill : on the left of his position were some hollows, screened from the eyes of those approaching from the plain by a rise in the ground. Comnenus drew up his main body, composed of the "Immortals" whom Michael Ducas had organised, and a body of Frankish mercenaries, across the road. He hid his left wing in the hollows, ordering them to keep wholly out of sight till the enemy should have passed them, and then to charge in upon Bryennius' right flank. His right wing, composed of garrison troops strengthened by a considerable force of Turkish mercenaries—all horse-archers —was placed under the command of Catacalon ; it was in military terminology "refused," and ordered to devote its whole attention to preventing the enemy from turning the flank of the main body. Thus, to use the technical terms of Leo's *Tactica*, Comnenus had ἐνέδροι or ὑπερκεράσται on his left wing, and πλαγιοφύλακες on his right.

Bryennius, on the other hand, came on with his host divided into three parallel columns. The right wing, five thousand strong, was led by his brother John, and contained the cavalry of the theme of Thessaly and the veteran remnants of the old army of Italy, which had long served under John Maniakes against the Normans and Saracens. The left wing, under Tarchaniotes, three thousand strong, was composed of Macedonian and Thracian regiments. The centre, led by the usurper himself, was also formed from Macedonian and Thracian corps, strengthened by a picked body of ἄρχοντες—local nobles and their followers. But Bryennius intended to strike his chief blow with a body of Scythian (Patzinak) horse detached from his main army and moving a quarter of a mile to its left, with orders to turn the right of Alexius' line,—serving in fact, as Leo would have said, as ὑπερκεράσται.

When the rebel army came level with the hollows where the Imperialist left was concealed, the hidden troops suddenly issued forth and charged John Bryennius in flank, while Comnenus and his main body rode down upon the usurper's own central division. Both these attacks failed: John Bryennius wheeled to his right in time, and beat off the attack of the troops in ambush. Nicephorus Bryennius defeated the squadrons of the Immortals, and drove them off the field, while the Frankish mercenaries who formed the remainder of Comnenus' centre were wholly encompassed by the rebels,[1] and cut off from the possibility of retreat. Meanwhile, on the extreme right of the Imperialist army, the garrison troops under Catacalon had been charged and routed by Bryennius' flanking force of Patzinak horse. The victorious barbarians went off in wild pursuit of the fugitives, and seem to have overlooked the other corps on the Imperialist right, the Turkish auxiliaries, who found themselves left without an enemy in sight.[2] When the Patzinaks returned, they began plundering their own employer's camp, instead of forming up to aid him in an engagement as yet by no means ended.

Alexius Comnenus had extricated himself with difficulty from the melée in the centre, and retired over the brow of the hill, where he at once halted and began endeavouring to rally his broken troops. During the combat he had charged into the personal escort of the usurper, and had chanced to come upon the squires who led the second charger of Bryennius, adorned with purple housings and a gold frontlet, and carried the two swords of state which were always borne on each side of an emperor. Alexius and those with him had the fortune not only to capture these insignia, but to cut their way out of the tumult without losing them. Displaying the horse and the swords to his routed troopers, Alexius proclaimed that he had slain Bryennius. Encouraged by this fiction, a considerable body formed up around him, and at the same time the Turks from the left wing came up and placed themselves at his disposition.

Without delay Comnenus determined to attempt a second

[1] I suppose by the wheeling in of Tarchaniotes' men, who must have outflanked Comnenus' line considerably to the right, as the army of Bryennius was stronger by far than that of the Imperialists.

[2] Probably the Patzinaks charged the extreme right corps, and so did not come into contact with the one which lay nearer the Imperialist centre. Or possibly, as one account of the fight might imply, the Turks were only just arriving on the field when Catacalon was routed.

attack. He placed two bodies of the rallied troopers under cover to right and left, and with part of the Turks and the "Immortals" came down the hill again towards the site of the first engagement. The victorious rebels were in some disorder: many had dismounted to plunder the slain, and with them were mixed their camp-followers, now fleeing from the Patzinak marauders, who were beginning to plunder the tents. Bryennius himself and the centre division were surrounding the Franks of the Imperialist army, who, when they had been cut off, had dismounted, and offered to surrender. The commanders of these mercenaries were standing on foot before Bryennius and doing homage to him just as Alexius came down the hill for his second charge.

Though much surprised by the return of the enemy to the fight, Bryennius and his men came boldly forward. Alexius set his Turks to skirmish, and bade them empty their arrows into the disordered rebels before he made any endeavour to close; he wished to fight a cautious battle, avoiding any general charge. As the enemy advanced, he retired before them slowly till he had reached the point far up the hill where he had left his ambush. When he saw the flanks of Bryennius exposed to the lateral attack, he halted, faced to the front, and charged. At the same time the concealed troops, dashing out "like a swarm of wasps," attacked the rebels on both flanks. Already much disordered, and with hundreds of horses disabled by the Turkish arrows, the squadrons of Bryennius could not face the charge, but broke and fled. The rebel chief himself, with a small body of devoted followers, refused to give ground, fought to the last, and was finally dragged from his charger and taken prisoner.[1]

The battle of Calavryta was fought in the time of the Byzantine decadence which set in after Manzikert: there were many raw troops in both armies,[2] and a large proportion of foreign auxiliaries not drilled or disciplined after the traditional methods of the Imperial army. Nevertheless, the incidents of the fight show the main characteristics of the system which

[1] Most of the details of this interesting fight came from Anna Comnena, who has, for a lady, a very fair grasp of things military. No doubt she accurately put down her father's account of his doings, and we are really reading Alexius' versions of his fight. Deducting the Homeric diction and the far too hairbreadth 'scapes of the narrator, they are very favourable specimens of Byzantine military annals.

[2] Alexius complained that the majority of the Immortals were recruits χθές τε καὶ πρώην ξίφους ἠμμένοι καὶ δόρατα.

prevailed during the better days of the empire. Both generals endeavour to win by flank attacks, Bryennius by an open one, Comnenus by a sudden sally from an ambush. The horse-bowmen—Turks on one side, Patzinaks on the other—are used to prepare the way for the general charge. The troops have enough discipline to rally around their unbroken reserve and return to the charge within a very short time. Anna Comnena most unfortunately forgets to tell us whether the corps fought, according to the old rule, in a double line, with *cursores* and *defensores* properly divided, and with a reserve. Nor does her spouse, Nicephorus Bryennius, whose account tallies almost exactly with hers, give us any more help on this point, though he is careful to compliment his grandfather and namesake, the usurper, on his military reputation.

The numerous contemporary chronicles which describe the reigns of the three able Comneni, Alexius, John, and Manuel (1071–1180), show us that the old military organisation based on the themes was never again restored. For the future the Imperial army was a very haphazard and heterogeneous body. When the western third of Asia Minor was reconquered by Alexius and John, it was not divided up again into army-corps districts. The Comneni, indeed, were centralisers, and preferred to manage affairs from headquarters rather than to trust their forces to the strategi of the themes. They preferred to raise bodies of troops for general service rather than to localise the corps. A dangerous proportion of the army was for the future composed of foreign mercenaries: the earlier emperors had enlisted Franks, Russians, and other aliens in considerable numbers, but they had never made them the most important part of the host. They had always been outweighed by the regular cavalry of the themes. The Comneni, however, found native troops hard to raise, now that the old Asiatic recruiting-ground was gone, and they had also learned, from their contact with the Normans of Robert Guiscard and with the knights of the first Crusade, a great respect for Western valour. Frankish adventurers were easy to enlist, they were less likely to rebel in favour of pretenders than the native soldiery, and they had proved at Dyrrhachium and many other fields that, man for man, they could ride down the East-Roman troopers. Hence Alexius I. and his descendants enlisted as many Western mercenaries as they could get together. Nor was this all: the

15

Franks were not suited for light cavalry service, but the Turks, Patzinaks, and Cumans excelled in it. To supplement the Western spear the Comneni called in the Eastern bow. Thousands of horse-archers hired from the nomad tribes rode in their hosts. The native corps began to take quite a secondary place :[1] they felt it, and resented it. In proportion as they were despised, they grew less confident in themselves, less efficient, and less daring.

The Comneni achieved many splendid feats of arms at the head of their mercenary bands. They reconquered half Asia Minor from the Seljouks, subdued the Franks of Antioch, and routed the Magyars beyond the Danube. But they never built up a real national army. When the strong hand of Manuel was removed, and the wretched Angeli sat upon the Imperial throne (1185–1204), the military machinery of the empire went to wrack and ruin. The weak and thriftless emperors Isaac II. and Alexius III. were neither able to find money to pay their troops nor to maintain their discipline. A state which relies for its defence on foreign mercenaries is ruined when it allows them to grow disorderly and inefficient : in times of stress they mutiny instead of fighting. Such was the fate of the empire in 1204: when the Franks were actually breaking into the city, the defenders struck for higher pay and refused to charge. The city fell, and the old Byzantine military organisation passed away.

[1] There seems to have been some revival of local native forces during the existence of the empire of Nicæa (1204–61). We hear of militia in Bithynia under Lascaris and Vatatzes, and their disbandment by Michael Palaeologus is said to have been one of the causes of the successful advance of the Ottoman Turks (Pachymeres, i. 129).

BOOK V

THE CRUSADES
1097–1291.

CHAPTER I

INTRODUCTORY

BY the end of the eleventh century the supremacy of the mailed horseman was firmly established all over Western and Central Europe. In many countries infantry had practically disappeared as a force that counted for anything in the day of battle; in all it had ceased to be the more important arm. Only in nations of the remoter North and East—the Irish, Scandinavians, and Slavs — did it still preserve its ancient importance.

The three enemies who had threatened Christendom in the ninth and tenth centuries had now been beaten off. The Magyars had been pushed back to the line of the Leitha; they were now converted, and had become members of the commonwealth of Christian Europe. Instead of forming an impassable barrier between Germany and Constantinople, they now offered a free line of communication down the Danube. The Moors had been driven out of Sicily and Sardinia—instead of plaguing Italy with their inroads, they were now busy in defending their own African shore from the raids of the Genoese, Pisans, and Normans. It seemed for a time as if the last-named of these three maritime powers would actually effect a lodgment south of the Mediterranean.[1] In Spain, too, the balance had turned definitely in favour of the Christians; Toledo had fallen in 1085, and with its fall had ended the Moorish domination in the central parts of the Iberian peninsula.

Lastly, the third and most formidable of the enemies of Christendom had at last begun to slacken in their assaults.

[1] The landmarks in the history of the struggle of the Italians and the Moors are the expulsion of the latter from Sardinia in 1016 and from Sicily in 1060–91, the raids on Bona and El-Mahadieh in 1064 and 1087. The last Moorish attacks on Italy had only ceased early in the century, Pisa having been sacked in 1011.

Scandinavia was now converted; the fiercest of its Viking hordes had found new homes for themselves in England, Normandy, and Ireland, and were no longer seeking whom they might devour. Harold Hardrada's raid of 1066, the last of the great assaults of the Norsemen on their neighbours of the South, had ended in utter defeat and disaster. Sweyn the Dane, a few years later, had failed to make the least impression on the new Norman kingdom of England. The peoples of the North were just about to sink into the comparative obscurity which covers them during the later half of the Middle Ages.

Free from external dangers for the first time since the days of Charles the Great, the European nations were themselves able to think of taking the offensive. The two all-important data which governed their enterprises were, firstly, that a free land route down the Danube to the borders of the Byzantine Empire had become available since the conversion of the Magyars; secondly, that the Italian states of Venice, Genoa, and Pisa had lately developed war-navies strong enough to guarantee a free passage for expeditions aiming at the Levant. Down to the year 1000 the only naval powers in the Mediterranean had been the Byzantines and the Moslems. The whole face of affairs was changed by the appearance of the Italian republics as a third party in the strife for supremacy at sea.

Even before the preaching of the first Crusade there were signs that Western Christendom was about to bestir itself and take the offensive. The steady advance of the Germans against the Slavs of the East, the attacks of the Genoese and the Sicilian Normans on Africa, were signs of the coming movement. But no one could have foreseen the shape which the advance of the European nations was to take. Swayed by a sudden religious impulse, they threw themselves upon the Levant, and began the long struggle for the dominion of the Eastern Mediterranean which was not to end till the fall of Acre in 1291.[1]

With the causes of the Crusades we are not concerned, nor are their religious, social, or commercial aspects our province. It is with their military side alone that we have to deal—a

[1] In a way we might say that the last effects of the Crusades were not over till the Turks evicted the Venetians from Cyprus (1571), Crete (1669), and the Morea (1715).

subject sufficiently vast and varied to fill many volumes if we had space to descend into detail.

Stated broadly, the problem which was started in 1096, and lasted till 1291, was whether feudal Europe, with the military customs and organisation whose development we have been tracing, would prove strong enough to make a permanent lodgment in the East, or perchance to make good the whole of the ancient losses which Christendom had suffered at the hands of the Saracen and Turk from the days of Heraclius to those of Romanus Diogenes.

The state of the Moslem powers of the Levant in 1096 was on the whole favourable for the assailants who were about to throw themselves upon Syria and Asia Minor. It had seemed in the early days of the Turkish invasion, and soon after the fatal day of Manzikert, that a single great empire might establish itself in Western Asia under the house of Alp Arslan. But no such result had followed the conquests of the Seljouks. At the moment when the first Crusaders crossed the Bosphorus, the Sultanate of Roum had separated itself from the main body of the Turkish Empire, petty princes governed Aleppo, Antioch, Damascus, and Mesopotamia, and the Fatimite sovereigns of Egypt were still clinging to the southern parts of Palestine. The political situation was most favourable for the assailants ; a few years earlier they would have found their task far harder, and the heroic courage which habitually saved them from the consequences of their incredible lack of strategy and discipline might have failed to accomplish the conquest of Western Syria. Fighting against jealous and divided enemies, they only just succeeded in conquering Jerusalem and Antioch. Opposed by a single monarch wielding all the resources of Asia Minor and the Levant, they would probably have failed on the threshold, and never have seen the Taurus or the Orontes.

The first crusading armies displayed all the faults of the feudal host in their highest development. They were led by no single chief of a rank sufficient to command the obedience of his companions. Neither emperor nor king took the cross, and the crowd of counts and dukes, vassals of different suzerains, had no single leader to whom obedience was due. If a mediæval king found it a hard matter to rule his own feudal levies, and could never count on unquestioning obedience from his barons, what sort of discipline or subordination could be expected from a host drawn

together from all the ends of Europe? It is perhaps more astonishing that the Crusaders accomplished anything, than that they did not accomplish more than their actual achievements. When we realise the nature of the numerous and unruly council of war which directed the army that took Jerusalem, we are only surprised that it did not meet with more disasters and fewer successes. Yet this host was superior to most of the other crusading expeditions in the efficiency of its fighting men, the high character of its leaders, and the care that had been devoted to its organisation. To understand the general aspect of the crusading armies, we must remember all the unfortunate hordes that perished obscurely in the uplands of Asia Minor and left no trace behind.

CHAPTER II

THE GRAND STRATEGY OF THE CRUSADES

LOOKED at from the most general point of view, the Crusades, as a whole, may be said to have had two main objects. The first was to relieve the pressure of the Turks on Constantinople, which had been so dangerous ever since the day of Manzikert. The second was to conquer the Holy Land and restore its shrines to the custody of Christendom. Both of these purposes were to a certain extent accomplished: the Turkish frontier in Asia Minor was thrust back many scores of miles, and nearly two centuries elapsed before the Seljouk Sultans were able to recover their lost ground. Jerusalem was stormed, and for ninety years remained in the hands of the Franks. But these ends were achieved in the most wasteful manner, by the most blundering methods, and at the maximum cost of life and material.

One of the main causes of the disasters of all the crusading armies was a complete lack of geographical knowledge. A cursory glance at the itineraries of the various expeditions shows that the majority of them were chosen on the most unhappy principles, and were bound to lead those who adopted them into grave peril, if not to utter destruction. We must not blame the men of the eleventh and twelfth centuries overmuch for their errors: to a great extent they were inevitable in face of their utter want of geographical information concerning the countries of the Levant. Any misdirection was possible in days when the whole available stock of information in the West consisted of garbled fragments of the ancient Roman geographers, reinforced by a certain amount of oral information gathered from merchants and pilgrims. The Franks could hardly be expected to have any knowledge concerning the Eastern waters: the Byzantines and Saracens had for many centuries divided

233

the control of the seas beyond Sicily, and the navies of the
Italian republics were but just beginning to trespass on them:
beyond Constantinople there was no accurate knowledge avail-
able. The land routes were even more uncertain than those of
the sea. The road to the Bosphorus across Hungary and
Servia had only become practicable after the conversion of the
Magyars to Christianity (1000–61).[1] It had not yet been adopted
as a channel for commerce or a route for pilgrimages. Beyond .
Constantinople there was only such information to be obtained
as the Greeks could give. This information was not always
honestly purveyed : the Byzantine emperors had purposes of
their own to serve, and often sent the pilgrim hosts on itineraries
which suited themselves rather than those which were best
adapted for the purposes which the Franks had in view. We
need not believe the constant complaints of the Western
chroniclers that the Comneni deliberately guided the pilgrims to
destruction, out of jealousy and treachery. But Alexius and
Manuel, if not John, were quite capable of serving their own
ends by despatching the invaders of Asia Minor on routes which
were not the best available. When the Crusaders had gone on
their way and beaten off the Turks, the emperor followed behind,
somewhat after the manner of the jackal, and seized what he
could. The recovery of Lydia and Mysia was undoubtedly due
to the first Crusade, and that of Northern Phrygia and Galatia
to the Crusade of 1101.

 It is only fair, however, to notice that in the case where de-
liberate misdirection by the Greeks seems on the face of things
most probable, a deeper inquiry shows that the Crusaders them-
selves were to blame. When, in 1101, Raymond of Toulouse
and the Lombards marched by the incredibly round-about
way of Ancyra–Gangra–Amasia, we might have suspected that
Alexius had recommended it to them in order that he might
follow in their rear and reoccupy Galatia, as indeed he did.
But both Raymond d'Agiles on the side of the Franks, and
Anna Comnena on that of the Byzantines, assert that the un-
happy choice was made by the Crusaders themselves. Anna
adds that her father pointed out to them the madness of their
attempt to march on Bagdad through the mountains of Armenia,
and that they utterly refused to listen to him. It was not his

fault if, after recovering Ancyra for the empire, they were starved and harassed in the trackless lands beyond the Halys, so that only a few thousands of them finally struggled back to Sinope. It must also be remembered that the Byzantines themselves, though they had all the old Roman road-books, and elaborate data for the distances in their own lost "themes" in Asia Minor, were not able to give accurate information concerning the present condition of the land. The Turks had wrought so much damage in the last twenty years, burning towns, filling up cisterns, and extirpating the population of whole districts, that the old information concerning the interior had no longer its full value. Routes easy and practicable before 1070 were broken and desolate by 1097. The many perils which the Comneni suffered in their own campaigns in inner Asia Minor are sufficient proof that their information as to the land was no longer reliable.

It would be unfair, therefore, to attribute to wilful misdirection on the part of the Greeks the whole of the misadventures of the Crusaders in Asia Minor. The larger part of their troubles were of their own creation, and came from carelessness, presumption, improvidence, and selfishness. Even when put upon the right road, they were apt to go astray from blind conceit or want of discipline. This comes out most clearly from the fact that many crusading expeditions miscarried in Hungary or the Slavonic lands just to the south of the Danube, before they ever reached Constantinople. For an elaborate example of a wrong-headed choice of route, nothing can be more striking than that which Raymond of Toulouse and the Provençals selected in 1096. In all South-Eastern Europe there is no district more destitute of roads and more inhospitable than the Illyrian coast-line. But Raymond chose to march from Istria to Durazzo through the stony valleys and pathless hills of Dalmatia, Montenegro, and Northern Albania, among the wild Croats and Morlachians. It is surprising that he was able to bring half his following to Durazzo: he must have failed altogether had not his expedition been by far the best equipped and the most carefully provisioned of all those which set out for the first Crusade.

For the pilgrimage to Syria there were two great alternatives open—the land voyage by Constantinople and the sea voyage direct to the Levant. The latter was in every way preferable when once the sea routes had been surveyed. But at the time

of the first Crusade it was practically unknown: only the adventurous sailors of Venice, Pisa, and Genoa attempted it: the French, Burgundians, Provençals, Germans, and Lombards all preferred the longer road by Constantinople. Even in later times the landsmen's horror of the water drove a majority of the Crusaders to shun the voyage by sea: all the greater chiefs of the second Crusade, and Frederic Barbarossa among the leaders of the third, persisted in taking the land route. The first great expeditions made by sea by any save the Italian powers were those of Philip Augustus and Richard of England in 1190. But from that time onward the advantages of the direct voyage to Palestine seem to have been recognised, and all the later Crusaders preferred it. It was obviously better to arrive fresh and unwearied at Acre or Tyre, rather than to run the thousand risks from Hungarian, Greek, and Turk which threatened all who marched by land.

(A) THE LAND ROUTES THROUGH ASIA MINOR.

Since, however, the majority of the early Crusaders were unaware of the superiority of the sea route, and chose to make Constantinople their basis for the march on Jerusalem, we must begin by pointing out the strategical aspects of their undertaking. In 1097 almost the whole of Asia Minor was in the hands of the Seljouks: the Emperor Alexius held little more than Chalcedon, Nicomedia, the Mysian coast-region, and a few isolated towns on the Black Sea, like Sinope and Trebizond. The Turks were established on the Sea of Marmora: they had chosen Nicæa, only twenty-five miles from its shore, as their capital. All the inland plateau of Asia Minor was in their hands, and all the coast-line also, save the few Byzantine sea-ports and a patch or two in Cilicia, where Armenian mountain-chiefs maintained a precarious independence.

If Alexius Comnenus had been able to direct the crusading army at his own good pleasure, he would have used it to clear Bithynia, Lydia, and Phrygia of the Seljouks. If the Franks, on the other hand, had been entirely their own masters, they would have marched straight across Asia Minor to the Cilician gates, and made Antioch their first halting-place. But since neither party could disregard the wishes of the other, a kind of compromise was concluded: the Crusaders took Nicæa for Alexius, and then went on their way. The reduction of the

Turkish capital was of inestimable advantage to the emperor: Constantinople could breathe freely when the Seljouks were dislodged from the stronghold almost in sight of its walls which they had been holding for the last fifteen years. With this Alexius had to be content for the present. Murmuring bitterly that they had been restrained from plundering and occupying the city, the Crusaders moved forward into Phrygia. The route across Asia Minor which they adopted was, except in some small details, the right one. Their successors in later years would have been wise if they had always adhered to it.

The great peninsula consists of a high central plateau surrounded by a number of small coast-plains. For those who wish to march from west to east there is no good road either along the Euxine shore or the shore of the Sea of Cyprus. On the north the mountains of Paphlagonia and Pontus, on the south those of Lycia and Isauria, come down to the water's edge at many points, and cut the practicable route in so many places, that it is for all intents and purposes impassable for an army. No traveller in his senses would attempt to use the coast-roads. The inland roads, one of which he must choose, are practically three in number. Two of them suit those who start from Nicæa, the third those whose base is Sardis, Miletus, or Ephesus. This last was not available for the Crusaders of 1097; they had no wish to make the long detour along the Ægean, through Mysia and Lydia, which would have brought them to Sardis or any of the other suitable starting-points for the march to Philadelphia–Philomelium–Iconium–Tarsus. There remained for their choice the two other routes, one of which passes north, one south, of the great Salt Lake of Tatta (the Tuz Gol of the Turks) and the little-known region of the Axylon [1] which lies around it. The southern route is that which they chose:.it runs by Dorylæum, Philomelium, Iconium, and Heraclea-Cybistra to the Cilician gates.[2] The northern and the longer way leads to the same pass by

[1] Mr. Hogarth informs me that the Axylon does not deserve its well-known reputation for barrenness and desolation.

[2] Why Godfrey of Bouillon and the larger half of the crusading host diverged from the obvious route by Heraclea, the Cilician gates, and Tarsus, and only sent Baldwin and Tancred upon it, it is hard to discover. But they undoubtedly took the extraordinary and circuitous road by Nigdeh, Cæsarea-Mazaca, Coxon (Cucusus-Goeksun), and Marash, and suffered severely from privations in the Anti-Taurus while crossing the Doloman Dagh, between Coxon and Marash. Probably they were attracted by the friendly Armenian population of Eastern Cappadocia.

Eatiæum, Ancyra, Cæsarea-Mazaca, and Tyana. Both were good Roman roads, and had been kept in order by the Byzantines down to the disastrous year 1071. Now, however, the land lay desolate: bridges were broken, cisterns empty, and for many stages the whole population had been slain or driven off by the Seljouks. There were no insuperable natural obstacles on either road: the two perils to the Crusaders were starvation and the chance of being wearied out and brought to a stand from exhaustion by the incessant attacks of the Turkish horse-archers. More fortunate than any of their successors, the hosts of Godfrey and Bohemund opened their march by inflicting a crushing defeat on the enemy, who was so utterly awed that he held off, and did not venture to harass the marching columns for many weeks. They moved by Philomelium, Antioch-in-Pisidia, and Iconium, with no let or hindrance. It was not till they reached Heraclea-Cybistra that they again met the Turks in arms, and then they defeated them with ease. Though unmolested by the Seljouks, the Franks suffered dreadfully from want of stores and forage. This was unavoidable in a desolate land, for the Western armies of that age had no proper conception of commissariat arrangements: they depended mainly on the districts they passed through; and if the countryside was barren, they were bound to suffer. The trouble was made far worse by the long and useless train of non-combatants of both sexes which the crusading host dragged behind it. If they had endured many privations in Christian regions like Hungary and Bulgaria, it was obvious that the passage through Asia Minor was bound to be accompanied by terrible loss of life. Nevertheless, the greater part of the host struggled through, some to Marash, others to Tarsus, where they could rest and recruit themselves for a space among the friendly Armenian population of Cilicia.

On the whole, therefore, the passage of the first Crusaders through Asia Minor may be described as fairly successful when their difficulties are taken into consideration. Far otherwise was it with their successors of 1101. The miscellaneous bands under Sweyn the Norseman, Archbishop Anselm of Milan, William of Poictiers, Stephen of Blois, and Eudes of Burgundy, all fared far worse. Some were wholly destroyed, others were turned back with the loss of nine-tenths of their numbers; of the remainder a few stragglers only succeeded in pushing their way to Tarsus and Antioch. The causes of their disasters are sufficiently obvious:

they showed even less discipline than their predecessors, and they had formed a wholly erroneous conception of the easiness of their task from the comparative immunity enjoyed by Godfrey and Bohemund's army during its passage. They were so puffed up with the idea of their own invincibility that they declared their intention of " crossing the mountains of Paphlagonia and forcing their way into Khorassan, in order to besiege and take Bagdad."[1] It was in pursuit of this mad design that the majority of their host started off on the route Ancyra–Gangra– Amasia, which, if they had been able to pursue it to the end, could only have stranded them in the mountains of Armenia. After a terrible march among the highlands of Pontus,[2] where the foot-soldiery died by thousands of weariness and starvation, and the cavalry were almost entirely dismounted, the Lombards and Provençals were brought to a standstill by the army of Mohammed ibn Danishmend, Emir of Cappadocia, whose light troops hovered around them day after day, cutting off their stragglers and foraging parties. When the Turks thought the Crusaders sufficiently exhausted to fall an easy prey, they offered them battle at a place named Maresh (or Marsivan), somewhere in the neighbourhood of Amasia. The combat was indecisive, but on the following night Raymond of Toulouse, the man of greatest note in the host, fled away by stealth and deserted his comrades. Others hasted to follow his example, and, in the disorderly retreat which then set in, Danishmend cut the whole army to pieces, with the exception of a few thousands who succeeded in distancing their pursuers and finding shelter in the Greek fortress of Sinope.

Meanwhile, the smaller division of this band of Crusaders, who had refused to take the unwise route along the northern edge of the plateau of Asia Minor, had been reinforced by William Count of Nevers and a large band of French pilgrims. They then marched fifteen thousand strong[3] by the long but not irrational line of Ancyra–Iconium–Heraclea. All the way from Iconium to Heraclea they were encompassed by the hordes of Danishmend and Kilidj-Arslan, fresh from their victory over the Lombards at Maresh. Harassed incessantly, day and night,

[1] Albert of Aix, viii. p. 7. Cf. the identical statement in Anna Comnena, book xi. § 8.

[2] We get from Anna only the fact that they had crossed the Halys; the Frankish chroniclers thought they were still in " Flagania," *i.e.* Paphlagonia.

[3] Albert of Aix, viii. p. 29.

by the enemy, and suffering horribly from thirst, they were reduced to the most pitiable condition when they reached Heraclea and had the passes of the Taurus in sight. Then the Turks, fearing that their prey was about to escape them, closed in and offered battle. In a long straggling fight between the city and the foot of the Taurus the Christian army was gradually broken up and shot down in detail. Seven hundred knights, who at last abandoned their unhappy foot-soldiery [1] and took to the hills, got off in safety over one of the minor passes of the Taurus, and reached Germanicopolis in Cilicia, where they took shelter with the Byzantine garrison. William of Nevers himself finally reached the same spot with only six companions. The rest of the fifteen thousand Franks had been slain ; the Parthian tactics of the Turks had not been frustrated by any such happy chance as that which saved Bohemund and Robert of Normandy at Dorylæum. [2]

A very similar fate befell a large body of Aquitanian Crusaders, led by their duke, William of Poictiers, who had started shortly after the departure of the Count of Nevers from Constantinople. This host, a much larger one than either of those which preceded it, followed the same route as Godfrey and Bohemund had taken four years before. They had little trouble from the Turks till they reached Iconium, and were successful in taking and pillaging the towns of Philomelium and Salabria. [3] But at Iconium their provisions gave out, and they learned of the destruction of the army of the Count of Nevers. Nevertheless, they resolved to press forward, and soon found themselves beset by Kilidj-Arslan and Danishmend. Their immunity from attack hitherto had only been secured by the fact that the division of Nevers was eight days ahead of them, and had attracted all the attention of the Seljouks. The fifty-five miles between Iconium and Heraclea proved as fatal to the Aquitanians as it had been to their predecessors. The want of water was their ruin, [4] and when they approached the river near Heraclea they broke their order and pushed forward without any thought save that of slaking their thirst. Some were across the stream, some on its banks, some still straggling up from the rear, when the Turks closed in

[1] Albert of Aix, viii. 30.

[2] See the account of this battle on pp. 271–274.

[3] This place, not far from the great Tuz Gol lake, must have been taken by an expedition sent out from Iconium, as it does not lie on the itinerary Nicæa–Iconium.

[4] Robert the Monk, book iii., tells us how Godfrey of Bouillon avoided this danger by taking water with him.

from all sides and began pouring in their arrows.　The Crusaders were too scattered to form a line of battle or oppose any regular resistance.　After a certain amount of fighting, those who were not utterly surrounded, or who could cut their way through the enemy, turned their faces towards the Taurus, and fled as best they might.　Most of the leaders and a certain number of the mounted men were able to reach the hills, and straggled into Tarsus in small parties.　The wretched infantry, as was always the case in these unhappy battles of ɪɪoɪ, were wholly destroyed.

When the wrecks of the hosts of the Lombards, the Count of Nevers, and William of Poictiers, had finally gathered themselves together at Antioch in the spring of ɪɪoɪ, they only amounted to ten thousand men.　This small force marched along the Syrian coast and took Tortosa.　No other profit came to Christendom from the waste of three armies, which are said to have amounted at their setting forth to more than two hundred thousand men.　Their failure, as it is easy to see, came from three causes: in the case of the Lombards from an impossible itinerary; in that of the Counts of Nevers and Poictiers from their absolute ignorance of Turkish methods of warfare and their insufficient supply of provisions and water.　The route taken by the two counts was the best available, and no blame can be laid upon the chiefs for adopting it.　But they were almost doomed to failure from the first by the number of useless mouths which they took with them.　A heavy train and a multitude of non-combatants made the army slow, when speed was necessary to prevent the food running out and to cross the many waterless tracts.　Even, however, if the provisions had held out, and the armies had been in fair fighting trim, it is doubtful whether they would have succeeded in discomfiting the Seljouks.　None of the leaders had the least notion of the proper method of resisting the Turkish tactics.　They had no idea of using infantry and cavalry in combination, and wished to do all the work with their mounted men alone.　Hence they were bound to fail: only a steady infantry largely armed with missile weapons could have saved them, and such a force they did not possess.

We have still to consider three more great expeditions across Asia Minor—those of Louis of France and the Emperor Conrad in ɪɪ48–49, and that of Frederic Barbarossa in ɪɪ90.

Between the opening of the twelfth century and the second Crusade the political geography of Asia Minor had been pro-

16

foundly modified by the conquests of the Comneni. Profiting by
the blows which the Crusaders had dealt the Seljouks, Alexius
and John II. had thrust forward their frontier far inland, and
reoccupied the western third of Asia Minor. Their line of posts
ran far into Phrygia, passing by Dorylæum, Philadelphia, and
Laodicea. They had also recovered the whole southern coast of
the peninsula, as far as Cilicia. The Sultans of Roum, thus
pressed back into the interior, had made Iconium their capital
instead of the lost Nicæa. It was just possible to march from
Constantinople to Tarsus without leaving Christian soil, though
to use such a route entailed an intolerably long itinerary. A
chronicler of the second Crusade thus describes the situation,
showing a geographical knowledge very unusual in his class:[1]
" From the Bosphorus [or the Arm of St. George, as it was then
called] there are three roads to Antioch, unequal in length and dis-
similar in their merit. The left-hand road is the shortest : if there
were no obstacles in the way, it would take no more than three
weeks. After twelve marches it passes by Iconium, the Sultan's
residence, and five days after that it enters Cilicia, a Christian
land. A strong army, fortified by the faith and confident in its
numbers, might despise its obstacles ; but in winter the snows
which cover the mountains are very terrible." This is the old
route of the first Crusaders by Dorylæum, Iconium, Heraclea, and
the Cilician gates. "Secondly, there is the road most to the
right, which is better in some ways, as supplies are to be had
all along it. But those who use it are delayed by two things—the
long gulfs cutting up into the coast-line, and the innumerable
rivers and torrents to be crossed, all dangerous in winter, and as
bad as the Turks and the snows on the first route." By this road
Odo means the long, circuitous passage by Pergamus to Ephesus,
and thence along the Carian, Lycian, Pamphylian, and Isaurian
coasts to Seleucia. " The middle road," continues our chronicler,
" has less advantages and also less drawbacks than either of the
other two. It is longer and safer than the first, and shorter but
poorer and less safe than the second." The middle route of
Odo is the line by Pergamus, Philadelphia, Laodicea, Cibyra,
Attalia, and thence by the Cilician coast, to which Louis VII.
and the French Crusaders committed themselves in the winter
of 1148–49. The Emperor Conrad and the Germans took the
"left-hand road," i.e. the short and dangerous line through the

1 Odo of Deuil, book v.

midst of the Turkish territory, which passes by the gates of Iconium.

The fates of the two expeditions were not wholly dissimilar, though the Germans fared much worse than the French. Both failed more by their own mistakes than by the difficulties which lay in their way. Conrad started from Nicæa, with guides lent him by the Emperor Manuel Comnenus. He only took with him supplies for eight days, a wholly inadequate provision when we reflect that he had much more than two hundred miles to cover, and that he was forced to accommodate his pace to that of his baggage train. The Turks allowed him to advance into the heart of Phrygia without resistance; but when he was somewhere near Philomelium, and was still some seventy or eighty miles from Iconium, his food-stores were completely exhausted. His army was involved in the spurs of the Sultan Dagh, which cut across the road at this point: seeing themselves starving and in a desolate and difficult country, the Germans accused their guides of treachery. When threatened, the Greeks absconded, and apparently fled to the Turkish Sultan. Hearing of the bad state of Conrad's army, Masoud at once determined to close in and attack them. Then began one of those long running fights such as had ruined the pilgrim hosts of 1101 a stage or two farther to the east. The Germans, in spite of all the warnings of previous Crusades, had no provision of crossbowmen [1] to keep off the Turks, while their cavalry had so suffered for want of forage that those knights who still bestrode horses could hardly spur them to a trot. Conrad determined to turn back, and was pursued for many scores of miles by the Seljouks, who regularly cut off the devoted rearguards which he detached to cover his retreat, and gleaned thousands of starving stragglers every day. At last the harassed Germans reached Nicæa, and could once more obtain provisions; but their past sufferings had been so great that thirty thousand men are said to have died of dysentery, cold, and exhaustion after reaching the shores of the Propontis.[2] As a military machine the army was ruined; the greater part of the survivors drifted back to Germany, and the emperor took only a few thousand men by sea to Palestine out of the seventy thousand who had set out with him.

Louis of France, seeing that the greater part of Conrad's

[1] This is especially remarked upon by Odo of Deuil, book v. p. 343.
[2] Odo of Deuil, book v. p. 347.

disasters had come from want of food and forage, was confirmed
in his design of keeping as far as possible within the borders of
the Byzantine Empire, where supplies would be procurable.
Accordingly, he marched through Mysia and Lydia by Prusias
(Broussa), Pergamus, Smyrna, and Ephesus. He kept his
Christmas feast in the valley of the Cayster, a few miles from
Ephesus, and then proceeded to move up the Mæander towards
Laodicea. His cautious route had hitherto kept his army free
from all trouble, and, as he was still within Byzantine territory,
he reckoned on a quiet march. But the Turks, hearing of his
advance, had resolved to cross the border and attack him. Near
Antioch-on-Mæander they opposed the advance of the French
as they were fording the river, and at the same time attacked
them in flank and rear. But Louis' troops were fresh and in
good order, and a vigorous charge of the French knights swept
the Seljouks away ; they gave no trouble for some days, so that
the army arrived safely at Laodicea, the border town of the
Byzantine Empire. Here their troubles began. Louis had pro-
posed to fill up his stores at Laodicea before beginning the
difficult march through the mountains of Pisidia to Attalia.
This region, full of small towns in the old Roman days, had
been harried bare by the Seljouks. There was hardly an
inhabited village on the route, which turned out to be no less
than fifteen days in length, though the French had calculated
on taking a much shorter time to traverse it. But the governor
of Laodicea refused to sell any provisions to the Crusaders—
from treachery, according to the French chroniclers, but more
probably because he dared not exhaust his stores when the
Turks were known to be in the immediate neighbourhood.

It was accordingly with a very insufficient stock of food that
the French marched past Laodicea and started on their way by
the pass between the Baba Dagh and the Khonas Dagh which
leads up into the highlands. On the second day after leaving
Laodicea their disasters began. The army was marching with a
proper advance guard and rearguard, the baggage and non-com-
batants in the centre. The whole occupied many miles of route.
At the difficult pass of Kazik-Bel (three thousand eight hundred
feet above the sea level), the van, under Geoffrey de Rancogne and
Amadeus Count of Maurienne, the king's uncle, was ordered to
seize and hold the exits of the defile till the whole army had
passed. But, preferring to spend the day comfortably in the plain

of Themisonium (Kara - Eyuk - Bazar), the commanders of the advance guard descended from the heights and pushed on several miles to encamp in the valley. The Turks had been hiding near the mouth of the defile, and, when Geoffrey and Amadeus had passed on, burst out upon the unprotected train of beasts of burden and unarmed pilgrims who were struggling through the pass. Shooting down from the more elevated points on the helpless crowd, they wrought great slaughter, and precipitated many into the ravine which winds at the bottom of the pass. The king hurried up from the rear with a small body of his retainers, but, since he had not his crossbowmen with him,[1] he could make no reply to the arrow-shower from above. Presently the Turks came down upon the confused mass and attacked them at close quarters. Louis himself had to fight for some time alone, with his back against a rock, and owed his life to his swordsmanship. At last the tardy return of the advance guard took off some of the pressure, and when night fell the Turks drew off, and the whole of the French armament struggled down into the plain. They had lost most of their stores, thousands of horses, a great part of the unfortunate non-combatant pilgrims, and not a few knights of note.

It was generally agreed that the blame of the disaster rested upon the careless commanders of the van, and Geoffrey of Rancogne would have been hung but for the fact that Count Amadeus, who shared his responsibility, was the king's uncle. When the host was reassembled, Louis, with a prudence and self-restraint seldom shown by the crusading chiefs, declared that he would hand over the future conduct of the march to experienced hands. The Grand Master of the Templars, Everard des Barres, accompanied the host, and many veteran knights of the Order with him. The king consigned to them the regulation of the army, and a certain Templar named Gilbert marshalled it for the rest of the way to Attalia. They moved for the remaining twelve days of the march with a vanguard of mounted men, and rearguard of bowmen, strengthened by all the knights who had lost their horses. So successful was the new commander that four attacks of the Turks were beaten off with ease and considerable slaughter of the infidels. Even at the difficult passage of the two branches of the Indus (near Cibyra) the army suffered no harm, for Gilbert had the Turks

[1] Odo of Deuil, book vi. p. 363.

driven away from the strong positions flanking the ford before he would allow the army to cross.

But if the enemy did little harm with his arrows, the want of forage for the horses, and the gradual exhaustion of the insufficient stores which remained for the men, ruined the efficiency of the army. For the last week of their march the French were living almost entirely on horseflesh, and a few days more would have reduced them to absolute starvation. On arriving at Attalia, the king held a council of war and abandoned his intention of proceeding any farther by land. It was, as men said, forty days' march to Antioch if they followed the Cilician shore, and all through difficult roads like those they had already passed over. On the other hand, it was but three days by sea to Syria if the wind was fair. So, hiring ships from the Greeks, the king and his knights and nobles passed over to Antioch. The winds, as it chanced, were contrary, and the voyage took three weeks instead of three days, but all reached their goal in safety. It was otherwise with the unhappy infantry; there had not been ships enough to take more than a small proportion of them, and they remained behind for months under the walls of Attalia, starving after they had spent their last deniers in buying food from the Greeks at very exorbitant rates. At last some eight thousand of them, headed by a few knights, resolved that anything was better than longer waiting, and started off by the coast road to cut their way to Tarsus. They forced the passage of the Cestrus, but the Eurymedon, the next river along the coast, proved unfordable, and on its banks they were attacked and cut to pieces by the Turks. Of the survivors some entered the Greek service, others turned Moslems in despair, "for the Turks, cruel in their kindness, gave them bread and took from them the true faith"; the majority, however, died of disease or famine in the neighbourhood of Attalia.

It might have been thought that the fate of the armies of Conrad and Louis would have finally demonstrated that the land route to Syria was inferior to that by sea. Yet one more great expedition passed over the central plateau of Asia Minor, and (unlike its predecessors ever since 1101) succeeded in reaching its goal. This army, however, was commanded by an experienced soldier, and adopted all the precautions which had been neglected by the ordinary crusading hosts; yet even Frederic Barbarossa nearly failed from the force of hunger, though he

beat the Turkish hosts in every encounter. The great emperor
took in the first half of his march (March–April 1190) a route
not very unlike that which had been followed by Louis VII.,
keeping well inside the Byzantine border in Mysia and Lydia.
He passed by Philadelphia and Tripolis into the valley of the
Mæander, and reached Laodicea. But from this point he did
not turn south like the French king, but set his face due east,
and moved by the great Roman road which passed by Apamea
and the Pisidian Antioch to Iconium. This was the main artery
of the communications of the central plateau, and it is curious to
find that no other crusading army had tried it. The Turks
closed round Frederic and attacked him at the sources of the
Mæander, near Apamea, but were beaten off with great loss
(April 30). They returned to the charge in the passes of the
Borlu Dagh, near Sozopolis, but only to receive a second check
(May 2). By this time, however, famine, the most trusty ally of
the Turks, was beginning to make itself felt in the German host,
and the horses were dying in large numbers from lack of forage
—the enemy having burned the grass in all directions. On
reaching the lake of Egirdir the stores were running so low that
Frederic resolved to quit the direct but desolate route to
Iconium by Carallis, "the royal road on which the Emperor
Manuel Comnenus had been wont to march."[1] Swerving from
it, he crossed the Sultan Dagh by a difficult bridle path, and
came down into the fertile plain of Philomelium—thus falling
into the route which the first Crusaders under Godfrey and
Bohemund had taken. The Germans found some resources
here, but had at once to fight for their lives — the Turkish
armies, no longer pent up in the hills, were operating in one
of the great rolling plains, which best suited their tactics of
circumventing the enemy. For twelve days, from the 4th to
the 16th of May, the army was slowly forcing its way over the
seventy-five miles which separate Philomelium from Iconium.
They had to march in order of battle, with a front in every
direction and the impedimenta in the centre. The rear, the
point of greatest danger, was brought on by the Dukes of Suabia
and Meran and the Margrave of Baden, with a great force of
archers and a body of dismounted knights. There was always
danger lest the rear, facing about to defend itself from an attack,
should get separated from the main body, and so the Turks

[1] See the *Epistola de Morte Frederici*, p. 346.

might slip in between. On one occasion this did occur, and a vast amount of baggage was lost. . The knights themselves suffered little; "many were wounded, but few slain," for their coats of mail effectively kept out the Turkish arrows. But their horses, not yet armed in steel like those of later times, suffered terribly. By the 13th of May there were only six hundred effective chargers left, and the majority of the knights were serving on foot. Nevertheless, the Seljouks were always beaten off. Twice they ventured to close in, on May 6 and May 13, and on each occasion they were well punished for their audacity : in the first fight three hundred and seventy-four chiefs and emirs and six thousand horsemen fell before the weapons of the Germans. On May 16 the army reached Iconium, wearied and almost starving; there it got food and plunder from the summer palaces of the Sultan outside the walls. After resting themselves for a day, part of the host made a front against the Turks, while the remainder stormed the town with unexpected ease, and obtained such an ample store of food that the danger of starvation was at an end. "The place was as big as Cologne," and full of all manner of riches, which the Germans plundered at their leisure for five days. The Sultan Kilidj-Arslan[1] was now brought to such a depth of discouragement that he began to treat with the emperor. He promised the Germans a free road to Cilicia if they would depart at once, and gave twenty of his chief emirs as hostages. This was better fortune than any crusading army had experienced before, and the emperor accepted the terms. He marched, not by the usual route of Heraclea and the Cilician Gates, but by Laranda, Karaman and the pass which leads to Seleucia-by-the-sea. Here the army arrived, without having suffered any further molestation, save from an earthquake which inspired it with great fear. On the very day of his arrival at Seleucia, Frederic Barbarossa was, by the most unlucky of chances, drowned while bathing in the Calycadnus (June 10, 1190). His army, deprived of its leader, but now safe, "after six weeks of constant marching and starving,"[2] took its way through Christian territory to Antioch, where it arrived in safety.

Having now surveyed all the Christian invasions of Asia Minor, we can legitimately draw our general conclusions as to their characteristics.

[1] Not Malek Shah. See Boha-ed-din, p. 272. [2] *Ep. de Morte Frederici,* 350.

Our first deduction must be couched in the form of a testimonial to the very efficacious nature of the Seljouk methods of warfare. The Turks had deliberately established a broad belt of wasted and uninhabited territory between themselves and the Byzantine border. Moreover, when a Christian army passed through their dominions, they did not hesitate to destroy their own crops and sacrifice their villages. The cattle were driven into the hills, the corn burned, the very grass in the valleys fired. Consequently, every crusading host which crossed Asia Minor suffered horribly from famine. Of all the causes of failure this was the most obvious.

A thoroughly disciplined regular army, with an organised waggon-train, could no doubt have triumphed over this system by bearing its own food with it. But the Franks were a mixed multitude, with little or no organisation, always clogged in their progress by the hordes of non-combatants, largely paupers, whom they dragged with them. Against such foes the Turkish system was most efficacious. We may, indeed, express our wonder that Godfrey and Frederic Barbarossa struggled through in spite of all opposition. That the Crusaders of 1101 and 1148 failed is less a matter of surprise.

The second among the main causes of the disasters of the crusading armies was that ignorance of geography on which we have already had to dilate. When men could dream of finding their way to Bagdad and Khorassan through Paphlagonia and Pontus, or deliberately consider the advisability of adopting the route from Constantinople to Tarsus by the Carian, Lycian, and Cilician coast-line, they might meet with any kind of disappointment. Concerning this topic we need not enlarge—the history of the individual expeditions forms a sufficient commentary on it. We need only add that over and above mere want of geographical knowledge we must allow for the effect of minor ignorances—that, for example, of climate. The extreme heat and cold of the plateau of Asia Minor in summer and winter respectively was a fact for which the Crusaders made no allowance. What could have been more mad than for Louis VII. to choose the months of January and February for his excursion through the Pisidian mountains? The torrents were at their full, the winter rains were destructive of stores and tents, and the snow was lying on the higher slopes of the hills.

Third among the causes of the failures of the Crusaders we

must place their own want of providence, discipline, and self-control. Even the best-behaved of their armies were, by the confession of their own chroniclers, terribly addicted to riot and plunder. Their interminable quarrels with the Greeks mostly arose from their own fault. That there existed a very considerable jealousy and ill-will on the part of Byzantines no one can dispute, but the conduct of the pilgrims was so bad that we cannot wonder at the resentment they provoked. Their want of discipline was as well marked as their proneness to plunder: deliberate disobedience on the part of officers was as common as carelessness and recklessness on the part of the rank and file. This was always the case in feudal armies: in the East the fault was seen even more clearly than elsewhere. Most notable of all is the evident inability of the Franks to learn from the unhappy experiences of their predecessors. The thousands of veterans who drifted back from the East did not succeed in teaching their successors to observe the precautions appropriate to Turkish warfare. Fifty years after the first Crusade, Conrad III. and Louis VII. committed exactly the same mistakes as the contemporaries of Godfrey and Bohemund. They marched without caution; they did not properly combine infantry and cavalry; they had not provided themselves with the necessary proportion of men armed with missile weapons such as the bow and arbalest; their stock of food was always running short. It seemed that the art of learning by experience hardly existed in the military circles of the West. The description of the faults of the Frank as a soldier which Maurice wrote in 580, and Leo the Wise repeated in 900, might still be utilised almost word for word in describing the Crusaders of 1150.

(B) The Strategy of the Conquest of Syria.

The primary impulse of the men of the first Crusade was religious, not strategic. Their end was to recover Jerusalem, not to establish a sound military base for the ultimate conquest of the whole of Syria. There were those among the Frankish leaders who saw that it was dangerous to march from Antioch to Jerusalem, leaving hostile towns to right and left, and sacrificing the connection with their only base; but they were overruled by the majority, whose ruling desire was to get possession of the Holy Places. We must not, therefore, criticise the campaign of 1099 as if it had been carried out on logical military lines.

It was only when Jerusalem had fallen, and the Crusaders had determined to establish a permanent feudal state in Palestine, that strategical considerations came to the front.

When Godfrey was crowned, the new kingdom consisted of nothing more than the towns of Jerusalem and Jaffa. Whether Bohemund, isolated at Antioch, and Baldwin in his distant county of Edessa, would ever truly become the vassals of their theoretical suzerain was most uncertain. The future of the Franks in Syria was not settled for many years: indeed it was not till about 1125 that any general conclusions as to the new states could be formulated.

Before passing on to consider the military history of the conquest, it is necessary to understand the general strategical aspect of Syria. It may be divided into four narrow zones running from south to north, one behind the other. The first of these—the shore—consists of a series of coast-plains of very varying size and width ; they are cut off from each other by mountains running down to the water's edge, like Carmel, the spurs of Lebanon, and the "Black Mountains" by Antioch. Most of these level coast-tracts are narrow, but the southmost of them, the celebrated plain of Sharon, is larger than the rest, and averages fifteen miles in breadth. Occasionally, too, the coast-plain runs inland up a river valley, as in the plain of Esdraelon just north of Carmel, and in the valley of the Orontes near Antioch. In the central districts of the Syrian shore, however, about Tripoli and Beyrout, it is exceptionally narrow and much broken up.

The second zone of territory comprises the mountainous upland overhanging the coast-plain. This region consists of the spurs of three main chains—the mountains of the Ansariyeh (the Casius of the ancients) in the north, Lebanon in the centre, and the mountains of Ephraim and Judæa in the south. The two former are lofty ranges rising at some points to eleven thousand feet above the sea level; the last has a broader and less well-defined crest, and seldom rises to a greater height than three thousand feet. The spurs and shoulders of all these chains contain many fertile and populous tracts.

The third zone consists of the deep-sunk valleys of three great rivers—the Orontes, Leontes (Litany), and Jordan. The two former find their way to the sea—the first by a gap between the mountains of the Ansariyeh and the Black Mountains (Ahmar

Dagh), the second by a much narrower defile just north of Tyre. But the Jordan, whose course is mostly below the level of the Mediterranean, falls into the Dead Sea, a sheet of water with no exit. The Orontes and Leontes have broad and fertile valleys, while that of the Jordan is a narrow, precipitous, and marshy defile, only to be crossed at a limited number of points. The deep depression through Central Syria formed by these three streams and by the Dead Sea is continued yet farther south by the gorge of the Wady-el-Arabah, which runs down to the eastern head of the Red Sea, and to the port of Elath or Akabah.

Beyond the valley—"hollow Syria," as the ancients called it—is the high-lying eastern plateau,—in some places flat, in others mountainous. It runs into the Great Desert, and is itself barren in many parts. But it contains many fruitful and well-watered districts, such as those around the great cities of Aleppo and Damascus.

Syria as a whole is eminently defensible: the sea and desert cover it on three sides—the west, east, and south; on the north the Amanus and the Euphrates give an excellent and well-marked frontier. But the Crusaders never got possession of the whole country: they only held the coast, the greater part of the mountain, and certain regions of the central valley. The larger half of the latter and the whole of the eastern plateau remained unconquered. It was for this reason that the kingdom of Jerusalem was always in a precarious position. A chain of Mohammedan states always shut it out from expanding to the eastward and reaching its natural boundary.

The cause of this anomaly is not hard to find. The crusading states were never really strong enough to complete the conquest of Syria: they would not even have succeeded in subduing the whole of the coast if they had been forced to rely on their own resources and could have counted on no external aid. But the great Italian republics were deeply interested in the conquest of the Syrian shore. It was of high importance to their commerce that the whole of the ports of the Levant should be in Christian hands. Hence they co-operated with the greatest zeal in the sieges of the coast-cities: they and not the kings of Jerusalem were really the conquerors of the whole coast-plain. The Venetians were the real captors of Sidon (1110)[1] and Tyre (1124). The Pisans gave assistance to the Prince of Antioch at

[1] Largely aided by King Sigurd of Norway on this occasion.

Laodicea (1103) and to Count Bertram at Tripoli (1109); they were also present at the siege of Beyrout (1110). The Genoese were still more energetic: to them were due the falls of Caesarea (1101), Tortosa (1102), Acre (1104), Giblet (1109), Beyrout (1110). Casual aid was often given to the kings of Jerusalem by other crusading fleets, such as those of the Englishmen Harding and Godric, and the Norse king, Sigurd the Jerusalem-farer (1109–10). But it was mainly by the aid of the Italians that the Syrian coast became Christian.

Inland, the aid of these all-powerful allies was not available. . Their interests did not bid them equip armies to conquer Damascus or Aleppo. Hence it was with their own weak feudal levies alone, aided by occasional hosts of Western pilgrims, that the kings of Jerusalem and princes of Antioch carried on their wars with the emirs of the inland. The military resources of the Frankish states were more than modest: the largest army that they ever put into the field was one of thirteen hundred knights and fifteen thousand foot,[1] a number only obtained by collecting every available man and leaving the towns and castles almost ungarrisoned. Larger numbers were of course assembled when a crusading host from the West was present; but the help of the pilgrims was transient: they always returned home after a short sojourn in the Holy Land. As a rule, the domestic forces of the Syrian Franks seldom took the field more than six or seven thousand strong. Often, when the fate of the kingdom was at stake, the numbers of the royal host were still smaller. Baldwin I. had only two hundred and forty knights and nine hundred footmen at Jaffa in 1101 to face the whole force of Egypt. At Ramleh, when he had unwisely left his infantry behind, he actually gave battle with no more than three hundred knights as his whole army, and was utterly defeated. Some years later he considered seven hundred horse and four thousand foot enough to face the united forces of the emirs of Syria. But perhaps the most extraordinary of all the expeditions of the Syrian Franks was a raid into Egypt in 1118, in which no more than two hundred and sixteen knights and four hundred infantry took part. They advanced within three days' march of Cairo, and actually returned safely to Palestine.[2]

[1] To withstand Saladin's invasion of 1183. William of Tyre calls it the largest host he had ever heard of among the Franks of Syria (xxii. p. 448).

[2] Albert of Aix, xii. p. 205.

Want of numbers, then, was the real cause of the failure of the Franks to conquer inner Syria. That they ever succeeded in establishing themselves firmly on the coast, and in holding many districts of the mountain zone, must be attributed to the divisions of the Moslems. As long as the interior lands were divided between three or four independent emirs, the Crusaders not only held their own, but actually advanced their frontiers. Down to the rise of Zengi, the first prince who began to unite the emirates, the Franks were slowly but surely occupying the cities of the Infidel.[1] Nothing, indeed, could have been more opportune than the fact that, in the early years of the twelfth century, Damascus, Aleppo, Kayfa, Mosul, Mardin, were in the hands of different families, all bitterly jealous of each other, and sometimes even ready to ally themselves with the Christian if thereby they might do their neighbours an ill turn.[2] This fact it was which enabled a few hundred Frankish knights to ride roughshod over Syria for some twenty years, till in 1127 Zengi took up the governorship of Mosul. The interesting picture of the state of the land in this year given by the Moslem chronicler who wrote the history of the Atabegs[3] is well worth quoting.

" At the moment when Zengi appeared, the power of the Franks extended from Mardin and Scheikstan in Mesopotamia as far as El-Arish on the frontier of Egypt, and of all the provinces of Syria only Aleppo, Emesa, Hamah, and Damascus were still unconquered. Their bands raided as far as Amida in

[1] The dates of the changes of dynasty in the emirates are all-important for understanding the history of the Crusades. They are as follows :—

Aleppo. Held by the house of Tutush-ibn-Alp-Arslan, 1094-1117,
 Held by Il-Ghazi of Mardin and his nephew Soliman, 1117-1123.
 Held by Balak-ibn-Bahram, 1123-1125.
 By Il-Borsoki and his son Massoud, 1125-1128.
 Surrendered to Zengi, 1128.
Damascus. Held by Dukak the Seljouk, 1095-1103.
 Held by Toktagin and his house, 1103-1154.
 Surrendered to Nur-ed-din, son of Zengi, 1154.
Mosul. Held by Kerboga, 1096-1102; by Jekermish, 1102-1107; by
 Javaly, 1107-1108 ; by Maudud and his nephew Massoud, 1108-
 1113; by Il-Borsoki, 1113-1127. Taken over by Zengi, 1127.

[2] The strange battle of Tel-basher in 1108 is worth notice. Tancred of Antioch and Joscelin, Lord of Tel-basher, had quarrelled. So had Ridwan of Aleppo and Javaly of Mosul. Each allied himself with a stranger against his own co-religionist, and in the fight Frank fought with Frank, and Turk with Turk. Tancred and Ridwan were victorious. Albert of Aix and William of Tyre both allude to the story.

[3] The Turkish deputies or generals of the great Seljouk Sultan, who ruled as practically independent princes in Syria and Mesopotamia.

the province of Diarbekir, and in that of El-Jezireh [Upper Mesopotamia] as far as Nisibis and Ras-Ain. The Mussulmans of Rakkah and Haran [Carrhae] were exposed to their oppression and the victims. of their barbarous. violence. All the roads to Damascus except that which passes by Rahaba [Rehoboth] and the desert were infested; by their plundering parties. Merchants and travellers had to. hide among the rocks and the wilderness, or to trust themselves and their goods to the mercy of the Bedouins. Things were growing worse and worse— and the Christians had begun to impose a fixed blackmail on the surviving Moslem towns, which the latter paid to be quit of their devastations. . . . They took a regular tribute from all the territory of Aleppo as far as the mill outside the garden-gate— only twenty paces from the city itself. Then Almighty God, casting his eyes on the Mussulman emirs and noting the contempt into which the true faith had fallen, saw that these princes were too weak to undertake the defence of the true religion, and resolved to raise up against the Christians a man capable of punishing them and exacting a due vengeance for their crimes." [1]

At this moment, when the progress of the Franks was abruptly stopped by the rise of Zengi, we may pause to define the limits of their conquests. The kingdom of Jerusalem held all the coast from Beyrout to Ascalon. The latter town was still in the hands of the Fatimite princes of Egypt, and gave them a good base for invasions of the Holy Land by the route of El-Arish and Gaza. But the Egyptian dynasty was in a decaying condition, and its armies seldom crossed the desert. Indeed, Frankish raids on the Delta were more common than attacks pushed by the Moslems into Palestine. Eastward, the boundary of the Latin kingdom was the Jordan, save that the strong castle of Paneas (Banias), placed beyond the head waters of that river, gave it a watch-tower to observe Damascus. The realm had also another outpost towards the East and South. In 1116 Baldwin I. had resolved to push his frontier towards the Red Sea, so as to cut the great caravan route from Damascus to Egypt through the desert. He had executed the fatiguing march to the head of the Gulf of Akabah, and there had established the castle of Ailath (Elim-Elath) at its northernmost point (1117). This stronghold communicated with Palestine by means of two other castles, Montreal (Schobek) near Petra in

[1] Quoted in Michaud's *Bibliothèque des Croisades*, vol. iv. p. 61.

the centre of the Edomite desert, and Kerak in the land of Moab. The fief of Montreal-Kerak or of "the land beyond Jordan" was one of the four great baronies of the Latin kingdom. It formed such a dangerous outpost, and its position was so forbidding, lost as it was in the desert, that we are surprised to find that the Franks held it from 1116 till 1187, the year of the fall of Jerusalem.[1] As long as it survived, it made the communication between Damascus and Egypt very precarious: Moslem caravans had to pay blackmail to its lords, or suffer untold danger of starvation and misdirection in passing by stealth between the three fortresses in the wilderness. Military communication between the Fatimites and the rulers of Damascus was equally hard; armies marching through the sands and rocks of Idumea were always exposed to sudden attacks from these garrisons. They were such thorns in the side of Islam that repeated attempts were made to capture them, all of which failed—even when Saladin himself took the matter in hand. They only fell with the fall of the Latin kingdom, and Kerak actually held out longer than Jerusalem.

North of Kerak the frontier of the Franks was guarded by a chain of castles watching the defiles which lead down to the fords of the Jordan. The line was composed of Paneas, Beaufort, Chateau-Neuf, Safed, Castellet, and Beauvoir. South of the last-named, where the valley of the Jordan is most deep and rugged, there seems to have been a gap left, the natural defences being apparently too formidable to require strengthening.

Stretching along the coast from Beyrout northward lay the county of Tripoli, the weakest of the four crusading states. Its rulers never succeeded in pushing inland through the passes of Lebanon or getting a lodgment in Cœle-Syria. They only possessed the series of narrow coast-plains round the strong cities of Markab, Tortosa, Tripoli, and Giblet, together with the spurs of the mountains above and between them. The great chain of Lebanon, however, gave a strong frontier for defence. In commanding positions, watching the few practicable passes through the range, were the inland castles of Montferrand, Krak, and Akkar. Weak for offence, but strong for resistance, the county of Tripoli preserved its mountain boundary far into the thirteenth century.

[1] Kerak fell in 1188 only, but Elath had been recovered by the Moslems in 1170, and Reginald of Kerak had failed to retake it in 1183-84.

The principality of Antioch, on the other hand, had not such advantageous frontiers. Extending far up the valley of the Orontes, it had no natural obstacles to divide it from the Mohammedans of Aleppo. Hence the boundaries of Frank and Turk were always fluctuating. Sometimes the Christians held Athareb, a fortress close up to the walls of Aleppo: sometimes the Infidels were at the gates of Antioch. The strongly-fortified capital was the one solid centre of resistance which the Franks possessed in Northern Syria: Athareb, Harrenc, and the other fortresses to the east were always changing hands. But the splendid Byzantine walls of Antioch, which had held Godfrey and Bohemund at bay for so many months, were impregnable when held by a Christian garrison, and the city was never taken till 1268. All its Eastern dependencies had fallen many years before.

The county of Edessa may almost be called an Armenian rather than a Frankish state. The number of Crusaders who settled in it was small, and its sovereigns, unlike their neighbours farther south, depended mainly on their Armenian subjects to fill the ranks of their armies. It would have been a fortunate thing for the rulers of Antioch and Jerusalem if they too could have recruited their infantry from among the native Christian population. But the Syrians were a far less warlike race than the Armenians, and gave little or no military aid to their masters. From a strategical point of view it was no doubt a mistake for the Franks to push into Mesopotamia when North Syria was still unsubdued. Surrounded on three sides by the emirs of Mosul and Aleppo and the Danishmend princes of Eastern Cappadocia, Edessa was always in danger. The county consisted of a few strongly-fortified places—the capital, Turbessel, Ravendal, and Hazart, with an indeterminate and ever-varying territory around them. It had no natural boundaries, and, being so weak in military resources, was bound to fall whenever a strong prince should arise and unite against it the resources of the neighbouring Mohammedan districts. The rise of Zengi implied the disappearance of the county: it vanished after maintaining a precarious existence for less than fifty years.

It had survived so long merely because the rival dynasties at Aleppo, Mosul, Mardin, and Kayfa had never united to crush it. At best it was no more than a useful outwork to protect the flank of the principality of Antioch, an outwork so distant, so

17

weak and so exposed that there was no hope of permanently retaining it. Edessa would have fallen long before if it had not been repeatedly saved by the intervention of its neighbours to the south. Tancred and King Baldwin I. led armies from Antioch and Jerusalem to save it: without their aid it must have succumbed in 1110, or perhaps even in 1104. It would undoubtedly have been better for the general defence of Syria if the first conquerors of the land had seated themselves at Turbessel rather than at Edessa, and contented themselves with holding only the districts west of Euphrates: they might then have made the great river their boundary, and served as efficient guardians of the marches of North-Eastern Syria.

The extension of the Frankish dominion ceased immediately on the appearance of Zengi. The only important conquest made after the year 1127 was that of Ascalon, taken from the Fatimite Sultan of Egypt by Baldwin III. in 1153. Before the end of the long reign of the great Atabeg, the balance had begun to turn definitely in favour of the Moslems. The great mark of the change was the destruction of the northernmost crusading state, the county of Edessa, by Zengi's hand, in 1144. The union of Mesopotamia and Northern Syria under Zengi's rule completely checked the expansion of the Frankish dominion inland. There remained the three surviving Christian states—the kingdom of Jerusalem, the principality of Antioch, the county of Tripoli, forming a long straggling strip of territory along the coast, much cut up by mountains, and nowhere much more than fifty miles broad. They had no good land communications with each other, and depended for their union solely on the maritime predominance of the Italian republics.

One chance only of triumph remained to the Franks—the possibility of the arrival of a new crusading host from the West sufficient to enable them once more to take the offensive. It was obvious that the strength of the Latin states of Syria unassisted would not even suffice to preserve themselves. For one moment in 1149 it appeared as if this chance might come into realisation. Deeply stirred by the news of the fall of Edessa, the nations of the West sent out the great hosts of Conrad III. and Louis VII. on the second Crusade. Only the broken wrecks of these expeditions ever reached Palestine, but even these were numerous enough to encourage the King of

Jerusalem to make a bold push forward. The great campaign of 1149 was made upon the right lines, and a systematic attempt was made to break the long belt of Mussulman territory in its centre by the capture of Damascus. All other Christian attacks on that great city were mere raids: this was a deliberate advance, intended to bring about its permanent subjection.

If the great city had now fallen, the line of Mohammedan states would have been cut in two, Egypt would have been definitely severed from Aleppo and Mesopotamia, and the fatal combination of the northern and southern Moslems under Saladin could never have taken place. At all costs the Crusaders should have endeavoured to break the line which links Mosul, Aleppo, Emesa, Hamah, Damascus, and Bozrah with the road to Egypt. But so far were the Syrian Franks from appreciating the fact, that there is good authority, both Christian and Mohammedan, for stating that the king and barons of Jerusalem were very slack in pushing the attack on Damascus, just because it seemed more likely to profit their French and German auxiliaries than themselves. Anar, the Vizier of Damascus, is said to have sent secret letters to King Baldwin III. to point out to him that the capture of the place would perhaps benefit some of his fellow-Christians, but would do himself no good; on the other hand, the strong fortress of Paneas by the sources of the Jordan should be restored to him if the siege was raised. Anar swore also that if Baldwin would not consent to depart, he would deliver Damascus to their common enemy, Nur-ed-din of Aleppo, the son of Zengi, rather than let it cease to be part of Islam.[1] It is certain that the King of Jerusalem pressed the leaguer slackly, and at last departed homeward, to the great disgust of the emperor and the other pilgrim princes from the West. Thus ended the one serious attempt of the Franks to establish themselves in inner Syria and carry their frontier up to the desert.

The fact that Zengi's dominions were divided up among his sons (Nur-ed-din taking Syria and Seyf-ed-din Mesopotamia),— so that for a time the unity of command was lost, and the Franks obtained a respite,—did not lead to any permanent change in the fortunes of the crusading states. The King of Jerusalem turned

[1] See Ibn-Alathir on p. 96, vol. iv. of the *Bibl. des Croisades*. Cf. also William of Tyre, book xvii. pp. 14, 15, who says that the Count of Flanders was to be made prince of Damascus by the Westerns, which the Syrian Franks would not endure.

aside to make a series of attempts to conquer Egypt, when his
eyes should have been fixed on Damascus and Aleppo. The
danger at his gates should have engrossed his attention, and no
distant enterprise should have been undertaken till the frontiers
of the kingdom of Jerusalem were safe. Four great invasions
of Egypt took place between 1163 and 1168, and more than
once King Amaury seemed on the point of succeeding. By
adroitly taking part in the war between the Egyptian vizier
Shawir and Shirkuh, the general of the Syrian prince Nur-ed-
din, he obtained a free entry into Egypt, and occupied many
towns as the ally of Shawir. For a short time a Frankish
garrison actually held Cairo in the name of the Fatimite caliph,
and defended it against the Turks and Syrians of Shirkuh.
But Amaury's position in Egypt was always precarious, because
he had continually to be keeping an eye on his own realm in
Palestine, exposed in his absence to the raids of Nur-ed-din's
governors in Damascus and Cœle-Syria. It was bad strategy
to strike at the Nile while Jerusalem and Antioch still had an
enemy encamped only a few score miles from their gates. It
was the consciousness of the danger of his own realm that
always kept Amaury anxious and preoccupied during his
Egyptian campaign. He had always, so to speak, to "keep one
eye behind him": a demonstration on Jerusalem by Nur-ed-
din might bring him back from Cairo at any moment. This is
the true reason why he lost the fruits of successful campaigns, by
allowing himself to be bought off by great sums of money.
Hence it came that he levied great fines from Egypt, and for
several years received a regular tribute from Shawir, but never
made a firm lodgment in the land. At last, the most unhappy
contingency for the Franks came to pass. Shirkuh murdered
Shawir, and seized Egypt for his master Nur-ed-din (1169).
Syria and Egypt were at last united in the hands of a single
prince, for the Fatimite caliph did not long survive his vizier,
meeting, like him, a bloody end at the hands of Nur-ed-din's
lieutenants (1171).[1] Amaury made one last invasion of Egypt
after the fall of his ally Shawir, leaguing himself with the
Byzantine emperor, Manuel Comnenus. But the Greek fleet
and the Frankish army lay long before Damietta, and failed to

[1] So at least say the Frankish historians. Saladin's biographers either pass over
the event without details, or say that El-Adid died a natural death. See the
Mohammedan authorities quoted in the *Bibliothèque des Croisades*, iv. 147.

take it. Presently came the news that Nur-ed-din was in the field, and harrying the borders of the kingdom of Jerusalem. At once Amaury raised the siege and hurried home to protect his own dominions. For the future the Franks were never able to make another offensive move.

The union of Syria, Mesopotamia, and Egypt ought to have brought about the instant ruin of the kingdom of Jerusalem. That the state survived for nearly twenty years more was due to a lucky chance. Yussuf Salah-ed-din (Saladin), who succeeded his uncle Shirkuh as the lieutenant of Nur-ed-din in Egypt, proved a disloyal vassal, and did not combine his power effectively with that of his master. He did not openly break with the Syrian prince, but played his own game, and not that of his suzerain. Hence it was only when Nur-ed-din had died (1172) and Saladin had overrun and annexed the dominions of his late master's sons (1179–83), that all the Moslem states from the Tigris to the Nile were really united under a single ruler.

The day of doom for the kingdom of Jerusalem was now at hand. Saladin's realm surrounded the crusading states on all sides, and when he threw himself upon them their fall was sudden and disastrous. At the great battle of Tiberias (Hattin) in 1187, the Frankish host was exterminated ; Jerusalem fell in a few months, and after its fall fortress after fortress dropped into Saladin's hands, till little remained to the Crusaders save Tyre, Tripoli, and Antioch. That these small remnants of the Christian states escaped him was due to the third Crusade. Richard of England and Philip of France failed to retake Jerusalem, but they recovered Acre and most of the coast-towns of Palestine. Richard inflicted a crushing blow on Saladin at the battle of Arsouf (1191), and shortly after the Franks and Moslems came to an agreement, which saved for Christendom a wreck of the kingdom of Jerusalem. The inland was lost, but the long narrow coast-slip from Antioch to Jaffa was preserved. Saladin died shortly afterwards (1192), and his dominions broke up ; his sons and his brother El-Adel each kept a portion. This disruption of the Ayubite realm was the salvation of the Syrian Franks; their hold on the coast-region of the Levant was to endure for yet another hundred years. But the kingdom of Jerusalem (it might more appropriately have been called the kingdom of Acre) was now a mere survival without strength to recover itself. It might have been stamped out at any moment;

if a leader of genius had arisen among the Mohammedans and united again all the resources which had been in Saladin's hands. But the unending civil wars of the Ayubites gave a long lease of life to the decrepit Frankish realm. Strange as it may appear, the Christians were even able to recover the Holy City itself for a moment. Jerusalem was twice in their hands for a short space—once in 1229, when the Emperor Frederick II. got possession of it—once in 1244. On each occasion the reconquest was ephemeral—it marked the weakness of the Saracen, not the recovered strength of the Frank. But along the coast the thin line of ports was firmly held; strengthened by all the resources of the scientific combination of Eastern and Western fortification, they long proved impregnable. The sea was always open to bring them food and reinforcements; the Italian maritime powers were keenly interested in their survival for commercial reasons. Hence it was that the banner of the Cross still waved on every headland from Laodicea to Jaffa till the thirteenth century was far spent and the house of the Ayubites had vanished. The end of the kingdom of Jerusalem only drew near when the new and vigorous dynasty of the Bahri Mamelukes had once more united Egypt and Syria. Then at last came the doom of the Frankish realm, and one after another the ports of the Levant yielded before the arms of the great Sultans, Bibars, Kelaun, and Malik-el-Ashraf. Acre—the last surviving stronghold—fell after a two months' siege in May 1291. The only wonder is that it had survived so long; had Saladin's life been protracted for ten years, the end would have come nearly a century earlier. But in the thirteenth as in the twelfth century the dissensions of the Mohammedans were the salvation of the Franks.

As an example of the importance of the sea-power in the Middle Ages, we may note that the long survival of the coast fortresses of Syria would have been wholly impossible if any of the Eastern powers had possessed a competent navy. But the Genoese and Venetians completely dominated the waters of the Levant, and the Frankish ports could only be attacked on the land side. Even when they had fallen, the Mamelukes made no attempt to use them as the base for the creation of a war-navy. They sank to mere fishing villages when they fell back into Mohammedan hands, and never appeared again as military ports. Hence it came to pass that the insular kingdom of

Cyprus, the last foothold of the Franks in the Levant, endured for more than two centuries after the fall of Acre. It was only lost to Christendom when there arose at last a Moslem power, which built a great fleet and determined to expel the Italian galleys from the Levant. The Ottoman Turks overran the island in 1571, and then only did the maritime domination of the Franks in Eastern waters come to an end.

(C) THE ATTACKS ON EGYPT.

Before dismissing the subject of the grand strategy of the Crusades, we have still to deal with two[1] considerable diversions executed by the Franks outside the limits of Syria during the thirteenth century—diversions rendered possible by their complete possession of the command of the sea. We refer to the two invasions of Egypt in 1218–20 and 1249–50—those of John de Brienne and St. Louis. There was more to be said in favour of these expeditions than for those which King Amaury carried out in 1163–69. At the earlier date there was still a kingdom of Jerusalem which needed protection, and to take away its garrison for a campaign on the Nile was dangerous. Things were much changed in the thirteenth century: the kingdom had shrunk to a few coast-fortresses, which were, for the most part, self-sufficing, and could take care of themselves. Its defence, therefore, had become much more easy: if during the Egyptian expedition the governors of Damascus or Jerusalem should march on Acre or Tyre, the cities could be trusted to hold out for many months. They had the sea at their backs and could count on the aid of Venice and Genoa. Moreover, the attack on Egypt was to be made, not by the home levies of the barons of Palestine, but by great crusading forces from the West. Nothing, therefore, was risked in Palestine over and above the ordinary danger from the inland.

Egypt was a tempting prey—rich above other lands, peopled by an unwarlike race, and ruled by a monarch depending for his military resources not on his born subjects, but on mercenary bands of Turks, Kurds, Syrians, and Arabs. Egypt and Syria, too, were divided between different branches of the Ayubite

[1] The expedition of St. Louis to Tunis has no bearing on the general history of the Crusades, and was inspired by a religious, not a military object—it being supposed that the ruler of Tunis might be converted to Christianity.

house in 1219: El-Kamil reigned at Cairo, El-Muazzam at Damascus; and though they were not unfriendly to each other, yet two rulers can seldom combine their efforts to act like one. The conquest of Egypt, regarded as an enterprise wholly independent of the defence of Palestine, presented both in 1219 and in 1249 many attractions. A commander of genius might probably have accomplished it with the forces led by either John or Louis. It is more doubtful whether the land could have been held when once subdued; but, at least, the experiment was worth making.

But if the problem was not an impossible one, it was one which required to be solved according to the general rules of strategy. Egypt must always be "grasped by the throat" by a bold march on Cairo, and for a march on Cairo there are only two practicable routes. It is absolutely necessary to avoid getting entangled in the countless canals and waterways of the Delta. The first of the two alternative routes is to land near Alexandria, to keep west of the westernmost branch of the Nile, as did Bonaparte in 1798, and to march by Damanhour and Gizeh. The drawbacks of this route are that its first two or three stages are through desert, and that it brings the invader opposite to Cairo, with the Nile still interposed between him and his goal. The crossing of the main stream in face of the enemy, when the army has pushed so far inland, might prove very perilous. The second and far preferable route is to start near the ancient Pelusium and march by Salahieh and Belbeis on Cairo, keeping east of the easternmost branch of the Nile. This brings the invader directly on to the capital; he has no canals or waterways to cross, and the distance he has to cover is no more than a hundred miles. Here also the main difficulty to be faced is that the first two stages are through desert country. Egypt has always been invaded by this line; it was followed by Cambyses, Alexander the Great, Antiochus Epiphanes, Amru, and Selim I. Lord Wolseley only diverged from it in 1882 because he was able to utilise the Suez Canal, and so shorten his land march by forty miles. This route was well known to the Franks; Amaury had used it in 1168, taking Belbeis, and actually laying siege to Cairo, which he might have captured if he had not allowed himself to be bought off by an enormous war-indemnity. It is therefore most astonishing that both John de Brienne and St. Louis neglected this obvious and easy line, and chose instead to land at Damietta.

The road from that place to Cairo leads through the very midst of the Delta, over countless canals and four considerable branches of the Nile. Across it lie a dozen strong positions for the defending army. It is not too much to say that the invasion of Egypt by this line is bound to fail, if the masters of the country show ordinary vigour and intelligence. The fates of the two Frankish expeditions are a sufficient commentary on the wisdom of their leaders. John de Brienne only took Damietta after a siege of eight months; his troops were already much exhausted when he advanced into the Delta ; they were brought to a stand by the line of the Ashmoun Canal, behind which lay the army of the Sultan El-Kamil. They made several unsuccessful attempts to break through, and were already despairing of success when they learned that the land between them and their base at Damietta had been inundated; the Nile was rising, and the Egyptians had cut the dikes. They hastily retreated towards Damietta; but the waters were out everywhere, the Sultan followed hard behind them, and, to save themselves from starvation or drowning, the Crusaders had to come to terms. El-Kamil granted them a free departure, on condition that they should evacuate Damietta (August 1221).

Far worse was the fate of St. Louis when he tried the same route in 1249. Considering how John de Brienne had fared, we can only marvel that he ventured to choose the same road. He started with somewhat better fortune than his predecessor, for Damietta fell into his hands after a very slight engagement with the Moslems. But he then wasted no less than six months in waiting for stores and reinforcements ; all this time was employed by the Sultan in increasing his army and in preparing obstacles for the march of the French. When, in November 1249, King Louis did at last begin his advance, he was promptly checked by the same bar which had ruined John de Brienne, the impassable Ashmoun Canal, defended by the Egyptian army. Time after time the bridges and causeways which he strove to construct were swept away by the military machines of the enemy. At last Louis got across by night with his cavalry at a deep ford practicable only for horsemen; the infantry could not follow. The Egyptians were for a moment surprised, but the king's brother, Robert of Artois, threw away all chance of a victory by charging rashly into the streets of Mansourah with the van long ere the king and the main body had come upon

the field. He and the whole of his division were cut to pieces, and when Louis arrived he only succeeded in forcing his way to the neighbourhood of Mansourah at the cost of half his knights. At last, however, he worked his way to the bank opposite his own camp, and his infantry were able to finish the causeway at which they had long been labouring, and so to join him. The French thus obtained a lodgment beyond the Ashmoun, but the success had cost them so dear that they could advance no farther. They lingered near Mansourah for some months, unable to move forward and unwilling to turn back, till at last famine and pestilence broke out, and compelled them to abandon the invasion. But the Egyptians had broken the road between them and Damietta, and as they straggled northward they were cut to pieces in detail in a long running fight extending over several days. At last the king was surrounded and taken prisoner, and soon after the few surviving wrecks of the army laid down their arms. They could not even make terms for themselves, as John de Brienne had done in 1221, and the greater part of the captives were put to death in cold blood by the Egyptians.[1]

As a comment on King Louis' strategy we need only point out that, even if he had successfully forced the passage of the Ashmoun when he first reached it, he would yet have had to pass three broad branches of the Nile and numerous canals, all susceptible of easy defence, before reaching Cairo. Nothing but the entire want of geographical knowledge in those mapless days can explain the madness of the Crusaders in twice selecting the utterly impracticable route Damietta–Mansourah–Benha–Cairo, when it was open to them to use the easy and obvious road by Salahieh and Belbeis. Apparently they were attracted by the port and fortress of Damietta, which seemed to offer an excellent base and storehouse, while there was no town at all in the tract east of the ancient Pelusium, the proper starting-place for the descent. There was nothing else to account for the preference: one landing-place was as open as another to an armament in full command of the sea, and the coast east of Pelusium, though shallow inshore, does not present any real obstacle to the approach of vessels of such light draught as were those of the thirteenth century. A careful examination of the Government Survey maps of the Delta seems to show that east of Pelusium and its marshes there is a sandy shore, with sufficient

[1] For a more detailed account of Mansourah, see pp. 340–347.

depth of water for light vessels to get close in. The region is
so remote from the military centres of Egypt that no local
resistance need have been feared.

We may fairly say, therefore, that the two great invasions of
Egypt in the thirteenth century failed mainly because they were
undertaken with insufficient geographical knowledge, and con-
ducted along an impossible route. That they would have had
a fair chance of success if they had been more wisely directed,
is best shown by the fact that the Moslem historians one and all
assure us that their compatriots had completely lost heart after
the first successes of the Christians. In 1220 El-Kamil actually
offered to surrender Jerusalem, Tiberias, Giblet, Ascalon,
Nazareth, and Laodicea, if the Crusaders would but restore
Damietta and return home. In 1249 Damietta was evacuated
almost without the striking of a blow, and the army which
mustered behind the Ashmoun was in great disorder and deep
depression. If forced to fight not covered by a broad water-
course, but in the open country about Salahieh or Belbeis, it
would certainly not have held its ground.

It was the same utter want of geographical knowledge which
had ruined the Provençal Crusaders of 1101, and the French
host of Louis VII. in 1248, that brought to such disastrous ends
the two formidable expeditions which endeavoured to subdue
Egypt.

CHAPTER III

THE TACTICS OF THE CRUSADERS

*Section I.—The Early Battles and their Tactics: Dorylæum,
Antioch, Ascalon, Ramleh.*

THE Western countries which contributed the largest propor-
tion of warriors to the first Crusade were precisely those
in which cavalry were at the time most predominant—France
and Aquitaine, Lotharingia, Western Germany, and Italy both
Lombard and Norman. In each of the contingents which
marched out in 1096 to join the great host which mustered at
Constantinople, the horsemen were considered the main combat-
ant force. If foot-soldiery followed by tens of thousands, it was
not because their lords considered them an important part of
the line of battle, but because the same religious enthusiasm had
descended upon the poor as upon the rich, and all were equally
bent on seeking the path to the Holy Sepulchre. It was evident,
too, that infantry would be required for sieges, the service of the
camp, and the more onerous and less attractive labours of war.
So little, however, were they esteemed, that in the first general
engagement in which the grand army of the first Crusade engaged
—the battle of Dorylæum—the foot-soldiery were left behind by
the tents, and the horsemen alone drew up in the line of battle.[1]
Nor did the infantry even prove competent to keep the camp
safe—they did not prevent the flanking parties of the Turks
from entering it and massacring hundreds of the non-combatants
committed to their care.

The Crusaders then were accustomed only to one development
of tactics—the shock-tactics of heavily-armed cavalry. They
regarded infantry as fit—at best—to open a battle with a dis-

[1] See p. 271.

charge of missiles, before the serious fighting began, or to serve as a camp-guard.

Ranged to oppose them, however, they found enemies of whom the most formidable were the Turks, a race long accustomed to defeat by their Parthian tactics the most powerful and the best disciplined heavy cavalry of the day—that of the East-Roman Empire. The other Moslem powers who still employed the older methods of Saracen war, such as the Egyptian Fatimites, were far less dangerous to the Crusaders. They—like their predecessors described by Leo and Nicephorus Phocas—still depended on the impact of their mailed horsemen, who were individually inferior to the Byzantine trooper, and still more so to the Frankish knight. But the Turkish horse-archers were the foe who were destined to prove the main danger to the Crusaders, as they had long been to the emperors of Constantinople. It was they who were to teach not only the first invaders of the East, but every army that followed them, many a bitter lesson.

We have already recapitulated in an earlier chapter the canons which the masters of military science in the Byzantine Empire had drawn up for use in campaigns against the Turks. They were, put shortly, (1) always to take a steady and sufficient body of infantry into the field;[1] (2) to maintain an elaborate screen of vedettes and pickets round the army, so as to guard against surprises;[2] (3) to avoid fighting in broken ground where the enemy's dispositions could not be descried;[3] (4) to keep large reserves and flank-guards;[4] (5) to fight with the rear (and if possible the wings also) covered by natural obstacles, such as rivers, marshes, or cliffs, so as to foil the usual Turkish device of circular attacks on the wings or the camp-guard;[5] (6) always to fortify the camp; (7) never to pursue rashly and allow the infantry and cavalry to get separated after a first success.[6] With the necessity of all these precautions well understood, the Byzantines had yet suffered many disasters at the hands of the Turks. How was it to be expected that the Crusaders would fare, to whom some of these precautions would have seemed impossible, some ignominious, all unfamiliar? As a matter of fact, they knew nothing of them, since they utterly despised the Greeks and their methods of warfare, disdained to learn anything from them, and took

[1] Leo, *Tactica*, xviii. 63. [2] *Ibid.* 68. [3] *Ibid.* 64.
[4] *Ibid.* 71. [5] *Ibid.* 73. [6] *Ibid.* 74.

nothing but guides and money from the emperor.[1] In their first campaign they were as successful in violating every one of these rules as if they had committed them to memory for the express purpose of not carrying them out.

The hordes under Peter the Hermit and Walter the Penniless which first crossed the Bosphorus can hardly be called an army. Even in the eyes of their own countrymen they scarcely counted as a military force, since they comprised but a very few mounted men. When they were destroyed by the Seljouks near Nicæa, they are said to have numbered only five hundred horse to twenty-five thousand foot:[2] they had lost many thousands on the way by the hands of the Greeks and Bulgarians, but it is certain that in these earlier disasters the infantry had suffered infinitely more than the cavalry, so that the original force must have shown a still larger preponderance of men on foot.

The great army which started from Constantinople in May 1097 was a very different host. According to Western ideas, it was a most formidable instrument of war. Many rich counts and dukes and their well-equipped retainers served in its ranks. Its numbers are given as high as a hundred thousand horse and six hundred thousand foot—figures impossible in themselves, but showing a proportion between the two arms which was infinitely more suited to the practice of the day than that which had prevailed in the unfortunate horde of Walter the Penniless.

Yet this great host came very near to suffering a complete disaster in its first serious conflict with the Turks. After laying siege to Nicæa and repelling with success the attempts of Sultan Kilidj-Arslan-ibn-Soliman to relieve it, they forced the place to surrender. On June 27 they started forth to march into the interior of Asia Minor, following the great Roman road which leads by Dorylæum, Philomelium, and Iconium to Tarsus. The countryside was wholly desolate: "Romania, a land once rich and excellent in all the fruits of the earth, had been so cruelly ravaged by the Turks, that there were only small patches of cultivation to be seen at long intervals."[3] Food for man and horse was difficult to procure, and it was perhaps to cover a

[1] Save, indeed, Raymond of Toulouse, who borrowed some "Turcopoles," *i.e.* cavalry taught to act as horse-archers after the Turkish fashion, for his second expedition. But he got no use out of them, except to escort his flight (Albert of Aix, viii. p. 19).

[2] William of Tyre, book i.

[3] Fulcher of Chartres, chap. v.

greater space for foraging, and not out of mere carelessness,[1] that the army split into two columns, marching parallel to each other at a distance of some seven miles. The right-hand corps was composed of the followers of Godfrey of Bouillon, Raymond of Toulouse, Hugh Count of Vermandois, and most of the French and Lotharingian contingents. The left column included Bohemund and Tancred with the Sicilian Normans, Robert of Flanders, Robert of Normandy, and Stephen of Blois. They seem to have been fairly equal in size and composition.

Battle of Dorylæum, July 1, 1097.

After debouching from the Bithynian mountains, the Crusaders found themselves in a broad upland plain, watered by the Thymbres, a tributary of the Sangarius. It was a rolling country, destitute of strong positions, and very well suited to the peculiar tactics of the Turks. Flying parties of their light horse soon began to hover around the advancing columns, but the crusading leaders did not take the obvious precaution of drawing together, or at least arranging to keep in close touch. On sighting the enemy they merely contracted their straggling line of march and kept vedettes out to prevent a surprise. On June 30 they camped some miles on the north side of the Thymbres, and not very far from the ancient and ruined town of Dorylæum. On the 1st of July the left division, with which we are most concerned, moved forward to resume its route, and had marched for about an hour when its scouts reported the approach of the Turks in huge numbers. Bohemund, to whom the other chiefs had committed the general charge of the host, ordered the tents to be pitched and the baggage unladed by the side of a reedy marsh[2] which gave a certain amount of cover, and deployed his men in front of it. The infantry were left to guard the impedimenta,[3] the cavalry alone drew up in line of battle. The camp was not fully pitched, nor the squadrons completely ranged in order, when swarms of Turks suddenly appeared from all directions, pressing in on the flanks and rear of the army as well

[1] Fulcher (chap. v) says that the parting was accidental, owing to the divergence of one column at a cross-road, and the failure to get into touch again. Albert of Aix says that it was deliberate, and ordered for the reason stated above. William of Tyre says that it was uncertain whether it was accidental or not.

[2] "Juxta quoddam arudinetum" (Fulcher, v.).

[3] *Gesta Francorum*, 6: "Pedites prudenter et citius extendunt tentoria, milites eunt viriliter obviam iis [Turcis]."

as upon its front. The Sultan had gathered all his available forces, and, though too late to relieve Nicæa, trusted to avenge himself on its conquerors by a battle in the open field. The most distant Seljouk hordes of Asia Minor had now had time to join him, and his host was enormous—the Crusaders estimate it at from a hundred and fifty thousand to three hundred and fifty thousand strong. What struck the Franks with the greatest surprise was that every man was mounted: the whole horde was composed of horse-archers, and not a foot-soldier was visible.

In a few minutes the Crusaders found themselves enveloped. The Turks pressed in from all quarters at once; some appeared in the rear and cut to pieces many belated parties who had not reached the camp at the moment when the fight began;[1] others threatened the flanks; the majority advanced against the Frankish line of battle. But they were not drawn up in any regular array or order: in loose swarms they kept riding along the crusading line and discharging their flights of arrows into the masses of heavy-armed cavalry. There was no main body which the Franks could charge, and Bohemund, lest his men should fall into disorder, refrained from ordering a general advance, hoping that the enemy might ere long close with him. But they showed no intention of doing so, and fresh hordes were continually pressing up, emptying their quivers, and then sweeping off to the flanks. At last the Crusaders grew restless and angry: many bands from various parts of the line broke out and dashed to the front. But they could not reach the Turks, who rode off at their approach, overwhelming them with showers of arrows and slaying their horses by scores — the mail-clad men suffered much less than might have been expected. But when they turned to make their way back to the line, the enemy closed around them, cut off the stragglers, and destroyed many of the parties wholesale. Seeing the little profit that the sallies brought them, the Crusaders soon desisted from attempting to drive off the enemy, and contented themselves with closing their ranks and standing firm. But this passive policy only made them a more helpless prey to the Turks, whose arrows fell so thickly among the crowd that the line began to grow loose and disordered. This unequal combat, in which the Franks suffered heavy loss and the Turks little or none, went on for several hours. At last the host grew more and more unsteady,

[1] Raymond d'Agiles, i.

and, instinctively began to fall back towards the camp, the flanks
especially giving ground and closing in towards the centre, so
that the whole tended to become a clubbed mass instead of an
orderly line of battle. But there was no help in the camp ; while
the main battle was going on, many bands of Turks had assailed
it from the rear, and had broken in among the disorderly infantry
who had been charged with its defence. They were already
pillaging the tents and slaying the non-combatants,—priests,
servants, and women,—whose screams rose loud above the tumult
as the cavalry fell back towards the encampment. At the
approach of the horsemen the Turks in the rear stopped their
plundering and drew off, thinking that the Crusaders were re-
turning to drive them away. " But," as an eye-witness remarks,
" what they thought was a deliberate move on our part was really
involuntary, and the result of despair. For, crushed one against
another like sheep penned up in a fold, helpless and panic-stricken,
we were shut in by the Turks on every side, and had not the
courage to break out at any point. The air was filled with shouts
and screams, partly from the combatants, partly from the multi-
tude in the camp. Already we had lost all hope of saving our-
selves, and were owning our sins and commending ourselves to
God's mercy. Believing themselves at the point to die, many
men left the ranks and asked for absolution from the nearest
priest. It was to little purpose that our chiefs, Robert of
Normandy, Stephen of Blois, and Bohemund kept striving to beat
back the Infidels, and sometimes charged out against them. The
Turks had closed in, and were attacking us with the greatest
audacity." [1]

Everything portended an instant and terrible disaster, when
suddenly the face of the battle was changed in a moment.
Messengers had been sent off earlier in the day to seek the right-
hand column, whose exact position seems to have been unknown
to the leaders of the left-hand corps. They had at last found it,
encamped some six or seven miles away.[2] On receiving the news,
Duke Godfrey, Raymond of Toulouse, and the other chiefs armed
and mounted, and spurred off for the battlefield, with all the
horsemen of their host. They sent before them some swift riders
to warn Bohemund of their approach. The infantry remained be-
hind to guard the tents.

The Turkish Sultan seems to have altogether neglected to

[1] Fulcher, i. 5. [2] Albert of Aix.

18

reconnoitre the march of Godfrey's division, or, at any rate, had forgotten to pay any heed to its possible arrival on the field. The Crusaders, as they pushed on towards the fight, found no one in their way, and at last, topping the ridge which bounded the valley where the conflict was raging, saw the whole battle at their feet. They had, in the most fortunate manner, come in upon the left flank and rear of the Turkish host, which had now closed in upon Bohemund's camp and was contracted into a small space.

Godfrey saw that the most splendid opportunity for a sudden attack on the flank and rear of the Turks was in his hands, if he struck hard at once, before his arrival had been seen and provided against. Sending back orders to those behind to gallop in at full speed, he himself dashed at the Turks with the head of his column, fifty knights of his own following. The Sultan and his bodyguard were visible, stationed on a hillock behind the centre of the Turkish semicircle. Godfrey charged straight at them, and his impetuous assault from the rear seems to have been the first notice of the change in the battle that reached the enemy. The rest of the Crusaders of the right column came riding in at full speed behind him, each band crossing the ridge by the shortest cut it could find—Raymond of Toulouse on the left next the camp of Bohemund, the Count of Flanders to the centre behind Godfrey, the Bishop of Puy by a distant hillside and through a gap in the ridge which brought him to the rear of the Turkish centre.

The Infidels had no time to form a front, before they realised that a new army was in the field. Thousands of Christian horsemen were dashing in upon them, rolling up their left flank, and striking their centre from the rear. They hardly attempted to rally, though the Franks in their hasty deployment and hurried advance must have come in upon them in considerable disorder.[1] Struck by a simultaneous impulse of panic, the whole Turkish host swept off the field in wild rout : only the Sultan's bodyguard

[1] The ground over which the right column reached the field was mountainous (Baldric of Dol; Guibert of Nogent. See Delpech, ii. 153). I conclude, therefore, that they cannot have marched in line : they had started off in haste, and no doubt the rear must have straggled far behind the head of the column. As a sudden blow was absolutely necessary, there cannot have been any time for them to deploy into a regular order of battle. If Godfrey had waited to do so, the Turks would have got off. It seems certain, therefore, that each contingent came over the ridge at the point nearest and most convenient to itself, the Count of Toulouse far to the left, so as to join Bohemund and the left column in their final attack.

held out for a few minutes to allow their master to get a fair start in the flight. The victory was made more crushing by the fact that Bohemund's tired troops delivered a desperate charge the moment that their friends appeared in the rear of the enemy. Thus the Turkish left wing was caught between the two Christian hosts, and suffered severely ere it could get off.

The victorious Crusaders pursued the defeated foe with the greatest energy, prevented them from rallying, seized their richly stored camp, and finally scattered them to the winds. Kilidj-Arslan did not dare to offer battle again during the many weeks occupied in the march through the interior plateau of Asia Minor. The panic among his followers had been so great that they continued flying at full speed long after the victors had stayed their pursuit. When the Crusaders resumed their march, they found the roadside, for three days' journey from the field, strewn with the horses which the Turks had ridden to death in the wild flight, "although the Lord alone was now pursuing them."[1]

The losses on both sides had been less than might have been expected. The Turks had only suffered in the last ten minutes of the battle, when their left wing was caught between the two Christian divisions. The Franks of Godfrey's host had not suffered at all: those of Bohemund's column had been under the arrow-flight for five hours, but their armour helped them, and more horses than men had been slain. We need not be surprised to hear that the victors had lost only four thousand and the vanquished only three thousand men. Much the largest share of the Christian loss fell upon the wretched foot-soldiery, who had been massacred among the tents.[2]

Dorylæum can only be called a victory of chance. The Crusaders had deserved defeat by their careless march in two disconnected columns. How utterly unknown the locality of the two divisions was to each other is best shown by the fact that it took five hours[3] for Godfrey's succours to reach Bohemund, though there were only six or seven miles between them. Evidently the greater part of this time must have been wasted while Bohemund's messengers, sent off when the Turks

[1] Fulcher, i. 5. Raymond d'Agiles, 239.

[2] Figures taken from William of Tyre—a late authority, though a very capable one.

[3] Fulcher gives five or six hours as the duration of the engagement, and also remarks that the messengers reached Godfrey very late : (chap. v.).

first threatened an attack, were vainly searching for the right
column. A body of men numbered by tens of thousands, and
carrying with it an enormous train of baggage, is not a hard thing
to find, if only its general direction is known. We can but con-
clude, therefore, that the two divisions must have completely lost
touch with each other, and have marched quite at haphazard.

The left column would obviously have suffered a terrible
disaster if the succours had not appeared at the right time and
in the most effective position. The Franks were wholly unable
to cope with the unexpected form of the Turkish attack. They
made no attempt to use their infantry in conjunction with their
cavalry, either by setting those armed with missile weapons to
return the hostile showers of arrows, or by employing those
armed with long weapons—spears and the like—to serve as a
refuge and shield for the cavalry in the intervals between its
charges. Probably in their untrained state the foot-soldiers
would have been unable to discharge either function very
effectively—we have seen that they were not even able to defend
the camp. But for want of them Bohemund and his colleagues
condemned themselves to fight that most hopeless form of battle
in which cavalry endeavour to act on the defensive and to hold
a position. This course was almost as dangerous as the one
which they avoided—that of making a general charge with
unprotected flanks into the midst of the great circle of Turkish
horsemen. To wait and receive the enemy's shafts without
being able to reply to them could only retard disaster, and not
avert it. As a matter of fact, after five hours of endurance the
Franks had recoiled to their tents in a disorderly mass, and
were about to break up and suffer massacre when their comrades
came to their aid.

Undeserved as the victory had been, it yet gave the Crusaders
a free passage through Asia Minor. They were not again
obliged to fight a pitched battle till they had arrived at Antioch.
By the time that the siege of that place had been formed, the
condition of the army had greatly changed. The privations
which it had been forced to endure on its long march had fear-
fully thinned its ranks. The infantry had fallen by the way in
tens of thousands: the cavalry had lost the greater part of its
horses. For the Western chargers could not stand the heat,
and the forage provided for them was both insufficient in
quantity and different in form from that to which they were

accustomed. In the winter of 1097–98 there are said to have been less than a thousand left in the Christian camp fit for service. The whole army would have been dismounted if it had not been for one or two lucky captures which furnished them with a quantity of Syrian horses won from the enemy.

With the long siege—or rather blockade—of Antioch we have not much to do. The military machines of the Franks proved wholly unable to deal with the splendid walls of the city—a legacy from Justinian. For many months the Crusaders lay encamped in a secure triangular position between the Orontes and the city wall, blocking three of the gates on the east and north-east, but leaving free ingress and egress to the enemy through those which led to the north-west and north. At this rate the leaguer might have gone on for ever—the besieged only began to be inconvenienced when, five months after they had arrived before the place,[1] the Franks built a tower to command the western gate,[2] and a sort of tête-du-pont (if we may use the term in an unusual sense) to block the exit from the Bridge-Gate, where the city ran down to the bank of the Orontes. After this the Turks were straitened for supplies of food, and especially for forage for their horses, but they were not thoroughly enclosed, as they could still get in and out at nights by posterns, and never lost their communications with their friends without. Meanwhile, the Christians were suffering quite as much as their adversaries: they had drained the immediate neighbourhood of supplies, the parties which they sent out to plunder at a distance were repeatedly cut off by the Turks, and though they succeeded in getting in touch with the sea at the port of St. Simeon, where a Genoese flotilla had come to anchor, their communication with it was often interrupted and always hazardous. Famine reigned in the camp all through the winter and early spring, and men and horses died off like flies.

It was fortunate for the Franks that the two most serious engagements during the siege were fought in places where the Turkish methods of fighting could not easily be employed.

The first fight was the more important one. The emirs of Syria had gathered an army, variously estimated at from twelve thousand to twenty-eight thousand strong, to raise the siege, or

[1] The siege began October 21st. The new works were not begun till February.
[2] The gate of St. George.

at least to harass the besiegers. Hearing of its approach, the crusading chiefs determined to make a bold stroke at it before it closed in upon them. The Turkish force had met at the town of Harenc (Harim), sixteen miles east of Antioch. Their best way of communicating with the place was by advancing through the open ground north of the Orontes and the Crusaders' camp, and so coming in upon the Bridge-Gate. But this route had one dangerous defile upon it. About seven miles east of Antioch, there is a place where the great lake of Begras at its southern end approaches within a mile of the Orontes:[1] the road passes through this narrow neck of land. This was the point at which the Crusaders resolved to intercept the relieving army: the neighbourhood of their camp was now well known to them, and Bohemund had noted this spot not only as giving a narrow front where superior numbers would not avail, but also as affording opportunities for a surprise, for the approach was hilly, and there were many dips in the ground where a considerable force could lie hid.

The Franks could only put into the field seven hundred well-mounted men: their horses had fallen into such bad condition that only that number could be found fit to face a short night march and a battle to follow. With this small band Bohemund, to whom the command had been given for the day, marched out under cover of the darkness, and, " passing over seven valleys and seven ridges,"[2] took post close to the narrow neck between the lake and the river. At dawn the Turks were seen advancing, with a swarm of horse-archers thrown out in front to cover their main body. When the whole were in the defile, the Crusaders, having formed a line of five small squadrons, with a sixth in reserve, galloped in upon this vanguard. The Turks yielded after a smart skirmish, and fell back in disorder on their main body. If there had been room and time for the Infidels to deploy,[3] the Crusaders must have been crushed, but

[1] The distance was apparently much shorter in 1098 than now; probably the marshy southern end of the lake is drying up and receding.

[2] Raymond d'Agiles, p. 253.

[3] Raymond d'Agiles and William of Tyre agree on this. The latter says: " Comprimentibus eos locorum angustiis, hinc lacu inde fluvio licentiam evagandi inhibente ad consuetas discurrendi artes et sagittandi habilitatem discurrere non dabatur." William of Tyre, however, does not seem fully to have grasped the topography when he speaks of the Turks as having " crossed the river during the night at the upper bridge." There is no river between Harenc and the battle-spot. The only stream between the Bridge-Gate and Harenc is the Iferin (Labotas), the river which

the Turks were caught still massed, and with the lake and river close on each flank. The van was thrown in upon the rest of the host in helpless rout, the main body was so crushed and cramped in the confined ground that they could not scatter or outflank the Crusaders, and though they made some attempt to bear up against the charge, yet, when Bohemund and his reserve were thrown into the fight, they slackened in their resistance and strove to fly. But flight was not easy, with the waters so close on each side, and no less than two thousand horsemen were slain or drowned. The Franks pursued vigorously, and captured the town of Harenc and the whole of the enemy's baggage before nightfall (Feb. 8, 1098).

The second fight was of a still simpler description. The garrison made a sally in force from the Bridge-Gate, and crossed the Orontes to operate in the plain beyond it. Promptly attacked, with the river at their backs, they could neither deploy into their usual crescent-shaped formation, nor practise the alternate advances and retreats which formed the basis of their system of tactics. Crushed back against the water by vigorous charges, they were badly beaten, and in struggling back to the gate, which had been shut behind them by a foolish inspiration of the Emir Baghi-Sagan, they suffered heavily, and many hundreds were drowned or slain (March 1098).

Antioch fell by treachery on June 4, 1098.[1] It obviously could not have been taken by force, and that it could have been reduced by starvation is very improbable, as its communications with the open country were straitened rather than cut off. The very day of its fall the vanguard of a great relieving army appeared in the vicinity. Not only the nearer princes of Syria, but the more distant powers of Mesopotamia and Persia, had combined to rescue Baghi-Sagan from his assailants; their host was headed by Kerboga, the Emir of Mosul, and was reckoned at one hundred and fifty thousand or two hundred thousand strong. In a few days the newly-arrived army overran the

drains the lake, and this lies considerably to the Orontes west of the defile between the lake and the Orontes. Therefore the Crusaders passed it, but not the Turks. If the narrow neck had been west of where the Iferin falls into the main river, we might suppose that this was the stream which the Turks crossed. But the fact being the reverse, William must be wrong. Apparently he was making some confusion with the Iron Bridge over the Orontes six or seven miles east of the camp.

[1] For a description of the walls of Antioch, their topography, and the Crusaders' entry, see chap. vii. of Book VI.

plain of Antioch, and forced the Crusaders to keep within their old camp and the newly-captured city. The position of the Franks was dangerous, as the citadel was still holding out. Shems-ed-Dowleh, the son of Baghi-Sagan, and the wrecks of the garrison had sought refuge in it when the place fell. They had to be watched, and their sallies were only restrained by the erection of forts on the precipitous heights leading up to their place of vantage.

Battle of Antioch, June 28, 1098.

The position of the Crusaders, therefore, was hardly altered for the better. Though they had taken Antioch, they were themselves practically besieged by Kerboga. After waiting for more than three weeks, during which things went from bad to worse, and the famine which had made the winter so miserable broke out for a second time, the Frankish chiefs saw that they must fight or perish. They accordingly resolved to sally out from the city by the Bridge-Gate and attack the Turks, whose main body lay encamped in the plain to the north of the Orontes. On this occasion they resolved to combine horse and foot in their line of battle. It was absolutely necessary to make the experiment: when the mounted men had dwindled to a very few thousands,[1] they could no longer suffice to cope with the vast army of Kerboga. There were many hundreds of knights of approved valour who had lost their chargers, and it would have been absurd to leave them out of the fight. If they marched on foot, they would serve to give confidence and steadiness to the untrained and untrustworthy infantry.[2] The infusion of mailed men of approved courage and high rank would naturally diminish the tendency to panic and disorder which made the Western foot-soldiery of that day so helpless before the enemy. Accordingly, the greatest care was taken to bring the infantry into fighting trim : it was divided into small bodies placed under competent leaders, and in all probability sorted according to the character of the arms it bore. We hear most about the archers and arbalesters, though there must have been thousands who were not armed with these missile weapons. But for fighting

[1] William of Tyre's number of one thousand and fifty is incredibly small. We know that on one occasion and another the Crusaders had captured more than two thousand chargers from the enemy.

[2] Albert of Aix, iv.

enemies like the Turks, who placed their whole confidence in their arrows, troops armed with long-range weapons would be especially valuable. We have already had occasion to remark more than once that the foot-archer is the most efficient check on the horse-archer, because he can carry a larger weapon with a longer range. Probably Western archery, save in some few districts, was not very efficient, yet it would still be of much avail against the Turk. Of course, however, it was not by the arrow that the crusading chiefs intended to win. The infantry were to be mere auxiliaries in the fight, and the charge of the mailed horsemen was to deal the decisive blow. The battle order was to consist of lines of infantry with small bodies of cavalry in the rear of each, the former to open the fight, the latter to end it.

On Monday, June 28, the army was drawn up in the streets of Antioch, corps by corps, with the van lying just inside the Bridge-Gate, and ready to sally out when the signal should be given. It is most difficult to make out the exact disposition of the various divisions; various chroniclers give almost every number between four and thirteen for them. Of the two really good authorities, Raymond d'Agiles and the Gesta Francorum, the first gives eight, the second six.[1] But Raymond adds the curious statement that "the princes had arranged eight corps, but when we had got outside the city, with every man able to bear arms put into the ranks, we found there were five more corps, so that we fought with thirteen instead of the original eight."[2] Comparing the elaborate list of names in each division which two or three of the chroniclers give, we find that there is little or no dispute about the first four and the last two of the corps, but that in the middle of the line we have a difficulty in reckoning the bodies formed by the Burgundian, South-French, and Provençal contingents. In these parts of the army, which were led by Godfrey of Bouillon and Adhemar, Bishop of Puy, some reckon only two large masses, some four, some as many as seven smaller ones. The general result of our investigation seems to be that though the original intention had been to compose the centre of two corps of Lorrainers and Burgundians, and

[1] Fulcher of Chartres gives four, the Gesta six (as also many chroniclers who copy the Gesta), Anselm of Ribeaumont and Orderic Vitalis seven, Raymond eight, (or thirteen), Gilo nine, Albert of Aix and William of Tyre twelve.

[2] Raymond d'Agiles, p. 287.

the left of two corps of Aquitanians and Provençals, yet on getting into the plain these two grand divisions were re-formed respectively into three and four brigades. If we can trust Raymond d'Agiles, it was an inspiration of the moment, caused by the fact that the numbers of these contingents had been underrated in the council of war which drew up the order of battle.[1]

Summing up our authorities, we may conclude that the probable order was as follows :—(1) North-French, under Hugh, brother of the King of France ; (2) Flemings, under their Count Robert ; (3) Normans, under Robert, son of William the Conqueror. These three divisions formed the right wing, and headed the column. The next to issue from the gate were the contingents (4) (5) (6), three corps of Lorrainers, Burgundians, and Mid-French, under the general command of Duke Godfrey—the other two bodies in this division seem to have been under Reginald Count of Toul, and Hugh Count of St. Pol. The whole was destined to form the centre in the fight. Next were (7) (8) (9) (10) four corps of Provençals, Aquitanians, and West-French, under the general command of Bishop Adhemar, the three other leaders in this wing (the left) being Raimbaud Count of Orange, Isoard Count of Die, and Count Conan the Breton.[2] Finally, (11) Tancred and Gaston de Béarn, with Apulians and Gascons ; and (12) Bohemund, with the main body of the Normans of Italy and Sicily. The last-named corps was to form a reserve division behind the others, and to guard the rear when all should have defiled over the bridge and into the plain.[3]

The only useful notice which we have concerning the number of men in each division is Albert of Aix's statement that Duke Godfrey's own corps consisted of no more than two thousand men, horse and foot all told. Albert grossly exaggerates the weakness of the Franks in all his account. But Godfrey's corps may have been smaller than the rest—we are told at least that

[1] The original design, according to Raymond, was to make four grand divisions —(1) North-French, Flemings, and Normans ; (2) Lorrainers and Burgundians ; (3) Aquitanians and Provençals ; (4) Sicilian and Apulian Normans (Raymond, p. 283). Each grand division was composed of "duo ordines duplices," *i.e.* two corps in two lines, one of foot and one of horsemen. So there were to be eight corps in all.

[2] Raymond of Toulouse should have shared the command of this wing with the bishop, but was left behind in Antioch to observe the citadel with two hundred knights. He was too sick to ride that day.

[3] All this array is given *with reservations* ; there may be, and probably are, faults in it. But the divergences of the chroniclers only allow us to give probabilities.

PLATE VII

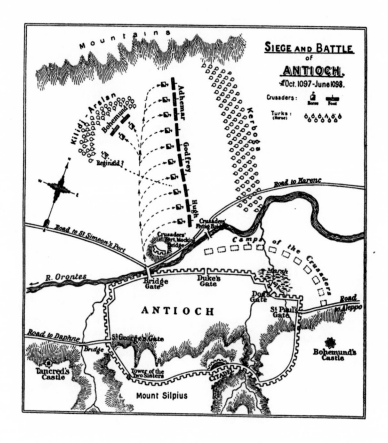

Bohemund's corps was much larger,[1] Yet it would be hazardous to put the full force of the army which marched out at more than from twenty-five thousand to thirty thousand men, of which one tenth, perhaps, may have been mounted. We know that the divisions in the front line covered, when deployed, a front of over two miles. Allowing for intervals between the corps, this would require twenty-one thousand foot-soldiers six deep; the formation is not likely to have been thinner than that depth, as the infantry were known to be unsteady, and could not have been trusted to stand firm if arrayed only in three or four ranks. Adding a few thousands more for Bohemund's corps and the cavalry, we may reach thirty thousand altogether.

Kerboga's camp lay to the north-east of Antioch, under the hills which rise abruptly two miles beyond the Orontes. The Crusaders were resolved to march straight upon it, after crossing the bridge and deploying into line. Thus their front would lie east-north-east, with the Orontes close to their right flank and the hills close to their left. It was arranged that as each corps passed the bridge it should deploy in order on the plain beyond, the van halting immediately that it had crossed and forming close to the river, the centre prolonging the line northward, and the left (which would have far the longest space to march) reaching to the foot of the hills. The danger of this plan lay in the possibility that Kerboga might let one or two corps pass, and then fall upon them while the rest were struggling out of the gate and on to the bridge. If he had done so, the fate of the Crusaders might have been like that of Earl Warrenne's army at Cambuskenneth,[2]—the van might have been battered to pieces before the main body could force its way to the front. But the Emir preferred to let the whole Christian army march out into the plain, where he hoped to have room to outflank and surround them in the usual Turkish fashion.[3] " The farther they come out the more they will be in our power " are said to have been his words.[4]

[1] Albert of Aix, iv. 47. But Albert much overstates the misery of the Crusaders, says that many knights rode to battle on asses, and that there were only two hundred horses in the army. He was not an eye-witness, and his informants exaggerated grossly.

[2] See chap. i. of Book VII.

[3] Albert of Aix, not an eye-witness, and William of Tyre, writing a century later, say that Kerboga sent out a corps of archers to hold the ground just across the bridge, and prevent the Franks deploying. No good authority mentions such a move.

[4] *Gesta Francorum*, xxix. 3.

It was only when corps after corps came pouring over the bridge, and it became evident that the Christians were far more numerous than he had supposed, and might when drawn up fill the whole breadth of the plain, and prevent any turning movement, that Kerboga roused himself and put his army in motion. Apparently, the divisions of Hugh, the two Roberts, and Godfrey were already in line, and that of Bishop Adhemar was beginning to take ground to their left, when the Emir endeavoured to throw his right wing across the level ground at the foot of the hill where the remaining Christian corps were intending to draw up. Fifteen thousand horse, filing along the foot of the hills, succeeded in getting round the flank of the Crusaders and placing themselves perpendicularly to the still incomplete left wing. These are said to have been the Turks of Kilidj-Arslan of Roum, and Ridwan of Aleppo.[1] The corps of Bishop Adhemar and the three which followed it had the greatest difficulty in fighting their way into line with the centre and right.[2] But they succeeded in doing so, and thereby cut the army of Kerboga in two, the detached corps under the Sultan of Roum becoming completely separated from the main force.[3] Hence the battle consisted of two independent fights—one between the main Christian army and the Turkish centre and left, the other between the detached right wing of the Infidels and the Christian reserve under Bohemund. For the latter prince, seeing the fatal consequences which might ensue if Kilidj-Arslan attacked Godfrey and Adhemar in the rear, hurried forward and deployed[4] his corps facing westward, with their backs to the main body. His position must have been parallel with the divisions of Adhemar and Godfrey, *i.e.* behind the left centre of the main army. Godfrey, according to some of our sources, hastily sent the corps of Reginald of Toul to assist in keeping off the attack from the rear.

In the main battle the Crusaders won a complete victory

[1] But this we have only from two secondary chroniclers, William of Tyre and his authority, Albert of Aix.

[2] Raymond d'Agiles, p. 286 : "We had to strive hard in the space at the foot of the hills, as the enemy was trying to envelop us, and had their largest corps in front of us."

[3] "Denique divisi sunt Turci : una pars ivit contra mare ; alii steterunt contra nos."

[4] Ralph of Caen compares the Christian army so arrayed to the snake of the fable which had a head at each end, or to a monster with two faces, and specially mentions that Bohemund "turned his back to his friends, and his face to his enemies" (pp. 169, 170).

with astonishing ease. Kerboga was a bad general, and his colleagues, the Emirs of Damascus and Aleppo, were mistrustful of him and of each other. Moslem historians tell us that at the moment of action a great body of Turcoman auxiliaries, with whom Ridwan of Aleppo had been tampering, treacherously took to flight and threw the whole line into confusion. It is certain, at any rate, that when the Christian armies advanced in steady line, with archers in front and knights behind, the Turks retired from their first station towards their camp. There they again made a front, but there was no further chance of putting their usual tactics into play, since the Franks filled the whole plain from the river to the hills, and could not be outflanked. Their first retreat had some semblance of order, but when pressed again the Infidels broke up more and more, and finally fled at full speed, the cowardly Kerboga at their head. They made off by the road between the Orontes and the lake of Antioch, abandoning their camp and the masses of unfortunate camp-followers to the sword of the Franks. " No man of rank fell," says Kemal-ed-din, " but there was a horrid slaughter of our foot auxiliaries, grooms, and servants." [1]

The combat in the rear had been much more serious. The Turks of Roum and Aleppo fell with fury upon Bohemund's corps, where the infantry threw themselves into a dense circle and did their best to hold firm. They were in great danger, exposed to the Turkish arrows and attacked at intervals by parties who abandoned their usual tactics and charged in with the sword. The corps of Reginald of Toul when it came up was also assailed with great vigour, and suffered heavy loss: according to some authorities, nearly the whole of its infantry was cut to pieces. But presently the Turks saw their own main army flying, and knew that the battle was lost. Apparently, too, the victorious Crusaders detached more troops to help Bohemund. Firing the grass to cover their retreat,[2] the Infidels made off westwards towards the sea, and left the corps of Bohemund and Reginald maltreated, but still holding firm. The diversion had utterly failed because of the cowardly conduct of Kerboga and the main army.

[1] See the quotations from Kemal-ed-din, Abulfeda, and Abulfarag in Michaud's *Bibliothèque des Croisades*, iv. 9.

[2] We need not believe the unlikely story about the smoke signals concerted between Kerboga and his lieutenants.

The battle of Antioch filled both Frank and Turk with wonder. The Christians marvelled at their own victory: with inferior numbers and men debilitated by famine and the heat of the Eastern sun, they had swept the Infidels before them in a single desperate charge. They attributed their success wholly to supernatural causes: the Holy Lance borne before Bishop Adhemar, they said, had turned the enemy to flight, and the hosts of heaven, headed by St. George and St. Demetrius, had been seen co-operating in the victory, "clothed in white, riding on white horses, and bearing white banners before them." The Moslems attributed the victory, of the few over the many, the famished over the well-nurtured, to the inscrutable will of Heaven, desiring to chastise the emirs for their sins.

To those in search of more earthly explanations the meaning of the fight is obvious enough. The Turks had fought once more in a space too confined for their usual tactics: the right wing of the Franks rested on the river, and could not be turned. Their left wing, the point in real danger, broke through the hordes sent to surround it and got in touch with the hills. When both flanks were protected, they had only to execute a straightforward charge, and the Turks must choose between the hand-to-hand combat, which they always disliked, and flight. They chose the latter alternative, and the day was won. If the rear had not been guarded by Bohemund and Reginald of Toul, a disaster might well have occurred; but while the attack on the rear was held in check, the main Turkish army could do nothing.

The lessons of Dorylæum and Antioch should have remained fixed deep in the minds of both Christian and Moslem, but we shall see that only the keenest minds on each side suspected the meaning. Both parties for the next hundred years frequently repeated their original blunders—the Turks that of fighting in cramped ground, the Franks that of failing to combine horse and foot in due proportions.

Battle of Ascalon, August 14, 1099.

There was no general engagement of importance beside the battle of Antioch during the conquest of Syria. The rest of the history of the year 1098–99 consists of a series of sieges, with which we shall have to deal when treating of the siegecraft of the early Crusaders. It was not till August 1099 that another battle in the open field was fought, and this time the enemy was not the

Turk, but the Fatimite ruler of Egypt, El-Mustali Abul-Kasim Ahmed. The Egyptians had been in possession of Palestine at the moment of the arrival of the Crusaders, and it was from them that Jerusalem had been wrested. Shortly after it had fallen (August 1099), El-Mustali sent his general, El-Afdal, with a large army to drive off the Crusaders and recover the Holy City. The forces of El-Afdal were unlike those with which the Crusaders had hitherto had to contend. They resembled the old Saracen armies with which the Byzantines had so often fought: there were many thousand infantry, all black Soudanese, armed with bows and iron maces (or flails); while the cavalry consisted partly of Moorish and Bedouin light horse, partly of mailed troopers of the Caliph's regular army. All of these were spearmen, and not archers like the Turks. Having long been at war with the Turkish princes of Syria, El-Mustali had no help to expect from them. But there seem to have been a few mercenaries of Turkish blood in his ranks. The whole army is estimated at the usual vague figure of three hundred thousand by the crusading writers. It may possibly have reached in reality some fifty thousand or sixty thousand in all.[1]

The Franks marched out from Jerusalem on August 13, with five thousand horse and fifteen thousand foot.[2] The knights, it will be observed, were all remounted since their victorious march through Syria, having found Arab horses for themselves to replace their lost chargers. Hence the proportion of cavalry to infantry is far larger than it had been at Antioch. When they arrived in the neighbourhood of the enemy, they feared to be surprised and surrounded on the march, and formed the army in nine small corps, each composed of foot and horse. These corps marched three abreast, so that whether attacked in front, rear, or flank there would always be three divisions to face the shock, three to sustain them, and three more in reserve.[3] So far, however, were they from suffering from any such danger, that they themselves surprised and captured the flocks and herds of El-Afdal's army, which were grazing, under the guard of three hundred men, in a valley some miles north of Ascalon.

[1] The Moslem Ibn-Giouzi says no more than twenty thousand. This is probably an understatement. Perhaps it only includes the Caliph's regular troops.

[2] So say the Princes in their letter to the Pope. The usually trustworthy Raymond gives the number as twelve hundred knights and nine thousand foot only.

[3] Raymond of Agiles, p. 388.

The fugitives soon brought the news to the Egyptian vizier, who prepared to fight next morning. He took up his position on the shore north of the town of Ascalon, with his left wing resting on the sea and his right on the hills, which here run some two miles inland from the water. In his rear was the town with its orchards and plantations, and the camp pitched outside the Jerusalem gate. He placed his Soudanese archers in the front line, his regular cavalry behind them. On the right a corps of Bedouins were to endeavour to encircle the enemy's flank: on the left the sea rendered any such attempt impossible.

On August 14 the Crusaders came in sight, marching down the sandy plain between the water and the hills, which gradually broadens as it approaches Ascalon. When they came into the neighbourhood of the Egyptians, they proceeded to deploy into line from the order of march in nine columns which they had hitherto kept. Apparently the front three columns, under Robert of Normandy, halted, while the second line, under Raymond of Toulouse, took ground to their right next the sea, and the rear line, under Godfrey of Bouillon, filed off to the left and took post towards the hills.[1] The whole nine corps thus came up into a single line, and no reserve was left behind: in each corps the infantry were formed in front, the cavalry to the rear.

When the two armies were within bowshot, the Soudanese opened fire on the Crusaders, "falling on one knee to shoot, according to the custom."[2] At the same time the whole Saracen army struck up a horrible din of trumpets and nakers to daunt the Christians, and the Bedouin squadrons rode out to the right to encircle the left flank of the enemy. The opening of the fight by the Infidels is described by one good authority as resembling "a stag lowering his head and extending his horns so as to encircle the aggressor with them ;"[3] but there can have been no attempt to do this on the western flank, where the sea was too close to allow of any such manœuvre.

The turning movement was easily stopped by Duke Godfrey, who charged with his knights and easily rode down the light-

[1] This deployment seems certain from the words of the *Gesta Francorum*, xxxix., which say that Raymond fought on the right, Godfrey on the left, and all the others *between* them: it names Robert of Normandy, Tancred, and Robert of Flanders as among those who commanded in the centre, but says that "alii omnes" were there also.

[2] Albert of Aix, vi. [3] Fulcher of Chartres, xix.

PLATE VIII.

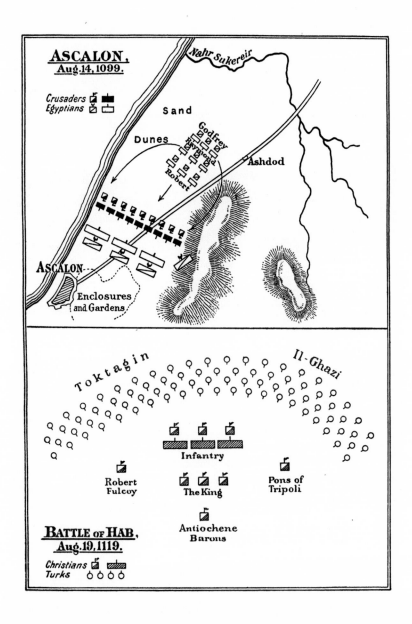

ASCALON,
Aug. 14, 1099.

Crusaders
Egyptians

Nahr Sukereir

Sand

Dunes

Godfrey

Robert

Ashdod

ASCALON

Enclosures
and Gardens

Toktagin

Il-Ghazi

Infantry

Robert
Fulcoy

The King

Pons of
Tripoli

Antiochene
Barons

BATTLE OF HAB,
Aug. 19, 1119.

Christians
Turks

armed Arabs. At the same time, a general advance was made all along the line, the Christian cavalry charging before the Soudanese had time to discharge their bows more than once.[1] In every quarter the Egyptian foot were rolled back on to their horse, and the whole army fell at once into complete confusion. They seem to have made a very poor resistance, and the Crusaders penetrated everywhere through their line. Robert of Normandy slew the vizier's banner-bearer, Tancred charged right into the Moslem camp, Raymond of Toulouse hurled the hostile left wing into the sea. Some of the Egyptians got into the town, others fled away to the south, some even swam out to their fleet, which lay moored off the shore. But thousands were slain on the field, many more crushed to death as they tried to force their way in at the crowded gates, and a considerable number were drowned. For some hours after the fight ended, the Crusaders were hunting down fugitives who had concealed themselves in the orchards or even climbed up trees to hide in their tops.[2] They captured the hostile camp with vast spoils, and narrowly escaped slaying or taking the Emir El-Afdal. The victory was a far more crushing one than either Antioch or Dorylæum, for the enemy had not so good an opportunity of getting off, and suffered much more severely. His wretched infantry were completely cut to pieces.

Obviously the Egyptians were an enemy to be treated far more unceremoniously than the Turks. They tried to face the heavy cavalry of the Crusaders with less efficient horsemen, armed only with the spear, and their infantry were in no wise superior to that of the Franks. Hence in an open field they were sure to be beaten, even though their numbers were largely superior, as undisciplined Asiatic armies have usually been when they meet Europeans under competent leaders. The Crusaders came to hold the Egyptians in such contempt that they neglected the most common precautions against them, and would attack them if they were but one to ten, and even in most unfavourable ground. This rashness was chastised a few years later at the battle of Ramleh, where King Baldwin suffered heavily at the hands of the despised foe.

[1] Albert of Aix, who was not an eye-witness, gives an unintelligible account of the fight : I follow the *Gesta*, checked by Fulcher and Raymond.

[2] This is mentioned by the Arab chronicler Ibn-Ghiouzi as well as by several of the Christian writers, *e.g.* Albert of Aix.

Battles of Ramleh, September 7, 1101, and May, 1102.

It had taken the Vizier El-Afdal two years to recover from the shock which the defeat of Ascalon had imprinted on his mind. But in the autumn of 1101 he sent out a new army to invade Palestine: Ascalon, still in Egyptian hands, served as a base for the operation of the host. Baldwin I. had now succeeded his brother Godfrey, who had only worn the crown of Jerusalem for a year. His little kingdom consisted of nothing more than his capital and the three seaports of Jaffa, Arsouf, and Caesarea: the last two he had only just subdued by the aid of a Genoese fleet in the summer of 1101. Baldwin all his life through was a rash and reckless leader, one of the typical Frankish generals on whom the Byzantine authors pour so much scorn. The Egyptian troops were not so strong as they had been at Ascalon, but still very numerous: Fulcher of Chartres estimates them at eleven thousand horse and twenty-one thousand foot;[1] the Moslem chroniclers state that they were led by the Emir Saad - ed - Dowleh. Baldwin, however, resolved to march against them with the scanty force that he could collect in Jerusalem at a few days' notice. He would not wait for outlying parties of his own followers, much less sit still for weeks while reinforcements should be summoned from Antioch or Edessa. The Egyptians having moved out from Ascalon, Baldwin left Jerusalem and marched down to Jaffa on September 5. The Egyptians did not come to meet him there, but pushed in between the king and his capital, marching to Ramleh—a point equidistant from Jerusalem and Jaffa. Thither Baldwin followed them with two hundred knights, sixty sergeants, hastily mounted on borrowed horses to swell the number of his cavalry, and nine hundred infantry. He divided this little army into six corps, each containing both horse and foot, and marched recklessly into the midst of the Egyptian host, who had been warned of his approach, and had formed up with a front far out-flanking the Crusaders on both wings. Baldwin and his little band plunged in among them "like fowlers into the midst of a covey of birds." Of the exact order of the Franks we have no further particulars than the vague statement of Fulcher, that they were "arrayed according to the rules of military art." Even the simple critics of the twelfth century, however, were

[1] Fulcher, chap. xxvi.

ready to grant that Baldwin's attack was made with a rash
disregard of possible dangers.[1]

It seems that when the lines were a thousand paces apart [2]
the knights put spurs to their horses and, leaving the foot-soldiery
behind, dashed at the Egyptians. Only Baldwin himself, with
one of the six corps of cavalry,—forty or fifty riders at the most,
—remained in the rear with the infantry. When the Christians
charged, the Egyptian host folded in its wings and fell upon
the Crusaders on all sides, attacking the infantry no less than
the horse. The two right squadrons of the knights were taken in
flank,[3] and completely rolled up, so that hardly a man escaped.
The other three were swallowed up among the multitude of the
Infidels, and seemed likely to succumb also, when Baldwin and
his small reserve of horsemen dashed into the thickest of the
fight and gave the necessary impulse to the surging mass. The
Egyptian centre broke and fled, and presently their victorious
left wing also quitted the field. While the battle was being settled
by the cavalry fighting, the infantry in rear had been beset on
all sides by the horsemen at the extreme wings of the Egyptian
host. They were very roughly handled, so that Fulcher acknow-
ledges that "while the Christians were victors in front, they
came off the worst in the rear." If Baldwin's victory had been
delayed a few minutes, the infantry would probably have been
entirely broken up and cut to pieces. As it was, the success had
been so dubious that a body of five hundred Arabs from the
victorious left wing of the Egyptians had ridden up to the walls
of Jaffa, displaying the shields and helms of the crusading
knights whom they had slain, and had shouted to the garrison
that Baldwin and all his host had perished. These troops were
returning, ignorant of the rout of their main body, when they
rode by accident into the midst of the Christians and were
mostly cut down.

The losses in Baldwin's army were very heavy. Eighty
knights had fallen—a third of the whole cavalry: no doubt they
nearly all belonged to the two squadrons which had perished at
the opening of the battle.[4] A much larger number of the

[1] "Minus caute," says Ekkehard in his *Hierosolymita*. [2] Ekkehard.

[3] Ekkehard says that one squadron only was cut to pieces by a flank attack;
Fulcher (a better witness) that two were destroyed. Albert of Aix, exaggerating
fearfully, makes four perish, and says that the king won the battle with his own forty
knights alone.

[4] Fulcher, p. 125.

infantry had also been cut down. The loss of the Egyptians is put as high as fifteen thousand men—an impossible figure; they probably did not suffer much more than their adversaries. The Moslem historians give no details, but allow that their chief Saad-ed-Dowleh was left on the field—killed by a fall from his horse, as had been prophesied to him long before by an astrologer.[1] The whole fight had only occupied a short hour.[2]

After having been within an ace of destruction in September 1101, it is astonishing to find that Baldwin repeated his reckless tactics in an aggravated form on the very same battlefield, only eight months after.[3] In May 1102 the Egyptians once more broke forth from Ascalon, and marched on Ramleh, where they pitched their camp. Baldwin set out against them with his military household, without waiting for any reinforcements from the outlying towns of his little kingdom. He picked up at Jaffa a band of pilgrim knights, survivors of the unfortunate Crusade of 1101, who were just embarking to return to France: they were led by Stephen of Blois and Stephen Count Palatine of Burgundy. This gave him no more than two hundred lances; nevertheless, he marched straight on Ramleh, believing (it is said) that the enemy were only a raiding party some eight hundred or a thousand strong:[4] as a matter of fact they were a whole army, about as large as that which had been beaten on the same spot in the previous year.[5] "It was pride and presumption that led the king," says Fulcher, "not to wait for more troops, not to move to the battle in proper military order, not to listen to any warning, not to wait for his foot-soldiery, and not to stop in his march until he saw before him, and far closer than he wished, such a huge multitude of the enemy." With no more than his two hundred knights Baldwin rode straight at the hostile centre, hoping to repeat his exploit of the previous year. But the odds were too great, and this time he had no infantry with him to protect his rear and take off some of the pressure. The Franks were engulfed in the hostile mass, and slain off almost to a man. Baldwin and a few more cut their way out of the mêlée, but the

[1] See the chronicle quoted on p. 17 of vol. iv. of the *Bibliothèque des Croisades.*
[2] Fulcher.
[3] In all that follows I have taken Fulcher as guide, not Albert of Aix, who varies hopelessly from Fulcher's tale, and was not, like the former, on the spot.
[4] Fulcher, chap. xxvii. p. 135.
[5] *Ibid.*: "Twenty thousand horse and ten thousand foot, the latter all Soudanese."—numbers grossly exaggerated, we need not doubt.

Counts of Blois, Burgundy, and Vendôme, and more than a
hundred and fifty knights, were left dead on the field. It was
possible to despise too much even an Egyptian army, and the
king had to learn that headlong courage of the most desperate
kind is not enough to compensate for a disparity of numbers in
the proportion of a hundred to one.

After several narrow escapes, Baldwin reached Arsouf, and
from thence sailed to Jaffa in the galley of Godric, an English
adventurer. There he received reinforcements which would have
reached him in time for the battle if he had only consented to
wait a few days—eighty knights from Galilee under Hugh of
St. Omer, ninety from Jerusalem, and a considerable body of
infantry. Some weeks later there arrived a great pilgrim fleet
of two hundred sail from England and Germany, under Harding
the Englishman, and the Westphalians Otto and Hademuth.
The crews landed armed, and with their aid Baldwin felt strong
enough to march out of Jaffa to face the Egyptians once more
in the open field. This time he had learned his lesson, and
combined his cavalry and his infantry. The foot-soldiery, no
less than seven thousand strong, owing to the reinforcements
from the fleet, were armed mainly with bow and arbalest, and
kept the enemy's horse at bay, while the knights, a thousand
strong, charged out again and again whenever the Egyptians
tried to close, and beat back every attack. At last the Infidels,
finding they could make no impression on the Franks, rode off,
abandoning their camp to the spoiler. They do not seem, how-
ever, to have lost any very great number of slain : the estimate
of the crusading chroniclers is only three thousand—a very modest
number compared with their usual figures. The victory was
indecisive, but it saved Palestine, while a defeat would have made
an immediate end of the Latin kingdom.

We should have been glad to have had more particulars as
to the service of the English in this fight. They must have
been present in considerable numbers, but none of our native
chroniclers tell of Godric and Harding—unless, indeed, the
former is the Godric of Finchale who afterwards became a
hermit and a saint.

CHAPTER IV

THE TACTICS OF THE CRUSADERS—*continued*

Section II.—*Tactics of the Later Battles: Victories at Hab, Hazarth, Marj-es-Safar, Arsouf, Jaffa.*

AS our task is not to write a history of the kingdom of Jerusalem and its wars, but to indicate the main military tendencies of the crusading age, we must not attempt to give in detail each of the numberless fights of Frank and Moslem, but only to comment on such of them as show features of importance. Speaking in general, we may say that the same points of interest which we have observed at Dorylæum, Antioch, Harenc, Ascalon, Ramleh, and Jaffa, are to be found repeated in all the fights of the twelfth century.

Against the Turk the Crusaders were generally successful if they took care (1) to combine their cavalry with a solid body of infantry armed with missile weapons; (2) to fight on ground where the Infidel could not employ his usual Parthian tactics of surrounding and harassing his enemy; and (3) to avert the danger of starvation by carrying a sufficient store of food. Against the non-Turkish Moslems, such as the Egyptians, the Crusader was far more certain of success; he had only to use the common military precautions, and he might fairly count on victory. The battles of the Franks with these less formidable foes sometimes remind us of the early English battles in India, where the few striking boldly at the many were so often victorious in spite of every disadvantage. The one all-important canon which had to be observed was that there must be infantry on the field to serve as a support and rallying point for the cavalry. If the foot-soldiery seldom won the battle, they always made the winning of it by the knights possible.

If, on the other hand, the Frank chose to advance recklessly

into unknown ground in desolate regions, where he could be surrounded, harassed, and finally worn out, or if he allowed his class-pride to lead him astray, and left his infantry behind, he was liable to suffer terrible disasters.

We have selected as examples of typical victories of the Crusaders the battles of Hab (1119), Hazarth (1125), Marj-es-Safar (1126), Arsouf (1191), Jaffa (1192). As instances of defeat brought about by neglect of first principles, we may take the fights of Carrhae (1104), Tiberias (1187), Acre (1189), and Mansourah (1250).

Battle of Hab, August 14, 1119.

On the 27th of June 1119, Roger, Prince of Antioch, had fallen with many of his knights in the disastrous fight of Cerep. The victor, Il-Ghazi, Emir of Mardin, began to overrun the whole principality of Antioch. To rescue it from the Infidels, Baldwin II. of Jerusalem, with his vassal Pons Count of Tripoli, hastened up from the south. The troops of Edessa also made their way to join their suzerain, and when the wrecks of the Antiochene army had united themselves to the host it counted seven hundred knights and several thousand foot. Baldwin advanced to relieve Zerdana, a castle to which Il-Ghazi had laid siege. It fell before his arrival, but he was unaware of the fact on the day of the battle. Il-Ghazi had also been joined by reinforcements: his rival, Toktagin of Damascus, had agreed to sink his private enmity, and had brought up a large contingent of his own riders, and some more levies from Emesa. The Infidels mustered in all some twenty thousand horse: of foot there is no mention; the Turkish emirs generally depended on their horse-archers alone.[1]

Advancing by Hab towards Zerdana, Baldwin drew up his army before daybreak in a less simple order of battle than was usual among the Crusaders. The front line was formed by three corps, each consisting of a body of cavalry supported by a body of infantry, "that each arm might protect the other." Behind the centre of this line was Baldwin himself, with the knights of his household drawn up in three corps; on his right was the Count of Tripoli with his vassals; on his left Robert Fulcoy, lord of Zerdana, with the barons and knights of

[1] All this comes from Gautier the Chancellor. William of Tyre, Fulcher, and the rest are vague, and speak at second-hand.

Antioch; another party of Antiochenes seems to have been detailed as a rearguard, if our chief source, Gautier the Chancellor, can be trusted. The squadrons of Pons and Robert were placed not parallel to, but somewhat to the rear of, the front line, in order that they might defeat attempts to turn its flanks, while the king could strengthen it if the main pressure of the enemy was thrown upon its centre. Whether by chance or design, this order bears a striking resemblance to that which the Byzantine Leo (the Wise) advocates for use against the Moslem. A comparison of the plan on p. 195, with the sketch of the battle of Hab on p. 290, makes this clear in a moment. The only difference is that Baldwin had infantry, perhaps two thousand or three thousand strong, behind his first line of horse, while Leo is describing the order of a division of cavalry unassisted by any foot-soldiery. The nine squadrons, each about eighty strong, were three in the first rank, three in the second, one on each flank, and one behind. Il-Ghazi and Toktagin seem to have hoped that they might be able to surprise the Franks at daybreak, but when the sun rose Baldwin's little host was already advancing in good order, and all the war-cries and din of trumpets and nakers with which the Infidels burst in upon it were completely thrown away. Il-Ghazi resolved, therefore, to use the ordinary Turkish tactics, and advanced in a half-moon, lapping round both flanks of the Christian army. He himself, with the Mesopotamians, was on the right, while Toktagin, with the men of Damascus and Emesa, held the left. The Turks were well aware that the greatest danger to themselves lay in the combination of infantry and cavalry by the Christians. Il-Ghazi had therefore resolved to do his best to overwhelm the front line of the enemy, and prepared a desperate assault on Baldwin's centre, where all the foot-soldiery were collected. They, and the three squadrons of knights in front of them, were very fiercely assailed; [2] the

This is the only way of construing "acie comitis Tripolitani a dexteris posita, aciebus baronum in sinistris et post a jussu regis quibusque suo loco positis" (Gautier, p. 460). If the Antiochenes had all been on the left of Baldwin in one body, we should have had *acie*, not *aciebus*. Bongars prints the colon before *et*, but evidently it should be before *jussu*, making no good sense if introduced after *sinistris*.

That the knights were in front of the infantry and not behind, is shown by Gautier, wording: "Turci, ambitiosi manum pedestrem prosternere, qua gravius refrenabantur, cum hanc *praecedentibus* aciebus, et acies hac protegi videbant, vi maxima, arcubus brachiis immissis, strictis ensibus, nostros percutiunt," etc. The word *praecedentibus* is conclusive (p. 461).

horsemen were driven back on the foot; and the latter attacked, not with the usual arrow-shower of the Turks, but by vigorous charges home with lance and sword. The Frankish footmen, when the knights were driven off, proved unable to bear up against the Mesopotamians. Armed with missile weapons to withstand the Turkish bow, they were less fitted for close combat. They fought well, but began to fall into disorder, and lost heavily.

Meanwhile, the fortune of battle on the wings had been evenly divided; on the right Il-Ghazi's men had assailed and beaten back the Count of Tripoli, whose whole corps was finally driven in and thrown on to the flank of Baldwin's own division in the second line. On the left, however, Robert Fulcoy and the Antiochenes had charged the men of Damascus with such vigour that they had completely scattered them, and driven them off in confusion. Robert might have won the day by promptly charging the hostile centre from the flank. But no such idea entered into his head; his main desire was to relieve his own castle of Zerdana, whose fall had not yet reached his ears.[1] Accordingly he pursued the Damascenes for a space, and then rode straight for Zerdana without making any further attempt to join in the battle. He and his corps were absent from the field during the remainder of the engagement.

Il-Ghazi's men on the other flank made no such mistake, but closed in on Baldwin's second line. The fight now became very confused; the van and right wing of the Franks were driven in on their centre in a disorderly mass, and it remained to be seen whether the king would be able to save the day with his reserve. Time after time he charged out with his knights and drove off each swarm of Turks as it pressed in to complete the victory. Whether the attack threatened front or flank or rear, he and his chivalry were always at the point of danger. Again and again the cry of " Holy Cross !" and the impact of the heavy squadron of men-at-arms drove back the Infidels from their prey.[2] Towards evening Il-Ghazi gave up the struggle and rode off, leaving Baldwin in possession of the field.

[1] So Kemal-ed-din, who seems very well informed. Gautier the Chancellor imagines that the news had already reached the Christians, which is improbable. Robert would not have acted so if he had been aware of it (p. 460).

[2] "Rex, virili audacia fretus, qua parte hostium turmas magis vigere comperuit, illic exclamando Sanctae Crucis protectionem et auxilium, velocissime irruit, perfidos prostravit et in dispersionem impulit," etc. (Gautier, p. 461).

As he retired, the lord of Mardin came into collision with the corps of Robert Fulcoy, returning tardily to join the king after they had discovered that Zerdana was already in the hands of the Infidels. The Antiochene knights, marching in disorder and without proper precautions, were easily dispersed by the Turks, and Robert himself, falling from his horse in the flight, was made prisoner. He was put to death by Toktagin in cold blood some days after the battle: it is impossible to say that his fate was undeserved, as his selfish abandonment of his comrades at the outset of the battle merited the heaviest punishment.

Baldwin, unaware of this disaster, held the field till night and then retired to Hab. He returned next morning to bury his own dead and strip those of the enemy. As the Turks had entirely disappeared, he with justification regarded himself as victor. The battle had in truth been indecisive; but as the enemy made no further advance against Antioch, the end for which it had been fought was achieved. The losses had been very heavy: Baldwin counted a hundred knights and seven hundred footmen among the slain, and many more were dispersed and did not rejoin for several days. The Turks had lost from two thousand to three thousand horse.

The incidents of this battle, in which the fortune of the day was for a long time so equally divided, remind us of those of Mont'l'hery, and Gautier's account of the flight of each side may well stand beside the well-known passage in Commines. "Our fugitives," he writes, "fled to Hab, to Antioch, and even as far as Tripoli, reporting that the king and the whole army had been exterminated. On the other hand, those of the Turks who had been driven off the field (by our left wing) poured into Aleppo, swearing that Il-Ghazi and Toktagin and all the Turkomans had been slain to the last man."[1] If Baldwin could claim that he had held the field at sunset, Il-Ghazi could display as trophies one of the royal banners of the Latin kingdom, torn from the king's squire who bore it, and Robert Fulcoy and many other noble prisoners. That, after massacring thirty of them, he then returned to Mardin to raise

[1] In face of Gautier's explicit statements, it is impossible to believe Kemal-ed-din's allegation that at nightfall the Turks pursued the Christians to the gates of Hab. If any of them did follow, it must have been at a safer distance, and as scouts rather than pursuers.

more troops instead of pursuing his campaign, is a sufficient proof that the claim of victory which he made was a very empty one. But it seems to have deceived his chronicler, Kemal-ed-din, from whose pages we should never gather that Baldwin also could declare himself the conqueror in the strife. The events of the succeeding months plainly showed who was the real victor. Il-Ghazi returned home; Baldwin kept the field, and retook in the autumn Zerdana and most of the other castles and cities which the Infidels had captured after the death of Prince Roger.

This battle of Hab or Danit has many points of interest. It shows us the Crusaders adopting for the first time a much more complex order of battle than the simple line of infantry supported by cavalry which they had displayed at Antioch, Ascalon, and Ramleh. Baldwin, instructed by his many battles with the Turk while he was but Count of Edessa, had employed as king the fruits of his experience. The Turks, too, have learned much: they no longer trust entirely to the bow, but charge home vigorously with sword and lance. They have come to see that the Frankish foot-soldiery with their missile weapons are even more dangerous to them than the knights, and devote most of their energy to clearing away the infantry, not endeavouring to shoot them down,—an attempt in which Turks seldom succeeded, owing to the inferiority of the horseman's bow to the arbalest,—but to ride over them with the lance. That they succeeded on this occasion was apparently due to Baldwin's mistake in drawing up his three squadrons of knights in front of and not behind the infantry of the centre.

For a further development of the tactics of both sides, we must advance a few years, to the battles of Marj-es-Safar and Hazarth.

Battle of Hazarth, June 11, 1125.

At Hazarth, which was fought on June 11, 1125, Baldwin seems to have returned to the simple order of battle of the days of Antioch and Ascalon. He drew up his army in thirteen small corps, each consisting of infantry and cavalry. As there were eleven hundred knights and two thousand foot, the squadrons must each have been about eighty strong (much the same as at Hab), and the infantry divisions have mustered somewhat over a hundred and fifty. These thirteen bodies were

divided into a centre and two wings; the right was composed of the troops of Antioch, the left of those of Edessa and Tripoli, the centre,[1] the strongest of the three divisions, was formed of the king's own vassals from Palestine. Presumably the wings contained each four and the centre five corps, but neither Fulcher nor William of Tyre, our two authorities, definitely state the fact.

Il-Borsoki, the opponent of Baldwin, arrayed his fifteen thousand horse in twenty-one corps, and pressed forward to attack the Frankish infantry—we have no mention of his attempting any encircling movement after the usual Turkish fashion. The interchange of missiles had gone on for some short time, and close fighting had begun, when Baldwin gave orders for a general charge of the cavalry. The Infidels stood firm for a moment, but, when the knights burst in among them, lost heart, broke, and fled. Two thousand of them fell, while the Christians only lost twenty-four. The proper combination of infantry and cavalry had secured an almost bloodless victory.

Battle of Marj-es-Safar, January 25, 1126.

In the following year the Turks for the first time put foot-soldiery in the field. They had evidently realised at last that the combination of the two arms was more effective than their own horse-archery. In January 1126 King Baldwin had crossed the Jordan and advanced toward Damascus, harrying the land far and wide, in revenge for a similar raid which Toktagin had directed against Palestine in the preceding autumn. Against him came forth the Atabeg chief and his son, bringing with them not only their riders, but "chosen youths trained to spring up armed behind the horsemen, who, when the enemy drew near, descended and fought on foot: for so they hoped to disorder the Franks by attacking them with infantry on one side and cavalry on another."[3] The Jehad had been preached

[1] I do not think we are justified in concluding from Fulcher's (chap. lxii.) calling Baldwin's own corps "derisior et posterior" that he was in a second line. Probably only "last and largest" is meant. William of Tyre evidently read it so when he wrote "in medio dominum regem," and not pone or post. Fulcher says that "Baldwin charged, bidding the rest follow," for they dared not commence the fray before he gave the word, and he was in the second line; this would have been impossible.

[2] "The boys had been bent, and the drawn sword was being used at close quarters," says Fulcher (chap. lxii.).

[3] Fulcher, last words of chap. lxxi.

in Damascus and its subject towns, and many thousands of un-
trained citizens went out on foot to fight for Islam.

The armies met at Marj-es-Safar, not far from Damascus,
on the 25th of January, the day of the conversion of St. Paul.
Baldwin drew up his men in twelve corps, each containing
both infantry and cavalry, "that the two arms might give each
other the proper support."[1] The Damascenes were not in any
very great numerical superiority, save in the number of their
irregular foot-soldiery ; the Christian chroniclers confess that
the two armies were not very unequal, and do not ascribe
the usual vast preponderance to the enemy. But whether it
was that they were fighting close to their capital to protect
their own homes and families, or whether it was the unwonted
assistance of infantry which helped them, it is certain that they
made a much fiercer stand than usual. It was one of the
stiffest, though not the most bloody, fights in which the Franks
had engaged for many years.[2] Fulcher allows that for a space
the battle seemed going against Baldwin ; the arrow-shower
was too bitter, and "no part of body or limb seemed safe against
the shafts, so thickly did they fly." The host recoiled for a long
space, and it was only by a desperate rally in the afternoon that
it saved itself and resumed its advance. "But our king bore
himself well that day, as did all his knights and vassals, and
Almighty God was with them."[3] At dusk the Turks fled, and
the day was won. Two thousand Damascene horse and an
innumerable number of the Infidel foot had fallen ; of the
Christians twenty-four knights and eighty infantry only were
slain. William of Tyre, in his rather unsatisfactory narrative
of this battle, says that the Christian foot, fired by the example
of the king and his knights, charged the enemy at the supreme
moment along with the cavalry, and that they did most damage
to the Turks by shooting their horses, so that the dismounted

[1] "Ordinatae sunt tam militum quam peditum acies duodecim, ut ab alterutra
corroboretur caterva, si necessitas admoneret" (Fulcher, cap. lxx.). This can only mean
that foot might help horse and horse foot, not that each of the twelve corps might
help the other. It is hardly necessary to point out that *alteruter* can only be used
of *two*, not of many ; but I have seen several accounts of the battle by modern
authors where this simple rule of Latinity is neglected.

[2] William of Tyre is of course wholly in error when he calls it the most
dangerous and doubtful fight since the foundation of the realm (xiii. § 18). At
Hab, only seven years before, the Christian losses were eight times as great and the
result far more uncertain.

[3] Fulcher, cap. lxx.

Infidels fell easy victims to the pursuer.[1] But it is not easy to make out whether the infantry, as he conceived the fight, were behind or in front of the knights. For, on the one hand, he makes the foot-soldiers " pick up and carry back to the baggage their wounded comrades, and set on their feet again those who had been overthrown ; " while, on the other, they are said to shoot the Turkish horses, so that the riders " fall into the hands of their companions who follow behind." The first statement seems to indicate that the knights had already charged over the ground which the infantry were crossing ; the second that they were following behind them. But William is not always happy in following his authorities for battles that took place before his own day, and his picture here is decidedly confused. In all probability the action began with the infantry in the first line, and the cavalry in support. When it grew hot, the cavalry must have charged out to the front, and in the final advance the foot-soldiery must have been following in the wake of the knights to complete the victory rather than preceding them. It is a pity that we have not any detailed account of the battle from Moslem sources ; if it existed, we might clear up its difficulties, as we can those of the fight at Hazarth, by the comparison of the two hostile chroniclers.

There are many Christian successes worth recording in the years between Marj-es-Safar and the fall of Jerusalem in 1187. But as they are not of any special tactical importance, presenting merely the same features that we have already noted, they may be passed over without any detailed narration. The defeats of this period are more interesting than the victories : notes on several of them will be found in the succeeding chapter, where we treat of the causes of the many failures of the Franks.

The battle which must next arrest our attention is the last of the great triumphs of the Christians, and the most notable, as it was won over the finest general whom the Infidels ever owned, the great Saladin himself, commanding the most powerful and most formidable—if not the largest—host which the Moslems ever put into the field. The Christians, too, were in far larger force than ever before in any battle of the Holy Land. It is

[1] " Equis hostium sauciandis omnem dabant operam, eorumque sessores subsequentibus sociis parabant ad victimam " (W. T. xiii. § 18). This, I presume, means shooting rather than stabbing the horses.

fortunate that we have excellent accounts of the fight from both sides, and that its topography can be easily ascertained. Every detail of it is well worth study.

Battle of Arsouf, September 7, 1191.

After a siege of nearly two years, Acre had been recovered by the Franks on July 12, 1191. The garrison had laid down its arms and surrendered to the kings of France and England, after having protracted its defence to the last possible moment. Saladin had done his best to succour the place, and delivered perpetual assaults on the camp of the besiegers, but all to no purpose. Seeing that there was no hope of relief, and that Acre must fall by assault in a few days, the Emirs Karakush and Mashtoub opened the gates, after promising that they would induce the Sultan to pay two hundred thousand bezants as ransom for the garrison, and also to restore the True Cross and fifteen hundred Christian prisoners, the survivors of the disaster of Tiberias, who were in chains at Damascus and elsewhere.

For some weeks after the fall of the great fortress, the Christians remained encamped in and around Acre, while Saladin still observed them from his camp on the mountain to the east. The delay was caused partly by the exhaustion of the victors, partly by the necessity for repairing the shattered walls of the city, partly by the protracted negotiations concerning the ransom of the garrison. Meanwhile, Philip of France took his way homeward amidst the curses of the whole army, swearing that on his return he would be a quiet and peaceful neighbour to the dominions of the King of England. "How faithfully he kept that oath is sufficiently notorious to all men, for the moment that he got back he stirred up the land, and set Normandy in an uproar."[1] He left the bulk of his army in the camp under the Duke of Burgundy and Henry Count of Champagne.

The attempts to come to an agreement with Saladin failed hopelessly. Into the ugly story of the massacre of the Turkish garrison, when their ransom was not forthcoming, we need not enter. On Tuesday, August 20, Richard and the Duke of Burgundy beheaded the two thousand six hundred unfortunate captives, and all chance of peace was gone. Two days after, the crusading army set out upon its march.

[1] *Itinerarium Regis Ricardi*, iii. § 22 : "Quam vero fideliter hoc steterit juramento satis innotuit universis," etc.

Richard had as his objective Jerusalem, whose recovery was the main end of the Crusade. But to move directly from Acre on the Holy City is impossible. The mountains of Ephraim interpose a barrier too difficult to be attempted when an alternative route is possible. For a march on Jerusalem the best base is Jaffa, and to that place Richard resolved to transfer himself and his army. He accordingly arranged that the host should march along the great Roman road beside the sea by Haifa, Athlit, Caesarea, and Arsouf, while the fleet should advance parallel with it, and communicate with it at every point where it is possible to get vessels close to the shore. This co-operation was all-important; for the army was lamentably deficient in means of transport, and depended on the ships for its food. So few were the beasts of burden, that a great part of the impedimenta had to be borne on the backs of the infantry, who loaded themselves with tents, flour-bags, and miscellaneous necessaries of all kinds. Nearly half of them were employed in porter's work, and thereby taken out of the ranks when the host began to move forward. No food was to be found on the way, for Saladin had already ravaged the shore, and dismantled Haifa, Caesarea, and Arsouf.

It was obvious that the Crusaders would be harassed by Saladin the moment that they started on their march. The temptation to assail a host strung out in one thin column along many miles of road would certainly draw the Turks down from their strongholds in the hills. Richard had therefore to provide an order of march which should be convertible at a moment's notice into an order of battle. His front, rear, and left flank were all equally liable to assault. Only the right would always be covered by the proximity of the sea.

In view of this danger the king made the best disposition possible. Next the sea moved the beasts of burden and the infantry employed to carry loads. Inland from them were the cavalry, distributed into compact bands and spaced out at equal intervals all along the line of march. Inland again from the cavalry were the main body of infantry, marching in a continuous column, and so covering the whole eastern flank of the army. Though the contingents were placed so close that no gaps were left between them, they were for purposes of organisation divided into twelve bodies, to each of which there was attached one of the cavalry corps, which marched level with it.

Thus there were twelve divisions of foot and twelve of horse; these smaller units were united into five main corps, of which the exact composition is not easy to ascertain. The Templars and the Hospitallers, who knew the country well, and had in their ranks many "Turcopoles," *i.e.* horse-bowmen armed like the Turks and specially fit to cope with them, took the van and the rear, the two points of greatest danger, on alternate days. With the centre division of the army moved the royal standard of England fixed on a covered waggon drawn by four horses, like the *carrochio* which the Milanese had used at Legnano a few years before. The order of the various corps was, as we gather, somewhat varied on different days. On one occasion Richard and his own military household took the van, but usually he reserved for himself no fixed station, but rode backward and forward along the line of march with his household knights, carefully supervising the movement of the whole and lending aid wherever it was required. The heat was great, September being not yet come, and the king was determined not to harass the army by long stages. Accordingly he moved very slowly, using only the early morning for the march, and seldom covering more than eight or ten miles in the day. Moreover, he habitually halted on each alternate day, and gave his men a full twenty-four hours (or even more) of rest. Thus the host took as much as nineteen days to cover the distance of eighty miles between Acre and Jaffa. It is well worth while to give Richard's itinerary, in order to show the care which he took of his troops.

Thursday, August 22.—From the neighbourhood of Acre to the river Belus [2 miles].

Friday, August 23.—The army crosses the Belus [2 miles].

Saturday, August 24.—Rest in camp and preparations for march.

Sunday, August 25.—To Haifa [11 miles].

Monday, August 26.—Rest at Haifa.

Tuesday, August 27.—From Haifa to Athlit, round the shoulder of Mount Carmel [12 miles].

Wednesday, August 28.—Rest in camp.

Thursday, August 29.—Rest in camp. The fleet arrives and lands stores.

Friday, August 30.—From Athlit to El-Melat [Merla] [13 miles].

Saturday, August 31.—From El-Melat to Caesarea [3 miles]. The fleet lands stores and reinforcements.

Sunday, September 1.—From Caesarea to the "Dead River" [Nahr Akhdar] [3 miles].

Monday, September 2.—Rest in camp.

Tuesday, September 3.—From the Dead River to the "Salt River" [Nahr Iskenderuneh] [7 miles].

20

Wednesday, September 4.—Rest in camp.
Thursday, September 5.—From the Salt River, through the Forest of Arsouf to Rochetaille [Nahr Falaik] [10 miles].
Friday, September 6.—Rest in camp.
Saturday, September 7.—From Rochetaille to Arsouf—Battle [6 miles].
Sunday, September 8.—Rest in camp at Arsouf.
Monday, September 9.—From Arsouf to the Nahr-el-Aujeh [6 miles].
Tuesday, September 10.—Nahr-el-Aujeh to Jaffa [5 miles]. The fleet lands fresh stores.

Throughout the march the army was incessantly worried by the attacks of the Turks, especially on the 25th and 30th of August and the 1st and 3rd of September. The respite on the 26-7-8-9th was due to the fact, that while Richard had hugged the coast from Haifa and gone round the shoulder of Mount Carmel, Saladin had struck across country, passed the hills farther east, and come down on to the neighbourhood of Caesarea, before the Crusaders, moving slowly and on a longer road, had drawn near the place. From August 30 to September 7, on the other hand, he was always within a few miles of them, waiting for his opportunity to dash down from the hills if they exposed themselves. The author of the *Itinerarium* gives an interesting description of the Turkish tactics during these days:—

"The Infidels, not weighed down with heavy armour like our knights, but always able to outstrip them in pace, were a constant trouble. When charged they are wont to fly, and their horses are more nimble than any others in the world; one may liken them to swallows for swiftness. When they see that you have ceased to pursue them, they no longer fly but return upon you; they are like tiresome flies which you can flap away for a moment, but which come back the instant you have stopped hitting at them: as long as you beat about they keep off: the moment you cease, they are on you again. So the Turk, when you wheel about after driving him off, follows you home without a second's delay, but will fly again if you turn on him. When the king rode at them, they always retreated, but they hung about our rear, and sometimes did us mischief, not unfrequently disabling some of our men" (*Itin.* iv. § 8).[1]

[1] NOTE ON THE BATTLE OF ARSOUF.

In my account of this fight I have followed the *Itinerarium*, Boha-ed-din, and King Richard's letter to the Abbot of Clairvaux in Hoveden. All these three accounts fit into each other admirably. On the other hand, the narrative of Benedict

Saladin, in keeping up this incessant skirmish along the flank of the crusading host, was not merely endeavouring to weary it out. Though he only showed small bands hovering about in all directions, often but thirty or fifty strong, he was always waiting close at hand with his main army. He kept it hidden in the hills, hoping that the Franks would some day be goaded into making a reckless charge upon his skirmishers. If they would only break their line by a disorderly advance, he would pounce down, penetrate into the gap, and sweep all before him. King Richard, however, kept his men in such good order that in the whole three weeks of the march they never gave the Sultan the opportunity that he longed for. The king himself and his meinie would occasionally swoop out upon bands that came too close, but the main order of march was never broken. Only on one occasion, on the first day of the march from the Belus (August 25), did the Turks get a chance of slipping in while the rearguard was passing a defile, and then the Crusaders closed up so quickly that the assailants had to fly, after accomplishing nothing more than the plunder of a little baggage. Boha-ed-din's account of the Crusaders' march is as well worth quoting as the note on the Turkish attack which we have cited from the *Itinerarium.* He is describing the events of Saturday, August 31.

"The enemy moved in order of battle: their infantry marched between us and their cavalry, keeping as level and firm as a wall. Each foot-soldier had a thick cassock of felt, and under it a mail-shirt so strong that our arrows made no impression on them. They, meanwhile, shot at us with crossbows, which struck down horse and man among the Moslems. I noted among them men who had from one to ten shafts sticking in their backs, yet trudged on at their ordinary pace and did not fall out of their ranks. The infantry were divided into two halves: one marched so as to cover the cavalry, the other moved along

of Peterborough is absolutely irreconcilable with them. He makes much of the fighting turn on the crossing of a river by the Christian army, and puts the engagement on the 16th instead of the 7th of September. It is satisfactory to know that his story is rendered wholly impossible by the topography of the place. For a mile north of the Nahr-el-Falaik the road is bordered by the impassable swamp of the Birket-el-Hamadan. North of this again it runs over flat sand dotted with salt-water ponds, and with the forest running down into it. This will not do for the battlefield as described by the *Itinerarium* and Boha-ed-din. On the other hand, the country south of the Nahr-el-Falaik suits the narrative excellently. See my map, carefully reduced from the 1-inch-to-the-mile Ordnance Survey of Palestine.

the beach and took no part in the fighting, but rested itself. When the first half was wearied, it changed places with the second and got its turn of repose. The cavalry marched between the two halves of the infantry, and only came out when it wished to charge. It was formed in three main corps: in the van was Guy,[1] formerly King of Jerusalem, with all the Syrian Franks who adhered to him ; in the second were the English and French ; in the rear the sons of the Lady of Tiberias[2] and other troops. In the centre of their army there was visible a waggon carrying a tower as high as one of our minarets, on which was planted the king's banner. The Franks continued to advance in this order, fighting vigorously all the time : the Moslems sent in volleys of arrows from all sides, endeavouring to irritate the knights and to worry them into leaving their rampart of infantry. But it was all in vain : they kept their temper admirably and went on their way without hurrying themselves in the least, while their fleet sailed along the coast parallel with them till they arrived at their camping-place for the night. They never marched a long stage, because they had to spare the foot-soldiery, of whom the half not actively engaged was carrying the baggage and tents, so great was their want of beasts of burden. It was impossible not to admire the patience which these people showed : they bore crushing fatigue, though they had no proper military administration, and were getting no personal advantage. And so they finally pitched their camp on the farther side of the river of Caesarea."[3]

From the 29th August to the 6th September, Saladin had been perpetually seeking an opportunity for delivering a serious attack. But the caution and discipline which Richard had imposed upon his army foiled all the hopes of the Infidel. It became evident that, if the Christians were to be stopped before they reached Jaffa, a desperate attempt must be made to break in upon them, in spite of their orderly march and firm array. Saladin resolved, therefore, to try the ordeal of battle in the ground between the Nahr-el-Falaik (the river of Rochetaille) and Arsouf. There was every opportunity for hiding his host

[1] This account of the distribution of the Christians does not tally with the *Itinerarium*, and is probably wrong. Boha-ed-din calls Guy "Geoffrey" by a curious error.

[2] Barons of the party among the Syrian Franks who opposed King Guy and wished to recognise Conrad.

[3] Boha-ed-din, p. 252, in the *Chroniqueurs Orientaux.*

till the moment of conflict, for in this district one of the few forests of Palestine, the "Wood of Arsouf," runs parallel to the sea for more than twelve miles. It is a thick oak wood covering all the lower spurs of the mountains, and reaching in some places to within three thousand yards of the beach. Two days of Richard's itinerary (the 5th and 7th of September) ran between this forest and the sea. He was not less conscious than Saladin of the advantage which the cover would give to an enemy plotting a sudden attack. Accordingly he warned the army on the 5th that they might have to fight a general engagement on that day, and took every precaution to prevent disorder.[1] But the Turks held back, and the first half of the forest was passed in safety. On the 6th September the Crusaders rested, protecting their camp by the large marsh which lies inland from the mouth of the Nahr-el-Falaik; this impassable ground, the modern Birket-el-Ramadan, extending for two miles north and south, and three miles east and west, covers completely a camp placed by the river mouth.

On the 7th the English king gave orders to move on: the day's march was to cover the six miles from the Nahr-Falaik to the dismantled town of Arsouf. The road lies about three-quarters of a mile inland from the beach, generally passing along the slope of a slight hill: between it and the foot of the wooded mountains there was an open valley varying from a mile to two miles in breadth. The forest on the rising ground was known to conceal the whole of Saladin's host, whose scouts were visible in all directions.

On this day Richard divided his army into twelve divisions, each consisting of a large body of infantry and a small squadron of knights.[2] The foot-soldiery formed a continuous line, with the crossbowmen in the outermost rank. The impedimenta and the infantry told off to guard them moved as usual close to the sea. The order of the march of the twelve divisions is not clearly given to us; we know that the first consisted on this day of the Templars, with their knights, Turcopoles, and foot-sergeants. The next three consisted mainly of Richard's own subjects—Bretons and Angevins forming the second, Poitevins (under Guy, the titular King of Jerusalem) the third, and Normans and English the fourth: the last-named corps had charge of the waggon bearing the great standard. Seven corps

[1] *Itinerarium*, iv. § 16. [2] *Ibid.* iv. § 17.

were made up from the French, the Barons of Syria, and the miscellaneous small contingents from other lands. Lastly, the Hospitallers brought up the rear. Probably the French contingents were divided into four "battles," under (1) James d'Avesnes, (2) the Count of Dreux and his brother the Bishop of Beauvais, (3) William des Barres and William de Garlande, (4) Drogo Count of Merle. Henry Count of Champagne was charged with the duty of keeping out on the left flank to watch for the breaking forth of the Turks from the woods. The Duke of Burgundy, the commander of the French host, rode by Richard's side up and down the line, keeping order and ready to give aid wherever it was wanted. The whole twelve corps were divided into five divisions, but it is not stated how they were thus distributed. Some of the five must have included three, some only two, of the brigaded bodies of horse and foot. Saladin allowed the whole Christian host to emerge from the camp and proceed some little way along the road before he launched his army upon them. While threatening the whole of the long line of march, he had resolved to throw the main weight of his attack upon the rearguard. Evidently he hoped to produce a gap, by allowing the van and centre to proceed, while delaying the rear by incessant assaults. If the Hospitallers and the divisions next them could be so harassed that they were forced to halt or even to charge, while the van still went on its way, it was obvious that a break in the continuous wall of infantry would occur. Into this opening Saladin would have thrown his reserves, and then have trusted to fighting the battle out with an enemy split into at least two fractions and probably more. He had, as we shall see, wholly underrated the prudence and generalship of King Richard, and was preparing for himself a bloody repulse.

The Crusaders were well upon their way when the Moslems suddenly burst out from the woods. In front were swarms of skirmishers both horse and foot—black Soudanese archers, wild Bedouins, and the terrible Turkish horse-bowmen. Behind were visible deep squadrons of supports—the Sultan's mailed Mamelukes and the contingents of all the princes and emirs of Egypt, Syria, and Mesopotamia. The whole space, two miles broad, between the road and the forest, was suddenly filled with these imposing masses. "All over the face of the land you could see the well-ordered bands of the Turks, myriads of parti-coloured

PLATE IX.

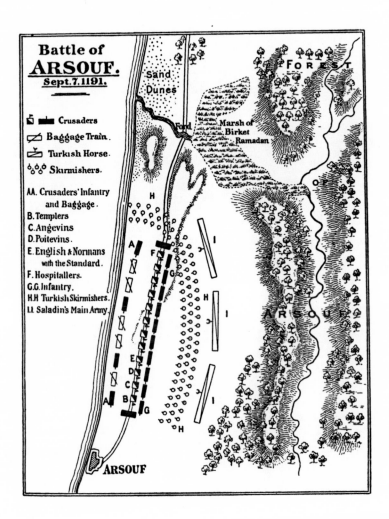

Battle of ARSOUF.
Sept. 7. 1191.

Crusaders
Baggage Train.
Turkish Horse.
Skirmishers.

AA. Crusaders' Infantry
and Baggage.
B. Templers
C. Angevins
D. Poitevins.
E. English & Normans
with the Standard.
F. Hospitallers.
G.G. Infantry.
H.H Turkish Skirmishers.
I.I. Saladin's Main Army.

banners, marshalled in troops and squadrons; of mailed men
alone there appeared to be more than twenty thousand. With
unswerving course, swifter than eagles, they swept down upon
our line of march. The air was turned black by the dust that
their hoofs cast up. Before the face of each emir went his
musicians, making a horrid din with horns, trumpets, drums,
cymbals, and all manner of brazen instruments, while the troops
behind pressed on with howls and cries of war. For the Infidels
think that the louder the noise, the bolder grows the spirit of the
warrior. So did the cursed Turks beset us before, behind, and
on the flank, and they pressed in so close that for two miles
around there was not a spot of the bare earth visible; all was
covered by the thick array of the enemy."[1]

While some of the Turks rode in between the head of the
army and its goal at Arsouf, and others followed the rearguard
along the road, the majority closed in upon the left flank and
plied their bows against the wall of infantry and the clumps of
horsemen slowly pacing behind it. The pressure seems to have
been hardest upon the rear, where the right wing of the Turks
delivered a most desperate attack upon the squadron of the
Hospitallers and the infantry corps which covered them. The
French divisions opposite the Turkish centre were less hardly
pressed; the English, Poitevins, and Templars in the van, though
constantly engaged, were never seriously incommoded.

In spite of the fury of the attack, the Crusaders for some
time pursued their way without the least wavering or hesitation.
The crossbowmen gave the Turks back bolt for bolt, and
wrought more harm than they suffered, since their missiles were
heavier and possessed more penetrating power than those of the
enemy. The cavalry in the centre of the column rode slowly
on, though their horses soon began to suffer from the incessant
rain of arrows. Many knights had to dismount from mortally
wounded chargers, and to march lance in hand among the foot.
Others picked up crossbows, stepped into the front rank of the
infantry, and revenged themselves by shooting down the Turkish
horses.[2]

The slow march southward went on for some time; the
infantry held firm as a wall, and no opportunity was given for
the enemy to break in. Saladin, seeing that he was making no
progress, flung himself among the skirmishers, followed only by

[1] *Itinerarium,* iv. § 18; [2] *Ibid.*

two pages leading spare horses, and continued to urge his men on and to press them closer in upon the Frankish foot. The stress soon became very severe in the rear division of King Richard's host, which was exposed to a double fire from flank and rear. Some of the crossbowmen began to waver, but the majority held firm, forced though they were to walk backwards with their faces to the pursuing enemy; for, when they turned for a moment to move on, the Turks rushed in so fiercely that there was grave danger that the corps of the Hospitallers might be broken up. "They had laid their bows aside, and were now thundering upon the rearguard with their scimitars and maces like smiths upon anvils."

The Grand Master of the Hospitallers repeatedly sent forward to the king, asking leave to charge. The horses were being shot down one by one, he complained, and the knights could no longer endure this passive kind of battle, in which they were struck themselves, but not allowed to strike back. Richard returned the reply that the rear was on no account to break their order: he had settled that there should be a general charge of the whole line when he bade six trumpets blow; before the signal no one must move. His design was evidently to get the whole Turkish army committed to close combat before he rode out upon it. At present the rear alone was seriously engaged: the van and centre were only being harassed from a distance. Moreover, there would be great advantage in waiting till the van had reached Arsouf, whose gardens and houses would give good cover for its flank when the moment for the decisive charge came.

In obedience to these orders, the Hospitallers endured for some time longer, but they were growing restive and angry as horse after horse fell, and man after man was disabled by arrows in the parts of his body which the armour did not fully protect. Presently the whole rear division lurched forward in disorder and joined the French corps which was marching immediately in front of it. At last, just when the head of the army had reached the outskirts of Arsouf, the patience of the rear was wholly exhausted. Ere the king had bade the six trumpets sound, but (as it would seem) only just before the moment that he would have chosen, the Hospitallers burst forth. The ringleaders in this piece of indiscipline were two of

[1] *Itinerarium,* iv. § 10, p. 264.

their leaders, their marshal and a notable knight named Baldwin de Carron, who suddenly wheeled their horses, raised the war-cry of St. George, and dashed out through the infantry upon the Infidels. Those immediately about them followed; then the French divisions ranged next them took up the movement. It spread all down the line, and Richard himself, seeing the die cast, was constrained to allow the cavalry of the van and centre to follow up the attack. To the Saracens it bore the appearance of a preconcerted movement. "On a sudden," says Boha-ed-din, "we saw the cavalry of the enemy, who were now drawn together in three main masses, brandish their lances, raise their war-cry, and dash out at us. The infantry suddenly opened up gaps in their line to let them pass through."[1] Thus the attack of the Crusaders was delivered in échelon, the left (i.e. the rear) leading, the centre starting a moment after, and the right (i.e. the van) a little later than the centre.

The Turks did not endure for a moment the onset of the dreaded knights of the West. The sudden change of the crusading army from a passive defence to a vigorous offensive came so unexpectedly upon them, that they broke and fled with disgraceful promptness. Nothing can be more frank than Boha-ed-din's account of the behaviour of his master's host.[2] "On our side," he says, "the rout was complete. I was myself in the centre: that corps having fled in confusion, I thought to take refuge with the left wing, which was the nearest to me; but when I reached it, I found it also in full retreat, and making off no less quickly than the centre. Then I rode to the right wing, but this had been routed even more thoroughly than the left. I turned accordingly to the spot where the Sultan's body-guard should have served as a rallying-point for the rest. The banners were still upright and the drum beating, but only seventeen horsemen were round them."

In the northern end of the battle, where the Hospitallers and the French corps immediately in front of them were already in close contact with the foe at the moment of the charge, a dreadful slaughter of the Infidels took place. The rush of the Crusaders dashed horse and foot together into a solid mass, which could not easily escape, and the knights were able to take a bloody revenge for the long trial of endurance to which

[1] Boha-ed-din, p. 258, in *Chroniqueurs Orientaux.* [2] *Ibid.* p. 259.

they had been exposed since daybreak. Before the Moslems could scatter and disperse to the rear, they had been mowed down by thousands. In the centre and the southern end of the battle the Turks had an easier flight, since their pursuers were not so close. Here the contact and the slaughter must have been much less. We know from the author of the *Itinerarium* that the English and Norman knights who formed the fourth division, counting from the van, never reached the flying enemy, though they followed in échelon the movement of the rear and centre corps.[1] The same was probably the case with the other three corps of the van, for King Richard, in his letter to the Abbot of Clairvaux, states that only four of his twelve divisions were seriously engaged, and that these four alone really defeated the whole host of Saladin.[2] Thus the attack, though——

Having pursued the Turks more than a mile, the Crusaders halted and began to re-form—there was no rash pursuit like that which had so often ruined the Franks in earlier fields. Those of the Infidels who still kept their heads, ceased to fly when they were no longer pursued, and turned to cut off the scattered knights, who had pushed far to the front, and were now riding back to fall into line with their comrades. Of these some few were cut off and slain—among them James d'Avesnes, a notable knight, who had commanded one of the rear divisions of the line of march. Among those of the Turks who rallied most quickly and came back first to the fight was Taki-ed-din, Saladin's nephew, with the seven hundred horsemen who followed his yellow banner.

When the Christian line was once more in order, Richard led it on to a second charge; the Turks broke again and made no stand. Yet when the king cautiously halted his men, after sweeping the enemy backward for another mile, there was still a considerable body which turned back and once more showed fight. A third and final charge sent them flying into the forest, which was now close at their backs. Here they dispersed in all directions, and made no further attempt to resist. Richard, however, would not pursue them among the thickets, and led back his horsemen at leisure to Arsuf, where the infantry had now pitched their camp together. That evening many of the foot-soldiery and camp-followers went out to the field of battle, where they stripped the dead

[1] *Itinerarium*, p. 272. [2] Letter printed in Hoveden, Rolls Series, iii. 131.

and found much valuable plunder, since the Turks, like the Mamelukes in later days, were wont to carry their money sewed up in their waist-belts or under their clothing. They reported that they had counted thirty-two emirs among the slain, and more than seven thousand of the rank and file.[1] Boha-ed-din names as the most prominent of the Moslems who had fallen Mousec, the prince of the Kurds, and two emirs named Kaimaz-el-Adeli and Ligoush.[2] Among the Christians, James of Avesnes was the only man of distinction who was slain: their total loss was under seven hundred men.

So ended this important and interesting fight, the most complete and typical of all the victories of the Franks over their enemies. The old morals of the earlier engagements are once more repeated in it. With a judicious combination of horse and foot, and a proper exercise of caution, the Crusader might be certain of victory. But we note that Richard, though new to the wars of the East, shows far more self-restraint, wisdom, and generalship than any of his predecessors. He could have driven off Saladin at any time during the day, but his object was not merely to chase away the Turks for a moment, but to inflict on them a blow which should disable them for a long period. This could only be done by luring them to close combat; hence came the passive tactics of the first half of the day. The victory would have been still more effective, as the author of the *Itinerarium* remarks,[3] if the charge had been delivered a little later. But the precipitate action of the marshal of the Hospitallers caused it to be made a moment earlier than the king had intended. Nevertheless, the results of the fight were very well marked. Saladin reassembled his army, but he never dared close in upon his enemy again: he resumed his old policy of demonstrations and skirmishes. As Boha-ed-din remarks, the spirit of the Moslem army was completely broken. Recognising that he could not hold the open country against the Franks, the Sultan at once dismantled all the fortresses of Southern Palestine—Ascalon, Gaza, Blanche-Garde, Lydda, Ramleh, and the rest. He dared not leave garrisons in them, for he was fully aware that his men would

[1] *Itinerarium*, p. 275. [2] Boha-ed-din, p. 260.
[3] iv. 19. "Quodsi [mandatum regis] fuisset observatum, universi illi Turci fuissent intercepti et confusi: praedictorum vero militum nimia properatio cedebat in detrimentum universi negotii " (p. 258).

not hold firm: the fate of the defenders of Acre and the result of the fight of Arsouf were always before their eyes, and they would not have maintained themselves for long. How well founded was this fear, became sufficiently evident from the one exception which Saladin made to his rule. He left a force in Darum, the last fortress of Palestine on the way to Egypt. Richard made a dash against it with the knights of his own household alone, a force inferior to the garrison in number. Yet so half-hearted had the Moslems grown, that the king stormed the place in four days. The Turks surrendered the citadel on the bare promise of life, though, if they had shown a tithe of the courage of the garrison of Acre, they would certainly have been able to hold out for weeks, if not for months.[1] Arsouf therefore gave the Franks the whole coast-land of Southern Palestine. After repairing the walls of Jaffa, to serve them as a basis for the attack on Jerusalem, they were free to resume the offensive. But the jealousies and divisions in the host ruined the campaign which had begun so brilliantly, and, though there were several gallant feats of arms performed during the stay of Richard in Palestine, the Holy City was never recovered, and the war ended in a treaty which did no more than confirm the Syrian Franks in the possession of the coast-region which the English king had reconquered for them.

One fight, little more than a skirmish in itself, deserves mention as illustrating Richard's methods of war. This was the engagement of August 5, 1192. While the king had returned to Acre with his army, Saladin had descended to the coast and endeavoured to retake the newly-fortified town of Jaffa. The garrison had been driven into the castle, and was on the point of surrendering, when Richard hastily returned by sea with eight vessels only and saved them (August 1). The Turks were driven off for the moment, but, learning that their enemies were very few in number, came down at daybreak on the 5th of August to surprise the Christian camp. Richard had with him only fifty-five knights and two thousand infantry, the latter largely Genoese and Pisan crossbowmen drawn from the ships which had brought him. Warned in time that seven thousand horse, all Mamelukes and Kurds, were swooping down upon the sleeping camp, he promptly proceeded to get his men

[1] *Itinerarium*, p. 356.

in order. He composed his front line of infantry armed with spears, who knelt down with one knee fixed in the sand, and with the points of their weapons levelled at the height of a horse's breast. Behind stood the crossbowmen, one in each interval between two spearmen: it was this soldier's duty to discharge as fast as possible the arbalests handed to him by another, who stood behind him, bending and loading each as it was handed back. Thus there was no intermission in the discharge. The Turks swept down, band rapidly following band, against the front of the Christian line, but never dared to close. Each squadron swerved and passed away without daring to rush on the spears ; they did little harm with their arrows, but suffered far more from the constant rain of arbalest bolts which beat upon them. When they were all in disorder, Richard boldly charged out upon them, though no more than fifteen of his knights were horsed. He cut right into their midst, and then hewed his way back again, saving by his personal valour the Earl of Leicester and Ralph of Mauléon, who had been surrounded and were nearly made prisoners. The fight lingered on for some hours after the surprise had failed, but when the king brought up some small reserves from the fleet (he left only five men on each galley) the enemy fled, leaving seven hundred men and fifteen hundred horses dead upon the field. Of the Crusaders only two men had fallen, so secure had their order of battle kept them ![1]

[1] All this from the excellent account in *Itinerarium*, vi. §§ 21-24.

in order. He composed his front into a line by armed with
spears who knelt down with one knee fixed on the same line;
with the points of their weapons a... ... the height of a
horse's breast. Behind stood the bowshooters, one in each
interval between two spearmen, and over the soldiers' shoul-
discharge as fast as possible the arrows handed to him...
another who stood behind him, kneeling and ready on the...
it was handed back... ... a...
of charge. The Turks swept down the hill-side against the
Each...
rush or the spears; they and... ...

CHAPTER M

THE GREAT DEFEATS OF THE CRUSADERS—CARRHAE, HARENC, TIBERIAS, ACRE, MANSOURAH

HAVING now given fair typical instances of the methods
by which the Franks won success in the interminable
campaigns which followed the establishment of the Latin States
in Syria, it remains that we should show in the same fashion
the manner and causes of their defeat. With those which were
the inevitable consequences of strategical blunders we have dealt
in our chapter on Strategy. It is with tactical errors that we
are now concerned. As illustration we have chosen four battles.
Carrhae (1104) will show the result of careless pursuit and the
neglect of the proper precautions required in Turkish warfare.
Tiberias (1187) displays a complicated series of blunders—the
neglect of commissariat arrangements, the choice of unsuitable
ground, the imperfect reconnoitring of the enemy, and (most
important of all) the fatal results of dividing the infantry and
cavalry. The battle in front of Acre (1190) proves that a victory
practically won might be turned into a defeat by the want of a
guiding hand and neglect of the most rudimentary discipline.
Mansourah (1250) points out that a fault originating in bad
strategy may logically lead to bad tactics, and illustrates as well
the normal want of discipline in all Western hosts.

The battle of Carrhae may be taken as an example of the
manner in which even the most practised veterans of the first
Crusade could fail when they neglected obvious precautions
and fought on unfavourable ground. In the spring of 1104,
Bohemund, now for the last six years Prince of Antioch, and
Baldwin of Bourg, Count of Edessa, resolved to make a bold
push into Mesopotamia. The Turks had lately threatened
Edessa; in retaliation the princes formed a project for seizing
and garrisoning the strong town of Harran (Carrhae), the frontier

post of the Moslems. It was close enough to Edessa to be a troublesome neighbour,—only twenty-five miles separated the two places,—while at the same time it was a favourable point to serve as a base for further progress eastward. Baldwin called in to his aid his cousin Joscelin, to whom he had granted a great lordship west of the Euphrates, round the town of Turbesel. Bohemund brought with him his kinsman Tancred, the hero of so many exploits in the first Crusade. The opportunity seemed fair, for by systematic ravagings Baldwin had ruined the countryside round Carrhae, and knew that the place was straitened for provisions. Moreover, the two Turkish princes who ruled in Mesopotamia, the Atabeg Sokman ibn-Urtuk of Kayfa, and Jekermisch the successor of Kerboga in the emirate of Mosul, were engaged in bitter strife with each other.

At the head of what passed for a considerable army among the Syrian Franks, the allied princes marched on Carrhae and formed the siege. The place, as Baldwin had known, was ill stored, and ere long the famished citizens began to treat for a surrender. But while the terms were being disputed, a relieving army came in sight: Sokman and Jekermisch had come to terms in face of the common danger, and had combined their forces to save Carrhae. The former brought to the field seven thousand Turkish horse-archers; the latter, three thousand Kurds, Bedouins, and Turks. They had resolved to threaten an attack on the Christian camp, and to throw a convoy into the city while the besiegers' attention was distracted. Their success was far greater than they could have hoped: when the Franks saw them, they formed in three "battles," each composed of horse and foot, and marched out to attack them. Bohemund held the right, Tancred the centre, Baldwin and Joscelin the left, in the Christian host. When the Franks advanced, the Turkish princes applied the ordinary stratagems of their race: they retreated into the broad plain eastward of the city, harassing the advancing enemy with their arrows. Old soldiers like Bohemund and Baldwin should have known better how to deal with such tactics, but with inexcusable rashness they pursued the Turks into the rolling sandy plain till they had got twelve miles east of Carrhae. The Turks, still falling back, crossed the river Chobar, and the Crusaders rapidly followed them. Men and horses were growing fatigued, the

infantry were tired to death, and, when the afternoon was far spent, Bohemund at last gave the signal to halt, and ordered his host to encamp for the night, not dreaming that the enemy was likely to suddenly take the offensive. This was the moment for which the Turks had been waiting. When they saw the Franks falling out of line, dismounting, and taking off their arms, they suddenly came charging in with loud shouts and dashed among their enemies, using the sword as well as the arrow. Baldwin's division was caught wholly unprepared, and ridden down before it had time to re-form; both he and his cousin Joscelin were taken prisoners, and with them Benedict, Archbishop of Edessa. The camp and all its stores fell into the hands of the Turks. Tancred, more cautious than the Count of Edessa, had not allowed his men to disperse, and was able to rally them and form up on a hill a mile or two behind the camp; here Bohemund joined him with the main body of the Christian right wing, which had been disordered, but not wholly destroyed.[1] The two princes waited to be attacked, but the Turks only demonstrated against them; they had no intention of closing, and were well satisfied with their partial victory, and eager to share the plunder they had taken. When night fell, the Franks found themselves in evil plight: they had lost not only their camp, but all their provisions; horses and men alike were famished and exhausted after the long day's march in the sandy plain. Nevertheless, the princes resolved to renew the combat next morning, and bade the starving army prepare for a second battle. But the Franks were demoralised: under cover of the darkness their foot-soldiery melted away towards the fords of the Chobar, drove off the guard which had been placed there to stop desertion, and made off towards Edessa. When the flight of the greater part of the infantry was observed, many knights stole away after them, and Bohemund and Tancred ultimately found themselves deserted by all save the men of their own military household. It was impossible to await the dawn and the Turkish advance, so the princes followed their panic-stricken host towards the ford. It was fortunate that the enemy kept a bad watch, or the whole Christian army might have been destroyed in detail. But the Turks were

[1] So Ralph of Caen; the Arab Ibn-Ghiouzi says that Tancred was at some distance from Baldwin, on the other side of a hill, and that the Count of Edessa was routed before his ally could come up to help him.

spending the night in a hot dispute; Sokman's men had been plundering the Frankish camp while Jekermisch's troops had been observing Tancred's rallied division. On their return at dusk, the Mosulite horsemen demanded their share of the prey, and Jekermisch seized the person of Baldwin, the chief of the captives, who had been placed in Sokman's tent. The Turks o Kayfa drew their swords to resent this insult to their master, and a general combat would have followed had not Sokman succeeded in appeasing his men, and at the same time bought off Jekermisch by a promise to divide the spoil fairly.[1]

Meanwhile, the Christians got a long start, and were all over the river and straggling back towards Edessa before the day dawned. They were, of course, pursued the moment that their departure was ascertained, and many stragglers were cut off; the main body, however, reached the city in safety.[2] But the blow had been a heavy one: more than half the army was missing,[3] and the Christians were thrown upon the defensive for some years. It is astonishing that the Turks did not make more profit from their victory, but, after besieging Edessa in vain for fifteen days, they dispersed and returned to their homes.

It is strange to find that the Crusaders were routed on the same field where the younger Crassus and his fifteen hundred Gallic horsemen were cut to pieces by the Parthian archers before the eyes of his father the Triumvir nearly eleven centuries before. That cavalry from the far West armed with the lance should strive again on that sandy plain with the Turanian horse-bowmen, and should succumb again, was one of the most curious coincidences of history. The march of the Triumvir and his legions among the evasive Parthians suggests somewhat the advance of Baldwin and Bohemund, but the Roman was worse

[1] Ibn-Alathir says (see Michaud, *Bibliothèque des Croisades*, iv. 19) that Sokman exclaimed, "Islam will have no joy from this victory if we quarrel after it. I will rather lose my spoil than let the Christians taunt us with folly."

[2] See in Ralph of Caen, 281, 282, the story of the flight, especially the comic tale of Archbishop Bernard, who, "when no one was pressing, thought he had behind him hosts of Turks with bended bows and drawn swords," and cut off his palfrey's tail to flee the faster.

[3] Ibn-Alathir no doubt exaggerates when he says that twelve thousand Franks were slain or taken, and that Tancred got away with six knights only. But the importance of the disaster is vouched for by William of Tyre's statement that "in no battle of the East down to our own day were so many strong and valiant men slain, and never did a Christian army fly so shamefully" (x. 110).

off than the Franks. He was fighting, as it were, blindfold, against a foe whose tactics were wholly unknown to him; while the veterans of Dorylæum and Antioch were experienced in Turkish wiles, and ought never to have been caught unprepared. Their failure to observe common precautions was all the more inexcusable, and if their host got off more cheaply than the unfortunate followers of the two Crassi, it was by good luck and not by their deserts.[1]

Battle of Tiberias, July 4, 1187.

Disastrous as was the battle of Carrhae, it cannot compare either in its scale or in consequences with the great fight eighty years later which gave Jerusalem to the Infidel. The battle of 1104 did not even destroy the single principality of Edessa: that of 1187 was the great turning-point in the whole history of the Crusades, since it entirely deprived the Crusaders of their hold on inner Syria, and left them for the future masters of nothing more than a narrow strip of coast-land.

In 1187 Saladin, after having cut short the borders of the Christians in many quarters, resolved to risk an attack on the centre of their strength, by a direct invasion of the kingdom of Jerusalem. He first despatched a considerable force to execute a raid into its northern parts: it was put in charge of Modhaffer-ed-din, Prince of Edessa and Haran, who crossed the Jordan, harried the hill-country of Galilee, and cut to pieces at the bloody encounter of Saffaria (May 1) the knights of the Temple and the Hospital, who had come forth against him with more zeal than discretion, before any succours could reach them. His safe return emboldened the Sultan to ride forth in person.

In June he gathered all his disposable forces from Egypt, Syria, and Mesopotamia at Ashtera in the Hauran. There were ten thousand mailed Mamelukes of his regular army, beside the innumerable contingents of his provinces: the total may have amounted to some sixty or seventy thousand men. On June 26 he led them down to the vicinity of the Jordan, and encamped at Sennabra, close to the bridge of El-Kantara, which crosses the river a mile south of the point where it issues from

[1] We find that there were men in Latin Syria learned enough to observe the coincidence. William of Tyre remarks that "this was that same Carrhae where Crassus the Dictator (!) had his celebrated mouthful of the Parthian gold for which he had been so greedy" (W. T. Book i.).

the Sea of Galilee. Three days later he passed the stream and advanced into Christian territory. His first aim was to capture the town of Tiberias, the capital of the principality of Galilee. Posting his main army on the hills east of that place, he sent a corps to lay siege to it. The town yielded with unexpected ease, but the garrison and their mistress, the Countess of Tripoli, withdrew into the castle, a strong fort overhanging the water, which was capable of holding out for many weeks.

Meanwhile, the Christians were assembling in great strength. Modhaffer-ed-din's raid had seriously disturbed them, and, when they heard that Saladin was concentrating his army in the Hauran, they had resolved to draw together in full force. King Guy summoned in all his barons and knights; the military Orders put all their available men into the field, thinned though their ranks had been by the disaster at Saffaria. The towns sent contingents even larger than they were bound to furnish. The Count of Tripoli, who had only lately reconciled himself to his suzerain, did his best to atone for past disloyalty by bringing the full levy of his county to the muster. The True Cross was fetched out from the Church of the Holy Sepulchre and sent to the front, in charge of the Bishop of Lydda. The castles and cities of Southern Palestine were left with garrisons of dangerously small numbers. By this concentration, the Franks were able to assemble twelve hundred knights, many hundred Turcopoles or mounted bowmen equipped in the Turkish fashion, and eighteen thousand foot,[1] the largest force that they had ever put into the field save that which had been mustered for the abortive campaign of 1184.[2] Their meeting-place was the village of Saffaria—the spot where the disaster to the Templars had occurred seven weeks before. It lies in a well-watered upland valley, three miles north of Nazareth and seventeen east of Acre. From thence to Tiberias is sixteen miles, by a road passing across one of the most desolate and thinly-peopled districts in the Galilean hills.[3] The time was the hottest month of the summer, and Saladin's raiders had burned the villages and destroyed the wells all around. They had even defiled the Church of the Transfiguration on the summit of Mount Tabor.

[1] So Ralph of Coggeshall, the best authority for the campaign, p. 218.

[2] On that occasion they had raised what William of Tyre calls the largest host ever seen in the kingdom (xxii. p. 448).

[3] There are only two small villages, Toron and Lubieh, on the road.

There was long talk and hot disputing at Saffaria as to whether the army should march to the relief of the castle of Tiberias. The Franks had mustered-in such full force that they could never hope to raise a larger army. Saladin had placed himself in a position where defeat would mean ruin, since he had the broad Sea of Galilee at his back, and his retreat either north or south would be through difficult and dangerous defiles. On the other hand, it was hazardous to risk the whole resources of the kingdom in a single fight. If the army at Saffaria was beaten, there were no reserves left on which it could fall back.

The Count of Tripoli, the most experienced warrior in the Christian host, took the side of caution. He pointed out that if they did not march against Saladin, the Sultan would be forced to march against them, since he could not long abide in the desolate country round Tiberias. His only other alternative would be to return to Damascus, a course which he certainly would not consent to take when his pride had risen so high and when his army was so strong. It would suit the policy of the Christians to be attacked at Saffaria, where they had a good position, plenty of food, and an ample supply of water. Saladin, on the other hand, would arrive with an army tired out by a fatiguing march and discouraged by the distance from its base ; for the Turks must fight, knowing that they had no shelter nearer than Damascus, and with the lake and the Jordan at their backs. Raymond added that he, if anyone, should feel interested in the preservation of Tiberias, since his own wife and children were being beleaguered in the citadel ; nevertheless, he advised that a waiting policy should be adopted, and the responsibility of the initiative thrown on the enemy. If the Christian army marched over the mountains, it would have to fight when worn out by thirst and heat ; it was far better that the Infidels should have these disadvantages on the day of battle.[1]

Unfortunately the advice of Raymond was ill received. His enemies whispered that he was the king's enemy, and that his cowardly counsel was that of a deliberate traitor. The majority of the barons voted that it would be shameful to abandon the garrison of Tiberias. The king assented, and on Thursday, July 3, the army marched out from Saffaria lightly

[1] Ralph of Coggeshall, p. 222, here agrees wonderfully well with the Moslem chronicler, Ibn-Alathír.

equipped, and leaving all its impedimenta behind in the camp. The order of march is not very clearly stated ; but we know that the Count of Tripoli, as the chief vassal of the Crown present, led the van, while the Templars brought up the rear. The king, with his military household, and with another corps told off to the defence of the True Cross, was in the middle. How many divisions the whole army contained we are not told, nor is it explicitly stated that each consisted of horse and foot combined, though this must almost certainly have been the case.

The Franks had marched about nine or ten miles, when they began to be surrounded by swarms of Turkish skirmishers. Saladin did not display his main force, but enveloped their army with a cloud of horse-bowmen, whose orders were to make the march slow and painful. By the time that the host drew near the deserted village of Marescalcia,[1] it was terribly weary and harassed. Only some six miles now separated it from the town of Tiberias and the lake.[2] The van, which had pushed down into the lower ground and was still advancing, was within three miles of the water. But between the weary Crusaders and their goal lay the hills of Tiberias, a range rising to about one thousand feet above sea level: the northern point, Kurn-Hattin, is eleven hundred and ninety-one feet high. Behind the crest of these hills the ground falls suddenly towards the deep-sunk hollow of the Sea of Galilee. Tiberias itself is no less than six hundred and fifty-three feet below the level of the Mediterranean. All along the range the Turks were arrayed, and it was necessary for the army to cut its way through them by one of the two passes which cross at its lowest points—the depressions called the Wady-el-Muallakah and the Wady-el-Hammam.

Tired as the army was, there was an absolute necessity that it should push on, for there was no water available for three miles around, and men and horses were already perishing of thirst. The Count of Tripoli sent back to King Guy, begging him to hasten the advance at all costs, as the day was drawing on, and the lake must be reached ere nightfall if the army was

[1] Probably the modern Lubieh.

[2] The distance is grossly understated in Coggeshall, who says that there were only three miles between Marescalcia and the lake, and that the van under the Count of Tripoli was actually only one mile from Tiberias (p. 223).

to be preserved. But the king and his counsellors were disheartened, and no longer possessed the courage to order a final assault upon the heights where the Turks clustered so thick. Moreover, the Templars in the rear were sending messages to say that they were so hard pressed that they had been forced to halt, and could not keep up with the advance of the column in front of them. Harassed and tired out, the king ordered the whole army to halt and encamp where it stood, on the hillside near Lubieh. The command was a fatal mistake; it would have been wise to push on at all costs to Tiberias: if this was not done, a lateral movement of only three miles northward would have brought the host to the perennial stream in the Wady-el-Hammam, where the whole army could easily slake its thirst, and four miles more would take them to the lake. Fearing, however, that the Templars would be cut off if any further advance was made, and shirking the attack on the formidable bodies of Turks holding the hilltops, Guy bade the trumpets sound for halt and encampment. Raymond rode back to join the main body, exclaiming, " Alas, alas, Lord God ! the war is ended ; we are all delivered over to death, and the realm is ruined."[1]

That night the Franks camped, huddled together around the royal standard on the hillside. There was little food and hardly a drop of water in the host: even sleep was impossible, for the Turks came close in under cover of the darkness, and kept up a constant shower of arrows into the camp. They also fired the dry grass to windward of the Crusaders, so that stifling clouds of smoke were drifting over it all night. "God fed the Christians with the bread of tears, and gave them to drink without stint of the cup of repentance, till the dawn of tribulation came again."[2] The Saracens were not much more easy in their minds than their enemies : with the lake at their back and the formidable Christian army still intact, they had many qualms of spirit when the fight was renewed on the morning of Friday, June 4.[3]

King Guy had once more ranged his army in order, with the same divisions as he had drawn up on the previous day—the Count of Tripoli in front, the military Orders in the rear. Swerving from his original route, he now ordered the march to

[1] Ralph of Coggeshall, p. 223. [2] Ibid. p. 224.
[3] Boha-ed-din, p. 94.

PLATE X.

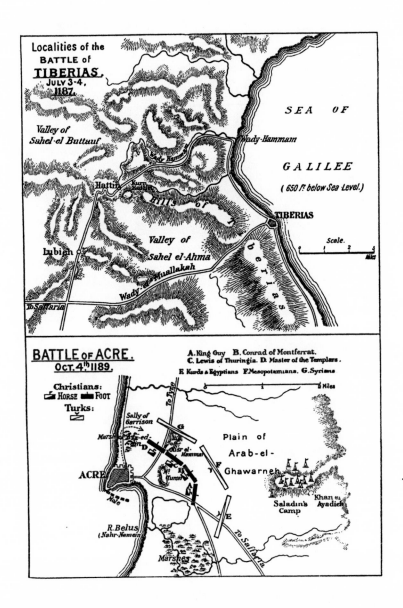

Localities of the
BATTLE of
TIBERIAS,
JULY 3-4,
1187.

Valley of
Sahel·el Buttuuf

SEA OF

Wady Hammam

GALILEE

(650 ft below Sea Level.)

Hattin Kurn Hattin

Hills of

TIBERIAS

Scale.

Valley of
Sahel el·Ahma

Lubigh

Wady el Muallakah

To Saffuria

BATTLE of ACRE.
OCT. 4th 1189.

A. King Guy B. Conrad of Montferrat.
C. Lewis of Thuringia. D. Master of the Templars.
E. Kurds & Egyptians F. Mesopotamians. G. Syrians

Christians:
HORSE FOOT
Turks:

Sally of
Garrison

G

Marsh Tel-ed-

Kisr el-
Hammam

D

Plain of
Arab-el-
Ghawarneh

ACRE

F

Turon

Saladin's
Camp

Khan el
Ayadich

E

R. Belus
(Nahr-Namein)

To Tyre

To Saffuria

Marshes

be directed towards the Wady-el-Hammam and the village of Hattin, aiming at the nearest water, and no longer taking the shortest way to Tiberias. Saladin had now brought up his whole host, which encircled the Christians on all sides, though the thickest mass lay across the road to the lake. The Crusaders moved forward for some distance, and were about to join in close combat, when the king detected great unsteadiness in his infantry. They had been told off to the various corps of cavalry, and were directed to form line in front of them, "that the two arms might give each other the proper support, the knights protected by the arrows of the foot, and the foot by the lances of the knights."[1] At the moment of close combat, however, the greater part of the infantry, after wavering for a moment, shrank together into one great mass, and, swerving off the road to the right, climbed a hill (probably Kurn-Hattin) which lay to that flank, and formed in a dense clump on its summit, deserting the horsemen on the road below.[2] The king sent messenger after messenger to them, imploring them to come down and play their part in the battle. The only answer which they returned was that they were dying of thirst, and had neither will nor strength to fight. Already despairing of the event of the day, but determined to push on as long as it was possible, Guy ordered the knights to advance towards the lake. But ere long the Templars and Hospitallers in the rear sent to him to say that they were so hard beset that they could not move forward any more, and must succumb if not strongly reinforced. "Then the king, seeing that the infantry would not return, and that without them he could not prevail against the arrows of the Turks, ordered his men to halt and pitch their tents. So the battles broke up, and all huddled together in a confused mass around the True Cross."[3]

It was not, however, the whole of the Christian knighthood which gave way to this impulse of despair and fell into a passive defensive which was bound to prove fatal in the long-run. The Count of Tripoli and the van division, seeing the ruin behind them, and finding the Turks already stealing in between them and the king's corps, resolved not to return, but to cut

[1] Ralph of Coggeshall, p. 224.

[2] " Conglobati sunt in unum cuneum, et veloci cursu cacumen excelsi montes, relinquentes exercitum, malo suo ascenderunt" (*ibid*, p. 225).

[3] *Ibid*. p. 225.

their way through the Moslems and seek refuge in flight. "The battle is hopelessly lost; let every man save himself if he can,?[1] cried Raymond, and, forming his corps in a close body, he charged the Turks immediately in front of him, aiming no longer at the lake, but at the hills to the north-west. His desperate assault burst right through the circle of horse-archers, and he, with his comrades, Balian of Nablous and Reginald of Sidon, and the whole of their retainers, got safely away to the north. The Moslem chroniclers say that Saladin's nephew, Taki-ed-din, who commanded in this part of the field, made no serious effort to check or pursue them, because he judged that it would be more profitable to let them go,—for their departure enfeebled the Christian army by a third, and left the remainder a more certain prey to Saladin. It is permissible to suspect that the plea was an afterthought, and that the Turks were in truth cowed by the sudden charge of these desperate men.

Meanwhile, all had gone to ruin in the rear. While one swarm of Moslem horse beset the confused mass of knights huddled together around the king's banner and the True Cross, the rest turned to assault the infantry. The wretched fugitives on the hill were too exhausted to offer any real resistance. The first charge of the enemy split up their ill-compacted ranks; some were ridden down, some were cast by the impact over the cliff at the back of the hill, and met their death in the fall. The majority threw down lance and arbalest and held out their hands to the conquerors. The Turks slew many, and accepted the rest as captives.

The fate of the king and his knights was no less dismal. They held out for a long time, though neither victory nor retreat was any longer possible. Encompassed on all sides by the dense swarm of Turks, they could only stand to be shot down. At last, though their horses were reduced to the last pitch of fatigue, and though they themselves had drunk their last drops of water on the previous night, the whole or part of the host resolved to make one more push for liberty. They might perhaps cut their way through to safety, as the Count of Tripoli had done a few hours before. A Mohammedan chronicler[2] has preserved a good account of this last charge,

[1] "Qui potest transire transeat, quoniam non est nobis praelium." A perfect mediæval rendering of "Sauve qui peut." (Ralph of Coggeshall, p. 225.)

[2] Ibn-Alathir.

which he drew from the memory of an eye-witness, Saladin's son, Malek-el-Afdal, who first drew sword at the battle of Tiberias. The prince rode by his father's side at the head of the Sultan's reserve, behind the circle of skirmishers which was besetting the Crusaders.

"When the king of the Franks and his knights," said Malek-el-Afdal, "found themselves pressed together on a hillock on the side of the hill of Kurn-Hattin, I was with my father. I saw the Franks make a gallant charge at those of the Moslems who were nearest them, and drive them back close to the spot where we stood. I looked at my father and saw that he was deeply moved; he changed colour, grasped his beard in his hand, and moved forward crying, 'Let us prove the devil a liar!'[1] At these words our men precipitated themselves upon the Franks, and drove them back up the hillside. I began myself to be overjoyed, and to cry, '*They fly! they fly!*' But the enemy presently came back to the charge, and for a second time cut their way to the foot of the hill; when they were again driven back, I began to cry afresh, '*They fly! they fly!*' Then my father looked at me and said, 'Hold your tongue, and do not say that they are really routed till you see the king's tent fall.' Shortly after we saw the tent come down; then my father dismounted, prostrated himself to the earth in thanks to God, and wept tears of joy."

When the second attempt to pierce the Moslem circle had failed, and all hope was gone, we are told that in their despair the Franks dropped from their exhausted horses, cast down their lances, and threw themselves sullenly upon the ground. The Turks ran in upon them and took them captives without another blow being struck. To their great surprise, they found that very few of the knights were seriously hurt; their mail-shirts had protected them so well from the arrow-shower that few were badly wounded and hardly any slain. Thirst and exhaustion had brought them down, rather than the shafts or scimitars of the conquerors. On the other hand, there was hardly a horse that was not sorely hurt, and not one that could have carried his rider out of the battle. The poor beasts were utterly worn out by two days' deprivation of water and forage.

In the corps which thus surrendered with the king were all

[1] Meaning, I suppose, that as God had promised victory to the True Believers, any thought of defeat must be an inspiration from Satan.

the great barons of Palestine save those who had got off in company with the Count of Tripoli. They included the king's brother Amaury, Constable of Jerusalem, the Marquis of Montferrat,[1] Joscelin, titular Count of Edessa, Reginald of Chatillon, lord of Kerak and Montreal, Humphrey of Toron, Hugh of Tiberias,[2] Hugh of Giblett, the Bishop of Lydda, the Master of the Hospitallers, and many scores of knights of wealth and name. Few persons of any note had fallen—the Bishop of Acre, who had borne the Holy Cross throughout the battle, is the only magnate reckoned among the dead.

That evening Saladin held a review of the prisoners. He kindly entreated King Guy and most of the barons, but he called out and slew with his own hand Reginald of Chatillon, who had earned his hate by breaking a truce and by plundering some pilgrims to Mecca who had passed by his castle of Montreal. He also bade his bodyguard slay off-hand all the knights of the Temple and Hospital who had fallen into his hands. Not content with this, he proclaimed throughout his host that any private soldier who had captured any member of the military Orders must give him up. For each knight so surrendered he paid the captor fifty *dinars*, and then sent the prisoner to join his comrades in death. More than two hundred Templars and Hospitallers were thus slain in cold blood. Saladin looked upon them as the professed and professional enemies of his faith, and never gave them quarter. When we remember that he had committed such atrocities, we need not blame too bitterly misdeeds on the other side such as Coeur de Lion's massacre of the garrison of Acre.

Few victories have brought in their train more important results than that of Tiberias: within a few months the whole of the kingdom of Jerusalem save a few coast-fortresses was in the hands of Saladin. The realm had been drained dry of men to supply the army which perished on the hillside of Hattin, and its towns and castles fell helplessly before the Moslem for sheer lack of defenders. Places that had braved the assaults of the Infidel for eighty years opened their gates at the first summons;

[1] Boniface, father of the more celebrated Conrad of Montferrat, who figures in the third Crusade.

[2] I suppose that the "son of the Lady of Tiberias," named by Boha-ed-din, is this Hugh, eldest son of the lady, who had by now married as second husband Raymond of Tripoli.

because there were none but clerks and women left within them. Jerusalem itself surrendered after a siege of only twelve days. A few remote castles like Kerak and Montreal had been left better garrisoned, because they lay in the extreme limit of the kingdom, and some of these held out till 1188. Montreal, enduring the extremities of famine, did not surrender till May 1189. But in the main body of the realm, Tyre, whither the sad survivors of Tiberias had retired, was the only stronghold of first-rate importance which remained in Christian hands.

Such were the consequences of the overhaste of King Guy, and of his determination to cut his way to the relief of Tiberias without having taken account of the character of the countryside in which he was to fight. We may safely say that if he had taken more care about supplies, and especially about his provision of water, and had carefully planned out his itinerary, he might have reached his goal. The Saracens were in a very uncomfortable position, with the lake at their backs and no place of refuge near; one more such push as the Count of Tripoli had advised on the evening of the first day would probably have led, to their withdrawal. But a much more easy alternative would have been to have encamped in some well-watered spot, such as Saffaria, and awaited the retreat of Saladin. The Sultan must have soon retired for want of provender (and especially of fodder) in the wasted country about Tiberias, and he could not have dared to disperse his army for foraging purposes, in the face of the Christian host, while it remained intact and concentrated in front of him. The whole battle, therefore, was unnecessary, and the details of Guy's bad generalship are comparatively small blunders when compared with the enormous initial mistake of fighting at all.

Battle of Acre, October 4, 1189.

When, only two years after the fatal day of Tiberias, we once more find the Christians capable of contending on equal terms with Saladin, it is of course due to the arrival of reinforcements from the West. The exhausted remnant of the Syrian Franks could have done nothing. When King Guy was freed from captivity in 1188, and set himself to gather forces for the recovery of some foothold in his lost realm, it took him a year to collect seven hundred knights and nine thousand foot, and these were not for the most part his own vassals (though Tripoli

and Antioch lent him some succour), but early arrivals from among the men of the West who had taken the Cross when the news of the capture of Jerusalem reached Europe. Guy was not even in possession of Tyre, the one important city of his realm which still remained in Christian hands. His rival and brother-in-law, Conrad of Montferrat, shut its gates and refused to admit him.

It was, therefore, an act of no small daring when, on August 28, 1189, Guy and his little army boldly challenged the power of Saladin by marching on Acre and encamping before its walls. The siege began as a blockade and nothing more, for the Turks were able to pass in and out of the place at will. But gradually the crusading contingents began to drop in one by one from the West, and, less than a month after the siege began, nearly forty thousand men were assembled around Acre. On September 14 they engaged in a bloody and indecisive fight with a relieving army which Saladin in person had led to the succour of the garrison ; the Sultan succeeded in throwing a large convoy into the city, but failed in his design of driving off the besiegers. This encouraged the Crusaders, whose numbers were still growing every day, to attempt a counter-stroke. They first completed the investment of Acre by extending their pickets from sea to sea across the neck of land on which the city stands. Then, after having shut off the garrison from the army without, they resolved to offer battle in the open by marching upon the Sultan's camp.

The crusading host lay in a semicircle round Acre, with the king's pavilion pitched on "Mount Turon" (Tel-el-Fokhar), a low hill ninety feet high, which lies about fourteen hundred yards from the walls. The Turkish army formed a much larger semicircle, separated from the Franks by an interval of about two miles. Its central rallying-point was the hill of Ayadieh, rising two hundred and fifty feet above the plain : here Saladin himself lay. His subordinates stretched out to right and left, watching the whole of the plain from the river Belus (Nahr-en-Namein) on the south to the sea on the north. That the armies engaged were really very large, and that the chroniclers for once cannot be very far mistaken in the numbers that they give, is best shown by the fact that the length of the Frankish lines must have been more than two miles, and the front covered by the Sultan's host no less than three miles.

Descending from Mount Turon into the plain of Arab-el-Ghawarneh, which stretches away to the foot of the hill of Ayadieh, the Crusaders formed themselves in four corps. The first (counting from the right) was commanded by King Guy, and consisted of the Hospitallers, the king's own following, and the French Crusaders under the Count of Dreux and the Bishop of Beauvais. In the second corps were the Archbishop of Ravenna and Conrad of Montferrat, with the greater part of the Italian Crusaders and such of the barons of Palestine as adhered to Conrad[1] in his feud with King Guy. In the third was Lewis, Landgrave of Thuringia, with the greater part of the German contingents and the Pisans under their archbishop. In the fourth marched the Templars, under their Master, Gerard of Rideford, the Counts of Bar and Brienne with the Crusaders from Champagne[2] and the smaller part of the Germans.

Geoffrey of Lusignan, the king's brother, and James of Avesnes remained behind in the camp with a reserve.[3] They had to watch the city, whose investment had to be relaxed when the army took the field. Apparently the space from Mount Turon northward to the sea was no longer observed, nearly a mile being left open; only the eastern face of the wall was covered by the camp, the northern face was free.

In each of the four marching divisions of the Christian host the proper disposition of horse and foot was carried out. The bowmen and arbalesters formed a long continuous first line: behind them marched the knights in close order. The whole host fronted north-east, and set its face towards the Sultan's tent, plainly visible on the hill of Ayadieh. The line looked very formidable and strong: the chroniclers give its numbers at four thousand horse and a hundred thousand foot—figures from which some deductions may be made.

On seeing the Christians moving forth from their camp, Saladin had promptly drawn up his host in front of them. The army reached from the sea to the Belus, with a semicircular front of more than three miles : the centre was somewhat refused, the wings somewhat thrown forward. The array of the various

[1] Conrad had been temporarily reconciled to King Guy, and had lately come to help him in the siege : with him had arrived the Archbishop of Ravenna.

[2] "Catalauni," as the letter of Theobald given in Ralph de Diceto calls them. Henry of Champagne himself came later to Acre, but the Counts of Bar and Brienne, both Champenois, were already in the field.

[3] Probably Syrian Franks and Netherlanders.

contingents is elaborately set forth by Boha-ed-din: to the south, next the river, were the garrison of Egypt, the old troops of Shirkuh; next to them were the followers of Modhaffer-ed-din, lord of Edessa and Haran; beyond these the contingent of Sinjar in Mesopotamia; next were the whole of the tribes of Kurdistan, under their great emir, Mashtoub. These four corps formed the left wing. The centre consisted of the Sultan's bodyguard and the Mesopotamian troops from Diarbekr, Mosul, and Hisn-Kayfa. The Sultan himself, his son Malek-el-Afdal, and his nephew Malek-ed-Dafer, were here in command. The right wing, which lay towards the sea, was composed of the Syrian contingents, headed by Saladin's nephew Taki-ed-din, Prince of Emesa.

When the Christians began to advance into the plain, they soon found that the intervals between the four corps in their line of battle were growing greater. This was necessarily the case when they marched out from a comparatively narrow position into a wide plain whose whole breadth was held by the enemy. When they began to extend their front to make it equal to that of the Turks, each step farther forward brought about a wider separation between the centre and the wings. This was a disastrous fact for the Franks, whose main chance of victory lay in their being able to keep a well-closed-up line. In the actual fighting, as we shall see, this was so far from being the case that three separate engagements were fought by the left wing, the right wing, and the two centre divisions.

The first contact occurred in the northern part of the field, where the Master of the Templars faced the Syrian contingents of Taki-ed-din. After a few minutes the Infidels began to give ground: Boha-ed-din assures us that the movement was voluntary, and that the Prince of Emesa was desirous of drawing away the Christian left wing from the main body by his retreat. Whether this was so or not, it is at any rate certain that Saladin, seeing his right wing retiring, sent to its aid heavy reinforcements from his centre. These succours enabled the Syrians to retake the offensive, and the Templars had to re-form their line on a hill lying toward the sea (probably the rising ground now known as Kisr-el-Hammar). Here the battle stood still for some time without marked success on one side or the other.

Meanwhile, Saladin's despatch of troops from his centre towards his right had been observed by the Franks, and the

two central divisions of the Christian host, led by Conrad of
Montferrat and Lewis of Thuringia, delivered a fierce assault
on the Sultan's main body. They marched at a moderate pace
with the infantry in front shooting hard, till they came in
contact with the Mesopotamian troops from Diarbekr and Mosul.
When the lines closed, the knights passed through intervals
opened out for them by the foot-soldiery, and crashed into the
Turkish ranks. The Infidels could not stand the shock: their
line was broken, and they fled in wild confusion toward their
camp on the hill of Ayadieh. Saladin could not rally them, and
many of the fugitives were so panic-stricken that they rode
without drawing rein as far as Tiberias, or even Damascus.
Following the routed Türks, the two divisions of the Frankish
centre stormed up the hill and plunged into the camp. It would
have been hard to keep them in order among the tents and
other obstacles which broke their line; but, as a matter of fact,
no one made any attempt to restrain them. Horse and foot
scattered themselves through the encampment and turned, some
to slaughter and some to plunder. The Sultan's own pavilion
was sacked and cast down, three of his body servants being slain
therein. Some of the Franks turned to cutting down the camp-
followers, others burst into the sutlers' quarter and plundered
the market. No one made any attempt to prevent the routed
Türks from rallying, or to take in flank the still intact wings of
Saladin's army.

Meanwhile, King Guy and the right wing of the Franks
seem not to have come to a decisive engagement with the
Kurds and Mamelukes of Saladin's left. Neither Western nor
Eastern writers give any clear account of the movements in this
part of the field. It seems likely, however, from a passage in
Ibn-Alathir, that the Moslems were somewhat outflanking the
Christians, since the latter had partly followed the advance of
their centre. Lest the enemy might use the opportunity and
get between him and the camp, the king may probably have
held back.

By the most untiring personal exertions Saladin at last
succeeded in gathering together a great part of his routed centre
somewhere at the western foot of the Ayadieh hill. His officers
besought him to lead them to storm their lost camp, but he
refused, and bade them wait till the Franks should leave it, and
then to charge them when their backs were turned to the

Moslems. Before long the Germans and Lombards began to evacuate the hill, some burdened with plunder, others wishing to re-form on the open ground and then to go to the help of the king or the Templars. The retreat was executed in great disorder, and not without panic: many thought that some disaster had happened in the rear to account for the fact that their comrades were tramping down hill. The author of the *Itinerarium* tells us that in one part of the field a knot of Germans, running to catch an Arab horse which had broken loose, were supposed by the rest to be flying, and caused a senseless rush to the rear.

When the Christians were trooping in disorderly masses back to the plain, Saladin suddenly let loose his rallied Mesopotamian horsemen upon them. The results of this charge were decisive: the scattered bands of Crusaders were caught wholly unprepared; they had no time to form up and defend themselves, but were hurried back across the plain by the shock of the Turkish horsemen. In utter rout some fled toward King Guy's corps, some straight to the camp. Saladin followed, slaying the hindmost and easily driving all before him. The crusading right wing seems to have made some attempt to rescue the fugitives, and Guy himself is said to have saved the life of his old enemy, Conrad of Montferrat, by hewing out a passage for him when he had been surrounded by the pursuers.[1] But the king and the Hospitallers could not restore the battle, and were themselves thrust back towards the camp by the rushing mass of pursuers and pursued. Apparently the Turkish left wing tried to push itself between the Franks and their place of refuge,[2] and, though it failed to cut off their main body, its movements must have hastened the retreat. The flight only ceased when James of Avesnes and Geoffrey de Lusignan led the reserve out of the camp and covered the flight of the disorderly crowd of horse and foot to their tents. Saladin halted below Mount Turon, and would not allow any attempt to be made to storm it: he dreaded the strength of the Franks when acting on the defensive.

Meanwhile, a separate battle had been fought on the hillside to the north by Taki-ed-din and the Master of the Templars. We have already mentioned that, after the first shock, the fight had come to a standstill in this quarter, owing to the reinforcements which Saladin had sent to his nephew. A second accession of forces to the Moslems settled the fate of the combat.

[1] *Itinerarium*, p. 71, cap. xxx. [2] Ibn-Alathir.

Seeing the Christians engaged in the battle and paying no heed
to the town, the garrison of Acre sallied out five thousand strong,
from the northern gate, that most remote from Mount Turon.[1]
Then, taking a circuitous route, they came out upon the rear of
the Frankish left, and fell upon the Templars and the Champenois
while the latter were hotly engaged with Taki-ed-din. The
intervention of this new corps broke the spirit of the Crusaders.
They gave up all for lost, and merely strove to cut their way
back to their camp. Being beset in front and rear, it was only
a portion of them who succeeded. Eighteen knights of the
Temple fell, and their Grand Master, Gerard, was captured, and
beheaded by Saladin's orders. Andrew of Brienne, the brother of
the Champenois count, was also slain, and forty knights more.
So great was the slaughter in this part of the field that the numbers
of the fallen in the Christian left wing far exceeded those lost
by the right and the centre.[2] Thus ended in defeat a battle
which might under proper guidance have led to the complete
discomfiture of the relieving host. The Franks had risked much
by engaging in the vast plain of El-Ghawarneh, where their
corps were certain to get separated the one from the other.
Nevertheless, the misbehaviour of the Sultan's centre put the
victory into their hands. If, instead of falling on the camp, and
there wasting a precious hour, Conrad and the Landgrave had
turned to take the Turkish wing-divisions in the flank, the
Infidels could not possibly have escaped a dreadful disaster.
Taki-ed-din's corps might have been hurled into the sea, and the
Kurds and Egyptians thrust into the marshes of the Belus, if
either of them had delayed a moment too long before taking to
flight. But when the battle was really won, the leaders and the
led were equally incapable of using their advantage. The men
turned to pillage, and we have no proof that any of their
officers thought of calling them off or conducting them to
another part of the field. Hence the Sultan, with his usual
ability, was able to rally his men, and snatch a victory out of
the jaws of defeat.

[1] *Itinerarium*, p. 70, and letter of Theobald and Peter Leo in Ralph de Diceto.

[2] Boha-ed-din (p. 145) took great pains to make out the sum of the Christian
losses. He considered the number of seven thousand, that which was generally
accepted in the Sultan's camp, as exaggerated. But having questioned the officer who
had been charged to make away with the Christian corpses on the northern part of
the field, he was told that four thousand one hundred had been carted off. He
therefore estimated the losses of the right and centre at less than three thousand.

22

Our only wonder is that he did not utilise his success for a further assault on the Franks. But he had a wholesome dread of the enemy when acting on the defensive, and (as we are told) his own army was in the greatest disorder. Not only the Crusaders, but the Turkish camp-followers had turned to pillaging the tents on the hill of Ayadieh, and for the whole day after the fight, as we read, the troopers were occupied in seeking their lost goods and extracting them from the plunderers. When a few hours were past, the Christians, whose losses had been far less than might have been expected,—only the left wing had really suffered much slaughter,—were safe in their camp, and more angry than afraid. When the Sultan held back, they were so far from being cowed that their next move was to run a line of circumvallation from sea to sea, and actually seal up the garrison of Acre within its walls.

As to losses, we have no good account of those suffered by the Moslems. The contemporary letter of Theobald and Peter Leo to the Pope estimates them at fifteen hundred horsemen, a not improbable figure. Boha-ed-din names as slain the Kurdish Emir Moudjelli and a few more chiefs, together with about a hundred and fifty persons of no importance. Considering the rout of the centre, these numbers are wholly improbable, and cannot be accepted. On the other hand, the Christian sources give the loss of the Crusaders at fifteen hundred only,[1] naming Andrew of Brienne and Gerard the Grand-Master as the only notable men among the slain. These figures are equally incredible, especially in face of Boha-ed-din's statement as to the counting of the corpses.[2] On the whole, we may perhaps guess that each side made a better estimate of its enemy's losses than its own, and put them at fifteen hundred Turks to seven thousand Franks.

Battle of Mansourah, February 8, 1250.

In our chapter on the Strategy of the Crusades we have already had occasion to mention the battle of Mansourah as the ill-fought end of an ill-planned advance into Egypt. We pointed out the madness of a march across the canals and waterways of the Delta, and showed how the campaign was certain to end in a check, owing to the numerous and strong defensive positions which were in the hands of the Egyptian army.

[1] *Itinerarium*, p. 72. [2] See p. 337.

St. Louis started on his adventure under much more favour-
able circumstances than his predecessor King John of Jerusalem
had met thirty years before. The Crusaders of 1219 had only
secured themselves a basis of operations by the capture of
Damietta after besieging the place for a year. Their strength
was exhausted before they even started on their march up-country.
By an extraordinary chance St. Louis in 1249 took the town
without striking a blow. All Egypt was in disorder owing to the
mortal sickness of Sultan Malek-Saleh,[1] and there was no single
strong hand at the helm. When the troops who had been told
off to oppose the landing of the French were beaten back, and
retired towards the interior, the corps which had been selected
to garrison Damietta evacuated the place in a panic and fled
after the rest.[2] It was to no purpose that the Sultan roused
himself from his sick-bed to order fifty of their officers to be
hanged: the strong city had passed into the hands of the
Crusaders, and gave them a secure starting-point and place of
arms: it was full of stores and in perfect order, since there had
been no occasion to batter its walls with siege engines (June
6, 1249).

Having begun so well, it was incumbent on the French king
to utilise his first success and push forward while the enemy
were still panic-stricken. It is therefore with nothing less than
astonishment that we hear that King Louis waited nearly six
months at Damietta before he began his march on Cairo. The
circumstances explain, but do not excuse, this halt: a large part
of the armament had been blown into the Syrian ports by a
contrary wind, and it was thought necessary to await its
appearance: the summer was at its height, and the Nile flood
was rising over Lower Egypt, so that the face of the land was
well-nigh covered with water. These would have been good
reasons for delaying the attack on Damietta till the approach of
the cold weather and the sinking of the flood: it was obviously
the worst possible month for an advance when the heat was at
its greatest and the country most water-logged. Undoubtedly
June was a bad season for the invasion, but, having once begun,
the French were bound to go on: their delay merely enabled

[1] The Sultan was dying of a malignant ulcer in his thigh, which contemporary
rumour ascribed to his having lain on a poisoned mat spread for him by one of his
slaves.

[2] Makrizi in the *Bibliothèque des Croisades*, iv. 42.

the Sultan to organise his resistance with a clear knowledge of the route which his enemies must take. There had been a fearful panic at Cairo when the news of the fall of Damietta arrived, but the long quiescence of the Franks enabled the Egyptians to recover their self-possession and bethink them of the best means of defence.[1]

It was not till October that the last contingents of the French army straggled in from Syria : they had brought with them a number of the barons of the Holy Land, who placed themselves under the Count of Jaffa.[2] There was some discussion when the whole host was mustered as to whether it should not be transferred to Alexandria,[3] and attack Egypt from that side. This plan was supported by Peter of Brittany and many other barons, and had its advantages, for the march into Egypt from Alexandria presents far less difficulties than that from Damietta. But it must have begun with a second disembarkment and a toilsome siege. When the king's brother, Robert Count of Artois, explained that those who wish to kill the snake strike at its head,[4] and voted for an immediate advance on Cairo along the Damietta branch of the Nile, he carried the king and the council with him, and the hopeless march began.

On the 20th of November[5] the army commenced its march, moving slowly forward past Fareskour, Scharemsah, and Faramoun, while the flotilla advanced parallel with it on the Nile. A few miles after Faramoun was passed, the advance came to a standstill (19th December), when four weeks had been occupied in advancing fifty miles. The check was caused by the fact that the king found in front of him the first formidable watercourse which cuts the way from Damietta to Cairo. At the town of Mansourah the Damietta branch of the Nile divides itself into two parts : the one flows down to Damietta, the other turns east and falls into the swamps of Lake Menzaleh. It was in front of the latter that the Christian army found itself stopped; this second waterway, which the natives call the Ashmoun Canal, lay across its path. Behind it the whole levy of Egypt was massed; the Sultan had taken post there when Damietta

[1] Jemal-el-din in the *Bib. des Croisades*, iv. 451, 452.
[2] John of Ibelin. He had himself been with the king at the first landing (Joinville, p. 215).
[3] By sea, I presume : not even the French barons can have dreamed of marching over three branches of the Nile and the whole breadth of the Delta.
[4] Joinville, p. 219. [5] William of Nangis, p. 374.

fell, knowing that it was the first strong defensive position which the French must attack. Just as the critical moment was approaching, his old malady carried him off in the last week of November, and he had been dead some time when St. Louis reached Mansourah. His widow and his ministers, however, kept his death secret, and orders were still issued in his name. The real charge of the defence of Egypt fell to the Emir Fakr-ed-din, the commander of the army, on whom it was agreed to confer dictatorial powers. Meanwhile, swift messengers were sent to seek Malek-Saleh's son and heir, Turan Shah, who was far away at Hisn-Kayfa in Mesopotamia. Till he should arrive the Sultan's death was concealed from his subjects.

The French army now found itself at the point of a narrow tongue of land, an "island" as Joinville calls it, between the main branch of the Damietta Nile and the Ashmoun Canal. It was necessary to force the passage of one or the other of these waterways ; and, both because it was smaller and because it covered the direct road to Cairo, the king chose the Ashmoun as his objective.

Opposite him lay the tents of the Egyptian army, stretching for two or three miles along the farther bank. In their midst rose the walls of Mansourah, and outside its western gate the palace of the Sultan. The place was but thirty years old ; in 1220, after he had beaten John of Brienne on this same ground, the Sultan El-Kamil had built a new city to commemorate his victory. The strategical exigencies of the roads of the Delta had placed St. Louis and Malek-Saleh in exactly the same position as was occupied by their predecessors during the fifth Crusade.

The Egyptian army was now composed of better stuff than had been the case in 1220. It was Malek-Saleh who had first organised the celebrated corps of the Circassian Mamelukes which was to dominate Egypt for the next six centuries. The mercenary troops of his predecessors had been mainly Kurds and Syrians, but he had learned the military worth of the men of the Caucasus, and had been steadily buying Circassian slaves for many years and incorporating them in his guard. The eight or ten thousand Mamelukes formed the core of his host : to support them were arrayed the horsemen of the Bedouin tribes and the general levy of Egypt, who had marched out at the exhortation of their mollahs and imams to save Islam. These

formed a great mass of troops, both horse and foot, but were of little military value. The whole brunt of the war fell upon the heavily-armed and well-mounted Mameluke horsemen.

Seeing the Egyptians clustering so thick around Mansourah, St. Louis resolved not to make any attempt to throw his army across the canal by means of his boats, but to build a solid causeway and so dam up the channel and cross on foot. Accordingly he set his foot-soldiery to cast earth into the Ashmoun on a broad front; the causeway advanced a few yards, but soon the discharge of missiles from the opposite bank became so deadly that the work was stopped; the king saw that the earth-bearers must be protected, and therefore built along the incomplete dam two "cats," i.e. covered-ways or penthouses, under shelter of which he trusted that the workers might complete their task. The "cats" were protected by two high wooden towers called "belfreys" placed at the water's edge. To batter down these protections the Egyptians soon set their military machines to work, and sixteen perrières and mangonels hurled large stones or barrels of combustible matter at the covered-ways and wooden towers. The French replied by setting up against them eighteen similar engines, and the two parties shot at each other across the river for some days.

As long as the "cats" were safe the causeway could advance, and the labourers succeeded in filling up the bed of the canal for more than half its breadth. But on the other side the Egyptians began cutting away the bank, and, the force of the current aiding them, they succeeded in keeping the Ashmoun open. "In one day they undid what it had taken us three weeks to accomplish," says Joinville, "for all our work in stopping the channel was useless when they enlarged it on the other side." [1]

Meanwhile, Fakr-ed-din threw a detachment across the canal lower down its course, and sent them to fall on the rear of the French camp; they were, however, beaten off with some loss by the king's brothers, the Counts of Anjou and Poictiers (December 25, 1249). This was but a diversion; the real centre of the fighting was the causeway; here the matter finally went ill with the French. By hurling barrels of Greek fire at the belfreys and "cats," the Infidels finally succeeded in setting them in flames. Nothing could be done till they were rebuilt with ship-timber which the king bought for the purpose. But only a few days

[1] Joinville, p. 221.

PLATE XI.

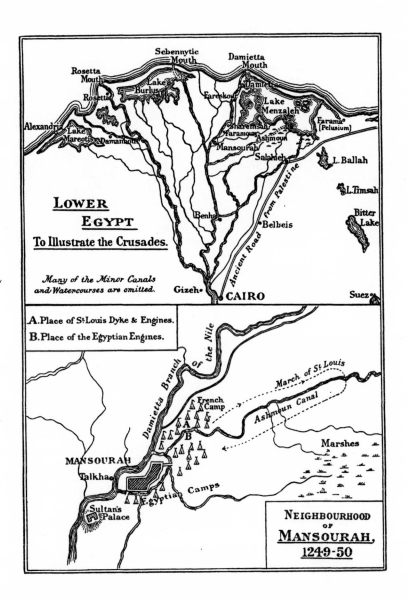

LOWER
EGYPT
To Illustrate the Crusades.

*Many of the Minor Canals
and Watercourses are omitted.*

A. Place of St Louis Dyke & Engines.
B. Place of the Egyptian Engines.

NEIGHBOURHOOD
OF
MANSOURAH,
1249-50

after the new engines had been erected, they were again burned by the same means as before.

A deep discouragement now pervaded the French host: it seemed that they had been brought to a complete standstill. But a few days later the Constable Humbert of Beaujeu discovered a Copt or a renegade Mussulman[1] who told him that four miles to the east of Mansourah there was a ford over the Ashmoun, deep and difficult indeed, but quite practicable for cavalry (Feb. 7, 1250).

The army had now been stranded for nearly two months in front of Mansourah, and Louis felt that he must leave no device untried, even though it were as dangerous as that of crossing a deep ford in face of the enemy and without any possibility of aid from his infantry. He accordingly resolved to attempt the passage on the next morning.

During the night of the 7th – 8th February his dispositions were made. The Duke of Burgundy and the barons of Palestine with their knights were to remain behind in the camp, and take charge of the great mass of foot-soldiery. When the king should have reached and captured the Egyptian machines which commanded the half-built causeway, they were to complete it in all haste and cross over to join their leader.

Meanwhile, Louis himself, with his three brothers, Charles of Anjou, Robert of Artois, and Alphonso of Poictiers, and the main body of the horsemen, was to march to the ford and pass it at daybreak. When they were on the southern bank they were to push along it to the Egyptian camp, burst into it, and capture or destroy the engines at the causeway before the enemy should recover from his surprise.

We have no complete account of the array of the cavalry corps which marched to the ford. We know, however, that the Templars, under their Grand Master, William de Sonnac, rode first, and that the van division included also the followers of Robert of Artois, Peter Duke of Brittany, John Count of Soissons, Raoul lord of Coucy, and the small English contingent which William Longsword, the titular Earl of Salisbury,[2]

[1] Joinville, p. 220, calls him a Bedouin, so does William of Nangis. But some of the Mohammedan writers call him a Copt.

[2] Henry III. had refused to give him his father's earldom, and conferred a pension on him instead. But William was nevertheless called earl by most of his contemporaries.

had brought to the Crusade. They had with them all the
king's mounted crossbowmen. In the second battle among the
Champenois was John of Joinville, who has left us our best
account of the campaign; unfortunately he has omitted to give
us the complete list of those who marched with him. Charles of
Anjou was probably commander of the corps.[1] The king and
his household knights, with his brother Alphonso of Poictiers
and Henry Count of Flanders, rode in the third division. Louis
had issued strict orders that no knight should straggle from his
corps, and that the three battles should keep close together;
the van was not to advance till all three had passed the ford.[2]

The Egyptians kept a careless watch along the canal, and
though the ford was only four miles from their camp, at the
village of Sahnar, the French reached it unobserved. The van
division crossed, not without some difficulty, for the bottom was
muddy and the opposite bank scarped and slippery: a few
knights lost their footing and were drowned. When they were
already over, a body of three hundred Arab horse appeared, but
promptly took to flight when the Count of Artois charged them;
they saw that the passage was lost,[3] and rode off to warn their
comrades.

Flushed with this trifling success, Robert of Artois forgot
his brother's orders, and began to move off in pursuit. The
Master of the Temple rode up to him and besought him to stop,
but the hot-headed count would not listen to his remonstrances,
and spurred off towards the Egyptian camp. Thinking that he
would be shamed if he abandoned his place in the van, the
Master unwillingly followed, and after him all the other con-
tingents of the van battle.[4]

Count Robert rode so hard and so recklessly that he came
hurtling into the eastern end of the Egyptian camp almost as
soon as the flying Bedouin whom he was chasing. He found
the Infidels in a state of disarray and unpreparedness, which
reflects little credit on their commander. The horses were not

[1] So I gather from the fact that he rescued Joinville before the king and the third
corps had reached the field (Joinville, p. 226).

[2] Rothelin MS., p. 602.

[3] Joinville, p. 224. They appeared when Joinville himself was crossing, *i.e. after*
the van had passed.

[4] Joinville tells a curious tale of a deaf knight who was pulling the count's bridle
and shouting " Forward and at them ! " at the top of his voice all the time that the
Master was pleading for delay.

saddled nor the men armed. The French rode through the camp, slashing right and left and driving all before them, till they came to the place where were the perrières and mangonels which commanded the unfinished causeway. They wrought great slaughter, and killed the Emir Fakr-ed-din himself, fresh from his bath and without his coat-of-mail, as he rode up and down trying to rally his men. Hitherto Robert's haste had not done any irreparable harm: if he had halted and taken post among the machines to guard the spot till the infantry should complete the work, he would almost have justified his reckless charge. For if he had waited till the second and third battles had crossed the narrow ford, the enemy would have had ample time of warning, and would not have been surprised in their camp.

But the fiery count was now to take the fatal step which ruined the whole enterprise. Seeing the Egyptians in hopeless disarray, he imagined that he had gained the day with his own division alone, and thought of nothing but pursuit and slaughter. After a very short breathing space, he ordered a second advance towards the town of Mansourah, into which many of the fugitives were pouring. The Master of the Temple again besought him to pause and await his brother's coming, and William of Salisbury added his remonstrances to those of William of Sonnac. Count Robert replied with inexcusable discourtesy, telling the Templar that the military Orders loved to protract the war for their own ends, and did not really wish Christendom to triumph, lest their own occupation should be gone.[1] Then, turning to the Earl of Salisbury, he flung in his face the old taunt about " Englishmen with tails" and the curse of cowardice that rested on them. " I shall go this day where you will not dare to keep level with the tail of my horse," replied Salisbury, and, replacing his helmet and lowering his lance, he rushed forward with the rest to meet his fate.[2]

[1] Artois' language to the Templar, as reported by Matthew Paris (v. 149), deserves record as showing the suspicion which the Crusaders entertained of the military Orders. "O antiqua Templi proditio ! Hoc est quod diu praecinimus augurio, quod terra tota Orientalis jamdiu fuisset adquisita nisi Templi et Hospitalis fraudibus nos seculares impediremur. Timent autem Templarii et eorum complices quod si terra juribus subdatur Christianis, ipsorum expirabit (qui amplis reditibus saginantur), dominatio. Hinc est quod fideles ad negotium crucis accinctos variis inficiunt potionibus, et Saracenis con foederati proditionibus interficiunt."

[2] Matthew Paris makes a bad error in placing this altercation after instead of before the irruption into the town of Mansourah.

The Egyptians were still so discouraged, that Artois and his followers were able to penetrate within the walls of Mansourah and to ride through the town, cutting down the fugitives; some of the knights even emerged at its western gate, and almost reached the Sultan's suburban palace. But they were scattered in the streets, and separated one from another, so that the impetus of their charge and the advantage of combined action were lost. The Egyptians fled into the houses and flung darts and tiles upon the knights as they galloped up and down the narrow lanes. Presently the troops from the camps west of the town, who had not shared in the panic of the rest of the Moslem army, began to pour into Mansourah. They found the French scattered in small bands, some intent on plunder, and some on slaughter, but all unprepared to receive a fresh attack. Hence the new-comers won an easy success over the Christians; many were slain in the streets, others hunted out of the town and cut down in the open. The only route which the fugitives could take lay through the eastern camp of the Egyptians, where the Mamelukes were now rallying and getting into battle order. Hence it is not surprising to find that nearly the whole of Artois' corps was annihilated. He himself was slain in the town, and his surcoat with the royal French lilies was exhibited to the Moslems as a proof that the King of the Franks had fallen. With Robert there died William Longsword, the Master of the Temple, the lord of Coucy, and many barons more. Joinville tells us that three hundred knights perished, besides the sergeants and horse-arbalesters who accompanied them.[1] The Temple alone lost two hundred and eighty horsemen of various ranks. The Moslems say that fifteen hundred French were cut off in all,[2] and the figure is very probably correct. Only a few scattered bands escaped, among whom were the Duke of Brittany and the Count of Soissons.

Meanwhile, during the hour which Artois had wasted by his mad charge, the remainder of the French cavalry had been gradually crossing the Ashmoun. Joinville, who was in the front of the middle corps, seems to have followed Count Robert at a distance, before the king was well over the ford. At any rate, he saw, when he reached the Egyptian camp, that some of the enemy were already rallying, having retired from the tents into the open fields where they were drawing up in line of battle.

[1] Joinville, p. 224. [2] Makrizi.

The seneschal charged the nearest squadron, but was soon swept back to the edge of the canal by the advance of the mass of the Infidels, whom he estimated at about six thousand horse. He and his followers only saved their lives by retiring into a ruined house, where they maintained themselves, fighting on foot in the doorway, till Charles of Anjou and the main body of the second corps came up and delivered them by driving off their assailants.

Soon after, King Louis himself and the rear division came upon the scene of battle. They were at once assailed by the Mamelukes, who were now rallied and in good order. A fierce struggle began in the outskirts of the camp, and was maintained for many hours. The Mamelukes poured a constant rain of arrows into the ranks of the French, and Louis was compelled to charge them again and again before he could resume his advance towards the all-important spot where the half-finished dam lay. It was absolutely necessary to reach it, in order that the infantry might have their chance of joining the horse. But being continually attacked on their left flank, the French could not advance as they wished, but were always having to face southward to beat off the Mamelukes. Seeing their enemy growing weary, and noting that hundreds of the knights were dismounted owing to the loss of horses under the rain of arrows, the Mamelukes at last threw their bows over their backs and charged down with mace and scimitar upon the king. Louis was hard pressed, and some of his followers lost heart and plunged into the Ashmoun to swim back to the Christian camp. But he persisted in his original plan of advancing to the causeway, and at last came level with it.

Then the French infantry, throwing earth, planks, fascines, broken military engines, and all manner of miscellaneous rubbish into the unbridged half of the canal, succeeded in making a rough but sufficient bridge over the gap. The arbalesters and pikemen began to pour across the crazy structure by thousands. Humbert of Beaujeu, the constable, at once drew up the first crossbowmen that arrived so as to cover the harassed cavalry. They opened a destructive fire upon the Mamelukes, and the battle took a new turn.

The moment that the Egyptian leaders—Bibars, who twenty years later became Sultan, is chiefly named among them—saw that the French infantry were entering on the scene, they ordered their horsemen to draw back. Retiring out of bowshot, they still

maintained a threatening attitude. The king might now have advanced, but his knights were so thoroughly tired out and harassed that he refrained from doing so. He contented himself with ordering the infantry to construct a large circular tête-du-pont covering a considerable space of ground on the farther bank of the canal. The work was easily and rapidly finished by using as materials the woodwork of the captured Egyptian machines.

Thus King Louis had acquired a solid lodgment on the southern side of the watercourse which had so long held him in check. But he had failed to defeat the Egyptian army, which still watched him at the distance of no more than a few hundred yards, and was rather encouraged than abashed by the results of the day's fighting. The losses of the French had been so much greater than those of their adversaries that the Moslems regarded themselves as the successful party. Louis had lost, as far as can be calculated, nearly half his cavalry and a still greater proportion of his horses. The real meaning of the battle was sufficiently shown by the fact that three days later[1] the Egyptians assumed the offensive, and vigorously attacked the tête-du-pont, while the French stood entirely upon the defensive, and even after beating off the assault made no further attempt to advance. The invaders had lost their impetus and their desire to push on: not long after we find them thinking of retreat. The battle, though it had ended in the crossing of the Ashmoun Canal, had so exhausted the Crusaders that they despaired of the result of the campaign. We cannot call it anything but a check and a disaster.[2]

Such were the main features of the fight of Mansourah, the

[1] The battle had been fought on Shrove-Tuesday, and the Moslem attack on the French lines followed on the first Friday in Lent.

[2] Joinville's interesting personal adventures after the king had come upon the field are well worth reading, but evidently had no important influence on the fortune of the day. He had been employed to ride on to Mansourah to look for the Count of Artois, who was said to be yet alive, but got involved in a long skirmishing encounter with a body of Egyptians on and about a little bridge which crossed a brook running into the Ashmoun from the south. He succeeded in detaining opposite him a body of the enemy who would otherwise have gone to aid in the attack on the king. But their arrival would not have turned the event of the day—indeed, these were Egyptian rabble, not Mamelukes, as many of them were on foot, and they pelted Joinville and his men with clods and shot at them with fire-arrows instead of charging in. His pp. 227–228 are of great interest, but we could wish that they contained more details about the king's main fight with the Mamelukes.

last of the great pitched battles of the Crusades. It displays, even more clearly than the other engagements with which we have dealt, the absolute interdependence of cavalry and infantry in the Christian hosts when dealing with the formidable horse-archers of the East. For want of men armed with missile weapons (all the mounted crossbowmen had been slain along with Robert of Artois) the king and his chivalry were on the very verge of destruction. They were saved the moment that their infantry succeeded in getting across the canal and joining them. Without that succour they would probably have been destroyed to the last man, for they had been cut off from their retreat to the ford, and the watercourse at their back proved impassable to such fugitives as attempted to cross it.

It is curious to note that the Mohammedan writers grasped much more clearly than the Christian the fact that the tardy arrival of the French infantry turned the engagement into a drawn battle, and that their earlier appearance would have made it a decisive victory for St. Louis. Joinville[1] and William of Nangis[2] mention the coming up of the crossbowmen indeed, but keep all their interest and admiration for the king's feats of personal valour. It is left for Jemal-ed-din and Makrizi to observe that "if the first division of the Christian cavalry had held out" (i.e. if Artois had remained by the engines instead of plunging into Mansourah), "and if the whole of the Christian infantry had been engaged, Islam would have been ruined,"[3] and that "if the French infantry could have joined their cavalry, the defeat of the Egyptians and the loss of the town of Mansourah would have been inevitable."[4] Blinded by chivalrous enthusiasm and class-pride, the French chroniclers omit to draw the moral which to the Moslem writers was obvious.

The separation of horse and foot while St. Louis was making his turning movement was unfortunate, but absolutely necessary. We cannot blame the king for it, as he had no other alternative before him. All the more must the gravest censure fall on

[1] "It happened that towards evening the king's constable, Humbert de Beaujeu, brought us the foot-arbalesters, who drew up in front, while we dismounted. Incontinently the Saracens went off and left us in peace," says Joinville—a very inadequate account of the crisis of the day, when whole pages have been devoted to individual exploits.

[2] "Nostri usque ad horam nonam graves sustinuerunt impetus. Tandem balistariorum subsidio multis Saracenorum vulneratis . . . nostri campum obtinuerunt" (p. 374).

[3] Jemal-ed-din, p. 459. [4] Makrizi, p. 548.

Robert of Artois for his mad charge into Mansourah in direct disobedience to his brother's orders. If he had only halted among the Egyptian engines opposite the French camp, and held his ground there till the infantry could complete the causeway, and till his brother could arrive with the main body of the horse, the day would have gone well for Christendom. The king did his best to detain him, sending ten knights to bid him halt and wait,[1] but Robert, in deliberate defiance of his chief, chose to make the second mad charge, which lost the day and ended his own rash career. Even the leader of a feudal army could not have rationally expected to see his plans wrecked by such a piece of wanton and wicked indiscipline.

[1] Joinville, p. 224.

BOOK VI

WESTERN EUROPE
FROM THE BATTLE OF HASTINGS TO THE
RISE OF THE LONGBOW

CHAPTER I

INTRODUCTORY

I N studying the Crusades we have seen the military art of the nations of Western Europe at its best and its worst. Nowhere are more reckless displays of blind courage, or more stupid neglect of the elementary rules of strategy and tactics to be found, than in the great expeditions to the Levant. On the other hand, we have also had to observe among the more capable leaders of the crusading armies a far higher degree of intelligent generalship than was usual among their contemporaries in the West. If the Crusades of 1101 and 1147 are decidedly more distressing to the critic than the average wars of France, England, or Germany, there are also battles and campaigns —such as that of Arsouf—which show very favourably beside those of the lands nearer home. Many of the Crusaders seem to have been at their best when facing the new problems of the East. Richard Coeur de Lion at Acre, Arsouf, and Jaffa rises far above his ordinary level: we find ourselves wondering how the very capable general of 1190–91 can on his return waste so much energy and ability to no purpose in the wretched peddling French wars of 1194–99. We may add that the great Frederic I. of Germany never shows to such good effect in his home campaigns as in the conduct of his expedition through Asia Minor. Many of the lesser figures of the Crusades, including the good Godfrey of Bouillon himself, are obscure and undistinguished in the wars of their native lands, and only show the stuff that is in them when they have crossed the high seas.

The worst military errors of the Christians in the East came, as we have seen, from their gross ignorance of the conditions of warfare in Syria or Asia Minor, and of the tactics of the enemies with whom they had to deal. At home leaders and led alike were safe from such dangers, since they knew the military

23

character and usages of their neighbours, and had some rough idea of the geography, climate, and productions of their neighbours' territory. But if this knowledge preserved them from certain dangers, it seems, on the other hand, that in the familiar border wars of the West the best qualities of a commander were often not developed. It is new and unforeseen dangers and difficulties that test most adequately the stuff that is in a man.

When we turn from the history of the Crusades to consider the contemporary history of the Art of War in Western Europe, the first thing that strikes us is the comparatively small influence which the great campaigns in the Levant seem to have had upon the development of strategy and tactics at home. Tens of thousands of barons, knights, and sergeants came back as veterans from the East, and one would expect to see the lessons which they had learned in fighting the Turk and Syrian perpetually applied to the wars of their native countries. Yet it is by no means easy to point out obvious instances of such application of new principles of war, save in the provinces of fortification and of arms and armour. In strategy and tactics it is difficult to detect from a broad survey much direct influence flowing from the Crusades.

We may take as the clearest example of this the entire neglect by the Western nations of the most important tactical lesson of the Crusades. We have shown by a score of examples that the one great principle which settled the fate of wars with the Turk was that generals who properly combined infantry and cavalry in their line of battle were successful, and that generals who tried to dispense with the support of foot-soldiery always failed disastrously. The fact that the combination of the two arms is better than simple reliance on one had been shown at Hastings long ere the Crusades began, but the lesson was even more clearly visible in the details of such fights as Antioch or Ascalon as compared with the disasters of 1101 or the narrow escape from destruction at Dorylæum.

We should expect, therefore, to find that the return home of the warriors of the first Crusade would be followed by the development of a rational use of infantry and cavalry in close alliance and interdependence. But we find little of the kind; over the greater part of Western and Central Europe the cavalry arm still maintains its exclusive predominance, and infantry is still despised and distrusted. In Italy, it is true, the

workings of the experience of the Crusades are to be recognised in the sudden growth of the popularity of the crossbow, and probably also in the increased importance of the civic infantry. But in the only other parts of Europe where foot-soldiery show to any effect—England and the Netherlands—we are dealing with an old Teutonic survival, not with any new development.

In many of the twelfth-century battles of Western Europe, when by some rare exception we do find combatants on foot entrusted with a principal part in the fight, we discover on closer inquiry that they are not ordinary foot-soldiery, but knights who have dismounted in order to carry out some desperate duty. We are, in short, merely witnessing a recurrence to that ancient habit of the Teutonic races which Leo the Wise had described two hundred years before.[1] Such instances are to be found on the part of the English and the Normans at Tenchebrai[2] (1106), and again at the first battle of Lincoln[3] (1146), where both King Stephen and the rebel earls dismounted the pick of their knights to form a solid reserve. The same is the case in the English army at Bremûle (1119), and at the battle of the Standard[4] (1138), where the Yorkshire knights left their horses and joined the yeomanry of the fyrd in order to stiffen the mass when it was about to be assailed by the wild rush of the Scots. The Emperor Conrad's German chivalry behaved in a similar way at the chief combat during the siege of Damascus in 1148.

Such expedients, however, are exceptional. On the other hand, we not unfrequently find battles in which neither side brought any foot-soldiery to the field, such as Thielt (1128), Tagliacozzo (1268), and the Marchfeld (1278). Cases where one side had no infantry whatever in the battle line are still more numerous. Such are Bremûle (1119), Legnano (1176), Muret (1274).

When true infantry are engaged on both sides, it is rare to find them actually settling the fate of the day. Generally they are only used as a very subsidiary force, employed merely for skirmishing and not for the decisive charge. The main exceptions to this rule are to be found, as we shall have to show later on, in Italy and the Netherlands. But if the infantry in most battles had no great part in the winning of the day, they were often the chief sufferers in a defeat. As a rule, those

[1] See p. 202. [2] See p. 379. [3] See p. 392. [4] See p. 386.

of the beaten army were fearfully mishandled by the knights of the victorious side. When the day was won, the infantry of the vanquished party were nearly always cut to pieces in the most ruthless manner, while their countrymen of the knightly classes were not slaughtered, but reserved for ransom.

The mailed horseman, then, maintains his place as the chief factor in battle down to the end of the thirteenth century, and the main features of the two hundred years from Hastings onward are the feudal knight and the feudal castle. We shall have to note that while tactics and strategy make comparatively small and slow progress in these two centuries, the art of fortification grows very rapidly. Between the simple castle of the time of William I. and the splendid and complicated fortresses of the end of the thirteenth century there is an enormous gap. The methods of attack made no corresponding advance, and by 1300 the defensive had obtained an almost complete mastery over the offensive, so that famine was the only certain weapon in siegecraft. It is not till the introduction of cannon and gunpowder in the fourteenth century that the tables begin to be turned.

In chapter iii. of Book III. we dealt with the origin and evolution of the feudal knight and the feudal castle. We have now to treat of their further developments.

regulate
... ...
...
...
...
... that
...
...

CHAPTER II

THE ARMIES OF THE TWELFTH AND THIRTEENTH CENTURIES

Section A.—England.

WE have first to concern ourselves with the knighthood of Western Europe and its tactics. Fortress - building and siegecraft, though equally important in their influence on the general history of the period, must take the second place. An English writer is inevitably forced to illustrate the period mainly from English military history, but we shall conscientiously endeavour to point out all the details in which continental practice differed from that in use in our own island.

The Norman Conquest brought about a complete change in the military organisation of England: under William the Bastard the system of raising the armed force of the realm, the tactics that it employed, and the weapons that it used, were all alike transformed. For the next two hundred years the Norman castle and the Norman horseman were to be the main features in the military history of England.

The kings continued to call out the fyrd on occasion, but they never treated it as the chief part of their host: it was indeed mainly employed when the feudal levy of the realm was, for some reason or another, not to be wholly trusted. William Rufus summoned the fyrd once for real active service, and once as a mere means of getting money. It was employed in the first year of his reign for the sieges of the castles of the barons who had rebelled against him under the pretence of supporting his brother Robert. Infantry were always required for siege-work—the knights would have resented the hewing and digging, and a large force of pioneers was needed. The second occasion on which we hear of the mustering of the old national host was

when Ralph Flambard taught the king to turn a dishonest penny by a new device. Rufus called the shire-levies to Hastings, nominally for a campaign in Normandy (1094). They came to the number of twenty thousand, each bearing the ten shillings which the shire was bound to provide for him. William took the money from them and then told them that they might disperse, as they were not needed.[1] Henry I. also used the fyrd early in his reign, in circumstances much like those which had forced his brother to employ it. Robert of Belesme and his fellows were in rebellion, and had manned and stored their castles. Large forces were needed for siegework, and Henry called upon the English, who came gladly, and, as Oderic tells us, greeted him, after the surrender of the enemy's great stronghold at Bridgenorth, with the joyful cry, " Rejoice now, King Henry, and say that you are truly lord of England, since you have put down Robert of Belesme and driven him out of the bounds of your kingdom."[2] Still later the shire-levies were raised by Stephen for the battle of the Standard,[3] and by Henry II. to put down the great feudal rising of 1174. The Assize of Arms of 1181 shows us how miscellaneous and heterogeneous was their armament, even when providing for the improvement and reorganisation of the force, the king does not dream of enforcing uniformity, and the poorer classes are allowed to come to the muster armed with nothing better than swords, knives, and darts. There is evidently a wish to assimilate the wealthier men to the armament of the mercenary Brabançon pikemen whom Henry was employing in large numbers at the time, as the sheriffs are directed to see that persons owning sixteen marks of chattels are to bear mail-shirt, steel cap, shield, and spear. The king continued to use

But alike for foreign expeditions and domestic wars, the Norman and Angevin kings relied mainly on the masses of mailed horsemen provided by their feudal vassals. Still armed like their fathers at Hastings, with the long mail-shirt, the peaked helmet with its nasal, and the kite-shaped Danish shield, the Norman knights were the flower of the chivalry of Europe, whether they served in their own land, in the conquered realm of England, in the new kingdom which they had built up in Apulia and Sicily, or in the Crusades of the far East. work--the second occasion and a large force of pioneers was needed. on which we hear of the mustering of

William I. had divided up the greater part of the soil of England among new holders. Only about a fifth stayed with the old Saxon owners; and such of them as survived were compelled to surrender their land to the king, and receive it back from him saddled with the duties of the continental vassal. We have seen[1] that "knight-service" and "castle-ward" were ideas not altogether unfamiliar before the Conquest, and that the obligation of every five hides of land to send a mailed warrior to the host was generally acknowledged. Theoretically, it would seem, the old notion that the five hides must provide a fully-armed man was remembered : the man, however, for the future was to be a horseman instead of a foot-soldier. But William, in distributing the burdens of military service among his tenants, seems often to have dealt loosely and liberally with the old system, frequently letting off his vassals with less men than their acreage should have called for. "Beneficial hidation," the counting by favour of four or five hundred acres as if they were but a mere hundred and twenty, was as prevalent in military arrangements as in taxation. It was specially frequent when Church lands were being dealt with ; e.g. we know that the Abbey of Ramsey had seventy hides, and should therefore have provided fourteen knights, but it was let off with an assessment of four only Nor was this favour confined to ecclesiastical estates alone : some lay tenants-in-chief got off very easily, though the majority were obliged to supply their proper contingent.

It has been clearly shown of late, by an eminent inquirer into early English antiquities, that the hidage of the townships was very roughly assessed, and that the compilers of Domesday Book incline towards round numbers.[2] Five-hide, ten-hide, or twenty-hide townships are so common that there was little difficulty in apportioning the military service due from the tenants-in-chief who owned them. Hence there was not so much difficulty from fractions as might have been expected. If estates had been assessed with absolute accuracy in acres and yards, nearly every landholder would have been responsible for eccentric fractions of a knight, over and above the units which his manors gave when their extent was divided by the normal five hides. But estates were not accurately measured and

[1] See pp. 111, 112.

[2] See Professor Maitland's Domesday Book, etc., passim.

assessed, and so the knights of "the old enfeoffment,"[1] as William's arrangement was entitled, are generally found in round numbers: the fractions which occur are for the most part quite simple ones.

The landholder, knowing his *servitium debitum* according to the assessment of the *vetus feoffamentum* of the Conqueror, had to provide the due amount of knights. This he could do in two ways: he might distribute the bulk of his estate in lots roughly averaging five hides to sub-tenants, who would discharge the knight-service for him, or he might keep about him a household of domestic knights, like the housecarles of old, and maintain them without giving them land. Some landholders preferred the former plan, but some adhered, at least for a time, to the latter. But generally an intermediate arrangement prevailed: the tenant-in-chief gave out most of his soil to knights whom he enfeoffed on five-hide patches, but kept the balance *in dominio* as his private demesne, contributing to the king for the ground so retained the personal service of himself, his sons, and his immediate domestic retainers.

An interesting series of documents, just a century later than the Conquest, survives, and can be used to show what the barons had been doing with their land during the three generations which had elapsed since the first assessment. These are the *Cartae Baronum* of 1166,[2] a series of answers given by the tenants-in-chief to Henry II. in response to certain inquiries which he made from them. The king demanded a statement as to the number of knights whom each tenant-in-chief owned as sub-tenants, how many were under the "old enfeoffment" of William I. and how many of more recent establishment, and also whether the lord provided his due contingent wholly by means of sub-tenants, or was accustomed to contribute the personal service of himself and his household for land held in demesne. It is interesting to find that the answers show that the majority of the baronage had given away the larger share of their estates, but still kept a certain amount in demesne for

[1] I think that there is no doubt that Mr. Round in his *Feudal England* has proved that we may be reasonably certain that the *vetus feoffamentum* really runs back to the Conqueror, and was a formal distribution. The other view, that it was irregularly and gradually established under Rufus and Henry I., seems less probable. On the other hand, Mr. Round's "Constabularies of Knights" are not convincing.

[2] The *Cartae Baronum* are printed *in extenso* in Hearne's *Liber Niger Scaccarii*. They are unfortunately incomplete, and do not cover nearly the whole of England.

which their own personal service was due. The smaller men, responsible only for the service of one or two knights, had not usually enfeoffed sub-tenants, but served themselves. At first a few great landholders, mostly abbeys, had refrained as far as possible from cutting up their estates into sub-tenancies, on account of the financial advantages of keeping land in demesne. But this plan had the corresponding disadvantage of compelling the abbot to keep up a household of idle knights, who drank and roistered about the abbey precincts, and made themselves an intolerable nuisance.[1] Thus the house was usually driven, even if unwilling, to give the knights their fiefs in order to get them away from headquarters. Where, as in the case of Ramsey, the abbey was very lightly assessed for knight-service, the proportion of its land which it would have to distribute to fulfil its *servitium debitum* would not necessarily be a large one. But though economy dictated the enfeoffing of as few knights as possible, nepotism, the curse of the mediæval monastery, often drove abbots to give land to their own needy kinsmen, so that not unfrequently it was found that a house had created far more sub-tenants than it required. In such cases the "due service" was sometimes obtained by making the body of enfeoffed knights undertake to send as many of themselves to the host as was necessary;[2] a private arrangement settled who was to go on each individual expedition.

In the twelfth century the hard-and-fast rule that five hides ought to make a knight's fee came gradually to be disregarded. In some cases a liberal lord gave his sub-tenant a good deal more than the normal holding ; in other cases knights were enfeoffed on a good deal less—occasionally on patches no larger than two hides. Thus we can find a tenant describing his holding as "pauperrimum," and grumbling at its counting as a fee at all. But such cases, in spite of their numbers, were theoretically abnormal, and the notion which connected five hides with the knight survived down to the time of Henry II. In the *Cartae*

[1] *Liber Eliensis*, 275.

[2] At Ramsey "Homines faciunt quattuor milites in communi in servititim domini regis, ita quod tota terra abbatiae communicata est cum iis per hidas ad praedictum servitium faciendum ;" *i.e.*, though only four knights are required (a very small contingent from seventy hides), the abbey has not designated four particular patches to discharge its knight-service, but all the tenants, as well as the abbey demesne land, club together to "make" four knights for the host.

Baronies we get a good example of this. Roger de Berkeley owed two knights and a half on the "old enfeoffment": giving more details than his fellows generally supply, he explains as follows. The first knight is thus made up—

Michael holds one hide	
William Fitz-Baldwin, two hides	= five hides,
Helyas de Boivill, one and a half hides	
Hugh de Planta, half a hide	

and from these you have an entire knight.

For making up the half knight—

Ralph de Yweley holds half a hide	
The wife of Ralph Cantilene, half a hide	
The wife of Richard Gansell, three virgates ($\frac{3}{4}$ hide)	= two and a
Roger de Albamara, one virgate ($\frac{1}{4}$ hide)	half hides,
Simon de Coverley, one virgate	
The Prior of Stanley, one virgate	

and here you have half a knight.

"For making up another knight, Walter de Holecombe, Gerard, and Reginald de Albamara hold between them ten hides, but deny their full obligation and say that they do me service only for one virgate each. From them you can make up a knight, and so you have two and a half knights enfeoffed."

Roger's argument in the third paragraph is hard to follow: either the figures in the text have got corrupted, or he thinks his disputed claim to ten hides will be compounded for half its value, and that Walter, Gerard, and Reginald will do one knight's service between them. However this may be, the first two paragraphs of his answer amply show that he conceived five hides to be the proper and normal allowance of land which should provide a knight. He concludes his " Carta " with a list of his demesne land, which shows that (unlike most of his fellows) he had let to sub-tenants only the smaller part of his ancestral estates.

As a rule, no one except a very great baron with plenty of house-room in his castle cared to have many domestic knights dwelling with him throughout the year. Most of the holders of middle-sized estates had carved the greater portion of them into knights' fees, and only kept in demesne as much as they themselves and their sons could do service for.

Hearne, *Liber Niger Scaccarii*, p. 163.

There was always a great deal of trouble in keeping the sub-tenants up to their work. In times of civil strife, a tenant-in-chief might rebel, or might remain loyal. If he rebelled, some of his vassals would try to save themselves from confiscation at the king's hands by refusing to join in the rising. Such indeed was the bounden duty of the English sub-tenant, ever since the Conqueror at the great moot of Salisbury had impressed upon the English knighthood the fact that their allegiance was primarily due to the Crown, and not to their immediate lords. On the other hand, when the tenant-in-chief adhered to the king, it was not unusual for some of his knights to slip into the rebel camp: if the rising succeeded, they would have every chance of shaking off their lord and freeing themselves for the future from the service that they owed him. In Stephen's reign, when anarchy prevailed for well-nigh a score of years, the relations of countless lords and vassals had been confused: disputed claims to overlordship were found on every side. Many of the answers of the barons of 1166 show that they were not quite certain as to all their own rights and possessions. They qualify their statements with clauses to the effect that they have replied to the best of their knowledge and belief, or note (like Roger of Berkeley quoted above) that some of their sub-tenants deny their obligations. The clerical tenants are specially bitter against spoilers who have robbed them of homage, or compelled them to enfeoff knights contrary to their will. We are surprised to find such a respectable person as the great Chancellor Roger of Salisbury reported as an oppressor by the Abbey of Abbotsbury in Dorset.[1]

The importance of King Henry's inquest of 1166 was twofold. It not only gave him the information that he required as to the proper maintenance of the *debitum servitium* due under the "old enfeoffment" of the Conqueror, but showed him how many more knights had been planted out since that assessment. Having possession of this valuable information, he was able to demand for the future, when raising aids and scutages from his tenants-in-chief, payment not merely for the theoretical number of knights whom they owed, but for the real number which they actually possessed. This

[1] *Liber Niger*, p. 76 : "Cum Rogerus episcopus habuit custodiam abbatiae, duas hidas apud Atrum ad maritandam quandam neptem suam dedit Nicolao de Meriet, contradicente conventu."

gave a welcome relief to the Treasury, as in many instances the
"old enfeoffment" had been—as we have already mentioned—
very lax and liberal, and did not adequately represent the re-
sources of the land.

The *Cartae Baronum* are unfortunately incomplete: if they
had all been preserved, we should have been able to say both
what was the number of knights due from the whole of England
under the "old enfeoffment" of the eleventh century, and
what was the number of knights' fees actually existing in 1166.
A careful and ingenious calculation has been worked out by
supplementing the *Cartae* from other sources, which makes it
clear that the full feudal force of England was well over four
thousand five hundred knights, but little, if at all, over five
thousand. Of these the Church fiefs supplied about eight hundred,
the lay tenants-in-chief between four thousand and four thousand
two hundred.[1] These modest figures contrast most strangely
with the vague numbers given by contemporary chroniclers,
who were so far from appreciating the actual size and resources
of the land that they often state that England could supply
thirty thousand or even sixty thousand[2] knights for the king's
service. The whole *fyrd* of foot-soldiery added to the knight-
hood would probably not have reached the latter figure.

We must be careful, when dealing with the knight of the
eleventh and twelfth centuries, to clear away from our minds the
chivalrous connotation of the same word in the fourteenth or
fifteenth century. The knight of William the Conqueror's army
was not necessarily nobly born, nor had he gone through the
elaborate ceremonial of admission to the knightly order which
prevailed three centuries later. He was simply a soldier who
fought on horseback, and who received from the king, or from
one of the king's tenants-in-chief, a patch of land on condition that
he should do mounted service in return for it. The original
knights of the "old enfeoffment" were a mixed multitude of
many races drawn from many different stations in life: some
were the kinsmen of great Norman barons, others were military

[1] Mr. Round's calculations on this point in his *Feudal England*, pp. 289-293, are
most valuable and convincing. The result is certainly surprising, and shows most
clearly the extraordinary want of appreciation of large figures in able thirteenth-
century chroniclers, and even in Government officials who ought to have known
better.

[2] Swereford in the *Liber Rubeus* says thirty-two thousand; Ordericus Vitalis is
responsible for the still more monstrous sixty thousand.

adventurers who had drifted in from all parts of the Continent.
Into this heterogeneous body were incorporated the remains
of the old English thegnhood, all the lucky survivors who had
been permitted to "buy back their land" from the king by
paying him a fine and doing him homage on feudal conditions
after his coronation. English-speaking men applied to this
newly-formed and miscellaneous class of military tenants and
sub-tenants the word "cniht," which had been used before the
Conquest for the military dependants of the great landholders.[1]
It was really equivalent to the *cliens*, *serviens*, or *famulus* of the
Continent, and has the same original meaning of subordination
and subservience. But names chance on different histories in
different countries; and while "knight" became in England the
equivalent of *miles*, the name *serviens* came across the Channel
some generations later, in the form of "sergeant," to express a
class of men distinctly below the knightly rank. It is curious
to note that in Germany *knecht*, starting with much the same
meaning as "knight" in the eleventh century, gradually came
to denote persons of a more and more inferior status, sinking
to mean combatants who were not of noble blood,[2] and finally
denoting mere servants and attendants of the army.

It will help us to realise the modest status of many of these
"knights" of the Norman period, if we remember that a sub-tenant
with a few hundred acres of land would probably have been called by
a chronicler of the time of Henry I. a "miles," by a chronicler of
the time of John or Henry III. a "sergeant,"[3] and by a chronicler

[1] For a picture of pre-Conquest "knights" in England, see the interesting
description of the rights and duties of the "radknights" of Bishop Oswald of
Worcester, which Professor Maitland has worked out in his *Domesday Book and
Beyond*," pp. 305–311.

[2] The word *Edelknecht* was invented to denote the non-knightly combatants of
good birth (=English esquire), and then *knecht* without the prefix came to distinctly
imply want of birth.

[3] That "sergeant" originally means not a professional soldier, nor a knight's
attendant, but a landed military dependant who is not a knight, is well shown by
the letter of Geoffrey Ferland, Sheriff of Leicester and Rutland in 1216, giving
"the names of all the *knights and sergeants* domiciled in his district who have
adhered to Louis of France" (Rymer, 144). Another good example is John's writ
of 1213, to call out the full feudal levy: "Rex vicecomiti de X. salutem, etc.
Summone comites barones milites et omnes liberos homines *et servientes*, de quocumque
teneant, ut sint apud Doveram cum armis et equis," etc. (Rymer, I. 110). The "armis
et equis" clause shows that we are dealing with mounted men, and the "de quo-
cumque teneant" that we are dealing with sub-tenants and not merely small tenants-
in-chief.

of the time of Edward III. a "squire bearing a pennon." The condition of the three men would have been much the same, but the name changed twice. By 1350 the title of knight had come to be restricted to persons of some importance, and we often find large bodies of men commanded by mere esquires in the wars of Edward III. The reigns in which the change first made itself felt were those of Henry III. and Edward I., whose repeated attempts to make holders of knightly fees take up the knightly title by the writs of "distraint" are well known. But the attempt did not succeed, and ere long we find the king conceding that even the parliamentary knights of the shire may be persons who have not actually received knighthood, because that in many counties there cannot be found sufficient competent persons who have taken up the required status.

Before proceeding to investigate the character of the battles of the twelfth and early thirteenth centuries, we must take note of one marked feature of the early Plantagenet reigns—the prominent place taken in their military affairs by mercenary troops. From the time of Stephen onward we perpetually find the feudal levies of the realm supplemented by great bodies of professional soldiers, nearly all foreigners. There had for a long time existed a large floating body of adventurers in Western Europe: from them William the Conqueror had drawn no small proportion of the host that fought at Hastings. The original Norman conquerors of Apulia had belonged to this class no less than the Varangian Guards of the Eastern emperors. During the early Norman reigns we not unfrequently find mention of *stipendiarii milites* in England,[2] but it is not till the time of Stephen that we begin to find them appearing in great force and forming a prominent feature in the host. Stephen, deserted by the greater part of the baronage, supplied the place of the missing contingents by bringing over great bodies of Flemings and Brabançons, under leaders such as William of Ypres and Alan of Dinan. Henry II. and Richard I. kept up the system: without the aid of a permanent army they could not have maintained their long wars over sea. For sieges in Normandy and Aquitaine the service of the English feudal levy would have been almost useless to them. Its forty days would have ended almost before it could arrive at

[1] Especially in the Henry III. and in the Edward I.

[2] See Florence of Worcester, *sub anno* 1085.

the distant seat of war. Moreover, a feudal host was untrained, undisciplined, disorderly, and sometimes disloyal. The mercenaries, on the other hand, were trained professional soldiers, who served with fidelity as long as they were regularly paid, and had no wish to cut the war short by an intempestive return to their homes. Hence for foreign service Henry and Richard preferred the steady squadrons of mercenaries who kept the field all the year round, to the short and uncertain aid of the knighthood of England. To repel a Scottish foray or to carry out an expedition into Wales, on the other hand, the *servitium debitum* of the English tenant-in-chief was still exacted. Such campaigns were short, and cost less if carried out by the levies of the border shires. Henry II., therefore, very seldom brought over his mercenary bands to England: the only occasion when they appeared in force on this side of the Channel was to aid in suppressing the feudal rebellion of 1173-74. In this campaign they met their likes in battle, for the rebel Earl of Leicester had enlisted a great body of Flemish *routiers*, and was fighting at their head when he was taken prisoner at Fornham.

When the king did not wish to call out the feudal levy of England, he was accustomed to exact from all the exempted knights a *scutage*. By this arrangement the holder of a fief compounded for his personal service by paying a fixed sum for every shield (*scutum*) that he should have brought to the host. The usual sum raised was 26s. 8d.—two marks—which seems to represent forty days' service at 8d. a day, the normal pay of a knight in the twelfth century. The individuals from whom the *servitium debitum* was due seem to have been allowed the choice of attending in person or paying the scutage.[1] If the campaign was near at hand, the majority would appear in arms ; if it was distant, only a few—mainly the larger tenants—would follow the host.

[1] The whole body of feudal tenants do not seem to have been so prone to accept the alternative of composition as might be inferred from the chroniclers. For example, as Mr. Round has shown, Robert de Monte tells us that in 1159 King Henry took with him "capitales barones suos cum paucis, solidarios vero milites innumeros" ; but the scutage figures show that the sum received was £1714, *i.e.* the money representing 1280 knights, not more than a third of the number liable to serve from the lay fiefs, so that not only the great barons must have followed the king, but some two-thirds of the smaller men also (*Feudal England*, p. 280). The reason advanced for the king's preference of a scutage is obviously not the right one. In reality he wanted the money to pay mercenaries.

Scutage appears as a recognised institution under Henry I, but it was his greater grandson who made it normal and customary. By the end of his reign the bulk of the rural knights had grown into the habit of compounding instead of going on wearisome expeditions to Poitou or Aquitaine, over the stormy seas so hateful to the mediæval mind. The payment of scutage became the rule, and the hiring of mercenary horsemen with the proceeds of this imposition gave the king a more permanent and trustworthy army than he could otherwise have kept together. It was mainly at the head of these professional soldiers that Henry II. and Richard Coeur de Lion fought out their weary and uninteresting French campaigns.

John, because he was more hated by his subjects than his father and brother had been, was still more prone than they to employ mercenary troops. No small part of his unpopularity in England came from the fact that after he had been driven out of Normandy in 1204 he brought back with him the horde of foreign adventurers who had followed his unlucky standard on the Continent. They were, as might have been expected, very undesirable guests: the barons resented the favour which the king showed to the leaders—unscrupulous ruffians, for the most part, like Fawkes de Bréauté. The common people suffered from the plundering propensities which the mercenaries had picked up on the Continent. To the hatred they won from rich and poor alike, the adventurers owe their dishonourable mention in the Great Charter. The king is forced to promise to dismiss all the "alienigenos milites et balistarios et servientes stipendiarios" who "venerunt cum armis et equis ad nocumentum regni."[2] A special clause names several of the leaders who were condemned to banishment—Gerard of Athies, Philip of the Mark, Englehard de Cigognes, Guy de Cancelles, and others.[3] As everyone knows, John slipped easily out of the obligation —the mercenaries were not expelled, and formed the best part of the army with which the king fought his unfortunate campaign of 1215. The troopers of Fawkes de Bréauté, and also his crossbowmen, are specially mentioned as having done good service early in the reign of Henry III., at the second battle of Lincoln. It is not till the reign of Edward I. that

[1] See the proofs in Mr. Round's *Knight-service*, pp. 268, 269.
[2] Magna Carta, clause 51. [3] *Ibid.* 50.

foreign mercenaries cease to form a prominent part in the armies of the Plantagenets.

Section B.—The Continent.

During the twelfth and thirteenth centuries the armies of the English kings differed less from those of the sovereigns of the Continent than at any other period in history. The Norman influence had assimilated the military forces of our island to those of the rest of Western Europe. The chief points of difference worth noticing are, firstly, that in England there was never such a clear line of division between the various classes of feudal tenants as elsewhere; and, secondly, that shire-levies of foot-soldiery, the lineal descendants of the fyrd, though occupying a very secondary place in war, are yet much more important than the infantry of most continental districts. Only in the Netherlands and to a certain extent in Italy do foot-soldiery come prominently to the front. In other regions the mercenary crossbowmen are the only dismounted men who receive much mention, till we come to the attempt of Philip Augustus to turn the levies of the French communes to account.

The normal army of an emperor or a French king was composed of the same elements as those with which our Norman or Angevin monarchs took the field—a mass of mounted feudal tenants and sub-tenants, often supplemented by a certain proportion of mercenary horsemen and crossbowmen. Occasionally we find civic militia in the field—it develops in Italy and the Low Countries long before it is found elsewhere. Very rare is the appearance for any practical purpose of the foot-levies of the countryside, which the feudal lords could as a last extremity drag out to battle.

In the eleventh century the important part of a continental army consists of all the warriors holding fiefs, either directly from the Crown or as sub-tenants, on condition of doing service on horseback. The chroniclers often speak of the whole mass of them as "*milites*," whether they be small men or great, but a careful inquiry into the character of the body shows that it is not homogeneous. When we find phrases like "*miles primi ordinis*" or "*miles gregarius*," we see that within the body of *milites* there are class distinctions. The highest rank is composed of free vassals of noble blood holding considerable fiefs: this is the only class which retains the knightly style in

24

subsequent ages, but the name *miles* in 1080 (abroad as in England[1]) is far more vague, and covers far more persons than it does in 1180 or 1280.

Below these *milites primi ordinis* are a number of other horsemen, some of noble but more of non-noble blood. Some are the king's personal retainers, serving him as minor officials or guardsmen: a twelfth-century German chronicler would probably call them "*ministeriales*," an English or a French chronicler "*servientes regis*." Much more numerous are the personal retainers of the barons, bishops, and abbots, whether enfeoffed or not enfeoffed on land. These "men" of the king or of the tenants-in-chief are sometimes styled *milites gregarii, milites ignobiles, milites plebei*, or *milites mediocris nobilitatis*. They are also found with names which differentiate them more clearly from the knights of higher rank, and point to their subservient and dependent condition — *e.g. satellites, servientes, clientes, famuli*. As a rule, they served on lighter horses, and wore less complete armour than the knightly vassals. Down to the thirteenth century they much exceeded in numbers the nobler and more heavily-armed horsemen.[2]

When in the later twelfth century the title *miles* becomes strictly confined to the upper ranks of the military class, *serviens* (sergeant) is the most usual term for the horsemen of lower status. In France it grew to be the only recognised name for them. In Germany it was not so common, *sariant* (the German form of the word) being used indifferently along with other appellations, such as *scutifer, armiger, strator*. These twelfth and thirteenth-century *servientes* or *scutiferi* are not to be confused with the squires of the fourteenth and fifteenth centuries who were the personal attendants of a knight. In the earlier age the knight had no mounted follower. His armour-bearer accompanied him on foot, and was not necessarily a combatant at all. The "sergeants" were often formed into separate corps, apart from the knights, and used for the purposes for which light cavalry are required; or, again, they were placed in the less important parts of the battle-array. Not unfrequently we find sergeants placed in the front line to open the combat, while the knighthood is held in reserve to deal the decisive blow. We

[1] See p. 440.

[2] *e.g.* we shall see that at Legnano the emperor's host comprised five hundred knights to fifteen hundred sergeants. See p. 442.

shall find Philip Augustus employing this arrangement in his right wing at Bouvines (1214).[1] Frederic II. did the same at Cortenuova in 1237. But it was by no means the regular rule to separate the lighter and the heavier horsemen. It was more common to compose each of the divisions of an army of sergeants, "stiffened" by the admixture of a certain proportion of knights, as did, *e.g.*, the elder Montfort at Muret (1213).[2]

A further complication is introduced into the nomenclature of the military class when, in the twelfth century, the word *miles* has its meaning still further changed by the spread of the new idea of chivalry. When the notion is introduced that a knight must be solemnly invested with the arms and insignia of the knightly rank by his feudal superior or some other personage of importance, and must not call himself *miles* till he has been so honoured, there necessarily comes into existence a class of holders of knightly fiefs who have not yet received the knightly name. A young baron with very large estates may serve for some time before earning the title. On the other hand, a warrior of approved courage, whether of noble or non-noble blood, may receive knighthood from king or duke for some notable feat of arms. Thus a baron not yet knighted was often followed to war by vassals who had attained the rank to which he was still aspiring.

Hence, in the later twelfth or in the thirteenth century, when we examine the composition of that part of the *personnel* of a feudal host which does not consist of knights, we find quite a large variety of classes represented in it. We may notice—(1) young holders of knightly fiefs who have not yet received the knightly title ; (2) men of knightly blood, holding small fiefs, who, on account of poverty (or some such other reason) do not intend to take up the honour ; (3) younger sons of barons and knights, who have no land and therefore cannot afford to aspire to knighthood (this was a class out of which the mercenary cavalry were very largely recruited) ; (4) various degrees of persons of non-knightly blood enfeoffed on land by their lords. The first three sections are men of the knightly class, but not knights : the last is the one to which the title of sergeant properly belongs. A cross-division is made by the fact that a wealthy sergeant may sometimes succeed in providing himself with a heavy war-horse and the full panoply of mail, while poor members of

[1] See p. 471. [2] See p. 453.

classes 2 and 3 may be serving in incomplete armour and on inferior chargers.

In the later thirteenth century we find the three latter classes tending to melt together, and to be considered as all equally forming part of the military aristocracy, so that most of the sergeants ultimately became " noble." Though not knights, they form the lower ranks of the knightly caste. It is easy to understand that when the knightly title became restricted to a comparatively few individuals of the knightly houses, and when the poorer members of them were continually serving along with the richer sergeants, the latter should ascend a step on the social ladder. It was more natural that the sergeants should advance to a better status, than that the brothers and younger sons of the holders of knightly fiefs should descend to a lower one. So by the fourteenth century the French *noblesse* and the German *Adel* have extended their ranks so as to include classes which two hundred years earlier would not have been considered to belong to the nobly-born. The term sergeant passes out of use as meaning a feudal horseman of the lower rank,[1] and armies are reckoned not as containing *milites* and *servientes*, but by the number of " helms " or " barded horses " that they muster. No one now stops to inquire whether the warrior who wears the full panoply and rides a heavy charger has or has not received the knightly spurs and girdle. He is an equally efficient member of the host, whether he bears the knightly name or not. The general body of the feudal horsemen who have not won their spurs are now called squires (*écuyers, knechte, armigeri*), or men-at-arms.

It is, of course, impossible for an army to dispense altogether with light cavalry ; they are needed for purposes of foraging and reconnoitring. In this capacity the place once held by the *servientes* is occupied in the fourteenth century mainly by mercenaries, but partly also by the incompletely armed servants of the knights and squires, who brought with them to the host a certain number of mounted attendants (*valets armés, Diener*). There were, however, to be found light horse who were neither mercenaries nor mere dependants of the men-at-arms. Such troops certainly existed in England ; we recognise them in the

[1] Remaining in use, however, as we shall see later on, for certain individuals, *e.g.* the king's personal retinue of " sergeants-at-arms," employed by him for various small official duties. It also survives in occasional use for foot-soldiery.

pauncenars, and hobilars of the Calais muster-roll of Edward III. (1347).[1] On the Continent, too, they appear as *panzerati* or *rennen* in Germany, as *haubergeons* in France.

No account of the armies of the twelfth and thirteenth centuries would be complete without mention of the mercenary cavalry. We have already seen that in England they occupy a very prominent place in military history, and the same is the case on the Continent. From the days of the Norman adventurers who ousted their unfortunate employers from Apulia and Benevento, the mercenary is always intermittently in evidence. Robert Guiscard and William the Conqueror were able to recruit them by the thousand, and in most continental wars we find them serving side by side with the emperor's or king's liege vassals. Their bands would include a much smaller proportion of knights and a much larger proportion of combatants of lesser status than did the normal feudal host. The knights who left their fiefs to follow the career of adventure were naturally not so numerous as the smaller men. The bulk of a mercenary band would be composed of the landless younger sons of sub-tenants, mixed with adventurers of lower birth who had taken to the profession of arms from love of fighting or from the wish to escape from villeinage. Whatever the origin of these mercenary horsemen, all who were not knights were commonly known as "sergeants," the escaped villein no less than his better-born companion. At first it was more common to buy the service of mercenaries by the gift of land, but by the twelfth century there was enough money in circulation to enable kings and emperors to retain the hired horsemen in service by the regular payment of a daily, monthly, or yearly salary. This was in every way better for the employer: the enfeoffed mercenary was generally a bad and turbulent subject (we need only recall to the English reader such instances as Fawkes de Bréauté), while the adventurer hired for a fixed term could be duly discharged when he was no longer needed.

The mercenary bands were increasing in importance all through the period with which we are now dealing. Only local wars could be conducted by the regular feudal levy; all long and distant campaigns and all large schemes of conquest required the co-operation of hired soldiery. Kings with a wide and scattered empire, like Henry II. of England, were necessarily

[1] See p. 366. Brady, vol. iii., Appendix.

driven to employ them. Adventurers in search of a realm, like
Charles of Anjou in the succeeding century, naturally relied
upon them. Long-continued wars hardened them into compact
masses, till by the end of the thirteenth century we find the
condottiere system coming into existence—noted mercenary
chiefs have collected huge bodies of men numbered by the
thousand, and hawk their services about from court to court.
The first[1] of these hosts of free-companions which comes into
prominence is the "great company" of Roger de Flor, formed
from the discharged mercenary bands of the King of Aragon,
turned loose when Peter ended his long struggle for Sicily with
Charles II. of Anjou. Roger's horde was strong enough to
shake the whole Levant, to bring the Byzantine Emperor
Andronicus to his knees (1308), and to carve out for itself a new
home in the duchy of Athens.

Turning to the continental foot-soldiery, we find that we
need not in the twelfth century concern ourselves greatly with
France or Germany; the Netherlands and Italy are the two dis-
tricts which demand our attention. Closely akin to the English,
the inhabitants of Flanders, Brabant, and the neighbouring regions
had, like their kinsmen on this side of the water, taken late to
horsemanship. Unlike England, the Netherlands had never
been conquered and divided up by any invader, and it seems
likely that their steady infantry descends directly and without
a break from the times of the Carolingians. The growth of an
indigenous feudal cavalry in the duchies and counties of the
Low Countries did not entirely extinguish the foot-soldiery, as
was the case in most other regions. As early as 1100 we have
notices of Netherlandish infantry armed with the pike which
enjoyed a reputation far above that of the foot-levies of other
countries.[2] In the earliest cases they are called *geldons*—the
same word, it will be remembered, which Wace uses for the
English axemen at Hastings.[3] We may guess that the mailed

[1] We can perhaps hardly count Stephen's Flemish captain William of Ypres or
Richard Cœur de Lion's follower Mercadier as real *condottieri*; as it does not seem
that they hawked about already formed bands for service, but rather that they gathered
and kept together new corps at the king's expense.

[2] In 1106 the Annals of Hildesheim, 3. 110, mention that the Duke of Brabant sent
to aid the Archbishop of Cologne "quoddam genus hominum qui vocantur *Gelduni*,
viri bellatores et strenui, et nimis docti ad prœlia."

[3] Wace, 12927. *Geldons* Engleiz haches portoient
 E gisardes ki bien trancheolent.

mercenary infantry armed with the pike which the Conqueror employed in that same fight were largely Flemings.

Later in the twelfth century we find these pikemen serving in all the wars of the Low Countries along with the feudal cavalry of their lords, and, ere long, pushing abroad as mercenaries. They generally appear under the name of Brabançons, which becomes a technical term for mailed mercenary foot-soldiery: English and French kings and Roman emperors are all found employing them; they appear in the Italian wars of Frédéric Barbarossa, the French expeditions of Henry Plantagenet, and the victorious campaigns of Philip Augustus. The last fight in which we note them taking a prominent part is Bouvines, where a small body of them[1] in the service of the Count of Boulogne did far the best service performed by any foot-soldiery in the allied army. In the thirteenth century the Flemings and Brabançons do not keep their place as mercenaries, —the crossbowman, rather than the pikeman, is the typical hired foot-soldier of that age; but in their native land they continue to serve as before, and the mailed militia of pikemen is still reckoned a notable part of the host. We may see their usual tactics at Steppes (1212),[2] and read of their greatest triumph at Courtray (1302). In the thirteenth and fourteenth centuries, the civic levies of the Flemish cities are the most prominent exponents of such methods of combat.

The Netherlandish infantry had little mobility or initiative. They fought in heavy masses, and could not manœuvre. But for purely defensive tactics they were formidable: the weapons of the pikemen were much longer than the knightly lance, and if only the mass held firm it was extremely difficult to break into it. But since it could not easily advance or change its front, it could not unaided win a battle: at the most it could only repulse its enemy. To be actively successful it must be helped by mounted men: when the pikes have checked the foe, the onset of horsemen is required to break him and pursue him. For use in combination with cavalry the pikeman is inferior to the man armed with missile weapons: he can only harm his adversary at the moment of contact, while the archer or crossbowman can keep up a continuous discharge as long as the

<hr/>

[1] "Homines de Brabanto, pedites quidem, sed in scientia et virtute bellandi equitibus non inferiores" (*Gen. Com. Fland.* in Bouquet, xvii. 567 c.).

[2] See p. 444.

enemy is within a hundred or a hundred and fifty yards of
him.

Roughly speaking, we may say that these early pikemen
could give valuable assistance in winning a battle, but could
not gain it by themselves. They could supply a rallying-point
for the cavalry, or bear the brunt of the fight while the latter were
re-forming; they could oppose a long passive resistance, but
had little or no active power. If we ever find them taking the
main part in a victory, peculiar local circumstances must be the
explanation; e.g., at Courtray the fearful slaughter of the French
chivalry was caused by the fact that they fought with a deep
marshy ditch in their immediate rear, so that they could not
easily retreat. Usually attempts of the Netherlanders to fight
without the aid of horsemen only brought them disasters like
Cassel and Roosebeke.

In Italy, where foot-soldiery had never been prominent since
the old Roman days, their reappearance is intimately connected
with the rise of the great towns. Just before the age of the
Crusades, the cities of Northern Italy were beginning to start
on their career of municipal independence, and had practically
freed themselves from their counts and bishops. We have
already noted the vigour with which they flung themselves,
first into the struggle to expel the Moorish pirates from the
central Mediterranean, and then into the more distant Crusades
of the Levant.[1] Seafarers like the Venetians, Genoese, and
Pisans naturally developed into foot-soldiery. It is as cross-
bowmen that they appear at every siege and battle in Syria
during the twelfth century. Of all the peoples of Europe none
had such skill in the use of the arbalest : after winning a high
reputation as marksmen in the battles of the East, we find these
Italian foot-soldiers, and especially the Genoese, passing north of
the Alps as mercenaries, and fighting in the French service at
Courtray, Sluys, and Crecy.

While the inhabitants of the seafaring towns were mainly
skilled in the use of the crossbow, the civic militia of the inland
cities was chiefly composed of pikemen. The army of an
important municipality like Milan or Verona consisted of a
mass of infantry, backed by a certain proportion of horse. For
the Lombard states owned a not inconsiderable amount of
cavalry, provided partly by the nobles of the countryside, who

[1] See pp. 252, 253.

had been more or less willingly incorporated in the civic body, partly by the richer burgesses of the city, the local patrician families. Every town of importance could put in the field some hundreds of mailed horsemen, while Milan mustered more than two thousand. But the bulk of the hosts of the Italian municipalities consisted of the infantry serving under the banners of their quarters or parishes. (At Milan the division of the city was into " gates.") They were well equipped with pike, steel cap, and mail-shirt, and, when properly led, showed great solidity in the field.

The Italian infantry never attempted, as did the Flemish more than once, to dispense with the assistance of cavalry. They always worked in company with the horsemen of their cities, and made no pretensions to be self-sufficient. When pitted against an enemy who used mounted men alone, or only brought inefficient and ill-armed foot-soldiery to the field, they often turned the scale in favour of their own side. As a typical fight of this description, we shall narrate the battle of Legnano,[1] where the steadiness of the Milanese foot saved the day, by allowing the routed Lombard horse time to rally and resume the charge.

[1] See p. 442.

CHAPTER III

ENGLISH BATTLES AND THEIR TACTICS, 1100-1200

Tenchebrai (1106)—Bremûle (1119)—Northallerton (1138)—Lincoln (1141)—Battles in Ireland (1169-71)

IT has been often observed that the period of the completest supremacy of cavalry in the West, the twelfth century, was not a period of great battles. There are more important fights in England in the open field during the sixteen years of the Wars of the Roses, or the six years of the Great Rebellion, than in the whole century between 1100 and 1200. The same is the case on the Continent, though in not quite such a noticeable degree. The main reason of this was, that the development of fortification during the century was so enormous, that it was more profitable for the weaker side to take the defensive behind strong walls than to fight in the open. Hence the century is pre-eminently one of sieges rather than of pitched battles. Henry I.'s victories of Tenchebrai and Bremûle were very small affairs, in which only a few hundred knights took part. The long civil wars of Stephen and Matilda abound with sieges, but only supply the two battles of Northallerton and Lincoln. All the long French wars of Henry II. do not give us a single first-rate engagement in the open ; the skirmish of Fornham and the surprise of Alnwick are the only fights in his reign that we need notice. The same is the case with the long bickering of Richard I. and Philip Augustus along the Norman and Poitevin borders. It is hardly too much to say that between Lincoln (1141) and Bouvines (1214) no English troops were present at an engagement of first-rate importance in Western Europe. If it had not been for the distant crusading battle of Arsouf (1191), we might have said that there was no really great battle in the whole period in which they were engaged.

For the most part, these unimportant conflicts of the twelfth century were both simple and short. Another notable point about them was, that they were accompanied by very little effusion of blood, save when some luckless infantry had been dragged into the field by one side or the other: in that case there was often cruel butchery in the pursuit; otherwise the knights gave each other quarter, and the main loss of the defeated side consisted of prisoners and not of slain.

Battle of Tenchebrai, September 28, 1106.

Henry I. of England had invaded the lands of his brother Robert and overrun most of the duchy of Normandy. He was beleaguering Tenchebrai, a castle of the Count of Mortain, when the duke resolved to make a desperate attempt to raise the siege. Gathering all the forces that he could muster, he marched on Henry's camp and offered battle; he was very inferior in the number of his knights, but had brought a mass of ill-armed peasantry and citizens with him. Possibly his experience in the Crusades had given him the idea that the knight and foot-soldier should be combined in the line of battle; but he evidently did not know how to turn his notion to profitable account. Finding himself outnumbered and outflanked, he dismounted his knights and put them at the head of the unsteady infantry. The army formed three corps; the right was led by William of Mortain, the centre by the duke, the left wing by Robert of Belesme, the rebel whom Henry had expelled from England six years before.

The king's army consisted wholly of mounted feudal levies; but, seeing that his brother had ordered his knights to fight on foot, Henry also bade a great portion of his host to send away their horses, in order that he might oppose a mass of equal solidity to the duke's columns.[1] The whole of the English and Normans were dismounted and formed into three corps, placed under Ralph of Bayeux, Robert of Mellent, and William of Warenne. The first-named faced William of Mortain, the second the duke, the third Robert of Belesme. But Henry commanded his vassals from Maine, under their count, Hélie of la Flèche, and his auxiliaries from Brittany, to keep their horses

1. "Rex namque et dux et acies caeterae pedites erant ut constantius pugnarent." (Henry of Huntingdon, 235).

and to ride off and to take position on his right wing, at some distance from the main body. The battles of the king and the duke clashed together with equal courage, and stood locked for a short time in close conflict. Then William of Mortain drove back Ralph of Bayeux and Henry's left wing for some space, while the centre and right of the king's army held their ground. But immediately after, Hélie of Maine led his horsemen against the flank and rear of the Norman left wing. At the first shock Robert of Belesme's corps broke up, then that of the duke, then that of Count William. The horsemen rode in among the fugitives and cut down two or three hundred of the unmailed Norman infantry. But the knights were mostly admitted to quarter: only a few escaped,[3] the rest, four hundred in all, were taken prisoners. Waldric, one of Henry's chaplains, was the captor of Duke Robert, for which unclerical feat he was soon after made bishop of Llandaff. With Robert were taken William of Mortain, Robert d'Estouteville, William de Ferrers, William Crispin, and all the chief nobles of Normandy. We are somewhat surprised to find in their company Eadgar the Atheling, who had broken his old friendship with Duke Robert some time before, but had returned to his side to share his day of misfortune.[3] Robert of Belesme, who fled too early for his own good fame,[4] was the only man of note in the duke's army who got away.

The whole fight had not occupied an hour, and not a single knight on Henry's side had been slain. We have to turn to Italian chronicles of the fifteenth century to find such a bloodless fight followed by such great results—for the victory of Tenchebrai gave King Henry the whole duchy of Normandy. He had used horse and foot combined, against isolated infantry, and had been properly rewarded for his adherence to his father's example at Hastings.[5] It is curious to see that it was the

[1] "Consul Willelmus aciem Anglorum de loco in locum turbans promovit" (ibid.).
[2] William of Jumièges, p. 573.
[3] Anglo-Saxon Chronicle, sub anno 1106. The king shortly released him, though he condemned the others to perpetual bonds.
[4] Orderic Vitalis, 701.
[5] Matthew Paris (writing a hundred and fifty years after the fight) thinks that Henry's English and Normans on foot are a different body from the three corps under Ralph of Bayeux, Robert of Mellent, and William de Warenne. This is an error, produced by misunderstanding Orderic's "Primam aciem, etc. . . . Rex autem Normannos et Anglos pedites secum detinuit, Cenomannos et Britones longius in campo posuit." The three corps are the pedites.

brother who had stayed at home, and not the brother who had been to the far East, that had best realised the military meaning of the experience of the first Crusade.

Battle of Bremûle (Brenville) August 20, 1119.

King Henry's second battle in Normandy was an even shorter and simpler affair than the battle of Tenchebrai; it hardly deserves, indeed, to be called anything more than a skirmish. It only lasted a few minutes, and the total number of men engaged on both sides was less than a thousand in all.

Louis VI. of France had invaded Normandy, to endeavour to place on its throne his young protégé, William Clito, the son of Robert, who had now been languishing for many years in Cardiff Castle, and was well-nigh forgotten. William, a clever and bright lad of eighteen, was now old enough to take the field in person along with his champion. They had crossed the frontier, and a few trusty old adherents of Robert had joined their standard, but the great bulk of the barons of the duchy stood firm in their allegiance to King Henry.

Since castles and cities kept their gates closed, the invasion dwindled down into a series of mere plundering raids. Based on the town of Les Andelys, Louis and his knights rode out, harrying the countryside, and pushing useless forays as far as the neighbourhood of Rouen and Evreux. Meanwhile, King Henry came upon the scene with a small army: he had a few English with him, but the bulk of his force was composed of the native feudal levies of Normandy ; he took post at Noyon-sur-Andelle, intending to cover the duchy from the destructive inroads of the French. On the 20th of August, the smoke rising from the burning barns of the monks of Bucheron[1] showed clearly to Henry that the French were out upon one of their habitual forays. He marched for the scene of destruction, with the five hundred knights who were around him, and soon came into sight of the scattered outriders of Louis. When the French king heard that his enemy was at hand, he swerved aside to meet him, in spite of the advice of his wiser counsellors, who pointed out to him that he had but four hundred horsemen with him, and that the force of the Normans was unknown. Without taking any military precautions, or even drawing up a definite plan of battle, Louis galloped off to attack Henry.

[1] The name of the place on which the abbey of Noyon-sur-Andelle was built.

Meanwhile, the English king had seen the foe approaching, and found ample time to draw up his host. He followed the same general arrangement that had served him so well at Tenchebrai. The majority of his knights were directed to dismount, and to send their horses to the rear. Only one hundred kept their saddles. The exact details of the marshalling of their host are not certain: of our three primary authorities—Suger on the French side, and Henry of Huntingdon and Orderic Vitalis on the Norman—no two agree. Suger tells us that the host was drawn up with the horse in front and the dismounted knights in a second line.[1] Henry of Huntingdon says that the king made three battles—the first of mounted Norman knights, the second consisting of his private military household, headed by himself, also mounted, the third on foot under his sons, Robert[2] and Richard, which was strongest of the three.[3] Orderic states that there were a hundred knights under the king's son Richard on horseback, while the rest of the Normans fought on foot around the king, who was himself dismounted.[4] He does not mention whether the horse were in front line or reserve, and might be understood rather to imply the latter, as in his account the first attack of the French seems to be directed against the dismounted knights.[5] But since Suger and Huntingdon agree in putting the horsemen in front, and Orderic does not actually contradict them, we must not press his wording, and may conclude that Henry placed his infantry (if one may call them such) behind his cavalry. Apparently he drew out the small body of horse to allure the French to attack, and kept his strong force of dismounted knights somewhat out of sight.[6] The one fact

[1] Suger, p. 45: "(Henricus) milites armatos, ut fortius committant, pedites deponit." Then the French charge, and "primam Normannorum aciem fortissima manu caedentes a campo fugaverunt, et priores equitum acies super armatos pedites repulerunt."

[2] The famous Earl of Gloucester of the civil wars of Stephen's day.

[3] "Rex Henricus in prima acie proceres suos constituerat: in secunda cum propria familia eques ipse residebat: in tertia vero filios suos cum summis viribus pedites collocaverat." (Henry of Huntingdon, p. 241).

[4] Orderic says that "Ricardus filius regis et c. milites equis insidentes ad bellum parati erant: reliqui vero pedites cum rege in campo dimicabant" (p. 722).

[5] There were no more than the five hundred knights present on Henry's side. The "grand pleinté de sergeants" whom the Grands Croniques de France introduce are an invention, as can be seen by carefully comparing them with Suger.

[6] This, I fancy, is what Suger means when he says that Henry "speculatus regis Francorum improvidam audaciam militum acies in eum dirigit: incentiva ut in eum extraordinarie insiliat, ponit: milites armatos pedites deponit."

on which our authorities are hopelessly at issue, is that Orderic says that the horse were commanded by the king's sons, while Henry of Huntingdon says that they were led by the "proceres Normannorum," *i.e.* the Counts of Eu and Warrenne, and that the royal bastards led the infantry reserve. We cannot hope to reconcile them on this point. The French can hardly be said to have had any battle-array at all :[1] they rode up in disorder in three troops, of which the first was headed by the Norman rebel William Crispin, and contained only eighty horsemen ; the second (mainly composed of the knights of the Vexin) was headed by Godfrey of Serranz, Bouchard of Montmorenci, Ottomond of Chaumont, and Guy of Clermont ; the third was led by the king and his seneschal, William de Garlande. Henry of Huntingdon, however, speaks of the first two squadrons as if they formed a single corps, and says that they had been placed by King Louis under the orders of the young duke, William Clito—which is likely enough in itself, but conflicts with the other authorities.

Orderic and Henry of Huntingdon agree in stating that William Crispin charged first, and won a certain amount of success : this success was, as we learn from Suger and Henry, that he scattered and drove off the hundred horsemen whom the English king had placed in front of his line. But then, plunging recklessly in among the serried ranks of the column of dismounted knights, his men were surrounded, torn from their horses, and made prisoners. He himself cut his way to Henry and dealt him a severe blow, which was only prevented from being fatal by the strength of the king's mail coif. But his horse was killed under him, and Roger de Bienfaite threw him down and captured him, saving him with difficulty from being slain by the angry knights of the king's household.[2] When the first French squadron was already practically disposed of, the second charged in with equal courage, made the Norman phalanx reel for a moment, but soon shared the fate of Crispin's men, nearly all being surrounded, pulled down, and taken prisoners.[3]

[1] Rex autem, nullum praelii constituere dignatus apparatum, in eos indiscrete evolat " (Suger, 45).

[2] Cf. Orderic and Henry of Huntingdon : the latter says that William got two fair cuts at the king's head, the former speaks of only one.

[3] Suger speaks of the Vexin knights as being in the first charge : "Priores qui manum applicuerunt Velcassinenses primam Normannorum aciem . . . a campo fugaverunt."

Seeing this disaster, the knights about King Louis advised him to retreat: he turned his rein, and then his whole corps broke up and fled in hopeless panic. The victorious Anglo-Normans called for their horses, mounted, and pursued the fugitives as far as the gates of Andelys. King Louis was so closely chased that he had to spring from his charger and plunge into a wood on foot. Thence he escaped by devious paths, and was led to Andelys by a friendly peasant. His horse and his banner fell into the hands of the conqueror. A hundred and forty knights were captured, but only three slain in the battle: "for they were clothed from head to foot in mail, and because of the fear of God and the fact that they were known to each other as old comrades, there was no slaughter." [1] Of the leaders of the two front squadrons of the French no one escaped captivity save William Clito. All the rest were made prisoners.

The conflict of authorities on minor points does not prevent us from having a very clear idea of the military significance of Bremûle. Disorderly charges of cavalry, unaided by either infantry or archers, avail nothing against a solid mass of well-armed knights on foot. Louis, seeing the Anglo-Norman host in such good order, could only have had a chance of success by dismounting some of his own knights, or by bringing men armed with missile weapons into the field, to harass the column of his adversaries. But he thought of nothing but of sweeping them from the ground by a desperate charge, and received the reward of his rashness in a crushing defeat.

The records of an insignificant skirmish, which occurred a few years after Bremûle and would have escaped notice but for its tactical interest,[2] suffice to show that the combination of archery with the mounted arm was not wholly forgotten in the Norman school of war. The memory of Hastings must always have kept it alive. In 1124 Waleran Count of Mellent was in rebellion against King Henry, and had drawn his kinsmen, Amaury Count of Evreux, and Hugh of Neuchâtel, into his plot. But the royal forces were too much for him; most of his castles fell, and he and his knights became wanderers on the face of the land. He had been raiding near Bourg

[1] Orderic, p. 722.

[2] M. Delpech must have the credit of bringing it into notice.

Théroulde, and committing horrid atrocities on the peasantry,[1] when he found himself intercepted by a body of three hundred of the king's mercenary troops who had drawn together from the neighbouring garrisons. They were headed by the chamberlain William of Tankerville, and Ralph of Bayeux.[2] The pursuers were superior in numbers, but they knew that Count Waleran was in a desperate state of mind, and that his followers were the best knights in Normandy. Instead of attacking, they resolved to place themselves across the road and offer battle in a defensive posture. Of the horsemen, part dismounted and formed a solid mass, the rest remained on their steeds; but Ralph and William had with them not only knights, but also bowmen, and, what is more surprising, mounted bowmen. We should not have known of their existence but for the explicit mention of them in William of Jumièges, for Orderic Vitalis, the other narrator of the fight, does not mention the fact that they were horsed.[3] Probably they were mercenaries, who had been furnished with a mount in order that they might be able to move rapidly along with the knights when pursuit was needed. There were forty of them in the party; these men Ralph and William placed on the left of their force, but thrown forward *en potence*, so that they would take in flank any body of men which charged up the road.[4] They were posted on the left, in order that they might shoot at the unshielded right sides of the rebels. Probably they dismounted in order that they might use their bows to better effect. Waleran of Mellent might have turned back and escaped by the way that he had come. But, as his adversaries had calculated, the desperate count had no such intention. He harangued his companions and bade them ride down the pack of "mercenaries and rustics"[5] who dared to block the way. He himself, with forty knights of his meinie, headed the charge; the rest, under the Count of Evreux,

[1] His pleasing habit was to cut off one foot of the peasants who fell into his hands (Orderic, p. 740).

[2] Orderic and William of Jumièges speak as if Ralph had been in command, but Henry of Huntingdon and William of Malmesbury mention Tankerville only.

[3] William, p. 576: "Denique catervis more pugnantium, necnon et equibus sagittariis (quorum inibi exercitus regis maximam multitudinem habebat) in dextra parte hostium praemissis clamor utrinque attollitur." William is a tiresome and confused author, but can hardly have gone wrong on a point like this.

[4] "In prima enim fronte quadraginta architenentes caballos occiderunt, et antequam ferire possunt sunt dejecti" (Orderic, p. 740).

[5] "Gregarios et pagenses milites."

25

followed. But when they came level with the archers, the latter let fly at their horses, and brought down nearly the whole of them by a few well-directed volleys. The second squadron suffered the same fate, and then the king's troops advanced and took prisoners the whole party, for some were pinned to the ground under their slain horses, and the others were too heavily weighted by their mail, and too bruised and shaken to get off rapidly. Eighty knights in all were captured, including Waleran himself, and his nephews, Hugh of Neuchâtel and Hugh of Montfort. The Count of Evreux would have suffered the same fate had he not fallen into the hands of an old friend, who collusively allowed him to escape.

This skirmish, exceptional in so many of its details, distinctly reminds us of the tactics which Edward III. was to employ at Crecy two hundred years later. To receive a cavalry charge by a body of dismounted men-at-arms, flanked by archers, while a mounted reserve remains behind to gather the fruits of the day, argues a high degree of soldierly skill on the part of the victorious commanders. Horsed archers are rarely found in Western Europe in the twelfth century; they were no doubt the predecessors of the mounted crossbowmen of the time of John and Henry III. Such troops were called into existence by the need of having men armed with missiles, who could keep up with the cavalry in their rapid marches against raiders. Foot-bowmen could not have intercepted Waleran's raid: but if provided with mounts of some sort, they might reach the field; they would then leave their horses, and join the knights, who had also sent their chargers to the rear.

Battle of Northallerton, August 22, 1138.

The celebrated "Battle of the Standard" differs in character from the other fights which we have been investigating, in that the enemy was not the mailed and mounted chivalry of France, but the wild hordes of Celtic tribesmen from beyond the Tweed. We might have expected that the commanders of the Yorkshire levies would have endeavoured to turn their superiority in horse to good effect against the disorderly masses of Highlanders and Galwegians: but as a matter of fact they dismounted every rider, as Robert of Normandy had done at Tenchebrai, and the sole cavalry charge of the day was delivered by the small

body of knights of English and Norman descent who served in the Scottish host. A short account of the battle will suffice, since neither side showed any tactical insight or attempted any new device. King David of Scotland had crossed the Tweed with a great horde of Highlanders and Galloway men arrayed in their clans. He led also the more orderly levies of the English-speaking Eastern Lowlands, and many mailed knights of the exiled English families who had removed to Scotland with Eadgar Atheling, or of the Norman settlers who had drifted in somewhat later. The Scots harried Northumberland and Durham with great ferocity, slaying the priest at the altar, and the babe at its mother's breast. Hence the Yorkshiremen looked upon the war as a crusade against savages, and marched out under the banners of their saints, St. Peter of York, St. John of Beverley, and St. Wilfrid of Ripon, all of which, together with that of St. Cuthbert of Durham, were placed on a chariot, and borne in the midst of their host. The large majority of the English consisted of the feudal levy and the fyrd of Yorkshire; but Stephen had sent some small succours from the south under Bernard Baliol, and among the barons present we detect a few who had brought their contingents from shires south of the Humber, such as Derby and Nottingham.[1] The chief person present was the young William of Albemarle, but Walter l'Espec Sheriff of Yorkshire, seems to have shared the command with him. They drew up their whole force in one deep line along a hillside on Cowton Moor near Northallerton, with the chariot bearing the standards in the rear of their centre. The knights all dismounted and served on foot with the shire-levies, apparently forming a mailed front line behind which the half-armed country-folk arrayed themselves. There were a considerable number of archers among the Yorkshiremen, who are said to have been "mixed" with the spearmen. Presumably they stood in the mass and shot over their friends' heads, down the slope; for there is no statement that they took position either on the flank or in front of the main body. Some of the elder knights formed a sacred band in reserve around the Standard: among them stood the commanders of the host, Albemarle and L'Espec.[2]

[1] See John of Hexham, p. 262, for the men from Derby and Notts.
[2] Richard of Hexham, p. 322; Aelred of Rivaulx, p. 343.

The King of Scots had a far larger army than his adversaries: the total of twenty-six thousand men ascribed to him is probably not very much over the real figure. But in mailed knights and in archers he was comparatively weak: the vast majority of his host were "Highland kerne" and Picts of Galloway, armed with nothing more than a dart, a target, and broadsword. Seeing the solid mass of the English awaiting him on foot, David resolved to assail them with their own tactics, and ordered his knights to dismount and form the head of the attacking column, while his archers were to advance along with them. The rest of the host was to follow, and to try to break in where the knights made a gap in the English front. But David had forgotten to reckon with the pride and headlong courage of his Celtic subjects: they refused to let the Lowland knights strike the first blow. The leaders of the Galloway Picts claimed that they had an ancient right to take the front place, and the Highlanders refused to give precedence to the Norman and English strangers.[2] When the king persisted in this design, Malise Earl of Strathern, one of the chiefs from beyond the Forth, angrily exclaimed, "Why trust so much, my king, to the goodwill of these Frenchmen? None of them, for all his mail, will go so far into the front as I, who fight unarmoured in to-day's battle." At this the Norman, Alan Percy, cried, "That is a big word, and for your life you could not make it good." The earl turned on him in wrath, and so hot an altercation burst out between the Highlanders and the Southern knights, that the king in despair withdrew his first order of battle, and granted the Galloway men the foremost place.

In the second scheme the Scots were drawn out in four masses: as far as we can follow Aelred of Rivaulx's description of the array, the Galwegians were in the centre of the front line, somewhat in advance. The two wings were formed, the right by the king's son, Henry, with the greater part of the knights of the Lowlands and the levies of Strathclyde and Teviotdale, the left by the English of Lothian combined with the West-Highland clans of Lorn, Argyle, and the Hebrides: among them stood the commanders of the host.

[1] " Placuit ut quotquot aderat militum armatorum et sagittarii cunctum praeirent exercitum, quatenus armati armatos impeterent, milites congrederentur militibus, sagittae sagittis obviarent." (Aelred, p. 342.)
[2] See John of Hexham, p. 262.
[3] Ibid. 342. Aelred of Rivaulx, p. 343.

King David was in reserve, with the men of Moray and the Eastern Highlands: he also kept about him as a bodyguard a few of his modest contingent of mailed knights.[1] When the Scots drew near the hillside where the English were arrayed, Robert Bruce, a Yorkshire baron, who held also the lordship of Annandale in Scotland, rode down to the hostile army and tried to induce the king to consent to terms of peace. But the young knights about David's person taunted Robert as a traitor, so that he had to withdraw, solemnly disavowing his feudal allegiance for Annandale ere he went.

A moment later the Galloway men dashed at the English centre, raising a terrible shout of "Albanach, Albanach!" Their wild rush made the fyrd waver for a moment, but the knights rallied and sustained the common folks, and restored the line without a moment's delay.[2] The Galwegians soon came back to the charge: they shivered their light darts on the serried line of shields which the Yorkshire men opposed to them, and then laid on with their claymores. But they could not break in a second time, and in the intervals between their charges the archery galled them sorely. Yet they furiously returned, "many of them looking like hedgehogs with the shafts still sticking in their bodies,"[3] to make one last bid for victory.

At this moment Prince Henry and his corps moved in upon the English left wing. He and his few scores of knights led the charge on horseback, the mass of Strathclyde men following on foot. The charge was fairly delivered, and the gallant prince with his horsemen hewed their way right through the line of the Yorkshire men till they came out at the back of the mass, scattering disorder all around them. Henry then saw the horses of the enemy held by the grooms of the English knighthood, a short way to the rear. He rode on to seize them, thinking that the infantry of his corps would penetrate into the entry that he had made, and reckoning the battle as won.

[1] Richard of Hexham, whose account of the Scottish array is incomplete, only says that the Galwegians were in front, the king and a bodyguard of English knights in the mid-battle, while the clans were around him, "cetera barbaries circumfusa erat" (p. 322).

[2] "Galwegensium cuneus tanto impetu irruit in australes, ut primos lanceariosstationem deserere compelleret, sed vi militum iterum repulsi in hostes animum et vigorem resumunt," (Aelred, p. 345).

[3] Videres, ut ericium, spinis, sic Galwegensem sagittis undique circumseptum nihilominus vibrare gladium, et caeca amentia proruentem nunc hostem caedere, nunc inanem aerem cassis ictibus verberare," (Aelred, p. 345).

Hardinge was sadly mistaken: he wasted but a few minutes in slashing at the horses, but those few minutes were the crisis of the day. The English closed up the gap through which he had cut his way, and drove back the Strathclyde men who strove to thrust themselves into it. Meanwhile, in the centre the fire and fury of the Galwegians was used up: leaving their chiefs Donald and Ulgeric dead on the field, they dispersed and fled. On the Scottish left wing the men of Lothian and Lorn behaved far worse: their leader (his name is not given) being slain by an arrow in the first clash of spears, they made no second charge, and retired tamely to the rear. King David now ordered his reserve of Highlanders to advance, and sprang off his horse to lead it forward. But, seeing the disasters in the front line, the fickle Celts began to melt off to right and left, and David soon found himself alone with his small body-guard of English and Norman knights. It was hopeless to proceed, so he bade his standard-bearer turn back, and withdrew to a neighbouring eminence, where there presently assembled round him the wrecks of his hosts. The mass looked so formidable that the Yorkshiremen dared not attack it, but waited till it began to retreat. Then they followed, at a distance, slaying stragglers and taking many knights prisoners. Prince Henry, having (as we have seen) worked his way to the very rear of the English line, was left in a position of desperate danger when the Scottish host broke and retired. He saved himself by a ready stratagem: he wheeled and faced to the north, then, bidding the few knights around him throw off their badges,[1] and mingle with the advancing line of the enemy, he pushed on unobserved along with the English, and gradually passed through them. When safely in advance of their foremost ranks, he moved off at a moderate pace, so as not to awaken suspicion, and finally got clear away, rejoining his father by a circuitous route on the third day. The Scots suffered very heavily in the fight, though the ten thousand or eleven thousand dead, of which the chroniclers speak are only one more instance of the usual mediæval inability to deal with high figures. It is more credible that of two hundred knights

[1] "Projectis itaque signis quibus a caeteris dividuntur, ipsis hostibus inferantur, quibus insequentes eum iis." What were the signa? Probably not coats-of-arms, which were only just coming into use, but some common token which the Scots were all wearing to distinguish them from the English.

whom Henry led to the charge fifty were captured, and so
many slain and wounded that only nineteen came back un-
touched with horse and arms. The prince himself had cast
off his mail-shirt when the battle was over,[1] refusing to be
burdened with it in the long ride across the moors which lay
before him ere he could rejoin his father. The slaughter
among the chiefs had been very heavy in all the front divisions
of the Scottish host: only the king's corps, which behaved so
tamely, had got off fairly unscathed.

Of the English, only one knight, the brother of Ilbert de
Lacy, had fallen; but a considerable number of the half-armed
fyrd had been trampled down in the first rush of the Galwegians
and in the desperate charge of Prince Henry.

Thus ended the Battle of the Standard, a fight of a very
abnormal type for the twelfth century, since the side which had
the advantage in cavalry made no attempt to use it, while that
which was weak in the all-important arm made a creditable
attempt to turn it to account by breaking into the hostile flank.
The tactics of the Yorkshiremen remind us of Harold's arrange-
ments at Hastings, even to the detail of the central standards
planted on the hill; but they had this advantage over the
Saxon king, that they were well provided with the archery in
which he had been deficient. David's plan of attack was not
unwise, but he was ruined by the Celtic pride and Celtic fickle-
ness of his followers. If his two hundred knights could have
opened a gap, and the fierce Galwegians could have thrown
themselves into it, the fortune of the day might have been
changed. But wild rushes of unmailed clansmen against a
steady front of spears and bows never succeeded: in this
respect Northallerton is the forerunner of Dupplin, Halidon
Hill, Flodden, and Pinkie. The most surprising incident of the
fight is the misconduct of the English-speaking spearmen of
Lothian on the Scottish left wing: it was not usually the wont
of the men of the Lowlands to retire after a single onset and
when there was no pursuit. Possibly they had no great heart
in the Celtic crusade against England, and were discontented
at the king's subservience to the Highlanders. It is certain
that during the retreat the Lowlanders and Highlanders fell
out and came to blows, each accusing the other of cowardice

[1] Aelred, p. 346. "He gave it to a peasant by the way, saying, "Accipe quod
mihi est oneri, tuae consulat necessitati."

and treachery, "so that they came home not like comrades but like very bitter enemies."

First Battle of Lincoln, February 2, 1141.

When we turn to the battle of Lincoln, we find ourselves on more familiar ground, and recognise the old tactics of Tenchebrai and other Anglo-Norman fields. Unfortunately we have for this important fight no account of such merit as Aelred of Rivaulx's excellent narrative of the Battle of the Standard.

In the winter of 1140-41 the barons of the West and the Welsh border were up in arms against King Stephen, and had sworn allegiance to his rival, the Empress Matilda. Among the many strongholds which they had taken was the very important castle of Lincoln. The king marched against it in the depth of the winter, and seized the city (whose inhabitants were friendly to him), while the rebels retired into the castle. He lay before its walls for a month, during which space the Earls Ralph of Chester and Robert of Gloucester were collecting an army with which they purposed to raise the siege. On the first of February[2] their approach was reported to the king; his counsellors advised him to refuse a battle, and to call in his adherents from the south, since he had but a small force with him. But Stephen despised his enemy, and announced his intention of fighting at once. To get at him the earls had to cross the flooded Fossdike,[3] and a guard had been set upon the fords to keep them at bay. But on the morning of February 2 Ralph and Robert forced the passage, though the water was deep and the marshes dangerous; the corps which Stephen had set to observe them was easily brushed away.

Hearing of their approach, the king drew up his army in front of the walls of Lincoln. In the absence of any precise indica-

[1] "Rex, recollectis suis qui sparsim de pugna, non ut consortes, sed potius sicut hostes inimicissimi fugerant, obsidionem apud Carham corroboravit. Nam Angli et Scoti et Picti, quocunque casu se inveniebant, alios mutuo vel trucidabant vel vulnerabant, vel saltem spoliabant, et ita a suis sicut ab alienis, opprimebantur" (Richard of Hexham, p. 323). *Angli* of course means the Lowlanders, *Scoti*, the Highlanders, and *Picti* the Galloway men.

[2] Stephen took the town "circa natale domini" (December 25), and was still before the castle on February 1, when the enemy appeared.

[3] A channel cut from the Trent to the Witham in the time of Henry I., which protected the south-west front of the city. This must be the stream, not the Trent, as some chroniclers put it. I am glad to find that on this point I agree with Miss Norgate's *Angevin Kings*.

tion of the battle spot, we have to put the following facts
together in order to identify it. (1) The earls forded the
Fossdike somewhere west of Lindoln. (2) They fought with it
at their backs, so that defeat meant disaster; *i.e.* they faced
north or north-west. (3) The routed cavalry of Stephen's host
escaped into the open country, not into the town; *i.e.* they were
drawn up so as to give a free flight to the north. (4) The infantry
fled into the town, which was therefore quite close. Probably
the battlefield lay due west of the city, and the Royalists
apparently faced south or south-west. Stephen used the
tactics which his uncle Henry I. had employed at Bremûle:
the greater part of his knights were ordered to dismount
and fight on foot around the royal standard; with them
were incorporated some infantry of the shire-levy, mainly
composed of the citizens of Lincoln.[1] In front of this mass
of dismounted men were drawn up two small "battles" of
horsemen; that on the left was headed by William of Albe-
marle, whom the king had made an earl for his services
at Northallerton, and by William of Ypres, a mercenary captain.
That on the right was under a multitude of chiefs—Hugh Bigot
Earl of Norfolk, William Earl of Warrenne, Simon of Senlis Earl
of Northampton, Waleran Earl of Mellent,[2] and the mercenary
Alan of Dinan, whom the king had created Earl of Richmond.
But these great names represented no great following; several
of them were *pseudo-comites,* men whom the king had made
earls in title, though their power and estates did not justify
the promotion;[3] it was said that they had no more connection
with the counties whose names they bore than that of receiving
the third penny of the shire-fines. The rest had come to Lincoln
without their full *servitium debitum* of knights, "as if to a
colloquy, and not to a battle."[4] The two squadrons between them
only mustered a very few hundred knights.

The rebel earls likewise drew up their host in three main
corps. One was headed by Ralph of Chester, the second division
by Robert of Gloucester, the third was composed of the numerous

[1] We get this fact from the speech of Earl Ralph in Henry of Huntingdon.
Recapitulating the king's forces, he says: "Cives Lincolnienses, qui stant suae urbi
proximi, in impetus gravedine ad domos suas transfugere videbitis" (p. 269).

[2] The vanquished rebel of the skirmish of Bourg Théroulde (see p. 384).

[3] "Paucos enim milites secum *ficti et facti* comites adduxerant"(Gervase, p. 1354).

[4] "Persuaserunt Seniores regi congregare exercitum, sese anim inermes ad regis
colloquium occurrisse, non ad praelii precinctum profitentes."

Midland knights and barons whose estates Stephen had declared confiscated for rebellion;) their chroniclers call this corps "the army of the disinherited." Robert had also brought with him from the marches a body of Welsh light infantry under two brothers named Meredith and Cadwalladen; these wild levies, "courageous rather than formidable,"[1] as the chronicler calls them, were thrown out on the flank of the front line. Ralph of Chester and his knights dismounted and formed the reserve, incorporating with themselves (just as Stephen had done) the remaining infantry of their host.[2] In the front line the "disinherited" faced Bigot, Mellent, Alan, and the other earls, while Robert and the Welsh were opposite Albemarle and William of Ypres. The number of horsemen on the two sides was about equal;[3] the king had the advantage in foot-soldiery.

The first clash came when the cavalry divisions of the front line charged. On the one wing the "disinherited" completely broke and scattered the five earls, whose whole squadron was in a moment either slain, captured, or in wild flight.[4] On the other flank William of Albemarle and William of Ypres came into collision with Gloucester's knights and the Welsh light infantry. The Royalists rode down the Welsh and drove them to take shelter with the Earl of Chester and the barons' reserve. But when they were assailed at once by Gloucester's horse and Chester's mailed foot, they gave way, and the two Williams fled in rout as prompt and complete as that of the earls in the other wing. None of the beaten Royalist horse made any attempt to rally: looking back on the field, William of Ypres observed that "the battle was lost, and that they must help the king some other day," and continued his flight.

Then the whole army of the rebel earls concentrated their efforts on the king's column of infantry: apparently Chester and his dismounted knights charged it in front, while the "disinherited" and Gloucester beset it on the flanks and rear. The Royalists made a gallant resistance, but at last the mass was broken up; those who could sought refuge within the gates of

[1] "Audacia magis quam armis instructi" (Huntingdon, 268).

[2] "Animosam legionem Cestreusium peditum" (Orderic, 269).

[3] See Baldwin's speech in p. 272 of Henry of Huntingdon: "Nobis numerus in equitibus non inferior, in peditibus confertior." This is more probable than Orderic's "hostes nimia multitudine peditum et Wallensium praevaluerunt" (769).

[4] "In ictu oculi dispersi sunt, et divisio eorum in tria devenit: alii namque occisi sunt: alii capti; alii aufugerunt" (Henry of Huntingdon, 273).

PLATE XII.

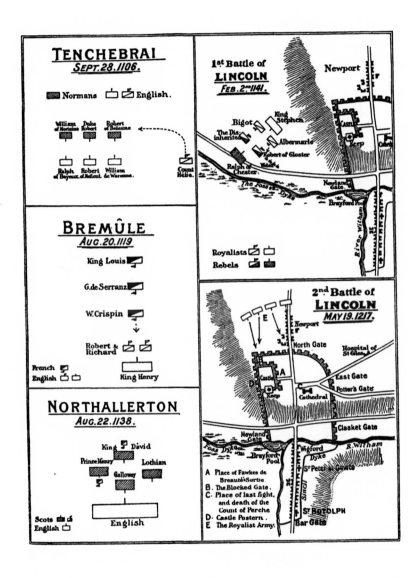

Lincoln, where the foe promptly pursued them and cut them up
in the streets. But Stephen and his truest followers stood firm
by the standard, and held out long after the rest of the fighting
was over. The king fought till his sword was broken, and then
used a Danish two-handed axe which a citizen of Lincoln
slipped into his hand.[1] His terrible strokes long held the rebels
at bay, but at last a final rush swept down his faithful band, and
he himself was thrown to the ground by William de Caimes, a
powerful knight, who caught him by the helmet and dragged
him over. With him were captured Bernard Baliol, Roger de
Mowbray, William Fossart, William Peverel, William de Clerfait,
Baldwin Fitz-Gilbert, Richard Fitz-Urse, and many other gallant
knights and barons.[2]

The first battle of Lincoln is a perfectly normal and typical
thirteenth-century engagement. Each side used the same tactics
of a front line of horse and a reserve of dismounted knights :
the Welsh light infantry on the rebel flank are the only unusual
feature, and they had no influence whatever on the event of the
day. Probably they were South Welsh archers, intended to gall
the flank of the Royalist horse by a cross-fire, like the bowmen
at Bourg Théroulde in 1124. Putting them aside, we see that
the battle was lost because Stephen's cavalry were so dis-
comfited that they could not rally behind the reserve and
return to the fight. When they had left the field, the king's
fate was sealed : like his uncle Robert at Tenchebrai, he found
that infantry unsupported must fail before horse and foot
combined.

Of the reign of Henry II. even more than of the rest of the
twelfth century is the statement true that the age was one of
sieges rather than of battles. All through his reign the king was
fighting hard, yet he was never present at an engagement of
first or even second-rate importance in the open field. Only twice
was he even on the edge of a great battle—once at the raising
of the leaguer of Rouen in 1174, and once when, in 1187, he lay
by Châteauroux with a great host, while Philip of France on the
other side of the Indre was drawing out his army day after day,
and offering to fight if the Anglo-Normans should endeavour to

[1] John of Hexham, p. 269.
[2] For the list see John of Hexham, p. 269. He is by far the most full in
enumeration.

pass the river. Both kings were prudent, and would not risk the passage, and finally they made a truce instead of settling their quarrel with the sword.

In the troublous years 1173–74, when Henry's enemies were in arms on all sides, and half England was overrun by the rebels, there were two engagements of high political importance, but neither takes rank as a real battle or gives us any interesting tactical features. The disaster of William the Lion at Alnwick was a curious instance of a great invasion stopped by the chance encounter of a few hundred knights. The King of Scots had invaded Northumberland with an army not less than that which his grandfather led to the Battle of the Standard. He lay before Alnwick with part of his force, while the rest were raiding far and wide in the valleys of the Tyne and Tees. Meanwhile, Robert d'Estouteville, the Sheriff of Yorkshire, had mustered the shire-levies of the great county, and the loyal barons of the north had gathered to his aid. They resolved to march towards Alnwick, but cautiously, since they knew that the Scots outnumbered them fourfold. In the long march from Newcastle to Alnwick the knights outrode the weary infantry. On the morning of June 13, 1174, they found themselves close to the beleaguered castle, but a heavy fog lay over the face of the land, and it seemed reckless for four hundred knights to try to pick their way between the besiegers' camps in the darkness. They attempted the dangerous feat, and were rewarded by an unexpected prize. When they had ridden some miles, the fog cleared, and Alnwick was seen close at hand; but closer still was a small body of mailed men riding at leisure round the castle. It was King William and a party of his knights; the rest were out raiding or scattered in distant camps. The king at first thought the English were some of his own host, and cantered unsuspiciously toward them. Only when he was too close to flee did he recognise the hostile banners; seeing his danger, he cried, "Now shall we see who is a true knight,"[1] and, levelling his lance, rode at the Yorkshiremen. This foolish feat of chivalrous daring had the natural result: his horse was slain, and he himself and all his companions were captured. His host broke up and retired in confusion into Scotland the moment that the disastrous news got abroad. Thus a great invasion was foiled

[1] "Modo apparebit quis miles esse invenit" (William of Newbury, 185).

by a trifling skirmish, in which less than five hundred knights took part.

Of the fight of Fornham (October 17, 1173), the other blow which crushed King Henry's enemies, we could wish that we had better details. The rebel Earl of Leicester was marching across Suffolk from Framlingham towards his own county with eighty knights and three thousand Flemish mercenaries, horse and foot, whom he had imported to strengthen his rebellion. To intercept him, the Constable Humphrey de Bohun and the Earls of Arundel and Cornwall marched to Bury St. Edmunds with a few loyal knights and three hundred of King Henry's stipendiary horsemen. The shire-levy of Suffolk and Cambridge joined them in great force, for the Flemings had made themselves hated by their cruel ravages in Norfolk. They were reported to have sung to each other,

"Hop, hop, Willeken, hop ! England is mine and thine,"

and the fyrd came out readily against them, though many were armed with nothing better than flails and pitchforks.[1] The host of the Constable outnumbered the rebels fourfold, but, as Ralph de Diceto remarks, if only properly armed men counted, the earl had far the more formidable following.[2] De Bohun, following, caught him as he was passing a marsh near Fornham, and, falling upon him suddenly, discomfited the rebels in a few moments. Apparently the whole fight was a surprise, for the Flemings seem to have found themselves in a helpless plight, and Leicester and his knights fled early.[3] The infuriated peasantry gave no quarter, and thrust the foreigners into bog and ditch till more were drowned than slain with stroke of sword.[4] Only a very few survived to share the captivity of the earl and his high-spirited countess, who had gone through the campaign at her husband's side. Such a rout of trained soldiers by raw levies led by a few hundred horsemen, can hardly be accounted for save by the hypothesis, that the rebels were surprised in a place where cavalry could not act freely : they

[1] Matthew Paris, *Hist. Angl.* 381.
[2] Ralph de Diceto, 377. "Si milites regis militibus comitis conferantur regalium numerus militiam, comitis expedit in quadruplum. Si vero capita capitibus, si armatorum copiam aequa lance quis colligat, multo plures erant cum comite quam ex adverso."
[3] "In ictu oculi victus est comes et captus" (Hoveden, 307).
[4] Jordan Fantosme, p. 294, line 1091.

allowed themselves to be attacked by the Royalists, made no
attempt to take the offensive, and hardly stood for a moment.
If the ground had been firm and open, they must surely have had
the better of the fyrd which crushed King Harry's enemies, we clearly have better details. The rebel Earl of Leicester was marching across Suffolk from Framlingham toward ... one country with eighty knights and three thousand Flemish mercenaries, horse and foot.

The English in Ireland, 1169-72

We have, as it chances, a far better knowledge of another
set of Anglo-Norman fights than of those of the great rebellion
of 1173-74. The *Expugnatio Hibernica* and the invaluable *Song
of Dermot and the Earl* enable us to form a very clear notion
of the tactics and strategy by which a few hundred knights of
the Marches of Wales subdued within the space of five years
the better half of Ireland. Of all the many conquests of the
Normans in East and West, this was perhaps the most astonish-
ing, for the resources of the invaders were weaker even than
those of the conquerors of Naples and Sicily, and the Irish
dwelt in one of the most difficult and inaccessible regions of
Europe.

Ireland in 1169 was one vast expanse of wood, bog, and
mountain, in which the tracts of open land were few and far
between. Between every tribal settlement lay difficult passes
over marshes or between woods and rocks. The natives, if
fickle and uncompacted, were not wanting in wild courage, and
had in their long wars with the Danes evolved a system of
defensive warfare which was well adapted to the character of
their country. On every trackway which led from district to
district there were well-known positions which the tribesmen
were wont to fortify with considerable skill. In the bogs they
dug trenches across the road and erected stockades on the farther
side, so that the passage was almost impassable for horsemen.
In the forest tracts they "plashed" the woods, i.e. cut down the
underwood and wattled it together in abatis across and along-
side of the roads, so that those who tried to force their way
through found themselves beset on flank and front by unseen
enemies, who could only be reached by hewing down the
screen of thick boughs. The *Song of Dermot and the Earl*
is full of descriptions of barriers of these two kinds: the
account of the pass of Achadh-Ur (Freshford in Kilkenny)
may serve as an example. This was a passage between the

¹ I have of course used Mr. Orpen's excellent edition of 1892.

river Nuenna and steep wooded hills." Mac-Donnchadh, king of Ossory—

> "Un fossé fist jeter aitant
> Haut e large roist e grant,
> Puis par afin ficher
> E par devant ben herdeler,
> Pur defendre le passage
> Al roi Dermod al fer córage."

"He bade his men throw up a trench high and wide, steep and large, and to strengthen it at the back with stakes and in front with hurdles, in order to dispute the passage of King Dermot the stout-hearted" (lines 1013–19).

Whenever the English marched out, the Irish "plashed the woods and dug across the roads" (line 1595), and it was hard to get from place to place "on the hard field and by the open ground." Such tactics were most distressing to invaders accustomed to win by the ponderous charge of mailed cavalry across the unenclosed fields and hillsides of England or Normandy. Yet, as we shall see, they succeeded in triumphing over these difficulties, and firmly established themselves in the conquered land.

The weak point of the Irish was their want of defensive armour and their inability to stand firm in the open. If once the enemy could close with them, and catch them far from the shelter of stockade and trench, they were easy to deal with, for they dreaded above all things the impact of the mailed horseman, and had never learned to stand fast, shoulder to shoulder, and beat off the charge of cavalry. Neither they themselves nor their old enemies the Danes were accustomed to fight on horseback, and they were utterly cowed by the Norman knight and his reckless onset. Their arms, indeed, were very unsuited to resist cavalry; only the Scandinavian settlers of the coast-towns and a few of the chiefs of the inland wore mail; the rest came out "naked" to war. As one of their own bards sang—

> "Unequal they engaged in the battle,
> The foreigners and the Gaedhil of Teamhair;
> Fine linen shirts on the race of Conn,
> And the foreigners in a mass of iron."[1]

Nor were the offensive arms of the Celts very suitable for repelling cavalry; they carried two darts, a short spear, and

[1] Poem of Gilla Brighde M'Conmidhe, quoted by Mr. Orpen in *Dermot and the Earl*, p. 268.

large-headed axes wielded by one hand, but had no long pikes
nor any skill in archery.[1] They hurled darts and stones at
close quarters from behind their stockades and fosses, but could
not keep off their enemy by the distant rain of arrows. In short,
they were formidable while skirmishing in woods and bogs, but
easily to be routed in the open.

The Anglo-Norman leaders soon learned to adapt their
tactics to those of the enemy. They had to avoid, as far as
possible, fights in woods or bogs, and to lure the enemy into the
clear ground. If this was impossible, and if the Irish stood firm
behind their defences, the only courses open were either to essay
surprises and night attacks—the Celts habitually kept a very
poor watch—or to gall the defenders with arrows from a dis-
tance. Fortunately for themselves, the knights of the Welsh
March had close to their hand the very associates most suited to
aid them in such difficulties. The men of South Wales were the
most skilled of all the inhabitants of Britain in archery, and drew
the longest and the strongest bows. It was by their aid that the
invaders were accustomed to triumph over the Irish hordes.
None of the barons who won Ireland ever marched forth without
a large provision of bowmen, and after a time they habitually
mounted them, in order that they might be able to keep up with
the knights in every chance of war, and might not be left behind
in rapid advances or pursuits. Giraldus Cambrensis in his
Expugnatio devotes the best part of a chapter to explaining the
advantage which the Welsh archers gave to the invaders, and
urges the leaders of his own day to enlarge the proportion of
Welsh in their bands,[2] on account of their lightness and swift-
ness, which enabled them to follow the Irish into heavy or moun-
tainous ground, where the mailed men could pursue only slowly
or not at all. A few descriptions of battles will show how the
Anglo-Normans contrived to deal with their adversaries.

Battle on the Dinin, 1169.

Dermot of Leinster, with his allies, Robert Fitz-Stephen and
Maurice de Prendergast, had executed a successful raid into
the lands of his enemy MacDonnchadh, King of Ossory. They
had with them three hundred knights and archers of Wales, and

[1] *Topographia Hiberniae* of Giraldus Camb. p. 151.

[2] See his *Expugnatio*, book II. chapter xxxviii. "Qualiter gens Hibernica
expugnanda sit."

a thousand of Dermot's followers from Hy-Kinselagh (County Wexford). On their return they had to cross a defile between wood and water, in the valley of the Dinin. The Irish were marching first, under Donnell Kavanagh, King Dermot's son; behind were the king himself and his Anglo-Norman allies. When the pass was reached, the men of Ossory were found stationed there in great force, under their king. The spot was dreaded by the men of Kinselagh; for three times had the army of Leinster been routed there within King Dermot's reign. When they found themselves attacked, they lost heart at once, and fled into the woods: Donnell Kavanagh only brought forty-three of his followers back to his father's side. The English were at the bottom of the marshy valley, in a place where they could not easily resist an attack, and a move onward to seize the well-manned pass seemed equally hopeless.

Maurice de Prendergast at once proposed a retreat from the valley and the woods up to the high open ground from which the army had descended in order to attempt the pass. If the men of Ossory should follow them, as was likely, it would be possible to turn upon them where neither trees nor marsh protected them from the charge of the Norman horse. His advice was promptly carried out; the Anglo-Normans retired up the hillside with every sign of hurry and dismay. When they began to approach the end of the wood, they dropped forty archers under a certain Robert Smiche (Smithe?) by the wayside, with orders to hide in a thicket till the Irish should have passed by; and to fall on their rear when the opportunity came.

The precipitate retreat of the invaders had the effect that Prendergast had hoped. MacDonnchadh and "all the pride of Ossory" came out in haste from their impregnable position, and followed them across the valley and up the hill. They passed the ambush without noticing it, and swept out into the open ground. When they had left the wood some way behind, they were surprised to see the Normans turn and form line of battle. Before the meaning of the movement was realised, the knights charged in among them, the archers and sergeants following close behind. The Ossory men were six or seven to one,—their numbers are given at from seventeen hundred to two thousand [1]

[1] In line 659 the author, of *Dermot and the Earl* calls them "mil e set scent," but in 718 "par aime erent ii millers." Neither figure seems too high, considering the usual exaggeration of the mediæval poet.

26

strong, but they could not stand for a moment against the impact of the mailed horsemen. They were broken and scattered in all directions with great slaughter: whether the ambush of archers fell upon the fugitives with much effect we are not told, but the cowardly men of Hy-Kinselagh emerged from the woods where they had been skulking, and hunted the fugitives for some distance. They brought back two hundred and twenty heads—no quarter was given in Irish war—and laid them at King Dermot's feet. To the horror of his auxiliaries, the brutal king was seen to pick out the head of one of his special enemies, and to tear with his teeth the nose of the fallen chief.[1]

The feigned retreat which won the battle of the Dinin was an old Norman device, whose most famous example was seen at Hastings. Without its use the army of Dermot and Fitz-Stephen must have been crushed in the valley between the marsh and the wood, where no cavalry charge would have been possible.

The next two engagements which we must notice were both fought close to the walls of Dublin,[2] which had fallen into the hands of the English in the autumn of 1170, its Danish lord, Haskulf Thorgilson, having been expelled and driven to seek refuge in the Western Isles. Richard de Clare, the famous "Strongbow," was now at the head of the invaders, and had laid claim to the whole kingdom of Leinster, since the death of his father-in-law, King Dermot, in May 1171. It was only a fortnight after his accession that a Viking fleet cast anchor in Dublin Bay. Haskulf had sought aid from the Scandinavian settlers in Man, Orkney, and the Hebrides, and had gathered a fleet of sixty sail to restore him to his lost possessions. His auxiliaries were led by an adventurer named John "the Madman," or "the Furious,"[3] a famous "Baresark," who had won much glory in the wars of the North. The Norsemen landed, ten thousand strong, or even more, according to the estimate of their enemies, which must be wholly futile: Orkney and Man could not have supplied half that number of warriors. They formed up on the

[1] Giraldus, *Expugnatio*, i. 4. The author of *Dermot and the Earl* does not give this discreditable trait of his hero's conduct.

[2] It is strange to find that Giraldus and the author of *Dermot* differ as to the order of the two sieges; Giraldus puts the Danish siege in May and the Irish siege in June, while the poet makes the Danish siege so late as September, three months after Roderick's.

[3] "Joannes Insanus" or "Vehemens" or "Le Wode" in Giraldus (p. 264). The *Song of Dermot* calls him Jean le Déve (from *desver*, to go mad).

shore and marched toward the city in a solid column, all clad in mail-shirts and bearing their Danish axes on their shoulders. This was a host very different from the hordes of naked Irish with whom the invaders had hitherto had to cope, and far more formidable.

Battle of Dublin, May 1171.

Miles Cogan was in command of Dublin in the absence of his master, Earl Richard. He had with him about three hundred mounted men,[1] besides archers and sergeants on foot, probably fifteen hundred men in all, if the infantry bore to the cavalry the proportion that was usual in the bands with which the Anglo-Normans overran Ireland. Miles came out at first into the open, with his archers and spearmen in front and his knights in second line. But he was unable to break into the Viking ranks, and was forced back against the eastern gate of Dublin (St. Mary's Gate or Dame's Gate). Foreseeing that this might occur, he had previously detached his brother, Richard Cogan, with thirty knights, to issue from the town by its western gate (Newgate), fetch a compass around the walls, and fall on the rear of the enemy. The main body of the English was barely holding its own about the east gate when a shout from the back of the Viking host told them that the diversion had begun. Richard and his knights had made a desperate charge into the rear ranks of the Norsemen. "When John the Wode scented the noise of those behind, and the shouting, he departed from the city; he wished to succour his friends who were left behind; John and his meinie, ten thousand strong or nine (I know not which), departed from the city to succour their companions in the rear."[2]

The diversion, trifling as it was, had checked the Norse attack, and in the confused movement towards the rear the solid column had been broken up, and gaps showed in it. Miles and the main body of the English, horse and foot, threw themselves upon the mass. The knights succeeded in penetrating into the heart of the column, and wrought so much damage among the Vikings that they began to retire in disorder towards their ships. John the Wode refused to fly, and fought with astonishing strength and courage; he struck one knight such a fearful blow with his two-handed axe that he hewed off his thigh in spite of hauberk

[1] *Song of Dermot*, line 2384. [2] *Song of Dermot*, lines 2375-80.

Macgille Moholmog[2] had been watching the fight from a safe,
ready to turn against whichever side had the worst of the
encounter. When they saw the Norsemen break up, they rushed
down and aided in the slaughter of the fugitives. Two thousand
were slain and five hundred drowned on the beach before the
survivors succeeded in thrusting their galleys out to sea, and
getting into the offing.

Surprise of Castle Knock, July 1171.

Only a month after the Vikings had been beaten, another
army appeared under the walls of Dublin. This time it was
Roderic O'Connor, the high-king of all Ireland, with sixty
thousand men levied from all the clans of the island. They
encamped around Dublin in four separate bodies—the high-king
and his men of Connaught at Castle Knock; Macdunlevy and
the clans of Ulster at Clontarf—the site of Brian Boroihme's
old victory; O'Brien of Thomond at Kilmainham; and Murtough
McMurrough with the men of Leinster at Dalkey. Earl Richard
had by this time returned to his capital and taken over the
command from Miles Cogan, but he was in despair at the over-
whelming strength of the array which O'Connor had brought
out against him, and did not dare to stir from the walls. After
a siege of six weeks, famine began to threaten the garrison.
The measure of wheat was sold for a silver mark, and the
measure of barley for half a mark. Nor was there any hope

of bringing in provisions by water, for Guthred, King of Man, was lying in the bay with a Viking fleet—the relics, no doubt, of the armament of John the Wode.

Richard endeavoured, therefore, to make peace with King Roderic, offering to hold Leinster as his vassal and do fealty to him. But O'Connor replied that he might hold the three towns of the Ostmen, Dublin, Waterford, and Wexford, but not a foot more. These terms appeared so hard to Earl Richard that he resolved to hazard a sortie, in spite of the desperate odds against him. On the very afternoon of the abortive negotiations he marshalled the forces which could be spared from garrisoning the ramparts, and marched out against the camp at Castle Knock (five miles from Dublin) in three small columns. Each was composed of forty knights, sixty mounted archers,[1] and a hundred sergeants on foot.[2] Miles led the first, Raymond Le Gros the second, and the earl himself the third. They hurried at full speed from the west gate and reached the camp of the men of Connaught before the alarm was given. The Irish were caught entirely unprepared; they were lounging about their cabins and huts, and the king himself was in his bath. They had surrounded their encampment with a stockade, but no one was in arms to guard it. The invaders broke in easily at three points, and rode through the lanes between the huts, hacking and hewing at every band that strove to concentrate against them. In a few minutes the fight was over, for the Irish broke up and ran off with disgraceful alacrity, the king, all naked from his bath, leading the flight. Fifteen hundred were slain, while the English only lost one single sergeant. On hearing of Roderic's defeat, the Irish in the other three camps dispersed and went homeward, and the siege was raised (July 1171).

Thus ended a fight which bears a strong similarity to another sortie made by an English garrison from Dublin, five hundred years later. Colonel Michael Jones in 1649 was beleaguered like Earl Richard by a vastly superior host dispersed in several distant camps. Like the earl, he hazarded a sortie against one of the hostile corps, and was successful in surprising and dispersing it. And when Ormond's men had been routed

[1] That the archers were mounted seems to follow from the correction of "satellites equestres" for "arcarii" in the later texts of Giraldus, I. xxiv.

[2] Giraldus makes the first two columns led by only twenty and thirty knights respectively, and says that Raymond rode before instead of after Miles Cogan.

at Bagotsrath, the other Irish divisions dispersed and retired without fighting. The rebels of 1649 were as divided in their counsels and as chary of giving each other prompt aid as the

The three battles which we have thus set forth give us the three main tactical devices by which the Normans won their victories—the feigned retreat, the flank attack by horsemen, and the sudden surprise. After three years of fighting, the Irish were so cowed that they habitually retired to wood or bog when the invaders advanced, and never fought save in night surprises or behind impregnable stockades and ditches. These defensive tactics handed over the open country to the conquerors, who forthwith secured it by erecting castles everywhere, structures against which the Irish could seldom prevail—indeed, a castle, when once completed, never fell save by treachery. On the other hand, the Anglo-Normans were almost equally incapable of mastering the woods and bogs in which their enemies took refuge. Hence came that unhappy division of the island, destined to last for four centuries and more, in which the natives held out in their fastnesses, while the invaders dominated the open land—each levying unending war on the other, yet neither able to get the advantage. The land could make no progress, and in the sixteenth century the natives were as barbarous as in the eleventh, while the invaders had almost sunk to their level, instead of advancing in civilisation parallel to the English and the other nations of Western Europe. The wars of Elizabeth's day in Ireland exhibit the "mere Irish" absolutely unchanged from their ancestors of the twelfth century; their primitive tactics, their arms, their plashed woods and wattled stockades are absolutely the same as those of the days of Strongbow. Except that some of their chiefs had learned to ride to battle, we see no change.

[1] Ormond was caught in bed—just as Roderic O'Connor was caught in his bath by the sortie party.

[2] And that as early as the fourteenth century, as is shown by the description of the Irish by the captive squire in Froissart, xii. p. 429.

[1] That the archers were mounted seems to follow from the correction of "satellites equestres" for "navali" in [...] Liber text of Giraldus i. xxiv.

[2] Giraldus marks the first two columns led by only twenty and thirty knights respectively, and says that Raymond rode before instead of after Miles Cogan.

CHAPTER IV

ENGLISH BATTLES OF THE THIRTEENTH CENTURY

*Second Battle of Lincoln (1217)—Taillebourg (1242)
—Lewes (1264)—Evesham (1265)*

AS we have already had occasion to remark, the wars of
Richard I. and John with Philip Augustus were singularly
unfruitful in battles. Bouvines is the one first-class engagement
in the whole generation ; and though there were English troops
—mainly mercenaries—fighting at that most decisive field, it
cannot be called an English battle. Salisbury and Hugh de
Boves were only present as the emperor's auxiliaries, and had
little to do with the conduct of the campaign or the marshal-
ling of the host for combat. We have therefore dealt with
Bouvines among continental and not among English battles.

It is not till the second battle of Lincoln (May 19, 1217)
that we come upon another field well worthy of notice, were it
only for the strange fact that it was a cavalry fight fought in
the narrow streets of a town—perhaps the most abnormal and
curious form of engagement which it is possible to conceive.
The Whitsuntide of 1217 found the barons who had espoused
the cause of Louis of France engaged in the siege of the castle
of Lincoln. They were in possession of the town, but the
castle was denied to them by Nicola de Camville, the castellan's
widow, who maintained the stronghold by the help of a small
garrison under a knight named Geoffrey de Serland.

Lincoln lies on a hill sloping down southward towards the
river Witham. On the high ground lie the castle, at the north-
west angle of the town, and the minster, more to the east. The
streets run down to the water, which is crossed by a bridge (then
known as Wigford Bridge) leading to the suburb of St. Peter's-

at-Gowts, beyond the Witham. The besiegers lay within the walls, and pressed the siege by battering the south and east sides of the castle with perrières. They had shaken part of the curtain, and hoped to see the battlements crumble within a few days.

The Royalist army mustered at Newark under William Marshall, the Earl of Pembroke: he had with him the Earls of Chester, Salisbury, and Derby, and the greater part of the barons who had remained loyal, as also Fawkes de Bréauté and the remnant of King John's mercenaries, horse and foot. Altogether they mustered four hundred and six knights, with three hundred and seventeen crossbowmen and a considerable number of foot-sergeants.[1] They marched from Newark northwestward when they heard of the straits to which the castle was reduced, and slept on the night of the 18th at Torksey and the neighbouring village of Stow, some nine miles from Lincoln. From thence they ascended the high ground along which the Roman road (Ermine Street) runs, and moved cautiously toward the north front of the city. This route gave them a chance of communicating with the castle, unless the enemy should choose to fight at a considerable distance from the walls. The host was marshalled in four [2] "battles,"—the first led by the Earl of Chester, the second by the Marshal, the third by the Earl of Salisbury, the fourth by Peter des Roches, Bishop of Winchester, the most unpopular but the most able of the late king's foreign favourites. The crossbowmen under Fawkes de Bréauté moved a mile in front of the knights. The baggage with a guard of infantry followed, the same distance in the rear, of the four corps of cavalry.[3]

Second Battle of Lincoln, June 19, 1217.

The besiegers of Lincoln received timely warning of the approach of the relieving army, and sent out Saher de Quincey, Earl of Winchester, and Robert Fitzwalter to reconnoitre the advancing columns. They soon returned with the report that the Royalists,

[1] So the *Song of William the Marshal*, 16264-8. Matthew Paris (p. 18) says four hundred knights and two hundred and fifty crossbowmen, as also *mille servientes qui vices militum possent pro necessitate implere.*

[2] Matthew Paris (p. 19) says seven "battles," but the *Song of William the Marshal* is so clear and full that it would be dangerous to refuse to follow it and to choose the older authority.

[3] Matthew Paris, p. 19.

seemed somewhat weaker than themselves, and that it would be advisable to attack them in the open, far from the city, in order that they might not be able to communicate with the garrison of the castle. The estimate was not far wrong, as the besieging army counted six hundred and eleven knights and a thousand foot-sergeants,[1] a force decidedly superior to the Marshal's host. But the Count of Perche, who commanded the French contingent in the rebel army,[2] insisted on going forth in person to take a second view of the enemy, before committing himself to a battle. Mistaking the distant baggage-guard and its column of sumpter-beasts and waggons for an integral part of the Royalist army, he came back with a firm belief that he was largely outnumbered, and insisted on keeping his men within the walls of the city, and taking the defensive.[3] This line of tactics seemed to promise absolute security, since it appeared impossible that the very modest host of the Earl Marshal would be able to do serious harm to the rebels, when the latter were covered by the strong fortifications of Lincoln. The storming of a city or castle by main force and without a long preparatory leaguer was an almost unknown thing in thirteenth-century warfare. Accordingly the barons continued their operations against the castle, and set their machines to play upon its walls with redoubled energy. The only precaution which they took against the relieving army was to tell off detachments to guard the four gates by which the Marshal might attempt to enter the city,—the north gate which lay immediately opposite him, the east gate and Potter's gate on the right flank, and the Newland gate on the extreme left between the castle and the river Witham. It cannot have escaped the notice of the commanders of the baronial army that their tactics allowed free communication between the castle and the Royalists, and that it was possible for the Marshal to enter the castle and sally forth into the town by the great gate in its eastern curtain. But this exit was well guarded by the detachment told off to operate against the castle, and such a

[1] *William the Marshal*, 16336-9.

[2] The chroniclers only preserve the names of three of the French chiefs in the host, though the French contingent seems to have been strong. These are the Count of Perche, the Marshal Walter of Nismes (Matt. Paris, p. 20), and the Chatelain of Arras (*Song of William the Marshal*, 16607).

[3] Matthew Paris, p. 19. He says that the barons had left many standards with the baggage-guard, and that their appearance misled the count into taking it for a reserve corps in the rear of the Royalist line of battle.

sally on a narrow front appeared to present no very great
danger. Any transference of troops from the relieving army
into the castle must take place under the very eyes of the
defenders, and could be easily provided against by a corre-
sponding shifting of their own forces.

When William the Marshal and his host approached Lincoln,
they were somewhat surprised to find that the enemy would
not come out to meet them in the open. Drawing up at a
cautious distance from the city, they proceeded to communicate
with the castle. John Marshall, the earl's nephew, swept round
the north-west corner of the place with a small party, and
entered the castle by its postern gate. He learned that the
garrison were reduced to great straits, and bore back the
message to his uncle. On leaving the postern he was pursued
by a party of rebel knights who issued from the Newland gate
to chase him, but outrode them and reached the main army in
safety.

The Marshal then resolved to send into the castle Bishop
Peter, who was renowned for his good military eye, that he
might decide whether the proper course of action would be to
throw troops into the castle and sally forth from it, or to attack
the gates and the city. The bishop made a rapid survey of
the place, and fixed his main attention on the point where the
castle joined the north-west front of the town wall. Here there
lay, quite unguarded, and close under the castle, so as to be
swept by its fire, an old blocked-up gate, on which the
barons had set no guard. He bade a party of the garrison
steal out and tear down the stones which closed the gate, so
as to make an opening in this unguarded front. Meanwhile, he

Song of William the Marshal, 16438-40.

"Une vielle porte choisi
Qui ert de grand antiquité
Et qui les murs de la cité
Joignet avec cels del chastel
Mès el fut anciennement
Close de piere e de ciment.
Quand li evesques ont veüe,
La fist abbatre et trebuchier
E que l'on velst et seüst
Que seüre entrée i eüst" (16505-17).

This gate must have been that generally known as Westgate: it must have been
rendered comparatively useless when the castle-building destroyed the north-west
houses of the town, and was temporarily blocked up.

rapidly returned to the Marshal, and advised him to throw part
of his men into the castle and make a sally from it, but to direct
his real attack on the blocked postern,—which would soon be
opened again,—and on the north gate of the city.

The Marshal therefore sent into the castle Fawkes de
Bréauté and all his crossbowmen, who ran to the walls and
opened a fierce fire on the party of the enemy which was
observing the castle gate. Many of the horses of the rebels
were slain, and the whole body thrown into confusion. Fawkes
then sallied out with his troops and made a vigorous attack on
the besiegers, but they were too many for him, and he was
beaten back into the castle with loss.[1] He himself was for a
moment a prisoner in the enemy's hands, but was rescued by a
party which turned back to save him.

While this assault was being delivered from the castle, the
Marshal and the main body of his host had drawn near to the
northern wall of the city, probably somewhat masked from the
rebels' view by the houses of the suburb of Newport.[2] Apparently
the attention of the defenders had been so distracted by the
sally of Fawkes de Bréauté, that they had not noticed that the
postern in the north-west wall had been broken open. At any
rate, when the Royalists made a simultaneous dash at this entry
and at the north gate, they succeeded in penetrating within the
city at the breach, though not at first at the more obvious and
better-guarded point.[3] A party headed by John Marshall, the
earl's nephew, broke right into the streets, and assailed the
detachment of the rebels who were busied with repulsing the
sally from the castle. They took the enemy's engines in flank
and killed their chief engineer, just as he was placing a stone in
his perrière to cast at Fawkes de Bréauté's men.[4] Having thus

[1] Matthew Paris, p. 21.

[2] That they were among houses seems to follow from line 16600 of the *Song of
William the Marshal*, where the earl before charging says—

> "Attendez mei a cest ostal
> Tant que j'ai mon helme pris."

[3] The assailants (line 16657)

> "Entra sis filz en la cité
> Par la breque o planté des suens."

But from Matthew Paris we gather that they succeeded in forcing the north gate
later on, as he says, "Januis tandem civitatis licet cum difficultate confractis,
villam ingrediens," etc. (p. 21). Probably this was done after the attention of the
rebels was distracted by the successful entry at the blocked gate.

[4] Line 16633.

won an entry into the place, and pushed his men through
the breach into the streets as fast as he was able. They could
not advance with ease, for the barons had rallied and massed
their forces against the assailants, who were obliged to advance
on a narrow front down the tortuous lanes of the town, and
could not deploy. A fierce jousting took place in all the north-
western streets of Lincoln, and it was only by very vigorous
fighting that the Royalists were able to win their way forward.
Their foot-soldiery slipped in among them, shooting, or ham-
stringing the horses of the French and the rebels. At last the whole of that part of the city which lay beneath
the castle was occupied. The enemy fell back, part along the
high ground towards the cathedral and the north-east quarter
of the place, part down the broad street leading to the bridge at
Wigford and the south gate. In the open space before the
minster the Count of Perche rallied the best knights of the
baronial army, and made head for some time against the
Marshal and the main column of the Royalists. At last his men
gave way, and he himself was surrounded; he was offered
quarter, but would not yield to any traitor Englishmen,[1] and
was slain by a thrust which pierced the eyehole of his helm.
After his fall the rebels lost heart and rapidly gave ground,
some flying by the east gate, others southward towards the
river and the bridge. At both exits there was soon a crowd
massed in hopeless confusion, the passages being too narrow to
allow so many fugitives to pass out at once. The south gate
had a swing-door, which closed automatically after each passer-
by pushed it open;[2] the east gate is said to have been jammed
on a frantic cow which got mixed with the horsemen.[3] Hence
the pursuers were able to make prisoners of an enormous
proportion of the rebel knights and barons. About four hundred
in all out of the six hundred and eleven who had engaged in the
battle were captured. They included three earls, Saher de Quincey
of Winchester, Henry de Bohun of Hereford, and Gilbert de
Gand of Lincoln. Among the other captives were several of the
twenty-five signatories of the Great Charter. The slaughter, on

[1] "Juramento horribili affirmavit quod se Anglico alicui nequaquam redderet
qui proprii regis proditores fuerunt."—Matt. Paris, 23. But from Matthew Paris's account, written a little
later on, as he says, "Januis fractis civitatis licet cum magno labore." Matt. Paris, ii. 22.
[2] This was the east gate; the poem of William the Marshal describes it as the
one that leads "dreit a l'Hospital," i.e. St. Giles's Hospital, founded by Remigius,
outside the east gate (line 16943).

[3] Line 16633.

the other hand, had been small, though the wounds were many. The victors lost but one knight, a certain Reginald le Croo; of the vanquished, only the Count of Perche and one other knight are recorded as slain, though many of the foot-soldiery on both sides perished.

It must be confessed that the details of the "Fair of Lincoln," as the battle was called in jest, do not give us a very high idea of the tactical accomplishments of either side. The arrangements made by the rebels were ill conceived and carelessly carried out. Their neglect to watch the blocked gate is most extraordinary, and, even when it was forced, they might have had a good chance of victory if they had barricaded the streets and fought on foot, instead of endeavouring to expel the Royalists by cavalry charges.

To the victors the only praise that we can give is that they knew how to utilise a false attack in order to distract attention from the real one. Bishop Peter must apparently take more credit for the plan adopted than the Marshal; the poem written in praise of the latter ascribes the idea to the Churchman, and only the execution of it to the earl—a piece of evidence conclusive as to the attribution of the design, for William's encomiast would certainly have claimed the glory for his hero had he been able to do so. The details of the fighting after the breach was once forced show nothing but hard blows; we have no evidence that the crossbowmen were used in the street fighting, as they well might have been, or that the enemy were evicted by flanking movements, by side streets. All apparently was done by vigorous jousting down the main thoroughfares and in the open space by the minster.

Nearly fifty years elapsed before Englishmen fought another battle on English soil, and we shall see, when we pass on to investigate Lewes and Evesham, that the art of war had moved on considerably in the interval. But there is no material for us to use in filling up the gap save the insignificant battle of Taillebourg, where the imbecile Henry III. allowed himself to be defeated by Louis IX., a general whose strategy we have learned not to admire in studying the campaign of Mansourah.[1] On Taillebourg we need not waste much attention. Stated shortly, the gist of the battle was as follows:—

Henry, with sixteen hundred knights, seven hundred picked

crossbowmen, and the general levy of the towns of Guienne, lay on one bank of the Charente near Taillebourg. The army was almost wholly composed of his continental vassals; only eighty English knights were present. Louis, with a much larger force, appeared on the other side: the river was broad and swift, and there appeared to be no means of crossing save the bridge, where Henry set a strong guard. Relying on the safety of his position, he kept no proper watch on the enemy. St. Louis determined to risk an attempt to force the passage, and prepared for that purpose a number of large boats. He then vigorously attacked the bridge, and at the same time threw across a body of crossbowmen, dismounted knights, and sergeants by means of his vessels. The guards of the bridge, fearing to be attacked behind by the newcomers, gave ground, and so allowed the main body of the French to evict them from the passage they were sent to guard. When King Henry saw the bridge lost he did not make any attempt to fall on the small part of the French army which had crossed, but drew off and sent his brother Richard to ask for a truce. It was granted, and under cover of it he withdrew at nightfall with shameful haste, abandoning his camp and baggage [no capable commander would have had his army in order, would not have been caught off his guard, and would have fallen on the French van when it had passed the bridge, and overwhelmed it before the main body could come to its aid]. Such were the tactics employed in a similar case by Wallace at the battle of Stirling Bridge.[1] But Henry was the most helpless and imbecile of leaders, and threw away his chances in the most faint-hearted manner. At the moment that he sent to ask for a truce, the number of French who were over the river did not amount to a tithe of his own army, yet he parleyed instead of charging.[2] If Louis had not listened to his demand, he would probably have given the signal for flight at once, and would have got off in even worse plight than was actually the case.

Lewes and Evesham show a distinct advance in the art of war, which we may fairly set down to the influence of Simon de Montfort, who, though not a general of the first class, had at

[1] See p. 563.

[2] Joinville says that there were "not one hundred" as many French troops over the bridge as Henry mustered. Matthew Paris conceals the facts of the disgraceful skirmish in a way not creditable to his veracity, when we consider what a capable writer he was and how fully he tells the rest of the campaign.

least a quick eye and a wide experience. He had been brought
up on the traditions of Muret and the rest of his father's victories.
He had himself seen several campaigns both on the Continent
and in the East, Though not an innovator, he was a capable
exponent of the best methods of his own generation. But it is
only as a tactician that he shines : strategy is nowhere apparent
in his campaigning, and in 1265 he was hopelessly outgeneralled
by the young Prince Edward. We shall see that he relied, like
all his predecessors, on the force of cavalry ; the infantry count for
nothing in his battles. He triumphed, when opposed by the
incapable Henry III., because he possessed decision, rapidity of
movement, and a cool head. But it was only in the fight of
Lewes that his abilities shone out : in the preceding campaign
he does not show to much more advantage than his incompetent
opponent.

 Far otherwise is it with the victor in the campaign of Evesham.
Here we shall see Edward showing a real mastery of strategy as
opposed to mere tactics. When we study his operations in 1265,
we shall be quite prepared to find him, thirty years later, presid-
ing at the inauguration of a new epoch in war at the bloody
field of Falkirk. But in his youth he was still, as regards
tactics, employing the old methods which he had learned from
Montfort as his teacher.

Battle of Lewes, May 14, 1264.

 Down to the day of battle the operations which led up to the
fight of Lewes show all the characteristic incoherence and in-
consequence of a mediæval campaign, and do no credit to either
of the parties concerned, King Henry had raised a considerable
army in the Midlands, while the baronial party had made itself
strong in London, but had also seized and garrisoned the im-
portant towns of Northampton, Leicester, and Nottingham.
The king resolved to subdue the three midland centres of revolt
before undertaking any further operations. Northampton fell
with unexpected ease, owing to the treachery of the monks of
St Andrew's Priory, who admitted the royal troops through a
passage into their garden. This was a severe blow to the
barons, for some of their chief leaders were made prisoners,
including Simon the Younger, the second son of the great Earl
Simon, his kinsman Peter de Montfort, and fifteen barons and
bannerets more (April 5, 1264).

A few days later (April 11) Leicester was sacked, and Nottingham, the spirit of whose defenders was shaken by the disaster at Northampton, surrendered at the king's summons (April 13). Having thus cleared the eastern Midlands of enemies, Henry should at once have marched on London with his victorious army. The fall of the capital would have settled the fate of the war, and, in spite of all the efforts of De Montfort, the spirits of his followers were sinking low. Simon himself had started to relieve Northampton, and had reached St. Albans when the news of disaster reached him. He immediately fell back and prepared to defend the city. Finding, however, that the king showed no signs of striking at London, and had marched northward, the earl resolved to make a rapid stroke at Rochester, the one Royalist stronghold in the neighbourhood of the capital. He stormed the bridge, penetrated into the town, and drove the garrison within the walls of the castle (April 18). He captured its outworks, but the massive strength of Gundulf's Norman keep was too much for such siege appliances as the earl could employ. The garrison, under John de Warrenne, the Earl of Surrey, held their own without difficulty.

Meanwhile, the king had received news of the siege, and left the Midlands. He should undoubtedly have risked all other objects, and thrown himself upon London. The mere news of his having turned southward was enough to draw Simon and his host back from Rochester to defend the capital (April 26). The earl merely left a few hundred men stockaded in front of the gate of the keep to hold the garrison in check—a thing easily done, because the narrowness of the exits of a Norman castle rendered sallies very difficult.

But, instead of striking at London, King Henry merely sent forward his son, Prince Edward, with a small cavalry force, to see if the city was in a state of defence, and then committed the extraordinary error of coasting round it by a vast circular march. Returning down the Watling Street, he struck off it by St. Albans, passed the Thames at Kingston, hastily rushed across Surrey by way of Croydon, and arrived at Rochester on April 28. The blockading force was easily driven off, and the few prisoners made were cruelly mutilated.[1] This huge flank march had no merit but its swiftness; Prince Edward and the mounted part of the royal army

[1] See Annals of Dunstable.

marched from Nottingham to Rochester—a hundred and fifty miles—in five days,[1] and the infantry were not very far behind. The pace, however, had told heavily on the Royalists: many of the horses were ruined when the prince arrived at Rochester, and the foot-soldiery had left thousands of stragglers on the way.

As it turned out, the king's hurried movement had no adequate object. Having relieved Rochester, he might again have turned towards London, though with less advantage, since he was now separated from it by the broad reaches of the Lower Thames. But this did not enter into his plan of operations: he marched instead against Tunbridge, a great castle of the Earl of Gloucester, and when it fell with unexpected ease (May 1) moved still farther from London, with the object of over-awing the coast-towns.[2] But the barons of the Cinque Ports had sent their fleet and their armed force to sea, and Henry obtained nothing but a few hostages from Winchelsea and Romney. His next move was still more inexplicable—he pushed westward between the Weald and the sea, and marched by Battle and Hurstmonceaux to Lewes. No object seems to have been served by this turn, save that of placing himself in the midst of the estates of his brother-in-law and firm supporter, De Warrenne. It had the disadvantage of putting the almost trackless forest of the Weald between himself and London, and of causing his army much discomfort as they threaded their way through the wood-tracks—for the men of Kent and Sussex cut off his stragglers and plundered his baggage, and a detachment of Welsh archers, whom Montfort had sent forward from London, are said to have molested the rear of the host.[3] The king's object is impossible to fathom, more especially as we are told that he feared that his enemies would strike at Tunbridge when he had marched off, and therefore garrisoned that castle with a very large force; no less than twenty bannerets and many of his foreign men-at-arms are said to have been left there.

De Montfort and the barons, however, had no intention of wasting their time in sieges when they could strike at the main objective, the king's army. Having collected every available man, and armed a great body of the citizens of London, they marched across Surrey, plunged into the paths of the Weald, and did not halt till they had reached Fletching, a village and

[1] Wykes. 1264, § 4. [2] Knighton. [3] Wykes. 1264, § 5.

27

clearing, nine miles north of Lewes (May 6th-10th). From
thence they addressed proposals for peace to the king, dated
with prudent vagueness "in bosco juxta Lewes." They must
have known well enough that Henry would refuse them, after
his late successes at Northampton and Tunbridge, and on re-
ceiving his angry reply prepared for instant action. Although
he had the smaller force, Simon was resolved to take the
initiative, trusting to his own skill, the greater enthusiasm of
his supporters, and the king's well-tried incapacity in war.

The town and castle of Lewes lie at a point where the line
of the South Downs is cut through by the river Ouse. To the
east of the place the steep sides of Mount Caburn rise directly
above the water, hardly leaving room for the suburb of Cliffe
along the river-bank. To the west of the Ouse there lies a
mile and a half of gently-undulating ground before the ascent
of the Downs begins. In this comparatively level spot lies the
town of Lewes, flanked to the north by De Warrenne's castle
on its lofty mound, to the south by the great Cluniac Priory of
St. Pancras, including within its precinct-wall some twenty acres
of ground. The Ouse in the thirteenth century was still a
tidal river as far north as Lewes, and at high water the south
wall of the priory and the southern houses of the town looked
out on a stretch of mingled pools and mud-banks which formed
an impassable obstacle. North and east, therefore, Lewes is protected by the river,
and on the south by this tidal marsh, but to the west it had
no protection but the castle and the town wall. If an enemy
approached from that side, the king's army would have either
to stand a siege, or to retire behind the Ouse, or to come out
and fight at the foot of the hills.

On this side the main range of the Downs descends rather
gently towards the river, not with a uniform slope, but in three
spurs separated by slight valleys. The road from Fletching to
Lewes passes over the easternmost of these spurs by the hamlet
of Offham, and by this path would have been the shortest
approach from the barons' camp. But Simon had wisely re-
solved not to come down a road cramped between the hills
and the river. Marching at early dawn on May 14, he
turned off the road north of the Downs, and ascended them at
a hollow slope called the Combe, four miles from Lewes.[1] This

[1] Blaauw and Prothero seem undoubtedly right on this point of topography.

he was able to do quite unmolested, as King Henry had made
no proper arrangements for keeping an eye on his adversaries.
He had not sent out any reconnaissance towards Fletching, and
the sole precaution that he had taken was to place on the
previous day a small party on a high point of the Downs
to keep watch. No measures had been taken to relieve the
watchers on the 13th, and, being tired and hungry, they
slipped back into Lewes to rest themselves, leaving a single
man on guard. This individual lay down under a gorse-bush,
and was caught sound asleep by the first of De Montfort's men
who climbed the slope. Thus the earl was able to put his whole
force in array on the ridge of the Downs before the Royalists
had the least idea that he was within two miles of them. Simon
had spent the previous day and night in distributing his men into
corps, and assigning the position of each on the march and in
battle-line—a task which, as the chroniclers tell us, no other
man in his raw army was competent to discharge.[1] Now he
had full leisure to see that his exact intentions were carried
out, and to settle the smallest details of the marshalling.

Owing to the disasters at Northampton and Nottingham,
the barons' army was much smaller than might have been
raised by the full levy of the party, for many of their most
important leaders were prisoners in the king's hands.[2] The
estimate of forty thousand men given by several chroniclers
as Simon's force is one of the hopeless and habitual exaggera-
tions of the mediæval scribe. But, small though the army was,
it was divided not into the usual three battles, but into four.
There is no doubt that the fourth, which was led by the earl
himself, was a reserve corps placed behind the others, but none
of the chroniclers expressly state this fact. It can be inferred,
without any danger of doubt, from the circumstance that the
three first-named battles of Simon's army each engaged with
one of the three bodies which formed the king's left, right, and
centre, and that the earl's division came later into the fight
than the other three.

As arrayed on the Downs before descending to battle, the

[1] Rishanger, p. 31.

[2] Including Simon de Montfort the Younger, Peter de Montfort and his sons
Peter and William, Adam of Newmarch, one of the greatest of the barons of the
Welsh border, Baldwin Wake, William de Furnival, all captured at Northampton,
William Bardolf, captured at Nottingham, and the young Earl of Derby who had
been taken in his own castle of Tutbury.

baronial army was drawn up as follows:—On the right or southernmost wing were Humphrey de Bohun, the eldest son of the Earl of Hereford, John de Burgh (the grandson of the great Justiciar, Hubert de Burgh), and De Montfort's two sons, Henry and Guy. In the centre was Gilbert de Clare, the young Earl of Gloucester, with John Fitz-John and William de Montchensy, two of the most vigorous members of the baronial party. The third or northern wing was composed of the numerous infantry of the Londoners, and of a body of knights commanded by Nicholas de Segrave, Henry de Hastings, John Giffard, and Hervey of Borham. The earl's reserve corps lay behind the centre; the horsemen in it consisted of his own personal retainers; the foot were probably Londoners, as they were commanded by Thomas of Pevelsdon, an alderman of the city, who had always been one of Simon's most sturdy adherents.

Deployed in this order, and probably with the knights of each division in front and the infantry behind, Simon's forces halted just as the bell-tower of Lewes Priory came in sight, to engage for a moment in prayer, after a short address from their leaders. Scattered over the slope of the Downs were small parties of the grooms of the Royalists, grazing their lords' horses, for forage had failed in Lewes. They caught sight of the baronial host as it came down the hill, and fled back to the town to rouse their masters. Simon's host followed close at their heels, leaving on the upper ridge of the hill such small impedimenta as they had brought with them, the chief of which was the earl's chariot,[1] to which he had bound his great banner, after the manner of the Milanese at Legnano or the Yorkshiremen at our own Battle of the Standard. Inside the carriage were three (or four) citizens of London whom Simon had arrested for opposing him, and was determined to keep in safe custody. The banner and baggage were left in charge of a guard of infantry under William le Blound, one of the signatories of the agreement for arbitration which had ended so unhappily at Amiens.[2]

[1] Simon had broken his leg in the previous year, and was forced to use this carriage for many months.

[2] Of the twenty-four laymen who signed for the barons' party in 1263, the following were at Lewes:—Earl Simon, Ralph Basset, William le Blound, Humphrey de Bohun, John de Burgh, Hugh Despenser, John Fitz-John, Henry de Hastings, Henry de Montfort, William de Montchensy, Nicholas de Segrave, Robert de Ros,

PLATE XIII.

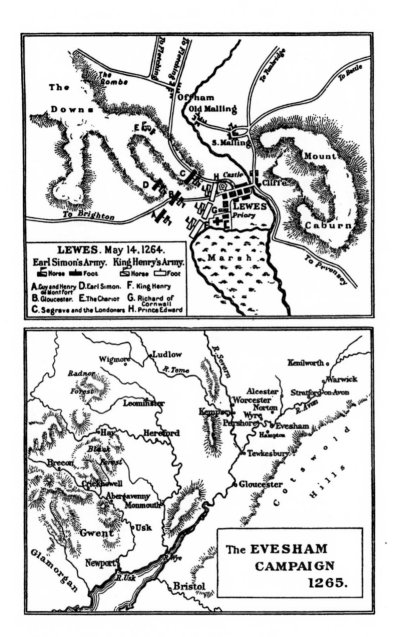

LEWES. May 14. 1264.

Earl Simon's Army. King Henry's Army.

Horse Foot Horse Foot

A. Guy and Henry de Montfort D. Earl Simon F. King Henry
B. Gloucester E. The Chariot G. Richard of Cornwall
C. Segrave and the Londoners H. Prince Edward

The EVESHAM CAMPAIGN 1265.

The king and his followers had barely mounted and armed and issued from the town of Lewes, when they saw the baronial army coming down upon them. But they had just time to form up in three " battles " before the conflict began. Knighton informs us that the king had originally organised his troops into four corps (like Earl Simon), but that the whole of the fourth division had been left behind to garrison Tunbridge, so that the Royalists had no reserve.[1] Perhaps Henry might have told off other troops to play that part had he been granted time to think. But he was completely taken by surprise, and considered himself lucky to be able to form any battle-order at all. His right division was led by his heir, Prince Edward, who was accompanied by his foreign half-uncles, William de Valence and Guy de Lusignan, as also by the Earl of Warrenne and Hugh Bigot the Justiciar. The centre was under the command of Richard of Cornwall, King of the Romans, brother to King Henry; with him was his son Edmund, and three great Anglo-Scottish barons, Robert de Bruce, John Baliol, and John Comyn, who had come to join the Royalists with a large body of light-armed infantry from north of Tweed. In this division also were John Fitz-Alan and Henry de Percy. The left or southern wing was commanded by the King of England himself under his dragon-standard:[2] in his company was the Earl of Hereford, whose eldest son was serving in the very division of the baronial host which was about to bear down upon his father. All accounts agree that the Royalists outnumbered the forces of Simon, especially in their array of fully-armed knights, though we cannot believe the exaggerated statement that the king had fifteen hundred men - at - arms on barded horses (*dextrarii coperti*) and the barons only six hundred.

Geoffrey de Lucy, John de Vesey, Richard de Vipont—fourteen in all. Simon junior de Montfort, Peter de Montfort, Adam of Newmarch, Baldwin Wake, William Marshall, had been captured at Northampton; William Bardolf at Nottingham. Richard de Grey was holding Dover Castle. Nothing is known as to the whereabouts of Walter de Colville and Robert de Toeny.

[1] H. Knighton, p. 247 of Rolls Series edition.

[2] There are some difficulties in the array of the Royalists, as in that of the baronial host. On the whole I am compelled to conclude that Earl Richard led the centre, and that the king the southern wing. I imagine that the position of the king on the left must have been due merely to the hurry and haste of the muster. Being encamped in the priory, he drew up in front of it. For by all mediæval military etiquette he should have led the right or centre, and not taken the post of least honour. But there was no time to rearrange the host, and each body fell into line as best it could.

When the Royalists had got into order, the castle lay behind Prince Edward, the exit from the town of Lewes behind Richard of Cornwall, and the priory at the back of the king's own wing. Before they had advanced more than a few hundred yards from the town, the baronial army charged down upon them. There seems to have been little or no preliminary skirmishing, the battle commencing with a sharp shock all along the line, starting from the northern wings of each host, who met the first. This came from the fact that the Londoners on the baronial left had a shorter space to cover before contact took place: some of the chroniclers observe that they were so much in advance that the Royalists supposed that they were trying to outflank the castle and the division of Prince Edward. There is at any rate no doubt that the first clash of arms started on this wing. It was unfavourable to the baronial party: the knights who followed Segrave, Hastings, and Gifford were broken by the furious charge of the prince. Gifford was taken prisoner; Hastings turned his rein too soon for his own good repute; their horsemen were flung back on the Londoners, and threw them into woeful disorder even before Edward's knights dashed into the wavering mass. A moment later the whole left wing of Simon's host broke up and dispersed, the knights flying northward between the river and the Downs, the infantry northwestward up the steep slope, where they thought that the Royalist horsemen would find it hard to follow. Prince Edward had an old grievance to settle against the Londoners, for the insults which they had heaped on his mother in the preceding year.[1] He urged the pursuit furiously, and forgot entirely the battle that was raging behind him in the centre and left of his father's army. The fugitives suffered fearfully from his fierce chase: sixty horsemen are said to have perished in striving to ford the Ouse; hundreds of the men of London were cut down as they fled along the slopes and then towards Offham, and the woods behind. The prince did not stay his hand till he was three miles from the battlefield, and quite out of sight of Lewes, which was hidden from him by the corner of the Downs. Then, at last rallying his men, he remounted the slopes to return to his father; but on his way he caught sight of Earl Simon's chariot and its great banner, standing isolated at the head of the slope,

[1] "Paene primus ad Hastings, audaciae formidinem anteponens, e proelio fugit" (Wykes, 1264, 9 6).

under the protection of Le Blound and the baggage-guard. The
Royalists jumped to the conclusion that Simon was still in his
chariot, not knowing that his broken leg was long since healed,
and that he was fighting hard on his horse in the valley below.
They therefore wheeled aside and furiously attacked the baggage-
guard. Le Blound and his men made a gallant resistance, but
were at last overwhelmed and cut down. Then shouting, "Come
out, Simon, thou devil,"[1] the prince's knights broke open the
chariot and hewed to pieces the unhappy hostages who were
confined in it, before they could explain that they were the earl's
foes and not his friends.[2] Disappointed of their prey, Prince
Edward and his men at last set forth to return to their main body.
But meanwhile complete victory had crowned the arms of
Earl Simon in the southern part of the field. The Earl of
Gloucester in the baronial centre had after severe fighting
broken the line of Richard of Cornwall's division, captured most
of its leaders, including Percy, Baliol, Comyn, and Bruce,—and
forced Richard himself to take refuge with a few followers in a
windmill, where he defended himself for a space while the tide
of battle rolled past him towards the town. It is probable that
Earl Simon threw his reserve into action against the northern
flank of the king's own corps, when he saw that the line was
giving way : at any rate, the Royalist left broke up soon after
the centre had failed. The king's horse was killed under him,
but he was dragged off by his household and carried into the
priory, where all who could followed him. But the greater
part of his centre and left wing had been thrust southward by
the successful advance of the barons, and found themselves with
the marshy ground, half covered by water at the full tide,
behind them. Some tried to escape by swimming over, but
the mud sucked them in, and next day scores were found at
the ebb, drowned in their saddles, with their drowned horses
still between their legs, lodged fast in the slime.[3] Others slipped

[1] Chron. de Mailros, 1264, § 1.
[2] Some of the Royalist chroniclers call the chariot a "vas dolositatis," and say
that Simon hung his banner on it and placed it on the height, specially to distract the
enemy from the main battle. This is most improbable : he would certainly not have
exposed to certain death Le Blound, one of his most trusted followers, and the whole
affair was, no doubt, a mere chance.
[3] Chronicle of Lanercost. This authority has some graphic touches given on the
authority of an eye-witness, but is mostly vague and erroneous ; e.g. it says that the
barons formed only three battles : and that one of them was led by Hugh le Despenser.

through the streets of Lewes and got over the bridge; a good many took refuge with the king in the priory; a certain number were slain, but the majority laid down their arms and were granted quarter by the victorious barons. These prisoners were soon joined by King Richard, who, after being blockaded in his mill for some time, and much scoffed at by his besiegers, had to come out and surrender himself to a young knight named Sir John Beavs.

While the barons were battering at the castle gate, and shooting arrows tipped with burning tow against the priory to set it on fire, Prince Edward and the victorious Royalist right wing came into sight on the slopes of the Downs. They rode hastily on to the field at about two o'clock in the afternoon, and the prince resolved to recommence the fight. But when the baronial host came swarming out of the town against them, the large majority of Edward's followers lost heart: the two Lusignans, Earl Warenne, and Bigot the Justiciar, with five hundred knights at their back, turned their reins and rode off. The prince himself, with a few faithful followers, charged and cut his way as far as the priory, which he entered and so was able to join his father. But it was clear by nightfall that they would be unable to make a long defence, and with great wisdom Henry and his son sent to ask for peace from the barons. Thus came about the celebrated "Mise of Lewes," by which the king laid down his arms, gave up his son as hostage, and agreed to abide by terms to be settled by arbitration.

The battle had not been so bloody as many mediæval fights; the estimate of the losses runs from twenty-seven hundred to four thousand, the better authorities inclining to the smaller figure. The captives were far more numerous than the slain: among the latter are named only two men of importance on each side; on that of the king, William de Wilton was slain, and Fulk Fitzwarren drowned in the marsh; the barons had to lament a Kentish banneret named Ralph Heringot, and William le Blound, the commander of the baggage-guard.

It will be observed from the above narration that Lewes was essentially a cavalry battle; the infantry seem to have had little or no influence on its fate: we only hear of them as suffering not as inflicting losses. It is especially curious that we have no mention whatever of the employment of archery on either side. One chronicler praises the slingers in the baronial

army, another mentions crossbowmen, but of archery there is no word, though the Assize of Arms of 1252 had named the bow as the yeoman's special weapon. In the whole campaign we only once hear of the use of that arm—when the king on his march to Lewes was molested in the woods by Simon's Welsh bowmen, and drove them off with some loss. It is obvious that the supremacy of cavalry was still well-nigh unchecked, and that the proper use of infantry armed with missile weapons was not yet understood.

The main interest of the fight is tactical : Simon won because he chose his ground well, because he surprised his enemy and forced him to fight in disorder before he could get his host completely arrayed, and still more, because he kept his victorious troops in hand, and employed his reserve at the proper moment and in the proper place. Henry lost, partly because he was surprised, and forced to fight in an unfavourable position, but far more because the victorious part of his army threw away its advantage, and was absent from the field during the critical hour that settled its fortune. Rash adventure and hot-headed eagerness in pursuit cost the Royalists the day. But neither discipline nor self-restraint were likely to be prominent in any army over which the imbecile Henry Plantagenet bore rule.

Battle of Evesham, August 4, 1265.

We have already had occasion to remark that while at Lewes the tactics are all-important, in the campaign of Evesham we have to deal primarily with strategy : the actual battle was comparatively insignificant.

In May 1265 all England seemed at De Montfort's disposal : there were only a few small storm-clouds on the edge of the horizon. Certain barons of the Welsh March, headed by Roger Mortimer, were in arms beyond the Severn ; a small party of Royalists had been holding for many months the isolated castle of Pevensey. The Earl of Gloucester was known to be discontented, but it was not supposed that he would lightly betray the cause for which he had fought so well at Lewes. To hunt down the insurgents in the March, Earl Simon left Gloucester in the middle of May, accompanied by several of his firmest adherents—his eldest son Henry, Despenser the Justiciar, John Fitz-John, Ralph Basset, and Humphrey de

Bohun. He took with him King Henry and Prince Edward, who, though nominally free, were never allowed to stir far from his sight except under safe custody. At Hereford, on May 28, the prince escaped from his guardians by a swift horse and an easy stratagem. He fled to Mortimer at Wigmore Castle, and soon met Gloucester at Ludlow. There De Clare did homage to him, and concluded a formal alliance with him. They at once raised their banners, and summoned all faithful subjects of the king to join them. Shropshire and Cheshire rose at once at their call.

Simon, still lying at Hereford, had now the choice whether he would strike at once at the earl and the prince, whether he would continue his campaign against the Marchers, or whether he would promptly fall back into England by Worcester or Gloucester, and take up a central position. He chose the second alternative, underrating, it would seem, the importance of the earl's rebellion. But as a matter of precaution he sent a detachment of three hundred men-at-arms under Robert de Ros to hold Gloucester, and so to provide him with a safe bridge over the Severn and good communication with London. He also bade the sheriffs of the western counties raise their levies against the insurgents, and made the king set his seal to documents outlawing both the prince and De Clare.

Montfort stayed at Hereford till June 10, thus giving time for his enemies to draw together in dangerous strength. They seized Bridgenorth and Worcester, broke their bridges, destroyed or removed all the boats on the Severn, and spoiled the neighbouring fords by dredging them deeper. Then, on June 13-14, they passed down the river-bank to Gloucester and laid siege to it. The town fell, but De Ros held out gallantly in the castle for fifteen days, in spite of the fact that he had been caught almost destitute of provisions.

Simon had not given his enemies credit for any such strategy as they had displayed. He had moved out from Hereford on June 10, to confer with Llewellyn Prince of Wales, and to enlist his services against the enemy—a task which he knew would not be hard, on account of the Welshman's ancient quarrels with the Royalist barons of the Marches. They met in conference at Pipton, where Llewellyn, in return for the restoration of many lands and castles which had been taken from his predecessors, promised his aid. He undertook to send

five thousand spearmen to join the earl, and to start himself at
the same time on a raid into the Mortimer and De Clare estates.
The treaty was concluded on June 19; on the 22nd the king
solemnly signed it at Hereford, to which place Simon had led
him back. They then marched southward to Monmouth,
probably intending by this move to place themselves between
the prince's army and the great De Clare estates in Gwent and
Glamorgan; at the same time, they were in a good position for
moving to relieve Gloucester, the all-important avenue for
communication with the Midlands and London. But the fates
were against Earl Simon: he stormed the great castle of
Monmouth,—one of De Clare's chief strongholds,—but when he
prepared to move eastward, a large division of the Royalist army,
detached to cover the siege of Gloucester against any attempt
at a relief, showed itself on the other side of the Wye. It was
headed by John Giffard, a baron who had fought for Simon at
Lewes, but had now deserted his cause on account of a private
quarrel. Giffard fortified himself in a good position com-
manding Monmouth bridge, and defied the earl to come over
and attack him. Simon saw that Giffard was unassailable, and
that he must find some other way of continuing his movement
eastward. The best course seemed to be an attempt to cross the
Bristol Channel; accordingly, he sent a message to the citizens
of Bristol, who were his good friends, though their castle had
been for some time held by a Royalist garrison, bidding them to
send ships over to Newport, at the mouth of the Usk, and thence
ferry him and his host over the Channel. Another message was
sent at the same time (June 28) to the earl's son Simon, who
was occupied far to the east, in the siege of the castle of Pevensey,
to warn him that the rebellion was spreading so rapidly that he
must at once raise the leaguer, collect his friends, and march
against Prince Edward.
 Meanwhile, De Montfort left Monmouth and marched on
Usk, a strong De Clare castle, which he successfully stormed
and took, as it had been left with an inadequate garrison. He
next seized Newport and Abergavenny, and (being now joined
by Llewelyn's promised succours) spread his troops abroad, and
fiercely harried the Earl of Gloucester's lands in the neighbour-
hood. Probably he designed by this move to draw De Clare into
South Wales, and so to secure an undisturbed march for his own
reinforcements from the east. His intention was to abscond by

sea, by means of the Bristol ships, when the prince and De Clare should come upon him. Gloucester Castle had fallen on June 29, and the Royalists, having now all the bridges over the Severn in their hands, marched to join the corps of observation under Giffard which had already been watching Simon. Prince Edward and De Clare retook Usk only three days after it had yielded to the enemy, and then marched to seek Simon at Newport. Before leaving Gloucester, they had heard of the fleet of transports which was being fitted out at Bristol, and sent against it three galleys which they had found at Gloucester, filled with a chosen band of men-at-arms. These vessels came upon the Bristol ships just as they had reached Newport harbour, and were being laden with De Montfort's baggage. They dashed into the river-mouth, and took or sunk eleven of them—practically the whole flotilla. At the same time, the Royalist army fell upon Simon's troops near Newport, and routed them by dint of very superior numbers. Their advance was only stopped when the bridge and town were fired in their faces by the retreating enemy, who took refuge behind the Usk (about July 8).

Simon was, thus, deprived of his chance of crossing the Bristol Channel, and thrown back into Wales; his prospect of reaching England and rejoining his partisans seemed more remote than ever. The only course that remained open to him was to strike northward again, keeping the Usk between him and the enemy, and regain Hereford by a toilsome march. In the wild and thinly-peopled country between Abergavenny, Crickhowell, Brecon, and Hay, his army suffered dreadful privations, the English troops complaining that they could not live on a Welsh diet of mutton and milk, and were lost without their daily ration of bread. Simon reached Hereford somewhere about July 20,[1] with a half-starved and dispirited army, and was obliged to pause for some days to allow his men to recover their strength. The only cheering feature in the situation was that news reached him from the east that his son and his friends were marching at last, to his aid. But meanwhile Prince Edward and Gloucester, after pursuing De Montfort in vain up the Usk, and capturing Brecon,[2] had fiercely harried the Earl of Gloucester's lands in the neighbour-

[1] The exact chronology of De Montfort's movements in July is (most unfortunately) not to be made out. But the dates given cannot be far wrong.
[2] Battle Chronicle. Prince Edward captured Brecon, while Gloucester retook Monmouth.

hastened back to Worcester, and prepared once more to hold the passages of the Severn. The last ten days of July were spent by Earl Simon in two unavailing attempts to force his way over the river. He was foiled, and got little profit by his single success—the capture of the Royalist garrison at Leominster. But the old chief was not yet disheartened, in spite of the unexpected skill and strategy which his enemies had displayed. He knew that his son and the army of succour were now closing in on the prince's rear, and encouraged his men by promising that they would catch the enemy in a trap between their two divisions. Having at last procured some large boats, he secretly brought them down to the water's edge, and determined to make a third attempt to cross, at a spot opposite Kempsey,[1] which he thought might be the more carelessly guarded, because it was so very close to the prince's main camp at Worcester.

Meanwhile, Simon de Montfort the Younger had wasted much time by marching to his father's aid by a most extra-ordinary and circuitous route. He moved from Pevensey to London, from London to Winchester (July 14), from Winchester to Oxford, and from Oxford to Kenilworth, where he arrived on July 31. Speed should have been his main object, but he had preferred instead to gather as large an army as possible by calling in all his father's partisans. Hence he came on the field far too late, but with an imposing force, quite capable of facing the Royalists. With him were most of the leaders of the baronial party—the young Earl of Oxford, William of Montchensy, Richard de Grey, Baldwin Wake, Adam of Newmarch, Walter Colville, Hugh Neville, and some fifteen other bannerets. They reached Earl Simon's castle of Kenilworth on July 31, and encamped below its walls, for the castle enclosure was not nearly spacious enough to hold such a large force.

All the combatants were now gathered in a space of thirty miles, and the campaign came to a sudden end with a short sharp shock. Prince Edward and Gloucester took the offensive; it was all-important to them that the two Simons should not meet, but should be dealt with separately. The old earl was still behind the Severn: his exact whereabouts was not known, but it was obvious that he could not cross the river and join his son in less than two days: he had also the less formidable of the two forces with which the Royalists had to contend. The prince,

[1] It is only four miles south of Worcester, the enemy's base of operations.

therefore, resolved to leave the earl unwatched for a moment, while he dealt a rapid, vigorous stroke at Kenilworth. He learned from a traitor in the baronial camp that Simon the Younger was keeping a careless watch, trusting to the thirty miles which separated him from Worcester. Accordingly he determined to copy the tactics of Earl Simon at Lewes, and to make his stroke in the early morning, so as to get a chance of surprising the enemy in his camp.

Starting on the evening of August 1, the prince made a forced march throughout the night, and reached Kenilworth in the early dawn. As he neared the place he heard the sound of a moving multitude, and imagined that young Simon had got wind of his approach, and was ready to meet him. But, pushing on, he found nothing but a train of waggons, bearing food and forage to the enemy. They were seized in an instant, and not a single man got away to warn the careless barons. A few minutes later the Royalists rushed into the streets of the sleeping town, cutting down the half-roused enemy as they poured out of tents and houses, and sweeping right up to the walls of the castle without a check. Well-nigh the whole of the barons fell into their hands, without giving or receiving a stroke. The young De Montfort escaped into the castle half-naked, but Oxford, Montchensy, and all the rest were captured in their beds. The baronial army was practically annihilated; only those who had slept in the castle escaped. Edward tarried no longer than he could help in the place; the moment that the prisoners and the booty were secured, he hurried back to Worcester to look after Earl Simon.

While the wearied Royalists were pouring back towards Worcester, a busy scene was in progress at Kempsey. The earl had launched his boats, and was throwing load after load of his men across the river, rejoicing greatly that no interruption came from the direction of Worcester. By the evening all were across, and Simon, on learning that his son was at Kenilworth, prepared to start on his way thither next morning. He dared not march past Worcester, and therefore chose the southern road by Pershore and Evesham. On August 3 he started, and covered the fifteen miles from Kempsey to Evesham. Meanwhile, the prince had returned to Worcester and learned that his enemy had crossed the long-guarded river in his absence. But Simon was not too far advanced to make it impossible to head

him off and intercept his path eastward. Though his men must have been even more fatigued than the earl's travel-worn host, the prince struck out from Worcester once more, and marched eastward on the evening of August 3.[1]

There are two roads from Evesham to Kenilworth—one by Alcester, the other by Stratford-on-Avon. It was Edward's object to throw himself across both these paths. His exact route is not specified by any chronicler, but we know that, having marched all night and an hour or two after dawn, he lay across the Evesham-Stratford road with his own "battle." He had divided his army into three corps, giving the second to De Clare, and the third to Mortimer and the Marcher barons. It appears that each body marched by a different road, with orders to converge on Evesham. The prince approached from the north, Gloucester from the north-west, on Edward's right, Mortimer from the west, and in the rear of the town. The routes of the three corps were probably therefore, (1) Worcester–Flyford–Dunington–Norton ; (2) Worcester–Wyre–Craycombe ; (3) Worcester–Pershore–Hampton.[2]

The town of Evesham, where Montfort's little army was resting on the morning of August 4, lies at the southern end of a deep loop of the Avon. The roads from Alcester, Worcester, and Stratford join at the base of the loop, and, after uniting, descend into the place by the gentle slope called Green Hill. At the southern end of the town lies the abbey, where Simon and the king were lodged, overlooking the bridge and the suburb of Bengeworth. Beyond the bridge the other roads

[1] He is said to have suspected that there were traitors in his ranks, and therefore to have marched to Claines, three miles north of Worcester, as if about to move on Bridgenorth, and then to have suddenly swerved east, and hurried off to get between Simon and Kenilworth.

[2] I cannot agree with Professor Prothero's view (in his *Simon de Montfort*) that Edward marched with his whole army by Alcester, crossed the Avon at Cleeve Prior, and recrossed it at Offenham, sending Mortimer by the south bank of the river to Bengeworth. The double crossing seems unnecessary, and has no justification but Rishanger's statement that Edward crossed a river unnamed, "juxta Clive," no second crossing being spoken of. That a whole army, twenty thousand strong, should pass at Offenham in full daylight, without being seen by anyone from Evesham—less than two miles away—is a sheer impossibility. We know that Edward came in sight of Simon on the Norton road, and was descried at some distance. We also know that Mortimer approached from the west (*i.e.* from Pershore), by Hemingford's statement that the earl's look-out saw "vexilla Rogeri de Mortimer ab occidente et à tergo." I therefore agree with Mr. New of Evesham, whose view Professor Prothero refuses to accept.

diverge in the directions of Pershore, Tewkesbury, and Broadway. Evesham is a good position to defend against an attack from the south, being well covered by the river, and approachable only by a single bridge. But if attacked from the north it is far less defensible, as the advancing enemy has the advantage of the slope, and the defenders must fight with a single narrow bridge at their backs. But if assailed at once on north and south by superior forces it is a fatal trap, for no escape is possible, owing to the loop of the river, which encircles it on three sides.

Simon's men took their morning meal and heard mass; but, just as they were mounting to commence their march, news came in that a large force was approaching by the Dunington-Norton road.[1] The earl hoped that this was the army of his son Simon, marching in from Kenilworth, for he was still wholly ignorant of the disaster that had befallen his friends on the 2nd. He was at first encouraged in this delusion, for Prince Edward had ordered that the banners taken at Kenilworth, the White Lion of Montfort, the silver star of De Vere, and the three escutcheons of Montchensy, should be borne in his van to disarm suspicion. But to gain certainty Earl Simon rode to the crest of Green Hill,[2] according to one account, or sent a keen-sighted attendant up the abbey tower,[3] according to another. Very shortly the royal banner was seen waving over the main body, and the earl recognised his mistake, and saw that he must either fight or fly. Shortly afterwards the red chevrons of De Clare were descried pressing on at the head of a new column, which was only just coming into sight to the prince's right. Only a few minutes later the blue and white banner of Mortimer was descried on the Pershore road, coming from the west, and in the rear of the baronial host. " Now may God have mercy on our souls, for our bodies are in the power of our enemies," cried the earl when the full horror of the situation dawned upon him. There was still a chance for well-mounted horsemen to escape over Evesham bridge and dash eastward; but the army was evidently doomed, unless it

[1] The Chronicle of Mailros says that Prince Edward was sighted when as much as two leagues away by the earl's scouts. If this is correct, the whole story of his having crossed the Avon at Cleeye and Offenham fails.

[2] Hemingford calls it Mount Elyn.

[3] Chronicle of Mailros and Hemingford.

could cut its way through Edward's host. Henry de Montfort
hastily bade his father fly, and swore that he would hold the
enemy at bay long enough to get him a good start. But the
old earl laughed the proposal to scorn. He had brought them
there, he said, and must take the consequent responsibility.
He had never fled from battle before, and would not begin in
his old age. He besought Despenser, Basset, and the other
barons about him to save themselves, but no one would flinch
from him, and all made ready for battle. There was still some
twenty or thirty minutes to spare before Mortimer would be able
to close in on their rear. Simon employed the time in forming
his host in a deep column, the knights at its head, the foot
behind, and steadily marched up the Green Hill, making directly
for the centre of Prince Edward's division. The front came on
steadily enough, but the Welsh infantry in the rear began to
melt away before a blow had been struck, slipping off into the
fields and gardens on each side of the road, and then plunging
into the Avon and swimming over as best they might, so as to
elude Mortimer's approaching corps.

The earl himself, meanwhile, dashed into the middle of the
prince's corps with such a desperate shock that the Royalists
wavered for a moment, and had to be rallied by Warren of
Basingburn, who taunted them with memories of Lewes, and
stung them into steadiness. They had indeed nothing to fear,
having a superiority in numbers of about seven to two,[1] and
every other advantage. When the baronial host was hotly
engaged with the prince, Gloucester came up and threw himself
upon their flank and rear. Though surrounded, Simon's men—
the Welsh excepted—showed no signs of flinching. They kept
up the fight for more than an hour, dashing themselves again
and again at one or another point of the narrowing circle
around them. At last Henry de Montfort fell mortally wounded,
and Earl Simon's horse was killed beneath him. "Is my son
slain?" cried the old man; "then indeed it is time for me to
die!" and, grasping his sword with both hands, he flung himself
on foot into the thickest of the fight, and was pierced by a
mortal wound in the back while hewing at half a dozen knights,
who disputed the glory of encountering him. All his com-
panions fell within a few yards of his corpse—his cousin Peter
de Montfort, Despenser the Justiciar, Ralph Basset, John de

[1] Chronicle of Mailros.

28

Beauchamp, William de Mandeville, Guy Baliol, Robert de
Tregoz, Roger de Rivle—well-nigh every man of name in the
host. A very few were so lucky as to obtain quarter, and these
were mostly wounded men who had been left for dead in the
first heat of the slaughter; among them were Humphrey de
Bohun, John Fitz-John, Henry of Hastings, and Guy de Montfort,
the earl's third son. The whole army was cut to pieces; even
the Welsh who had fled before the battle began were hunted
down among the houses of Evesham and along the Avon bank
as far as Tewkesbury by Mortimer's men, so that hardly a tithe
of them escaped. A chronicle which gives the losses of the
vanquished with some detail and considerable show of pro-
bability, says that the slain included one hundred and eighty
knights, two hundred and twenty squires, two thousand of
Montfort's own foot-soldiery, and five thousand Welsh.[1] On
the other hand, the Royalists lost only two knights, though,
according to one source, nearly two thousand of their infantry
were killed or wounded. It is probable that this number is
much exaggerated, for the end of the battle was a massacre
rather than a fair fight. As Robert of Gloucester sang—

"Such was the murder of Evesham, for battle it was none."

The reader will have noticed that at Evesham ended the first
example of a real strategical campaign with which we have had
to deal in England. The whole gist of the struggle was the
maintenance by the Royalists of the line of the Severn, and
their successful warding off of De Montfort's successive attempts
to pass. It must be confessed that the old earl's reputation as
a master of the art of war does not gain from a study of his
operations. Luck was, it is true, against him; but there was
much to blame in his slowness of movement at the commence-
ment of the campaign, and his resolves to escape, first by
Gloucester, and then by sea from Newport, were made too late,
and executed too tardily. Evesham was a wretched position to
take when an active enemy was known to be near. Of the
imbecile leadership of Simon the Younger, his slow and circuitous
march to Kenilworth, and his culpable carelessness when en-
camped there, it is impossible to speak without contempt.

All the more brightly, therefore, does the generalship of
Prince Edward shine out. In the single year since Lewes, he

[1] Chronicle of Lanercost, sub anno 1265.

had developed from a mere headstrong knight into a com-
mander of the first class. If this campaign alone had been
recorded of all his wars, it would be enough to stamp him as a
good officer. His prompt blows at Worcester and Gloucester
gave from the first a waft of success to his rising. To maintain
a river-line fifty miles long against an active and determined
enemy is no small achievement. His march to Newport and his
chase of Simon into Wales were bold and well planned. But the
last three days of the campaign are the real test of his ability.
History contains few such splendid examples of two successive
strokes at two converging hostile forces as the victories of
August 2 and August 4. And the details of Evesham, the neat
arrangement of the encircling columns, and the full advantage
taken of Simon's unhappy position in the loop of the Avon, are
enough to prove that Edward had not only the brain of the
strategist, but the eye of the tactician. On the whole, the
campaign is the most brilliant piece of mediæval generalship
which we have yet had to record.

CHAPTER V

CONTINENTAL BATTLES, 1100–1300

Thielt—Legnano—Steppes—Muret—Bouvines—Benevento—
Tagliacozzo—The Marchfeld.

THE characteristics which we have noted in the English
wars of the twelfth and thirteenth centuries are to be
found reproduced in the contemporary wars of the Continent,
with certain small variations. The chief feature of the epoch,
abroad as well as at home, is that the main blow in each battle
is entrusted to the cavalry, while the infantry, if present at all,
almost invariably plays a subsidiary part. In the English fights
which we have considered, Bremûle and Northallerton are the
only ones in which men on foot really settle the fate of the day,
and even in these instances we are dealing with dismounted
knights rather than with real infantry. On the Continent we
shall not find any example of similar kind between Legnano
(1176) and Courtray (1302). It would of course be impossible
to follow out the whole of the wars of Europe in the detailed
fashion in which we have dealt with English campaigns. We
can but select six or eight typical fields, from each of which we
can gather one or more of the leading characteristics of the
military art of the age.

We have put together the following types of battles, following
chronological order in the narrative rather than arranging the
fights according to the tactical points which they illustrate:—

1. Fights of cavalry with cavalry, neither side bringing
infantry into the field. Thielt-Hackespol (1128), Tagliacozzo
(1268), the Marchfeld (1278). The former is a simple, the two
later are complicated examples of their class.

2. Fights of cavalry with infantry and cavalry combined.
Legnano (1178) gives us a typical defeat, and Muret (1213) a

436

typical victory for the employers of this very hazardous experiment. (Compare Bremûle in the chapter on English battles.)

3. Fights in which both sides bring infantry into the field, but neither uses it for more than mere skirmishing, the fate of the day being settled by the use of a cavalry reserve. A good example is Benevento (1266). (Compare Lewes in the English chapter.)

4. Fights in which each side employs solid masses of infantry as part of its fighting line, and uses them as central rallying-points for the support of its cavalry. Steppes (1212) is a simple example of this class, Bouvines (1214) a very complicated one. (Compare the first battle of Lincoln in the English chapter.)

A cross-division is made by noticing whether the troops were drawn up in one single line of corps,—with or without a reserve,—or in several lines one behind the other. Of the first and simpler class are Legnano, Steppes, and Bouvines. Of the second typical instances are the Marchfeld, Muret, and Benevento. The latter class is much worse represented in English military history than the former, all the leading fights on this side of the Channel having been fought with a broad front ; the first instance where we find an English commander massing corps behind corps on a narrow front is Bannockburn (1314).

Battle of Thielt (or Hackespol), June 21, 1128.

After the murder of Charles Count of Flanders (1127), the succession to his wealthy fiefs was disputed between Dietrich Count of Elsass and William the Clito, son of Duke Robert of Normandy. The former claimed as son of the late count's aunt Gertrude, the latter as descending from Charles' great-aunt Matilda of Flanders, the wife of William the Conqueror. The Clito received the energetic support of Louis VI. of France, the suzerain of Flanders: having failed to recover for his *protégé* the duchy of Normandy, owing to the disaster of Bremûle, he was anxious to compensate him in another quarter. The majority of the Flemings adhered to Count Dietrich, though a considerable number took the side of William.

After much indecisive fighting, the two pretenders met at Hackespol[1] near Thielt on the 21st of June 1128. Dietrich

[1] The *Genealogia comitum Flandriae* and John of Ypres, p. 466, give the locality as Hackespol ; Galbert only names Thielt.

had been besieging the manor of a certain knight named Fulk, who was a partisan of the Clito,[1] and the latter had hastily marched to his vassal's relief. He had brought only horsemen with him, and if Dietrich had any infantry he must have left them to observe the beleaguered place, since he displayed none in the battle.

Each army was arrayed in three corps, apparently placed one behind the other, as the French had been at Bremûle nine years before. But there was this cardinal difference in their order, that William placed his third corps out of sight of the enemy, while the whole of Dietrich's squadrons were drawn up in the open. The Clito headed the van-battle of his host, where his banner must have been conspicuous, handing over the conduct of the all-important reserve to an unnamed knight. Count Dietrich had entrusted the marshalling of his men to his seneschal, Daniel of Dendermonde, and undertaken for himself only the command of one of his three divisions, apparently the reserve; another was headed by his brother Count Frederic, the third by Daniel.[2]

The front squadrons of the two hosts met in close combat, and soon afterwards the second corps on each side was brought up. Then Dietrich, believing that all the Clito's troops were already engaged, threw in his reserve, with the result that William's men were broken and forced to retire. It appeared that the victory was in Dietrich's hands, but, just as his foes seemed crushed, the hidden reserve corps of William's army came storming into the fight, to the great surprise of the victors. Thus the battle was restored. Then, while all the horsemen of Dietrich were concentrating their efforts on the newly-arrived enemy, the Clito succeeded in rallying a compact body of his own scattered van-battle, and threw it into the mêlée. This charge decided the equally balanced fray, and Dietrich's host, who had no reserve to save them, burst asunder and fled in all directions. William bade his knights cast off their mail-shirts, that they might be lighter for the pursuit, and hunted the broken partisans of Dietrich to such good effect that they were either captured or hopelessly

[1] "Applicuit cum gravi exercitu ad Tiled et obsedit domum Folket militis" (Galbert, p. 388). As Thielt was from early times an important place, it cannot be the "domus Folket," which I presume was merely a fortified manor, near Thielt, but not in it.

[2] It is impossible to make out from Galbert's narrative which of the three corps of Dietrich's army was in front; probably it was that of Daniel of Dendermonde, for "In ingressu primo Daniel, qui caput erat militiae Theoderici, volebat se inferre cuneis Willelmi" (Galbert, p. 388, B).

scattered in all directions. Most of the disputed county fell into William's hands in consequence of his victory, and he might have established a line of Norman counts of Flanders if he had not died, less than two months after the victory of Thielt, from blood-poisoning. He received a scratch in the hand from the spear of a foot-soldier while beleaguering Alost, which he neglected till the wound turned malignant and carried him off before he had reached the age of thirty.[1] As he was unmarried, and his father a prisoner in Cardiff, there was no one left to maintain the Norman claim, and Dietrich of Elsass entered into peaceable possession of Flanders (August 1128).

This very simple fight, where the whole fortune of the day depended on the fact that William concealed while Dietrich displayed his reserve corps, should be compared with Tagliacozzo, where Charles of Anjou was victorious by exactly the same expedient. But we have no evidence that William took such elaborate pains to deceive his adversary as did Charles. The Clito headed his own first line in person; while the Angevin sent his royal banner to his second corps, and made its commander disguise himself in the royal arms in order to convince the generals of Conradin that they had his whole host in sight.

Battle of Legnano, May 29, 1176:

It is most unfortunate that no really adequate and detailed account of this fight, perhaps the most epoch-making engagement of the twelfth century, has been preserved. But though it is impossible from our sources to reconstruct the battle-array of the two hosts, or to arrange the incidents of the battle in their exact order, we have enough information to enable us to divine the general character and the military moral of the struggle. It was one of those battles of the type which we have seen at Bremûle, where an army which used a solid infantry reserve to support its front line of horsemen triumphed over one which employed cavalry alone for the shock. With Bremûle it has another similarity, for in both the victors considerably outnumbered the vanquished, and the defeated general ought never to have allowed himself to get involved in an attack on an enemy so much his superior. Barbarossa showed just the same impetuous arrogance as Louis VI., and suffered the same fate.

[1] Galbert, p. 390. He only survived four days after his wound (John of Ypres, p. 466).

In the winter of 1175–76, Frederic I. had been in Western Lombardy, making head with no great success against the league of the Guelf cities. Seeing that he could do nothing without large reinforcements, he sent messengers to the nobles of South Germany, bidding them cross the Alps to bring him aid as soon as the melting of the snows made the passes practicable for an army. In obedience to this behest, the forces of Suabia and the Rhineland marched to his aid in April 1176. They followed the Vorder-Rheinthal up to Dissentis,[1] and, crossing the Luckmaneier pass, came down the Val Blegno on to Bellinzona. The army was not very large; according to the emperor's chancellor, Godfrey of Viterbo, it mustered five hundred knights and many mounted sergeants.[2] The Milan Chronicle says that the total force was two thousand. There was apparently no infantry other than mere camp-followers with it. The commanders were Philip, Archbishop of Cologne,[3] Conrad, Bishop-elect of Worms,[4] and Duke Berthold of Zähringen, the nephew of the empress. About the middle of May, the Germans, much fatigued by the passage of the Alps, but wholly unopposed by the enemy, safely arrived at the loyal town of Como. The emperor on hearing of their arrival hastily left Pavia, where he had been lying, and rode to Como with a small escort, carefully skirting round the dangerous neighbourhood of Milan. His plan was to lead back the host to Pavia, where it was to be joined by the forces of the Ghibelline towns of Lombardy before it undertook any serious operations. Unfortunately Milan lay directly between Como and Pavia: a straight line drawn from the one to the other of the Imperialist towns passes through the great Guelf stronghold. Frederic was therefore bound to make a circular march round Milan; it only depended on himself whether the turning movement should be at a short or a long distance from the hostile city. The route which he selected was that by Cairate, Legnano, and Abbiategrasso, which in its central stages passes at no more than twenty miles from Milan. The host marched with proper military precautions, three hundred horsemen preceding the

[1] "Quos venire fecerat per Desertinam tam privatissime quod a nemine Lombardorum potuit sciri. Immo cum dicebatur quod apud Birizonam essent, fabulosum videbatur." (*Agns Mediolanenses, sub anno* 1176).

[2] "Vix ibi quingentos equites ad bella retentos
 Noveris inventos, reliquos designo clientes" (G. V., lines 997, 998).

[3] Chronicle of Romuald of Salerno, *sub anno* 1176.

[4] *Cont. Sanblasiana,* § 23.

main body at a considerable distance. The emperor had taken the militia of Como with him; the foot-soldiery of the city, the only infantry in the army, were probably escorting the baggage in the rear; there is no mention of them in the battle.

Meanwhile, the Milanese had received news of the arrival of the Transalpine host at Como: up to the moment when it reached that place they had disbelieved the rumours of its approach. They were accordingly somewhat late in assembling their allies, but by May 27 the contingents of the nearer Guelf towns had come in,—fifty horsemen from Lodi, three hundred from Novara and Vercelli, two hundred from Piacenza, and large succours from Brescia, Verona, and the Veronese March.[1] The levies from the towns south of the Po had not had time to arrive, but even without them the confederates largely outnumbered the army of Frederic. Godfrey of Viterbo gives them twelve thousand cavalry,—an absurdly exaggerated figure;[2] but Milan by itself could put two thousand horse in the field, and there were probably as many more from the allied towns. The foot-soldiery of Verona and Brescia were left to guard the city, while those of Milan, under the banners of their "gates," joined the field army; they formed the whole or the greater part of its infantry.

Hearing of the emperor's circular march, the Lombards struck out from the centre to reach a point on the circumference where they were sure of anticipating the arrival of the enemy. On May 29 they attained their purpose. Between Busto Arsizio and Borsano their advanced guard, composed of seven hundred horsemen, came into collision with the head of the Imperialist line of march, the three hundred knights who preceded the host of the Germans. Owing to an intervening wood, the meeting was sudden and unexpected: the Germans showed fight, but were repulsed by the superior numbers of the Lombards, and fell back on their main body, which gained by their resistance time to deploy into line of battle. The pursuing cavalry were sharply driven off when they came into touch with the emperor.[3]

[1] All these details are from the Milanese Chronicle, p. 378, *sub anno* 1176.

[2] "Millia bis sena Lombardus miles habebat,
Et peditum numerosa manus vexilla ferebat" (G. V., lines 991, 992).

[3] Chronicle of Romuald of Salerno: "Exeuntes quoddam nemus ex insperato Imperatori, qui militares acies jam ad bella paraverat, subito occurrunt" (p. 215). From the *Vita Alexandri Papae IV.* we have the preceding skirmish.

Meanwhile, the Lombards emerged from the wood and drew up opposite the Germans; they were apparently formed in four corps of cavalry with an infantry reserve; presumably the horse lay in two lines, each composed of two "battles." In the midst of the infantry lay the *carroccio* of Milan, the sacred car with the city banners hoisted on its mast, just as those of the Yorkshire saints had been at Northallerton forty years before.

In spite of his inferior numbers, Frederic at once took the offensive, and charged the Lombards. He was set on fighting, and had refused to order a retreat when the first approach of the rebels was reported, "counting it unworthy of his Imperial Majesty to show his back to them."[1] His horsemen, charging with desperate resolve, broke one after another all the four corps of the Lombard cavalry,[2] and then pressed on to attack the mass of infantry around the *carroccio.* No attempt seems to have been made to pursue or to keep in check the beaten horse, and the whole of the German knights devoted themselves to the task of breaking up the infantry. The Milanese foot held out with undaunted courage, "with shields set close and pikes held firm," and succeeded in holding the enemy at bay for a long space.[3] But they would probably have succumbed at last had not their comrades of the cavalry come to their aid.[4] Though many of the Lombard horse had dispersed in flight and sought their homes, a considerable body rallied when it saw that it was not pursued. This corps, largely composed of the knights of Brescia,[5] formed up again, and, apparently aided by some reinforcements which had just arrived, charged the Imperialists in the flank. The Germans were already somewhat wearied by their fight with the infantry; the emperor's banner-bearer had fallen, and Frederic himself, after leading repeated charges,

[1] Annals of Cologne, *sub anno* 1176: "Quum a quibusdam suaderetur ut tantae multitudini ad tempus cederet, et bello abstineret, indignum judicans imperatoriae majestati terga dare, hostibus viriliter occurrit."

[2] "Hostibus infestus cuneos binos penetravit,
 Tercius atteritur, quartum virtute fugavit:
 Quintus erat validus terribilisque magis" (G. V., lines 995–997).

[3] "Imperator videns Lombardorum equites aufugisse, pedestrem multitudinem facile superari credidit. Illi oppositis clypeis et porrectis hastis coeperunt illius furori resistere, et se venientes viriliter repellere." (Romuald, p. 215).

[4] The *Annales Mediolanenses* show that a small body of cavalry stood firm along with the foot.

[5] *Continuatio Sanblasiana*, § 23.

had his horse slain under him and was thrown down among the pikes. When the fierce flank charge of the Brescians was pressed home, at the very moment that the emperor had disappeared, the hitherto victorious Germans broke up and sought refuge in flight. Many were captured, many slain, and still more drowned in the Ticino, which lay across their line of retreat towards their left rear. Nearly the whole civic militia of Como[1] was cut down or captured, and it was only in scattered bands that the survivors of the vanquished host reached the friendly walls of Como and Pavia. It was universally believed that Frederic himself had fallen, but he appeared at Pavia three days after, after having passed through a series of dangerous adventures. His relative Berthold of Zähringen and the brother of the Archbishop of Cologne were taken captive, with many scores of knights.[2] No personage of first-rate importance fell on either side, but the losses were considerable among the rank and file both of the victorious and the vanquished armies.

The causes of the victory are obvious enough: Frederic had not enough men to face the leaguers. If he could have spared a corps to disperse and pursue the beaten cavalry, he might have succeeded in breaking up the mass of infantry, in spite of its bold defence. But he could not spare a man, and the Lombards were able to rally at their leisure. Frederic would also have done better if he had employed more infantry: a comparatively small force of cavalry would have been able to break into the square round the *carroccio* if it had been aided by footmen armed with the crossbow, or even with the pike. But the Germans had no foot-soldiery save the militia of Como, which was probably not more than a thousand strong, and we hear nothing of their employing even this body. It was apparently in the rear guarding the baggage. To sum up, infantry is not yet self-sufficient, but it can save a lost battle by its solidity, if only the cavalry combined with it can rally and keep the field. But cavalry is still the arm which gives the decisive blow.

[1] *Annales Mediolanenses*, 378.

[2] A fact to be found (curiously enough) only in the English chronicler Ralph Diceto, who gives *in extenso* a letter of the consuls of Milan to their allies of Bologna: it is bombastic and very unpractical ; it has no account of the battle that is of any use, but waxes eloquent on the booty and the captives.

Battle of Steppes, October 13, 1213.

In the early years of the thirteenth century anarchy reigned all over the Holy Roman Empire, and the princes, under cover of the names of Philip, Otto, or Frederic, settled their old feuds with the sword, just as in England during the Wars of the Roses every baron used the claims of Lancaster or York to hide his private grudges. Duke Henry I. of Brabant had an old-standing quarrel with the bishops of Liége, part of whose broad dominions he claimed as wrongfully withheld from him. Thinking the time suitable for making good his pretensions, he marched into the bishopric in October 1213, and harried it as far as the Meuse. Hugh of Pierrepoint, who then sat on the episcopal chair of Liége, was a courageous prelate, who would not endure such wrongs from his powerful neighbour. He summoned in his feudal vassals, gathered together the civic militia of his towns of Liége, Huy, Dinant, and Fosses, and sent for aid to the Count of Loos, whose territories lay in the same danger from the duke's covetousness as did the bishopric.[1] Lewis of Loos was perfectly willing to join him, gathered the forces of his little county, and joined the Liégeois on the 12th of October near Glons. The united army then marched in search of the duke, whom they found retiring homeward with his plunder. He had been warned of their approach, and was found with his host arrayed in an advantageous situation on a hillside near the village of Steppes.[2] The count and bishop drew up opposite him at the foot of the slope and offered battle.

The two armies, as it chanced, were arrayed in exactly the same formation: each had the bulk of its infantry massed in its centre, while the horsemen were drawn out on the wings. But the Liégeois wings had some infantry supports, and it is possible that there was also a small reserve of knights behind the bishop's centre.[3] Our account of the array of the Brabançons is not so full and satisfactory.

[1] Lewis of Loos was vassal for some, but not all, of his county to the Bishop of Liége. He was an old enemy of Henry of Brabant, who had opposed him when a few years before he had tried to make himself Count of Holland in right of his wife Ada.

[2] Between Hutain and Montegnies, according to Alberic of Trois-Fontaines, *i.e.* between Hottain l'Evêque and Montenaken (not Montegnée).

[3] This may follow from the statement of Reiner that the centre contained "Leodienses et Hoyenses et quotquot venerant ab episcopatu *bellatores*"; when compared with Aegidius Aureae-Vallis, p. 659, who says that the central infantry were to

In the army of Liége the Count of Loos, who assumed command of the combined host, took the right wing with his own retainers, horse and foot. The left was composed of the greater part of the feudal levy of the bishop's vassals, supported by the infantry of the citizens of Dinant;[1] it was headed by Thierry of Rochefort. In the centre were the civic levies of Liége, Huy, and the rest of the bishop's towns, under the orders of a veteran knight named Thierry of Walcourt. For the duke's army we are not given any details, but are merely told that his infantry formed the great central mass of his line, and his cavalry the wings. He himself had put on a plain suit of mail and handed over his banner and his armorial surcoat to a trusty follower named Henry of Holdenberg.

It is to be noted that in each host the foot-soldiery were the solid civic levies of the Netherlands, armed with spear, mail-shirt, and steel cap, and not the miserable and ill-equipped horde that generally constituted the infantry of a feudal army. When the Liégeois advanced, the duke ordered his army to descend the slope, and came rushing down on his adversaries. The bishop's men received the charge at a standstill: Thierry of Walcourt ordered the front ranks of the central mass of infantry to kneel and fix the butt ends of their lances in the ground; he warned them not to open their order on any account, and bade them push off even their own cavalry if they should be driven in upon them.[2] Nevertheless the first assault of the Brabançons, who had the impetus of the slope in their favour, was so violent that it rolled back the Liégeois and nearly broke their line in two. It says much for the solidity of the bishop's men, that they held up under the pressure and did not disperse.

Meanwhile the Count of Loos, dashing forward somewhat in advance of the infantry, had made such a vigorous charge upon the cavalry of the duke's left wing, that it sent for succour to its

be "pro muro militibus *retro sequentibus*," this looks as if Walcourt had a cavalry reserve behind him. Are these Reiner's *bellatores*, or is the latter using the word merely in a general sense, and meaning infantry only?

[1] Reiner in Bouquet, xviii. p. 626.

[2] Aegidius Aureae-Vallis in *M. F.*, vol. xviii. p. 659: "Fecitque (Theodericus) suarum hastas lancearum acui et in terram figi, et in directum contra milites teneri cuspides lancearum. . . . Sed et si quis militum nostrorum metu mortis super vos redierit, et nostrum ordinem transilire voluerit, equum ejus figite, et ipsum in praelium revertere compellite."

chief. Henry was obliged to come to its aid, supporting it very probably (though the chroniclers do not definitely say so), with a detachment which he brought round from his right wing. Crushed by these overwhelming reinforcements, the Count of Loos and his knights, though fighting hard, were borne back in disorder.[1] But meanwhile the left wing of the Liégeois under Thierry of Rochefort made a desperate attack upon the enfeebled right wing of the Brabançon host. They soon thrust it back in disorder upon the infantry of the duke's centre. If Henry had possessed any reserve, he could now have used it to re-establish the day, but all his horse had been called off to his left wing to crush Lewis of Loos, and he had no men to spare. Hence it came to pass that the success of the horsemen of Rochefort was decisive. The infantry of the Liégeois main body plucked up courage when they saw their left wing victorious, and threw themselves so vigorously upon the Brabançon foot-soldiery that they broke and routed them. The duke's hitherto successful left wing, terrified by the disaster in their centre, hardly opposed any resistance to the horsemen of Rochefort,[2] and the whole of his army fled in confusion from the field. The men of Liége followed them up with relentless cruelty, for they were set upon revenging the harrying of their countryside during the last ten days, and slew more than three thousand of the flying enemy.

So hastily did both armies move from the field, that when the routed horsemen of the Count of Loos reassembled and came forward again, they were surprised to find the scene of combat occupied by the dead and wounded alone.[3] Uncertain as to the fate of the battle, they stripped the slain and plundered the Brabançon camp before their victorious comrades returned to the spot. If the triumph had been less crushing, the bishop's men would have resented such conduct, but with four thousand prisoners to hold to ransom, including many wealthy Brabançon knights, they could afford to overlook the incident. The count's men, too, as we have seen, had done their full share in the fighting;

[1] And driven right off the field, so that they returned only after the battle was over (Aegidius Aur., p. 660). "Gens comitis in fugam conversa est, perseverantibus in proelio Leodiensibus."

[2] "Dux autem et complices sui, videntes belli eventum, et tantum impetum ferre non valentes, in fugam se verterunt qui erant equites, et passim capiebantur vel interficiebantur pedites" (Reiner in Bouquet, xviii. p. 627).

[3] Aegidius Aur., p. 660.

if they had not drawn on to themselves the main force of the duke's cavalry, the Liégeois could not have won the fight.

Nothing could be simpler than the tactics of Steppes: they give us a fair sample of the manner in which cavalry and infantry were combined in those parts of Europe where a solid civic militia armed with the pike was in existence. The main duty of the foot-soldiery is to form a steady reserve which may allow their knights to rally and re-form. Such a mass[1] can hold out for some time against cavalry, but cannot stand against horse and foot combined, as we have seen was the case with the Brabançons when assailed by Rochefort and Walcourt simultaneously. It is of course the cavalry—in this case that of the bishop's left wing—which gives the decisive blow and settles the day. If we seek for the source of the duke's defeat, we find it in the fact that he had been compelled to mass so many horsemen against Lewis of Loos, and to spend so long in driving him from the field that he had not time enough to turn against the infantry of the Liégeois before his own foot-soldiers were attacked and scattered by Rochefort.

Battle of Muret, September 12, 1213.

The battle of Muret was the most remarkable triumph ever won by a force entirely composed of cavalry over an enemy who used both horse and foot. At the first glance it seems to contradict the general military teaching of experience, and to justify that blind belief in the omnipotence of the mailed knight which we have pointed out as the cause of so many disasters alike in East and West. It is only when we examine its details that we recognise its abnormal character. The victorious squadrons were conducted by a general of exceptional ability, and practically surprised the enemy before he was in proper battle-array. The vanquished fought in separate divisions, which gave each other no aid, and utterly failed to secure any proper combination between horse and foot. The battle had two episodes—a hard cavalry fight, and a subsequent massacre of foot-soldiery by the victors. In this respect it may perhaps

[1] The Liégeois infantry were "conglobati pro muro militibus" (Aeg. Aur., p. 659). This does not mean actually ranged in a circle (for a circle cannot charge), but merely massed in close order, I presume. But Reginald of Boulogne at Bouvines seems actually to have put his men in a hollow circle when thrown on the defensive at the end of the battle.

be compared to Tiberias[1] rather than to any field of Western Europe. It would never have been fought unless the quick eye of the successful general had caught a moment when his adversaries were widely dispersed and wholly unprepared for an attack. It was pre-eminently not a pitched battle, but a sudden rout.

In 1213 the wicked and bloody Albigensian Crusade seemed drawing toward its end. The victorious Crusaders had reduced their chief enemy, the Count of Toulouse, and his allies the Counts of Foix and Comminges, to the lowest depths of despair : there hardly remained anything to conquer save the towns of Toulouse and Montauban, and the majority of the victors were already turning homeward, leaving Simon de Montfort and the knights whom he had enfeoffed on the conquered land to deal the last blow at the exhausted enemy.

At this moment a new actor suddenly appeared upon the scene. The King of Aragon had long possessed a broad domain in Languedoc, and looked with jealousy upon the establishment of a new North-French power upon his borders. Carcassonne and other smaller places which owed him homage had been stormed and plundered by the Crusaders: they sheltered themselves under the plea of religion, and King Peter had long been loth to intervene, lest he should be accused of taking the side of the heretics. But as it grew more and more obvious that the war was being waged to build up a kingdom for Simon de Montfort rather than to extirpate the Albigenses, he determined at last to interfere. His vassals had been slain, his towns harried, and he had every excuse for taking arms against the Crusaders. Accordingly he concluded a formal alliance with the Counts of Toulouse and Foix, and promised to cross the Pyrenees to their aid with a thousand men-at-arms. He spent some months in preparing his host, mortgaged royal estates and pawned his jewels to raise money, and finally appeared near Toulouse in the month of September with the promised contingent. Most of his followers were drawn from Catalonia ; his Aragonese subjects showed little liking for the expedition, fearing that they might be sinning against Christendom by lending aid to heretics. At the news of Peter's approach the men of Languedoc took arms on all sides, and the Counts of Toulouse and Foix were soon able to assemble a large army

[1] See pp. 327, 328.

beneath their banners. They stormed Pujols, the nearest hostile garrison, and slew sixty of De Montfort's followers. The whole countryside was with them, and Simon's newly-won realm seemed likely to disappear in a moment.

The king and his allies next moved against Muret, a small fortified town at the junction of the Garonne and the Louge, which lies about twenty miles south-west of Toulouse. It was held for De Montfort by a small garrison, which, when briskly attacked, was forced to evacuate the suburbs and to shut itself up in the old town and the castle.

The unexpected irruption of Peter of Aragon into Languedoc had caught Simon unprepared. He lay at Fanjaux with the knights of his household ; the rest of the army which had served him was far on the way to France. His pressing messages only succeeded in catching and bringing back a few hundred men-at-arms under the Vicomte de Corbeil and William des Barres, one of the heroes of the third Crusade.[1] When Simon had gathered in all the men that he could assemble, there were less than a thousand horsemen in all ready to accompany him. The chroniclers are fairly agreed among themselves that he had about two hundred and forty knights and five hundred mounted sergeants. With this small force he did not hesitate to march on Muret : he felt that it was absolutely necessary for him to be at the point of danger, even though he might not for the moment be able to face the foe in the open field. He could at least make Muret too strong to fall into the king's hands, and hold him in check till there should be time to summon succours from Northern France. Perhaps, too, the enemy might commit some fault which would make it possible to deal a sudden blow at him.

The news of the coming of Count Simon filled the King of Aragon with joy. "Let him but enter into Muret," he said, "and then we will surround the city on all sides, and take him and all his French Crusaders, so will we cause the enemy a harm that can never be repaired."[2] Accordingly he bade the

[1] We have seen him commanding a division at Arsouf. See p. 310.

[2] " Quen Simos de Montfort vindra dems armatz
 E can sera lains vengutz ni enserratz
 Assetiarem la villa per totz latz
 E prendrem los Frances e trastoz los Crosatz
 Que jamais los dampnos no sira restoratz."
 Canso de la Crozada, lines 2958–62.

willed to Toulouse evacuate the lower town, so as to leave a free entry on every side too the approaching hosts. That evening the relieving army appeared, and crossed the Garonne bridge in full view of the besiegers, who counted every man, and noted with joy and surprise the small number of De Montfort's following (September 11).

The position of Muret is one of considerable strength. It lies on a narrow tongue of rising land between the Garonne and the Louge; the castle at its northern end occupies the extreme angle where the two rivers meet. The Garonne is broad and unfordable, the Louge, quite a small stream, can be passed at many points above the town, but its northern banks are in many places marshy, and it constitutes a serious military obstacle. Two bridges gave exit from Muret: the great bridge over the Garonne started from the market-place in the centre of the town; the lesser bridge across the Louge is at its north-western angle; over it passes the road to Toulouse. Besides the two bridges there is only one other way out of the place—that by the gate of Sales, looking south-westward along the narrow space between the two rivers. The Aragonese king and the Count of Toulouse had fixed their camp along the northern front of the city, on the farther bank of the Louge; it extended as far as the Garonne, on whose banks the tents of the contingent of Toulouse were pitched. The count had sent to his capital for a supply of battering-machines—perrières and others—which had arrived, and were already placed in front of the walls. The place was not sufficiently provisioned, nor were the defences of the southern suburb very strong; so that the besiegers were in high spirits and full of confidence. After Simon's arrival, the Count of Toulouse proposed to fortify the camp with a palisade,[2] in order to provide against any sudden sortie of the garrison. His previous experience had taught him to fear Montfort, and he had seen at Castelnaudary in 1211 that nothing short of entrenchments would stop the French cavalry.[3] But the

[1] Here we are much indebted to the late M. Delpech's careful topographical sketch in his *Tactique au xiime siècle*.

[2] "Fassam entorn las tendas las barrieras dressar,
 Que nuls hom n'aval non puesca intrar,
 E los ab las balestas los farem tots nafrar."
 Canso, lines 3009-11.

[3] See the *Canso*, § 105.

PLATE XIV.

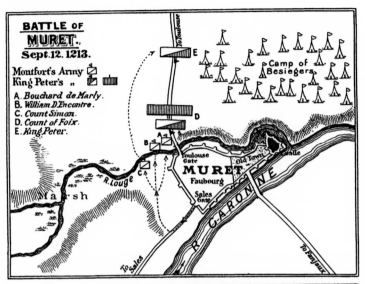

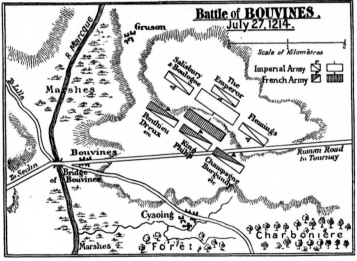

Aragonese laughed him to scorn. "It is by such pieces of cowardice, Sir Count," cried Michael de Luzian, "that you have already allowed yourself to be disinherited of your vast domains." "After that word," replied Raymond, "I can say no more," and his proposal dropped.

King Peter, who allowed his barons to use such discourteous language to his ally, was no fit leader for a host that had to cope with the fierce and wily Simon. He was a mere knight-errant, the hero of many tourneys and many raids against the Moor, but wholly unable to match himself with the accomplished professional soldier who was watching him from behind the walls of Muret. What Montfort thought of his adversary we know from a characteristic anecdote preserved by William of Puy-Laurent. One of Peter's couriers was surprised on his route by the French: he bore a letter to the king's mistress, the wife of a baron of Languedoc, telling her that he had under-taken his great enterprise for her sweet sake. "We need not fear," said Simon, "to get the better of this light king, who has declared war on God's cause to please one sinful woman." [1]

The Count of Toulouse had shown his wisdom when he proposed to fortify the camp against Montfort's possible sorties. It was just such a sally as he had feared that his foe was meditating. Simon's only hope lay in striking some deadly and unexpected blow: if the siege were allowed to proceed, the town must fall ere long, for the stock of provisions within its walls was insufficient for the garrison, much more therefore for the army of relief. After reconnoitring the enemy's position from the battlements of the castle, Montfort resolved to try a desperate expedient: he would allure the King of Aragon to attempt the storm of the town, and fall on him from the flank while the storm was in progress. Accordingly he bade his followers throw open the Toulouse gate—that which lay nearest to the Aragonese camp: such a challenge could not fail to stir the besiegers to activity, yet nothing very serious was risked, since the narrow entry across the bridge over the Louge was easy to defend. The count sent all his foot-soldiery, of whom he had about seven hundred, to hold the passage ; his knights he reserved for the counter-stroke. The crusading infantry were

[1] "Regem non vereor, qui pro una venit contra Dei negotium meretrice." (G. de Puy-Laurent, p. 208).

neither well armed nor much esteemed by their commander,[1] but they might stop the gap long enough to allow him to carry out his great scheme.

Montfort's knights had sufficient confidence in the holiness of their cause and the wisdom of their leader to make them obey his orders with alacrity. It was not so, however, with the troop of bishops and clergy who accompanied his host. They besought him to hold back, and to treat with the enemy for terms. It was only when the war-cry was heard at the Toulouse gate, and the bolts from the enemy's siege-machines came hurtling across the Louge into the castle, where they had met in council,[2] that the Churchmen withdrew their opposition, and bade Simon go forth and conquer.

There had been for a short time a sharp fight about the Toulouse gate; there the Count of Foix (who, with his own knights and some of the Catalan barons, formed the van of the king's army) had striven to force his way into the town. A few horsemen had actually penetrated for a moment within the walls,[3] but they were slain or driven out, and the count had bade his men rest and take a meal before trying a second assault.[4] They withdrew from the walls, broke their ranks, and kept no watch, for they had apparently no thought that Simon might burst out on them.

When the bickering at the Toulouse gate died down, the count quickly assembled his knights and led them out of the town by the Sales gate, on the road which starts south-westward along the Garonne. Emerging in this direction, they seemed for a moment to be evacuating Muret and retiring, rather than preparing for a battle. But after riding a few hundred yards

[1] William the Breton calls them "Pedites peregrinos fere septingentos *inermes*" (p. 92). Peter of Vaux de Cernay says, "Paucissimos, et quasi nullos, pedites habebat" (p. 86).

[2] The bishops were Fulk of Toulouse, Arnold of Nismes, Raymond of Uzès, Peter of Lodève, Bernard of Beziers, Raymond of Agde, and Peter of Comminges. See Peter of Vaux de Cernay, p. 89.

[3] Peter of Vaux de Cernay, p. 86: "Ecce plures de hostibus, armati in equis, intraverunt burgum; erant enim fores apertae, quia nobilis comes non permittebat ut clauderentur."

[4] "Lodit Conte de Montfort et sasditas gens se son ben et valentamen deffenduts, sans estre en rès esbatits: et talemen an fait que los an fait recular d'eldit assault, et retirar en lor sety. Et quand son estats retirats, se sont metuts a manjar et a beurre, sans far degun gait et sans doubtar del rè" (Anonymous Chronicle of the Albigensian War, p. 153 c).

down the Sales road, Simon fronted his men northward and formed them in battle-array. He made the usual three "battles," in honour of the Holy Trinity, as several of his encomiasts assert.[1] They were not on a level front, but *en échelon*, apparently with the right battle advanced and the left battle "refused." Each of the corps counted between two hundred and fifty and three hundred knights and sergeants: the first was commanded by Bouchard lord of Marly, the second by William d'Encontre, the third by Simon himself. The crusading hero William des Barres rode in front of the first squadron, and with him Montfort had sent on all the banners of the host, apparently to concentrate the enemy's attention on the front corps and to distract it from the third, which practically acted as a reserve.[2]

Having wheeled so as to face northward from the Sales road, Simon rapidly covered the short space of ground intervening between the Garonne and the Louge, crossed the latter at a point where the passage of the marsh was feasible, and came hurtling into the midst of the incautious enemy, taking the tents of the camp as his point of direction.[3]

It is impossible to get any satisfactory estimate of the host which Simon was about to assault: the crusading chroniclers give for it all manner of wild figures, ascending as high as a hundred thousand men. There may possibly have been fifteen or twenty thousand foot, of which the burgess militia of Toulouse must have formed the most solid portion. For the cavalry we can only make our estimate by guess-work; but Peter of Aragon had raised a thousand knights, of whom all were not yet arrived,[4] and his troops formed in the three horse-battles of the allied host the whole of the second corps and part of the first. If, therefore, he had eight hundred or

[1] *e.g.* Peter of Vaux de Cernay, p. 87.

[2] "Guilheumes de la Barra los prez a capdelar
 Et fels en tres partidas totz essems escalar
 Et totas las senheiras el primer capanar."
 Canso, lines 3052–54.

[3] "Tuit sen van a las tendas per meias las palutz,
 Senheiras displegadas els penons destendutz."
 Canso, lines 3056–57.

[4] Peter only intended to fight when "Nunos mos cozis sera sai aribatz" (*Canso*, 2958), and we know from the chronicle of Jayme of Aragon that this Sancho Nunez, together with another baron named William de Monçada, had not arrived when the battle was fought, *i.e.* the thousand knights of the Aragonese contingent are not quite complete.

eight hundred and fifty knights with him, of whom some hundred and fifty or two hundred rode in the van under the Count of Foix, his own corps may have been six hundred and fifty to seven hundred and fifty strong. Tripling this for the whole effective of the allied cavalry, we obtain some nineteen hundred or two thousand one hundred horsemen. They can hardly have mustered less, for the chroniclers speak of two of Count Simon's corps (i.e. five hundred and fifty to six hundred riders) as being outflanked and outnumbered by one single battle of the King of Aragon's host.[1]

It was apparently at the broad ford of the Louge, not far from the bridge and the Toulouse gate, that Montfort's men passed the water. The moment that they had crossed it they were in the midst of the enemy. The confederates were, as it seems, entirely taken by surprise — certainly they were in disarray when the Crusaders charged them. "When the King of Aragon," says one of our chronicles,[2] "saw his enemies working such mischief, he straightway armed himself, and bade all his folks get to horse, crying Aragon! and the rest cried Toulouse! or Foix! or Comminges! And, observing neither order nor array, all who could make their way to the mêlée betook themselves thither." The first corps on which Montfort's assault fell was that of the Count of Foix and the Catalans, who formed the van-battle of the combined host. In a very few minutes it was scattered "like dust before the wind"[3] by the impact of the two front squadrons of Montfort's little army. The knights of Foix and Catalonia dispersed, some taking refuge with the rear divisions of their own host, some flying from the field. The foot-soldiery poured back into the camp, which they began to barricade with waggons and carts. But the Crusaders made no attempt to follow them: they had still to defeat the main body of the king's knights.

King Peter with his household knights and the barons of Aragon were now assembled under the royal banner. Short

[1] When the squadrons of Bouchard and William d'Encontre charged King Peter's own corps, they were "swallowed up" in it, says Peter of Vaux de Cernay, p. 87: "Videns comes noster duas acies suas *in medios hostes immersas quasi non comparere*, irruit," etc. Even if the Aragonese were in loose and the French in compact order, this still presupposes a superiority in numbers.

[2] The Anonymous History in the dialect of Languedoc in Bouquet, vol. xix. p. 153.

[3] William de Puy-Laurent, p. 209.

as was the stand which the vaward battle had made, it seems
to have been long enough to allow the second corps to get into
some sort of array. Probably a considerable number of the
less panic-stricken knights of the first division had also rallied
on it. At any rate, the force around the Aragonese banner out-
numbered that of the two crusading squadrons which had
hitherto been engaged. But without any delay D'Encontre and
Bouchard of Marly led their men against the king, and charged
him full in front. To the eyes of a spectator their small solid
masses of men seemed for a moment swallowed up in the less
orderly and less closely-arrayed ranks of the Aragonese.[1] The
latter, accustomed to battles with the Moor, were probably
drawn up in much looser formation, and relied on the tilting
powers of the individual rather than the impact of the mass.
The French, however, were easily holding their own even before
help came to them. The mêlée was swaying backwards and
forwards, and the din "as of countless woodmen hewing down
a forest"[2] was heard as far as the camp of the Toulousans and
the walls of Muret.

But the combat had not lasted for long when Simon him-
self, with the third corps of the crusading host, came upon the
scene. He had not been engaged in the first charge, as the
third échelon had not been required to complete the rout of
the Count of Foix and his men. Now, coming up on the left
of his two other divisions, he did not strike in at the front of
the fray, but wheeled westward and came in upon the right
flank of the Aragonese. He himself, riding at the head of his
knights, received a shower of blows as he closed with the enemy,
and was nearly beaten from his saddle.[3] But he held his own,
cleared a space around him, and cut deep into the mêlée. In
a few moments the fight was over: King Peter was recognised [4]
and slain by a band of Crusaders, who had sworn before the
fight to mark him down and stoop at no meaner prey. The
most faithful of the knights of his household fell around

[1] See the remarks on p. 454.

[2] We owe this graphic touch to the narrative of a spectator, the young son of
Raymond of Toulouse, then a mere boy, who witnessed the fight from the front of
the camp, and related his experiences many years later to his confessor, William of
Puy-Laurent, one of the historians of the Crusade (W. of P.-L., p. 209).

[3] Peter of Vaux de Cernay, p. 87.

[4] He had given his royal trappings to one of his knights, and was fighting in
plain armour, so that he was not at first identified.

him, the rest dispersed and fled in all directions. The slaughter was great, for the victors gave little quarter to heretics,[1] and the prisoners were much less numerous than the dead.

After the Aragonese were beaten, we hear nothing more of resistance on the part of the allied troops. What the Counts of Toulouse and Comminges were doing during the critical moment of the combat we cannot say. If they had formed up a third corps in rear of the king, they certainly made no attempt to use it. But we have no direct statement that they had even got into battle-array. They are only mentioned as flying from the field; some of our authorities[2] even hint that they fled before the final mêlée, at the same time as the routed troops of the Count of Foix.

It is at any rate certain that when King Peter was slain the Crusaders found no other enemy remaining but the foot-soldiery of Toulouse barricaded in their camp. While the cavalry fight was going on, Bishop Fulk had sent a messenger to them, to offer them quarter and pardon. But, confident in the success of the Aragonese, they drove the emissary away with hoots and blows. When, however, they saw Count Simon turning back towards them, and recognised that their friends were defeated, panic seized them; they made no attempt to defend their extemporised entrenchments, and thought only of flight. One of their leaders, Dalmace d'Entoisel, started the panic by crying, "Evil has come upon us! The good King of Aragon and the barons are slain," and plunged into the river, for the flight by land was barred by the approaching Crusaders.[3] The multitude followed him as best they could, some crossing by boats,[4] others swimming the broad stream. But the victors were upon them long ere they could all escape, and many thousands were cut down among the tents. A considerable number more perished in the water. The slaughter both in the fight and the rout had been heavy, but can certainly not have amounted to the fifteen or twenty thousand men of the chroniclers. It is surprising to read that in Simon's host only one knight and three (or eight)

[1] The Anonymous Chronicle of Languedoc (p. 153) says that they were "more like tigers or bears than reasonable beings," and slew the wounded.

[2] Both the Anonymous Chronicle of Languedoc and William of Puy-Laurent expressly make it *after* Peter's death. The Spanish Chronicle *De Gestis Regum Aragoniae* naturally makes it occur first.

[3] *Canso*, lines 3080–85. [4] William of Puy-Laurent mentions the boats, p. 209.

sergeants were slain. But the knightly armour was already
in 1213 such a protection to its wearers that scores were
hurt for one who received a mortal stroke. The carnage was
always among the dismounted or wounded knights of the
losing side, and still more among the wretched unarmoured
infantry.

Battle of Bouvines, July 27, 1214.

No engagement offers a greater contrast to the short, sharp
cavalry combat of Muret than the great pitched battle of
Bouvines, the most important from the political point of view
of all the fights which lay between Legnano and the March-
feld. To that victory modern France owes its existence: if the
fortune of the day had been different, the consolidation of the
French monarchy might have been delayed for centuries. The
Plantagenets might have won back their lost Norman and
Angevin dominions, the counts of Flanders might have cut
themselves free from their suzerain, and the emperor might
have excluded the French influence from the Lotharingian
border-lands. Never again till the time of Charles V. and
Francis I. did France see such a formidable array of enemies
gathered against her. That Philip Augustus was able to beat
them off with the forces of his newly-constituted realm is a
cause for wonder, and the best testimony to his personal abilities
and courage. Without Bouvines he would go down in the
records of history as an intriguer of the type of Louis XI.
rather than a warrior. Assuredly no one would have
guessed from his conduct in the Holy Land, or from the
details of his weary war with Richard Coeur de Lion, that
he would have the firmness and the nerve to put everything
at stake, and deliver and win the greatest pitched battle of
his age.

Freed from his long quarrel with the Pope by the homage
done at Dover on May 15, 1213, John of England had set his
considerable diplomatic talents to work, in order to build up a
great coalition against the King of France. He was determined
to win back the lost lands of his ancestors on the Seine and
Loire, and, since his own discontented realm could not furnish
him with sufficient forces for carrying out the scheme, it was
necessary to seek foreign aid. England was chafing against
his misrule so bitterly that he could only aid the confederacy

with his purse and his hordes of mercenaries. The most important of John's allies was his nephew, the Emperor Otto IV, who had his own grievance against Philip, because the latter was supporting against him the young Frederic of Swabia, who claimed the Imperial throne. Otto was losing ground in Germany, and hoped to recover his reputation by a successful campaign in the West, where he could count on the aid of the majority of the princes of the Netherlands. Next in importance to the emperor, though not next in rank in the coalition, was Ferdinand [1] Count of Flanders, who had fallen out with his suzerain owing to Philip's grasping behaviour in taking from him his towns of Aire and St. Omer. Another discontented French vassal, Reginald Count of Boulogne, had the same grievances and the same intentions as Ferdinand, and joined the allies in his company. All the princes of the Netherlands, with the exception of the Duke of Luxemburg, the Count of Guelders, the Bishop of Liége, and the latter's firm ally, Lewis Count of Loos,[2] followed the lead of the emperor, not merely because they were Otto's partisans in the German civil war, but because they dreaded the advance of the cunning and unscrupulous King of France. We find in the ranks of the coalition Henry Duke of Brabant (the vanquished of Steppes),[3] Henry Duke of Limburg, Theobald Duke of Lorraine, William Count of Holland,[3] and Philip Count of Namur.

It would have been easy for King John to have shipped himself over to Flanders with all his mercenaries, and there to have joined his allies. But his plan of campaign was more ambitious and more complicated: we seem to detect in it the project of a great strategical combination. It would appear that he had resolved to take upon himself the conduct of a great diversion on the Loire, which was intended to draw the King of France southward and distract his attention. Meanwhile, the emperor and the princes of the Netherlands were to collect on the Flemish frontier, and, when all were assembled, to march on Paris. If the French should already

[1] A Portuguese prince who had married Joanna Countess of Flanders, the elder daughter and co-heiress of Baldwin of Flanders, the ephemeral Emperor of the Latins at Constantinople in 1204-5.

[2] See p. 444.

[3] An old enemy of Lewis of Loos, since they had disputed the inheritance of Holland between them.

be involved in a campaign in Poitou or Anjou, the allies would find comparatively little resistance, and might overrun the whole of Northern France.[1] This was a very broad and far-reaching plan for a mediæval strategist; unfortunately it required accurate timing, a thing impossible to secure when the distances were so great and communications so difficult.

In accordance with this project, John crossed to Aquitaine at a very unusual season. Sailing from Portsmouth, he landed at La Rochelle on the 15th of February 1214, with a force almost entirely composed of his mercenaries: the English baronage could not be trusted.[2] He called the feudal levies of Guienne to his aid, and marched into Poitou, where he was joined by Hugh of La Marche, who now consented to aid him in spite of his old grievance about his lost bride,[3] and by Hervé Count of Nevers. Making a great display of his troops, John overran Poitou in March, and then crossed the Loire and invaded Anjou, the ancient patrimony of his house. As he had expected, the King of France was profoundly moved by this invasion: he marched to check it, taking with him his son, Prince Louis, and the pick of the feudal levies of his realm. Moving by Saumur and Chinon, he endeavoured to cut off John's line of retreat towards Aquitaine. But, abandoning Anjou, the King of England hastened rapidly southward, and, evading the enemy, reached Limoges (April 3).

By these operations John had drawn Philip far to the south, and if only the emperor and his allies had been ready to move, they might have forced their way to Paris with small difficulty. They were, however, far too late. Philip refused to pursue John any farther, and, after ravaging the revolted districts of Poitou, marched homewards. At Châteauroux he handed over to his

[1] The chroniclers seem to recognise that this was John's plan, *e.g.* Chron. St. Victor (Bouquet, xvii. 427): "[Johannes] mandasse dicitur Othoni, dicto Imperatori, ut congrederetur cum Philippo rege Francorum, *quia Ludovicus totam Galliae juventutem secum habebat, quàm occupatam detinebat* : et rex Philippus non habebat nisi inertes milites et emeritos." Matthew Paris says: "Ipse quoque rex apud Portesmuthe exercitum congregavit immensum, ut ad Pictaviam transfretaret, *disponens a parte Occidentali, sicut illi qui erant in Flandria a parte Orientali, regnum Franciae inquietare.*"

[2] See Matt. Paris, ii. 252.

[3] John, it will be remembered, had carried off and married Hugh's affianced wife, Isabella of Angoulême. After his death she married her old lover, and became mother of the Lusignans.

son eight hundred knights,[1] two thousand sergeants, and seven thousand infantry, and returned with the rest to the north.

John, however, was determined to detain in front of himself as large a force as possible. When he heard that the King of France had departed, he at once faced about and re-entered Poitou in May. Rapidly passing the Loire, he again invaded Anjou, and, after subduing many towns, laid siege to the strong castle of La Roche-au-Moine (June 19). He had lain in front of it for fifteen days when Prince Louis marched to its relief with his own army, reinforced by four thousand Angevin levies under William des Roches, seneschal of Anjou, and Amaury de Craon.[2] The English king was not prepared to fight, as he knew that his Poitevin allies were untrustworthy:[3] destroying his siege implements, he hastily recrossed the Loire (July 3). His rearguard suffered severely at the hands of the French. The prince pursued him as far as Thouars, and then halted and turned back to Anjou.[4]

Meanwhile, a natural but very fatal mistake had been made in carrying out the great combination. John had done his share most effectually, but the emperor's intervention came too late. Otto moved towards the Netherlands in March; he reached Aachen on the 23rd of that month, and should have pressed forward at once towards the French frontier. But he lost time in striving to collect German troops to add to his own personal following, and in negotiating with the princes of the Low Countries. From the military point of view it was fatal—though from the political point of view it was pardonable—to linger in Aachen in order to celebrate his marriage with the daughter of

[1] *Philippeis*, x. 130:

> "Tu nate manebis
> Hic cum militibus demptis de mille ducentis,
> Ast ego cum reliquis Othonem visere vado;"

and *ibid.* x. 202:

> "Interea Ludovicus adest cum prænominato
> Militiae numero, septies quem mille sequuntur
> Armati pedites, et equis duo millia vecti
> Ghaviter, edocti bellum instaurare clientes."

Aegidius Aureae-Vallis stupidly supposed that the four hundred knights whom Philip took home were his only force at Bouvines three months later (Bouquet, p. 662).

[2] *Philippeis*, x. 241:

> "His sibi Guillelmus et Amalricus sociatis
> Quattuor auxerunt Ludovici millibus agmen."

[3] Matthew Paris, ii. 577.

[4] *Philippeis*, x. 322.

his powerful ally, Henry of Brabant (May 19).[1] Only in June
did he move forward again, bringing with him a very small
contingent from the empire:, of all the great vassals of the
Crown, only the Counts of Tecklenburg, Katzenellenbogen, and
Dortmund were with him. The war was not popular in
Germany, and the three counts, together with Otto's own
Saxon followers, formed but a small nucleus for the army of
invasion. But on the 12th of July he had reached Nivelles in
Brabant, where he held counsel with the Dukes of Brabant,
Limburg, and Lorraine, and many more of his vassals. Dis-
posing at last of a large army, he marched into Hainault, and
named Valenciennes as the final mustering-place of his forces.
He arrived there about the 20th of July, but it was now far too
late for him to carry out his uncle's plan effectively. If he
had been there three or even two months earlier, matters
would have been very different, but by the end of July all
France was in arms, and Philip had full information of the
oncoming storm, and was prepared to beat off the attack from
the north.

The army of Otto was nevertheless very formidable. The
Count of Flanders had joined him with a very large contingent
of horsemen, and William Longsword, Earl of Salisbury,
brought a great band of mercenaries to the Imperial standard.
King John had sent his half-brother over to Flanders with
forty thousand marks,[2] and bade him take into his pay every
soldier of fortune that could be found. The documents in
Rymer's *Foedera*[3] show us that Longsword had hired twenty-
five knights from the Count of Holland. He had also taken
into his pay the French exiles Reginald of Boulogne and Hugh
of Boves, with all their followers. The contingent maintained
by English money was large enough to form one whole wing
of the allied army. It included great numbers of Brabançons
and other foot-soldiery, as well as the hired knights and
sergeants of the cavalry arm.

When the campaign commenced, the allies had not fully
concentrated their host. King Philip was in contact with them

[1] This did not prevent Henry from playing a double-faced part, and giving secret
information to the French king of his rival's plans. See *Philippeis*, p. 253, v. 671.

[2] There must have been very few native English in Salisbury's band. Ralph Bigot
is the only English knight named among the hundred and forty captives of Bouvines
(Bouquet, xvii. 101).

[3] Rymer, vol. i. p. 110.

while five hundred knights and "an infinite multitude of infantry"[1] were still wanting. Otto had with him at Valenciennes, as the better contemporary chroniclers agree, fifteen hundred knights.[2] This figure of course represents only a small proportion of his cavalry; of light horse and mercenary sergeants there must have been a very much larger number—perhaps as many as five thousand or even more, for John's hired bands always contained a very small proportion of knights, and the Flemish towns sent many of their richer citizens to war on horseback. Of foot-soldiery there was a huge array. Salisbury had enlisted thousands of Brabançons, and the Netherlandish princes could always put into the field enormous levies of pikemen.[3] All the writers of the day were impressed with the vast multitude of Otto's infantry, "which covered the whole face of the earth";[4] but we can get no acceptable figures for it. Richer of Sens,[5] who estimates it at eighty thousand men, shows his own untrustworthiness by adding that the horse reached the impossible figure of twenty-five thousand. Even allowing for the absolute want of sense as to numbers which reigned among the writers of the age, we must still suppose that the allied host was very large—perhaps fifteen hundred knights, five thousand mounted sergeants, and forty thousand foot may have been present under the Imperial standard, but it is impossible to give any satisfactory figures.

Meanwhile, King Philip had been watching the northern frontier since May, and, when he saw that the invasion was really impending, had summoned all the available levies of France. He could not call away men from his son, who needed every lance that had been left him to make head

[1] Chronicon Turonense in Bouquet, xviii. 299.

[2] Chronicon Turonense in Bouquet, xviii. 299 : *"Numerus militum erat mille quingentorum."* Andreas Marchianensis : *"Cum mille quingentis militibus."* The Chronicle of William of Nangis gives the same number, perhaps copying ; while the Chron. S. Columbae says, *"Ad summam mille trecentorum militum."*

[3] Hainault alone had put into the field in 1183 ten thousand men. The Duke of Brabant lost at Steppes three thousand slain and four thousand prisoners ; and yet his foot, though sorely mishandled, had not been entirely annihilated.

[4] "More locustarum legionibus occulit agros". (*Ph. x. 712*).

[5] Rich. Senonensis in Bouquet, xviii. p. 689. Richer is wildly wrong in all his tale of Bouvines. He makes the battle open with a tilt between Ferdinand of Flanders and Walo of Montigny, in which the latter pierced the former with the oriflamme, which came out all bloody at his back ! (p. 692).

against John. From the southern army the king had only
withdrawn the four hundred knights whom he had taken home
from Châteauroux in April. No help could be expected from
Brittany and Anjou, all of whose levies were with the prince,
nor very much from Normandy. But in Eastern, Central, and
Northern France the *ban* was proclaimed, and every possible
effort made to concentrate all the forces of the countryside.
We have, as in the case of Otto's army, no trustworthy esti-
mate of the whole host. In cavalry, especially in mounted
sergeants, it must have been very strong, as the figures of such
contingents as have been preserved clearly indicate. The
knights of the Count of Champagne (he himself was a minor
and not present) amounted to one hundred and eighty.[1] The
rolls of service due to the king (drawn up about 1211) show
that the Viscount of Melun owed the king eighteen knights,
while the Counts of Beaumont and Montmorency each were
bound to serve with twenty, and the Count of St. Pol with
thirty.[2] Eudes III. of Burgundy, successor of the duke whom
we have met at Acre and Arsouf, must have brought a much
larger following even than Champagne. Now, the contingents
of these nobles, with certain other smaller ones,[3] composed the
right wing of the French army at Bouvines. It must therefore
have counted at least five hundred knights : allowing as much
for the left wing and for the centre, we should conclude that
Philip had at least fifteen hundred knights with him.[4] If we
grant him for sergeants the same proportion as prevailed in
the army on the Loire under his son (8 to 20), he must have

[1] *Philippeis*, x. 467 :

> "Cum pene ducentis
> Militibus quales Campanicus educat axis."

[2] All these from the service rolls in Bouquet, xxiii. 686, 693. See M. Delpech,
Tactique au xiiime siècle, 127.

[3] *e.g.* those of the Count of Sancerre and Michael of Harmes.

[4] The right wing, as we shall presently see, contained at least four corps. (1)
The Champenois—one hundred and eighty knights. (2) Montmorency, Beaumont,
Sancerre, Hugh of Malaunay, and Michael of Harmes, who "post Campanenses acie
glomerantur in una" (*Ph.* x. 475). Montmorency and Beaumont had twenty
knights each, Sancerre probably as many ; of the others we cannot speak, but the
corps may well have mustered one hundred knights. (3) Burgundy, which must
have given at least two hundred. (4) St. Pol and the Viscount of Melun, probably
a small corps ; they were only bound to bring forty-eight knights between them, but
other small contingents may have been added to bring their squadron up to a higher
figure. Looking at these figures, it seems that the whole right wing must have had
well over five hundred knights.

had at least four thousand of the lighter sort of horse. But that this figure is too small is shown by the facts that one single great feudatory, the Abbot of St. Medard, could send three hundred,[1] and that at the end of the fight Philip was able to mass in one part of his line, to make a final onslaught on the Count of Boulogne, no less than three thousand sergeants.[2] When we remember that every possible combatant had been collected to repel the great Teutonic invasion, we may perhaps believe that the total may have reached even the two thousand knights given to Philip by one German chronicle,[3] a number which would presuppose at least five thousand sergeants. There is nothing incredible in the figures, and they help to explain the victory of the French army, which in that case must have outnumbered the allied host in horse, though it is quite clear that it must have been much inferior to it in the number of its foot-soldiery.

It is certain, nevertheless, that Philip had collected a very considerable force of infantry. All the militia of the communes which he had done so much to foster were called out, and in addition the baronage had brought the much less valuable *ban* of their vassals.[4] If we may draw any conclusions from such an instance as that Thomas of St. Valery, lord of Gamaches, had brought no less than two thousand foot-soldiery from his not very extensive fief,[5] we must believe that this levy appeared in great strength. We may guess that the king had some twenty-five or thirty thousand infantry with him, but the smaller part must have consisted of the well-armed civic levies and the mercenary Brabançons, of whom he maintained many bands; the greater proportion must have been composed of the worthless feudal troops.

Philip had concentrated his army at Peronne about the 20th of July. Finding that the long-threatened invasion still hung fire, he resolved to take the offensive himself, and crossed

<hr />

[1] *Philippeis*, xi. 58.

[2] *Philippeis*, xi. 613.

[3] The Magdebürger Schoppenkronik (*Städtechroniken*, vii. 140). I get this reference from General Köhler's *Kriegsgeschichte*, etc., i. 126.

[4] M. Delpech shows that the number of the militia owed by the communes in 1212 was about ten thousand men, and some of these must have been with Prince Louis in Poitou.

[5] "Hinc sancti Thomas Galerici nobilis haeres
 Quinquaginta parat equites in bella, clientes.
 Mille bis, audaces animis et robore fortes". (*Ph.* xi 494).

the Flemish frontier (July 23). He had seized Tournay (July 26) and pushed his scouts through it to Mortagne, when he learned that the emperor was not in Flanders, but in Hainault. Otto, as a matter of fact, had reached Valenciennes about the same time that Philip marched from Peronne. The news that the enemy lay so far to the south of him that they could by a rapid march cut in between him and Paris, disturbed the king. He must, he thought, either attack Otto at once, or retreat, and by a flank march regain secure communication with his base. The first alternative was rendered dangerous by the fact that the ground between Tournay and Valenciennes was marshy and wooded, and therefore very unsuited for the powerful French cavalry.[1] It only remained, therefore, to withdraw from Tournay and place the army, if possible, between Otto and Paris. After holding the city for only a day, Philip evacuated it and marched west, intending to cross the river Marque at the bridge of Bouvines, to sleep at Lille, and then probably to turn south by Lens and Arras. His ultimate destination was the plain of the Cambrésis, where the level and open country was suitable for cavalry.[2]

It remained, however, to be seen what Otto would do on receiving the news of the advance of the French on Tournay. He might turn aside to meet them, or else make use of the strategical advantage which Philip's march so far to the north had put in his hands, and strike at Paris. Confiding in the superiority of his numbers,[3] as we are told, he resolved to take the former course. Turning north-westward, he marched past the woods of the Forêt Charbonnière to Mortagne on the Scheldt, some nine miles south of Tournay. On the 26th, the day he arrived there, his spies brought him the news that Philip was about to evacuate Tournay next morning and retire towards Bouvines. After taking counsel with his allies, he resolved to start in haste and pursue the King, hoping to come

[1] " Ista nimis via perniciosa quadrigis
Esse potest et equis: sed eis sine quis velit ire,
Aut pugnare pedes?" (*Ph.* x. 685).

[2] " Retro vertamus signa, Bovinas
Praetereamus, item Cameraci plana petamus
Hostes unde gradu facili possimus adire" (*Ph.* x. 688, 689).

[3] " Et licet illorum numerus qui bajulat arma
Militiae vix esse queat pars tertia nostrae," etc. (*Ph.* x. 657).

30

up with him when part of his host had crossed the bridge of
Bouvines and part was still on the east side of the Marque.
Unfortunately there was a traitor in his camp; his own father-
in-law, the Duke of Brabant, sent secret intelligence of the
plan to King Philip, by the hands of a confidential chaplain of
his suite.[1]

Next morning (July 27), at break of day, the French
abandoned Tournay and retreated by the old Roman road
leading to Bouvines. The king had caused the bridge to be
hastily widened by his engineers,[2] so that it would take twelve
men or eight carts abreast. Thus he trusted to get the whole
army across it, and to shelter them by the marshes of the
Marque before the enemy came up. There are only nine miles
between Tournay and the Marque, but an army retreating with
all its impedimenta by a single road trails out to an immense
length. Hence it came to pass, that when the baggage and the
infantry and many of the horse were safely across the river, but
the main body of the cavalry was still far to the east of it, the
heads of the Imperialist columns came in sight, marching hastily
up from the south-east. For a moment the French hoped that
Otto might be aiming at Tournay,[3] but on reaching the Roman
way his vanguard turned off, and began to follow the road to
Bouvines.

Philip had detached to cover his march a body of mounted
sergeants, under Adam Viscount of Melun, who was accompanied
by the warlike Garin, Bishop-elect of Senlis, an old Knight-
Hospitaller, on whose military talents his master placed great
reliance. After surveying the approaching host, Garin hastily
rode back to inform the king that the enemy intended to fight,
for he could see that the knights' horses wore their bardings,
and that infantry columns were advancing at the head of the
line of march.[4] Meanwhile the Imperialists came on so fast that they drove
in the viscount and came into contact with the rear of the

[1] *Philippeis*, x. 672.

[2] "Continuo pontem rex fecit amplificari
 Corpora quod bis sex lateraliter ire per ipsum
 Cumque suis possent tractoribus octo quadrigae" (*Ph.* x. 810).

[3] "Exiit ergo sermo inter milites nostros quod hostes declinabant Tornacum"
(G. le Breton, 269). The Imperialists were here passing the brook of the Barge, near
Villemaux and Le Marais.

[4] G. le Breton, p. 268.

French army. First the king's horse-arbalesters, and then a
body of sergeants belonging to the county of Champagne,
lastly the Duke of Burgundy and his knights, faced about to
hold back the Flemish cavalry which formed Otto's vanguard.[1]
But in five successive skirmishes they were perpetually driven
back.

Garin had found Philip lunching under an ash not far to the
east of the Marque, and watching his columns slowly trailing
across the bridge. Hearing that the enemy was so close that
it would be impossible to get the rearguard over the water
without a disaster, the king determined on the bold step of
ordering his whole army to face about and take up a position
on the low rolling ground which lies above the east bank of the
marshy river-bottom.[2] Leaving the space about the Roman
way clear, that the Duke of Burgundy and the rearguard
might draw up upon it, Philip began to extend his army, as
each division came up, in a north-westerly direction from the
road, and tending towards the modern village of Gruson. The
reason for arraying the line in this aspect, and not perpendicular
to the road, would seem to have been that bodies of the Imperial-
ists were already visible far to the north, evidently intending to
push past the French rearguard and outflank it as it approached
the bridge.

Thus it came to pass that when the Duke of Burgundy, still
bickering with the Flemings of the Imperialist vanguard, came
in sight of the bridge, he found the greater part of his suzerain's
army already drawn up and ready to help him. When he
wheeled about and fell into line with them, the Flemings halted :
it was obviously impossible for them to attack the main body
of the French before their own reserves came up. Soon the
emperor arrived upon the field, and, seeing the enemy in array,
ordered each of his corps as it came up to extend itself north-
westward from the Flemings on the main road, so as to assume

[1] *Philippeis*, x. 820. G. le Breton, p. 270. *Chronique et Istorie de Flandres*,
i. 117.

[2] I walked carefully over the battlefield in October 1897. It is now almost
entirely under the plough. There is room for an army of any size on the low rolling
slopes above Bouvines, and there is no ground over which a horseman could not
easily pass. The Marque has shrunk to a mere rivulet, and its marshes have almost
disappeared. It is a pity that the column commemorating the victory has been set
up close to the bridge of Bouvines on the outskirts of the village, and not on the
actual field of battle.

a front parallel with that of King Philip's host.[1] The long time which it required for such a large force to come up and deploy gave ample leisure to the belated parts of the French army to recross the Marque and join the king. The infantry, which had gone farthest, only came up just in time to take part in the battle. The Duke of Burgundy and the rearguard meantime obtained a grateful hour of rest, after their exertions of the morning.

We must now endeavour to reconstruct the battle-array of the two hosts. Among the Imperialists the south-eastern wing was composed of Count Ferdinand's knights of Flanders and Hainault, who lay on and about the Roman way. Next to them was the centre, composed mainly of infantry, for Otto had massed there all his immense contingents of Flemish and Netherlandish infantry, as also, it would seem, the bulk of the mercenary Brabançons, whom the gold of King John had hired. In the rear of them he himself was stationed with his own comparatively small force of Saxon and Rhenish knights, strengthened by the cavalry of the Dukes of Brabant and Limburg and the Counts of Namur and Holland. The left wing was composed entirely of the troops in English pay, the knights and sergeants of the Earls of Salisbury and Boulogne and of Hugh of Boves. The whole front of the Imperialist host was two thousand yards from end to end.[2] In the centre of the

[1] G. le Breton, p. 270 : "Hostes itaque videntes regem praeter spem suam reversum . . . diverterunt ad dexteram partem itineris quo gradiebantur, et protenderunt se quasi ad occidentem et occupaverunt eminentiorem partem campi. Rex etiam alas suas extendit e regione contra illos, et stetit a parte australi cum exercitu suo." In the *Philippeis*, xi. 12, Otto

> "A laeva paulum retrahit vestigia parte
> Componensque acies gressus obliquat ad Arcton."

[2]
> "Occupet ut prima armatorum fronte virorum
> Directe extensa passus duo millia terrae" (*Ph.* xi. 17).

We have above (p. 462) estimated the Imperialists roughly at fifteen hundred knights, five thousand mounted sergeants, and forty thousand foot. The infantry, unable to afford intervals on account of the danger of being pierced, would be in one great mass. So forty thousand men, twenty deep, with two feet of front for each pikeman, gives us a line of (roughly) thirteen hundred and fifty yards. We have now to account for the cavalry : if we allow the emperor and the central reserve to have counted four hundred knights and fifteen hundred sergeants, we have left eleven hundred knights and three thousand five hundred sergeants for the wings, to occupy the six hundred and fifty yards remaining out of our two thousand. At three feet front per horse, this would give us a depth of somewhat over seven horsemen, which is hardly sufficient : if there were some small intervals (large ones were not possible in hosts whose chief danger was that of being broken through), the depth may have been eight or nine ranks.

line, behind the infantry and guarded by the cavalry reserve, was the Imperial banner, a silken dragon hoisted on a pole whose summit was crowned by a golden eagle. It was fixed on a car drawn by four horses, as the Milanese standard had been at Legnano, or Richard Coeur de Lion's at Arsouf.

The French army which stood opposite the Imperialists had at first occupied only about 1040 yards in length,[1] the infantry had not yet come up, and the mounted men, when ranged in the usual deep formation, were not numerous enough to face the whole line of the enemy. But Bishop Garin, who on this day seems to have acted almost as a chief of the staff for King Philip, hastily rode along the front, bidding the horsemen take ground to the flank, and make their files less dense. "The field is broad enough," he said; "extend yourselves along it, lest the enemy outflank you. One knight should not make another his shield; draw up, so that all the knights may be in the front line."[2] In this way he made the French cavalry face the whole Imperialist army: if there were enough knights to form a continuous front rank, the king must have had some two thousand of them. The five thousand sergeants with which we have credited him in our estimate would only suffice to make the line three, or at the most four deep. But, just as the fight was beginning, the French infantry came marching hastily up from the rear, and, passing through the horsemen of the centre, who made intervals for them, ranged themselves in the midst of the host, and in front of the king and his personal retinue. The civic militia of Corbey, Amiens, Beauvais, Compiégne, and Arras are especially mentioned.[3] They had with them the oriflamme, the red banner of St. Denis; the king's personal ensign, the blue flag powdered with golden lilies, was borne at Philip's side in the central division of horse, by a gallant knight named Walo of Montigny.

[1] "Prima frons pugnatorum protensa erat et occupabat campi spatium mille quadraginta passuum" (G. le Breton, p. 275).

[2] "Campus amplus est; extendite vos per campum directe, ne hostes vos intercludant. Non decet ut unus miles scutum sibi de alio milite faciat; sed sic stetis ut omnes quasi una fronte possitis pugnare" (G. le Breton, p. 277).

"Sic etiam rex ipse suae protendere frontis
Cornua curvavit, ne forte praeanticipari
Aut intercludi tam multo possit ab hoste" (*Ph.* xi. 17).

[3] "Supervenientes communiae, et specialiter Corbeii, Ambianenses, Belvaci, Compendii, et Atrabate, penetraverunt cuneos militum et posuerunt se ante regem" (G. le Breton, 282).

In the line of French cavalry, the south-eastern wing was mainly composed of the old rearguard which had been engaged with the Flemings in the morning. It consisted of the horsemen of the county of Champagne, of Eudes of Burgundy, of the Counts of St. Pol, Beaumont, Montmorency, and Sancerre, and certain smaller feudal contingents. We gather from William le Breton that the Champenois were nearest the centre, that next them was a corps composed of the retainers of Beaumont, Montmorency, Sancerre, and two less important vassals, Michael de Harmes and Hugh de Malaunay.[1] Farther down the line were the Burgundians, and also the Count of St. Pol and the Viscount of Melun. But whether the former or the latter formed the extreme right wing, we cannot determine.

In the French centre, round the banner of the lilies, rode the king's personal retinue, strengthened by seventy knights of Normandy, the only contingent which that rich duchy could spare, the greater part of its forces being on the Loire. Here also were the smaller noblesse of the Isle de France, and also the young Count of Bar and his retainers. Among the immediate following of the king we hear of his chamberlain, Walter de Nemours, of William de Garlande, Barthélemy de Roye, Peter Mauvoisin, Gérard la Truie, Stephen de Longchamp, William de Mortemer, John de Rouvray, and William des Barres, the old crusading hero who came fresh from the triumph of Muret to win new laurels in the North.

The left wing of Philip's host contained the contingents of Robert Count of Dreux (who lay nearest the centre), William Count of Ponthieu, Peter Count of Auxerre, the Bishop of Beauvais, and Thomas of St. Valery, lord of Gamaches and Vimeux; it is probable that in this part of the field lay also many other troops from Picardy, Vermandois, and the other regions of Northern France. We know, for example, that the Counts of Grandpré, Guisnes, and Soissons were with the host, but are not informed of their places in the line; it would be

[1] " Praeclarique viri tecum de Montemorenci,
 Quos eduxisti Matthee, comesque Johannes
 Bellimontensis, et Sacrocaesaris ortum
 Et cognomen habens Stephanus—vir nomine clarus—
 Et dominans Harmis Michael, Hugoque Malaunus
 Post Campanenses acie glomerantur in una " (*Ph.* x. 470-476).

natural that they should be ranged near their neighbours of Beauvais, Ponthieu, and St. Valery.[1]

The battle was opened by the French, in spite of the fact that their array was only just being completed by the arrival of the infantry at the moment of contact. The intention of the Imperialists had been to make a converging attack on the French centre: while Otto charged it in front, Reginald of Boulogne and Ferdinand of Flanders, with the right centre and left centre of the allied host, were to have closed in upon it from the sides.[2] But before they had advanced a step, the warlike Bishop of Senlis had made the first move. He sent out from the right wing—where he seems to have taken charge of the general conduct of affairs—three hundred mounted sergeants belonging to the Abbey of St. Medard by Soissons, bidding them ride at the Flemish knights in front of them, and endeavour to provoke

[1] General Köhler, who has devoted much attention to Bouvines, and from whom I have taken one or two useful points, thinks that both hosts were ranged in three lines, one behind the other. I confess that I cannot find any evidence of weight in favour of the idea. It certainly cannot be constructed from William le Breton's long and minute accounts of the battle in the *Philippeis* and the continuation of Ricord. If some other chroniclers seem to allude to such an order, they are writers who from their whole account show that they have no grasp or intelligent knowledge of the fight (*e.g.* Aegidius Aureae-Vallis and Wendover). It is incredible that William should have written so many pages on the battle and not told us of the three ranks if they had existed. Moreover, to get enough mounted men to make three whole lines, each of fair depth, extending over two thousand yards of front in the French army, is impossible. If the lines were six deep (and we know from G. le Breton, 286, that the array was *valde densa*), each must have contained twelve thousand men, and the whole army therefore thirty-six thousand horse, or, allowing for intervals (which probably did not exist to any appreciable extent), more than twenty-five thousand. To get his three lines in the right French wing, General Köhler has to directly contradict William, who was actually present. The *Philippeis*, x. 470-476, says that Montmorency, Beaumont, Sancerre, Harmes, and Malaunay "acie glomerantur" in una post Campanenses." The general, however, puts Sancerre and Beaumont in his first line, and Montmorency in his second (*Kriegsgeschichte*, i. 140). Moreover, the whole tactics of the field are against his idea. How could individual knights like St. Pol and Melun (see p. 472) have cut their way through the front Flemish line, taken a turn around its rear, and cut their way back at another point, if a second line had been waiting behind the first to catch them? It is quite true that there were three-line battles in the thirteenth century, *e.g.* Benevento, but Bouvines was not one of them. Curiously enough, of the two arrays from William of Tyre, which the general quotes as parallel to Bouvines in i. 137, one (Ascalon) was a march order, not a battle order, and the other William has entirely muddled.

[2] "Iste comes [Reginald of Boulogne] et Ferrandus et imperator ipse, sicut postea didicimus a captivis, juraverunt quod ad aciem regis Philippi aliis omnibus neglectis progrederentur; et quousque ad illum pervenirent non retorquerent habenas. . . . Ferrandus voluit et incepit ire ad illum, sed non potuit, quia interclusa fuit via a Campanensibus" (G. le Breton, p. 286).

them into an encounter which would break the uniformity of the Imperialist line and prepare the way for a general movement of the French right. The Flemings, indignant at being charged by mere sergeants, would not spur to meet them, but received them at a standstill. Stabbing at the horses of their assailants, they dismounted most of them in a few minutes and drove them off. Then they began to advance, their leaders, Walter of Ghistelles and Baldwin Buridan of Furnes, shouting to them "to think upon their ladies" as if they were in a tournament.[1] The knights of Champagne who had followed in support of the three hundred sergeants were the first to come into collision with the Flemings, but soon the fight spread down the line, and all the other divisions of the French right wing became engaged with the adversaries in their immediate front. For a long time a confused cavalry fight raged all along this part of the line of battle. The main bodies on each side kept their relative positions, but individual knights at the head of small bodies of their retainers sometimes pierced through the hostile line, came out at its rear, and then cut their way back to their friends. An infinite number of single combats took place, with which we need not concern ourselves, though they form a large part of William the Breton's tale of the battle. The whole encounter must have borne a great resemblance to a vast tourney — individual knights fought till they were tired, fell back awhile to take breath, and then returned to the mêlée.[2] It was a long time before either side obtained a marked advantage, and meanwhile more decisive fighting was in progress in the centre.

The infantry of the French communes had only just had time to get into line in front of the king and the cavalry of his centre, when the emperor moved forward with his enormous force of Flemish and German foot-soldiery. The two great masses clashed against each other, but very soon the French, less numerous and less noted as combatants on foot, gave way and scattered to the rear. The victorious Flemings, pushing the routed enemy before them, then came pressing forward against King Philip and his horsemen, the flower of the French

[1] "Galterus et Buridanus . . . reducebant militibus suarum memoriam amicarum, non aliter quam si tirocinio luderetur" (G. le Breton, p. 277).

[2] "Comes Sti. Pauli ab illa caede paululum digressus, ut qui ictibus innumeris tam sibi quam a se illatis fatigatur, aliquantulum repausavit" (*ibid.* p. 280).

noblesse. Philip met them with a desperate charge: he and his knights at once broke into the now disorderly multitude, and were practically engulfed in it. Though inflicting a dreadful slaughter on the Netherland foot-soldiery, they were borne apart and almost submerged in the weltering mass. While William des Barres and the greater part of the French knights cut their way deep among the enemy,[1] the king was caught some way behind and surrounded by a band of furious Flemings, who almost made an end of him. Though he hewed about to right and left, he was struck by a dozen pikes, and finally dragged from his horse by a soldier who caught the hook of a halberd in the chain-mail about his throat and pulled him down to the ground. Philip would have been slain but for the agility with which he regained his feet and the prompt and loyal aid brought him by the few knights who were in his immediate neighbourhood. Peter Tristan sprang from his horse and mounted his master on it; while Walo of Montigny signalled for assistance by alternately raising and lowering the banner which he bore, till a compact band of horsemen had collected round him. The French were now rending the mass of infantry in all directions, and many of the Flemings began to melt away to the rear, the men of Bruges,[2] who had been in the front line of the host, and who had therefore suffered most, taking the lead in this backward movement. The French centre, however, had still to cope with the emperor himself and the knights of Saxony, Brabant, and Limburg, who had hitherto been hidden from them by the intervening hordes of foot-soldiery.

Meanwhile, a separate combat had been taking place on the left. When Otto had advanced, the Imperialist right wing had followed suit, and Reginald of Boulogne had tried to converge upon the French centre in accordance with the original plan of battle.[3] But the Count of Dreux, who stood nearest to the centre among the various corps of the French left, closed in and

[1] "Quo viso [the defeat of the communes] milites praenominati qui erant in acie regis processerunt, rege aliquantulum post se relicto, et opposuerunt se Othoni et suis. Eis itaque praecedentibus, pedites Teutonici circumvallerunt regem et ab equo uncinis et lanceis gracilibus in terram provolvunt" (G. le Breton, p. 202 ; cf. *Philippeis*, xi. 270-280).

[2] This we get from the Flemish Chronicle *Gen. Comitum Flandriae* in Bouquet, xviii. 567.

[3] We need not pay much heed to G. le Breton's notion that Reginald turned off because at the last moment he shrank from attacking his feudal superior (p. 286) ; Dreux no doubt pushed in and blocked his way.

intercepted him. The fight then spread north-westward along the front of both armies, and Salisbury and Hugh de Boves, with John's mercenaries, engaged in a hot struggle with the Counts of Ponthieu and Auxerre, the Bishop of Beauvais, and Thomas of St. Valery. It was on this wing, curiously enough, that the French met both the weakest and the most desperate resistance that they encountered in the whole battle. On the one hand, the Count of Boulogne made the toughest and longest stand of any of the allied princes: as a rebel and a traitor he had more at stake than the rest. On the other hand, the mercenary hordes of King John made a poorer show than any other troops on the field—with the exception of the French infantry. They closed boldly enough at first, and made head against the enemy, but when their leader, William Longsword, was felled from his horse by the club of the Bishop of Beauvais and taken prisoner, they lost heart. Headed by Hugh de Boves, Longsword's second in command, they began to give ground, and finally rode off the field. Thus, though the left centre under Count Reginald held its ground, the extreme left was beaten and in flight before any other part of the Imperialist host was definitely crushed.[1] The corps of Ponthieu, St. Valery, and their neighbours in the line of battle, thus became disposable for operations in other regions of the field: we shall find them coming up in time to take part in the rout of the emperor's centre.

About the time that the allied left wing broke up, their right wing was beginning to show signs of distress. Though they had been more than once broken through, notably by charges led by the Count of St. Pol and Adam of Melun, the Flemings clung together, closed their ranks, and fought on till most of their leaders were struck down. Count Ferdinand was severely wounded in three places, cast from his horse, and captured. Walter of Ghistelles and Baldwin Buridan shared his fate. Eustace of Mechlin was slain. Seeing no hope of victory, the stubborn Netherlanders at last gave way and scattered themselves in flight. The hour was now too late to allow the French right wing to intervene in the centre; the day had already been settled in that part of the field. Moreover, as

[1] G. le Breton tells that Salisbury was pressing the Count of Dreux hard (from the flank, I suppose, as Boulogne had engaged him in front) when the Bishop of Beauvais came in to his brother's help, cast the earl down, and broke up his squadrons (*Ph.* xi. 540).

we should suppose, the victors were too fatigued for any further fighting.

We left the French centre moving forward to engage the emperor after it had cut through the mass of infantry in the allied centre. King Philip's squadrons were probably superior in number to their adversaries, but their order was broken and they themselves fatigued, while the knights of Germany and Brabant were fresh. The odds, therefore, were not unequal, and both sides fought with the most undaunted courage. The first advantage gained by the French was that the emperor himself left the field. Otto was fighting gallantly in the midst of his retinue, armed with an axe,[1] when a band of French knights headed by William des Barres threw themselves upon him, resolved to capture or slay him at all costs. Peter Mauvoisin seized his bridle, Gerard la Truie dealt him two blows, the second of which fell upon his charger and mortally wounded it. The maddened horse plunged off and fell dead a few paces to the rear. The French knights followed fast, and tried to seize the emperor, but the Saxons thronged round to defend him. Bernard of Horstmar leaped down and gave his master his own steed, on which he began to draw off to the rear. William des Barres, however, followed hotly after him, and was again grasping at his helm when a knot of Saxons closed upon him, stabbed his horse, and forced him to give up the pursuit. Sorely bruised, and dazed by the imminent peril he had gone through, Otto did not turn back when he was safe, but rode off the field accompanied by three knights only;[2] he took no further thought of the Imperial standard which he was deserting nor of the brave vassals whom he left behind, but did not draw rein till he reached Valenciennes.

Otto's flight sorely discouraged his knights. The Saxons and Westphalians fought gallantly to cover his retreat, but the Netherlanders soon began to melt off to the rear. The Duke of Brabant, whose heart was not whole in his suzerain's cause (we have seen him sending treacherous messages to King Philip[3]), was one of the first to fly. The battle indeed was now obviously lost, for troops from the French left wing were coming in to the aid of the centre. William des Barres, whom we have

[1] *Philippeis*, xi. 354.
[2] Andreas Marchianensis in Bouquet, xviii. 558.
[3] See p. 466.

left pressing far in among the Germans in pursuit of the emperor, was saved from imminent capture by the arrival of Thomas of St. Valery,[1] who had pushed in with his fifty knights to aid the king, after taking his part in the rout of Boves and Salisbury. We cannot doubt that other corps from the victorious left must have come up at the same time. It is probably their arrival which accounts for the fact that almost all the German knights of Otto's corps, who fought on after the Netherlandish dukes had fled, were taken prisoners. St. Valery and his companions no doubt arrived upon the right rear of the Imperialists, and so cut them off from their retreat. Count Otto of Tecklenburg, Count Conrad of Dortmund, a third noble in whose odd name we seem to recognise a Raugraf from the middle Rhine,[2] Bernard of Horstmar, Gerard of Randerode, and all the leaders of the emperor's personal following, were taken captive.

Thus the battle ended in the centre, but there was one point at which it was still raging. Reginald of Boulogne had not fled when Hugh of Boves and the rest of the Imperialist right wing gave way, but, cursing Hugh as a coward, had determined to fight on to the last. He formed a corps of seven hundred Brabançon mercenary foot-soldiers into a circle,[3] and took refuge in it with a small body of knights of his own personal following. Repeatedly charging out from his stronghold, he kept in check the Counts of Dreux and Auxerre and the other corps in the French line which were opposite to him. Their repeated onslaughts could not break the circle of pikes in which he took refuge when he wished for a breathing-space, for the Brabançons stabbed the horses of the French and kept them at bay by the length of their weapons.

[1] G. le Breton, p. 285, and *Philippeis*, xi. 510.

[2] "Comes Pilosus," the hairy count, probably a mistranslation of Raugraf. He is mentioned repeatedly by the *Philippeis*, but the author says (x. 400) that he came from the land where Meuse and Rhine join, and dwelt near Trajectum (Utrecht). There were no Raugraves there, so possibly G. le Breton had confused Utrecht with Trier, and the Meuse with the Moselle.

[3] Were these Brabançons part of Reginald's original command? If so, there were infantry in the Imperialist right wing, of which we get no other sign. The way in which they are spoken of certainly seems to imply that they were under Reginald's command. Nevertheless, I am inclined to suspect that they were really part of the right flank of the Imperialist centre, and that the count called them in to him when the rest of the centre and of the left broke up and fled. Being part of John's mercenaries, they would know him, and would have been previously under his orders.

It was only after the whole of the rest of Otto's army had been dispersed that the chivalric feats of Count Reginald were brought to an end. King Philip concentrated against him the overwhelming force of three thousand mounted sergeants, giving charge of the operation to the Count of Ponthieu and Thomas of Valery. They, charging the circle on all sides simultaneously, at last succeeded in breaking it up. The Brabançons were cut to pieces, and the Count of Boulogne dragged from his horse and taken prisoner, fighting to the last.[1]

So ended this great pitched battle, "durissima pugna sed non longa," as one chronicler calls it.[2] The whole of the fighting had probably been comprised in a space of not more than three hours. The loss of life among the infantry of both sides had been heavy, but the knights had suffered little : their impenetrable armour had saved them—

> "Tot ferri sua membra plicis, tot quisque patenis
> Pectora, tot coriis tot gambesonibus armant—
> Sic magis attenti sunt se munire moderni ! " [3]

It would seem that about a hundred and seventy knights had fallen on the emperor's side—a very moderate figure considering the crushing nature of the defeat.[4] The really important feature of the victory was the number of the prisoners of importance—five counts[5] (Flanders, Boulogne, Salisbury, Dortmund, and Tecklenburg) and a hundred and thirty-one knights, of whom twenty-five were barons bearing a banner.[6] The French loss in cavalry was very small, though we can hardly believe that it amounted to no more than three knights, as some chroniclers allege. The most important personage who had fallen on their side was Stephen de Longchamp, a gallant baron who had fought in the central corps under the king's own eye. He was slain by a thrust which entered the eye-slit of his helm and pierced his brain.

[1] Cf. *Philippeis*, xi. 614, with Aeg. de Roya in Bouquet, xix. 258.

[2] John of Ypres in Bouquet, xviii. 606.

[3] *Philippeis*, xi. 127.

[4] See M. Delpech's remarks in p. 169 of *Tactique*, vol. i. The Chronicle of Mailros, which goes into figures, is, like other chronicles on this side of the water, not to be trusted for the account of Bouvines.

[5] Six if the "Comes Pilosus" be counted, but we cannot satisfactorily identify him.

[6] The official list of the prisoners is in Bouquet, xvii. 101, etc.

Bouvines is a very typical battle for the display of thirteenth-century tactics. We note that there was little manœuvring on either side when the fight had once begun : each corps fought its own enemy and concerned itself little with its neighbours. The three engagements of the centre and the two wings went on quite separately, and the only influence of one of them on another that we can trace is the participation, late in the day, of Thomas of St. Valery and his fellows of the French left in the attack on the allied centre. Upon the wings the engagement seems to have resembled a colossal tilting-match, where the combatants closed, fought, withdrew, and after a rest came back to the charge. On neither side did the infantry much distinguish itself. The French foot were broken irretrievably and left the field. The Imperialist foot, disordered by their first success, allowed themselves to be pierced and ridden down. Only Reginald of Boulogne showed that he knew how to handle the two arms in unison : his charges out from his circle of pikemen remind us of Richard Coeur de Lion's [1] exploits at Jaffa. It is to be noted, too, that his tactics, while effective enough, were only suited for a leader taking the defensive : by adopting them he sacrificed the power to advance or retreat, and did no more than detain in front of him a certain amount of hostile troops. Such action could have only an indirect effect on the fate of the battle.

If we seek the ultimate causes of the French victory, we must cite, firstly, the misconduct of the mercenary cavalry in the allied right wing ; secondly, the numerical superiority of the French in knights, which far more than compensated their weakness in sergeants and infantry ; thirdly, the accident which removed the emperor from the field ; fourthly, the slackness and perhaps treachery of the Duke of Brabant.

We cannot ascribe much influence on the fate of the day to the French king. Philip showed courage and decision in offering battle ; a further retreat would inevitably have led to the destruction of his rearguard, and the chances of an engagement were far preferable to such a disaster. But during the fighting we look in vain for proof that he exercised any sort of command over his host. He did nothing more than conduct into battle the cavalry of the centre : he bore himself as a good knight, not as a general. Bishop Garin was the only

[1] See p. 317.

Frenchman on the field who seems to have possessed a military eye.

On the side of the allies the conduct of the battle was even worse. They started with a general plan for overwhelming the French centre, but, when it was frustrated, each division settled down to fight its own battle in complete disregard of its neighbours. The emperor exercised no general control whatever. It is evident that during the opening moments of the battle, while his infantry were engrossing the whole attention of the French centre, he and his knights sat idle, and paid no attention to the fight on the wings. If they were not required on the left, they certainly might have done something to repair Salisbury's disaster on the right. But apparently Otto thought of nothing but staying by his banner and keeping his central post: of the true uses of a cavalry reserve he showed no appreciation whatever.

It is curious, indeed, to note that neither side fought with any real reserve whatever, though the numbers on the field were so great that it would have been easy to provide one. Otto should have told off some of his solid Flemish infantry for the purpose; properly placed, that would have enabled the knights to rally. But he chose to array the whole of his foot-soldiery in the front line and to endeavour to execute an offensive move-ment with them—a task which the heavy mass was incapable of carrying out without losing its formation. Philip, on the other hand, might have spared some of his numerous cavalry to form a reserve; even a small body of fresh knights could have settled the encounter on the right between the Flemings and the Champenois and Burgundians, for the combatants there were so equally balanced that they fought on for nearly three hours before any definite result was reached. As a matter of fact, the only troops in Philip's host which did more than dispose of the enemy in their immediate front were the contingents of Ponthieu and St. Valery on the left wing, who very wisely turned to aid their comrades when they had disposed of Salisbury's mercenaries.

That the thirteenth century could show far better general-ship than either side displayed at Bouvines we have already seen, when observing the elder Montfort at Muret and his son at Lewes.

The next two fights with which we have to deal, both victories

won by a grandson of Philip Augustus, will give us a much higher notion of the development of mediæval cavalry tactics.

Battle of Benevento, February 26, 1266.

The interminable struggle between the Papacy and the house of Hohenstaufen was still dragging on in the third quarter of the thirteenth century. Frederic II. was dead, as was also his heir Conrad, but his policy was continued and his line still represented by his bastard son, King Manfred, who after twelve years of constant struggle still held the kingdom of the Two Sicilies (1254–65). The Papacy had raised up against him a succession of enemies, but he had hitherto beaten them all off. In 1265 the newly-elected Pope Clement IV. enlisted in his cause Charles of Anjou, the able and unscrupulous brother of St. Louis. Not contented with his own Angevin county, nor with the wealthy Provençal dominions which had come to him with his wife, Charles accepted the offer of the Sicilian crown, and undertook to drive out the bastard. His own resources would not have sufficed for the task, but the Pope offered him ample grants of money, and with it he hired mercenaries from all parts of France and the Low Countries. Pursuing the same methods as William the Conqueror had adopted just two hundred years earlier, he promised high pay and grants of fiefs in Italy to every adventurer, gentle or simple, who would follow him. Clement aided him by declaring the expedition a crusade, and authorising all who took part in it to wear a red and white cross as a symbol of their profession.

In May 1265 Charles arrived in Rome with about a thousand knights of his personal following. He came himself by sea, but the great bulk of the adventurers had resolved to march by land. They mustered at Lyons under the conduct of Giles le Brun, the Constable of France, and Robert the son of the Count of Flanders. The army was much belated: while Charles lay waiting for it in Rome through the months of the summer, and there exhausted all the Pope's money, his confederates started late in the autumn, and crossed the Alps only just in time to avoid being stopped by the snows. They passed through Lombardy in November, numbering, according to the best accounts, about six thousand mounted combatants, six hundred horse-arbalesters, and twenty thousand foot of very

varying quality, about half of which was composed of cross-bowmen,[1]

Manfred had hoped to hinder or perhaps to wreck the crusade by arming against it the Ghibellines of Northern Italy. But the French brushed them aside with ease, and, passing by Mantua, Bologna, and Ancona, crossed the Apennines, descended the valley of the Tiber, and joined their employer at Rome on January 12, 1266.

Charles had long exhausted the Pope's gratuities, and was at such a pitch of destitution that he was compelled to hurry on his army at once, in the depth of the winter, that he might at all costs get them into hostile territory, where they could live at free quarters. He only allowed them eight days to recruit themselves, and then marched straight on Naples by the Latin way.

King Manfred had taken his post at Capua behind the Volturno with the bulk of his troops, but till he was certain of his adversary's route he was obliged to keep detachments watching various roads into his kingdom. One of these, pushed forward to the strong position of San Germano on the Garigliano,—the same ground on which Gonsalvo de Cordova and the Marquis of Saluzzo fought in 1504,—came into contact with the invaders the moment they left the Papal States, and was badly beaten on the 9th of February. The result of this skirmish was appalling, from Manfred's point of view; he knew that many of his subjects were disloyal, but he was not prepared to see the whole countryside from San Germano to the gates of his own camp instantly pass over to the enemy.[2] This treachery must have filled him with dark thoughts as to the probable result of the oncoming battle.

Charles, meanwhile, learning that his adversary lay in great force behind the Volturno, and that the bridge by Capua was strongly fortified, resolved not to assault him in front, but to turn his position by a flank march. Striking off into the Samnite Apennines, he took the difficult road which passes by Telesia and Vitolano into the valley of the Calore near Benevento. From the last-named city he would be in a

[1] *Annales Januenses* in Pertz, Mon. Germ. xviii.
[2] Letter of the Provençal knight Hugues de Baux in Andreas Ungarus in Bouquet, xxi.: "Non paucis comitibus militibus et baronibus Manfrido relicto, ad eundem illustrem regem adfluentibus."

31

position to reach Naples without having to force the line of the Volturno. Charles had, however, utterly miscalculated the dangers of the rough defiles which he had to pass. In February they were almost impassable on account of the mountain torrents, and the army had to abandon all its vehicles, and take forward only such food as the horses could carry. Many beasts of burden and a considerable number of the chargers perished; at the end of the march flour ran short, and the French were compelled to begin eating the flesh of their foundered pack-animals.[1] Nor was this all; on descending from the passes and nearing Benevento, they found the army of Manfred waiting for them in good order on the other side of the Calore. The King of Sicily had received early news of the invaders' flank march, and, having a good high-road to follow, arrived at the point of danger before Charles had been able to extricate himself from the mountains.

The French were now in a most dangerous position: the road was barred by the swollen river, which could be passed only by the well-guarded bridge of Benevento. Men and horses were exhausted, and there were hardly any provisions left in the camp. If Manfred had been content to wait a few days, the invaders must have surrendered or died of hunger.[2] But the king was not in a mood to wait; he had just received the last reinforcements of trustworthy troops that he could reckon upon—a body of eight hundred German mercenary horse.[3] He knew that every day that he delayed would give time for more of the Neapolitan barons to desert him. He believed the condition of the enemy to be even more desperate than it actually was.[4] Perhaps, in the spirit of the mediaeval knight, he preferred to beat his adversary by the sword rather than by hunger. Whatever were the reasons that weighed most with him, it is at any rate certain that, on February 26, he bade his army cross the Calore and advance into the plain on the

[1] "Per necessità molti convenne vivere di carne di cavalli, e loro cavalli di torsi, senza biada" (Ricordano Malaspina in Muratori, viii. 1003).

[2] "Si fosse solamente atteso uno dì, o due, lo Re Carlo e sua gente erano morti o presi, senza colpo di spada, per difetto di vivande di loro e di loro cavalli" (Ricordano Malaspina in Muratori, viii. 1002).

[3] Letter of Hugues de Baux in Andreas Ungarus.

[4] The Italian chronicler Saba Malaspina makes Manfred in his oration to his army say that the French chargers "extenuati prae labore nimio parum valent" (in Muratori, viii. 824).

farther side, toward the French camp, which lay on the opposite hillside.

Manfred's army was composed of very heterogeneous elements. The best part of it consisted of his German mercenary horse, twelve hundred strong: these troops, as the chroniclers note, were armed with the plate armour which was just beginning to come into fashion, and not with the usual mail-shirt and gambeson of the thirteenth century. As trustworthy as the Germans, but not so formidable in the hour of battle, were his Saracen horse and foot; the Sicilian Moslems, whom Frederic II. had transplanted to Luceria and Nocera, had always served him and his son with great fidelity. Their infantry were composed of archers not provided with any defensive arms; of cavalry there were three hundred or four hundred light horse. Manfred had also a considerable body of mercenary horsemen, Lombards and Tuscans for the most part: they are estimated at a thousand strong. Lastly, there were his born subjects, the barons of the Two Sicilies—perhaps a thousand knights and squires in sum. Their ranks were full of traitors, and their master was aware of the fact.[1]

Manfred sent his Saracen foot-archers forward to begin the battle. After them followed his cavalry in three divisions, one behind the other. The first was composed of the twelve hundred Germans, under the king's cousin, Giordano Lancia, Count of San Severino. In the second were the thousand Italian mercenaries under Galvano Lancia, Prince of Salerno, the king's uncle. In the third Manfred himself led the faithful Saracens, combined with untrustworthy barons of the Regno. About his person were his two treacherous brothers-in-law, Richard Count of Caserta, and Thomas Count of Acerra, the Count Malecta his High Chamberlain, as also a Roman patrician, Tibaldo dei Annibali. To the last named, one of his most trusted friends, Manfred gave his royal armour and surcoat—preferring, like Henry of Brabant at Steppes and Henry of England at Shrewsbury, not to attract too much notice in the mêlée.

On seeing the enemy preparing to cross the bridge, Charles

[1] The numbers from Ricordano Malaspina, M. viii. 1003, and Saba Malaspina, p. 826. The French views on the force of their adversaries are of course less valuable; they exaggerate the three thousand six hundred horse into five thousand (Hugues de Baux).

of Anjou, overjoyed at the unexpected advantage which Manfred was placing in his hands, drew up his army outside his camp and prepared to descend into the plain. Like his adversary, he drew up three successive corps of cavalry.[1] The first was mainly composed of knights and sergeants from his own Provençal dominions : they numbered nine hundred, and were led by Hugh Count of Mirepoix, Marshal of France, and Philip Count of Montfort. In the second, which Charles took under his personal orders, were a thousand knights and men-at-arms from Southern and Central France. Their chiefs were the Count of Vendôme, the Bishop of Auxerre, Guy de Montfort, Peter de Beaumont, and Guy de Mello. The third corps was composed of seven hundred Flemings and Northern French ; it was commanded by the Constable Giles le Brun and Robert of Flanders. In addition, the invaders numbered four hundred Italian men-at-arms of the Guelf faction, led by the Florentine Guido Guerra : it is not easy to make out exactly where they stood ; apparently they were not with the reserve, but struck in with the second line at the moment of contact.

Charles ordered each of his men-at-arms to have behind him a couple of foot-soldiers, whose duty it would be to aid those of the horsemen who were dismounted, and to slay those of the enemy who were overthrown. The rest of the infantry, among whom the arbalesters were very numerous, were thrown out in front of the line, to skirmish with the Saracen foot-soldiery of Manfred's host.

It will be noted that Charles had the enormous advantage of leading an army which was practically homogeneous ; save the few Italians, all were vassals of the French or Provençal crowns, and fairly equal to each other in military worth. We are somewhat surprised to see the smallness of the whole array : six thousand French horse had crossed the Alps, a thousand had been at Rome with Charles, and the Italian allies had sent a contingent. Yet we only find three thousand men-at-arms in the battle line ; even remembering that garrisons had been left behind in the conquered places on the Garigliano, we must still conclude that the army had suffered severely from the wintry weather in its march down Italy, and especially in the defiles between San Germano and Benevento.

[1] This order is arrived at by comparing Andreas Ungarus, Primatus, and Ricordano Malaspina, who does not quite agree with the others.

PLATE XV.

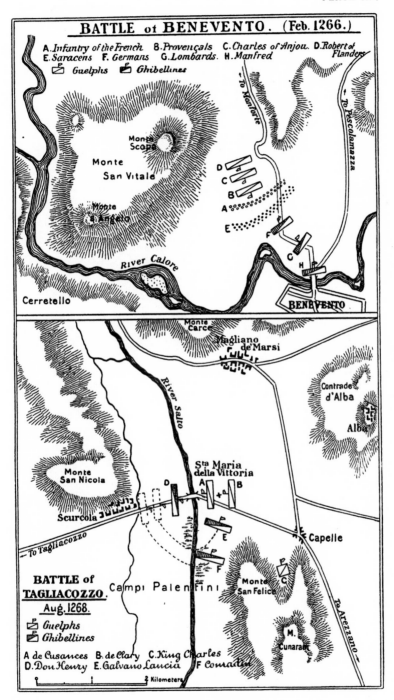

BATTLE of BENEVENTO. **(Feb. 1266.)**

A. *Infantry of the French* B. *Provençals* C. *Charles of Anjou.* D. *Robert of Flanders*
E. *Saracens* F. *Germans* G. *Lombards.* H. *Manfred*

Guelphs Ghibellines

Monte Scope
Monte San Vitale
Monte S. Angelo
River Calore
Cerretello
To Montorte
To Pescolamazza
BENEVENTO

BATTLE of TAGLIACOZZO.
Aug. 1268.
Guelphs
Ghibellines

A *de Cusances* B. *de Clary* C. *King Charles*
D. *Don Henry* E. *Galvano Lancia* F. *Conradin*

Monte Carce
Tagliano de'Marsi
River Salto
Contrade d'Alba
Alba
Monte San Nicola
Sta Maria della Vittoria
Scurcola
To Tagliacozzo
Capelle
Campi Palentini
Monte San Felice
M. Cunaratt
To Arezzano
2 Kilometers

The battle opened with a futile infantry skirmish which had no effect on the fortune of the day, and only serves to show the low esteem in which both sides held their foot-soldiery. It is characteristic to find that only one of the chroniclers who describe the fight, Saba Malaspina, thinks it worth while to narrate it.

The Saracen archers, as he tells the tale, ran out in front of Manfred's army before the command had been given them, intending to harass the front line of French horse, and so to prepare the way for the charge of the Germans. Charles of Anjou threw out against them his *ribaulds*, the half-armed irregular infantry of his host, and also no doubt his arbalesters. The Saracens had the best of the skirmish; the French were shot down by hundreds, and gave way. To save them, Mirepoix and De Montfort directed a body of sergeants from the first line of horse to charge the Saracens.[1] This they did with great effect, and sent the whole rout of Infidels flying; meanwhile, the German horse moved up to attack the sergeants, and the real battle began. There is no mention of the infantry on either side during the rest of the fighting; apparently they had done all that was expected of them, and were relegated to the rear.

When the Germans met the Provençal knights and sergeants of Anjou's first line, they had at first the advantage over them. They were heavier men on heavier horses, and their armour of plate was quite impenetrable to the strokes of their opponents. Advancing at a slow trot,[2] and keeping their order so close that no one was able to force his way into their ranks, they slowly but effectively pushed the Provençals before them.

Seeing his front corps about to break up, Charles thought it time to bring on his second line to its aid. Accordingly he charged with all his French chivalry; apparently also his four hundred Italian knights joined in the attack. Assailed now by double their own force, the Germans still held out gallantly, and

[1] Saba Malaspina says that these sergeants were a thousand strong, p. 826: "Irruunt igitur in Saracenos praedictos servientes equites, numero forte mille." This is impossible, as the whole of Mirepoix's corps was only nine hundred strong, and it must of course have contained many knights beside these sergeants.

[2] "Moverunt se aliquantulum, planis tamen passibus, adversus nos" (Andreas Ungarus, 575). "Les anemis, par malice, s'estoient si estroitement joins ensamble, que ils ne pouvaient estre perciés si n'estoit par fine force" (Primatus in Bouquet, xx. 28.

it appeared at first as if they were about to drive the foe back. They seemed invulnerable in their double harness to the French swords. But the enemy ere long noted the weak point of their equipment; plate armour was still in its infancy, and the pieces were not yet protected by the scientific superposition of part to part, which was perfected in the next century. Some sharp-eyed French knight noted that as the Germans lifted their great swords to strike, an undefended opening was visible at their armpits. A cry ran down the Crusaders' ranks to "give point" (à l'estoc), and stab under the arm. Closing in, and wedging themselves between the somewhat shaken ranks of Manfred's men-at-arms, they grappled with them, and thrust their blades, which were shorter and more acutely pointed than those of their enemies, into the undefended gaps. A considerable number of the Germans were mortally wounded in a few minutes, their close order was broken, and when once they were thrust apart, the superior numbers of the French overwhelmed them; the whole corps was practically annihilated.

We are at a loss to know why Manfred's second line did not come up to aid the Germans at the same moment that Charles of Anjou threw himself into the fight to assist the failing Provençals. It is possible that the long time spent in passing the bridge of Benevento on a narrow front had retarded Manfred's men, and caused a very wide space to arise between each of his corps. Of intentional slackness we cannot suspect Galvano Lancia, the king's uncle and faithful adherent, who was in command of the Lombard and Tuscan mercenaries which formed this second division.

His late arrival, however, was fatal to his nephew's cause. The Germans had been cut to pieces before he came up, and the French first and second corps outnumbered him by more than two to one. While some charged the Lombards in front, others swept round their flanks and beset them from the rear. Shaken in spirit by the sight of the fate of the Germans, "who were to have been to them as a wall of defence,"[2] Galvano's

[1] Primatus in Bouquet, xx. 28: "Les François boutoient les espées grelles et agiles sous les esselles d'iceulx, ou ils apparoient tous désarmés, et les transperçoient si tost comme il levoient les bras pour ferir, et leur boutoient les espées parmi les entrailles." Clericus Parisiensis in Mon. Germ. xxvi. 582: "Clamatum est a parte nostra quod in hoste de ensibus percuterent, dextc."

[2] "Esquels [Alemans] Mainfroy se fioit moult, et avoit fait aussi comme ung mur pardevant son ost" (William de Nangis in Bouquet, xx. 425).

riders made a very poor resistance. Seeing themselves about
to be surrounded, they broke, and those who could galloped off
the field; the majority were slain or taken prisoners.
King Manfred was now left alone on the plain with his
third line, a force formidable in numbers, but not in spirit.
Apparently he was as far behind his uncle as the latter had
been behind the Germans,—at any rate, we are not told that he
made any attempt to help Galvano. Charles even found time
to bring up his fresh third corps of Flemings and Picards, and
to array it in front before the clash with Manfred's troops came
on.[1] In the moment before, the final charge, the latent treachery
among the Neapolitan nobles broke out; the king's two brothers-
in-law, the Counts of Caserta and Acerra, suddenly swerved off
and left the field with their retainers. Many other barons
followed them; their master had to choose between death or
instant flight. His undaunted spirit led him to take the first
alternative: closing up the trusty few who were left with him,
knights of his personal retinue and Saracen horsemen, he rode
straight into the midst of the enemy, and found the death that
he sought.[2] At his side, there fell his friend, Tibaldo dei
Annibali, to whom the royal surcoat proved fatal, and other
faithful retainers. The French gave little quarter: it will be
remembered that Charles had placed *ribaulds* behind his cavalry,
with orders to slay the wounded and dismounted knights of the
enemy. Hence it is quite possible that the frightful loss of
three thousand men out of three thousand six hundred, which
trustworthy chroniclers ascribe to Manfred's army, may be not
much exaggerated. The river was at the backs of the fugitives,
and only the bridge was safe; those who tried to swim the
flooded Calore in their heavy mail were mostly drowned.[3] Of
the few prisoners taken, the most notable were Giordano Lancia
and his cousin, Count Bartolommeo. We need not pay much
attention to the assertion of the best chronicles on the French
side that only one knight among the victors perished; the loss
in the Provençal corps must have been very heavy, even if the
second and third lines came off with light damage.

[1] Primatus in Bouquet, xx. 29.
[2] "Sed cum nonnulli de Regno proditorie abscessissent, Manfredus cum reliquis mori potius eligens, ruit in medium, pugnat, percutit, percutitur et expugnatur, proh dolor! a suis sic perditus." (Saba Malaspina in Muratori, viii. 827).
[3] *Ibid.* 828.

The main point worthy of notice in this interesting fight is that Charles of Anjou showed himself perfectly able to manage his cavalry, supporting one corps by another at the critical moment whenever it was needed. Manfred's divisions, on the other hand, gave each other absolutely no assistance; the only explanation for the extraordinary want of co-operation shown in his host is the time which the defile over the bridge of Benevento must have taken. This throws us back on to the king's original fault—that of crossing the Calore at all. Nothing could be more unwise than to pass a narrow defile and place a river behind him when he had to deal with a formidable and desperate enemy. But, granting that the battle must be delivered, it was necessary at all costs to keep the infantry and the Germans close to the bridge, and not to allow them to advance heedlessly into the plain, while the rear divisions were still threading their way over the passage. If it be true that the Saracens advanced without orders,[1] and the Germans followed, equally without orders, to support them, we must deduct somewhat from Manfred's faults as a tactician, by adding to those which he showed as a disciplinarian.

Battle of Tagliacozzo, August 23, 1268.

Charles of Anjou had worn for eighteen uneasy months the crown which he had won at Benevento, when he was called upon to defend it from the last male heir of the house of Hohenstaufen. Conradin, the young grandson of Frederic II. and the nephew of Manfred, crossed the Alps in October 1277 with a considerable German army, and was received by the Ghibelline town of Verona. About the same time, Don Henry, brother of the King of Castile, and Galvano Lancia, whom we have already heard of at Benevento, seized Rome at the head of the Ghibellines of Central Italy.

Charles had advanced into Tuscany, prepared to fall upon Rome, or to defend the passage of the Apennines against Conradin, when he was called southward by the imminent danger of losing his own realm. He had made himself detested by all the nobles of the Two Sicilies, who now bitterly regretted their treachery to Manfred. An alien king who placed all power and authority in the hands of his Provençal and French satellites, was unbearable to them. Sicily rose in arms in the

[1] As Saba Malaspina says.

autumn of 1267, and the royal governors were constrained to seek refuge in Messina and other strongholds; during the winter the Saracens of the mainland followed the example of Sicily, and fortified themselves in their stronghold of Luceria. The danger of a general insurrection in all the provinces of the Regno was so great that Charles was constrained to quit Tuscany and hurry home. His departure was hastened by the defeat of part of his host which had been sent to make a dash at Rome; it was badly beaten by Henry of Castile, with the loss of a thousand men.

While Charles lay in Apulia beleaguering Luceria, the young heir of the Hohenstaufens pushed down Italy, and on the 24th of July 1268 entered Rome and joined his ally, the Castilian prince. The Ghibelline party seemed to have triumphed all along the line, and the exiled nobles of that faction from all parts of the peninsula flocked into Rome to join the army which was first to make an end of Charles of Anjou, and then to destroy the minor champions of the Guelf cause. Some six thousand knights were soon arrayed round Conradin's eagle banner: the nucleus consisted of the Germans who had crossed the Alps with him, but the large majority of the host was composed of Italian contingents; Henry of Castile had also with him several hundred Spanish men-at-arms.

Two main lines present themselves for the invasion of the Regno to an army lying in Rome. The obvious route to choose is that along the Latin way, which Charles of Anjou had followed during the first part of the campaign of 1266. It runs direct to Naples through Latium over the passages of the rivers Garigliano and Volturno. This was the road which the King of Sicily expected his adversary to take; he therefore hurried back from Apulia and concentrated his forces north of the bridge of Ceprano on the Garigliano, just beyond the frontiers of his realm.

The leaders of Conradin's host, however, were resolved to adopt the other route. The prince himself was a boy of fifteen, and the leading of his army was really in the hands of Don Henry of Castile and the veteran Galvano Lancia. Being assured of the presence of the enemy on the direct route to Naples, they determined to elude him by marching up the Anio along the Via Valeria and entering the Abruzzi. From thence it was their intention to pass southward by Solmona

into Apulia, and join their friends the Saracen insurgents.[1] There can be no doubt that the plan was faulty in every respect; it can only have proceeded from an insufficient geographical knowledge: the difficulties of the route across the side-spurs of the Apennines which cover the whole province of the Abruzzi are enormous. Moreover, an adversary starting from Ceprano or its neighbourhood, and using reasonable diligence, can employ interior lines of communication, and be certain of intercepting somewhere in the Abruzzi, where the roads are few, any army marching from Rome in the direction of Apulia. It would seem, however, that Conradin's advisers were unwise enough to dream that they would get many days' start of King Charles: they should have remembered that the whole Guelf party in Rome were acting as his spies, and that information as to their march was bound to reach him with short delay. As a matter of fact, the Ghibelline army started from Rome on August 18, and, making good speed (for it was entirely composed of horse) passed up the valley of the Anio by Tivoli and Vicovaro. It crossed the frontier of the kingdom of the Two Sicilies near Carseoli, and, passing the town of Tagliacozzo, which has given its name to the subsequent battle, emerged from the passes into the upland plains of the ancient Marsian territory, the Campi Palentini. On the night of the 21st the Ghibellines encamped at Scurcola; starting next morning to pursue their march, their vanguard suddenly came full tilt against the advanced troops of the army of King Charles.

Conradin's men had not lingered on the way: they had covered over sixty miles in four days; but Charles of Anjou had been even more prompt. Breaking up his position on the road covering Campania, he had struck across the Apennines, probably by Sora, moving parallel with his enemy's line of advance [2] (it is about forty-five miles from Ceprano to Avezzano). As he had a somewhat shorter distance to cover, and made

[1] Contemporary letter of Charles of Anjou to the Pavians: "Dicti hostes per Sculculae partes ingressi sperabant libere transiti via recta descendere et pervenire Solmonam et exinde ire Luceriam."

[2] Charles in his letter to the Pope describes his movements thus: "Ego ipse de passu in passum per tres dies totidemque noctes sequens et prosequens . . . de pratis, Ovinuli secus lacum Fucini et villa Aneceni aciebus instructis, divina me gratia comitante, demum ad quemdam collem prope Albam perveni." Here he came in sight of the enemy.

even greater speed, he had succeeded in getting across Conradin's line of advance. It was now as necessary for the invader to fight as if he had taken the straight and easy road by Campania. All the exertions of the long and hasty flank march had been purely lost pains.

When the two vanguards clashed together, that of the Ghibellines gave ground and retired on its main body. Charles did not pursue, and left the river Salto between him and the enemy. His army was utterly tired out by its forced march, and he did not intend to fight till next day.

The respective positions of Conradin and Charles were now exactly the same as those of Charles and Manfred on the day before the battle of Benevento. In each case the invader had executed a flank march; but, having completed his movement, had found the enemy still in his front and covered by a river. Conradin, however, had several advantages which his rival had not enjoyed in 1266. The weather was better,—August being the month, not February,—his army was not suffering from the lack of supplies which afflicted the French at Benevento, the Salto is not such a broad and unfordable stream as the Calore, and (most important of all) the Ghibelline army outnumbered that of the new king, while on the previous occasion the forces of Manfred had been somewhat superior in mere numbers to those of the invaders. It is fair to set on the other scale the fact that Charles had on both occasions the more homogeneous and loyal army, but there were no traitors like the Counts of Caserta and Acerra in Conradin's ranks.

Charles had taken warning by Manfred's disaster : he was determined not to cross the Salto in order to attack his enemy. The disadvantage of having to pass the river he left to the Ghibellines ; he was resolved to wait on the other side, to take the defensive, and to fall on the adversary when he should be disordered by the passage—if, indeed, Conradin should succeed in passing the obstacle at all.

It being reasonably certain that an engagement would take place on the 24th, the King of the Two Sicilies set to work to array his forces. He formed the usual three " battles," and placed them one behind another, as he had done at Benevento. But there was one essential change made upon this occasion : he resolved to conceal his reserve and only to display two corps to the enemy. In so doing he is said to have acted on the

advice of a veteran knight, Alard of St. Valery, who had just
joined him on his return from Syria. The device was not
unknown in Europe—we have seen it practised at Thielt as
early as 1128,—but it is probable that Alard had learned it
from the Turks and Mamelukes.

Of the three corps which Charles arrayed, the first—
composed mainly of Italian Guelfs, with a sprinkling of
Provençals—was drawn up close to the bridge of the Salto.
It was commanded by the Marshal Henry of Cusances, who
wore that day the king's surcoat, and had the royal banner
borne before him. The second, composed of French, under
John de Clary and William l'Estendard, lay some distance to
their rear in the plain. Probably it was intended to be taken
by the enemy for the reserve. But the flower of the army—
eight hundred (or a thousand) chosen knights—were concealed
in a lateral hollow of the hills which border the plain, very far
to the rear, and even behind the king's camp. The whole army
is variously stated as from three thousand to five thousand
strong; if we estimate it at four thousand we shall probably be
not far from the mark. In this case each of the first two corps
must have been more than fifteen hundred strong.

Conradin also formed his army in three divisions, one behind
the other. The first was comprised of Don Henry's Spanish
men-at-arms and the Roman Ghibellines, led by the prince him-
self. In the second were Galvano Lancia and Count Gerard
of Pisa, with the Lombard and Tuscan Ghibellines and the
Neapolitan exiles; a few Germans were arrayed among them.
But the bulk of the Transalpine contingents under Frederic
Duke of Austria formed the third or reserve corps, which
rode around Conradin's person, under the two banners of the
Imperial Eagle and the Cross. The whole army was decidedly
more numerous than that of King Charles; it is estimated at
between five and six thousand strong, so that each of the three
corps must have counted between fifteen hundred and two
thousand men-at-arms.

Advancing from their camp by Scurcola in orderly array, the
Ghibellines rode along the road towards the bridge over the
Salto, behind which the two first "battles" of the enemy were
But there was one essential change made upon this occasion.

[1] Saba Malaspina alone says that there were only two, reckoning apparently
Lancia and Henry of Castile as forming only one battle; he has the excuse that they
fought simultaneously and had a different fortune from the third corps.

visible. Henry of Castile then attempted a feint: he sent his
camp-followers forward to pitch the tents of the army close
above the river, as if he had no intention of crossing that
morning. His horsemen dismounted, but did not break their
ranks. Charles ordered a similar movement on his own side,
but was equally cautious not to allow his men-at-arms to
disperse.[1]

Suddenly, about nine o'clock, the Ghibellines sprang
simultaneously into the saddle, and rode towards the river,
hoping to find the enemy less ready than themselves. But the
trick had no success whatever; the king's army was perfectly
prepared to receive them.

The front corps of Conradin's army, or at least some part of
it, made for the bridge and attempted to cross; they were, of
course, easily held in check, by the first division of the king's
horsemen, and utterly failed to win the narrow pass.[2] But
meanwhile the rest of Henry of Castile's "battle," followed, it
would seem, by the whole of Galvano Lancia's, moved up the
stream from the bridge, and rapidly made their way to a spot
where a broad reach of water, spreading out between gently
sloping banks seemed to indicate that the river was fordable.
Their expectation was not deceived; they were able to cross
the Salto without losing a man, and thus found themselves on
the enemy's bank unharmed.[3] Nor was this all: distracted by
the contest at the bridge, the king's knights had apparently
paid no attention to the turning movement. The Ghibellines
were able to come in suddenly upon their flank before either of

[1] This we get from the king's own letter to the Pope.

[2] "Et quant les anemis furent assemblés outre le fleuve, au chief du pont et
environ, et s'efforçoient de tout leur povoir venir à force parmi le pont as nos, les
nos qui estoient à l'autre rive de l'eaue au bout du pont, si gardoient l'entrée et les
boutoient forciblement el cours du fleuve " (Primatus in Bouquet, xxiii. 32).

[3] "Il descendirent au plus bas du fleuve, là ou l'eau estoit et plus plate et plus lèe,
et la ou les rives estoient rompues, et estoit là le pas accoustumé pas ou les chevaus
aloient qui passoient à gué. Et tant comme aucunz d'iceulx se combatoient encore as
nos por passer le pont et l'entente encore de nos estoit de garder le passage du pont,
tout le nombre a bien pou de celle bataille estoit passée outre parmi le gué."
(ibid.). I imagine that the Ghibellines passed the Salto above and not below the
bridge; for the Italian maps of the Government Survey show the only indications of
low banks and marshy ground south of the spot where the vanguard was fighting.
Moreover, the general direction of the flight of the routed French was towards Alba
and Aquila, which is only consistent with their southern flank being turned. If
outflanked on the north, they must have retired towards Avezzano or on the king's
reserve.

the Angevin battles had been able to change its front so as to meet them face to face. The natural result was that the Guelfs fared very badly, while Galvano Lancia was attacking the second corps in flank and rear, Henry of Castile succeeded in forcing the bridge and breaking up the Provençals and Italians of the first corps, who were naturally shaken by the arrival of a new enemy in their rear. Presently Conradin's third corps came up in good order, and, thrusting itself into the press, swept all before it. The king's then broke and fled in all directions; many of them did not draw bridle till they reached the city of Aquila, twenty miles from the field. The slaughter was terrible, for many of the Guelfs were caught between two hostile corps and could not easily escape. The Marshal Henry of Cusances was caught and promptly slain: the royal armour was fatal to him; if he had not been taken for Charles, he might have been put to ransom. De Clary and L'Estendard cut their way out of the press and succeeded in escaping to the king. Imagining that the battle was over, Henry of Castile and his men set themselves to pursue the fugitives along the road which leads to Aquila. Of the other corps, the majority dispersed to plunder the enemy's camp. Conradin was left under his banner, with the greater barons and a comparatively small following.

At this moment Charles of Anjou at last put himself in motion. He had been watching the battle from the brow of the hill behind which his reserve lay hid, and had been sorely vexed when he saw the sudden turning movement by which the enemy had passed the river. He had for a moment entertained the idea of moving forward at all costs to rescue his main body. But Alard of St. Valery bade him pause, pointing out that he was too far off to avert defeat by striking in promptly with his own reserve. He therefore took the hard but prudent decision of allowing the Ghibellines to exhaust their strength upon his two front corps before he should intervene. Few generals in ancient or modern times would have found the heart to allow the greater part of their army to be cut to pieces without striking in to aid them, for the reserve could certainly

¹ The tactics of the Ghibellines were not at all unlike those of Marshal Soult at Albuera: there, too, the assailant distracted the enemy by pressing an attack on the bridge with a fourth of his host, and then suddenly crossed the river lower down with the rest, and came unexpectedly against the hostile flank.

have disengaged them and covered their retreat. But Charles was aiming, not at an honourable retreat, but at a victory: his callous soul would have sacrificed every man of his following without scruple, if a final triumph could be thereby secured.

When, therefore, he saw Don Henry sweep off the field, and the Germans disperse; he at last gave orders to his knights to advance from the fold in the hills which had so long screened them. Trotting down the slope in close order, they made for Conradin's banners and the troops which were still gathered round them. At first the Ghibellines did not recognise them as enemies, but thought that they were part of their own men returning from the pursuit. They had just time to recognise their mistake, and to draw up in some sort of a line, when the king charged in upon them. The fight was sharp but short, for the Germans, though not lacking in courage, were fatigued by their previous exertions and imperfectly arrayed. The fresh and compact body of French knights soon broke them asunder and drove them from the field in disorder. Conradin and a large body of knights escorting his person took the road to Rome; his eagle banner fell into the hands of the enemy after its bearer had been slain. His uncle, Conrad of Antioch, was captured.

Of the many small bodies of Ghibelline horsemen who had dispersed to plunder, we have no further account; probably they took to flight when they saw Conradin's banner fall. But Charles had still to deal with the main body of the enemy's front corps, under Henry of Castile, which had gone off in pursuit of the Provençals. Some time after Charles had won his first success, the Infant and his men came in sight, returning along the hills above Alba; they were fatigued, but not in disorder. Don Henry must have been a good and cautious captain, so to collect and array his men before setting out on his return march. The French, therefore, had not before them the comparatively easy task of dispersing isolated bands dropping back from the pursuit, but had to face a solid mass of combatants ready for battle. If King Charles had permitted his own men to scatter after their first success, he would have been ruined, but, knowing that some of the Ghibellines were still unaccounted for, he had prudently kept his eight hundred knights in close order, and merely allowed them to dismount and take off their helms for a space.

When Don Henry discovered that the troops below him, in the plain, were under a hostile banner, he closed up his men and advanced to the attack. So formidable was his solid front, that Alard of St. Valery is said to have remarked to King Charles that he must use cunning as well as force or the battle might still be lost. At all costs the Ghibellines must be induced to break their firm array, or their impetus would be too heavy to be withstood. In accordance with this advice, Alard proposed that the French should make a semblance of retreat, so as to allure Don Henry to charge. Receiving the king's leave, he took thirty or forty knights with him, and rode to the rear, as if intending to leave the field. The enemy took this movement for the commencement of a general dispersion and disbandment of the Guelfs, and, shouting, "They fly, they fly," loosed their ranks and charged in upon the king. Charles met them full in front, and his force was still so inferior in numbers to the enemy that his knights seemed to be engulfed in them and lost to sight.[2] But they were individually so superior to the wearied men and horses of the Infant's "battle" that they easily held their own. Presently, when Alard and his small following swerved back and charged the Spaniards in flank with good effect, the fight commenced to turn to the king's advantage. The French found the enemy so exhausted under their double armour of mail and plate that they could hardly raise their sword arms. The cry "Aux bras, seigneurs!" ran along the ranks, and the king's knights began to seize the Ghibellines by their shoulders and cast them from their saddles[3]—a far more effective way of dealing with them than to use the sword, which rebounded without effect from their thick panoplies. Don Henry soon saw his men failing and faltering: some turned to fly, but he rallied a considerable body for one last charge at the enemy. It was useless; the horses could hardly be spurred to a trot, and the men-at-arms were utterly exhausted: after one short final struggle the

[1] "Sire roy, ceus ci vienent très forment et sagement a bataille, et sont si joint a destroit ensemble en leur bataille que en nulle manière, si comme il m'est avis, nous ne les pourrions départir ne tresprecier. Et pour ce convient-il ouvrer contre euls par aucun engine de subtileté, par quoi il puissent estre aucun pou espartiz, si que l'entrée soit aucunement ouverte, et puissent soi combattre avec euls main à main." (Primatus in Bouquet, xxiii. 35).

[2] "Tunc rex movens cum acie sua in eos _mergitur_" (Latin version of Primatus); the French only has "se plunga entre euls" (Bouquet, xxiii. 35).

[3] "Et quant ceste chose fu aperceue des François, crioient, 'A bras, seigneurs! à bras!' et donc les prenoient par espaules et tiroient et trebuchoient a terre" (_ibid_.).

Ghibellines were broken, and those whose chargers could still bear them fled from the field.

Thus did Charles of Anjou obtain a complete but a most costly triumph: "never was victory so bloody, for nearly his whole army had fallen."[1] His two front corps had been encompassed and mostly cut to pieces: his reserve had not won the day without loss. It is probable that the sum-total of killed and wounded in his ranks was far higher than that of the Ghibellines: the defeated party had been scattered rather than slaughtered. It was, no doubt, owing to his irritation at his fearful losses that Charles beheaded his prisoners as traitors, reserving only Conrad of Antioch in bonds.[2] It will be remembered that he also slew the young Conradin and his kinsman Frederic of Austria when they fell into his hands, a few weeks later, after an unsuccessful attempt to escape by sea.

Few battles have commenced so disastrously for the victor, and ended so favourably owing to the judicious employment of a reserve. Charles was thoroughly outmanœuvred in the opening engagement—he evidently had intended to hold the line of the Salto, yet had not discovered and guarded the ford. When once the enemy was across the river, and the two front divisions of the royal army attacked in flank and rear, it looked as if the day were lost: by bringing up his hidden reserve Charles might have disengaged and covered the retreat of the survivors of his van, but could have done no more. To stand by and allow the victors to disperse was therefore the only course remaining, if he was still determined to make a stroke for victory. From the political point of view a complete success was necessary—a defeat (even if it were not a crushing one) would have effectually ruined his cause: the whole of the Regno would have been up in arms in ten days if Conradin had brushed the royal army aside and forced his way deep into the country. Charles therefore took the one chance which still lay open to him, and was completely triumphant. It is right, however, to point out that there was but a fair chance, and no more, left him: he would have been utterly

[1] "Carolus cruentam victoriam habuit, nam pene omnis exercitus proelio occidit" (Ricóbaldi of Ferrara in Muratori, vol. viii.).

[2] "Capti sunt insuper C. de Antiochia et T. de Aquino et plures alii proditores nostri, qui excepto Conrado, propter detestabilem proditionem quam contra majestatem nostram commiserunt, jam capitali sententia sunt damnati" (Letter of Charles to the Paduans, dated the day after the battle). Conrad was spared in order that he might be exchanged for some Guelf prisoners who were in his wife's hands.

32

ruined if some of the pursuing Ghibellines had happened to discover him before their main body had dispersed. This was a very possible contingency ; and it was equally within the limits of fortune that some traitor or prisoner from among the first two corps of his host might have betrayed his position to the enemy. It so fell out that neither of these possibilities were realised : the Ghibelline army broke up in utter heedlessness to plunder or pursue, and Charles was thus able to snatch victory out of the very jaws of defeat.

In all the operations which followed his sudden appearance on the field, his tactical management of his troops appears to have been admirable. His strokes were strong and rapid, yet he lost nothing by haste and rashness. It required the coolest of brains to refrain altogether from chasing the Germans, on the chance that new enemies might yet come upon the field. But it was only by allowing his young rival to ride off unpursued that Charles was able to meet the corps of Henry of Castile with his horsemen in good order and refreshed by a short rest. If he had pushed on to endeavour to capture Conradin, as most mediæval generals would have done in his place, he would inevitably have been caught and crushed by Don Henry's returning troops. That he avoided this danger is the best proof of his military capacity.[1] It is curious to find that, in spite of Charles' long and successful career, Italian writers attributed his crowning victory to St. Valery's inspiration, and not his own. To Dante Tagliacozzo was the place—

"Ove senz' arme vinse il vecchio Alardo".[2]

Battle of the Marchfeld, August 26, 1278.

Of all the cavalry fights of the thirteenth century, the great battle on the Marchfeld, which settled the future destinies of

[1] It is perhaps worth while to develop further the curious similarity between the details of Albuera and Tagliacozzo. In each case the party acting on the defensive took position behind a river crossed by a bridge, and neglected the fords. In each case the assailant threatened the bridge, but crossed the ford with the greater part of his army, and took the defenders in flank. He scattered the two nearest corps (the Spaniards and the second division at Albuera ; Cusances and De Clary at Tagliacozzo); but when he seemed certain of victory, he was suddenly attacked and routed by the defenders' last reserve (Myers' and Abercrombie's brigades at Albuera, the king's thousand knights at Tagliacozzo). The essential difference in the cases is of course that Soult had not allowed his men to get out of hand, and was not surprised as Conradin was. Nor does Beresford shine when compared with Charles of Anjou.

[2] *Inferno*, xxviii, 18.

Austria, was that in which the greatest number of mounted combatants took part. There were more troops on the field at Bouvines, but there the numbers of the French and Imperialist armies had been swelled by large masses of infantry: at the Marchfeld, on the other hand, cavalry alone were employed by each side. Though King Ottokar and Kaiser Rudolf had both brought a certain amount of foot-soldiery with them, they did not array them in the battle line, but apparently relegated them to the position of a mere camp-guard.

The political significance of the fight was very great—even greater than its military importance. It settled the question whether the eastern regions of the empire should be occupied by a compact Slavonic realm, or whether the Hapsburgs were to preserve the heritage of the extinct house of Babenberg as a Teutonic state. Ottokar of Bohemia, the most striking figure in the history of the great Interregnum (1254–73), had set himself to the task of extending his kingdom down to the borders of Italy, and for a time had succeeded in laying hands on both Austria and Carinthia. Beaten back from them by the newly-elected Emperor Rudolf, and forced to consent to a disadvantageous peace in 1276, he returned to the charge two years later, and invaded Austria at the head of an army in which his native subjects of Bohemia and Moravia were backed by a considerable contingent of North German mercenaries and a great mass of Polish allies: even the distant Russian prince Leo of Ruthenia came to his aid. His renewal of the war was not unjustifiable. The emperor had shown himself prone to interfere in the internal affairs of Bohemia in a manner which could not be tolerated—he had, indeed, striven to treat Ottokar much as Edward I. of England treated John Baliol twenty years later. Moreover, many of the Austrians, and notably the citizens of Vienna, were discontented with their new ruler, and had let it be known that they would not be indisposed to return to the allegiance of their former master.

The Emperor Rudolf was not at this moment able to count on the co-operation of the whole, or even the majority, of the princes of the empire. Many of them regretted the end of the anarchy of the Interregnum, and nearly all had been disagreeably surprised by the cunning and force which the new emperor had displayed during the first five years of his reign. To resist the Bohemian invasion Rudolf had practically to count

only on the resources of his new dominion in Austria, Styria, and Carinthia, aided by his old neighbours and vassals of Swabia. From North Germany he did not draw a man—such Saxons and Brandenburgers as appeared on the field came there as the mercenaries of Ottokar. Bavaria, too, whose dukes were ill pleased to find themselves shut in between the Swabian and the Austrian territories of the Hapsburgs, was inclined to side with the king: many mercenaries from the duchy were in the Bohemian ranks.

On the other hand, Rudolf was able to swell his army to a formidable size by the addition of a great mass of auxiliaries from the East. King Ottokar had been a bad neighbour to Hungary: he had invaded her borders again and again,[1] and had won her permanent ill-will by the great victory of Cressenbrunn (1260), when he had cut to pieces the whole of her royal host, and left every noble family of the realm in mourning. The young King Ladislas came forth gladly to avenge the defeat of his father, and brought a great host of horsemen to the emperor's aid. The lowest figure at which they are estimated is fourteen thousand:[2] some chronicles give thirty thousand, or even forty thousand. They were mainly horse-bowmen very lightly equipped, though a certain proportion of the nobles wore the ordinary mail of the Western world, and were as heavily armed as their German neighbours. The Hungarian contingent included several thousand wild Cumans, heathen savages from the Steppes, who had recently been driven over the Carpathians, and had obtained permission to settle among the Magyars. Their ferocious appearance and manners shocked even their allies— they gave no quarter in war, and habitually mutilated the dead and wounded.

After advancing a short distance into Austrian territory, Ottokar displayed an inexplicable sluggishness: he besieged

[1]
> "Ouch râchen si daz herzenleit
> Den schaden und die schande
> Daz si in ir lande
> Uf Ungerischen acker
> Von Beheim Kunic Ottacker
> Mit brande und mit roup
> So dicke het gemachet toup."
>
> *Reimchronik*, 16252-58.

[2] Given by the not very important Colmar Chronicle. Probably the real figure was higher, as the realm was enormously strong in light horse, and this was a popular national campaign against an old enemy.

and took one or two small fortresses, but did no more: thus his enemies found time to cross the Danube, to concentrate, and to march to meet him.[1] The Hungarian light horse swept away several of his foraging parties, and brought back to the emperor an accurate account of the Bohemian position. The army was encamped on a hillside just west of the river March, eight miles north of the little town of Stillfried, after which the ensuing battle is often named.

Kaiser Rudolf, after mature deliberation,—he waited three days, August 23 – 25, before attacking, — resolved to march forward against the enemy, who showed no signs of taking the initiative against him. According to the Bohemian chronicles, Ottokar's army was so scattered abroad in search of plunder that the king could not concentrate them for the battle, and the Germans and Hungarians beset him before he had drawn all his men together.[2]

Between the two armies lay a marshy bottom, the bed of the Weidenbach: this the assailing party would be compelled to cross. Rudolf sent forward bodies of Hungarian horse to try if it were easily passable, and, when they reported that they had ridden over almost dry-shod, resolved to follow with his whole force. Accordingly the Austro-Hungarian army passed the stream and advanced towards the enemy, who were clearly visible drawn up outside their camp in six (or seven) corps, and ready for battle.

It is a strange fact that, although we possess something like a dozen narratives—short and long—of the battle, we are not able to determine accurately the formation of either army. Though we know what divisions were comprised in each of the hosts, we cannot fix with certainty the juxtaposition of each to the next.

King Ottokar had formed his host in six corps[3] and a reserve. The first corps was composed of the bulk of the Bohemian horse; the second of Moravians strengthened by the Bohemians

[1] The Austrians concentrated at Vienna; the Magyars at Stuhlweissenberg. They crossed the Danube separately and met at Marcheck.

[2] *Annales Ottokariani*, p. 92: "[Rudolphus] comperiens quod rex cum exercitibus suis nullam spem haberet de adventu inimicorum, et essent dispersi huc atque illuc, sicut consuetudo Boemorum est, causa predae rapiendae, et rege cum paucis commorante, repente irruit cum exercitibus suis super improvisos et in modum semicirculi per ordinatas acies circumcingit eos multitudine innumerosa."

[3] This we have both from John of Victring (in Böhmer, i. 309) and the Styrian Rhyming Chronicle, with some variations. The order I give above is that of the latter, which is more detailed. The Kloster-Neuburg Annals say *seven* corps.

of the district of Pilsen ; the third consisted of German auxiliaries from Misnia and Thuringia, the fourth and fifth of Poles, the sixth of Bavarians and North Germans, mainly Brandenburgers sent by "Otto with the Arrow," the Ascanian Margrave, who was a determined enemy of the Church, and therefore a sympathiser with Ottokar.[1] The Bohemian king had taken his post with the last-named corps, a formidable body of nine hundred horsemen on barded horses, the pick of the whole army.[2] There was also a separate reserve, probably of native Bohemians, under Milita of Diedicz, chamberlain of Moravia.[3] The whole army were furnished with green crosses as a badge to distinguish them from the enemy : their war-cry was " Praha !" (Prague), the name of their capital.[4]

So far we are able to make our various authorities fit together. But to say with certainty how the six corps and the reserve were ranged with reference to each other seems almost impossible. It is of course conceivable—(1) that the six divisions were drawn up in single line, with the reserve behind the centre ; (2) that they were drawn up in two lines of three corps each, with the reserve making a third line ; (3) that they formed three lines of two corps each, the reserve making a fourth line. The first order of battle directly contradicts a statement of our best authority, the Salzburg Chronicle, to the effect that the Bohemians came on in three lines, since it only gives *two* lines ; similarly the third of our alternatives gives *four* lines, and is therefore faulty from this point of view. If, therefore, we elect to stand by the Salzburg annalist, No. 2 seems the most likely choice. In this case the first rank in Ottokar's host (counting from right to left) would be the Bohemian, Moravian, and Thuringian corps ; the second would be composed of the two Polish divisions and the Bavarians and Brandenburgers ; the third would consist of Milita of Diedicz and the reserve. The chief anomaly in such an array would be to find the king posting

[1] The Rhyming Chronicle calls them "Saxons," 16395.

"Dise der Markgraf mit der Pfeile
Braht dem Kunic von Beheim."

Otto of Brandenburg is often called "Otto with the Arrow," from the curious fact that he lived many years with one sticking in his head.

[2] "In der selben schar sie niht vermisten, gezalt und us gesundert, Verdacter Ros niunhalp hundert" (S. R. C. 16175).

[3] This reserve was, according to the Rhyming Chronicle itself, line 16044, composed of two corps (*zwain Rotten*).

[4] Or "Budewetze Praha !" (Rhyming Chronicle, 16075).

himself on the *left* of the second line. But we know that he
was reserving himself for an onslaught on the emperor in person,
and, as we shall see, Rudolf was in the right rear of the Austro-
Hungarian host, *i.e.* just opposite the place which we have
assigned to Ottokar.[1]

It is impossible to get any clear idea of the total numbers of
the Bohemian host. Some German chroniclers rate it very high,
saying that Ottokar had four men to every one of Rudolf's.[2] In
this comparison they very unfairly omit all mention of the
Magyars, who formed three-fourths of the allied army. But no
doubt Ottokar had a large superiority in fully-armed knights
and barded horses, of whom the Hungarians had a low propor-
tion in their ranks. If there were about nine hundred barded
horses (besides lighter horsemen) in one of the king's six or
seven corps, we cannot rate the whole at less than ten thousand
horse. Wild estimates giving the Bohemians at thirty thousand[3]
men may be disregarded, or taken as including the foot, which
never appeared on the battlefield.

In endeavouring to ascertain the array of the Imperial army,
we are confronted by even greater difficulties, mainly owing to
the fact that the majority of the German chroniclers entirely,
or almost entirely, ignore the part taken in the battle by the
Hungarians, who must nevertheless have constituted at least
three-fourths of the combined army. It is only fair to say that
the one contemporary Magyar annalist who has described the
fight, Simon Keza, is equally unjust to the Germans, whom he
describes as merely looking on while the Hungarians did all
the fighting.[4]

The combined army is described as drawn up in three or

[1] Chron. Salz. in Pez. i. 379 : "Ipse vero rex Boemiae in ultima sua acie [does
this mean in the corps at *end* of his line, or in his *rear* line?] . . . insignis emicuit,
seipsum et aciem illam conservans pro Romani regis cuneo conterendo."

[2] As does the Rhyming Chronicle.

[3] *e.g.* John of Victring in Böhmer, i. 309, and Thomas Tuscus.

[4] Simon Keza in Pertz, vol. xxix. 545, says : "Sed quoniam gens Rudolphi in
motu gravis erat propter arma graviora, nimisque timorata ad resistendum tam validae
multitudini . . . moveri dubitabat. Hoc autem rege Ladislao percepto, Otacaro ad
praelium properanti, juxta castrum Stilfrid prope fluvium Morowe adpropinquabat,
Boemicum exercitum convallando circumquaque. Quorum quidem equos et etiam
semetipsos sagittis Hungari et Cumani sic infestant vulnerando quod Milot militiae
princeps, in quo exercitus praesertim confidebat, sustinere non valens Hungarorum
impetum cum suis fugam dedit. . . . Rudolphus rex Teutoniae stabat cum suis inspici-
endo quae fiebant."

sometimes four divisions; but, on closer investigation of the sources, we find that some of the chroniclers who speak of only three corps are describing the Germans alone, and leaving the Magyars quite out of sight. Referring once more to the Salzburg Chronicle, our best source, we find it stated that the King of Hungary drew up his army in three *acies*, with the Cuman horse-bowmen loosely hovering on the flank, while Rudolf had also three *turmae*, the first arrayed under the Imperial banner with the black eagle, the second carrying the Austrian flag, "gules a fess argent," and the third (in which rode the emperor himself) carrying a red flag with a white cross.[1] This third or reserve corps must have been very strong: it consisted of the Styrians, Carinthians, Carniolans, Salzburgers, and Swabians. The last-named alone counted more than two hundred "barded horses." Frederick of Hohenzollern, burgrave of Nuremberg (who also served here, and bore the white-cross banner), had brought a hundred more with him. The Bishop of Salzburg had sent three hundred horsemen. The heavy cavalry of Styria, Carniola, and Carinthia must also have been numerous, so that the reserve line was very formidable. Chroniclers who rate it at only three hundred "barded horses" must evidently be understating it grossly.

The two corps which bore the banners with the eagle and the Austrian shield were composed of the knights of the two Austrias. Since the Salzburg Chronicle calls them *acies*, we should naturally suppose that they formed two lines, one behind the other. But it seems strange to suppose that the archduchy could have supplied enough men to form two-thirds of Rudolf's army, when Styria, Carniola, Carinthia, Salzburg, and the Swabian and other auxiliaries, only made up one-third between them. Possibly the two Austrian corps were formed in a single line, as we should gather from the Styrian Rhyming Chronicle and several other authorities. It is inconceivable that either the eagle or the Austrian flag should have been borne by the Hungarians, whom the Rhyming Chronicle places as the first *two* divisions of the host.

[1] Chron. Salz. in Pez. i. 379: "Verum exercitus regis Romanorum tribus distinguitur aciebus et signis totidem. Nobiles Austriae dividebantur in duas turmas: una portavit vexillum Romanae aquilae; altera sub vexillo Austriae militavit. Alia turba victoriosissimae S. Crucis insignia juxta morem Imperii sequebatur: sub hoc signo rex Romanorum militat. . . . Rex etiam Hungariae suum exercitum tribus divisit aciebus. Cumani vero sine ordine cursitabant," etc.

PLATE XVI.

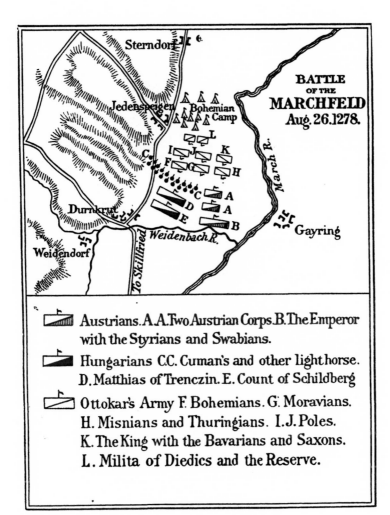

Austrians. A. A. Two Austrian Corps. B. The Emperor
with the Styrians and Swabians.

Hungarians C.C. Cuman's and other light horse.
D. Matthias of Trenczin. E. Count of Schildberg

Ottokar's Army F. Bohemians. G. Moravians.
H. Misnians and Thuringians. I. J. Poles.
K. The King with the Bavarians and Saxons.
L. Milita of Diedics and the Reserve.

As to the array of the Hungarian army, the Salzburg Chronicle gives three *acies*, while the Styrian Rhyming Chronicle says that there were only *two* corps—one under the Palatine Mathias of Trenczin, the other under the Count of Schildberg. We may possibly reconcile them by supposing that the swarm of Cuman and other bowmen thrown out in the front formed the third line of which the first-named authority speaks. It is not absolutely certain that we are to press *acies* into its proper meaning of line of battle, and say that Schildberg's corps lay *behind* Trenczin's. *Acies* is used so vaguely by mediæval writers that it is possible that the two divisions were in a single line. In drawing the plan of the battle, however, the first and natural meaning of the word has been taken, and three lines represented. King Ladislas, a youth of eighteen, did not take part in the battle, but watched it from the hills to the west. Some say that Rudolf induced him not to risk his person; others, that it was a Hungarian custom not to expose the king.[1]

We now come to the question how the Magyars and Germans stood in relation to each other. Some of our sources, but not the best, speak of the former being drawn out *in front* of the latter.[2] On the other hand, the most detailed account on the Imperialist side, the Styrian Rhyming Chronicle of Ritter Ottokar, speaks of the Austrians as being in the front of the Imperial army and engaging with the first line of the Bohemians.[3] This is impossible if the Hungarians composed the first rank of the whole allied host. Moreover, the same authority speaks of several newly-knighted horsemen in Rudolf's front division as riding out and challenging the enemy to joust.[4] This would be a sheer impossibility if a thick line of horse-bowmen supported by two corps of Magyar heavy cavalry were already engaged with the Bohemians. We must therefore hold, with Herr Busson,[5]

[1] Rhyming Chronicle, lines 16125–26.

[2] *e.g.* the unintelligent Chronicle of Colmar in Böhmer, ii. 72. The author makes the Magyars refuse to close, whereupon Rudolf orders up his second corps, the Austrians.

[3] " Din voderiste schar
 Din der Teutschen holp kom dar
 Daz waren die von Osterrich " (*S. R. C.* 16170–71).

[4] " Vor den scharn ward groz,
 Von den newen swertslegen
 Das tiostire under Wegen " (*S. R. C.* 16714–17).

[5] See his admirable article in the *Zeitschrift für Oesterreichische Geschichte*, vol. lxii. 1–145, which has helped me greatly in working out this fight.

that the two allied armies were drawn up side by side, each in
three corps, the Austrians on the right (the emperor taking the
place of honour) and the Magyars on the left. But the latter
were at least four or five times as numerous as their allies, and,
moreover, the open method of fighting to which they were
accustomed would cause them to take up a much broader front
than the solid squadrons of the Imperial horse. Probably, there-
fore, they faced two-thirds of the Bohemian front, and also
outflanked it on the left. If this was so, the Austrians must
have faced only the Misnian-Thuringian division in Ottokar's
first line, while the Magyars were opposed to the two corps of
the Bohemians and Moravians. This fits in well with the fact
that in none of the German accounts of the battle is there
mention made of any conflict between the Austrians and the
Bohemians and Moravians. Rudolf's men are found fighting
only Ottokar's German auxiliaries and (to some slight extent)
the Poles.[1]

When the Imperialists drew near the Bohemian camp, the
fight was opened by the Cumans, who rode round the right
flank of the enemy, and, ranging themselves in a semicircle, began
shooting into the mass of men and horses. The Hungarian
light cavalry followed their example, and ere long the right wing
of Ottokar's host was hardly pressed: they had with them
neither horse nor foot bowmen to oppose to the masses of light
cavalry who were thus infesting them. Perhaps only when the
Bohemian and Polish corps in this part of the field were already
in disorder, perhaps somewhat earlier, the heavier squadrons of
the Magyar nobility rode in to support their skirmishers and
engaged in hand-to-hand fighting with the enemy. We have
no details of the fighting, except the notice of individual feats
of arms done by Hungarian champions, which are wholly useless
for any tactical comprehension of the combat. It is certain,
however, that, after a prolonged struggle, Ottokar's men fled,
and were pursued for many miles by the victorious Hungarians
and Cumans, who slew many and took still more prisoners.
We may be reasonably certain that the Magyars fought and
routed all or most of the four divisions which formed the
Bohemian right and centre; it is probable, too, that it was their
victorious advance which caused the reserve under Milita of

Diedicz to leave the field ;[1] on this point we must speak later. Apparently the moment of the definite victory of the Hungarians must nearly have coincided with the final success of their allies on the right wing.

Meanwhile, the battle had been taking a very different shape upon the Bohemian left, where King Ottokar rode with his two German corps next to the river. Here the king's knights had no horse-archery to vex them, and were able to close lance to lance with the enemy. The left corps of the front line (Misnians and Thuringians) broke the Austrian corps which marched in the van, and drove it back with loss.[2] Ottokar lost his head, and, when he saw the enemy give way, followed his front line into the fight. Scattering the whole of the Austrians before them, the victorious troops pushed straight along the river-bank, never looking round to see how their centre and right were faring in the struggle with the Hungarians. Driving ever southward, Ottokar at last came in front of Rudolf's own corps, the third division in the Imperial host—the Swabians, Styrians, Salzburgers, and Carinthians. This struggle took place a long way behind the main battle, and perhaps even as far south as the line of the Weidenbach morasses.[3]

The engagement between the two bodies of German knights was prolonged and obstinate. For a moment the Imperialists seemed likely to be beaten : a stalwart Thuringian knight slew Rudolf's charger, and cast him down among the horses' hoofs, where he was in danger of perishing, and only escaped by putting his shield over his head and lying still. But when a faithful friend[4] dragged him out from the press and gave him another horse, he was found to be so little hurt that he was able to fight on to the end of the struggle.

[1] So says Simon Keza, the Hungarian narrator of the battle. He names the Bohemians and Poles as the two nationalities against whom the Magyars and Cumans fought, and specially notes that " Milot, who had the chief confidence of the hostile army," was turned to flight by the arrows of his countrymen. See Pertz, xxix. 546.

[2] The rout of the Austrians is vouched for by the Salzburg Chronicle (Pez. i. 377) : " Et tamen cum videret primam nostrae partis aciem a suorum facie improbe declinantem, de victoria adeo confidebat ut velocem suorum militum impetum morosum crederet, et festinos nimium se judice desides censeret." John of Victring and the Colmar Chronicle (less good authorities) are equally clear on the defeat of the Austrians.

[3] This seems to be suggested by the fact that Kaiser Rudolf, in his letter of commendation to the knight who saved his life, says that he had been overthrown *in a brook* ; the Ober Weidenbach is the only brook on the field.

[4] Walter of Ramswag, a Swabian knight from the Thurgau.

In spite of Rudolf's mishap, the battle went decidedly in favour of the Imperialists. Ottokar and his knights were gradually beaten back towards the main body of their host, which must at this moment have been just on the point of yielding before the Hungarians. The final stroke was given by a knight named Ulrich von Kapellen, whom Rudolf had told off with some sixty men-at-arms to make a flank attack on the last body of the Bohemian host which was still standing firm. When his men were breaking up and turning to fly, King Ottokar sent to bid Milita of Diedicz bring up the reserve corps, which was still intact. But the chamberlain, either because he feared being out-flanked and surrounded by the Magyars, or out of pure treachery,[1] rode off the field with his men and fled away to the north.

While the Bohemian army was melting away from the battle, their king kept fighting to the last, till he was left almost alone. As he strove to cut his way through the press, he was unhorsed and taken prisoner. While his captors were leading him to the emperor, two knights who were his personal enemies fell upon him and slew him in cold blood.[2] With him fell many thousands of his followers: the encircling movement of the Hungarians had cut off from their line of retreat those who were slow to fly, and many knights who would not surrender strove to swim the March, in which the greater part of them were drowned. The camp was easily seized, and many of the infantry who had been left to guard it must no doubt have shared the fate of their lords. The greater part of the plunder and the prisoners fell to the Magyars and Cumans, who went home heavily laden with spoil, and elated at the prospect of the ransoms which they would be able to squeeze from Duke Nicholas of Troppau and other captives of high rank. They took no further part in the campaign, and the invasion of Moravia which followed the battle was carried out by the emperor and his German forces alone.

Two main points of tactical importance are to be noted in the battle of the Marchfeld. The first is the helplessness of

[1] The Rhyming Chronicle and John of Victring both say that Milita had an old grievance against his master, who had put to death his brother in prison twelve years before (1266), and now took the opportunity of revenging himself. On the other hand, the Hungarian Simon Kera claims that he was fairly driven from the field by the Magyar arrows.

[2] Apparently one of these knights was Berchthold von Emberwerch (Emerberg), and the other Rudolf's cupbearer (Rhyming Chronicle, 16720).

ordinary feudal cavalry against an army such as that of the Hungarians, which combined horse-bowmen with heavy mailed supports, quite in the style of the ancient Byzantine hosts. If the Bohemians had been beset by the Cumans alone, their task would have been not unlike that of the Crusaders when attacked by the Turkish horse-archery. But to back the Cumans were heavy squadrons of Hungarian nobles and knights armed in the Western fashion. Ottokar's men seem from the first to have been unable to make head against them. They were outflanked and apparently more than half surrounded by the light troops, and had to protect themselves from assaults on all sides without the aid of any infantry on which they could rally. Hence came utter disaster.

The second notable point is that on the right of the allied host, where Rudolf's Austrians and Swabians met Ottokar's Saxons and Thuringians, the battle was lost by the side which engaged its reserve recklessly and too early in the fight. Ottokar's front line having won an initial success, he should not have pushed it so hastily forward, nor thrown his second line into the mêlée before his adversary's reserve had struck a blow. Rudolf's tactics in keeping his third corps far to the rear, and apparently out of sight of the enemy, remind us of those of Charles of Anjou at Tagliacozzo. He cannot, however, be accused of sacrificing his front corps with the cold-hearted calculation which the Angevin king showed in the last-named fight. He did not hang back, but rallied the beaten troops on his reserve and took up the fight without any delay. Having to deal with an enemy wearied out by previous fighting and disordered by a hasty advance, he was naturally successful. In all probability we may add to the causes of his victory the fact that he outnumbered the two hostile divisions immediately opposed to him. It is hardly credible that Ottokar's Thuringian, Saxon, and Bavarian mercenaries can have approached the strength of the full feudal levy of Austria, Styria, Carniola, and Carinthia, backed by a large contingent from Swabia and Salzburg. Rudolf seems personally to have shown considerable military virtue, but his task was made easy for him, first by the co-operation of his powerful Hungarian allies, and secondly by Ottokar's recklessness. That he knew how to use a small reserve of cavalry at the last moment is shown by his timely despatch of Von Kapellen and the sixty knights, who struck the last and decisive blow of the day.

CHAPTER VI

ARMS AND ARMOUR (1100–1300)[1]

IN the fifth chapter of our Third Book we described the development of knightly armour down to the end of the eleventh century, when it consisted of the conical helmet furnished with a nasal, of a long mail-shirt with or without a coif to cover the head and neck, and occasionally of guards for the legs (*ocreae, bainbergae*).[2] We must now make clear the stages by which this comparatively simple equipment gradually passed into the heavy and complicated plate armour of the fourteenth century.

For some time after the Norman Conquest the improvement of armour progressed very slowly. Before the end of the eleventh century the short broad sleeves of the mail-shirt had been lengthened so as to reach the wrist, and made more closely-fitting. The Great Seal of William II. displays the change very clearly when compared with that of his father.[3] But, with the exception of this single alteration, there is practically no variation in armour till the third quarter of the twelfth century. In the time of Henry II. the fully-equipped knight was armed exactly as had been his great-grandfather who served under the Red King. It is astonishing to find that sixty years of contact with the East had affected European arms so little, but it is not till the end of the century that modifications in equipment to which we can ascribe a crusading origin make much progress. The long warfare with the Turks and Byzantines did, as we have shown on an earlier page,

[1] In this chapter I must acknowledge that I am deeply indebted to Mr. John Hewitt's admirable *Ancient Armour* (Oxford, 1860).

[2] Only a very few of the personages in the Bayeux Tapestry wear leg armour. Duke William, however, generally shows it : probably only chiefs and wealthy barons were so equipped.

[3] Cf. the two Great Seals of the two Williams in Plate XVII.

PLATE XVII.

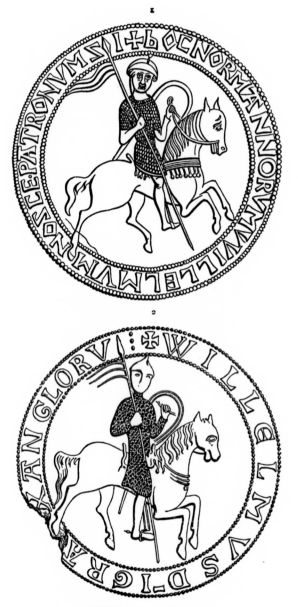

ARMOUR OF THE 11TH CENTURY

(1) GREAT SEAL OF WILLIAM THE CONQUEROR
(2) GREAT SEAL OF WILLIAM II.

have some effect in inducing Europe to esteem the horse-bowman;[1] that he could be used effectively in war we have seen when dealing with the combat of Bourg Théroulde;[2] but we never find him assuming such importance in the West as the "Turcopoles" of the military orders and the Kingdom of Jerusalem had in the Levant. It is probable that the surcoat was borrowed from the Byzantines, whose cavalry had been wont to wear it as early as the ninth century.[3] But it is only at the very end of the twelfth century that we find this light over-garment growing common: of the English monarchs John is the first who is represented as regularly wearing it.

It is also probable that the great development of the use of quilted protections for the body came from the East; where the Saracens had long been acquainted with them. The *wambais* or *gambeson*, which grows common in Europe in the twelfth century, was a defence of this sort, composed of layers of cloth, tow, rags, or suchlike substances,[4] quilted on to a foundation of canvas or leather, and then covered with an outer coat of linen, cloth, or silk. The knightly class took to wearing gambesons under their mail-shirts as an additional protection for the body, while infantry and the poorer sort of horsemen wore them as their sole defence. They are well known to Wace, who mentions them repeatedly as worn by Normans at Hastings.[5] The great Assize of Arms of Henry II. orders that "burgenses et tota communa liberorum hominum" are to wear "wambais et capellet ferri," as opposed to the knights who bear "loricas, cassides, et clypeos."[6] One of the forms of the gambeson, the acton (hacqueton), shows its Oriental origin by its name, derived from the Arabic *al-qutun*. It was so called because the quilting was stuffed with cotton. Students of the third Crusade will remember that Saladin gave to Richard Coeur de Lion "unum *alcottonem* satis levem, nullo spiculo penetrabilem" as a specimen of the best Eastern armour. The *perpunctum*

[1] It must be remembered that Europe was acquainted with the Magyar horse-archer long before the Crusades. There is a horse-archer in the Bayeux Tapestry among the three Normans who in its last group are represented as pursuing the flying English. So the idea was not absolutely new.

[2] See p. 385. [3] See pp. 185, 186.

[4] The gambeson (wambasia) is defined in a thirteenth-century document (Hewitt, i. 127) as "tunica spissa ex lino et stuppa, vel e veteribus pannis, consuta."

[5] "Plusors orent vestu gambais" (*R. de Rou*, 12811).

[6] Assize of Arms in Stubbs' *Charters*, p. 154.

(*pourpoint*) was another name for one of the many varieties of the gambeson.

By the middle of the twelfth century it would seem that a distinction had been established between *lorica* and *albergellus*, the two forms of the mail-shirt—the former being the newer and more complete form with the coif, the latter the old byrnie without that extra protection. Hence, in the Assize of Arms of Henry II. mentioned above, while the knights and all having chattels to the value of more than sixteen marks wear the *lorica* and *cassis*, persons owning between sixteen and ten marks are only expected to provide themselves with a hauberk and steel cap ("albergel et capellet ferri").[1]

It is only at the end of the twelfth century that serious changes in the character of the knightly equipment begin. The helm is the first part of the panoply to be affected: abandoning the conical shape, it begins sometimes to be flattened at the top, though it still retains the nasal and leaves the face exposed. Such a shape may be seen in the figures of knights in the well-known Life of St. Guthlac in the British Museum.[2] Very shortly after this modification in headgear began, a more complete one follows,—the nasal expands into a covering for the whole of the face, leaving only the eyes exposed. Thus is produced the pot-helmet or casque, whose earliest form we see on the second Great Seal of Richard I.[3] This is the first headpiece concealing the whole head which had been used since classical times. It was enormously heavy, so much so that it was often made to come down on to the shoulders, so as to relieve the neck from as much weight as possible. In the figure of King Richard the casque is filled with a movable vizor with two long slits for the eyes, which can be lifted at need. But the prevailing form in the thirteenth century was a helm without vizor, but having eyeholes; and below them a group of circular or square openings for breathing, such as is displayed on the Great Seal of Henry III.[4] This very heavy and cumbrous headpiece lasted throughout the thirteenth century, retaining generally its original flat-topped shape; but it is occasionally found with a conical summit like a sugar loaf.[5] Owing to its weight, it was assumed only the moment before the battle: at the Marchfeld we are told how the cry, "Helms on !" ran down

[1] Assize of Arms in Stubbs' *Charters*, p. 154. [2] Harleian Roll, x.
[3] See Plate XVIII. Fig. A. [4] See Plate XVIII. Fig. B. [5] See Plate XIX. Fig. C.

PLATE XVIII.

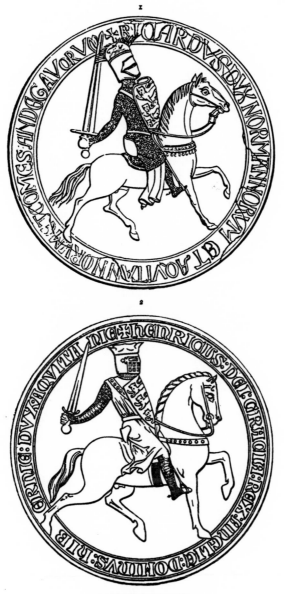

ARMOUR OF 1190-1250

(1) GREAT·SEAL OF RICHARD I.
(2) GREAT SEAL OF HENRY III.

Rudolf's ranks when the Bohemians came in sight. At Tagliacozzo the knights of Charles of Anjou removed their helms during the short interval between the discomfiture of Conradin's corps and the reappearance of Henry of Castile upon the field. A knight whose helm had been knocked awry so that the eye-slits no longer came opposite the eyes was in a most helpless condition. We are told of Guy of Montfort at Tagliacozzo that he got his helmet battered aside, and consequently laid about him like a blind man, and wounded his friend Alard of St. Valery, who came to set it straight for him.[1] It must be remembered that this head-dress was by no means universally worn. Many knights disliked it on account of its weight, and preferred to wear the older and simpler mail coif. This we see on the effigy of William Longsword [1227], as also in the much later battle scene on Plate XX.

The pot-helm of the thirteenth century was not unfrequently adorned with various sorts of ornaments, a thing which had not been seen since the crested Frankish helm was superseded by the plain helm with nasal three centuries before. Richard I. on his second Great Seal wears a large fan-shaped ornament. The Count of Boulogne at Bouvines had crowned his helm with two large horns of whalebone:[2] even more complicated additions to the headpiece are sometimes seen.

These were probably assumed not only for decorative purposes, but to identify their wearers, who, since the face was completely covered by the pot-helm, could no longer be recognised by their friends. For the same reason, the surcoat, instead of being left plain, was now embroidered with the coat-of-arms of the bearer. Heraldry had begun to come in about the middle of the twelfth century,[3] but it was not till its end that all members of the knightly class assumed regular armorial bearings. Richard I. is the first king who displays the three golden lions on a red ground, which have become the arms of England.

About the same time that the pot-helm and the armorial

[1] Primatus in Bouquet, xxiii. 35.

[2] *Philippeis*, xi. 232:

"Cornua conus agit superasque eduxit in auras
E costis assumpta nigris quas faucis in antro
Branchia balenae Britici colit incola ponti."

[3] The Great Seal of Philip of Flanders (1161) is one of the first on which definitely heraldic bearings as opposed to mere ornamental designs are to be found displayed.

surcoat came into fashion, the shield was very considerably reduced in its dimensions. The knight was now so well protected by his body armour that it had become less necessary to him. In the thirteenth century it was no longer kite-shaped, but triangular: all through that age it steadily diminished in size, till by 1300 it was comparatively insignificant, and could no longer be used (as it had been for many ages) to carry a wounded knight, or to convey a corpse.

It will be easily seen that the knights who fought at Bouvines or Mansourah were very different in outward appearance from their ancestors of the early twelfth century. The closed pot-helmet and the surcoat, together with the small shield, presented a totally different appearance from the nasal-helmet, the uncovered hauberk, and the long kite-shaped shield. But beneath these outward trappings the main body armour was not very much altered. The mail-shirt and its coif were still the universal wear, though they had been rendered more effective for defence by improved gambesons or actons worn beneath. All accounts agree that the armour of 1200 discharged its purpose very well: it will be remembered how thoroughly the Franks at Tiberias were protected by their mail against the Turkish arrows,[1] and how even the gambesons of the foot-soldiery proved impenetrable at Arsouf.[2] Guillaume le Breton remarks in his account of Bouvines how much the battles of his own day differed from those of antiquity. Formerly men fell by the ten thousand, now the slaughter was comparatively slight—

"Corpora tot coriis, tot gambesonibus armant."

The same author shows us that already a further form of protection for the breast was coming into use: under the gambeson some knights were beginning to wear a thin plate of iron. When William des Barres and Richard Cœur de Lion tilted against each other—

"Utraque per clipeos ad corpora fraxinus ibat,
Gambesumque audax forat, et thoraca trilicem
Disjicit: ardenti nimium prorumpere tandem
Vix obstat ferro fabricata patena recocto
Qua bene munierat pectus sibi cautus uterque."[3]

This first hint of plate armour differs entirely from its later development, in that it was worn *beneath* and not *above* the rest of the panoply.

[1] See p. 329. [2] See p. 307. [3] *Philippeis*, iii.

PLATE XIX.

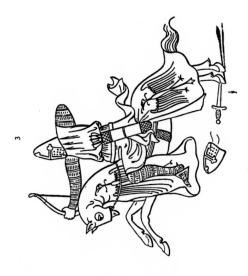

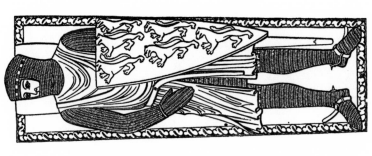

ARMOUR OF THE 13TH CENTURY

(1) WILLIAM LONGSWORD, EARL OF SALISBURY, CIRC. 1225
(2) WILLIAM DE BALNES, CIRC. 1280
(3) A MOUNTED ARCHER, LATE 13TH CENTURY

As the manufacture of chain mail was perfected, it was found possible to use it in more delicate sizes for the protection of the hands and feet. Mail mittens consisting of a thumb and a single covering for the other four fingers came in with the thirteenth century: the effigy of William Longsword in the nave of Salisbury Cathedral displays them very well.[1] They were fixed to the sleeves of the mail-shirt, but there was left in the palm of the hand an opening like that of a modern glove, but larger, through which the wearer could draw out his hand, leaving the mitten dangling at his wrist. It was only at the end of the century that the art of the smith advanced so far as to provide separate openings for each finger, and so to turn the mitten into a glove.

Leg coverings were much improved at the same time: in the twelfth century they had generally guarded the outer side of the leg, being laced together and leaving the inner part, which touched the saddle, unprotected. In the thirteenth century they became continuous and complete coverings for the limb, which came up to the hips and were joined there to the inner side of the mail-shirt, which overlapped them. At Bouvines, when Reginald of Boulogne had been thrown from his horse, one of the French sergeants endeavoured to thrust him through under the skirts of his hauberk, but failed because the leg mail and the shirt were firmly secured together.

The beginnings of plate armour applied *above* the rest of the panoply appear about the middle of the thirteenth century. At first they were used only for exposed parts, such as the elbows, knee-caps, and shins, small plates being here fixed over the mail. Somewhat later the cuirass of plate commences to appear. It was no more than an iron covering for the breast, not guarding the armpit or the neck, and, though it weighed down the wearer considerably, gave him no very complete protection. The reader will remember how ill the German knights at Benevento (1266) fared, in spite of their breastplates, when contending with the French knights, who still wore mail-shirts alone. The development of plate armour is really a matter of the fourteenth century — the thirteenth saw no more than its commencement.

Typical figures from the end of the thirteenth century may serve to show the modest nature of these first beginnings of

[1] See Fig. A of Plate XIX.

plate armour. In the battle-piece from the celebrated *Lives of the two Offas*[1] in the British Museum (Plate XX.), King Offa himself wears defences for his knees and greaves of plate strapped above his chain-mail hose. One of the defeated enemies, who is receiving a spear-thrust in the throat, has a vizor of plate curiously fitted on to the front of his chain-mail coif—a composite head-dress much less common than either the plain coif or the massive pot-helm. The effigy of William de Balneis, from the cloisters of the Annunziata at Florence (1289) (Plate XIX. B), gives decidedly more plate than the representation of King Offa. He is protected to the thigh, and not merely to the knee, by highly-ornamented plates girt on above his mail. It will be noticed that his mail gloves have fingers, and not merely the mitten-like divisions between thumb and fingers shown by Offa and his knights as well as by the figures of the early part of the thirteenth century.

[1] Nero. D. i.

PLATE XX.

ARMOUR OF THE LATE 13TH CENTURY

BATTLE-PIECE FROM THE 'LIVES OF THE TWO OFFAS' IN THE BRITISH MUSEUM

CHAPTER VII

FORTIFICATION AND SIEGECRAFT (1100–1300)

IN the third, fourth, and sixth chapters of our Third Book we indicated the causes which led to the rehabilitation of military architecture in the West after nearly five centuries of neglect. Under the stress of the concentric attack from Viking, Magyar, and Saracen, which was at its worst between 850 and 950, all the peoples of Latin Christendom had been compelled to avail themselves, to the best of their power, of the resources of fortification. Hence came the patching up, of countless Roman walls in every region between England and Apulia ; hence, too, the erection of the palisaded *burhs* and *burgs* of Edward the Elder and Henry the Fowler, and the fencing in of the innumerable private strongholds of the feudal aristocracy of Europe.

Down to the eleventh century it is not too much to say that stonework was the exception, and palisaded earthworks the general rule, in all places where Roman works were not already in existence. Where the ancient enceinte was susceptible of repair, it was of course utilised by the tenth-century builder, *e.g.* at London or Chester. On the Continent (though not on this side of the Channel) there were a certain number of great towns which had preserved a continuous existence as fortresses since the fall of the Western Empire, whose walls needed only to be kept in good order, not to be rebuilt ; such were Rome, Verona, Narbonne, and Carcassonne. But such cases were exceptional. Even of the old Roman towns many had been so repeatedly destroyed that their original walls were too far gone for repair, and the tenth-century builder had practically to start afresh in the task of fortification. Often we find mere ditches and palisades surrounding what had once been a city, possessing a regular Roman enceinte. The

new works might coincide with the lines of the old, or they might enclose a greater or a lesser space. At Lincoln, for example, the Anglo-Danish city stretched much farther down the hillside towards the Witham than the Roman walls had done. At York, on the other hand, the tenth-century city occupied less ground than the ancient Eboracum. But both were alike in that they were now defended only by earthworks and stakes, not by solid masonry.

Of the centres of urban life in Western Christendom, therefore, some were guarded with stone walls, many more by ditch and palisade, while perhaps most numerous of all were those which were dominated by a royal, episcopal, or baronial castle, but were not themselves girt with any complete ring of defence. On the Continent especially, counts and bishops were often jealous of allowing the townsmen to fortify themselves, and preferred to make them rely on a place of refuge which was in the hands of their feudal lord. In time of war the population were able to retire into their master's palisaded mound or walled castle. In time of peace the fortress dominated the town and kept the burghers in obedience. During the tenth and the first half of the eleventh century these seigneurial fortresses were, as a rule, mere moated mounds; the stone castle was a rarity. Castle-building was not, indeed, unknown in much earlier ages. In the second half of the sixth century, Venantius Fortunatus describes Nicetius, Bishop of Trier, as building a real stone fortress to dominate the ancient city below him.[1] But the art of building had actually retrograded between 550 and 800, and it was long before stone castles came into general use. They were both too expensive for the ninth- or tenth-century count or bishop's purse, and too hard of construction for his master-builder. Instead, rocky fortresses were strengthened with banks, or, where rocks did not abound naturally, hillocks or artificial mounds were trenched and palisaded. *Motte* (mound) seems to have been the general name for these structures among the Romance-speaking races.

[1] " Hic vir apostolicus Nicetius, arva peragrans
 Condidit optatum pastor ovile gregi.
 Turribus indixit terdenis undique collem,
 Prebuit hinc fabricam quo nemus ante fuit.
 Turris ab adverso quae constitit obvia clivo
 Sanctorum locus est, arma dehenda viris."

The English called them *burhs*, a word which was very early extended in meaning, so as to apply to the town which clustered round the mound. Among the continental Teutons they were known as *burgs* in exactly the same way: the term was applied both to strongholds and to palisaded cities.

The character of the seigneurial "motte" is well expressed in a passage from the *Acta Sanctorum*, describing the life of St. John, Bishop of Terouanne in Flanders, who died in 1130. It is worth quoting at full length.[1]

"Bishop John had in the town of Merchem a mansion where he could abide with his retinue, while perambulating his diocese. Beside the court of the church there was a stronghold, which we might call a castle or a *municipium*.[2] It was a lofty structure, built, according to the local custom, by the lord of that town many years before. For the rich and noble of that region, being much given to feuds and bloodshed, fortify themselves in order to protect themselves from their foes, and by these strongholds subdue their equals and oppress their inferiors. They heap up a mound as high as they are able, and dig round it as broad a ditch as they can excavate, hollowing it out to a very considerable depth. Round the summit of the mound they construct a palisade of timber, to act as a wall; it is most firmly compacted together, with towers set in it at intervals in a circle as best can be arranged. Inside the palisade they erect a house, or rather a citadel,[3] which looks down on the whole neighbourhood. No one can enter the place save by a bridge, which starts from the outer edge of the ditch and is carried on piers, built two or three together gradually rising in height, so that it reaches the flat space on top of the mound and comes in opposite the gate of the palisade. . . . The bishop returned to the stronghold with his retinue after holding a confirmation, in order to change his vestments, for he was next proposing to consecrate a cemetery. As he was coming down again from his abode, with no small crowd before and behind him, and had reached the middle of

[1] I owe my knowledge of this most interesting description to Mr. G. T. Clark (*Mediæval Military Architecture*, London, 1884), as I do many other notes in this chapter.

[2] What did the author, John of Colmieu, intend by a *municipium*? Certainly not a "corporate town"; but probably a "burg," taking the word *municipium* straight from *munire*, to fortify.

[3] *Arx.*

the bridge, some thirty-five feet or more above the level of the ditch, the structure gave way—no doubt owing to the illwill of our Old Enemy [Satan]. The bridge fell, and all the crowd upon it, beams, planks, and supports came down with a fearful crash. So great was the cloud of dust which rose up above the ruin, that no one could see exactly what had happened."

The description of this Flemish mound-fortress might serve for that of countless tenth- and eleventh-century strongholds in England, France, and Germany. Such undoubtedly were the burhs of the English thegnhood which William the Conqueror found in existence when England submitted to him. His own barons in Normandy were, as a rule, provided with no better fortresses, for it is a mistake to suppose that the stone castle was prevalent everywhere on the Continent, while the old palisaded mound lingered on upon this side of the Channel. William himself, though a great builder, was only able to erect a very limited number of castles of the type of the Tower of London. Domesday Book mentions forty-nine castles as existing in 1086; and of these, thirty-three at least were on sites which had been previously occupied by Saxon strongholds: Twenty-eight of these thirty-three are built on artificial mounds of the burh type. When the buildings of those which still survive are investigated, the large majority of them are found to be of Norman work, but of a date distinctly later than the Conqueror—of the time of Henry I. and Stephen. As it is incredible that one Norman keep should have been removed merely to make way for another of the same type, slightly modified, we are driven to the conclusion that the greater part of William's castles were merely adaptations and additions to the old English strongholds. The masonry was added half a century later.[1]

Historical evidence bears out this conclusion, for we know that many of William's "castles" were constructed in a few months—a time wholly insufficient for the building of stone works. The castle of York, for example, he ordered to be built during the summer of 1068. It was finished and garrisoned by 500 men. But in March 1069 the Northumbrians rose in revolt and besieged it. William returned to

[1] I must again acknowledge my deep indebtedness to Mr. Clark's third chapter, where so much information on the Norman castles is collected.

relieve it, and supplemented it by the erection of a second
castle on the opposite bank of the river. This structure was
completed in *eight days*.[1] But in September 1069 the natives
rose again, aided by the Danes, stormed the castles, and
demolished them by burning them with fire. Obviously such
hastily-constructed works, capable of being burned down,
cannot possibly have been composed of masonry, and must
have been palisaded burhs in the old English style. Such
undoubtedly were the large majority of William's strong-
holds.

But there were also a certain amount of true stone castles
erected by the Conqueror, either in places where no earlier
fortifications existed, or where an important town or region
needed to be held down by a citadel of exceptional strength.
The Tower of London may serve for an example: it rises to a
height of ninety feet, and consists of an enormous quadrangular
keep (a hundred and seven feet by a hundred and eighteen),
built of rubble rudely coursed, and with a very large proportion
of mortar to the stone. Only the windows, quoins, and pilaster
strips were of ashlar. The individual stones are not very large,
so that the loss of a certain amount of them by the attacks
of an enemy using the bore (*terebrus*)[2] would not have been
very dangerous to the stability of the fabric. The walls are
fifteen feet thick in the basement storey, thirteen in the first,
between ten and eleven in the second and third. The entrance
was probably on the south side on the first floor level; there
was also a small postern on the same stage. These entries
were at a considerable distance above the ground, and could
only be reached through some sort of a fore-building, which
disappeared when the original keep was surrounded by outer
walls, on which the main stress of the defence fell. A vertical
wall within the tower divides it into a smaller eastern and
a larger western half; each of these halves, again, is sub-
divided into chambers. The gloomy basement served as a
storehouse; the first floor, hardly less gloomy, must have been
intended for habitation, perhaps as guardrooms for the garrison,
as it is fitted with chimney flues. The second floor contains the

[1] Orderic Vitalis, 512 D: "Rex autem dies octo in urbe morans, alterum
praesidium condidit, et Gulielmum comitem Osberni filium ad custodiendum
reliquit."

[2] See p. 133.

large Chapel of St. John and the banqueting-chamber; the third, or state floor, comprises the council-room and the king's apartments. There are, of course, other smaller rooms in each stage. The largest individual spaces of the chambers (excluding the vast storeroom in the basement, which measures ninety-one feet by thirty-five) are those in the western half, of which several are ninety feet long: the chapel is forty feet by thirty-one. The main access from floor to floor is given by a spiral staircase, eleven feet in diameter, contained in the north-eastern angle of the keep, which is curved out into a turret for the purpose; there are also smaller spiral staircases contrived in the thickness of the wall.

In the Conqueror's time this vast quadrangular building stood by its own strength: any outer defences which existed must have been unimportant; they amounted to no more than the usual ditch, mound, and palisade. It was not till William had been dead some years that his son the Red King set to work to surround the keep with a wall of masonry; it was an extensive and expensive undertaking, so that "the shires which with their work belonged to London suffered great detriment by reason of the wall, and of the king's hall work which was being wrought at Westminster."[1]

The strength of such a structure as the Tower of London lay in the extraordinary solidity of its construction. Against walls fifteen or twenty feet thick the feeble siege-artillery of the day beat without perceptible effect. With no woodwork to be set on fire, and no openings near the ground to be battered in, it had an almost endless capacity for passive resistance. Even a small garrison could hold out as long as its provisions lasted. Mining was perhaps the device which had most hope of success against such a stronghold;[2] but if the castle was provided with a deep ditch, or if it stood on rocky ground, mining even was of no avail. There remained the laborious expedient of demolishing the lower parts of the walls by the bore, worked under the shelter of a penthouse. If the ditch was shallow enough to be filled, and a "cat" could be brought close to the foot of the tower, this method might have some

[1] A.-S. Chronicle, sub anno 1097.

[2] The classical instance of the success of a mine against a Norman keep is the capture of Rochester by King John in 1215. He succeeded in bringing down a corner of the building. See p. 133.

faint hope of success. Before brattices [1] or bastions were invented, there was no means by which the missiles of the besieged could adequately command the ground immediately below the wall. The loopholes were very small, and did not permit of vertical fire, so that the only way by which the garrison could get at the engineers of the besieger was by leaning over the battlements at the top of the tower. Here they would be exposed to the fire of the military engines and archers of the enemy, who were brought up to protect the men working under the shelter of the "cat." Hence something might be done by the method of demolishing the lower stages of the walls; but the process was always slow, laborious, and exceedingly costly in the matter of human lives. Unless pressed for time, a good commander would generally prefer to work by starvation, the one form of attack which the keep was wholly unable to withstand. It will be noted that the defenders had no facilities for annoying the besiegers by sorties; the entrance of their stronghold was narrow, visible, and high above the ground. A force could only issue from it slowly, and when checked would have the greatest difficulty in returning to their fastness. Hence the defender seldom wasted his men in endeavouring to attack the assailant: the only occasion on which he would be likely to essay it would be when military machines were doing such damage that they must be at all costs destroyed.

The square stone-keep, however, was comparatively rare in King William's own day: his son's reign saw the erection of more; but the great castle-building age of the Normans was the twelfth century.

It must not be supposed that the prevalent type of stronghold in the twelfth century was one in which a square solid keep was the really important part of the fortress, and the rest merely subsidiary. Far more usual was another type, on which the name of shell-keep has been bestowed. It consists of a ring of fortification surrounding an open court, and assuming many different shapes of a circular or polygonal sort. The shell-keep was the form of work invariably selected by the Norman architect when he was dealing with one of the old palisaded mounds which he had inherited from his English predecessors. It was formed by

[1] The brattice was a hoarding of woodwork projecting outside the stonework of the tower, being supported on beams fixed in the wall, or on corbels built into it. From holes in its floor it commanded the ground at the foot of the tower.

substituting a ring of masonry for the earlier structure of earth and stakes round the crown of the hillock. Unlike the square and solid keep of the other type, it is a regular evolution from the stage of fortification which had gone before it. When architects grew more competent and masons more numerous, it was an obvious improvement to substitute stone and mortar for earth and beams. Hence almost invariably the Anglo-Saxon burh was followed by a Norman shell-keep. It seems also to be true that in many cases the loose artificially-made soil of the mound was not strong enough to bear a solid structure, and could only support a ring-wall. Within the circle of masonry were erected the buildings which sheltered the owner and his garrison; they were built with the ring-wall for their back, and faced inwards into the little court; often they seem to have been mere slight timber structures, for even in Norman days the lord did not always live in his stronghold, but only repaired thither in time of war, spending most of his time in riding from manor to manor, with his large and miscellaneous household and retinue. Only in exposed frontier fortresses like Alnwick did the master find it necessary to make his keep his permanent abode.

Berkeley and Arundel may be taken as showing good specimens of the shell-keep built on old English mounds. A plan of the former, with its later additions, is annexed on Plate XXI. Abroad the same type is very common: such was the old burg at Leyden, where the ring-wall circles the crown of an early Frisian mound. The castle of Bôves in Picardy, besieged and taken by Philip Augustus in 1185, shows a similar character; but the shell-keep on its steep mound was strengthened by a square tower, which acted as a last refuge for the garrison when the miners of the French king broke the ring-wall. There are ruins of structures of the same sort both in Eastern and in Western Germany. Wherever the old mound-fortresses existed, the shell-keep was the first and most natural stage in their evolution into regular mediæval castles.

Both the square solid keep and the shell-keep were normally

[1] My friend Mr. Doyle, of All Souls College, pointed out to me an interesting phenomenon in the little castle of Tretower, near Crickhowell, where a Norman shell-keep had been utilised by a later owner as the outer wall of his fortress, a very narrow tower being erected in the centre of the shell-keep, so as to make a little "inner ward" of the ground between the new building and the old shell.

supplemented by outer defences, either at their first construction
or at a later date. It is rare to find examples of them without
any additional walls outside—though Bowes Castle in North
Yorkshire seems to be such an exception. The original English
or continental mound-fortress was of small extent, but round
it grew up the dwellings of the owner's retainers, and presently
some light defences of ditch and hedge were drawn round them,
so that the burh or motte became only the citadel. The name
burh, as we know, soon came to be applied to the settlement
round the palisaded mound as well as to the structure itself.
When the defences of the suburb were made stronger, and walls
supplanted ditch and hedge, we have arrived at a very common
eleventh- and twelfth-century type of fortress—the keep sur-
rounded by a curtain-wall containing a considerable space of
ground. The enclosed area may be large, and a whole town
may be built within it. On the other hand, it may be quite
small, only affording room for the few buildings and store-
houses needed by the garrison of the keep. As a general rule
the keep lies not in the middle of the space, but at one end of
it, or set in the wall. This was often due to the fact that the
mound was the end of the spur of a hill or rising ground, cut off
from it by the excavation of its ditch. The extension of the
fortress was along the top of the spur, not below that front of
the mound which looked towards the plain. So we often find a
castle with its original keep on the end of the spur, its first
extension just beyond the original ditch, and then a second
extension, or "outer ward," still farther remote from the early
citadel. When a castle was not on a spur, but upon an isolated
mound in the plain, it must of course have been more or less a
matter of chance on which side the outgrowth began. But as a
general rule the keep stands at one end of the enclosed space,
not in its midst. The same is true of towns and their citadels
—the normal type has the castle at one end of the place, like
London, Winchester, or Oxford. It is rare to find it set right
in the midst of the inhabited space, though Ferrara and Evreux
may serve as examples. Obviously there was danger in the
close juxtaposition of houses to the citadel: they gave too much
cover to an enemy, and if set on fire might stifle the defenders
of the stronghold which they surrounded.

Such was the stage at which fortification had arrived in
Western and Central Europe, when a new influence was brought

to bear upon it. The Crusades put the men of the twelfth century in touch with the Levant, where they had the opportunity of studying the splendid fortresses which the Eastern emperors had built, and of which so many were now in the hands of the Turks and Saracens. To have to undertake the sieges of great fenced cities like Nicæa, Antioch, or Jerusalem was almost an education in itself to the engineers of the West. Their feeble engines and their primitive methods of attack were utterly unable to cope with such strongholds, and as a rule famine or treachery alone enabled them to win the places which they beleaguered. The essential features of Byzantine military architecture were the erection of double and triple defences round the core of the fortress, and the careful provision of towers set at intervals in the "curtain" of the walls. Both were new ideas to the Crusaders, whose notion of a fortress was nothing more than a keep surrounded by a plain outer curtain not strengthened with towers.

Constantinople, the most perfect of all the Eastern fortresses, struck the Franks as absolutely impregnable: it had a triple enceinte, with a deep ditch in front of the outermost face. The first wall was commanded by the second, and the second by the third, each overtopping the line below it, and all three furnished with military machines capable of playing on the siege-works of the beleaguering army. Moreover, the two first walls were loopholed at a stage below the battlements, so that the garrison could fire not merely from the parapets, but from a well-protected second line of openings. The siege-artillery of the enemy would therefore have before it at any point five separate lines of engines, each rising above the other, and all commanding the ground beyond the ditch where the investing army must necessarily begin to erect its works. As a matter of fact, no hostile force ever dared to attempt a regular attack on this tremendous front till the days of the invention of gunpowder. The Avars, Persians, and Saracens in the seventh and eighth centuries only blockaded the place and tried to starve it out. The Crusaders of 1204 studied the tremendous triple enceinte, found that it was impregnable, and then turned all their energies against the sea face of the city, where there was only a single wall to oppose them. Previous besiegers had never possessed that complete command of the water approaches which made such an attack possible. In the days of Heraclius, Constantine

Pogonatus, and Leo the Isaurian, the Byzantine fleet had always been strong enough to render regular assaults on the sea wall too hazardous. Even when not in complete command of the straits (as, for example, during the Saracen siege of 673), the Imperial navy had invariably been present in strong force within the Golden Horn, and any attempt to assail the water front would have caused it to sally out and fall upon the besiegers while their ships, crowded with land troops, were trying to haul in under the wall. Hence such attempts were never made: the "navy in being" of the besieged rendered them too hazardous. But in 1204 the wretched emperors of the house of Angelus had so neglected the fleet that the Venetians were able to draw under the sea wall and assail it without any fear of interruption. Thus it was that Constantinople, for the first time in history, fell before an attack by open force: before, it had never been captured save by treachery from within.[1]

Constantinople was of course quite exceptional in showing a triple line of defence extending over several miles of front: as a rule, it was only citadels and not cities which displayed such a formidable series of walls. Even the wealthy Byzantine Government could not afford to surround places of large size with more than a single enceinte. For castles and fortresses, however, where the space was moderate, the concentric lines were possible, and often were erected: the citadel of Antioch, for example, had a double wall on the north and west sides, though not on the more precipitous southern and eastern fronts.[2] The vast town which lay below it, on the other hand, had but a single wall, but this was made very strong by its splendid diadem of towers.

The fortifications of Antioch may serve as an example of the Byzantine methods of guarding a city of first-rate importance. The place had been retaken from the Saracens by Nicephorus Phocas in 968: in 976 both walls and city were terribly injured by an earthquake, and the whole enceinte had to be repaired. It then remained in the hands of the Eastern emperors till 1086, when the Seljouk Sultan Suleiman captured it by treachery. Thus we see that the Turks had only been in possession of the place for a trifle more than ten years when the Crusaders came against it. The barbarian conquerors had of course added nothing to the Byzantine walls, and the

[1] e.g. As when Alexius Comnenus took it in 1081.
[2] See the Plan in Rey's *Architecture Militaire des Croisés en Syrie*, Paris, 1871.

fortifications erected by Justinian, and remodelled in the tenth century by the engineers of John Zimisces and Basil II., were those with which the Franks had to deal in 1098. When Antioch fell, and became the capital of Bohemund's principality, the old walls needed no repair—the siege operations had done no harm to them. The Byzantine enceinte protected the Latin princes for nearly two hundred years: its remains are still sufficient to enable us to reconstruct the whole system of defence. It consisted of a line of curtain, in which towers were placed at frequent but irregular intervals: in the more exposed parts of the wall the towers were no more than fifty yards apart; in the more inaccessible parts they were some eighty or a hundred yards from each other. Where the walls lie along the river Orontes to the north-east, and along precipices on the southern, south-eastern, and south-western fronts (see Map facing p. 250), they are not furnished with a ditch, but on the north-western and northern fronts the channel of the Orontes had been diverted along their foot, so as to form a large moat, or rather a broad marshy depression. The curtain was solid, and not pierced with loopholes; its main protection came from the projecting towers set in it at such close intervals. These formidable structures were about twenty yards square; half of their bulk stood out beyond the curtain wall, and commanded a side view of the ditch, or of the ground at the foot of the walls where no ditch existed. They were about sixty feet high, and had three storeys; each storey was loopholed both to the front and to the sides, so as to furnish a flanking fire along the ditch as well as a direct fire towards the open country. Being set in the curtain for half their bulk, the towers blocked the road round the walls at frequent intervals. No one could walk for a quarter of a mile along the enceinte without passing through six or seven towers, and, as each tower had strong doors where its second storey opened on to the ramparts, each section of curtain could be isolated by the closing of these doors. So if by chance the besieger mastered a part of the curtain, the two towers on each side prevented him from making his way to right or left along the walls, and, as there was no way of getting down from the ramparts to the interior of the town (all stairs being within the towers), the assailant would have gained nothing but some sixty or eighty yards of narrow rampart walk. The Crusaders in 1098 were admitted into one of the

towers (that of the "Two Sisters") by the treachery of the renegade Firouz,[1] and by means of the gate on the ground floor of the tower got into the town. If they had merely scaled the curtain they would have gained nothing; but, emerging from the tower, they were able to break open first a blocked postern-gate and then the great bridge-gate (see Map of Antioch facing p. 250); through these two entries the main body of the Franks poured in, and the place was won.

Once established in Syria, the Franks not only repaired the castles and city walls which the Moslems had left behind them, but erected an infinite number of new strongholds, varying in size from small isolated watch-towers to the most formidable fortresses of the first class, capable of holding garrisons of two or three thousand men. To trace the exact stages by which they perfected their military architecture is not easy, as most of the castles were being perpetually strengthened, and present now the appearance which they showed in the thirteenth century, when they finally fell back into Moslem hands and were dismantled or left to decay. The most perfect ruins, such as those of Markab and Krak-des-Chevaliers, do not therefore give us so much information as to the twelfth century as could be wished. To ascertain the earlier developments of Frankish architecture in the Holy Land, places must be studied which were surrendered to Saladin after the battle of Tiberias and never again were in possession of the Crusaders, such as Saona and Blanche-Garde (captured in 1187) and Kerak-in-Moab (surrendered in 1188).

An examination of such castles shows that in the twelfth century the two great principles of Byzantine military architecture—the defence of the curtain by towers and the construction of concentric lines of fortification—were thoroughly well understood and practised by the Frankish builders. The early strongholds differ from the later mainly by their want of finish and greater simplicity of detail. In the thirteenth century castles were built not only with more elaborate and ingenious defences,

[1] The first sixty combatants mounted by a rope ladder on to the curtain adjoining the tower which Firouz commanded. He led them from thence into the tower. Next some descended to break open the postern, while others pushed right and left along the curtain. They were so swift and silent that they were able to penetrate into the towers, whose doors were not closed, and to massacre their sleeping garrisons before the alarm was given. Masters of five hundred or six hundred yards of the enceinte, they could not be withstood.

34

but also with a certain regard to decoration and ornament. They show carvings, shields of arms, and occasional inscriptions, of which the buildings of the preceding age are destitute. But the general principles of construction are the same throughout the two centuries during which the Franks held their footing in Syria.

It was probably quite early in the time of the existence of the kingdom of Jerusalem that the crusading architects adopted and improved on the Byzantine models. The shell-keeps or square donjons with a plain towerless curtain-wall, which they had left behind them in the West, were so obviously inferior to the military architecture of the Levant that there was no temptation to reproduce them without an improvement. Thus a great change in the fundamental conception of the castle took place early in the twelfth century : instead of being considered as a keep provided with an outer wall, it becomes an enceinte with or without a keep as final place of refuge. Formerly the great donjon was the more and the outer wall the less important part in the scheme of defence. But now the main resistance was to be opposed by the enceinte with towers set in it at intervals, and the donjon was a last resort, to which the garrison only retired in desperate extremity. It might even be merely the greatest of the several towers of the enceinte. When King Amaury about 1165 erected the small but strong fortress of Darum on the borders of Egypt, he merely built a square enceinte with four large towers at its angles, of which one was larger than the others.[1] Though this served as a donjon, it only differed in size from the other three.

Another deviation from the old practice of the West was that the strongest tower was sometimes built not in the most secure and well-defended part of the castle, as a place of final refuge, but at the fore-front of the most exposed side of the fortress, so as to bear the brunt of the attack. In this case the keep, if keep we may call it, would be the first part of the place which would be assaulted by the besieger, and the first, perhaps, to fall into his hands. As an example of this kind of castle we may quote Athlit (Château Pèlerin), a castle built on a promontory,

[1] William of Tyre, xix. 19, describes it as "castrum modicae quantitatis, vix tantum spatium inter se continens quantum est jactum lapidis, formae quadrae, turres habens quattuor in angulis, quarum una grossior et munitior erat aliis." See Rey's *Architecture Militaire*, etc., p. 125, for its present state.

PLATE XXI.

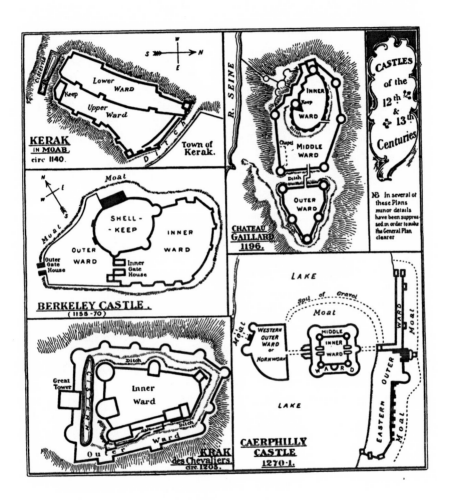

KERAK IN MOAB. circ 1140.

BERKELEY CASTLE. (1155-70)

CHATEAU GAILLARD 1196.

KRAK des Chevaliers. circ 1205.

CAERPHILLY CASTLE 1270-1.

CASTLES of the 12th & 13th Centuries

NB In several of these Plans minor details have been suppressed in order to make the General Plan clearer

where the main defensive structure consisted of two massive
towers connected by a short curtain and placed across the neck
of the promontory. Behind them, seaward, the rest of the castle
was only protected by an ordinary enceinte with a few small
towers. All the strength of the place lay in the two splendid
towers at the isthmus. But Athlit was built late (1218), and
must not be quoted as an example of twelfth-century archi-
tecture.[1]

 As a fair example of the strongholds which the Franks
erected after they had been seated for a generation in the Holy
Land, we may describe Kerak-in-Moab, the eastern bulwark of
the kingdom of Jerusalem, built about 1140 by Payn of Nablous,
the high-butler of King Fulk. It was only forty years in
Christian hands, and seems never to have been much altered
from its original shape. It stands on one of the two narrow
crests which connect the hill of Kerak with the mountains of
Moab. To east and west the slope of the crest is too steep to
be accessible: to north and south, where the danger is greater,
two enormous ditches have been hewn in the rock, so as to isolate
the castle from the rest of the ridge of which it forms part; they
were only to be crossed by narrow bridges removable in time of
war. The fortress consisted of a donjon in the south-east angle
of the oblong enceinte, and of an upper and a lower ward,
separated from each other by a strong wall. The northern front
of the castle was the most exposed: it consisted of a curtain
flanked by two large towers, which gave a lateral fire into the
ditch: the curtain contained at least two stages pierced with
loopholes. The only opening in it was by a gate close under the
western flanking tower: it was closed by a portcullis, and opened
not directly into the court of the castle, but into a long passage
between the curtain and a wall built at its back. Two more port-
cullises were placed at intervals in this passage, and it was only
after passing them that the court was reached. (See Plan facing
page 530.)

 Kerak-in-Moab proved utterly impregnable to all the attacks
of Saladin. Though repeatedly assailed, it was never harmed, nor
did the assailants even enter its lower ward. It held out for
many months after the battle of Tiberias, and only surrendered
when provisions had failed and all hopes of relief were
absolutely at an end (1188).

[1] All this comes from M. Rey's admirable and oft-quoted work.

It is safe to say that such a fine example of a fortress with a double line of defence could not have been built anywhere save in the East so early as 1140. Nothing approaching it for completeness of design was reared in England, France, or Germany till fifty years later, when Richard Coeur de Lion planned his famous Château Gaillard on the bluff above Les Andelys. Richard, we cannot doubt, was utilising his Eastern experience when he erected this splendid and complicated structure, whose arrangements pleased him so well that he boasted that "it might be held even if its walls were made of butter."

Nevertheless, the influence of Eastern military architecture began to be felt in the West not long after the first Crusade, though the Western builders worked on a smaller scale, and were for many years timid copyists of the crusading architects. The old type of the keep standing in a base-court girt by a plain curtain begins about 1130 or 1140 to develop into a more complicated structure. The enceinte wall becomes more important, towers are presently set in it, and the outer line of defence becomes less wholly subordinate to the keep. At the same time the keep itself ceases to depend entirely on its passive strength, and requires a gate-house, and a larger provision of loopholes.

In a few important castles, instead of building a mere shell-keep or rectangular keep, the architects of the wealthier barons began about 1140–50 to erect a more complicated central pile as the main feature of a new castle. At Alnwick, for example, the powerful Eustace de Vesey set on the ancient mound which he found there existing, not a shell-keep (such as his father would have built), but a circular cluster of towers enclosing an open court. His outer enceinte was also probably furnished with a few small towers, though these have been so reconstructed by thirteenth- and fourteenth-century holders of the place that it is difficult to be certain on the point.[1] The Tower of London, round which Rufus had drawn a plain curtain-wall,[2] began to be strengthened with towers under Henry II.[3] The Wakefield tower, oldest of those of its inner ward, seems to belong to that time; the others have been so pulled about by later kings, that it is impossible to attribute any of them with certainty to so early a date.

[1] See Clark's *Military Architecture*, etc., i. 176–185.
[2] See p. 522. [3] Clark, ii. 224.

It must not be supposed that the "adulterine" castles erected in Stephen's reign showed any such improvements. Built hastily by men of precarious fortunes, they were often mere walled enclosures, or at best rough shell-keeps. Hence it comes that they were so easily destroyed by Henry II., and that the majority of their sites exhibit very slight traces of masonry. Perhaps some may have been mere palisaded mounds of the ancient type. If they had been fitted with massive rectangular keeps of the first Norman model, or with the more complicated defences introduced from the East, they would undoubtedly have left far more solid ruins behind them.

By the end of the twelfth century the military architects of the West had learned their lesson, and were utilising everywhere the notions which had originally been borrowed from the Byzantines. Outer wards and fore-works begin to appear beyond the original curtain-walls; towers grow numerous and strong, and flanking fire is always provided to cover exposed fronts. It may be worth while to give a sketch of the strongest fortress of the day, in order to show the enormous advance which had been made since the first Crusade. Château Gaillard, as we have already had occasion to mention, was considered the masterpiece of the time. The reputation of its builder, Coeur de Lion, as a great military engineer might stand firm on this single structure. He was no mere copyist of the models which he had seen in the East, but introduced many original details of his own invention into the stronghold. It is therefore not exactly a typical castle of the last years of the thirteenth century, but rather an abnormally superior specimen of its best work.

Château Gaillard was placed in a splendid strategical position, covering Rouen from all attacks along the line of the Seine. By the aid of its outworks and the fortified bridge below, it completely blocked the main avenue of invasion from France. But it is with the castle itself, not with its dependencies, that we have to deal. Like so many mediæval strongholds, it lies on the end of a long spur of steep ground, connected only by a narrow neck with the hills behind. The slopes below it are so steep and lofty that it can only be attacked with advantage along the cramped front of the isthmus which joins it to the main block of the upland. Its fortifications are intended to oppose four successive lines of defence to an enemy advancing against the single accessible side. Thus it cannot be

called a "concentric" castle, though each of its wards dominates and commands that below it. The first of its defences is a lower ward or outwork at the narrowest point of the isthmus. This outwork forms an isosceles triangle, with its point facing toward the enemy. The acute angle at its apex is occupied by a great circular tower, which is flanked and supported by two other towers placed a little distance down the curtain. The brunt of the attack must therefore fall on these three towers and the short front of curtain between them. If the apex of the triangle was beaten in, the outer ward was lost, and the defenders could retire to the middle ward. This was separated from the outwork by a ditch thirty feet deep, crossed only by a single narrow causeway. Across the ditch lies the middle ward, which exposes to the enemy, when he has gained the outer ward, two massive towers joined by a curtain. Here lay the chapel and many other buildings, whose cellars only now remain. Placed within the northern half of the middle ward was the inner ward, to which King Richard had devoted special attention. Instead of composing it of towers connected by curtains, he constructed the whole wall in segments of circles, so that on a ground plan its outer defences present a scalloped shape. His idea was to give the enceinte all the advantages of towers without their heaviness, for the centre part of each scallop so advances as to command the space between it and the next segment. The general effect is as if he had cut towers into slices, and then placed the slices side by side along the steep edge of the hillside.

The donjon forms part of the western wall of the inner ward; it is not completely round, but has a broad spur projecting into the open court of the inner ward. It splays out towards the bottom—a device adopted both to give greater thickness to its base and to throw outward missiles dropped from its parapet. Moreover, it is furnished with machicolations, intended to command the foot of the wall; i.e. a series of corbels carry round it a narrow gallery with holes pierced in its floor, from which the defenders could shoot downwards, pour liquid combustibles on the enemy, or drop stones on him. This is a very early example of stone machicolation: the majority of builders at the time were only employing wooden galleries (brattices) projecting so as to overlook the ground below the wall. But it seems that stone machicolation was invented in the Holy Land, where large

timber was so scarce that the architects of the Crusaders were
forced to replace it by solid masonry.

It is interesting to note the methods by which Château
Gaillard was taken by Philip Augustus in 1204. King John
neglected it, and allowed it to stand or fall on its own resources
without making any vigorous attempt to raise the siege. The
French, therefore, were able to beleaguer it at leisure, and
employed six months in reducing it by formal siege-operations[1]
(September 1203–March 1204). The gallant governor, Roger
de Lacy, Constable of Chester, made an obstinate defence, but,
getting no help from outside, was bound to succumb in time.
King Philip appeared in front of the place in August 1203, and
captured the isolated defences in the neighbourhood lying out-
side the castle. He spent the autumn in erecting works of
circumvallation and contravallation round it, and in levelling a
platform opposite the apex of the outwork, from which he
intended to begin his attack. The French army lay within its
lines all the winter, fearing that, if it did not remain before the
place in force, King John would appear with a relieving army
and raise the blockade.

In February King Philip began the attack by erecting
military machines on the isthmus, and battering the great tower
at the apex of the outwork and the short curtains on each side
of it. He filled the ditch with rubbish, and then set miners to
burrow their way beneath the foundations of the masonry. They
finally succeeded in undermining part of the defences, which fell
in, leaving a breach:[2] through this the outer ward was stormed.
The garrison, much reduced by famine, were unable to hold
their ground, and retired to the middle ward. This line of
defence did not protect them very long: it fell, if Guillaume le
Bréton is to be believed, by a kind of escalade. In the south-
western angle of the ward lay the chapel, whose outer wall
formed part of the western front of the enceinte. Where the
chapel looked out on the cliff, which lies immediately below it,
there were some small windows not very far above the foot of
the wall. A little party of French crept along the cliff, and

[1] Elaborately described in the *Philippeis* of Guillaume le Breton, book vii.
[2] From G. le Breton, vii. 705–10, we should conclude that they got in by throw-
ing down the great angle tower; but Mr. Clark suggests that as that building shows
no signs of having been breached and repaired, it must have been the curtain next it
which fell in (Clark, i. 384).

succeeded in clambering into one of these windows, the first to mount pulling up his comrades. They found themselves in a crypt below the chapel: when they had entered they raised their war-cry, and at the same time the main body made a demonstration along the causeway against the gate of the middle ward.

The garrison, seeing enemies within the walls, and not realising their small numbers, did not exterminate the few men who had got in below the chapel, but hastily evacuated the middle ward and took refuge in the inner ward, the strongest of all the enceintes of the castle. The small party in the chapel then came out and admitted their friends. Philip now set to work to erect opposite the gate a perrière of unwonted size, which, as Guillaume le Breton says, was called a *Cabulus*.[1] While thus distracting the attention of the garrison, he advanced miners under cover of a large "cat," to sap the foot of the walls. This was successfully done, and then the perrière was set to work on the shaken masonry. Its discharges brought down a considerable mass of stone, and Philip bade his knights attempt to storm the breach. They would not in all probability have succeeded had not the defenders been reduced to great extremities by hunger. There only remained twenty knights and a hundred and twenty men to guard the breach; they failed to hold it, and then (if Matthew Paris may be trusted), instead of retiring into the donjon, tried to cut their way out by the postern-gate and to escape into the open. In this they failed, and were all taken prisoners. (March 6, 1204.)

The real work in this siege, it will be seen, was done by the miners: it was they who broke two of the lines of defence, while the third was taken only by the unlikely chance of an escalade. The siege-engines only contributed an inconsiderable part to the main result: the "Cabulus" might have battered for ever at the scalloped walls of the inner ward if the way had not been prepared for it by the pick of the engineers.

Rounded keeps like that of Château Gaillard were just commencing to supersede the old square Norman shape when Richard built his great castle. The probable reason for their adoption was that such a shape is better adapted to resist the battering-ram, and even the miner's pick, than a rectangular

[1] Guillaume le Breton, vii. 805. Is this strange word short for Catabulus, and equivalent to Catapult (catapulta)? Or is Viollet-le-Duc's derivation from *cable* correct?

structure, where the corners are the vulnerable point. The last square keep built in England was that of Helmsley in Yorkshire, reared about the year 1180.[1] In the next century the circular donjon is universal. The best specimen on this side of the Channel is Coningsborough, but on the Continent there were far larger and loftier structures. Not unfrequently these thirteenth-century donjons are not exactly round, but have a projecting spur on one face, looking towards the direction from which attack was most probable. The great towers of Château Gaillard and Coucy both show this feature.

While gaining in solidity by ceasing to be square, the donjon did not profit in all respects. When the outer defences had fallen and the garrison had taken refuge in their last stronghold, they had an even smaller power of concentrating their fire from the loopholes of a round structure than from those of a rectangular one, and there was a greater difficulty in commanding any given spot at the actual foot of the wall. The passive strength of the building was still, it would seem, its chief protection, not the rain of missiles which it could direct on the besieger. But by this time the main line of resistance was far outside the donjon: when the defenders had retired to it they were drawing to the end of their hopes, and, unless relief arrived from friends outside, were unlikely to hold out for much longer. There were many sieges in which the garrison gave in when the inner ward fell to the enemy, and did not care to protect the game by defending the donjon when all chance of success was over. It is noticeable that in the great series of sieges 1268–91, which ended the domination of the Christians on the Syrian coast, nearly all the castles surrendered very shortly after their second line of defence was pierced, without any serious attempt being made to hold out in the donjon or (where no donjon existed) in the innermost ward. Such was the case at Beaufort (1268), Krak-des-Chevaliers (1271), Montfort (1271), and Margat (1285). Even the tremendous tower which forms the core of the complicated fortification of Château Gaillard fell, as we have already seen, at the same time that the inner ward was stormed by the knights of Philip Augustus. By the thirteenth century the feature of the castle which was originally all-important had sunk to a secondary place in the scheme of defence. In some of the Syrian castles, as we have

[1] See Clark's *Military Architecture,* i. 138.

already seen, the architect had so far ceased to think of it as a secure place of final refuge, that he placed it in the forefront of the structure to break the first vigour of the besieger's assault.

It was reserved for the thirteenth century to bring to perfection the development of castle-building by the invention of the concentric type of fortress. The places which we have hitherto been considering, such as Kerak-in-Moab or Château Gaillard, are not rigidly and logically concentric; although they oppose a series of barriers to the assailant. Each enceinte in them is not wholly surrounded by that lying below it; the outer ward does not entirely encompass the inner, nor the inner the donjon. The latter may be set in one of the exterior walls of the stronghold, and the inner ward may be placed against the side of the outer, and not within it. The only idea of the architect was to fit his buildings upon the ground that lay before him in such a way that it was reasonably probable that the assailant would have to deal with the lower lines of defence before he could get at the core of the castle. It was conceivable that an enemy who attacked on an unlikely front and in an unexpected manner might gain possession of the donjon or the inner ward without having first to deal with the front line of defences.[2] In such a case the latter would of course prove useless.

To guard against such chances as this, the only possible resource was to make the castle absolutely concentric, i.e. to place each ward so completely within the next that the besieger could not conceivably reach the centre point of the defences without having worked through every one of the exterior lines. A system of fortification embodying this principle appears in the Levant very early in the thirteenth century; there is some reason to think that it was first put in practice after the terrible earthquake of May 20, 1202, which threw down great portions of nearly all the fortresses occupied by the Syrian Franks.[3] At

[1] See p. 531.

[2] To take a modern example: Wellington in 1812 failed in his main attempt to storm the breaches in the enceinte of Badajoz, but succeeded in escalading the castle by a secondary attack. The castle commanded the town wall, which had therefore to be abandoned, though it had been maintained against all the desperate onsets of the main storming columns.

[3] Tortosa alone is said to have escaped unharmed. But even Tortosa shows much thirteenth-century work, and is planned on the concentric style, and many of the details of its architecture show distinct thirteenth-century features. No doubt the Templars rebuilt it on the newest lines during the early thirteenth century. The rectangular keep, however, belongs to the previous age.

any rate, the majority of the thirteenth-century castles of the East show an attempt to reach this ideal which we do not find so clearly visible in those which belong to the previous age. Most of the strongholds which show, by their well-developed pointed architecture, their display of architectural ornament, and their stone machicolation, that they belong to the later half of the crusading period, are distinctly of the concentric type. Krak-des-Chevaliers, Chastel-Bland (Safita), and the castle of Tortosa are good examples—the last only differing from the other two in that one of its sides rests on the sea. At the first-named fortress the outer ward is so thoroughly separated from the inner that a wet ditch divides them for a great part of their extent. (See Plan facing p. 530.) At the last-named the outer ward, the middle ward, and the donjon each has a ditch of its own, wholly cutting it off from the line of defence immediately beyond it.

It was not till much later in the century that the concentric castle became common in Western Europe. English writers on architecture have often styled the type "Edwardian," because some of the best specimens of it in this island were built by the Greatest of the Plantagenets. But the name is inappropriate, as the earlier examples of the system go back to the reign of Henry III.: the Tower of London became a very perfect instance of a concentric castle when that monarch added to it its outer ward, between the years 1240 and 1258. Caerphilly, too, the largest and most imposing example of its class, was completed a year before King Edward came to the throne. To say, therefore, that he brought the design back from the East after his crusading tour in 1270 is obviously absurd. It was used in England, and still more on the Continent, long before that date. The Emperor Frederic II., a great builder of castles in his unruly Italian dominions, sometimes employed it in the latter half of his reign (1230-50). Carcassonne, as remodelled by St. Louis about 1257-65, is practically concentric, the outer enceinte completely surrounding the inner; only, the fact that the castle forms part of the outer wall of the inner enceinte prevents it from being a perfect example of the type.

Among the castles on our own side of the Channel, Beaumaris, Caerphilly, and the Tower of London are absolutely complete examples of the style. Harlech and Kidwelly are for all intents and purposes concentric, though in each of them for some short fronts of wall the defences of two of the wards are

blended, and only two lines of resistance presented to the assailant. It is to be noted that in all these strongholds, save the Tower of London, there is no longer any donjon. The final refuge of the garrison is not a massive keep standing alone, but a quadrangular enclosure guarded by several towers, which forms the inner ward of the castle. If the Tower of London forms an exception, it is only because Henry III. found the old Norman keep already existing: if he had been building on new ground, he would have made the inner ward the last core of his fortress.

Caerphilly is worth describing as the grandest specimen of its class. It has failed to meet with the fame which its splendid architecture should command, because no great historical memories cluster around it. The Marches of South Wales were completely reduced to order just after it was built, and so it never endured a siege in the Middle Ages,[1] and was only once assailed in the whole of its history—when wrecked by the Parliamentarians in 1648.

The castle was erected by Gilbert de Clare, Earl of Gloucester and lord of Glamorgan, and was finished about 1271. It stands on a mound of gravel, in an artificial lake formed by damming up two watercourses and turning a marsh into a sheet of water. The inner ward consists of a quadrangular enclosure flanked by four large round towers at its corners, and with massive gate-houses rising above the curtain in the midst of its east and west fronts. Completely encircling the inner ward is the middle ward, a narrow space bounded by a curtain-wall much lower than that of the inner ward, and commanded by it at every point. Its corners are low semicircular bastions, into which the towers of the inner ward look down. The middle ward is encompassed by the lake on every side: the only access to it from the shore is given by two causeways in its eastern and western fronts: each of these passages is broken in the middle by a wooden drawbridge, which could be removed at will. A curious spit of gravel (see the plan facing p. 530) separated the moat from the main lake on the northern side of the middle ward, but does not seem to have been properly connected at either end with the outer ward.

[1] Unless some obscure allusions to "William de la Zouche and his accomplices who are molesting the castle of Caerphilly" in 1329 (Rymer, Foedera, iii. 755) be taken to imply that there was an actual siege under Edward III.

Beyond the bridges we come to the outer ward, which is composed of two separate works of very unequal size, each destined to play the part of a tête-du-pont. The eastern and smaller defence is a hornwork forming an irregular pentagon with a curtain fifteen feet high. It is completely surrounded by a moat of its own, and the only approach to it is through two strong gatehouses. Its sides run back to the lake, so that it forms an island, joined to the inner ward at one side and the open country at the other by well-guarded bridges.

The western outer ward is a much more important and imposing structure. It partakes, like the hornwork to the east, of the nature of a tête-du-pont, both of its ends touching the water of the lake, while its middle portion projects towards the open country. This central and salient section of the work consists of a great gatehouse-tower, forming the main approach to the castle : from each side of it curtains run north and south till they touch the brink of the lake. The northern curtain, which is absolutely straight, terminates in two strong square towers set side by side at the water's edge. The southern curtain, on the other hand, curves back considerably at its end, and terminates in a group of three towers where it reaches the water. The outer ward has a moat of its own, communicating with the lake at each end. It is cut in two by a dividing wall, so that, if its northern end fell, the southern could still be maintained, and *vice versâ*.

Thus an enemy attacking Caerphilly either by the eastern or the western face (the northern and southern are rendered inaccessible by the lake) would have had to cross two moats and three lines of wall before he could make an end of the garrison's power of resistance. It is small wonder that the place was never assailed—much less taken—in the days before gunpowder became the ruling power in war.

It is obvious that concentric castles could only be built in situations where there was room to develop their special form of strength. On the open ground, on islands, or on plateaux of considerable breadth they might well be erected. But it was impossible to place them upon long narrow sites, such as the crests of hills or the ends of rocky spurs. Where breadth was not obtainable, it was only feasible to set ward behind ward, the outermost facing the normal approach, the innermost receding as far as possible from it. Edward I. showed at

Harlech and Beaumaris that he fully appreciated the merits of the concentric system, but, when he had to build castles on sites which were not of sufficient lateral extent, he merely placed his wards one behind the other, each covering the full breadth of the crest which they crowned. Caernarvon, for example, resembles an hour-glass or a figure-of-eight in shape. The lower ward and the upper are connected only by a broad and lofty gatehouse-tower. Conway, built at the steep end of a promontory, is a parallelogram divided by a cross-wall into a lower and larger and an upper and smaller section. It has also, it must be mentioned, a very elaborate system of gate defences projecting from the lower ward towards the town, which it dominates. Where cliff or water sufficiently protect three sides of a castle, the advantages of the concentric system were practically secured by wards placed one behind the other, each commanding that below it, and all facing towards the one point whence attack is to be feared. It is obviously unnecessary to pile wall on wall upon fronts where the enemy cannot possibly appear. Conway and Caernarvon, therefore, resemble Château Gaillard rather than Beaumaris or Harlech, merely because they are set in positions similar to that of the great Norman fortress, where only one front needs serious defence and the rest are protected by the strength of their sites.

With the concentric castle we have reached the final development of the military architecture of the Middle Ages. There was to be no further change of importance, till the introduction of gunpowder in the first half of the fourteenth century introduced an entirely new factor into the art of war, and began to turn in favour of the offensive the advantage which the defensive had hitherto enjoyed. In 1300 we leave the balance still inclined to the defender: the art of building strongholds had improved during the last two centuries far faster than that of destroying them. Siegecraft had made notable advances since the simple days of the first Crusade, but its developments always lagged behind those of military architecture. There was a limit to the mechanical application of the three powers of torsion, tension, and the counterpoise, on which the engineer had to rely when constructing his siege-artillery. If he tried to gain increased force by enlarging the size of his machines, they not only grew too costly, but became hopelessly unwieldy and slow in their action. If, on the other hand, he tried to prevail

by increasing their number, it was impossible, on account of
their short range and great bulk, to concentrate the fire of a
large quantity of them on a single piece of wall.

The artillery and siege engines of the twelfth and thirteenth
centuries were, with one important exception, the same in gene-
ral character as those of the previous age, with which we have
dealt in the sixth chapter of our Third Book. Many improve-
ments in detail were made, but only one notable introduction
of a new principle. This was the invention of machines worked
by counterpoises, the chief of which was the Trebuchet. This
engine did not depend for its power on either torsion or tension,
but on the sudden releasing of heavy weights. It consisted of
a long pole, balanced on a pivot supported by two uprights at
about one quarter of the distance between its butt end and its
point. The longer part was pulled down to the ground, and
the missile was placed either in a spoon-shaped cavity in its end
or in a sling attached to it: it was held down till the moment
of discharge by ropes or wooden catches worked by a winch.
Meanwhile, the shorter part of the pole at its butt end was
loaded with heavy weights of iron or stone, attached to it in a
sort of box or basket or permanently bound to it with cords.
The heavy weights would have dragged down the butt of the
pole to the ground if the small end had not been already fixed
back by its catches. When these were suddenly released, the
counterpoise at the other end of the pole was able to act: it
dropped suddenly, and tossed the thin end and the missile
attached to it into the air. The stone flew off in a great parabolic
curve, like that of a bomb from a modern mortar.

By the end of the thirteenth century several kinds of trebuchets
were in use, all built on the same principle, but differing
slightly in the way in which the weights were worked. Egidio
Colonna, who wrote his treatise *De Regimine Principum* for the
young Philip the Fair of France somewhere about the year
1280, gives four varieties. The first has a fixed counterpoise,
composed of boxes filled with earth, sand, stones, or iron.
The second, which he calls *biffa*, has a movable counterpoise,
which is shifted closer to or farther from the butt of the pole,
according as the engineer wishes to lengthen or shorten the
distance to which he intends to discharge his missile. The
third has one fixed counterpoise at the butt, and another
movable one which can be made to slide up and down the

beam: this gave a greater power of exact shooting than either of the first two forms of the machine. It was called the *tripantum*. In the fourth (which is not properly a trebuchet at all) the place of the counterpoise was taken by a number of ropes destined to be pulled down by the main force of men's arms. This device was inferior in accuracy and force to the other three, but had the one advantage of being easily transportable: it was the counterpoises which made the other shapes so heavy and so difficult to move. The light machine could be moved about from place to place, and set to batter a new point of the wall before the enemy could make any provision against it by erecting counter-machines or strengthening the fortification of the assailed point. The trebuchets generally discharged stones, but not unfrequently they were used to throw pots or barrels of combustible material, destined to set fire to the brattices or roofs of towers, or to start a conflagration in the town which they were employed to bombard.[1]

Egidio Colonna calls all these shapes of the trebuchet by the general name of *petrariae* (perrières), but that word is not unfrequently used in the thirteenth century for other machines working by the older principles of tension or torsion rather than by counterpoises. Many chroniclers call every machine that casts stones a perrière, whether it was of the older mangon type or the newer trebuchet type. Where we find the names of mangonel and perrière mentioned together after 1200, the latter generally means the trebuchet: it was obviously a more powerful engine than the mangon. Guillaume le Breton, describing the missiles discharged at the siege of Château Gaillard, writes—

"Interea grossos petraria mittit ab intus
 Assidue lapides, mangonellusque minores," (*Ph.* iii. 673, 674).

But when *petraria* occurs in writers of the twelfth century, before the trebuchet and its counterpoise had been invented, we must evidently look for another meaning to the word. As *petrariae* and *mangana* are sometimes found mentioned together,[2] it is evidently not the same as the latter. Not improbably it was the machine with beam and pivot, but without counterpoise, worked with ropes and the force of men's arms, which Egidio

[1] *De Regimine Principum*, iii.
[2] See General Köhler's *Kriegswesen*, etc. iii. 164–166.

Colonna describes (somewhat illogically) as the fourth kind of trebuchet in the passage which we have just been quoting from his work.

As another example of the hopeless way in which the nomenclature of military engines was confused by the chroniclers, we may mention the passage in Otto of Freising, where he calls the mangon a kind of balista. The balista, as will be remembered, was properly the machine working by tension and throwing darts, while the mangon worked by torsion and cast stones. But Otto chooses to use *balista* in the widest sense for "military engine" at large. He says that a stone cast "vi tormenti e balista quam modo mangam vulgo dicere solent" fell into the midst of the beleaguered town of Tortona, and, splitting into fragments against a wall, killed three knights, who were taking part in a council of war before the cathedral door[1] (1155).

A careful examination of the confused terms of the writers of the twelfth and thirteenth centuries shows that under the great variety of words which they employ only three or four kinds of machines are really concealed. In the twelfth century the balista or catapult of the original sort, working by tension and throwing shafts rather than balls, is known, but not so frequently employed as engines working by tension and casting heavy stones. In the thirteenth, on the other hand, the mangon is no longer so prominent, but is largely superseded by the more powerful trebuchet. At the same time the original balista-catapult of the crossbow type comes to the front again ; it was largely used by the Emperor Frederic II. in his Italian wars. About the end of the century it receives the new name of *springal* (*espringale*), and is found mounted on wheels and used in battle as a sort of light movable artillery.[2] It was nothing more than a large arbalest whose cord was pulled back by winches, and hence it is sometimes called merely a *balista de turno*.

Before leaving the subject of military engines, we must make some mention of Greek fire, an appliance which the nations of Western Europe never seem to have thoroughly understood, but which was not unfrequently used against them by the Byzantines

[1] Otto of Freising, *Gesta Friderici*, ii. § 16, p. 123.

[2] As, for example, in the battle of Mons-en-Pevéle, where Philip the Fair used two in the open field against the Flemings. See General Köhler's *Kriegsgeschichte*, iii. 189.

35

and the Moslems. It was invented, we are told, by a Syrian architect named Callinicus of Heliopolis about the time of the great siege of Constantinople by the Saracens in 673. Callinicus fled to Constantine Pogonatus, and put his device at the disposition of the emperor. It was a semi-liquid substance, composed of sulphur, pitch, dissolved nitre, and petroleum boiled together and mixed with certain less important and more obscure substances. Constantine fitted fast-sailing galleys with projecting tubes, from which this mixture was squirted into hostile vessels. When ejected, it caught the woodwork on which it fell and set it so thoroughly on fire that there was no possibility of extinguishing the conflagration. It could only be put out, it is said, by pouring vinegar, wine, or sand upon it. The combustible was successfully used against Saracen fleets by Constantine in 673 and by Leo the Isaurian in 718.

Leo the Wise directs that every war-vessel should have a brazen tube at its prow, protected by a solid scantling of boards, from which "prepared fire with thunder and smoke" is to be shot at the enemy.[2] But he does not give any account of its ingredients—the composition was a great State secret, not to be committed to paper. He also suggests that jars of the substance should be cast into the enemy's ships from above, "so that they may break out into flames," and adds that his officers "may also use the other device of little tubes discharged by hand from behind iron shields, which are called 'hand-tubes,' and have lately been manufactured in our dominions. For these can cast the 'prepared fire' into the faces of the hostile crews."[3] We could wish for a better description of these small weapons, which were presumably some kind of blow-pipe easily worked by a single man. They are probably constructed on the same principle as the devices used by the Byzantine garrison of Dyrrhachium against the Normans in 1108, which Anna Comnena describes as having been long hollow tubes[4] filled with a powder composed

[1] They are called by Theophanes δρόμωνες σιφωνοφόροι.

[2] Leo calls it (xix. 51) τὸ ἐσκευασμίνον πῦρ μετὰ βροντῆς καὶ καπνοῦ.

[3] Χρήσασθαι δὲ καὶ τῇ ἄλλῃ μεθόδῳ τῶν διὰ χειρὸς βαλλομένων μικρῶν σιφώνων ὄπισθεν τῶν σκουταρίων σιδηρῶν κρατουμένων, ἅπερ χειροσίφωνα λέγεται. Ῥίψουσι γὰρ καὶ αὐτὰ τοῦ ἐσκευασμένου πυρὸς κατὰ τῶν προσώπων τῶν πολεμίων (Leo, xix. 57).

[4] Ἀπὸ τῆς πεύκης . . . συνάγεται δάκρυον εὔκαυστον. Τοῦτο μετὰ θείου τριβομένον ἐμβάλλεται ἐς αὐλίσκους καλάμων καὶ ἐμφυσᾶται πυρὰ τοῦ παίζοντος λάβρῳ καὶ συνεχεῖ πνεύματι, καθ' οὕτως ὁμιλεῖ τῷ πρὸς ἄκραν πυρὶ καὶ ἐξάπτεται καὶ ὥσπερ πρηστὴρ ἐμπίπτει ταῖς ἀντιπροσώπον ὄψεσι (A. C. xii. § 3, p. 189).

of resin mixed with sulphur, which shot out in long jets of flame when a strong continuous blast was blown down the tube, and scorched the enemies' faces like a lightning flash.

The Greek fire was of course a much more complicated and formidable substance than the simple mixture employed by the defenders of Dyrrhachium. How it was used may be gathered from a description of a sea-fight with the Pisans given by Anna in her eleventh book. She says that her father, knowing that the enemy were skilled and courageous warriors, resolved to rely on the use of the device of fire against them. He had fixed to the prow of each of his galleys a tube ending in the head of a lion or other beast wrought in brass or iron, "so that the animals might seem to vomit flames." The fleet came up with the Pisans between Rhodes and Patara, and, pursuing with too great zeal, did not attack in a body. The first to reach the enemy was the Byzantine admiral Landulph, who shot off his fire too hastily, missed his mark, and accomplished nothing. But Count Eleëmon, who was the next to close, had better fortune: he rammed the stern of a Pisan vessel, so that his prow stuck in its rudder chains. Then, shooting fire, he set it in flames, after which he pushed off and successfully discharged his tube into three other vessels, all of which were soon in a blaze. The Pisans then fled in disorder, "having no previous knowledge of the device, and wondering that fire, which usually burns upwards, could be directed downwards or to either hand at the will of the engineer who discharges it."[1] That the Greek fire was a liquid, and not merely an inflammable substance attached to ordinary missiles, after the manner used with fire arrows, is quite clear from the fact that Leo proposes to cast it on the enemy in fragile earthen vessels which may break and allow the material to run about, as also from the name πῦρ ἔνυγρον, "liquid fire," which Anna uses for it.[2]

The Moslems are found in possession of Greek fire in the end of the twelfth century. The story of the Damascene engineer at the siege of Acre who burnt all the siege-machines of the Crusaders in 1190 is well known. He flung jars of the fluid on the "beffrois" and other structures which the Franks had reared against the walls, and wherever the vessels broke there arose an inextinguishable conflagration. The author of the *Itinerarium Regis Ricardi* describes the substance as "oleum incendiarium,

[1] Anna, xi. § 10. [2] Anna, xiii. § 3, p. 192.

quod vulgo Ignem Graecum nominant,"[1] and says that it could only be put out by sand or vinegar. He adds that it stank abominably, burned with a livid flame, and did not go out even if it fell on stone or iron, but continued to blaze up till it was consumed. Joinville, who saw St. Louis' machines and "cat-castles" destroyed by it at Mansourah, says that it was discharged by the Saracens both from perrières and from great arbalests. "It was like a big tun, and had a tail of the length of a large spear: the noise which it made resembled thunder, and it appeared like a great fiery dragon flying through the air, giving such a light that we could see in our camp as clearly as in broad day." When it fell it burst (presumably the fragile vessel containing it was shattered), and the liquid ran along the ground, burning in a trail of flame, and setting fire to all that it touched. Its progress could only be stopped by smothering it with sand.[2] All this description applies only to the fire cast from the perrières; that discharged from arbalests cannot, of course, have been thrown in the same way. Apparently tow or some such substance must have been soaked in the oil and then fixed to the arbalest bolt. The latter would lodge itself in the wood of the French machines, and then the flaming substance attached to it would lick up the boards. Such a device must have been much inferior in effect (owing to the small quantity of the blazing material which a bolt could carry) to the large jars hurled from the sling of the perrière.

Having dealt with the artillery of the twelfth and thirteenth centuries, we must turn to the other siege-appliances of the age. For the most part they are only perfected types of the machines of the previous age. The movable tower and the penthouse are still the most notable of the structures employed. The latter, under the name of *cat* (less frequently *sus* or *vinea*), is the invariable concomitant of every siege of the time; it was still, in its essential form, nothing more than the wooden framework of the earlier centuries, but as carpenters grew more skilful it became a stouter and stronger building. Its front parts were even faced with iron plates to keep off combustibles, and the timbers of its roof were made more and more solid as the projectiles of the improved machines grew heavier. A variant of it was the "cat-castle," such as St. Louis used in Egypt in 1249, where the penthouse was combined with a tower built

[1] *Itin.* i. 81. [2] Joinville, ii. 407.

above it. The latter was filled with archers or arbalest men, who tried to keep down the fire of the enemy, while the men below in the penthouse continued to work at filling the ditch or breaking down the wall which was opposed to them.

The movable tower (generally called *beffroi, berefredum, belfragium*) is more prominent in the twelfth than in the thirteenth century. It is unnecessary to give lists of the innumerable sieges at which it was employed in West and East, from Bohemund's siege of Dyrrhachium in 1108 to the great leaguers of Acre in 1189-90 and Château Gaillard in 1204. In the succeeding age it was less used than the mine: apparently the improvement in combustibles had made the towers more liable than ever to the danger of fire; Coeur de Lion before Acre had even been driven to the costly expedient of coating his beffrois with iron plates. At any rate, the device does not play any great part in the later sieges of the thirteenth century.

The art of mining, on the other hand, which, though always known,[1] had not been very much practised before the twelfth century, was at its prime in the thirteenth. There is hardly a siege in which it does not appear; only when a castle was built on solid rock was it difficult to use. Even then the assailants would advance their "cats" to the foot of the wall and endeavour to pick out stones, if they could not actually undermine the fortifications. The garrison, if they ascertained that the enemy was mining, would try the effect of counter-mines, and, when the line of approach had been discovered, would break into it, slay the miners or smoke them out, and break down their works. The counter-mine is found as early as the mine, *e.g.* at the sieges of Dyrrhachium (1108) and Tortona (1155). For an elaborate instance of the employment of the device both by besiegers and besieged, the often-quoted document relating to the siege of Carcassonne (17th September to 11th October 1240) may be cited.[2] William des Ormes, the seneschal of the city, reports to the regent, Queen Blanche, that the rebels under Reginald Trencaval, Viscount of Béziers, after finding that their

[1] We have seen it used by the Danes at Paris (p. 142), and by William the Conqueror at Exeter (p. 134). Bohemund employed it largely in 1108, at his siege of Dyrrhachium. Yet that it was not very frequently tried seems to be shown by the passage in Otto of Freising, where in 1155, at Tortona, Frederic Barbarossa "inusitato satis utens artificio, cuniculos versus turrim Rubeam per subterraneos meatus fieri jubet" (O. F. ii. § 16, p. 124).

[2] From the document in the *Bibliothèque de l'École des Chartes*, ii. 2. p. 372.

siege-artillery availed them little, set to work to mine. Carcassonne was then only defended by the ancient Roman or Visigothic works and an outer enceinte of palisading (*lices*). Its elaborate later works had not been added.

"The rebels," writes the seneschal, "began a mine against the barbican of the gate of Narbonne. And forthwith, we, having heard the noise of their work underground, made a counter-mine, and constructed in the inside of the barbican a great and strong wall of stones laid without mortar, so that we thereby retained full half of the barbican, when they set fire to the hole in such wise that the wood having burnt out, a portion of the front of the barbican fell down.

"They then began to mine against another turret of the *lices*; we counter-mined, and got possession of the hole which they had excavated. They began therefore to run a mine between us and a certain wall and destroyed two embrasures of the *lices*. But we set up there a good and strong palisade between us and them.

"They also started a mine at the angle of the town wall, near the bishop's palace, and by dint of digging from a great way off they arrived at a certain Saracen [1] wall by the wall of the *lices*; but at once, when we detected it, we made a good and strong palisade between us and them, higher up the *lices*, and counter-mined. Thereupon they fired their mine and flung down some ten fathoms of our embrasured front. But we made hastily another good palisade with a brattice upon it and loopholes; so none among them dared to come near us in that quarter.

"They began also a mine against the barbican of the Rodez gate, and kept below ground, wishing to arrive at our walls, making a marvellous great tunnel. But when we perceived it we forthwith made a palisade on one side and the other of it. We counter-mined also, and, having fallen in with them, carried the chamber of their mine."

After this, abandoning mining, the assailants tried to storm the barbican below the castle. The assault failed, and a week later, news arriving that an army of relief was close at hand, the rebels abandoned their lines and retreated.

We have already had occasion to mention the use of the

[1] *i.e.* Ancient Roman or Visigothic. All walls in the south of France were often ascribed to the short-lived occupation by the Saracens in the eighth century. In this case it must have been an outwork rather than the main wall of the city.

mine in English sieges of the thirteenth century—as at Rochester
by King John in 1214, and at Bedford against the adherents of
the turbulent Fawkes de Bréauté in 1224. There is in our history,
however, no such example of complicated mining and counter-
mining as that of the siege of Carcassonne. In the Levant, on
the other hand, mines come prominently to the front, during the
sieges of the last crusading strongholds by the great Mameluke
sultans of Egypt. How thoroughly their power was recognised
may be shown by the incidents of the fall of Markab in 1285.[1]
Sultan Kelaun having taken the outer defences, the knights of
St. John, to whom the fortress belonged, retired into the inner
enceinte. The Egyptians next set to work and mined a section
of the curtain; they brought down part of a tower and made a
practicable breach, which they then attempted to storm. The
knights repulsed the assailants with great loss and barricaded
the breach. Kelaun then set the miners to work again, and in
eight days succeeded in driving a gallery right under the great
tower. He then summoned the garrison to surrender, offering
to allow them to send engineers to survey his mine before making
their answer. The knights accepted the proposal, and their
envoys inspected the works and reported to the governor that
the firing of the mine must certainly be fatal. Thereupon the
Hospitallers surrendered on terms, quitting Markab with their
horses, baggage, and treasure, and retiring to Acre.

General Considerations on Fortification and Siegecraft, 1100–1300.

We have already had occasion to remark (p. 378) that the
ascendency of the defensive over the offensive in the matter of
siegecraft is the main reason for the fact that the twelfth and
thirteenth centuries show comparatively few engagements in the
open field when compared with other ages. The weaker side
was always tempted to take shelter behind its walls rather than
to offer battle. With modern standing armies such strategy
would be faulty, since the combatant who renounces all attempts
to take the offensive must almost inevitably fail in the long-run.
But in the Middle Ages a feudal host could only be kept together
for a few weeks, and a mercenary host was so costly that many
princes could not afford to purchase its services. Hence a city
or castle might hope to tire out the patience or the resources of

[1] See the Arabic authors (Ibn-Ferat, etc.) quoted in Rey's *Architecture Militaire
des Croisés*, pp. 36, 37.

its besiegers, long before its own inevitable fall by famine came about. A ruler who was both obstinate and wealthy, and did not disband his men at the approach of winter, might be certain of attaining his end—like Philip Augustus at Château Gaillard. But men of Philip's type and provided with Philip's resources were rare.

It is the number and strength of the fortified places of Europe which explains the futility of so many campaigns of the period. A land could not be conquered with ease when every district was guarded by three or four castles and walled towns, which would each need several months' siege before they could be reduced. Campaigns tended either to become plundering raids which left the strongholds alone, or to resolve themselves into the prolonged blockade of a single fortified place. A narrow line of castles might maintain its existence for scores of years against a powerful enemy, as did the crusading fortresses of the Levant during the whole course of the thirteenth century. This is the most notable instance of such a resistance during the whole of the age, for the Mameluke sultans were formidable foes, furnished with inexhaustible resources and utilising the best engineering methods of the day. After three generations of incessant strife they ultimately achieved their end when crusading energy ran low, and after a long series of leaguers had broken the Christian line of defence at many points. At last the final departure of the Franks was the result of despair; they resigned the game because they were certain that no more help was to be expected from the West. It will be remembered that, even after Acre fell in 1291, there were still isolated strongholds of formidable strength in the hands of the Crusaders; but they evacuated the triple concentric enceintes of Tortosa and the sea-girt castles of Athlit and Sidon because their hearts failed them, and they judged it useless to protract the inevitable end.

Similar chains of castles, when used against more barbarous foes destitute of perseverance and unprovided with the resources of engineering, almost always achieved their purpose, and held firm. We need only mention the line of forts which held the English Pale in Ireland, and the "burgs," by which the Teutonic knights first subdued and then held down the warlike savages of Prussia.

It is of course possible to overstate the superiority of the defensive in the days before the invention of gunpowder.

Towns and castles often fell, not only by treachery or faint-heartedness, but before open force. Weak situations or ill-designed and ill-built walls might prove fatal. A garrison too weak to hold a long front might be crushed by the easy expedient of simultaneous escalades directed against many points at once. A very large and well-provided besieging army might by the mere multitude of its crossbowmen and the incessant use of its military engines wear down the defenders of a post. There is a limit to the power of fortification, and a commander reckless of the loss of life and possessing a measureless superiority of numbers might often win his desire. Such was the explanation of many of the successes of the Mameluke sultans over the castles of the Levant. A hundred men, unless placed in a strong-hold of exceptional natural strength, cannot resist ten thousand. But if they are crushed, their failure does not in the least vitiate our general statement that the defensive had an enormous advantage over the offensive in the age with which we have had to deal. Otherwise, we should have to acknowledge that the victory of Zulus over a British battalion at Isandhlwana proved that the Martini-Henry rifle had no advantage over the assegai.

The thesis which we have asserted merely lays down the rule, that with any reasonable proportion of resources between the besiegers and the besieged, it was the latter who during the early Middle Ages had the best chance of success. Hence come two of the main characteristics of these centuries—the long survival of small States placed among greedy and powerful neighbours, and the extraordinary power of resistance shown by rebellious nobles or cities of very moderate strength in dealing with their suzerains. These features persist till the invention and improve-ment of artillery made the fall of strongholds a matter of days instead of months. In the fourteenth century the change begins, in the fifteenth it is fully developed, in the sixteenth the feudal fastness has become an anachronism. The great Earl of Warwick battering Bamborough to flinders in a week (July 1464), and Philip of Hesse beating down Sickingen's eyrie of Landstühl, the strongest feudal castle of the Rhineland, in a single day (April 30, 1523), give us the landmarks of the end of the ancient predominance of the defensive on this side of the Channel and beyond it.

BOOK VII

ENGLAND AND SCOTLAND, 1296–1333—
DEVELOPMENT OF THE LONGBOW

CHAPTER I

ENGLAND AND SCOTLAND, 1296-1328—DEVELOPMENT OF THE LONGBOW.

DOWN to the time of Edward I. we may roughly say that all the fighting in which English armies had been engaged had fallen into one of two categories. The larger part of the wars had conformed to the ordinary continental type of the day, and had been waged mainly by mailed horsemen, the infantry only appearing as an auxiliary arm of no very great efficiency. Such had been all the English wars with France, and all the civil wars from Lincoln to Evesham. The other class of war had been waged against irregular enemies such as the Welsh and Irish, who lurked in hills or bogs, generally refused battle, and were only formidable when they were executing a surprise or an ambuscade. Campaigns against them had been numerous, but had affected the English art of war no more than Soudanese or Ashantee expeditions affect the military science of to-day.

The reign of Edward I. forms a landmark in the history of the English army, as showing the first signs of the development of a new system of tactics on this side of the Channel, differing from continental custom by the much greater importance assigned to infantry equipped with missile arms. It is, in short, the period in which the longbow first comes to the front as the national weapon.

The bow had of course always been known in England. In the armies of our Norman and Angevin kings archers were to be found, but they formed neither the most numerous nor the most effective part of the host. On this side of the Channel, just as beyond it, the supremacy of the mailed horseman was still unquestioned. It is indeed noteworthy that the theory which attributes to the Normans the introduction of the long-

bow cannot be substantiated. If we are to trust the Bayeux Tapestry, the weapon of William's archers was in no way different from that already known in England, and used by a few of the English in the fight of Senlac.[1] It was the shortbow drawn to the breast, not to the ear. The archers who are occasionally mentioned during the succeeding century—those, for example, who took part in the Battle of the Standard—do not appear to have formed any very important part of the national host. Nothing can be more conclusive as to the insignificance of the bow than the fact that it is not mentioned at all in the "Assize of Arms" of 1181. In the reign of Henry II., therefore, we may fairly conclude that it was not the proper weapon of any class of English society. A similar deduction is suggested by Richard Cœur de Lion's predilection for the arbalest: it is impossible that he should have so much admired it, and taken such pains to secure mercenaries skilled in its use, if he had been acquainted with the splendid longbow of the fourteenth century. It is evident that the bow must always have a great advantage in rapidity of discharge over the arbalest: the latter must therefore have been considered by Richard to surpass in range and penetrating power. But nothing is more certain than that the English longbow at its best was able to beat the crossbow on both these points. The conclusion is inevitable that the weapon superseded by the arbalest was merely the old shortbow, which had been in constant use since Saxon times.

However this may be, the crossbowman continued to occupy the place of importance among infantry till the middle of the thirteenth century. Richard I., as we have said before, valued the arbalest highly; John maintained great numbers both of horse and foot arbalesters among those mercenaries who were such a curse to England. Their evil memory is enshrined in the clause of Magna Carta which binds the king to banish the "alienigenas milites, balistarios, et servientes, qui venerunt cum equis et armis ad nocumentum regni."[2] Fawkes de Bréauté, the captain of John's mercenary crossbowmen, is one of the most prominent and the most forbidding of the figures of the civil war of 1215-17. Even in the reign of Henry III., the

[1] e.g. by the diminutive archer who crouches under a mailed thegn's shield, like Teucer protected by Ajax.

[2] Magna Carta, § 51.

epoch in which the longbow was beginning to come into prominence, the arbalest was still considered the superior weapon. At the battle of Taillebourg, a corps of seven hundred men armed with it were considered the flower of the English infantry. Though Simon de Montfort must have had both cross-bowmen and archers at Lewes, the former receive most of the small notice which the chroniclers take of the infantry in that fight. The archers in the actual battle receive less mention than the men armed with the archaic and very inefficient sling.

To trace the true origin of the longbow is not easy: there are reasons for believing that its use may have originally been learned from the South Welsh, who seem to have been provided with it as early as the reign of Henry II. Giraldus Cambrensis speaks repeatedly[1] of the men of Gwent and Morganwg as excelling all other districts in archery. For the strength of their shooting he gives some curious evidence. At the siege of Abergavenny in 1182 the Welsh arrows penetrated an oak door four inches thick. They were allowed to remain there as a curiosity, and Gerald himself saw them six years later, in 1188, when he passed by the castle, with the iron points just showing on the inner side of the door. A knight of William de Braose received an arrow, which went first through the skirts of his mail-shirt, then through his mail breeches, then through his thigh, then through the wood of his saddle, and finally penetrated far into his horse's flank. "What more could a bolt from a balista have done?" asks Gerald. He describes the bows of Gwent as "neither made of horn, ash, nor yew, but of elm: ugly unfinished-looking weapons, but astonishingly stiff, large, and strong, and equally capable of use for long or short shooting."

It is noticeable that on the first occasion when an English king made really efficient use of archery in a great pitched battle,[2] we are told that his infantry were largely composed of Welshmen. But the first mention of the bow as much used by the English is, curiously enough, not from any district near the South Welsh border, but from Sussex, where in 1216 more than a thousand bowmen under one Wilkin are said to have molested the army of the Dauphin Lewis and the rebel barons

[1] Pp. 54, 123, 127 of the Rolls Series edition of the *Itinerarium Cambriae*.
[2] At Falkirk, according to Walter Hemingford, who gives far the best account of the battle "Numerati sunt pedestres qui aderant, et quasi omnes erant Hibernici et Wallenses" (p. 159).

as they marched through the Weald. But the great landmark
in the history of archery is undoubtedly the "Assize of Arms" of
1252. After ordering that the richer yeomanry who own a
hundred shillings in land should come to the host with steel
cap, buff-coat, lance, and sword, that document proceeds to
command " that all who own more than forty and less than a
hundred shillings in land come bearing a sword and a bow with
arrows and a dagger." Similarly, citizens with chattels worth
more than nine marks and less than twenty are to be arrayed
with bow, arrows, and sword. There is a special clause at the
end of the paragraph providing that even poor men with less
than forty shillings in land or nine marks in chattels should
bring bow and arrows if they have them, instead of the "falces
gisarmas et alia arma minuta" which are spoken of as their
usual weapons.

In face of the provisions of the Assize of Arms, made
twelve years before the battle of Lewes, it is most curious to
find that in the campaigns of 1264 and 1265 the crossbow—an
essentially foreign weapon, and one not prescribed for the use
of any class of subjects of the realm—should still keep the
upper hand. It is, as we have already remarked, named far
more frequently than the bow by the chroniclers of the barons'
war. The only notable mention of archery is—characteristically
enough—that which describes the attack made on King Henry's
marching columns in the Weald by De Montfort's Welsh
auxiliaries.[1]

The longbow comes to the front only in the wars of Edward I.,
and its predominance in later English wars is directly due to the
king's own action. Edward had come to realise that more ad-
vantage might be got from a judicious combination of cavalry
and of infantry armed with missile weapons, than from the use
of horsemen alone. We have no signs that he had learned this
at the time of Lewes and Evesham, but it appears clearly enough
during his Welsh wars. In expeditions among the hills of
Gwynedd the horseman was often useless: he could not storm
crags or scramble down ravines. Welsh fighting was mainly
work for infantry, and the king—as his conduct in the Evesham
campaign had shown—was quick to learn in the school of war.[2]

[1] Wykes. 1264, § 5.
[2] It is well to remember that Edward had served in several Welsh wars long
before he came to the throne, and was no novice in such fighting in 1280.

Having come to know the strength and the weakness of infantry as well as of mailed knighthood, he was quite capable of combining his lessons. The deliberate use of foot-soldiery armed with missile weapons to prepare the way for the horseman's charge seems first to appear at the engagement with Llewellyn at Orewin Bridge in 1282.[1] But no account that we have of this fight is so detailed as that of a battle fought against the Welsh of Madoc-ap-Llewellyn in 1295 by Edward's lieutenant, the Earl of Warwick. The insurgents were encamped on a bare hillside between two woods, into which they intended to retire when attacked. But Warwick, by marching all night, was able to come suddenly upon them at dawn, so that they had no time to fly. "Then," says Nicholas Trivet,[2] " seeing themselves surrounded, they fixed the butts of their spears in the earth, with the heads pointing outward, to keep off the rush of the horsemen. But the earl placed an archer or a crossbowman between each two knights, and when by their shooting many of the spearmen were slain, he burst among them with his horse and made such a slaughter as no Welsh army ever suffered before." It is to be observed that Warwick had both bowmen and arbalesters with him, the crossbow still being in full repute among the English. Indeed, the crossbow seems distinctly to have been considered the better weapon at the time, for in the pay-roll of the garrison of Rhuddlan Castle for 1281 we find, " made over to Geoffrey the Chamberlain for the wages of twelve arbalesters and thirteen archers for twenty-four days, £7, 8s., each arbalester receiving by the day 4d., and each archer 2d."

In Edward I.'s inglorious French wars in Aquitaine we find little sign of the proper combination of horse and foot. The English armies in those campaigns were largely composed of the king's Gascon vassals, whose military ideas were wholly continental; but it is curious to find that their English leaders seem to have taught them nothing. Take, for example, the battle at Peyrehorade (near Bayonne) in 1295. The Earl of Lincoln with six hundred men-at-arms and ten thousand foot set out to relieve the town of Belgarde, then threatened by the Count of

[1] " Steterunt Wallenses per turmas in supercilio montis : ascendentibus nostris per sagittarios nostros (qui inter equestres mixti erant) corruerunt multi, eo quod animose steterunt. Tandem nostri ascenderunt equestres et caesis aliquibus reliquos in velocem fugam compulerunt " (Hemingford, vol. i. p. 11).

[2] Nic. Triv. 1295, p. 282.

36

Artois. Issuing from a wood, his vanguard was suddenly charged by the French, who were waiting for them with fifteen hundred horse ranged in four "battles." The English cavalry came up successively, forcing their way out of the forest-road, and engaged —not very advantageously—with the French. But the footmen "hung back in the wood without advancing, and did no good whatever,"[1] though the knights were in grievous need of infantry, "qui projectos armatos hostium spoliarent vel interimerent." The last clause shows the very modest task which Lincoln expected his foot-soldiery to discharge.

It must have been from the experience of his Welsh expeditions that King Edward learned how to combine horse and foot with such effect in his great Scottish war. The interest of that struggle, from the military point of view, lies in the alternate success and failure of the English according to the manner in which they were handled by their leaders. The Scottish tactics were uniform, and were dictated by the fact that the northern realm was hopelessly inferior to England in the number and quality of its men-at-arms. Not only were the Scottish nobility and knighthood too few to cope with the English, but throughout the war a large proportion of them adhered to King Edward's cause, and were often found fighting beneath his banner. The Scots therefore were forced to rely almost entirely on their sturdy yeomen, whose hearts were firmly set against the Southron. On no occasion did Wallace or Bruce bring to the field much over a thousand mounted men, and no good feat of arms can be set to the credit of their horsemen save a single charge at Bannockburn, which we shall have to describe in its proper place.

From the English point of view the Scottish war had many resemblances to a Welsh campaign. It was fought in a hilly and thinly-peopled country, where roads were few and provisions hard to find, and against a foe whose whole reliance lay in his infantry. But there were many points of difference: the fiery and unstable Welsh loved rapid and disorderly attacks in passes or ravines, and seldom or never fought in the open of their own free will. The Scots, on the other hand, partook more of the nature of a disciplined army, put their confidence in their close array and steady resistance, and were often ready to accept a pitched battle. The Welsh — as Giraldus Cambrensis had

[1] Hemingford, vol. i. p. 74.

observed a hundred years before — risked everything on the result of one tempestuous charge,[1]—in five minutes they were either victorious, or routed and in full flight for their hilltops. The Scot came on less wildly to the fray, or even waited to be attacked; but he grew sterner and harder as the day wore on, and was capable of any amount of dogged resistance. Between these two nations of spearmen there lay all the difference between the Celtic and the Teutonic temperament,—for the Scottish war was waged by the Teutonic Lowlands, not by the Gael from beyond the Grampians, who took small part in the struggle.

In Edward's first invasion of Scotland, which terminated with the rout of Dunbar and Baliol's resignation of the crown, there was no serious fighting. The struggle did not begin in earnest till the rebellion of Wallace—a purely popular rising in the interest of national independence, which was viewed with very scant sympathy by the greater part of the Scottish baronage. For half the nobles of the land held manors south as well as north of Tweed, and were almost English in blood and in sympathies. The insurgents found no leader but an obscure outlawed knight of Galloway, who was treated with small courtesy by such of the baronage as chose to dally with the cause of independence.

Battle of Cambuskenneth Bridge, September 11, 1297.

The first important engagement of the war gave a fine object-lesson as to the way in which a Scottish army ought not to be dealt with. Edward had left, as his representative beyond Tweed, John Earl of Warrenne, the hero of the well-known incident of the rusty sword during the *Quo Warranto* inquest. The earl had served at Lewes[2] and Evesham,—though with no particular credit,—and was now nearing his sixtieth year. He appears to have been a type of the ordinary stupid and arrogant feudal chief, who had learned nothing of the art of war though he had gone out on many campaigns. The insurgents had been making head beyond the Forth, and had just captured Perth. Warrenne therefore concentrated his army at Stirling, where he drew together a thousand men-at-arms and a great body of

[1] *Itinerarium Cambriae*, p. 209.

[2] He was one of those who had deserted Prince Edward and fled away at the end of the first-named battle. See p. 424.

foot-soldiery raised in the six northern counties and in North
Wales. Wallace and the Scots at once set out to meet him at
the Forth, camping on the wooded hills which overlook the
sinuous course of that river as it passes Stirling. Their host
counted no more than a hundred and eighty mounted knights
and squires, but many thousands of sturdy spearmen. The
sole bridge over the stream was that which takes its name from
the adjacent abbey of Cambuskenneth. It was a long narrow
structure, on which no more than two horsemen could ride
abreast. Towering above it only a few hundred yards away
was the Abbey Craig, the steep wooded height which forms the end
of the Ochil Hills: on it Wallace lay encamped. Finding that
the Scots treated his summons to lay down their arms with
derision, Warrenne determined to cross the bridge and storm
their position. The wiser heads in his camp were filled with
dismay at a resolve inspired by a foolish and overweening
contempt for the enemy. Sir Richard Lundy, a Scottish knight
of the English party, pointed out to the earl that it would take
eleven hours for his whole host to defile over the bridge in face
of an active enemy less than a mile away. He pointed out a
ford not far off at which men could cross sixty abreast, and
begged that the army might pass there, or that at least he might
be permitted to take a few hundred horsemen and create a
diversion on that point. Warrenne refused to listen to him,
and bade his troops begin to defile across the narrow bridge.
Wallace was observing every movement of the English from
his lofty post on the Abbey Craig, and his men were lurking in
a solid mass behind its woods. He allowed the enemy's van-
battle, commanded by Sir Marmaduke Twenge and Hugh
Cressingham the Treasurer, to cross the water and to begin to
form up on the northern bank. Then, when the main-battle
was still on the farther side, he flung his whole army down the
hill, against the troops who had crossed. A picked body of
spearmen charged for the bridge-head and reached it in the first
rush, while the mass of the Scots fell upon Twenge and Cressing-
ham's men. The bridge-head once seized and firmly held,
Warrenne could not push forward, nor the van-battle retrace its
steps. After a short struggle the whole body that had crossed
was either trampled down or flung into the river. Twenge by
prodigies of valour cut his way back across the bridge almost
alone. But Cressingham and more than a hundred knights,

with at least five thousand English and Welsh foot, were slain
or drowned (Sept. 11, 1297).

Warrenne, whose whole conduct contrasts most shamefully
with Wallace's splendid action, was so cowed by the encounter,
that, instead of preparing to defend the line of the Forth, he
threw a garrison into Stirling and retired to Berwick, abandon-
ing the whole of the Lowlands to the enemy.

Wallace followed up the victory of Cambuskenneth Bridge by
a fierce inroad into Northumberland and Durham. His ravages
drew King Edward in person into Scotland in the next year,
with the whole feudal levy of England at his back. He brought
three thousand knights on barded horses, and four thousand
other men-at-arms, mustered under the colours of more than a
hundred barons and bannerets. For foot-soldiery he had not
summoned the full shire-levies under the sheriffs, but only
called for volunteers. The Welsh and Irish came in large
numbers, for they were always ready to serve for plunder,[1] but
the English foot were comparatively few. The enormous
figures given by the chroniclers for the array of infantry—fifty or
even eighty thousand—are of course absurd ; they probably did
not greatly exceed the horsemen in number.

Battle of Falkirk, July 22, 1298.

When Edward marched from Berwick into Lothian and
began to waste the land and storm the few castles which were
defended against him, Wallace did not make any attempt to
protect the plain. He had summoned all Scotland to his
banner, and may perhaps have had the thirty thousand foot
and the thousand men-at-arms[2] with which the more sober
of the English chroniclers credit him. But he had withdrawn
them into the Torwood, the great forest which lay between
Falkirk and Stirling, and there kept quiet. He was resolved to
take the defensive in a favourable position, and not to meet the
king's overwhelming force of cavalry in the open.

It seemed for a moment possible that no battle might take
place, for Edward spent so much time in Lothian that his
provisions began to run low, and no more could be procured

[1] Hemingford, i. p. 259.

[2] The wilder guesses of others make the Scots at a hundred thousand or even
three hundred thousand strong. Even the usually sensible Hemingford gives the
latter figure (i. p. 165).

from the wasted countryside. He could not hear of any hostile army in the field, and was beginning to think of returning to England. But presently there came to him the Earls of March and Angus, two Scottish lords of the English faction, with news that Wallace lay only eighteen miles away at Falkirk, and that, hearing of the approaching retreat of the royal army, he was preparing to fall upon its rear and harass its march. "He shall not come to me, for I will go to him," exclaimed Edward, and straightway set his army—famine-stricken though it was—to march on Falkirk. He slept at Linlithgow on the night of July 21; that night he had two ribs broken by a kick from his horse, but, though suffering much pain, he pushed on next morning to seek for Wallace. A Scottish reconnoitring party was sighted early in the day, but promptly retired. Following it up, and moving past the town to the south, by the hillside called Slamannan Muir, the English at last came in sight of the enemy. Wallace had selected a very strong position on a hillside about two miles south of Falkirk, not very far from the edge of the forest which covered all the face of the country to the west. His front was protected by a broad morass—now called Darnrig Moss. His pikemen were arrayed in four great masses—schiltrons, as the Scots called them; behind them were the body of a thousand mounted men-at-arms which composed his cavalry. On each flank and also between the schiltrons were a few thousand archers—mainly from Ettrick and Selkirk. The whole hope of Wallace lay in the solidity of his impenetrable masses of spears; he was resolved to fight a thoroughly defensive battle, and knew that all depended on the steadiness of his followers. "I have brought you to the ring," he is reported to have said; "now hop (dance) if ye may."[1]

Edward at once formed up his men on the opposite side of the Moss, in the three "battles" dear to the mediæval general. The vaward or right wing was led by Roger Bigot Earl of Norfolk, the Marshal, and by Humphrey Bohun Earl of Hereford —the pair whose constitutional opposition to the king had led to the *Confirmatio Cartarum* in the preceding year. The main-battle was headed by Edward himself; the left wing was entrusted to Antony Beck, the warlike bishop of Durham. Each column contained from thirty to thirty-five banners of barons

[1] The elaborate story of Falkirk in Blind Harry's *Wallace* is hopelessly garbled and useless. Bruce does all the fighting on the English side!

and bannerets. The vaward first started to the charge, but rode into the Moss, and found it wholly impassable. The Earl Marshal, therefore, drew back his men, and started to turn the obstacle by a long march round its flank. The left wing had observed the morass more clearly, and the bishop, without making any attempt to pass it, wheeled off and rode round its flank. Arriving at a point at right angles to the line of the Scots, he halted his battle and waited for the king, whose division was following him. This delay maddened the rash barons, of whom he held command. "Stick to your mass, bishop, and don't teach us the art of war," cried Ralph Basset of Drayton. "Sing your mass here to-day, and we will do the fighting."[1] So saying, he led his horsemen against the flank schiltron of the Scots, and all the other banners streamed after him, in despite of their commander. A few minutes later the Earl Marshal's battle completed its detour round the Moss, and executed an equally headlong charge against the other flank of the Scottish host.

The result of the onset of the two English cavalry corps was indecisive. Wallace's archers were ridden down and scattered; the thousand men-at-arms in his rear rode off the field in disgraceful flight without striking a blow for Scotland. But the great schiltrons of pikemen easily flung back the onset of the horsemen. The front ranks knelt with their spear-butts fixed in the earth; the rear ranks levelled their lances over their comrades' heads; the thick-set grove of twelve-foot spears was far too dense for the cavalry to penetrate. Many English riders fell; the rest wheeled round and began to re-form for a second charge. Now came the decisive moment of the day: if the onsets had been repeated with a similar fury, the English cavalry would undoubtedly have failed, and Falkirk would have been even as Bannockburn.

King Edward and the main-battle had now arrived on the ground. His quick eye at once grasped the situation; instantly he applied the tactics which had been so successful in his Welsh wars. The knights were ordered to halt for a moment, and the bowmen were brought to the front. They were bidden to concentrate their fire on fixed points in the hostile masses. Loosing their arrows at point-blank range into the easy target

[1] "Non est tuum, episcope, docere nos de militia: vade missam celebrare si velis." etc. (Hemingford, p. 164).

of the great schiltrons, they soon began to make a fearful slaughter. Nor could there be any retaliation; the Scottish archers had been ridden down and driven away, while the pikemen dared not break their ranks to chase off their enemies while the English cavalry were waiting to push into the gaps. Accordingly, the result of a few minutes of the deadly arrow-shower was that many points of the masses had been riddled, and the whole had been rendered unsteady. Then Edward bade his knights charge for the second time, aiming at the shaken sections of the enemy's front. Bursting in at points where the killed and wounded were thicker than the unstricken men, the English men-at-arms broke all the schiltrons in quick succession.

The rest of the fight was little more than a massacre. One-third of the Scottish host was left on the field: the survivors, among whom Wallace was numbered, only saved themselves by a prompt flight into the woods. Those who were at the eastern end of the line, and too far from the friendly shelter of the trees, had to rush down the rear slope of the hill and save themselves by swimming the river Carron. Many thousands were cut down, and a considerable number more were drowned in the stream. Of the Scottish chiefs there were slain Sir John Stuart of Bonkill, the leader of the Selkirk archery, Sir John Graham, Macduff, the uncle of the Earl of Fife, and about twenty knights more. The English loss was small, consisting only of the horsemen who perished on the pikes in the first charge: among them were, curiously enough, the two chiefs of the Order of the Temple in the two British kingdoms—both the Master of the English Templars, and Brian de Jaye, who bore the corresponding office in Scotland.

The lesson which Falkirk taught to those who could read its true importance was much the same as the lesson of Hastings, that even the best of infantry, if unsupported by cavalry and placed in a position that might be turned on the flanks, could not hope to withstand a judicious combination of archers and horsemen. Such, without doubt, would have been the moral which King Edward would have drawn from it had he left us a written record of his military experience. Such was the way in which it was viewed by Robert Bruce, who saw the fight from the English side, for he served in the left-hand battle under Bishop Beck. We shall note that at Bannockburn, when it fell to him to face the selfsame problem that Wallace had vainly

tried to solve, he took special care that his flanks should be covered and that his cavalry should be turned to good use. But it is clear that less capable men on both sides overlooked the real meaning of the fight. Many of the English forgot that the archers had prepared the way, and only remembered the victorious charge of the knights at the end of the day. Many of the Scots, equally misreading the facts, attributed their defeat to the treachery of their runaway horsemen, or to the jealousy which the other leaders felt for Wallace, instead of imputing it to the inherent weakness of pikemen unsupported by any other arm.

There was much fighting of the minor kind between Falkirk and the day of Bannockburn. For the greater part of the eighteen years which intervened between them, hostilities on a larger or a smaller scale were going on in some part of Scotland. On the whole, the English had the advantage, owing to the disunion of the Scots and their inability to find any leader whom his equals would obey. On half a dozen occasions Edward's armies marched up and down the land without meeting open opposition: the Scots meanwhile retired to the hills, and only came down when their enemies had turned homewards. Such fighting as there was mainly consisted in ambuscades and surprises: such, for example, was the rout of Roslin in 1302, when John de Segrave's army was surprised by the Scots in three separate cantonments six miles apart. Segrave's own division was cut to pieces at dawn; the other divisions under Robert Neville came up only in time to save a few of the fugitives, and then retired from the field. A similar instance on the other side was the rout of Methven, when Aymer de Valence, Earl of Pembroke, scattered Robert Bruce's host by just such another assault at daybreak. A much greater interest attaches to a fight on a far smaller scale, that of Loudon Hill in 1307, if we can trust the details— sufficiently probable in themselves—which Barbour gives of it. In its own way it was a forecast of Bannockburn. Bruce, with his six hundred followers, was lying on Loudon Hill, when De Valence, with a force which the Scottish chroniclers give at three thousand men, came to hunt him down. Bruce had found a position about two bow-shots broad, through which a road ran. On each side of it was a broad moss. He narrowed the front of the position by cutting three lines of ditch from the edges of the morasses on each side, so as to leave open only the

road and about fifty yards more on each side of it. On this short front he drew up his men, all on foot and with pikes levelled. De Valence should of course have sent his archers to the front, and, as Bruce could not have advanced, might have mishandled him dreadfully. But, instead, he committed the usual fault of feudal commanders; he sent his cavalry to charge down the road, expecting to ride easily over the pikemen. Two furious onsets were promptly turned back by the line of spears; then, seeing more than a hundred men-at-arms lying dead in front of the Scottish line, De Valence tamely withdrew, though his infantry and his rear-battle had not struck a blow.

Without any pitched battle, but by a long series of sieges, raids, and adventurous assaults on castles, Bruce had by 1314 cleared the English out of the whole land. Nothing but the strongholds of Stirling, Dunbar, and Berwick remained in the power of Edward II. It was to relieve the first-named place, the most important strategic point in the whole of Scotland, that the imbecile son of Edward Longshanks at last bestirred himself. The governor of Stirling, Sir Philip Mowbray, had promised to yield unless he was relieved before St. John's Day, June 24, 1314. And not even Edward of Caernarvon could view unmoved the loss of the last of his father's conquests.

Battle of Bannockburn, June 24, 1314.

When once Bruce knew that the King of England had sworn to raise the siege of Stirling, and was spending the spring in summoning up contingents not only from England and Wales, but from Ireland and Gascony, he had ample time to devote to the choice of a good position for standing on the defensive against the great host which was arming against him. He determined to make no opposition in Lothian, but to let the English army push well into the bowels of the land. Two reasons led him to this conclusion; the enemy would be much harassed by want of food in passing through the devastated lands between Tweed and Forth, and the nearer he fought to Stirling the more certain would he be of intercepting the enemy, who, if the battle was offered to him at a greater distance from the place, might easily slip off to right or left and turn the Scottish host without an engagement.

Bruce mustered his men in the forest of Torwood, the same trysting-place which Wallace had chosen before the battle of

Falkirk. But it was not his intention to fight on the banks of the Carron, but much nearer to Stirling. The position which he had selected was no more than two and a half miles south [1] of the beleaguered castle, on the rolling hillsides which overlook the Bannock Burn.

Passing southward out of Stirling, a gentle ascent leads to the village and church of St. Ninians; half a mile farther on, the crest of the ascent is reached, and a new valley comes in view. Down this depression, which is less than a mile broad, runs the Bannock Burn, now an insignificant brook, which flows to join the Forth not far from its mouth. In 1314 the burn was a much more formidable obstacle; its course ran through bogs and mosses, and towards the eastern end of the field was connected with some broad shallow pools, which covered a considerable expanse.[2] In most of its course the Bannock could be crossed, though with some difficulty, both by horse and foot: the only thoroughly good passage was in the middle of the field, where an old Roman road, running out from the wall of Antoninus, cuts across the battle-ground from north-west to south-east. The advantage of the position from the point of view of Bruce lay, not so much in the difficult passage of the Bannock, as in the fact that the front to be defended was comparatively short. For at the west end of the field the New Park, a wooded tract which King Alexander III. had afforested, ran down to the stream; while at its east end the Carse, or low land falling away towards the Forth, was then one vast morass. The front between the wood and the marsh was not much more than a mile broad, a space not too great to be defended by the forty thousand men whom Bruce had brought together for the defence of the land.

When the English army advanced from Edinburgh and Falkirk, Robert fell back from the Torwood into his chosen position. His intention was to hold the northern brow of the valley of the Bannock, leaving the enemy to force their way

[1] At the Borestone, the centre of the Scottish position, the ridge is one hundred and eighty-six feet high; it is lower towards its eastern end, but at its western rises to two hundred and forty feet. The corresponding slope on the English side of the Bannock varies from two hundred and twenty to two hundred and eighty feet in height.

[2] I was delighted to find these pools, of which no trace now exists, in old Scottish maps of the eighteenth century. Barbour distinctly mentions them in his lines 62–64, p. 255 of the Edinburgh edition of 1758.

across moss and brook and over the gentle slope which led up
from them. He had taken the additional precaution of digging
a great quantity of "pottes," or small circular holes three feet
deep, in front of his line. They were covered with branches
and grass, so that they could not be seen by the advancing foe,
and were intended as traps for Edward's horsemen. This
defence extended a long way on each side of the Roman road
which cut across the field, and practically covered the whole
assailable front of the Scottish host.[1]

The Scottish army had been told off into four "battles" and
a small cavalry reserve. Only five hundred picked men-at-arms
were kept on horseback, under Sir Robert Keith, the Marshal
of Scotland; the rest of the knights and barons descended to
fight on foot among their retainers. The main line was com-
posed of three solid "battles" of pikemen of approximately
equal strength; they were commanded (counting from right
to left) by Thomas Randolph Earl of Murray, who had the
"vaward," Sir Edward Bruce, the king's brother, who had the
"mid-battle," and Sir James Douglas and Walter the Lord
Steward of Scotland, who had the "rearward." Behind, as a
reserve, lay the king with the fourth "battle" of spearmen and
the small body of horsemen under Keith.

This array having been settled, the Scots encamped, out of

[1] The "Pottes" have given some trouble to the narrators of the battle. Some
of the English chroniclers do not mention them. Others, e.g. Baker of Swinbrook,
speak not of a number of small holes, but of one long ditch: "Scoti locum nacti
opportunum, subfodiebant ad mensurum trium pedum in profundo, et ad ejusdem
mensurae latitudinem fossas protensas in longum a dextro in sinistrum cornu exercitus,
operientes illas cum plexis et viminibus." But an even better authority than the very
sensible Baker is Robert Baston, the unfortunate prisoner whom Bruce compelled to
celebrate the victory in Latin verse. He says that

> "Plebs foveas fodit, ut per eas labantur equestres.
> Machina plena malis pedibus formatur equinis
> Concava, cum palis, ne pergant absque ruinis."

This certainly means a series of holes, not a ditch, and fully bears out Barbour's
account of the "Pottes." As to their position, Barbour says that

> "On either side the way wele brad
> It was pottit, as I have tald.
> Gef that their faes on horse will hald
> Furth in that way, I trow they shall
> Not well escape withouten fall."

And in another passage he speaks of the "Pottes" as "in ane plane field by the way."
I suppose that "the way" means the Roman road, and that the pits lay on each side of
it for many hundred yards, probably reaching to the very flanks of the army.

PLATE XXII.

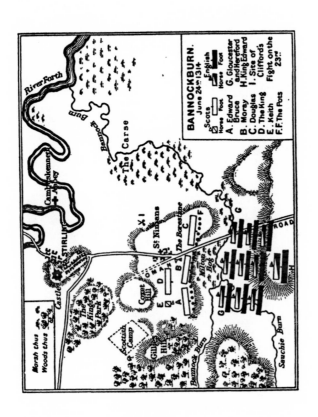

sight of the enemy approaching from the south, behind the
shelter of Gillies' Hill, a wooded eminence at the right rear of
their position, leaving only small detachments out to watch the
advance of the English—one at the "entry," *i.e.* the place where
the Roman road crossed the burn and marsh, the other at St.
Ninian's Kirk, to guard against any attempt of the enemy to
turn the position by its eastern end through the mosses of the
Carse. The king watched at the former place, the Earl of
Murray at the latter.

Presently the English army came in sight on the low line of
hills which form the southern horizon. Edward II. had brought
a vast host with him: the estimate of a hundred thousand men
which the Scottish chroniclers give is no doubt exaggerated, but
that the force was very large is shown by the genuine details
of the mustering which have come down to us. There have
been preserved of the orders which Edward sent out for the
raising of this army only those addressed to the sheriffs of
twelve English counties, seven Marcher barons, and the justices
of North and South Wales. Yet these account for twenty-one
thousand five hundred men, though they do not include the
figures of any of the more populous shires, such as Norfolk,
Suffolk, Kent, or Middlesex. The whole must have amounted
to more than fifty thousand men.[1] The barons, too, were
in full force. Only the self-seeking Thomas of Lancaster
and his adherents did not come to the muster—on the poor
pretence that the king, according to the ordinances of 1311, ought
to have consulted Parliament before levying his host. But,

[1] Rymer, *Foedera*, May 27, 1314. The figures are perhaps worth giving. They
run as follows :—

	Men		Men
Yorkshire	4000	Leicestershire and Warwickshire .	500
Northumberland	2500	Justices of S. Wales ; *i.e.* counties	
Bishopric of Durham . .	1500	of Cardigan and Caermarthen .	1000
Lancashire	500	Certain Marcher lords . . .	1850
Lincolnshire	3000	Justices of N. Wales ; *i.e.* counties	
Notts and Derby . . .	2000	of Anglesea, Caernarvon, and	
Salop and Stafford . .	2000	Merioneth	2000
Cheshire	500		

Comparing this with military assessments of England at a later time, we find that the
twelve counties and Wales used to give on an average about one-third of the whole
host. I presume, therefore, that at Bannockburn the shire-levies in all should have
amounted to some sixty thousand, if all the shires were represented. But we may
doubt if the extreme South sent its full contingents for so distant a campaign.

though absent themselves, the Lancastrians seem to have sent their retainers.

The host was told off into ten battles, probably (like the French at Crecy) in three lines of three battles each, with the tenth as a reserve under the king. We have no proper details of the marshalling, knowing only that the Earls of Gloucester and Hereford led the "vaward" line, and that the king with the Earl of Pembroke headed the rear-battle. But details as to the array are of little importance, because (as all accounts agree) the host was so cramped and crushed together on the battlefield that to the enemy it appeared all one vast "schiltron," speckled from front to rear with the flags of barons and bannerets. Only the "vaward" was distinguishable, the rest was one huge weltering mass.

The English advance guard arrived on the field on the afternoon of the 23rd June, and proceeded at once to reconnoitre the position. Two bodies of cavalry pushed forward on two points, one crossing the burn at the Roman road, the other making a detour through the Carse to endeavour to communicate with the castle by riding round the marshy ground on the left of the Scottish line. The first body halted and retired when it found Bruce in force at the head of the slope. Its advance was only noticeable for the chivalric incident of Sir Henry Bohun's death. Bohun was in the van of the party which came up the slope, and caught sight of King Robert riding up and down some distance in front of his pikemen. Setting spurs to his horse, the daring knight charged at the Bruce, hoping to end the war with his single lance. Robert, though he was not horsed on his barded destrier, but only on a little hackney, and though he had no lance in his hand, but only the axe at his saddlebow, did not shrink from the single combat. Warily awaiting his adversary's charge, he turned Bohun's lance aside with his axe, and as the knight passed him, brained him with a tremendous blow on the back of his helmet.

The other attempt of the English to feel the eastern flank of the Scottish position led to more serious fighting. Eight hundred men-at-arms, under Sir Robert Clifford and William Deyncourt, made such a wide sweep through the Carse that they were close below St. Ninian's Kirk before the Earl of Murray sighted them. Burning to repair this neglect, Randolph rushed down the hill with five hundred pikemen and threw himself

across their path. Clifford bade his knights ride over the Scots,
and delivered a furious charge which utterly failed to break the
compact mass of spears. For many minutes the English horse-
men rode round and round the Scots, trying to burst in, and
angrily casting maces and lances into their ranks, in the hope of
making a gap. Some scores perished among the pikes, includ-
ing Deyncourt, the second in command. The rest, finding their
efforts all in vain, and seeing succour coming down the hill to
Randolph, at last rode off foiled, and made no further attempt
to communicate with the castle.

 While this petty action was going on, the English army was
slowly reaching the field, and by nightfall had crowned the
heights above the Bannock and formed its encampment. There
Edward's host rested, spending the night, as all the chroniclers
both Scots and English agree, in wassail and vain boasting.
Next morn the king got his unwieldy force into such array as
he might. The assailable ground of the Scottish position was
much too narrow to suit his numbers : there was only something
slightly more than a mile of slope between the wood and the
marshes, and, to make even this space available, the English right
wing had to throw rough bridges of hurdles and beams across
the great pools on the lower Bannock. Two thousand yards
of frontage only affords comfortable space for fifteen hundred
horsemen or three thousand foot-soldiers abreast. This was
well enough for the main line of the Scottish host, formed in
three battles of perhaps twenty-five thousand men in all, i.e. eight
or nine deep in continuous line. But, allowing for the greater
space required for the cavalry, the English were far too many
for such a front, with the ten thousand horse [1] and fifty thousand
or sixty thousand foot which they may have mustered.

 The result of this fact was that from the very beginning of the
battle the English were crowded and crushed together, and
wholly unable to manœuvre. The worst point of all was that in
each corps the archers had been placed behind the horsemen, not
on their flanks or in the intervals between the separate squadrons. [2]

 [1] Trustworthy details of the English host, as we said before, are missing. But if
they had, as is said, three thousand " equites coperti," men-at-arms on barded horses,
the whole cavalry was probably ten thousand. Barbour makes it forty thousand
" armed on horse both head and hand."
 [2] "Nonnullos detraxit in cladem phalanx sagittariorum, non habentium destinatum
locum aptum, sed prius armatorum a tergo stantium, qui nunc a lateribus solent
constare " (Baker of Swinbrook, p. 9).

Thus a magnificent body of perhaps thirty thousand bowmen, able to have settled the whole matter if granted a judicious support of cavalry, was condemned from the first to almost entire uselessness.

There was some little skirmishing before the main engagement commenced. Bruce had scattered a few archers along his side of the burn : they were, as a preliminary measure, driven off by a detachment of English bowmen from the "vaward" battle.[1] But the moment that this affray was over, the whole front line of the English horsemen set themselves in motion, swept down their own slope, scrambled through the brook and bog and dashed up hill against the Scottish host. At the same moment the three battles of Bruce's front line, which had been held back hitherto, to keep them out of range of the English arrows, moved forward in perfect order to the top of the slope and the position marked out for them by the line of "pottes." Many of the English men-at-arms were caught in these traps,[2] but the majority sweeping onward, rushed headlong against the Scottish battles. "And when the two hosts so came together and the great steeds of the knights dashed into the Scottish pikes as into a thick wood, there rose a great and horrible crash from rending lances and dying horses, and there they stood locked together for a space."[3] But if the English, with all the impetus of their first charge, had failed to break the hostile line at any point, much less were they able to do so when they had been brought to a standstill, and could only cut and thrust away the pikes, or endeavour to wedge themselves into some weak spot. They died by hundreds, without accomplishing anything, but were far too courageous to fall back and acknowledge themselves beaten. A retreat would have been their best move, and it would not have been too late to bring forward the archery after the horsemen had retired. Yet, since the vaward refused to draw off, the second and third lines in their turn poured down the English slope, through bog and brook, and up the farther bank. But they could not get at the Scots, with whom the first line was desperately engaged, and were forced to stand idle on the slope while the conflict was going on above their heads. Individuals of course got a chance of pushing forward to take the place of those in the vaward battle who had fallen, but the mass stood helpless and utterly unable to help their fellows.

[1] Chronicle of Lanercost, p. 225. [2] Baker of Swinbrook, p. 8.
[3] Chronicle of Lanercost, p. 225.

Somewhere about this stage of the battle it seems to have occurred to some of the English leaders that the archery must be used at all costs if the day was to be won. It was impossible to deploy the infantry, so the bowmen were bidden to let fly into the air, with a high trajectory, and try to reach the Scots over the heads of their own horsemen in front: the result was not encouraging; the arrows "hit some few Scots in the breast, but struck many more of the English in the back."[1] At one point only, at the western end of the battle, some of the archers seem to have succeeded in struggling out from the mêlée towards the edge of the wood, and opened a lateral fire on to the flank of Edward Bruce's division. King Robert had foreseen that some such thing might happen, and had kept Keith and his five hundred men-at-arms on horseback in reserve, to provide against such a chance. The Marshal[2] swept round Edward Bruce's flank, charged the archers from the side, and threw them back against their own mid-battle, into which they fled in disorder. Keith then wheeled back to his old post, and had no further occasion to move, as the English made no second attempt to establish a flank fire of archery.

The whole of both hosts were now locked in one great mêlée, for King Robert had brought up his infantry reserve, the fourth Scottish battle, to strengthen his front line. The advantage was definitely on the side of the Scots: the English vaward was "fought out," and only kept from recoiling by the masses behind; Gloucester and the majority of the other barons who led it had fallen, and in front of the Scottish line was a great bank of slain and wounded horses and men, which no one could now pierce. Meanwhile, the English rearward had stood for hours vainly trying to get to the front, and losing heart when the impossibility of doing so was fully realised. It only needed some impulse from outside to turn the whole host backward; and this was soon supplied.

[1] Baker of Swinbrook, p. 10. Was this suggested by William I.'s action at Hastings?

[2] Barbour, p. 263:

> "But King Robert that well can ken
> That their archers were perilous,
> And their shot right hard and grievous,
> Ordained forouth the assembly
> His marshal with a great meinie,
> Five hundred armed into steel
> That on light horse were horsed well," etc.

37

The Scottish camp-followers, of whom there were several thousands, had been watching the fight from behind the screen of trees on the slope of Gillies' Hill. Seeing that their enemy seemed faltering, they were seized with the happy inspiration of making a demonstration against the English flank. Snatching up such irregular weapons as the camp afforded, and raising coloured cloths on spears to simulate banners, they came down the wooded slope of the hill, blowing horns and shouting "Slay, slay!"

Imagining that a new Scottish reserve was about to operate against their flank, the English lost heart and began to melt away to the rear long before the emptiness of the demonstration could be perceived. The king himself hastily left the field with five hundred knights, and when he was gone his followers thought it no shame to flee after him. The Scottish line pushed down the slope after the fugitives, taking many prisoners, and thrusting their enemies by heaps into the burn, where many hundreds were drowned or smothered.[1] Those who got off made at once for the English border, and considered themselves fortunate if they reached Berwick or Carlisle without being intercepted and butchered by the peasantry.

Never in all history was there such a frightful slaughter of the English baronage as took place at Bannockburn : even the red field of Towton was far less fatal. There fell one earl, Gilbert of Gloucester, forty-two barons and bannerets, and many scores of knights.[2] Humphrey Earl of Hereford, twenty-two barons and bannerets, and sixty-eight knights, were taken prisoners either on the field or in the pursuit. Of men-at-arms and foot-soldiery the numbers slain were enormous, but no safe guess can be made at the exact figures : the Scots gave thirty thousand as their estimate, but this would be (no doubt) far too high. The victors are said to have lost only two knights and some four thousand of their pikemen—figures which are not at all improbable.

So ended the most lamentable defeat which an English army ever suffered. Its lessons were obvious. With the experience of Falkirk and Loudon Hill before him, Edward II. was culpably

[1] Chronicle of Lanercost : " Quum ante transissent unam foveam magnam, in quam intrat fluxus maris, nomine Bannockburae, et cum confusi vellent redire, multi nobiles ceciderunt . . . et nunquam se explicare de fovea potuerunt" (p. 225).

[2] Barbour says two hundred, and seven hundred esquires.

mad when he endeavoured to ride down the Scots by mere
cavalry charges. At all costs he should have used his archery,
supporting them properly with bodies of horsemen kept close
enough to the front to give instant aid against any attack by
the Scots. The second fatal error was the crowding such a vast
army on to a front of no more than two thousand yards. For
if he had kept back his rear divisions, and refused to thrust them
forward on to the already overcrowded battlefield, his over-
great numbers need not in themselves have prevented success.

For the conduct of the fight on Bruce's part no praise can
be too great. It was the culminating point of that whole
method of war which he left as a legacy to his subjects. The
lines in which his "testament" was committed to memory by
after-generations are well worth quoting:—

> "On fut suld be all Scottis weire,
> By hyll and mosse themseiff to reare.
> Lat woods for wallis be bow and speire,
> That innymeis do them na deire.
> In strait placis gar keip all store,
> And byrnen ye planeland thaim before.
> Thane sall thai pass away in haist
> When that thai find na thing but waist.
> With wyles and waykings of the nyght
> And mekill noyis maid on hytht,
> Thaim sall ye turnen with gret affrai,
> As thai ware chassit with swerd away.
> This is the consall and intent
> Of gud King Robert's testiment."

The fourteen lines contain all the principles on which the
Scots, when well advised, acted for the next two hundred and
fifty years. They were to maintain the defensive, only to fight in
strong positions among hills and morasses, to trust to retirement
into the woods rather than to the fortifying of castles, to ravage
the open country before the advancing enemy, and to confine
their offensive action to night surprises and ambushes.

The fifteen years which followed Bannockburn differed from
most of the periods of war between England and Scotland in
that for the greater part of the time the southern realm was on
the defensive. It is not till the battle of Dupplin Muir in 1332
that the balance turned again in favour of the English. The
period is of no very great interest from the military point of
view, being mainly covered by a series of skilful raids of the
Scots into the northern counties, which reached sometimes well-

nigh to the gates of York. They came not to conquer, but
merely to ravage, and were as a rule more set on carrying their
plunder safely home than on meeting the enemy in battle. So
great was Bruce's caution in risking a general engagement that
even in 1321 he allowed an English army to march as far as
Edinburgh unfought with, and turned it back only by a careful
cutting off of its commissariat. There were, however, two con-
siderable collisions between English and Scottish hosts during
the time, in both of which the latter had the advantage. At
Mytton in 1320 the Yorkshire levy, under the leading of its
archbishop, was easily scattered by the Earl of Murray and
James of Douglas. This was a rout rather than a battle, the
Yorkshiremen having retired as the Scots drew near without any
serious attempt at a fight. At Byland in 1322 Bruce himself won
his last victory, beating up the English quarters by a sudden
attack at dawn, both in front and in flank. There was no regular
fighting, as the English were surprised, and those of them who
rallied only strove to defend a narrow pass long enough to let
their master King Edward escape, which he did with great
difficulty, leaving his kinsman, John of Bretagne, Earl of
Richmond, in the hands of the Scots.[1]

[1] Cf. Barbour with Baker of Swinbrook, p. 14.

CHAPTER II

CONTINUATION OF THE SCOTTISH WAR: FIRST COMBINATION OF ARCHERY AND DISMOUNTED CAVALRY — DUPPLIN AND HALIDON HILL

WITH the disasters of Mytton and Byland the second period of the Scottish war comes to an end. King Robert died on June 7, 1329, and with his death the ascendency of the Scottish arms passed away. Taught by their misfortunes, the English were about to try a new tactical combination. They had failed in many disastrous attempts to cut off Scottish raiders, and had suffered many checks when they still attempted to take the offensive. The first campaigns of the young Edward III. had been perfectly fruitless. When at the head of a vast levy of all the strength of England he tried to hunt down Douglas and his plundering bands in 1328, he had been obliged to return to Newcastle wearied out and utterly foiled.[1] The "Shameful Peace" of Northampton had followed (May 4, 1328). Four years of uncertain truce intervened, and then the English and Scots met again with changed fortune.

In 1332 an invasion of Scotland was prepared. The disinherited nobles of the English party, who had adhered too long to the cause of the Plantagenets, backed by the many English barons and knights who had been granted, and had since lost, Scottish estates, were determined to attempt the recovery of their fiefs. The peace of Northampton had provided that they should receive back their holdings on doing homage for them to the Scottish king, but Bruce had distributed most of the land in question to his own partisans, and the regents who ruled after his death made no attempt to carry out the terms of the treaty.

[1] Froissart's account of this chase on the Northumbrian moors may be incorrect in detail, but well deserves reading as a picture of Scottish tactics.

The leaders of the "Disinherited" were the young Edward
Baliol, son of the unfortunate King John, Gilbert Umphraville
Earl of Angus, David Earl of Athole, Henry de Beaumont, who
had married the heiress of Buchan, and Walter Comyn. The
rank and file of their little host was almost entirely composed
of Englishmen, with a few Scots and still fewer foreign mercen-
aries, among whom the Netherlander Walter Manny (destined
to be one of the prominent figures of the Anglo-French wars) is
the only name of note. Their number was no more than five
hundred knights and men-at-arms, with between one thousand
and two thousand archers.[1] King Edward had refused to
afford them help, holding himself bound by the Treaty of
Northampton. He had even prohibited them from crossing
the Tweed, and given his Wardens of the Marches orders to
use force to prevent any such attempt. The Disinherited there-
fore collected at Ravenspur near the Humber mouth, hired
ships, and passed into Scotland by sea.

They landed near Kinghorn in Fife, drove off the Scots who
tried to hinder their disembarkation, and then moved on
Dunfermline. From thence they marched on Perth, but soon
found a large army under the regent, Donald Earl of Mar,
lying across their path on the other side of the river Earn. All
Central Scotland had been roused, and the least estimate given
of the regent's army encamped on Dupplin Muir is that it
comprised two thousand men-at-arms and twenty thousand
foot.[2] It might have been expected that the Scots would cross
the river at once to attack the small body of invaders; but the
Earl of Mar was cautious: either he feared treachery in his own
host, or he grossly over-estimated the number of Baliol's men.
He contented himself with placing the flower of his army at the
bridge which crosses the Earn, intending perhaps to force the
passage next morning.[3]

[1] The Bridlington Chronicle, p. 106, says five hundred men-at-arms and one
thousand foot. Knighton, ii. p. 462, gives three hundred men-at-arms and three
thousand foot—not such a likely proportion, for the archers were never ten times the
number of the cavalry in English armies of this time. The Lanercost Chronicle
gives fifteen hundred, but says that some gave two thousand eight hundred.

[2] Forty thousand is the figure of Knighton, vol. i. p. 462, and the Bridlington
Chronicle, p. 106.

[3] "Omnes equites et armati pontem pariter obsidebant, aestimantes advenas vada
ignorare" (Brid. Chron. 106).

Battle of Dupplin, August 9, 1332.

The Disinherited were quite conscious that their attempt was a mere forlorn hope; and that their only chance of success lay in extreme audacity. When the dusk had fallen, they set forth to make a night attack on the regent's camp, crossing the river by a ford pointed out to them by some of the Scottish exiles.[1] They fell on to the rear of the Scottish bivouac and made a dreadful slaughter of the foot-soldiery who lay on its outskirts. But when day dawned they found the regent and all his men-at-arms marching against them in good order: being at the other side of the camp, near the bridge, they had escaped the surprise, and had gained time to arm and array themselves.[2] The Scots advanced in solid columns, two in number according to the Chronicle of Lanercost,[3] while the Bridlington Chronicle's clearer narrative gives the more probable statement that there was one large central column flanked by two smaller ones.[4] All were on foot, according to the ancient custom of the Scots.

Seeing the enemy approaching in such force, the invaders drew back from the Scottish camp and ranged themselves on the slope above it.[5] The knights and men-at-arms dismounted and stood in a single mass in the centre; the archers were drawn out in a thin line on either flank, scattered among the heather of the hillside, and presenting no formed body at which an enemy could strike. Forty men-at-arms, all continental mercenaries, were alone told off to remain on horseback and form a reserve,[6] destined to deliver a last desperate charge, or, in the event of victory, to strike in as pursuers. It

[1] "Instructi per quosdam patrias et vada fluminis cognoscentes" (Brid. Chron. 105). Scottish tradition said that Andrew Murray of Tullibardine guided them.

[2] I must here make my acknowledgments to Mr. J. E. Morris, whose article on the battle of Dupplin in the *English Historical Review*, 1897, pt. iii., first set me studying the details of the fight. He undoubtedly is the discoverer of the true meaning of it.

[3] "Fuerunt duae magnae acies, in quibus erant vexilla duodecim." (Chron. Laner. p. 268).

[4] "Dispositis itaque turmis et sagittariis suis, ut *callaterales* cuneos hostium invaderent, ipsi armati [the barons and their men-at-arms] *magnum exercitum* [the Scottish main body] expugnabant" (Brid. Chron. 106).

[5] "Festinaverunt ascendere montem, ubi Scoti hospitati sunt, in sinistra parte" (Knighton, p. 463).

[6] "Praeliari coeperunt, exceptis xl armatis qui venerant de Alemannia in auxilium Anglorum, qui se a latere continebant *ascensis equis suis*" (Knighton, p. 463).

seems clear that the archers were arrayed not in the same straight line as the men-at-arms, but with their flanks thrown forward so that the whole army resembled a half-moon.

The English can hardly have been in array for more than a moment when the Scottish columns, with twelve banners, of earls and great barons waving over them, rolled up the hillside. Utterly neglecting the archers on the wings, the regent made for the central clump of men-at-arms, and dashed into it with lances levelled. The first onset was so heavy that the "Dis-inherited" were borne back some paces. It was with the greatest difficulty that they held together and preserved them-selves from being trampled down. But the impetus of the Scots being deadened by the first shock, and the slope being against them, they were for a moment checked, and the two hosts stood pressed together, with their spears locked, and hardly room to swing a sword.[1] Ralph Lord Stafford, seeing that the fight had now become a matter of pushing rather than of hack-ing and hewing, called to his men to turn sideways and thrust with their shoulders instead of opposing their breasts to the enemy. Using this device, and struggling desperately, the invaders succeeded in holding their line unbroken for some time,[2] and brought the Scots to a stand.

Meanwhile, the archers on the wings had closed in upon the enemy, and were pouring a blinding shower of arrows upon the smaller flanking columns which protected the sides of their main body. At first the Scots seem to have paid no heed to them, but to have set all their attention on pushing forward to the centre. But the shafts fell like hail, and so deadly were they that the advancing masses involuntarily swerved inwards and refused to face the incessant shower.[3] They thus fell in upon the centre column and became blended with it. The enormous lateral pressure produced by their junction with the "main-battle," which was already so hotly engaged with Baliol's men-at-arms, had the most disastrous results. The whole mass

[1] "Facto congressu Scotorum impetum primo non ferentes aliquantulum retro-cedere compelluntur, sed de superius animati resistunt." (Knighton, p. 106).

[2] "Clamabat Baro de Stafford, Vos, Anglici, vertatis contra lanceas vestras humeros et non pectus, et ipsi hoc facientes Scottos protinus repulerunt." (Chron. Lanercost, 268).

[3] Hostium vero minores turmae per sagittarios plurimum lacerati magno exercitui compelluntur, et in breve conglobati alius ab alio premebatur." (Chron. Brid. p. 106).

was hustled together and wedged in hopeless confusion, which only became worse when the archers again closed in on the flanks and continued to pour their arrows into the heaving mass. " In a short space they were thrust so close that they were crushed to death one by another, so that more fell by suffocation than by the sword." [1] They were soon piled into a great heap, which grew higher as the inward pressure continued, and " a marvel never seen or heard of before in any battle of the past was observed, for the heap of dead stood as high from the ground as the full length of a spear." [2]

 Unable to break through to the front, and horribly galled on the flanks, the Scottish host at last broke up, and all who could escape from the press made their way to the rear. Henry de Beaumont and some of the " Disinherited " then sprang on their horses and chased the fugitives for several miles. The Scots were not merely beaten, but well-nigh exterminated. Only fourteen knights are said to have escaped.[3] Among the slain were the regent, Donald, Earl of Mar, the Earls of Menteith and Murray, Robert Bruce Earl of Carrick, the young king's bastard cousin, Alexander Fraser the High Chamberlain, eighteen bannerets, fifty-eight knights, eight hundred squires, twelve hundred men-at-arms, and an innumerable multitude of foot-soldiery.[4] Not one single living man was found in the frightful heap in the centre of the host. Among the "Disinherited" there fell thirty-three knights and men-at-arms, of whom the chief were John Gordon and Reginald de la Beche : not a single archer is said to have been slain ; the Scots had never come to handstrokes with them.[5]

 The battle of Dupplin formed the turning-point in the history of the Scottish wars. For the future the English always adopted the order of battle which Baliol and Beaumont had discovered, dismounting their heavily-armed men and forming the centre from them, while the archers were thrown forward on the flanks. This was the array which King Edward III. used at Halidon Hill in 1333 : it is to be noted that Edward Baliol,

[1] " Ita a suis suffocati et magis quam gladiorum ictibus verberati, acervum valde mirabile composuerunt ; sicque condensati ac si fuissent funibus colligati miserabiliter expirabant " (ibid. 106).

[2] Chron. Lanercost, p. 268. [3] Knighton, p. 107.

[4] Chron. Brid. p. 107. Knighton gives (p. 463) twelve bannerets and more than a hundred knights.

[5] Knighton, p. 463.

Gilbert Umphraville, Beaumont, and David of Athole, the victors of Dupplin, were all serving under him in that engagement; it must have been from them that he learned the most effective way of dealing with the Scottish masses.

Battle of Halidon Hill, July 19, 1333.

The main facts of Halidon Hill are very clear, though we are not so well furnished with its details as might be wished. Edward was besieging Berwick when a great Scottish host appeared to deliver it. Leaving a considerable portion of his troops in the trenches to keep up the blockade, the king marched with the rest to beat off the army of succour. He took up a position such as Bruce would have loved, on a hillside with a marshy bottom below it and a wood on its brow. Edward made all his knights and men-at-arms dismount, and formed them in line with the archers. The host was divided into three "battles," each furnished with small wings. The right division was headed by the Earl Marshal, Thomas Earl of Norfolk, the king's half-uncle; he had with him Edward's young brother, John of Eltham, and Henry de Beaumont. The wings of their corps were composed of troops under the Earl of Athole on the right and the Earl of Angus on the left. In the centre was the king himself; on the left wing Edward Baliol; each of their divisions was furnished, like the right-hand battle, with small wings. All the knights fought on foot.[1]

The Scots were forced to attack, as Berwick could not be relieved unless the English were beaten in the open field; their old defensive tactics of Falkirk and Bannockburn could not be used. But they, nevertheless, arrayed themselves in the great masses which formed their habitual order of battle, and came lumbering down the opposite hillside in four columns.[2] The marsh at the bottom forced them to slacken their pace, but, pushing through it, they began to climb Halidon Hill. They

[1] This is expressly stated by Baker of Swinbrook. "Hic dicit a Scotis Anglorum generositas dextrariis reservare venationi hostium, et contra morem hommum patrum pedes pugnare" (p. 51). He had evidently not appreciated the importance of Dupplin in the military history of England. Herein all historians have followed him, wherefore Mr. Morris deserves the more credit for calling attention to that much-neglected field.

[2] Hemingford gives for their army the very moderate and probable figures of twelve hundred men-at-arms and thirteen thousand five hundred pikemen. At the same time he says that the available force of Edward was smaller. Many of the English authorities give absurd figures for the Scottish losses, running up to sixty thousand!

could not, however, win far up its side, for such a terrible storm of arrows began to beat upon them the moment that they commenced to mount the slope, that all the front ranks went down together. The masses strove to push forward, but each party as it emerged from the weltering crowd and tried to climb higher up the slope was promptly shot down, and it seems that very few of the Scots struggled up so far as the line of English men-at-arms on the brow. When at last the mass wavered and began to tail off to the rear, King Edward bade his knights mount, charged the fugitives, and pursued them fiercely for five miles. There fell of the Scots Archibald Douglas, the regent of the realm, Hugh Earl of Ross, Kenneth Earl of Sutherland, Alexander Bruce Earl of Carrick, three other earls,[1] and such a multitude of barons and bannerets, that Bannockburn was well repaid. As the English ballad-maker sang—

"Scottes out of Berwick and out of Aberdeen,
At the Burn of Bannock ye were far too keen,
King Edward has avenged it now, and fully too, I ween."

Halidon Hill is the second, as Dupplin is the first, of a long series of defensive battles fought against the Scots, and won by the skilful combination of archery and dismounted men-at-arms. Neville's Cross, Homildon, Flodden, Pinkie, are all variations upon the same theme. At the first-named fight the archers so riddled the Scots left wing that it broke up when attacked by the English men-at-arms, and left the centre bare to flank attack. At Homildon they so teased the Scottish masses by a careful long-range fire, that they came storming down from a strong position (like Harold's axemen at Hastings), and were caught in disorder and utterly dispersed by the English main body as they strove to pursue their lightly-moving assailants. Of Flodden and Pinkie we shall speak in a later volume ; in their main features they belong to the same class as Dupplin, Halidon, Homildon, and Neville's Cross. The moral of all is the same: invaluable against cavalry, the Scottish pikemen were helpless when opposed by a judicious combination of lance and bow. It was in vain that enlightened men in the northern realm, like King James I., tried to encourage archery: for want of old tradition and hereditary aptitude, Scotland never bred a race of archers such as flourished south of Tweed. When she got

[1] Apparently Lennox, Strathearn, and Athole, the last-named being the Scottish claimant who disputed that title with David of Strathbogie.

the better of England in war, it was always through a careful adherence to "good King Robert's Testament," by the avoidance of general engagements, the harrying of the land before the advancing foe, and the confining of offensive action to ambushes and night surprises,—"the wyles and wakenyngs of the night," which that wise and cautious soldier had prescribed.

BOOK VIII

THE LONGBOW IN FRANCE AND SPAIN

1337–1370

BOOK XIII

THE HUNDRED YEARS' WAR—THE ARMIES OF EDWARD III

WE have seen that the result of the thirty years of almost uninterrupted war between England and Scotland, which began at Dunbar and lasted down to Halidon Hill, had profoundly modified the habitual tactics of English armies. Taught by the events of Falkirk and Bannockburn, they had abandoned the old idea that battles were won solely by the charge of armed horsemen. Success, it had been found, depended far more upon the judicious use of archery. But archers alone would not be sufficient to decide the day ; they could be driven off (as at Bannockburn) by a charge of horse, unless they were properly supported. For an offensive battle the support might consist of mounted men (as at Falkirk). For a defensive battle dismounted men would be more useful, for all history has shown that cavalry cannot easily defend a position ; once tied to a fixed spot, they lose the impetus which is their strength.

Edward III., as we shall see, was a very competent tactician, but a very unskilful strategist. It fell to him to apply the lesson of the Scottish wars to a new struggle fought on a larger scale and under very different conditions. The use that he made of them was excellent, and led to such successful results that it stereotyped the tactics of English armies for the next century and a half.

England was now about to engage in war with a power which excelled her in military strength much in the same proportion in which she herself excelled Scotland. Just as England surpassed the realm beyond Tweed in the size of her hosts, and especially in the number of heavy cavalry that she could put into the field, so did France surpass England in those points. To hope to meet the French, lance for lance, in the open field was just as impossible for Edward III. as it had been impossible

for Wallace or Bruce to set knight against knight at Falkirk or Bannockburn. Hopelessly outmatched in the numbers of his mounted men, Edward had to bethink him of some way in which the superiority of the French in that respect might be neutralised. His resolve was to adapt to English needs the tactics which Bruce had made famous—to fight defensive battles in good positions, and keep off the horsemen by a steady and unbreakable line of infantry. But he had an advantage which Bruce had never possessed—that of being able to command the services of a very numerous and efficient archery, far surpassing any continental troops armed with missile weapons that then existed. The strength and adaptability of this arm was now known to every English commander, but it was wholly unsuspected beyond seas, for its development had taken place since the last continental campaigns of the Plantagenets in the thirteenth century.

Edward's great experiment, therefore, first worked out at Crecy, was to apply the tactics of Dupplin and Halidon Hill—which had told so well against masses of spearmen on foot —against masses of cavalry. In France those absurd perversions of the art of war which covered themselves under the name of Chivalry were more omnipotent than in any other country of Europe. The strength of the armies of Philip and John of Valois was composed of a fiery and undisciplined *noblesse*, which imagined itself to be the most efficient military force in the world, but was in reality little removed from an armed mob. A system which reproduced on the battlefield the distinctions of feudal society was considered by the French aristocracy to represent the ideal form of warlike organisation. The French knight believed that, since he was infinitely superior to any peasant in the social scale, he must consequently excel him to the same extent in military value. He was therefore prone not only to despise all descriptions of infantry, but to regard their appearance on the field against him as a species of insult to his class-pride. A few years before, the self-confidence of the French nobility had been shaken for a moment by the result of the battle of Courtray (1302). But they had soon learned to think of that startling and perplexing event as a mere accident, brought about by the folly of the Count of Artois in leading his chivalry into a broad ditch and marsh through which they could not penetrate to the enemy. Comforting themselves with the

reflection that it was the morass and not the Flemish infantry which won the battle, they were confirmed in their views by the event of the two bloody fights of Mons-en-Pevèle (1304) and Cassel (1328). The fate which had on those days befallen the gallant but ill-trained burghers of Flanders was believed to be only typical of that which awaited any foot-soldier who dared to match himself against the chivalry of the most warlike aristocracy in Christendom. Pride goes before a fall, and the French nobles were now to meet infantry of a quality such as they had never supposed to exist.

Against these presumptuous cavaliers, the wretched band of half-armed villeins whom they dragged with them to the field, the king's mercenaries, and the disorderly militia of the French communes, the English archer was now to be matched. The men whom Edward III. led over-seas were not hasty and miscellaneous shire-levies such as had fought at Bannockburn. In the beginning of the war the English armies were entirely raised by Commissions of Array, under which designated commissioners selected from each county a definite number, usually a very moderate one, of picked men-at-arms, archers, and other soldiers. Comparing the orders for the levying of the host which went to Scotland in 1314 under Edward II. with those of the host which his son caused to be arrayed in 1339,[1] we note that

[1] The muster-rolls of the arrays of Feb. 1339, given in Rymer, II. vol. ii. p. 1070, are so characteristic that they are worth giving in full. The archers, it will be noted, form exactly half the foot. In later years they were a much larger proportion.

	Men-at-arms.	Armati.	Archers.		Men-at-arms.	Armati.	Archers.
Yorkshire . .	200	500	500	Cambridgeshire .	18	70	70
Gloucestershire .	63	250	250	Huntingdonshire	18	70	70
Worcestershire .	30	120	120	Buckinghamshire	20	80	80
Staffordshire .	55	220	220	Bedfordshire .	20	90	90
Shropshire .	55	220	220	Lancashire . .	50	300	300
Herefordshire .	30	120	120	Norfolk . .	40	160	160
Oxfordshire .	20	80	80	Suffolk . .	25	100	100
Berkshire . .	15	60	60	Northumberland	70	250	250
Wiltshire . .	35	140	140	Westmoreland .	25	150	150
Devonshire .	35	160	160	Cumberland .	50	200	200
Cornwall . .	25	100	100	Lincolnshire .	80	350	350
Hampshire .	30	120	120	Nottinghamshire	35	150	150
Somersetshire .	35	160	160	Derbyshire . .	35	150	150
Dorsetshire .	25	100	100	Leicestershire .	25	120	120
Sussex . .	50	200	200	Warwickshire .	30	120	120
Surrey . .	20	80	80	Northamptonshire	35	160	160
Kent . . .	35	140	140	Rutland . .	10	40	40
Essex . . .	35	160	160				
Hertfordshire .	18	70	70		1407	5600	5600
Middlesex . .	10	40	40				

38

the Commissions of Array in the latter year were directed to levy only from about one-third to one-fifth of the numbers which the sheriffs had been told to provide in the former year.[1] They were, of course, individually better in proportion to the greater care which could be taken in selecting them. A considerable number, no doubt, would be willing men who volunteered to serve. Provision was made for allowing those who were unfit or reluctant to provide themselves with substitutes, on the principle of scutage, by paying a reasonable sum of money in compensation.[2] The commissioners themselves were responsible for seeing that the deputy should not be a waif or a wastrel, but a competent and proper representative of the man who stayed at home. Sir John Falstaff's methods, it is clear, were not prevalent in the fourteenth century, for we seldom get any complaint as to the kind of recruit that was provided, and the achievements of the English hosts are the best testimonials to the character of the men who served in them.

As the long struggle with France wore on year after year, another method was often used for the raising of men. It was probably suggested by the treaties of subsidy which the king had often concluded with German princes during his earlier campaigns. If a Duke of Gueldres or Count of Loos could engage to bring the king so many hundred lances or crossbows for a given payment, the same thing might be done with native English peers or knights. Instead of calling on a baron merely to carry out his feudal obligations, and paying him for the time that he spent over-seas "at the king's wages," it might be possible to get more use out of him by offering him more advantageous terms. Thus came into existence the system of "Indenture," by which the king made a bargain with his subject—whether the latter chanced to be earl, baron, or simple veteran knight. The acceptor of the indenture contracted to bring a fixed number of followers to the war, or to maintain a certain sort or

[1] e.g. Lincoln seven hundred instead of four thousand, York one thousand instead of six thousand, Derby three hundred instead of one thousand, Nottingham three hundred instead of one thousand, Warwick two hundred and forty instead of five hundred, Leicester two hundred and forty instead of five hundred.

[2] e.g. In the year of the levying of the Crecy army the arrayers of arms are allowed to make agreement "ad tractandum et concordandum cum omnibus hominibus ad arma et hobellariis qui fines, pro progressu suo, facere voluerint, habita consideratione ad bona et catalla sua : ita quod loco eorum de denariis illis provenientibus alios homines conducere valeamus," etc. (Rymer, 1346, p. 78).

garrison at his own risk, in return for certain payments and allowances to be made him by the sovereign. The contract was wholly outside and unconnected with feudal obligations; it was a pure matter of bargaining. The contractor might not even be a vassal of the king's. Sir Walter Manny, Wolfhard of Ghistelles, and other well-known captains were aliens born. A simple knight with only a few acres of his own might contract for hundreds of men if he was a popular and capable leader whose name would attract numerous volunteers.

The use of the "Indenture" system saved the king the friction and show of compulsion caused by the use of the conscription carried out by Commissioners of Array. The men brought in by the contractors were all freely enlisted and willing soldiers, serving under the leader of their own choice. They would also be, on the average, more efficient than the pressed men from the shires. The long continuance of the wars had created a large class of adventurers who had seen one or two campaigns on compulsion, but had then stuck to the trade of war from choice. These professional soldiers were as ready to make their bargain with the holder of an indenture as the latter was to make his bargain with the king. Thus came into being the mercenary armies of the second stage of the war, composed of hardy unscrupulous veterans, terrible to the enemy's host, but still more terrible, from their habit of scientific plunder, to the peaceable inhabitants of any district through which they chanced to pass. The best of soldiers while the war lasted, they were a most dangerous and unruly race in time of truce or peace, for they had no wish to return to their homes and fall back into civil life.

As an early example of the forms used in the system of indenture, the agreement signed by the king and Thomas Holland Earl of Kent, on September 30, 1360, may be noted.[1] The earl contracts to serve the king "at the accustomed wages of war" for a quarter of a year: the sum due is to be paid him beforehand, in order that he may have sufficient ready money for the equipment of his contingent. He is to provide sixty men-at-arms, of whom ten are to be knights and one a banneret, and a hundred and twenty archers, all of whom are to be provided with horses. The high proportion of "spears" to "bows" deserves notice, and also the fact that all the archers are to be mounted;

[1] Rymer, *Foedera*, iii. p. 510.

it was by this provision of horses for even the infantry that the English armies were enabled to move so fast in the later French campaigns.

In the case of indentures providing for the custody of fortresses on French soil, we may note some curious provisions for the protection of the contractor. When Sir John Chandos undertakes to garrison a castle, it is stipulated that if the king or any of his sons pays him a visit, the castellan shall have an extra allowance for entertaining them: again, if any English forces pass by and consume the stores of the garrison, the king undertakes to pay an additional sum to make up the value of the food which Chandos supplies to them. But the ordinary expenses of war must be defrayed by the governor from the regular allowance guaranteed in his indenture.

CHAPTER II

THE LONGBOW IN FRANCE—CRECY

FROM the very first moment of the Hundred Years' War we find the English archery exercising a preponderant influence in battle. The first clash of arms came when the Earl of Derby landed in Flanders on St. Martin's Eve 1337. The English had to force their way on shore, which they did under cover of a rain of arrows which completely drove off the Flemish crossbowmen who had lined the quays of Cadzand haven.[1] Then, when the expedition had landed, there was a sharp fight on shore: the earl posted his archers on his flank, a little in advance of his men-at-arms.[2] The Bastard of Flanders, who commanded the enemy, charged the English when they were formed, but was completely routed, mainly owing to the irresistible flank fire of arrows, and taken prisoner with most of his chief followers.[3]

When King Edward himself came over to Flanders in 1339 and called in to his aid the German princes that he had subsidised—the Margrave of Brandenburg, the Dukes of Brabant, Gueldres, and Juliers, and the rest—he had under his hand the largest army that any English king ever set in battle-array on continental soil. Of men-at-arms alone there were twelve thousand,[4] and the Flemish and Brabançon infantry swelled the host to enormous proportions. With such forces at

[1] Froissart, K. de Lettenhove's edition, p. 436: "Traioient arbalestier a leur pooir, mais Englais n'en faisoient compte, car archier sont trop plus isniel au traire que ne sont arbalestier."

[2] MSS. de l'Arsenal, 148, p. 187: "Luy et ses gens descendirent a terre et les archiers à l'un des lés ung peu devant eulx, et commenchérent a traire moult druement."

[3] Froissart, p. 436: "Au vrai dire li archier ensonnoient trop grandement les assaillants et deffendants Flamens, ... et finablement li Flament ne peurent porter ne soustenire le faix," etc.

[4] Baker of Swinbrook, p. 64. Cf. also Knighton and others.

597

his command, we might have expected that Edward would have
planned an offensive battle, in spite of the fact that Philip of
France had brought out against him an even greater multitude.
He was resolved, however, to fight a defensive engagement,
and to employ the very tactics that had served him so well
at Halidon Hill. The army was formed up in front of La
Flamengerie in three lines. The front line was composed
entirely of English, and was divided into a centre with two
smaller wing divisions, or *échelles* as the king himself calls them
in his account of the campaign. In each division the whole
of the men-at-arms were dismounted and formed in line, with
the archers ranged on each flank of them. The Margrave of
Brandenburg and the German princes composed the second
line; the Duke of Brabant's contingent the third. In these lines
it would seem that, according to the custom of the Continent,
the knights were on their steeds, for it is recorded that the
Margrave and the Duke of Brabant, riding forward to view the
king's order of battle, were much surprised to see the array that
he had adopted, though they concluded, after inspection, that
it was admirably arranged.[1]

If King Philip had advanced from Buironfosse and attacked
the confederate army, there would have resulted a battle on the
same lines as that which took place seven years later at Crecy,
but on a much larger scale. But the English tactics were not
yet to be put to the test: the French king ranged his host in
order at a prudent distance and refused to move forward. He,
no less than Edward, wished to be attacked. Thus it came to
pass that no general engagement took place, and that the
enemies retired each toward his own base when they had
exhausted the provisions of the countryside.

The seven years that followed were singularly deficient in
events of any tactical or strategical interest. The bickering
of the French and English alike in Flanders, Brittany, and
Aquitaine led to no single engagement of first-class importance.
The war was carried on by a series of forays, sieges, and
chivalrous but unscientific exploits of arms, which led to no

[1] The French original of the " Ordonnance des Anglois à la Flamengerie " clearly
enough states that the archers were on each side of the knights: "Le roy fist touts
ses gents descendre à pié, et mis ses gents en arraie, les archiers à l'encoste des gentes
d'armes." The English chroniclers who translated the document, e.g. Hemingford,
rendering *à l'encoste* by *juxta*, make the arrangement obscure and vague.

OPENING OF THE CRECY CAMPAIGN

decisive result. The one really striking event of the time, the battle of Sluys, was a fight on sea, not on land. Such encounters as did take place ashore were for the most part surprises, ambuscades, or night attacks—like the Earl of Derby's brilliant surprise of the Gascons at Auberoche,[1] or Sir Walter Manny's victory at Quimperlé.[2]

All the more startling and important, therefore, was the event of the battle of Crecy, when the new English tactics were first put to the proof on a large scale. It was not till it had been fought that the importance of this new development of the art of war was realised on the Continent.

King Edward, as we have already had occasion to observe, was not a great strategist, and the details of the campaign which led up to the battle of Crecy are as discreditable to his generalship as those of the actual engagement are favourable. Disgusted at the repeated failure of his attempts to invade France with the aid of an army of German or Breton auxiliaries, he had sailed from Portsmouth on July 5, 1346, at the head of a host composed entirely of his own subjects. It seems to have numbered about four thousand men-at-arms, twelve thousand English archers, and six thousand Welsh light infantry. But, most unfortunately, the complete muster-rolls of the army have not been preserved, though those of several of the hosts which went out on less important expeditions exist in full. We only know that the corporate towns (as opposed to the shires) of England sent a hundred men-at-arms and seventeen hundred archers, and that the Principality of Wales was assessed at three thousand five hundred and fifty men, half archers, half spearmen, while the Welsh Marcher lords were responsible for three thousand two hundred and fifty.[3] The best means of guessing at the whole is to consult the figures which have been preserved, giving the state of the army before Calais eight months later, as those troops were virtually the same who had fought through the Crecy campaign. Re-inforcements received since the siege began had probably made up for the losses suffered in battle.

[1] Adam Murimuth gives all the credit of the fight of Auberoche to the archers (p. 190 of the Rolls Series edition).

[2] Sir Walter surprised the camp of Louis of Spain in his absence, routed the troops left there, and then encountered the enemy as he hastily returned homeward, and beat him in a running fight, not a pitched battle.

[3] Rymer, *Foedera*, 1346, pp. 80, 81.

At the moment of sailing, the general impression on board the fleet had been that the expedition was destined for Guienne, where the Earl of Derby had been calling for succour. But, much to the surprise of the army, the king, when well out of sight of land, sent orders round the squadron to steer for Cape La Hogue, as he was about to invade Normandy. Strategical reasons might conceivably have dictated such an invasion; Edward might have purposed to land as near as possible to Paris, and to make a dash at the capital with the object of doing something to justify his claim to the French crown. On the other hand, he might have aimed at a conquest of Normandy or some part of it—the projecting peninsula of the Cotentin; perhaps — in order to secure a firm basis of operations for future attacks on France. Or, again, he might have aimed merely at causing such a diversion in the north as should compel the French to abandon their pressure upon the Earl of Derby in Aquitaine.[1] But Edward's conduct of the campaign shows that none of these rational schemes was definitely formulated in his mind, and that the expedition partook rather of the character of a chivalrous adventure, or of a great raid of defiance pushed deep into France to provoke its king.

Edward landed at La Hogue on July 22, and marched at a leisurely pace[2] through Normandy for twenty-eight days, wasting the countryside, spoiling open towns, and accumulating much plunder, but making no attempt to secure any hold on the land by seizing and garrisoning its fortresses. The only important place which fell into his hands was Caen, a rich but unwalled town, which was captured on the 26th of July, after a severe engagement, in which the militia of Normandy was scattered, and the Counts of Eu and Tancarville, the Constable and Chamberlain of France, were taken prisoners, with more than a hundred knights of their following. Pushing eastward,

[1] This is the version given by Froissart (4th redaction in Kervyn de Lettenhove's edition): he makes the Norman exile, Godfrey of Harcourt, persuade the king to attack Normandy merely because of its wealth and defencelessness. Edward perseveres in his plan of sailing to Gascony, till Harcourt points out that a foray into Northern France will probably cause the French to raise the siege of Aiguillon and evacuate Guienne (pp. 384, 385).

[2] e.g. on July 26 he marched only three miles, on July 24 only five: he halted five days after taking Caen, July 26-31, and three more at Lisieux. For the itinerary and its dates, carefully worked out, see the excellent notes in Maunde Thompson's edition of Baker of Swinbrook, pp. 255, 256.

the king made a movement on Rouen, but he found all the
bridges of the Lower Seine broken, and could not harm the
city. Philip of France, on receiving news of the English
invasion, had called out the whole ban and arrière-ban of his
realm. He had sent for aid to the army of his son John, who
was facing the Earl of Derby in Guienne, and had ordered a
large body of Genoese crossbowmen, who lay on board his fleet
at Harfleur, to come to his assistance. Breaking all the bridges
of the Seine, he hoped to confine the ravages of Edward to
Western Normandy until he should be able to muster a force
large enough to justify him in advancing against the English.

Finding the Lower Seine impassable, and knowing that a
great army was gathering at Rouen, King Edward had now to
make up his mind what course to pursue. He could either
return to his ships and cross the Channel homeward with his
plunder,—a safe but not very glorious course,—or he might send
home his fleet and make the hazardous experiment of striking
deeper into France. The latter course offered few attractions
to a prudent general, but many to an adventurous knight; it
involved cutting the army loose from the fleet,—its sole base of
operations,—and rendered it necessary to retire, when the raid
should be over, on one of two very distant points—Flanders or
Guienne. Meanwhile, King Philip's host was growing larger
day by day, and ere long he would be able to take the offensive
with a vast superiority of numbers. Nor was there now any
chance of catching Paris inadequately garrisoned, as there might
have been if Edward had hurried on after his landing without
stopping to plunder Normandy.

The English king, therefore, could plead no rational justifica-
tion for the line that he took after failing to capture Rouen.
He plunged headlong into a hazardous adventure, by sending
off his fleet and moving inland up the left bank of the Seine
towards Paris. He was able to burn several open towns, and to
lay waste the countryside up to the very gates of the French
capital; but when he found it well guarded, and learned that King
Philip with a hundred thousand men lay at St. Denis watching
him, he must have begun to feel that "his bolt was shot." He
had now only to decide whether he would retire towards
Bordeaux, or force his way over the Seine towards Flanders.
He chose the latter, the more hazardous, alternative, probably
because he had received information that his allies the

Flemings had just crossed the frontier and laid siege to
Béthune. King Philip meanwhile had grown so strong that he sent a
message of defiance to the English, and bade them meet him in
the open field if they dared, offering to fight on whichever bank
of the Seine they might prefer. Such a proposal must have
been a sore temptation to the chivalrous spirit of Edward, but
the risk was too great to allow him to accept it. Putting it
aside, he hastily repaired the broken bridge of Poissy (near St.
Germain-en-Laye) and crossed to the northern bank of the Seine.
A great body of the communal militia of Amiens and other
northern French towns came up while he was completing his
bridge, but they were beaten off with loss, and the English were
able to start on their march northward before King Philip and
his main army could reach them (Aug. 13–14). The time for
leisurely movement was now past, and in four days Edward
pushed on nearly sixty miles, with the French not far behind
him. He was now nearing the first obstacle that lay in his
path—the broad river Somme and the long line of peat-bogs
which border its banks. Edward sent on his two marshals, the
Earl of Warwick and Godfrey of Harcourt, to find a suitable
place for his crossing. A disagreeable surprise awaited him:
the marshals made four separate attempts to force a passage—
at Pont-à-Remy, Fontaine-sur-Somme, Loucq, and Picquigny.
They were foiled at every point; the bridges were broken, and
the fords held by the levies of Picardy in such strength that it
was impossible to cross. Nor was this all; King Philip and his
host had marched parallel with the English, and their van had
reached Amiens. Thus Edward found himself shut into a
triangle, whose three sides were closed by the Somme, the sea,
and the French army. The position was most hazardous; it
seemed that Edward must turn and fight in a position from
which there was no retreat. He was able to burn Poix and other places
towards Paris.
But, just as he was beginning to despair, he learned that there
was one more chance to be tried. The lowest ford on the
Somme was that of Blanchetaque below Abbeville, where the
river grows tidal. Twice a day the ford was passable for a few
hours, but it was guarded by two thousand Picard men-at-arms
under Godemar de Fay, and one large body of crossbowmen.
Under the guidance of a peasant who was tempted by the bait of
a hundred gold nobles, Edward marched down to the passage.

His knights entered the water, and made for the farther bank, while the archers kept up a long-distance flight of arrows over their heads. The Picards made a stout defence, but were beaten off, after a hard struggle, and the English poured over the ford in such haste that King Philip only came up in time to capture a little of their baggage. The tide then rose, the French could not follow, and Edward was saved (Aug. 24).

Battle of Crecy, August 26, 1346.

He had now secured a clear retreat on Flanders, and made two short marches which took him to Crecy-en-Ponthieu, where he halted. No longer solicitous about being surrounded, he had resolved to face about and strike a blow at the French if they should pursue him too rashly. At Crecy he had found a position which pleased his eye, and he announced to his host that "being now in Ponthieu, his own inheritance,[1] he should await his enemies there, and take such fortune as God might send him."

Ponthieu is a country of rolling downs, which slope down to the course of two small streams, the Maye and Authie. The downs are for the most part low and gentle elevations of not more than a hundred and fifty or two hundred feet in height. The district is, except at one point, rather bare of trees, though each village is set in the midst of its own elms and orchards. But one great wood, the forest of Crecy, stretches across the district and forms its most prominent natural feature. The forest of Crecy lies due north of Abbeville, and has a length of some ten miles and a breadth of four or five. It forms an impassable military obstacle, and the two great roads which run northward from Abbeville to Hesdin and Montreuil turn aside to avoid it. A single narrow path, however, cuts through the heart of the wood, and this line Edward had taken, conscious that his adversary would hardly dare to pursue him along it. Having reached the northern side of the wood, the English lay on the banks of the Maye, above the little town of Crecy, "subter forestam de Crecy," as the chronicler puts it. The

[1] The county of Ponthieu had been the dowry of Eleanor of Castile, the wife of Edward I., whose mother Joanna had been Countess of Aumâle and Ponthieu in her own right. But Edward III.'s own mother, Isabella had also a charge of two thousand crowns a year upon it in her marriage settlement, so that the king's statement was doubly true.

French king could pursue only by two roads; and one of these, that through the wood, was practically barred to him by the impossibility of deploying from the single narrow path in the face of the enemy. It was probable that he would, as indeed he ultimately did, take the Abbeville-Hesdin road, which turns the eastern end of the forest and comes in sight of the English position when it reaches the village of Fontaine-sur-Maye.

Edward had therefore to face south-eastward to await the approach of his enemy, and just outside Crécy town there lies a position eminently suited for a defensive battle. The rolling hills between the Maye and the Authie are here cut by a lateral depression or cross-valley, running from south-west to north-east. It is the best defined break in the line of downs which forms the watershed between the two little rivers: for this reason the engineers of to-day have utilised it when they built the Abbeville-Dompierre railway. At no other point could the rolling slopes be crossed at such an easy gradient. The little valley is about one and a quarter mile long: on each side of it a gentle ascent rises to the main level of the downs. When this ascent is climbed, to right or left, the pedestrian finds himself on an undulating plateau. On that to the right (or east) lies the village of Estrées; on that to the left (or west) lies the village of Wadicourt. Each of these little places is set in the midst of its belt of trees, and barely shows a few roofs and chimneys through the greenery. Estrées is the centre of the ground where the French army formed up for battle; Wadicourt the northern end of the English position. Crécy, which gave its name to the fight, lies low, pinched in between the southern descent of the Wadicourt downs and the little river Maye, a quarter of a mile behind the English line. A bowshot beyond the town, and on the very edge of the water, commences the forest of Crécy, a fine, well-grown wood, covering the whole southern horizon.

The Crécy-Wadicourt position is bounded to the south, not by the Maye,—an insignificant thread of water, fordable anywhere,—but by the thick, impenetrable forest, for there is no sufficient space for an enemy to thrust himself along the river-bank between the downs and the wood so as to turn the southern flank of the English line. At the northern end, at Wadicourt, the protection is not so strong: the village and its straggling orchards are sufficient to prevent any attempt to attack from

the immediate flank; but there is nothing to hinder an enemy approaching from the south-east from making a wide sweep along the summit of the plateau in the direction of Ligescourt. It is possible that in 1346 the country north of Wadicourt was more wooded than it is now; but there is only the vaguest evidence to prove it.[1] As things actually went, the French arrived and attacked in such disorder that they made no attempt either to properly reconnoitre or to turn the position.

Edward's army had seen some fighting since it landed at La Hogue, and had suffered, as all armies must, from the wear and tear of two months' active campaigning.[2] But it cannot have been very greatly diminished in numbers, and the figures given by Froissart[3] are probably not far from the truth, viz. three thousand nine hundred men-at-arms, eleven thousand archers, and perhaps five thousand Welshmen.

The host was divided into the usual three "battles." Two formed the front line, the third a reserve. On the right wing lay the Prince of Wales, with twelve hundred men-at-arms, four thousand archers, and the Welsh contingent from his own Principality,[4] probably three thousand strong. The men-at-arms, all on foot, were formed in a solid line—perhaps six or eight deep, —in the centre of the "battle." The archers stood in two equal divisions to the right and left of the men-at-arms: Baker of Swinbrook, the best authority for the battle on the English side, remarks that "they had their post given them not in front of the men-at-arms, but on each flank of them, as wings, so that they should not get in their way, nor have to face the central charge of the French, but might shoot them down from

[1] The Valenciennes Chronicle, which seems to have no good topographical knowledge, says that Edward was encamped on the edge of the wood which lies between Crecy and La Broie. This is probably a mistake for the wood which lies between Crecy and Abbeville. No other chronicler mentions a great wood to the north.

[2] Michael of Northburgh says in his contemporary letter, written from Calais just after the fight, that from Caen to Crecy the army lived by foraging, "a grand domage de nos gens."

[3] In the first edition these are the figures : those of the second are lower, or two thousand men-at-arms, four thousand two hundred archers, and a thousand Welsh. That these are wrong we may pretty certainly conclude from the fact that in the muster-rolls in Rymer we learn that the king started with six thousand Welsh. They may well have been reduced to five thousand by now, but certainly not to one thousand.

[4] The contingent of the Principality as opposed to that of the Marches (i.e. North as opposed to South Wales) had started three thousand five hundred and fifty strong.

the side. He adds that while waiting for the French the archers dug many small holes, a foot square and a foot deep, like the Scottish pottes at Bannockburn, to cause the French cavalry to stumble if they chanced to charge them—which, he adds, the French did not do. Those of the Welsh infantry who bore spears were placed behind the archers, not in the front line.[1] The prince's division occupied the hillside from the point where it sinks down to the banks of the Maye as far as half-way to Wadicourt. North of him, but somewhat drawn back, so as to form an échelon rather than a parallel line with him, lay the Earls of Arundel and Northampton with the second battle. This was somewhat smaller than the first, consisting of twelve hundred men-at-arms and three thousand archers: we do not hear that any Welshmen were attached to it. It was drawn up in the same array as the prince's division, with the dismounted men-at-arms in the centre and the archers on the wings. From the left rear of the first battle it reached as far as the enclosures of the village of Wadicourt.[2]

The king himself with the reserve lay on the plateau above the slope, in front of the wood of La Grange: he seems to have stationed himself in the rear of his son's battle, nearer to Crecy than to Wadicourt. His corps consisted of fifteen hundred men-at-arms, four thousand archers, and those of the Welsh who were not with the prince, perhaps two thousand five hundred strong. Edward himself took post on the windmill at the southern edge of the plateau, the spot from which the whole battlefield can be best embraced with a single glance.[3] Behind the English line, on each side of the road to Estrées court, the whole baggage of the army had been parked in a

[1] Baker of Swinbrook, pp. 83, 84: "Effodiebant foramina . . . ut si, quod absit, equites Gallorum nimis fuissent insecuti, equi ad foramina titubassent."

[2] What are we to make of Froissart's puzzling statement that the English archers were drawn up in the fashion of a herse with the men-at-arms au fond de la bataille"? On the whole I am inclined to agree with Mr. H. B. George's theory, stated in his British Battles, that the English line was compared to a harrow, the archers making the projecting points, and the knights lying a little to their rear. Certainly, the point where Prince Edward's archers touched Warwick's must have presented an angle to the approaching French. My plan of the battle will make the array clear. The line would have three projections, and two retiring spaces where the men-at-arms stood.

[3] Walking carefully over the field, I found no spot commanding such a good general view as that where lie the foundations of the ruined mill, now no more than a ring mound and a few stones. Local tradition still calls it the Moulin d'Edouard.

PLATE XXIII.

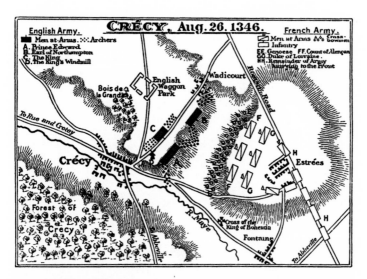

CRÉCY, Aug. 26. 1346.

English Army.
■ Men at-Arms. ⠂⠂⠂ Archers
A. Prince Edward.
B. Earl of Northampton
C. The King.
D. The King's Windmill

French Army.
Men at Arms ◊◊ bowmen
Infantry
EE. Genoese FF. Count of Alençan
GG. Duke of Lorraine.
HH. Remainder of Army
hurrying to the Front

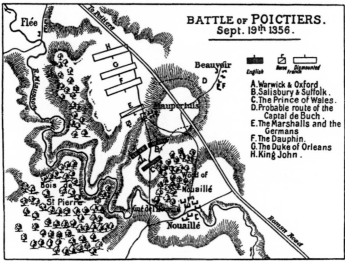

BATTLE of POICTIERS.
Sept. 19th 1356.

English Horse French Dismounted

A. Warwick & Oxford
B. Salisbury & Suffolk.
C. The Prince of Wales.
D. Probable route of the
 Captal de Buch.
E. The Marshalls and the
 Germans
F. The Dauphin.
G. The Duke of Orleans
H. King John.

square enclosure, with the horses tethered inside. A very
slender guard was told off for its protection.[1]
The better part of the baronage of England had followed
Edward over-seas; we read that in the right-hand battle the
prince had under him Thomas Beauchamp Earl of Warwick,
John de Vere Earl of Oxford, Thomas Holland Earl of Kent,
and the Lords Stafford, Cobham, Latimer, Audley, Clifford,
Burghersh, Bourchier. In the second corps lay Richard Fitzalan
Earl of Arundel, William Bohun Earl of Northampton, Robert
de Ufford Earl of Suffolk; and the Lords de la Warre,
Willoughby, Roos, Basset, Multon. In the king's reserve were
the Bishop of Durham, Roger Mortimer Earl of March, William
Montacute Earl of Salisbury, and the rest of the barons
present.

On the same morning that King Edward drew up his host
on the hillside of Creçy, his adversary had started from Abbe-
ville to continue the pursuit. He had no knowledge whether
the English intended to fight or to continue their retreat;
indeed he had lost touch of them since they crossed the Somme
at Blanchetaque. Hence it came to pass that he started forth
on the Abbeville-Montreuil road, to go round the western side of
the forest of Creçy. It was only after the head of the army
had reached Braye, some eight miles north of Abbeville, that
the news arrived that the English had crossed the forest and
thrown themselves on to a more easterly and inland road.
Philip on receiving this intelligence sent off in haste four knights,
who were charged to gallop round the eastern end of the forest
and search for the enemy. Meanwhile, the army was wheeled
to the right, and set to march by a cross-path on to the Abbe-
ville-Hesdin road. The French had no conception that King
Edward was waiting for them only a few miles away; they
marched in great disorder, and straggled over the whole face of
the country. The rear, indeed, had not yet left Abbeville when
the van was at Braye.

The four knights who had been sent out to seek for the
English had no sooner reached the village of Fontaine than they
suddenly came in sight of the whole English army, not retreating
(as they had expected) along the Hesdin road, but drawn up

[1] It is certain that the two or three distant chroniclers who speak of the waggon
park as a part of the English line (e.g. Villani) are wholly wrong. None of the good
authorities place it anywhere save in the rear.

in its three battles on the hillside by Wadicourt. Hastily returning to King Philip, they informed him of what they had discovered. Their spokesman, Alard de Baseilles, a knight of Luxemburg, who followed the King of Bohemia, besought him at once to halt his host and defer the battle till the morrow, For the head of the vanguard was now but a mile or two from the English position, and would soon come in sight of it, though the host was in disorder, neither arrayed for battle, nor at all expecting it. The French king fully saw the danger of running blindfold upon the English position, with his host strung out for miles upon the roads behind. He sent orders for the van to retire, and for the troops in the rear to advance no farther, but to halt for the night. For the afternoon was now far advanced, and vespers were at hand.

Philip, however, had failed to take into account the rashness and insubordination of a feudal host. "The king's orders were soon passed round among his lords, but none of them would turn back, for each wished to be first in the field. The van would not retire because they had got so far to the front, but they halted. But those behind them kept riding forward, and would not stop, saying that they would get as far to the front as their fellows, and that from mere pride and jealousy. And when the vaward saw the others pushing on, they would not be left behind, and without order or array they pressed forward till they came in sight of the English. Great shame was it to see such disobedience, and better would it have been for all if they had taken the counsel of that good knight who advised the king to stay his march. For when the van came suddenly in face of the enemy, they stopped, and then drew back a space in such disarray that they rushed in upon those in their rear, so that all behind thought that the battle was begun, and the vaward already routed. And the foot-soldiery of the cities and communes, who covered the roads behind as far as Abbeville, and were more than twenty thousand strong, drew their swords, and began to cry, Death to those English traitors! Not one of them shall ever get back to England.'"

In consequence of the utter confusion in which the French arrived in the presence of their enemy, it resulted that they never succeeded in forming any orderly and definite line of

¹ I have here put together passages from the first and the fourth editions of Froissart in Kervyn de Lettenhove's text.

battle. The host had been told off, before leaving Abbeville, into a number of battles—nine or ten according to some authorities, five according to others. But these divisions were not reproduced on the field, for each contingent scrambled to the front as best it might, and took post where it found a gap. The only vestige of order which remained was that the picked infantry who had marched with the " vaward " battle — the Genoese crossbowmen disembarked from the fleet—had got forward to their proper place, and had time to deploy in front of the village of Estrées on the slope that faced the English position. Behind them was nothing but a seething mass of feudal contingents jostling each other and seeking to thrust themselves forward as best they might, while the communal militia in the rear was still crowding up to join the horse.

What the exact strength of the French army was it will never be possible to ascertain. That it was at least thrice that of the English is clear ; the lowest estimate for its cavalry given by any chronicler of repute is twelve thousand men-at-arms.[1] Froissart and other writers of fair authority raise this figure to twenty thousand. The crossbowmen were at least six thousand strong—though the fifteen thousand given by some writers is of course a ridiculous overstatement of their force. The communal militia was certainly not less than twenty thousand, and the total muster of the foot was swollen by a number of mercenaries other than the Genoese, the " bidets " of whom Jean le Bel, Froissart, and the rest make mention, as well as by those of the retainers of the feudal chiefs who did not serve on horseback. We can hardly state the whole host at less than sixty thousand strong ; it included not only the whole levy of Northern France, but a great part of the army which had been serving in the south. The names of many chiefs who had been operating against the Earl of Derby in Guienne, two months before, are to be found among the list of the slain or the captives of Creçy. Nor was it French forces only which had taken the field ; there had come to Philip's aid John King of Bohemia, and his son Charles, afterwards emperor, who already styled himself King of the Romans. They had brought not only a contingent of Bohemian and German knights, but a large body of men-at-arms from their ancestral duchy of Luxemburg. Other subjects of the Holy Roman Empire were present in great numbers

[1] Villani's figure, and that of Northburgh in the letter from Calais.

under the Duke of Lorraine and the Counts of Namur and Hainault, of Salm, Montbeliard, Blamont, and Saarbrücken. James, the exiled King of Majorca, had also come to fight for his host, King Philip. Of the vassals of the French crown there were present the Counts of Flanders, Blois, Alençon, Aumâle, Auxerre, Sancerre, Harcourt, St.-Pol, Roussy, Dampierre, Beaujeu, Forez, the Dauphin of Auvergne, and many scores of barons of more or less note—all the nobility, in fact, of Northern and Central France.

When King Philip struggled to the front, he found his army so close to the English line that it was impossible to draw it back with safety. The whole face of the earth between Estrées and Fontaine was covered by the weltering mass, but the more advanced troops were forming up in some semblance of array on the hillside in front of Estrées. Despairing of his power to get the chaos into order, or carried away by his anger and vexation at seeing the English army sitting quietly on the slope by Wadicourt, Philip gave orders for the vaward to move on. The six thousand crossbowmen under the two Genoese condottieri, Odone Doria and Carlo Grimaldi, prepared to open the fight, and a deep line of men-at-arms under the Counts of Alençon and Flanders formed up in their rear. The rest of the host was still in utter disarray, presenting no semblance of any division between foot and horse, main-battle or rearward.

The hour of vespers was now past, and the French were moving towards the edge of the Estrées plateau, when a sudden thunderstorm swept up from the sea and burst just over the battlefield. The combatants on both sides were drenched to the skin, and the darkness caused the advancing columns to halt. But in a few minutes the clouds rolled by, and the evening sun burst forth with great brilliance, shining brightly in the eyes of the French army.[1]

At once the crossbowmen began to descend the valley which lies between Estrées and Wadicourt. Twice they halted, uttered a shout of defiance, and saw to the alignment of their advance. Then they moved on for the third time, cheered once more, and began to let fly their bolts at the enemy. It was at

[1] Only one chronicler, and he not one of the best, the second continuer of William de Nangis, mentions the often-repeated allegation that the shooting of the Genoese was spoiled by the wetting of the crossbow cords in the storm.

long range, and English accounts say that they slew hardly a
man, their missiles falling short a few yards in front of the mark.
Far otherwise was it with the answering volley. The English
archers took one pace forward, drew their arrows to the head,
and shot so fast and close that it looked as if a snowstorm were
beating upon the line of Genoese. Their shafts nailed the
helmet to the head, pierced brigandine and breast, and laid low
well - nigh the whole front line of the assailants in the first
moment of the conflict. The crossbowmen only stood their
ground for a few minutes ; their losses were so fearful that some
flung away their weapons, others cut their bowstrings, and
all reeled backwards up the slope which they had just
descended.[1]

The Count of Alençon and his horsemen failed to perceive
the plight in which the Genoese had been placed ; they imagined
that treason or cowardice was driving them back. Instead of
opening intervals in their line to let the routed infantry pass to
the rear, they came pricking hastily down the slope, crying,
"Away with these faint-hearted rabble ! they do but block our
advance," and crashed into the panic-stricken mob which was
recoiling towards them. Then, finding themselves caught in the
press and unable to advance, they drew their swords and began
to slash right and left among the miserable Genoese, to force
their way to the front. This mad attempt to ride down their
own infantry was fatal to the front line of the French chivalry.
In spite of themselves they were brought to a stand at the foot
of the slope, where the whole mass of horse and foot rocked
helplessly to and fro under a constant hail of arrows from the
English archery. "For the bowmen let fly among them at large,
and did not lose a single shaft, for every arrow told on horse or
man, piercing head, or arm, or leg among the riders and sending
the horses mad. For some stood stock-still, and others rushed
sideways, and most of all began backing in spite of their
masters, and some were rearing or tossing their heads at the
arrows, and others when they felt the bit threw themselves
down. So the knights in the first French battle fell, slain or

[1] We need not pay much heed to the statements of Villani and the *Grandes
Chroniques de France* that the English had two or three small cannon in their front
line, which scared the Genoese and the horses of the men-at-arms. It is most un-
likely that cannon could have been brought across France with the field army at such
an early date : we do not find them used in the field for many years later. Moreover
no English chronicler mentions them.

sore stricken, almost without seeing the men who slew them."

Only a few of the men-at-arms of the Counts of Alençon and Flanders succeeded in piercing through the press and drawing near the English line. It is doubtful whether a single rider reached it and got to handstrokes with the enemy. The battle, however, was but commencing; the main body of the French host made no attempt to allow the vaward to draw off and clear the way, but pushed down the slope to rescue them. In the second charge fell King John of Bohemia, who, though blind, or nearly so, had refused to hold back. He bade the knights at his bridle-rein "lead him so far forward that he should have one fair blow at the English." He had his desire: his followers succeeded in piercing through the press and reaching the line of the Prince of Wales' men-at-arms, by "coasting along the archers," so that they were able to ride in upon the English spears. But their charge was but an isolated effort, and the whole party fell dead around the king, save two squires who cut their way home to tell of his fate. Charles of Luxemburg, who had been separated from his father early in the battle, left the field unharmed, and survived to wear the Imperial crown for thirty years.

The battle of Creçy was but a long series of reckless and ill-ordered charges, such as that which John of Bohemia led. After the first onset there was no attempt to set the main-battle and rearward in array, or to arrange for a simultaneous onset all along the English line. As each body of French knights worked its way to the front, it launched itself at the English, and soon fell back discomfited into the seething mass behind. By far the greater part of the loss was due to the arrows of the English archery, who succeeded in maintaining their position all through the fight, and kept up a deadly flank discharge on each wave of assailants that surged forward. The main assault of the French seems in every case to have been directed against the English men-at-arms: as they advanced, the arrows beat upon the outer riders and slew or dismounted them, but the central section of each squadron, protected by their fellows' bodies from the flanking fire, often reached the front of the prince's or Arundel's dismounted knights and pressed hard upon them. The main stress seems to have fallen on the southern "battle," probably because the enemy emerging from the Fontaine-

Abbéville road made haste to strike at the nearest foe. On one occasion,[1] at least an attack was pushed home with such dangerous vigour that those about the prince sent a hasty request for succour to the king. Edward, commanding the whole battlefield from his post at the windmill, was better able to judge of the general aspect of the fight, and refused to move his reserve, though he consented to send down thirty knights under the Bishop of Durham[2] to strengthen his son's division.

The prince's battle, though hard pressed at this time, did not yield a foot, and the stress which lay upon them was apparently drawn off when the Earls of Arundel and Northampton pushed forward their corps, which had hitherto lain somewhat farther up the hillside, and aligned it with the first battle on a level front. As the dusk advanced, the assaults of the French grew more and more haphazard and partial; but the barons of the rear divisions still persisted in pushing to the front and trying their fortune. A few seem to have ridden in among the archers, and Froissart records the fate of a Hainault knight who pierced their line at one point, rode unharmed along their rear, and galloped back through a gap towards the French, before he was shot down and disabled.[3] But the late-comers, as well as those who opened the battle, seem to have spent themselves in trying to ride down the men-at-arms rather than in the more rational attempt to dispose of the bowmen.

From first to last the English counted that fifteen[4] or sixteen[5] separate and successive attacks were delivered against them, all with equal ill success. The fighting lasted long after dusk—indeed it was not till midnight, according to one trustworthy authority, that the last broken bands of the French ceased to dash themselves against the impenetrable line. But since the sun set the more faint-hearted of the enemy had gradually begun to withdraw themselves from the field, and as the night wore on the host melted away, and Philip of France at last found himself with no more than seventy lances beside him as he rode up and down the slope below Estrées and tried

[1] This is the time when the prince, according to Baker, was actually beaten to his knees, and to which the celebrated saying in Froissart about "the boy must win his spurs" belongs.

[2] Baker of Swinbrook, p. 84, and the Valenciennes Chronicler, p. 232.

[3] Froissart in K. de Lettenhove's edition, v. p. 61.

[4] Baker of Swinbrook, p. 84.

[5] Northburgh's letter from Calais in Ayesbury.

to organise one more hopeless assault on the hostile position. Then John Count of Hainault laid his hand on the king's bridle and led him to the rear, to take shelter for the night in the castle of La Broye, six miles behind the battlefield. Philip had had a horse killed beneath him by one arrow, and had received a slight wound in the neck from another.

The English, well content to have beaten off their enemies, and not fully conscious of the fearful damage they had wrought, lay down in their ranks to snatch a few hours of repose before the dawn. The morning of the 27th was foggy, and it was impossible to see what had become of the French army, though the piles of corpses in the valley at the foot of the English slope and on the hillside below Estrées showed clearly enough that the enemy had suffered tremendous losses. Accordingly the king bade the Earls of Suffolk and Northampton take five hundred men-at-arms and two thousand bowmen, and push forward on to the French position and beyond it. This reconnaissance led to a sharp skirmish: the earls found still lingering about the field many of the bodies of communal militia, who had come up too late to take part in yesterday's battle, as well as a force of men-at-arms under the Archbishop of Rouen and the Grand Prior of the Hospitallers, who had only just arrived from Normandy. Both these corps were scattered with much slaughter: it is said that as many as three thousand of them fell.[1]

When the last of the French had been driven away, King Edward allowed his army to break their ranks and strip the slain. The heralds went round to identify the nobler dead, and found that one thousand five hundred and forty-two lords and knights had fallen:[2] the number of those not of gentle blood who had perished was never clearly ascertained; the estimates given vary from ten thousand up to thirty thousand. On the other hand, the English had lost no more than two knights, one squire, some forty men-at-arms and archers, and a few dozen Welsh, who, as one eye-witness[3] says, "fatue se exposuerunt" by running out from the line between two charges to slay or plunder the disabled knights who were lying about at the foot of the English slope.

[1] Baker of Swinbrook, p. 85.
[2] Northburgh's letter in Avesbury, p. 369 of Rolls Series edition.
[3] Wynkeley's letter, Avesbury, p. 216.

The most notable among the slain in the defeated army were the King of Bohemia, the Duke of Lorraine, the Counts of Flanders, Alençon, Auxerre, Harcourt, Sancerre, Blois, Grandpré, Salm, Blamont, and Forez. Among the few prisoners were the Bishop of Noyon and the Archdeacon of Paris, who had unwisely thrust themselves among the fighting men. The Counts of Aumâle, Montbeliard, and Rosenberg were borne wounded from the field: the last-named died of his wounds two months later.

The fight of Creçy was a revelation to the Western world. The English but a few years before had no special fame in war:[1] their victories over the Welsh and Scots were hardly known on the Continent; their French wars under Henry III. and Edward I. had brought them no glory. It was contrary to all expectation and likelihood that with odds of three to one against them they should easily discomfit the most formidable chivalry of Europe. But the moral of their victory was not fully grasped at first. It was obvious that they had won partly by their splendid archery, partly by the steadiness of their dismounted men - at - arms. The real secret was that King Edward had known how to combine the two forms of military efficiency. But that it was the combination which had been his stroke of genius, was not altogether understood by his enemies. They dreaded the English arrow for the future; they copied the English practice of sending the horses to the rear. But they did not show, by any improvement in their tactics, that they had grasped the meaning of the English victory.

[1] See Jean le Bel, *Chroniques*, i. p. 154.

CHAPTER III

POICTIERS, COCHEREL, AND AURAY, 1356-64

A VERY interesting piece of evidence as to the terror which the English archery inspired after the day of Creçy is given in Sir Thomas Dagworth's letter describing his victory at La Roche Darien on June 20, 1347. He says that Charles of Blois, expecting to be attacked in his camp, had taken the pains to cut down every hedge and fill up every ditch for a full mile around it, in order that the English bowmen might not be able to find any cover or secure any advantageous position which might protect them from a charge, but be obliged to fight in the open field.[1] Dagworth made these precautions of no effect by attacking before dawn; but in the confused night-struggle which followed it cannot be said that his archery were of any greater use than billmen or spearmen would have been, since they were fighting hand to hand all through the engagement. It is curious to find how little resemblance there appears between Dagworth's succinct narration of the fight and the long and picturesque description in Froissart. But there can be no doubt which of the two versions must go to the wall: the contemporary despatch must take precedence over the chronicler's tale.

There was no fight of first-rate importance between the day of Creçy and that of Poictiers, and little military instruction is to be found by investigating the details of such disorderly skirmishes as those which took place near Taillebourg in April and near Ardres in June 1351. At the former engagement both sides kept to their horses—the English men-at-arms, indeed, were

[1] "Lequel Monsieur Charles hors de sa forteresse avoit fait plenir et enracer à demi-leage du païs tout manères de fosses et de haies, par quei mes archiers ne puissent trover leur avantages sur lui, mais convient à fyn force de combatte en plains champs" (Robert of Avesbury, p. 159).

fighting merely to delay the French while their infantry were
making off in charge of the great convoy of plunder which they
had collected in Saintonge. Taillebourg was simply "a good
joust": the two bodies of horsemen, not very different in
numbers, charged each other front to front, and, having passed
through each other's lines, wheeled and came back to the shock.
All was then a confused mêlée, in which the English finally had
the better.

At the fiercer combat of Ardres, on the other hand, the
English tried their new method of dismounting and sending
their horses to the rear, but with disastrous results, because
they had too few of the necessary archers with them. Sir John
Beauchamp had pushed out from Calais with three hundred
horsemen and two hundred mounted archers.[1] He swept the
countryside as far as Boulogne and St. Omer, and collected
many hundred head of cattle and a considerable mass of booty
of other kinds. There was a large French garrison in St. Omer,
headed by Edward lord of Beaujeu, the Marshal of France,
which promptly turned out to pursue the raiders. The lord of
Beaujeu himself, with a hundred men-at-arms, outstripped the
rest of his force, and soon came in sight of the English: the
rest of his followers, horse and foot, were straggling along the
road for miles to the rear. Seeing the enemy near at hand,
Beauchamp sent off his convoy in charge of twenty men-at-arms
and eighty archers, and stopped behind himself to cover its
retreat. He got off the road and ranged his force behind the
ditch of a large field, sending the horses to the rear. Edward
of Beaujeu came rushing blindfold against the English line, and,
hurtling against ditch and lances, was overthrown and slain.
Beauchamp might then have marched upon Calais, but, over-con-
fident with success, he lingered till the rest of the French were
coming up, and it was no longer possible to withdraw without a
second fight. Guichard of Beaujeu, brother of the fallen marshal, led
a second charge against the English, but was wounded, and only
succeeded in crossing the ditch and coming to handstrokes with
Beauchamp's men. But shortly afterwards the remainder of the
French men-at-arms, under the Count of Château-Porcien, came
hurrying up, and, passing round the flanks of the English, beset
them on both sides. Finally, the infantry of the garrison of

[1] These are the numbers of Knighton and Baker of Swinbrook. Froissart says
four hundred men-at-arms and three hundred archers.

St. Omer, "five hundred *brigans* armed with spear and shield," reached the field, and, wheeling round the mass of the combatants, charged the English in the rear. The blow was decisive, for the invaders were tired out, and already giving way before the superior numbers assailing them. Beauchamp gave up his sword, and the survivors of his party were captured to a man. Beauchamp's error is easily seen: he had too few archers with him,—only one hundred and twenty after the plunder had been sent off, —and these had used up their arrows before the third French division came on the field. He had taken a position which had some cover in front, but none on the flanks, and could easily be turned by superior numbers. Lastly, he might have retired after checking the first French onslaught and slaying the lord of Beaujeu, but stayed to fight again, "animose sed non sapienter," out of mere chivalrous enterprise.

Battle of Poictiers, September 19, 1356.

Such secondary combats are of no great interest or importance. The next military lesson of real moment is only found when we reach 1356, and investigate the details of the celebrated battle of Poictiers. In the autumn of 1355 the Black Prince had sallied forth from Bordeaux and pushed a destructive but rather objectless raid as far as Toulouse and Narbonne. The French had not dared to meet him in the open field, and he had returned to Bordeaux loaded with spoil. In the summer of 1356 he resolved to conduct a similar foray into the heart of Central France—the districts along the upper and middle course of the Loire. Like his father, the younger Edward does not shine in the sphere of strategy. Though he seems to have had some vague idea of ultimately pushing northward to join the force under his brother John of Gaunt, which was operating on the borders of Normandy, his route and his whole conduct of the campaign shows that his primary object was merely to harry as much of France as he could, to defy King John, and to bring back to Bordeaux as large a store of plunder as his men could convey. His army, indeed, was too weak to do much more than execute a destructive raid, mustering only between three thousand and four thousand men-at-arms, two thousand five hundred or three thousand archers, and a thousand light troops of other kinds, "sergeants," "brigans," and Gascon "bidowers." Apparently the bowmen were all mounted, that they might be able to keep

up with the knights if hard marching became necessary. This fact accounts for the small proportion in which they appear in the host; ordinarily the archers outnumbered the men-at-arms four or fivefold in an English expedition. But on this occasion a very large part of the prince's army was composed of the noblesse of Guienne, who brought with them hardly any followers save their contingent of mailed horsemen.

The prince started from Bergerac on August 4; he swept through Limousin and Berry as far as Châteauroux and Vierzon; then, turning somewhat westward, he wasted the valley of the Loire, confining himself to its southern bank because all the bridges had been broken by the French. He made no attempt to seize on garrison towns,—indeed the castle of Romorantin in Berry was the only fortified place which he assailed,—but pushed steadily on, not tiring his men by long marches, but covering only three or four leagues a day, and gathering in a vast quantity of plunder.

Meanwhile, John of France had begun to collect his army at Chartres, to repel the invasion with which the Duke of Lancaster had threatened Normandy. But when the duke's expedition had failed, he was able to turn his attention to the far more dangerous attack from the south. Accordingly he marched against Prince Edward, who was now feeling his way westward along the southern bank of the Loire. When the English had reached Tours and were battering away at its suburbs, they learned that King John, with an army of some forty thousand men, had crossed the Loire at Blois, thirty miles east of them, and was hastening to throw himself between them and their base in Aquitaine. The great road southward from Tours to Bordeaux ran through Poictiers, and John was marching on that town, where he would be in a good position for intercepting the invaders' retreat. On hearing that his enemy had moved southward, Prince Edward hastily abandoned his demonstration against Tours, and made off in the very direction which the king had expected him to take.

The intelligence department of both armies seems to have been conducted with even more than the usual slackness of the Middle Ages, for, though each was looking out for the other, they finally collided in the most casual way and by the merest chance. Though they were converging on the same place, they remained entirely ignorant of each other's exact position, with the result that on September 17 the prince, marching from Châtelherault

on Poictiers, suddenly came on the rear of the French army, which had been marching across his front all the morning as it moved from La Haye on Poictiers. The English vanguard pounced on the straggling corps at the tail of the French host, routed them, and took prisoners the Counts of Auxerre and Joigny. If John had been a little slower in moving or Edward a little quicker, the result would have been that the English would have struck into the very midst of the French host. As it was, they not only avoided this danger, but found that, most providentially, the enemy had overshot his mark, and left the way to Bordeaux open to them.

Accordingly the prince, now certain of his rival's position, avoided Poictiers, pushed southward by a cross-road, and halted for the night at the little village of Maupertuis, seven miles south-east of the ancient city.

To halt even for a few hours was to risk a battle, but the English were now fatigued with several days of forced marching, and no doubt their beasts of burden were tired out. The huge mass of booty heaped on waggons or piled on the backs of sumpter-horses must have brought down their speed to a mere three miles an hour, and rendered rapid motion wholly impossible. Edward had now to choose whether he would sacrifice his plunder and execute a hasty retreat on Bordeaux, or whether he would risk a fight rather than abandon his baggage. The first alternative would have been safe, but wholly ignominious to one who, with all his military virtues, was, after all, a typical knight of the fourteenth century. He resolved to take his chance, and to stand his ground on the next morning, ready to receive the French if they should move against him, but ready also to move off and avoid a conflict if the enemy should hang back long enough to allow him to start off his train on the Bordeaux road.[1]

So far our chronicles are fairly unanimous; but, as to the circumstances which led up to the actual opening of the battle there are two divergent accounts, between which we have to choose. They turn on the topography of the field, concerning which it is necessary to say a few words.

The prince's position lay close to the village of Maupertuis, a place which has now entirely disappeared, and is represented only by the isolated farm of La Cardinerie. The whole face of the country was much covered with trees and thickets, and

behind lay the dense wood of Nouaillé. The ground was fairly
level all around; there is only some twenty or thirty feet of
difference between the highest and the lowest level of the rolling
plateau. But to the south the field was bounded by the river
Miausson, a stream with a deep muddy bottom, running along
a marshy valley some hundred feet below the level of the
plateau. It was crossed to the left rear of the English position
by a ford named the Gué de l'Homme, over which lay the line
of retreat on Bordeaux. If the prince could have been certain
of getting his enormous train over the Miausson without being
attacked, he might have gone on his way with a light heart.
But it was obvious that, while baggage and army were defiling
across the ford, there would be great danger of a disaster if the
French made a brisk assault on the rear of the long line of
march. For King John and his army were too close to the
English to be easily eluded: their watchfires were in sight of
Maupertuis, and both sides were watering their horses at the
same stream.

It seemed inevitable that a collision would take place when
the morning of the 18th dawned, and the prince made hasty
efforts to strengthen his position. He seems to have lain
facing north-west, with his right placed in the thickets which
ran out from the north end of the wood of Nouaillé, and his
left somewhat beyond La Cardinerie (Maupertuis). Behind his
right centre was a low hill, if a rise of twenty feet deserves that
name, which has still preserved the name of "La Masse aux
Anglais." His horses were parked so as to be hidden from the
French by this rolling ground. The whole position was so
masked by hedges and thickets that it was difficult to reconnoitre
it, or even to ascertain its limits. On one or both flanks waggons
had been hastily drawn together, to cover gaps in the line of
scrub and bush. This is said to have been specially the case
on the flank farthest from the river.[1] The front of the position
was formed by a thick thorn hedge with a ditch in front of it,
pierced only on one point by a country road wide enough for
four horses abreast: this was probably the path that led down
to the Gué de l'Homme, the prince's line of retreat.

[1] I conclude that when the French scouts on September 19 reported that they
had reconnoitred the English line, and found *the left* so barricaded, that they meant
their own left, and did not put themselves in the prince's position and think of *his*
left.

To hold this position Edward had divided his army into the usual three "battles" of the mediæval host. The vaward was led by the Earls of Warwick[1] and Oxford,[2] but consisted to a very large extent of the prince's Gascon vassals under the seigneurs of Pommiers, Albret, L'Esparre, Montferrand, and Mucident, and the Captal de Buch. The main-battle, under the prince himself, included the English barons Audley, Cobham, De la Warre, Despenser, Burghersh, and the pick of the professional soldiers who followed the English banner—Sir John Chandos, Sir William Felton, and Sir Nigel Loring. The rearward was given to the Earls of Salisbury[3] and Suffolk,[4] who had with them the Lords Willoughby, Multon, and Basset, Sir Maurice Berkeley, and some of the prince's mercenaries from the Netherlands, under Daniel Pasele and Denis of Morbeke. Each battle contained somewhat over a thousand men-at-arms, about the same number of English archers, and a few hundreds of Gascon light troops.

In the original drawing up of the host Warwick must have held the northern and Salisbury the southern end of the position. But, as we shall see, the array of the host was wholly changed before the battle, and it was the rearward which ultimately opened the fight, the vaward taking post south of it, and not in its proper place.

The prince's position, however, was not destined to be assailed on the 18th. That the fighting did not occur till the next day was due to the well-intentioned but hopeless intervention of the Cardinal of Perigord.[5] The good prelate had been hovering about the two armies for some days, in the hope of prevailing on the princes to spare the effusion of Christian blood by concluding a treaty of peace. He now begged John to allow him to visit the English camp and offer his services as intermediary: the invaders, indeed, were in a position sufficiently hazardous to justify Edward in thinking twice before refusing reasonable terms. The French king very unwisely granted the

[1] Thomas Beauchamp, then a man of forty-three, a veteran of Creçy.
[2] John de Vere, aged forty-three, like Warwick, and also, like him, a Creçy man.
[3] William Montacute, aged twenty-eight, had served as a youth at Creçy, and been knighted by the Prince of Wales.
[4] Robert de Ufford, then aged fifty-eight, had served in Flanders, and at Creçy.
[5] Bearing the name, destined to be famous four hundred and fifty years later, of Talleyrand de Perigord.

cardinal's request: he should undoubtedly have spent the morn-
ing in endeavouring to march round the English flank, either
on the left or the right bank of the Miausson: such a movement
would have forced the enemy either to abandon his baggage
and decamp at once, or to risk being surrounded.

The negotiations, as was to be expected, came to nought.
According to Froissart's account, the prince offered to dismiss his
prisoners without ransom, give up any castles or towns he had
taken during the expedition, and make a seven years' truce.
The French demanded that he and a hundred chosen knights
should give themselves up as hostages, and on this point the
discussion was broken off. Chandos Herald gives the more
probable statement that Edward replied that he was not
authorised to make any treaty or truce without his father's
knowledge and permission. It is at any rate certain that
English and French commissioners met between the two
armies, discussed terms, and parted without any satisfactory
result.

The cardinal's futile diversion had wasted the greater part
of the 18th of September: while the negotiations were going on,
Edward might probably have absconded, for the French army
had not properly reconnoitred his position nor taken any
measures to watch the exits from it. But knightly honour
demanded that no movement should take place during time of
truce, and the prince deferred all action till the 19th.

Of his plan for the next morning we have two distinct
accounts. Chandos Herald, a first-rate authority with a good
military eye, tells us that he had determined to draw off from
his position and quietly march for Bordeaux. "The prince,"
he says, "put his men in order, and willingly would he have
avoided an action, if he could have managed it. But he saw
well what he had to do: . . . accordingly he summoned the Earl
of Warwick, gave him charge of the van, and said to him, 'You
shall first go over the passage and take our baggage in charge:
I will ride after you with all my knights, that if you meet with
any mischance we may reinforce you: and the Earl of Salisbury
shall follow behind and lead our rear-battle. Let us each be
upon our guard, and, in case the French fall upon us, let every
man dismount as quickly as he can, to fight on foot.'" So they
settled the matter over-night, and in the morning "the prince left
his quarters and set out to ride away, for on this day he did not

think to fight, but thought rather that he could avoid an action." Warwick had already passed the Miausson with the convoy, and the prince himself had marched off, when the French hastily moved forward and assailed Salisbury and the rear-battle, who were still holding the position of the previous day, to cover their comrades' retreat. To save Salisbury, the prince had to wheel back and take up his old line of defence. But ere he had returned, the covering force had beaten off the first French assault, "long before the van-battle could be turned and pass back to them, for it was already beyond the river."

This account of the circumstances which brought about the battle is eminently probable and rational, but unfortunately it does not coincide with any other narrative, English or French. Froissart, the majority of the chroniclers who wrote from English sources, and also the French historians, speak of Edward as having made no movement to the rear, but as having deliberately waited for the assault of the enemy in his old position. Only one of the English writers, Baker of Swinbrook,[1] speaks of the prince as having been occupied in drawing off the field at the moment when Salisbury was attacked, and his account differs in its details from that of Chandos. "The prince," he says, "saw that away on his flank there was a hill girt round with hedges and ditches, with its top occupied partly by scrubby pasture-ground, partly by ploughed fields and vine-yards; he thought it probable that a body of French might be hidden in these fields.[2] Between us and the hill was a consider-able valley with steep banks, and a marsh with a stream flowing through it. The prince's battle and the convoy of baggage passed the stream at a narrow ford, and, having crossed the valley, made its way through the hedges and ditches and occupied the hill, where he was hidden from view by the thicket, and yet himself commanded a view of the enemy. The French, seeing the prince's banner clearly in sight at first, then gradually moving off, and finally concealed from their sight by the intervening ridge, thought that he was retreating." Accordingly they fell hastily upon the English position, and became engaged with Salisbury and the rear-battle.

[1] But Baker, it is to be remembered, gives far the best and longest account of the fight after Froissart and Chandos. The other chronicles are short and poor.

[2] I imagine myself that it was the hill partly covered by the Bois de St. Pierre on the south side of the Miausson. (See Map.)

So far this account might pass for a variant of the tale told by Chandos. What the latter considers to have been the commencement of a general retreat, Baker may have chosen to represent as a lateral movement destined to occupy the hill beyond the Miausson, and so to prevent the main position from being turned by any French corps detached to the south of that stream. But the difficulties of Baker's version only commence when the prince has reached the outlying hill, for he never gives any account of Edward's return from that position, and presently speaks of him as joining in the resistance to the later attacks of the French. Either, therefore, he has forgotten to describe Edward's recrossing of the Miausson, or he conceives of the flanking hill as on the north side of that stream, and not out of touch with the rest of the English army. Sir Edward Maunde Thompson in his learned exposition of Baker's story leans to the latter view, and holds that the stream and "marsh" which the prince crossed on his way to the hill were the little runlet which flows, or rather once flowed, from a long-vanished pool[1] near La Cardinerie, down to the Miausson. I must confess that I cannot recognise in the "ampla profundaque vallis et mariscus, torrente quodam irriguus" of which Baker speaks, the fifteen or twenty feet dip in the hillside with a mere trickle of water running down it, which lies south-west of Maupertuis. Allowing for all possible exaggeration in the description, I fail to see that Baker can be speaking of any stream except the Miausson. When his narrative is read along with that of Chandos, the identification of his *torrens* with the Herald's *rivière* seems absolutely necessary. The only alternative, therefore, which remains to us, is to believe that Baker, in his hurry to get on to the picturesque details of the fighting, forgets to say that the prince, when he saw Salisbury beset by the French, reversed his lateral movement and came back to join his rear-battle on the original position. I shall adopt this hypothesis in my account of the engagement.

The French king had drawn up his army early on the 19th for a general assault on the English line, but was still very imperfectly informed as to the strength and exact position of his enemy. The countryside was so masked with woods and hedges that he had not been able to learn much from the

[1] The "Abreuvoir aux Anglais" of Colonel Babinet, the local antiquary, who has done much to fix the sites of the battle.

40

knights whom he had sent out to reconnoitre the hostile front.[1]
They could only report that the English were "strongly posted
along a road with a hedge and a ditch beside it, with the hedge
lined with archers, and the men-at-arms drawn up behind among
the vines and thorn bushes, all on foot; the hedge had but one
gap in it, where four knights might ride abreast; save at this
point there was no way of getting at the English except by
breaking through the archers, who were never easy to dislodge."[2]

In preparing his assault on the English position, King John
adopted a method of fighting which had never before been
practised by the French. At the suggestion of Eustace de
Ribeaumont (according to Froissart) or of William Douglas
(as Baker tells the tale), he resolved to make the greater part
of his men-at-arms dismount and assail the English on foot.
Only a small body of picked horsemen, a kind of forlorn hope,
was to precede the main army and endeavour to break through
the archers by a sudden charge, so as to prepare the way for
their comrades.

The reasons which led John to adopt this order of battle
were much disputed at the time, and have caused much
discussion in after-ages. The approach to the English position
was difficult for horsemen, and the ground all about it was sown
thick with bushes and trees, which might have thrown a great
body of cavalry into disorder.[3] The deadly accuracy of the
arrows of the English archers, who had made such havoc among
the horses at Crécy that the French knights had never been
able to push their charge home, was a second reason. If on the
bare downs of Crécy the horsemen had been completely checked,
they would fare far worse on the plateau of Maupertuis with its
scrubby thickets, hedgerows, and vineyards.[4] Something, no
doubt, was due to the king's unskilful argument by analogy—
the English of late had always been successful by dismounting,

[1] They were sent out before the Cardinal's intervention; John does not seem to
have made any second reconnaissance on the 19th.

[2] This account in Froissart agrees very well with Baker's statement that "at
the upper end of the hedge, where it was farthest from the slope down toward the
marsh, was a gap or opening, made by carters, and our third (or rear) battle was
drawn up a stone's throw in rear of this gap, under the Earl of Salisbury."

[3] This is the only reason given in the speech which Froissart puts into the mouth
of Eustace de Ribeaumont: "Car il y a tant de vignes que cheval ne s'i poroient
avoir."

[4] This is John le Bel's view: "Tous se combattoient a pyè, pour doubtance des
archers, qui tuoient leurs chevaulx, comme à la bataille de Crecy" (vol. ii. 197).

why should he not turn their own tactics against them? He
forgot, unfortunately, that the English victories had all been
won by acting on the defensive, and that tactics which might be
admirable for a small army defending a position against superior
numbers might be absurd for a large army striving to evict a
lesser one from its chosen ground. Baker of Swinbrook may
perhaps be right in attributing this unhappy suggestion to
William Douglas, who—as he says—told John that "since the
present king came to the throne the English have generally
fought on foot, imitating the Scots ever since their disaster at
Bannockburn. Wherefore he advised that the French should
copy the Scots manner, and attack the enemy on foot rather
than on horseback." Whether Douglas or the king first
conceived the idea, it was a hopeless misapplication of the facts
that lay before them. The French men-at-arms of 1356 were
now far too heavily armed to make it easy for them to march a
mile on foot, scramble through bush and brier, and assault a
well-guarded position: like the Austrians at Sempach, they were
to find that the knightly armour was grown too cumbrous to
allow of operations which would have been quite feasible eighty
years before, when chain mail had not yet been superseded by
plate. All through the day they were fighting against fatigue
and over-exhaustion as much as against the enemy. Very
different was the case of the English, who, as at Halidon and
Crecy, had only to hold their ground and keep their line, and
did not move to the assault till the last phase of the battle.
Finally, we should remember that King John forgot, in his
misapplied endeavour to learn the secret of victory from his
enemy, that the essential part of the English tactics was not
the mere dismounting of the men-at-arms, but the proper
combination of them with the archery: Crecy and Halidon were
won by the bowmen even more than by the knighthood. The
latter would in each case have been surrounded and over-
whelmed but for their auxiliaries on the wings. At Poictiers
John had a considerable body of troops armed with missile
weapons,—two thousand arbalest men besides many other light
troops,—but he did not attempt to combine them with his men-
at-arms after the English fashion. He sent the crossbowmen,
indeed, forward with his first battle, but did not dispose them so
as to endeavour to check the English archery; in this respect
he seems to have acted even more unreasonably than his father

at Crecy; Philip had at any rate given the Genoese some opportunity of trying their mettle in 1346. John so mixed them up with his men-at-arms that they never had a fair chance of using their weapons.

His disposition of his forces must be shortly stated. The first battle, which was smaller than the other three, was given to the two Marshals D'Audrehem and Clermont. Under them were arrayed the three hundred picked horsemen whom we have already mentioned; their orders were to ride in rapidly upon the English, and at all costs close with them and cut up the archers. Next behind the forlorn hope came the main body of the first battle, which included a considerable body of German auxiliaries under the Counts of Saarbrücken, Nidau, and Nassau. These, like the marshals' three hundred, kept to their horses: with them marched the two thousand crossbow-men of whom we have spoken above, and two thousand "sergeans à pied," armed with darts and javelins.

The second battle was led by the king's eldest son, Charles Duke of Normandy, and the Duke of Bourbon: it is said to have mustered four thousand men-at-arms. The third was under the king's brother, Philip Duke of Orleans, and is reckoned at three thousand men-at-arms. The fourth and far the largest battle marched under the command of John himself, who had at his side his youngest son, Philip, a mere boy of fourteen. In his company were the Counts of Eu, Longueville, Sancerre, and Dammartin, and twenty-three banners in all of great counts and lords. The division was at least six thousand strong.

In all, the French army appears to have counted about six-teen thousand cavalry, of whom half were fully-equipped men-at-arms, and some four thousand or five thousand foot-soldiery, these latter all trained mercenaries. The infantry of the communal militia were not on the field to swell the numbers and decrease the efficiency of the host. Froissart is undoubtedly stating the numbers of the French too high when he reckons them at forty thousand or fifty thousand strong. A good corrective to his exaggerated figures is to be found in the letter written from the field by Bartholomew Lord Burghersh, who estimated the beaten army at no more than eight thousand horsemen and three thousand footmen.[1] But Burghersh was

[1] Baker of Swinbrook also speaks of "eight thousand men-at-arms, to take no account of sergeants, under eighty-seven banners." He makes no mention of foot-

just as far out in underrating as Froissart in overrating the enemy.

It was apparently the half-descried withdrawal of the English van and main body which led King John to order the advance. At once the marshals and their battles pricked forward at full speed, leaving the three great bodies of dismounted men-at-arms to follow as best they could. They reached the English line long before their fellows were on the field, for their only care was to close in haste before the enemy should have withdrawn. Clermont is said to have wished to hold back and allow the main body to come up, but D'Audrehem taunted him with sloth and over-caution, and, after a sharp exchange of words, both dashed forward towards the hedge. Clermont made for the gap in it, towards the north end of the English position; D'Audrehem attacked lower down.

The result of this hasty and inconsiderate charge was as disastrous as might have been expected. The English archers lined the hedge and shot down the horses of the greater part of the three hundred knights of the forlorn hope; the survivors and the German men-at-arms who followed them were only able to close slowly and in small parties. A fierce combat raged all along the hedge, but Salisbury held his own without difficulty, and he was presently relieved by the hasty return of Warwick and the Prince of Wales, who had left the convoy to take care of itself when they saw the French approaching, and had hurried back to fall into line with the rearward. The rout of the battle of the marshals and the Germans was completed by a device of the Earl of Oxford, who hastily led out part of the archers of the vaward into the marshy low ground by the Miausson, at right angles to the English line, and bade them shoot up the valley at the flank of the French.[1] Harassed beyond endurance by this side attack, the hostile van broke up and retired in disorder. The Marshal Clermont had been killed, his colleague D'Audrehem and the German Counts of Saarbrücken and Nassau had all been taken prisoners—cast down, no doubt, by their slain or wounded horses, and left at the mercy of the English.

soldiery, but we know from Chandos Herald, Burghersh, and Froissart that they were present to the number of some thousands.

[1] This they could do with safety, because the ground where they stood was too marshy to allow the French cavalry to make a dash at them.

The defeat of the French van had been completed before the three great bodies of dismounted men-at-arms which formed the bulk of their host could reach the field. The first of them, the Dauphin's battle, just arrived in time to be somewhat incommoded by the fugitives sweeping past its flank. It is said that some cowardly spirits took advantage of the disorder to call for their horses and make off in company with the wreck of the marshals' division. But the main bulk of the Dauphin's men came steadily to the front and attacked the whole length of the hedge. So vehement was their onslaught that the Prince of Wales had to put into line against them not only Salisbury's and Warwick's troops,[1] but all his own battle, save four hundred picked men-at-arms whom he retained as a last reserve. The struggle was long and hard; but the line of the hedge was sternly held, the French could never pierce it, and at last the Dauphin's knights, after suffering a dreadful slaughter, gave back, and repassed the little valley across which they had advanced to assault the hedge.[2] They were not pursued save by a few hot-headed young knights like Sir Maurice Berkeley,[3] for the prince knew that half the French army had not yet come into action, and refused to allow his men to break their line.

Meanwhile, a wholly unlooked-for piece of good fortune had befallen the English: at the sight of the rout of the Dauphin's battle, the division under the Duke of Orleans, which ought to have delivered the next assault on the English line, was completely demoralised. Without having struck a blow or suffered any loss, the duke's whole corps followed the defeated battle in hasty flight, and made off north-eastward in the direction of La Chaboterie. Only a few scores of knights and squires, who

[1] To meet this attack, says Baker, the battles of Salisbury and Warwick had to get together, and re-form in close line, "nostra prima secundaque custodia pariter se glomerarunt." The place taken by the prince's own battle is not given; but at the end of the attack everyone had been engaged, "demptis solis cccc qui vexillo principali subservierunt reservati," etc.

[2] Baker and Chandos Herald agree that the fighting with the Dauphin's division raged all along the hedge. They differ, however, in that Baker says that Warwick was back in position before the marshals' battle was entirely beaten, and that his archers took part in routing it; while Chandos says that Warwick arrived much later, after the marshals had been wholly discomfited, and only just in time to prevent the Dauphin from forcing the hedge (line 1220).

[3] Both Froissart and Baker tell with some differences of detail the story of Berkeley's foolish pursuit of the French, and of his capture.

scorned to copy their leader's example, stayed behind and joined the king's still intact reserve.

King John himself was in a very different frame of mind from his cowardly brother. Furious at the disgraceful repulse of the leading divisions, he urged on his own corps, and pushed to the front to resume the combat. Nor was he without reasonable hope of success. In numbers he was still almost or quite equal to the English, whose ranks had been fearfully thinned by the two desperate mêlées in which they had been engaged. His troops were fresh, while the prince's were utterly exhausted. The English line presented a by no means cheering spectacle as described by Baker. "Some were carrying the wounded to the rear and laying them under the shelter of trees and thickets, others were replacing their broken swords and lances from the spoils of the slain; the archers were trying to replenish their stock of arrows, even pulling them out of the bodies of the dead and wounded. There was in the whole host no one who was not either hurt or utterly worn out with the battle, save only the reserve of four hundred men whom Edward still kept about his standard." As the king's battle rolled up the hill, a knight of well-tried courage remarked to the prince that all was over and defeat inevitable. But the English leader's spirit was still high; he threw an angry rebuke at the doubter,[1] and gave his orders for the new combat with an undaunted bearing.

Seeing the French sending their last reserve into action, and conscious that there was nothing more to be feared if it could be beaten off, Edward had now resolved to take the offensive. Putting his four hundred fresh men into the front of the battle, and hastily forming all the exhausted host into a single mass, he bade his standard-bearer, Walter of Wodeland, bear his ensign straight against that of King John, and charged down the gentle slope.[2] One last precaution he had taken: before the moment of the shock, he had directed the Captal de Buch, the best trusted of his Gascon vassals, to take sixty men-at-arms and a hundred archers—all that he could spare—and to fall on the flank or rear of the French battle, after fetching a compass unseen behind the slight rising ground, the Masse aux Anglais, where his baggage had been stacked on the preceding night,

[1] " Mentiris pessime vecors, si me vivum posse vinci blasphemeris " (Baker, 150).
[2] Froissart says that he bade his knights mount for the final charge, which is rational enough, but Chandos and Baker do not mention it.

and through the thickets which bounded the field of battle on the north.

Meanwhile, the two main bodies had met on equal fronts at the foot of the slope below the English hedge, with a clash which, as one chronicler tells us, could be heard as far as the walls of Poictiers, seven miles away. Both sides were desperate, and for many minutes the two hosts stood locked together, neither winning nor losing ground. The English archers, having exhausted their last few arrows, threw themselves into the mêlée, and fought hand to hand among the men-at-arms. Fierce as had been the fighting during the two preceding encounters, it was as nothing compared to this final shock. The victory was still hanging in the balance, when the Captal de Buch and his small detachment suddenly appeared in the left rear of the French. He had gone round the Masse aux Anglais, taken a turn to the north-west, which brought him on to the ground from which King John had originally started, and then followed the enemy's track on to the scene of the combat.[1]

Ignorant of the small numbers of the force which had charged them from behind, the French wavered, and the more faint-hearted began to melt away to the right rear, in the direction of Poictiers, where the way of retreat was still open. King John himself, however, utterly refused to fly, and held his ground, surrounded by his personal retinue and the most loyal of his vassals. It took the English some time to crush the resistance of this faithful band, but at last the mass was broken up, and the king, with his young son Philip, who had stuck to his side to the last, were made prisoners. All those who had stayed by them were either captured or slain: the routed main body of the French rear-battle reached Poictiers, though many were taken by the way ; the English made no great slaughter of the fugitives, being far more intent on taking prisoners with good ransoms than on shedding blood.

Thus ended a battle far more hazardous and far better fought than that of Crecy. From first to last it had filled some seven hours: "the first attack had commenced at prime, and the last of

[1] "Graditur iter obliquum, sub declivo recedens a monte quem cum principe nuper dimisit, et occulte girans campum venit ad locum submissum primae stacionis coronati. Exinde conscendit altiora campi per viam Gallicis ultimo tritam, et subito prorumpens ab occulto, per veneranda signa Georgica significavit se nobis amicum" (Baker of Swinbrook, p. 151).

the English had not returned from the pursuit till vespers."
Considering the long struggle, the French loss in killed was not
so large as might have been expected, though several of the
greatest lords of France had fallen. On the other hand, the
number of prisoners of the highest rank was almost unparalleled.
The slain amounted to about two thousand five hundred, of
whom just two thousand were knights and men-at-arms.[1]
The chief of them were the Marshal Clermont, who had led
the first division ; Gautier de Brienne Duke of Athens,[2] the
Constable of France ; Peter Duke of Bourbon ; Guichard
lord of Beaujeu, younger brother of the Edward of Beaujeu
who had fallen at Ardres in 1351[3] ; Robert of Durazzo, a cousin
of the King of Naples ; Geoffrey de Charny, who bore
the oriflamme that day ; Renaud Bishop of Chalons ;
and the Viscounts of Brosses and Rochechouart. Far more
striking is the list of the prisoners : they included King John
himself and his son Philip ; James Count of La Marche, John[4]
Count of Eu, Charles Count of Longueville, John Count of
Tancarville, Bernard Count of Ventadour, John Count of
Auxerre, Henry Count of Vaudemont, John Count of Sancerre,
Charles Count of Dammartin, John Count of Vendôme, John
Count of Nassau, John Count of Saarbrücken, John Count of
Joigny, Robert Count of Roussy, William Archbishop of Sens,
Arnold d'Audrehem, the marshal whose inconsiderate advance
had opened the battle, ten more great lords bearing banners,
and two thousand five hundred others, of whom nineteen
hundred and thirty-three were men-at-arms and knights.[5] The
English loss must have been considerable : unfortunately, no
trustworthy chronicler has stated it : only Lord Burghersh's
letter gives figures—the impossibly small total of four men-at-
arms and sixty others.

The political results of Poictiers were, owing to the king's
captivity, very considerable, but the immediate strategical results

[1] The Black Prince in his letter to the Bishop of Worcester gives two thousand four
hundred and six men-at-arms, besides the princes and barons whose names he cites.
The letter of Burghersh speaks of two thousand men-at-arms and five hundred others.

[2] Only titular duke, as his father, Gautier I., had been deprived of the duchy
and his life by the Catalans at the battle of the Cephissus in 1310.

[3] See p. 618.

[4] It is curious to notice the preponderance of the name John among the prisoners ;
nine out of sixteen bore it.

[5] The figures of the Prince of Wales and Lord Burghersh, agreeing closely together,
and both sent from the actual field, can no doubt be trusted.

were *nil*, as the prince retired to Bordeaux with his plunder and his more important prisoners, dismissing the rest under a pledge to surrender themselves again, or to bring in their ransom on a fixed day. He made no attempt to hold Poitou or any of the neighbouring districts. Evidently his intention was to attain his political ends by bringing pressure to bear on his prisoner, and not by the series of lengthy sieges which would have been required to secure the results of his victory.

Experience proved that this was the right policy: the attempts of the English during the next four years to complete the conquest of France came to nothing. Though King Edward marched to and fro through the heart of the land, ravaging Champagne, Burgundy, and Isle de France, and encamping at the very gates of Paris, he could make no permanent lodgment. Cowed by the results of Crecy and Poictiers, the French refused to meet him in the open field, and shut themselves up in their towns and castles. To take one by one these innumerable strongholds would have been an interminable process; it did not suit his temper, nor were his resources adequate for such an enterprise. But he obtained some considerable part of what he had desired by playing on King John's dislike of captivity, and on the desire of the French estates to put an end to the anarchy which had resulted from the removal of their sovereign. Hence came the Treaty of Bretigny, signed on the 8th of May 1360, which gave up to the English Poitou, Angoumois, Limousin, Rouergue, and many districts more, so as almost to reconstitute the old duchy of Aquitaine as it had been held by Henry II. two hundred years before. Nor was this all: the English got back Ponthieu at the Somme mouth, and retained the all-important harbour of Calais, the open gate of Northern France.

Thus ended the first act of the Hundred Years' War; yet fighting was by no means at an end in France. There were two quarrels still on foot which were fated to cost much blood. The long war of succession in Brittany between Charles of Blois and the younger John de Montfort was not yet settled, and Charles the Bad, the intriguing king of Navarre, was still trying to fish in troubled waters and get some private profit from the misfortunes of his cousin John of Valois. The disbanded mercenaries, French and English, who had been fighting in the main war gladly hired themselves to serve in the minor struggles. It was not till the battles of Cocherel (May 16, 1364) and Auray

(September 29, 1364) had taken place that France could really be said to be at peace. Both these combats were practically fought out entirely by the free companies; at Cocherel two-thirds of the French army and five-sixths of the Navarrese army were veteran mercenaries. At Auray half the army of Charles of Blois was composed of French free companies, and four-fifths of that of John de Montfort of English auxiliaries of the same kind. Neither fight is of any permanent importance in the art of war; they are only interesting as showing the way in which the lessons of Creçy and Poictiers had impressed themselves on the minds of the professional soldiers of the day. Both sides in each of the fights descended and fought on foot; the only exception to this rule being that Duguesclin at Cocherel kept a small reserve of thirty horsemen, who were ordered to wait till both sides were locked in close combat, and then dash in at the person of the hostile leader, the famous John de Grailly Captal de Buch, who had struck the decisive blow at Poictiers. It is noteworthy that the Captal at Cocherel and Sir John Chandos at Auray both adopted the tactics they had learned under the two Edwards, and took a defensive position on a slope, on which they waited to be attacked by the superior forces of the enemy. The Captal was prevented from carrying out his plan by the rashness of one of his wing-commanders, the condottiere John Jowel, who was lured down into the plain by a feigned flight of the wily Duguesclin. At Auray Chandos was more lucky, and received on his chosen ground the attack of the French and Bretons, who crossed the river and ascended the slope to assail him. Both the Captal and Chandos, though commanding mercenaries who had long fought under the English flag, were very short of archers. It was only in a national levy that these could be found in proper proportion to the other arm. At Cocherel there were only three hundred archers to twelve hundred men-at-arms, a number insufficient to have any influence on the event of the battle. At Auray Chandos had about a thousand archers to eighteen hundred men-at-arms, a larger but still an insufficient proportion. It was not they who decided the fate of the day; the four battles of dismounted horsemen, whom Charles of Blois led, all succeeded in closing with the English in spite of the arrow-flight. That they succeeded in doing so was due to the greatly increased heaviness of the knightly panoply, which had been growing thicker and more

complicated year by year for the very purpose of keeping out the arrow. Only a lucky shot disabled a man in the new plate armour; a large proportion of the shafts glanced off the surface obliquely. In serried ranks, and carrying shields before them, the French succeeded in closing without suffering any overwhelming loss. When the mêlée commenced, the archers cast down their bows and joined in the hand-to-hand combat with axe and sword, as they had done at Poictiers. They are said to have done good and efficient service, fighting side by side with the knights, just as their grandsons did at Agincourt fifty years after. Tactically the victory at Auray was decided by the fact that Chandos used his reserve—two hundred lances under Sir Hugh Calverley—to strengthen weak points in his line one after another, never allowing it to become so entangled that it could not be withdrawn for service in another part of the field. The far larger reserve-battle which Duguesclin had set aside for a similar purpose got mixed with the fighting line, and ceased to be a tactical unit, so that the first break in the French array proved fatal, there being no organised body of fresh men who could be thrust into the gap. It is perhaps worth noting that Calverley made his two hundred men-at-arms strip off their cuissarts (thigh-pieces) to allow them to move about more easily—a proof that the full knightly armour had now grown heavy enough to make all motion difficult when the wearer had been wearied by long fighting. Without this expedient his reserve would not have been movable enough for use at each point of the line, as it was successively in danger of being broken through.

CHAPTER IV

NAVARETTE AND ALJUBAROTTA

THE details of the tactics of Cocherel and Auray serve to show that the day of the horsemen was now considered to be at an end. After Creçy and Poictiers cavalry ceased to be the preponderant arm in Western Europe for some century and a half. For the future French and Netherlanders, as well as English and Scots, dismount as a general rule for battle. But the new tactics had still to be learned by the nations of the Iberian peninsula; the lessons which taught the Spaniards and Portuguese the importance of the dismounted man-at-arms were both given by English teachers. In the first, the battle of Navarette (1367), the Black Prince himself showed the Spaniards the same tactics which his father had used against the French at Creçy. In the second, the battle of Aljubarotta (1385), the Portuguese king Joao (John I.) was directed by English officers of experience, and assisted by a considerable English contingent, so that we may fairly look upon his victory as another of the great series which commenced at Dupplin and Halidon Hill.

It was Navarette which first brought Spain into contact with Western military science. The Castilians, unlike their neighbours of Aragon, had since the first foundation of their State had very little to do with the general politics of Europe. Their history touches that of Portugal, Aragon, and Navarre, but had hitherto been seldom connected to any important extent with that of France. Indeed Castile was not conterminous with any part of the royal domain of France, and only touched at one single point the English duchy in Aquitaine. On the other hand, she was in constant contact with the Andalusian Moors, and the most important part of her history is concerned with their gradual conquest. One hundred and twenty years before, St. Ferdinand had finally penned up the Mohammedans in the

kingdom of Granada.[1] But there they still survived, and Moorish campaigns were still frequent. Hence it was natural enough that Castile had shared little in the later developments of the art of war in the fourteenth century, and that the military customs and organisation of her people bore strong marks of their long contact with the Moslem.

When, in February 1367, the Black Prince crossed the Pyrenees to restore Pedro the Cruel to the throne from which he had been driven by his bastard brother Henry of Trastamara, the strength of the Castilian army was considered to reside wholly in its cavalry. And among these mounted men the light horse bore a more important part than they had ever occupied in any other European kingdom save Poland and Hungary. The "Genetes,"[2] or "Genetours" as the English called them, took their name from the jennets or light coursers which they rode. They were equipped in a semi-Moorish fashion, with a round steel cap, a large shield, a quilted gambeson, and two long javelins, which they launched at the enemy with good aim, even when galloping at full speed. Their tactics were not to close, but to hover round their opponents, continually harassing them, till they should give ground or break their formation, when a chance would occur of pushing a charge home. Such troops would have been formidable foes to infantry not armed with missile weapons, or to dismounted men-at-arms; but against the combination of archers and knights they were helpless. At Navarette, as we shall see, they were shot down helplessly by the archers long before they could get near enough to use their javelins. The Spanish heavy cavalry, supplied by the baronage and the great military Orders of Santiago and Calatrava, were in 1367 much in the condition in which English and French feudal horsemen had been fifty years before. They were late in adopting the heavier armour which had been coming into vogue farther north, and their horses were not for the most part barded, but unprotected by armour. They knew nothing of the new device of fighting on foot, but still charged in mass like their ancestors. They do not seem to have been

[2] The word was used down to the present century for the cavalryman in the Spanish army; a Spanish "morning state" shows the heads *Infantes, ginetes,* and *artilleros* as late as the Peninsular War.

very highly esteemed by their opponents in this campaign, and are accused of being too prone to fall into the skirmishing tactics of their compatriots the "genetours" when their first charge failed.[1]

The Spanish infantry appeared in considerable numbers on the field, the chartered towns contributing spearmen and crossbowmen, while considerable numbers of slingers were also used. But they played a very poor part in the campaign of 1367, and were of no practical use at Navarette.

The army with which Prince Edward crossed the Pyrenees, though English in name and led by many English leaders, was far less national than that which had fought at Creçy or even at Poictiers. The large majority of the troops were supplied either by the Gascon vassals of the duchy of Aquitaine, or by the huge bands of mercenaries, the celebrated "great companies" whom the prince had raised for this campaign. There were, no doubt, many thousand Englishmen in the ranks of the "free companions," but they were swallowed up in the general mass of cosmopolitan adventurers. Beyond the prince's personal retinue, and those of the English peers and knights who accompanied him, the only contingent from this side of the Channel was composed of the four hundred men-at-arms and six hundred bowmen whom John of Gaunt had brought over.

The army which fought at Navarette was larger than most of those which served under the English banner in the Middle Ages, though much smaller than Edward II.'s host at Bannockburn. It mustered, according to the new phraseology which was just beginning to come into use in military circles, more than ten thousand "lances." The lance meant a man-at-arms, an archer, and an unarmed groom, who took care of the horses of the other two when they descended, as usual, to fight on foot. Hence ten thousand lances meant ten thousand men-at-arms and ten thousand archers for use in the field. The grooms were mounted, so that, as Chandos Herald observes, the prince's train comprised no less than thirty-two thousand horses. The van marched under the Duke of Lancaster, the main-battle under the prince himself, the rear under James the exiled King of Majorca, who, driven out of his realm by the Aragonese, hoped ultimately to re-establish himself there by the prince's aid.

[1] So Froissart, xi. 182.

Edward would have been able, had he chosen, to put an even larger force in the field, for the free companies had flocked in to his call in such numbers that he was obliged to dismiss many of them because of the enormous financial strain on the resources of his duchy. He could not afford to take into his pay all who presented themselves. It was the need of finishing the matter quickly, before his money should run out, which induced him to start so early as February, when the Pyrenean defiles are barely passable. As it was, both his van division and his main-battle suffered terribly from cold and piercing winds, while threading on successive days the lofty pass of Roncesvalles.

The beginning of the campaign was much complicated by the double-dealing of Charles of Navarre, in whose hands the passes lay. He first was bribed by Henry of Trastamara to shut them against the English ; then, rather than fight the prince, he made a convention with him, received English gold, and fed the army of invasion while it passed through his realm. Lastly, to avoid committing himself too much against the Castilians, he got himself taken prisoner by Oliver de Mauni, a French knight in the service of the King of Aragon, who seized his person and put him in custody. Under cover of this compulsion, he pretended to be unable to aid either party. But three hundred of his men-at-arms, under his chief confidant Martin Henriquez de Lacarra, joined the prince's banner.

Charles the Bad having thus sold the passes to the English, the King of Castile had the choice either of defending the line of the Ebro, a fierce and broad river in early spring, or of advancing beyond that river and endeavouring to block the exits from Navarre—the defiles which lead out of the plains of Vittoria and Pampeluna, through the mountains of Alava. He chose the latter alternative, broke up his camp at San Domingo de la Calzada, crossed the Ebro, and posted himself at Añastro, so as to block the difficult road which leads from Vittoria to Miranda, the main line of communication between Navarre and Burgos, the capital of Castile. From his new position he sent forward his brother Don Tello with six thousand horse to reconnoitre the English camps round Vittoria. Don Tello carried out his orders with considerable enterprise and cleverness : he beat up the camp of the Duke of Lancaster and the English vaward, did considerable damage before the

invaders could get into array, and galloped off before they could harm him. On his homeward way he surrounded and cut to pieces an English scouting party under Sir Thomas and Sir William Felton on the hill of Arinez. This skirmish had some interest as throwing light on the value of the tactics of the two armies. The two Feltons had little more than a hundred lances with them ;[1] encompassed by the Spaniards, they let their horses loose, and ranged themselves in a solid clump on the hill. They stood firm under the shower of javelins which the genetours of Don Tello cast at them, beat off several charges of the Spanish heavy horsemen, and were only taken or slain when some hundreds of French knights in the Spanish service dismounted, attacked them hand to hand, and overwhelmed them by force of numbers.

For about a week the English and Castilian armies lay opposite each other (March 20-26), the former in the plain of Vittoria, the latter on the hills to the south, each waiting for the other to advance, and both suffering from bad weather and want of food. Don Henry, warned by his French auxiliaries that it would be easier to starve the prince than to beat him, refused to come down into the plain ; Edward, on his part, thought the pass too difficult to force, and matters seemed at a deadlock.

The only exit from this situation was to endeavour to turn the Bastard's position by a sweeping flank march. This the prince at last resolved to undertake : secretly breaking up from Vittoria by night, he left the main road, took a by-path, and then turned southward and crossed the Sierra de Cantabria at the pass of La Guardia. He reached the Ebro near Viana after a forced march of two days, and shortly afterwards crossed the great river at the bridge of Logroño—a place which, unlike the other towns of Northern Castile, had adhered to Don Pedro. At Logroño the prince was upon the high road from Pampeluna to Burgos, and had completely turned Don Henry's position, blocking the Burgos-Miranda-Vittoria route. The Castilians, who seem to have entirely lost touch of the English army between the 26th and the 30th of March, were forced to break up hastily from their camp on the heights of Bañares and Añastro, and to recross the Ebro in order to throw themselves

[1] So Froissart. Ayala says (p. 446) two hundred men-at-arms and two hundred archers.

41

between Edward and their capital. Passing by the bridge of San Vincente near Haro, the Bastard marched for Najera, the nearest point on the Logroño-Burgos road that he could reach. Here he halted on April 1, his front covered by the Najarilla, a considerable stream which falls into the Ebro from the south. On the same night the prince lay at Navarette, six miles to the eastward of him.

The change in the scene of operations was all in the prince's favour: he had got down into the fertile valley of the Ebro, and between him and the Castilians there was now nothing but the Najarilla and "a fine plain where there was no bush or tree for a good league around."[1] Don Henry was practically under an obligation to fight in the open, unless he should choose to sacrifice Castile and retire into the interior. This course had been urged on him by the French some weeks before, but he had replied that if he retired without fighting, half Spain would go over to Don Pedro: indeed, desertions from his ranks had already begun.[2] He had now only to choose whether he would fight east or west of the Najarilla, and, as he placed his main confidence in his cavalry, he resolved to advance into the broad plain beyond the river, instead of staying on his own bank and waiting for the prince to attack him. Horsemen, as he perhaps reflected, are not suited to defend a position.

Battle of Navarette, April 3, 1367.

To the great joy of the prince, his scouts brought him news, at the dawn of April 3, that the Castilians had crossed the Najarilla and were advancing upon him in battle-array. The tactics which the Bastard had adopted for the drawing out of his host were precisely the reverse of those which the French had tried at Poictiers. King John in 1356 had sent a forlorn hope of cavalry in front of his army, and dismounted the rest of his men-at-arms. King Henry in 1367 sent out in front a picked body of dismounted knights, and kept the rest of his army on their horses.

This vanguard was mainly composed of the Bastard's French auxiliaries under the great Breton condottiere Bertrand du Guesclin and the Marshal d'Audrehem, who after his experiences

[1] Chandos Herald, lines 3450, 3451.

[2] Ayala, p. 454: "Antes que las batallas se ayuntasen algunos genetes e la pendon de Sant Esteban del Puerto pasaronse á la parte del rey Don Pedro."

at Poictiers was, we doubt not, glad enough not to have to fight on horseback. To the French, who were some seven hundred lances strong (*i.e.* fifteen hundred combatants), the king added a picked body of several hundred Castilian men-at-arms under his brother Don Sancho and the Grand Master of Santiago. Included among them were the Knights of the Scarf, an order of chivalry founded in 1332, which corresponded somewhat to Edward III.'s better-known order of the Garter. Pedro Lopez de Ayala, the chronicler of the fight on the Castilian side, bore that day the pennon of the Knights of the Scarf. The whole body of dismounted men was probably about two thousand strong (Ayala says only one thousand): to them the king had joined some crossbowmen, who no doubt were drawn up on the flanks of the men-at-arms.

Don Henry's second line was formed of the bulk of his horsemen. It was composed of three bodies, not drawn on a level front, but with the side divisions somewhat advanced, so as to cover the flanks of the vaward "battle" of dismounted knights. On the left wing was the king's brother Don Tello and the Grand Prior of the Hospitallers, with one thousand men-at-arms and a great body of "genetours," probably two thousand strong;[1] in the centre was the king with fifteen hundred chosen knights; on the right Gomez Carillo de Quintana, High Chamberlain of Castile, Alfonso Count of Denia, a nephew of the King of Aragon, and the Grand Master of Calatrava, with one thousand men-at-arms and a like number of genetours to the left wing. Some crossbowmen seem to have been attached to the cavalry of the second line, but the great bulk of the Spanish infantry, at least twenty thousand strong, were formed behind the king's battle as a third or reserve line. Little confidence was evidently placed in them, and they did no more than had been expected of them[2] when they fled from the field.

[1] Chandos Herald, lines 3015–20, says that Henry had six thousand men-at-arms and four thousand genetours. Ayala, stating the Castilian numbers at the lowest, no doubt, says four thousand five hundred men-at-arms, and gives no figures for the genetours. Chandos Herald says that the Spanish foot were fifty thousand strong, with six thousand crossbowmen. Ayala states that they were very numerous, but gives no definite number.

[2] In this account I follow Ayala. Chandos Herald gives the same divisions, but very different numbers. He says that Bertrand's battle on foot was four thousand men-at-arms, that Don Tello had twelve thousand genetours (no men-at-arms apparently), and Gomez Carillo four thousand one hundred men-at-arms (but no genetours apparently). The king, according to him, had fifteen thousand "hommes

The Black Prince's host was, like the Spanish, formed in three lines, but each of them consisted of men-at-arms and archers in about equal proportions; it is not explicitly stated that in each case the bowmen were drawn up on the flanks of the knights, but we can have no doubt that this was the case. The vaward, led by the Duke of Lancaster, is said to have consisted of about three thousand lances (*i.e.* three thousand men-at-arms and three thousand archers). It contained the personal following of the duke, those of the two marshals of the host, Sir Stephen Cossington and Guichard D'Anglé, with those of Hugh Lord Hastings, and of Thomas Ufford, William Beauchamp, and John Neville—the sons respectively of the Earls of Suffolk and Warwick and the Lord Neville. But the core of the division was composed of the twelve hundred veteran lances of the free companies who served under Sir John Chandos' banner, the pick of the mercenary troops of Western Europe.

The prince's own main-battle, like that of Don Henry, was drawn up in a centre and two wings: Edward himself, with Pedro of Spain, governed the centre; the right wing division was led by the Captal de Buch, the Count of Albret, and Martin Henriquez the Navarrese. The left wing division marched under Sir Thomas Percy,[1] the Breton Oliver de Clisson, and Sir Walter Hewett.[2] Each of the three corps must have contained about two thousand lances.

Finally, the rearward, under the King of Majorca, consisted of Gascons under the Count of Armagnac, and a great body of free companions led by Sir Hugh Calverley and Perducas d'Albret. They were apparently about three thousand lances strong, like the vaward-battle. The whole amount of the English host should have been about twelve thousand lances, but they had suffered much during the last two months from cold, rain, forced marches, and insufficient feeding, so that their

armés" in his division, besides a vast multitude of arbalesters, sergeants, and other footmen. This makes twenty-three thousand men-at-arms, but a few pages before Chandos had made Henry say that he had but six thousand men-at-arms and four thousand genetours. Obviously these are much more like the real figures. One can but follow Ayala, who served in the Castilian host, and must have known all about it.

[1] Afterwards Earl of Worcester. He was in 1367 a young man of twenty-five. Beheaded after Shrewsbury fight by Henry IV.

[2] Chandos puts Sir Thomas Felton here also.

PLATE XXIV.

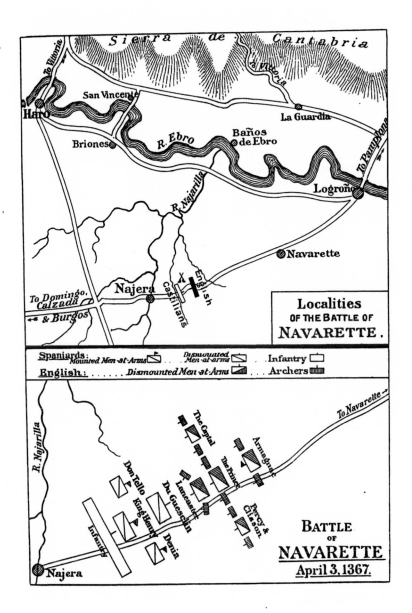

Localities
OF THE BATTLE OF
NAVARETTE.

Spaniards: Mounted Men-at-Arms Dismounted Men-at-arms Infantry

English: Dismounted Men-at-Arms ... Archers

BATTLE
OF
NAVARETTE
April 3, 1367.

opponent Ayala is probably near the truth when he states that
the prince's army contained ten thousand men-at-arms. Among
the corresponding number of infantry who accompanied the
men-at-arms the term "archer" must cover many Gascon
"bidowers" and foreign crossbowmen and javelinmen of all
sorts, for there were certainly not ten thousand native English
archers on the field.

The prince drew up his host close to Navarette, and then
marched forward, not by the high road to Najera, but over the
open plain, screening his advance by a rolling hill to the right
of the road. It was only on descending this rising ground that
he came in sight of the Castilians. He then halted, bade his
men send their horses to the rear, and marched down to meet
the enemy. Their fronts seem to have exactly corresponded, as
we do not hear of any outflanking. In numbers (as we have
already seen) the prince had a large superiority in men-at-arms—
probably about ten thousand to five thousand five hundred;
on the other hand, the Spaniards had their four thousand light
horse and perhaps thirty thousand foot to oppose to the prince's
ten thousand archers.

The course of the battle was very simple: the two vawards
first met; the English archers of Lancaster's division seem to
have driven off the crossbowmen, but the two bodies of dis-
mounted knights met and remained locked together fighting
desperately. At the first clash the English are said to have been
borne back a spear's length,[1] and Chandos was cast to the ground
and nearly slain.[2] But neither side gained any further advan-
tage, and the fate of the battle was decided elsewhere.

The next bodies which came into collision were the Spanish
knights and genetours of Don Tello and Gomez Carillo, and the
flank divisions of the English main-battle, under the Captal de
Buch on the right and Percy and Clisson on the left. In these
two combats the Castilians were disgracefully beaten; they
never closed with their opponents or came to handstrokes;
apparently they tried their usual skirmishing tactics, intending
to hover around the English and cast javelins at them. But the
English archery shot down horse and man while the Castilians
were still far away, and, instead of closing, the whole horde,
genetours and men-at-arms together, turned their bridles and
fled off the field. Several prisoners of importance fell into the

[1] Ayala, p. 457. [2] Chandos Herald.

hands of the English from these divisions, including Gomez Carillo and the Count of Denia ; probably their horses had been shot and they were cast to the earth and unable to get away.

After driving off the Spanish horse, both the Captal de Buch and Percy wheeled their divisions inward, to attack the flanks of the Castilian vaward, which was still hotly engaged with Lancaster's battle. At the same moment Prince Edward came up in the centre to reinforce his brother. To succour his advanced guard, now wholly encompassed with foes, Don Henry hurried up in person with his fifteen hundred chosen knights and the great mass of his infantry. The Bastard, as all the chroniclers agree in stating, showed the greatest courage. He charged three times at the head of his personal following, endeavouring to cut his way to join the vaward-battle ; but he could not break the lines of the English dismounted knights, and was thrice forced to recoil. Meanwhile, the English arrows were making fearful slaughter among the great masses of his infantry, who were already beginning to fall into disorder.

At last the King of Majorca and the English rear-battle came upon the scene, striking in on the left of the combat. The Castilians could stand no longer, " for arrows flew thicker than rain in winter-time ; they pierced through horse and man, and the Spaniards soon saw that they could no longer endure. They turned their steeds and commenced to flee away. Then when Henry the Bastard saw them fly he was sore enraged, and three times he tried to turn them back, crying, ' Sirs, for God's sake give me aid, for you have made me king and sworn me your oath to help me loyally.' But his word availed nothing, for the attack grew stronger every moment, and the Spaniards turned backward, and every man loosed his rein. Sore grieved and wroth was the Bastard, but it behoved them to fly, or they would all have been slain or taken. Therefore he fled down the valley, though the French in his vaward were still standing their ground." [1]

Du Guesclin and his band of dismounted knights, long surrounded by the English, and growing fewer every moment, did not yield till the whole of the Spanish army had been driven off the field. It is impossible to praise their determined courage too highly. But, seeing themselves abandoned, they were at

[1] Chandos Herald, line 3385 *et seq.*

last forced to surrender. More than four hundred of them had
fallen, including the Bégue de Villiers, one of the captains of
the French mercenaries, and of the Spaniards Garcilasso de la
Vega, Sancho de Rojas, Juan Rodrigo Sarmiento, and Juan
de Mendoza. Bertrand du Guesclin gave up his sword to
Sir Thomas Cheney; Audrehem and Don Sancho, the king's
brother, were also taken.

The rest of the Castilian chivalry had suffered comparatively
little: as the total number of corpses of men-at-arms, counted by
the heralds after the fight, was only five hundred and sixty, the
divisions headed by Don Henry, Don Tello, and Gomez Carillo
must only have lost a hundred and sixty all told. The un-
fortunate foot-soldiery, who could not flee so fast, suffered
more. Their masses blocked the bridge of Najera, towards
which they all fled, and the English cut down great numbers of
them. A freshet from the mountains had swelled the Najarilla
during the morning, so that it was not fordable, and many who
strove to escape by swimming were drowned. Altogether the
Spaniards are said to have lost over seven thousand men. In
the pursuit several important prisoners were taken: the Grand
Master of Calatrava was caught hiding in a cellar at Najera;
the Master of Santiago and the Grand Prior of the Hospitallers
were trapped in a blind entry between high walls into which
they had incautiously ridden, and forced to surrender.

The total loss in the prince's host was absurdly small: four
knights had fallen—two Gascons, a German, and Sir John
Ferrers, son of the English baron of that name; in addition,
forty men-at-arms and twenty archers had perished. Almost
the whole loss must have fallen on the vaward, who had fought
so desperately with Du Guesclin's men.

Thus ended in disaster the last attempt of continental
cavalry to pit itself against the combination of archers and
dismounted men-at-arms, which Edward III. and his son had
perfected. Nothing could have been more miserable than the
show made by the Castilian light-horse and crossbowmen when
they came under the deadly rain of English arrows, or that of
the Bastard's chivalry when they strove to ride down the
English men-at-arms.

The battle, however, was won, but not the campaign. As
long as Henry of Trastamara lived, Pedro the Cruel's throne
was insecure. It was in vain that the tyrant strove to massacre

all the Castilian prisoners, and actually, in spite of Prince Edward's opposition, beheaded Gomez Carillo, the Commander of Santiago, and two other knights.[1] No amount of cruelty could secure him the throne that the English had given him back. Less than two years after Edward had retired in disappointment to Gascony, Spain was up in arms again, and Don Pedro had fallen into his brother's hands, and been murdered by his brother's own dagger (1369).

Battle of Aljubarotta, August 14, 1385.

To end the chapter in the history of the art of war which began with Creçy, it only remains that we should make some mention of the battle of Aljubarotta, the last fight in Western Europe in which mounted men were to take a prominent part during the fourteenth century. In 1385 John King of Castile, the son of Henry of Trastamara, was making a great effort to put down his namesake John, the Master of Avis, who claimed the throne of Portugal. In right of his wife, the only daughter of Ferdinand, the last of the male line of the Portuguese house, the Castilian had a better hereditary claim than the Master of Avis, who was but the late king's bastard brother. But the national spirit of the Portuguese revolted against a union with Spain, and the large majority of the people, both gentle and simple, adhered to the Master, who took the crown under the name of Joao I. To crush him, the King of Castile called out the full levy of his realm, strengthened by a large corps of mercenary men-at-arms, led by certain lords of France, such as Regnault de Solier, Jean de Rye, and Geoffrey de Partenay. So large a proportion of these auxiliaries were drawn from the county of Bearn that Froissart sometimes calls the whole body of them "the barons of France and Bearn." John of Avis, on the other hand, was assisted by a much smaller band of English adventurers who had come in three great ships from Bordeaux under two squires, veterans of the French war, named John Northberry and Hugh Hartsell. They numbered in all about five hundred men.[2]

The Portuguese army was far less numerous than that of the invaders, but, on the advice of his English allies, John of Avis

[1] Ayala, p. 458.

[2] Lorenzo Fogaça in Froissart (K. de L.), vol. xi. p. 305, says only two hundred.

resolved to offer battle. He marched out from Lisbon to Thomar, and looked for a good position. The chosen spot was hard by the abbey of Aljubarotta, where the hills of the Sierra da Estrella sink into the plain. On one of the spurs _lie the monastic buildings, thickly surrounded by orchards and plantations. Half-way down the slope the Portuguese took their post ; they felled trees so as to cover both their flanks, but left a fairly broad open space opposite their centre.[1] Behind the two flanking abattis were placed the English archers and such native crossbowmen as could be got together, forming two projecting wings. The men-at-arms, all on foot, were formed in one solid battle in the middle, opposite the gap in the barricades. This order of battle was obviously a direct copy of that of the Black Prince at Poictiers : the army was masked by the trees, and the natural gap in the hedge, which figured in the former battle as the sole point of entry into the English position, was deliberately reproduced in 1385 by the extemporised barricades with the open space in their centre. A few yards in front of the line there was a shallow ravine with a thread of water running through it,[2] which reproduced the dip in the ground which lay in front of the farm of Maupertuis. Some way to the side were two other ravines, which guarded the flanks of the army.[3]

The King of Castile had marched from Ciudad Rodrigo by Celorico and Leiria to Santarem: his army consisted of at least two thousand lances of his French auxiliaries, about twenty thousand Spanish cavalry of the same character as that which fought at Navarette, and a large contingent of crossbowmen on foot. Thus he much outnumbered the Portuguese, whose whole force was estimated at two thousand five hundred knights and men-at-arms [4] and twelve thousand infantry.

On a hot and bright Saturday noon—it was the Vigil of the Assumption (August 14)—in the heart of the summer, King John of Castile received news of the determination of the Portuguese

[1] "Adont firent-ils au costè devers les champs abatre les arbres et couchier à travers, à celle fin que de plain l'on ne peust chevauchier, et laissiérent ung chemin ouvert qui n'estoit pas d'entrée trop large" (Froissart (K. de L.), vol. ii. p. 164).

[2] "Ung fossé, et non pas grant que ung cheval ne peust bien saillir oultre" (Lorenzo Fogaça in Froissart (K. de L.), vol. xi. p. 314).

[3] Ayala, p. 231 : "Los dos alas de los nuestros tienen delante dos valles, que non pueden paser pera acometar à nuestros enemigos."

[4] Froissart, xi. p. 308. Ayala says two thousand two hundred men-at-arms and ten thousand foot (p. 227).

to offer him battle. He was three leagues from Aljubarotta, and
doubted whether he should fight that day, or advance to a
convenient distance from the enemy and put off the battle till
the morrow. Regnault de Solier, whom he had made marshal
of his host, hotly urged the propriety of an instant attack, and
was supported by nearly all the French knights and many of
the younger Spaniards, who had never been present at a stricken
field. On the other hand, certain of the Spanish barons spoke
in favour of deferring the attack : it would be late in the day,
they said, before the host could be properly drawn up in front
of the hostile position, and battles begun in the evening seldom
lead to a decisive result. Jean de Rye, an aged knight of
Burgundy,[1] lent his support to their arguments, but the French
talked down the advocates of delay, and the king gave orders to
advance. He gave his command to draw up the host in two
lines : the vaward was to be composed of the auxiliaries, who
were to dismount (like Du Guesclin's knights at Navarette) and
to endeavour to force the Portuguese centre. Behind them
were to come the mass of the Spanish horsemen, arrayed in a
centre and two wings.[2] The crossbowmen and other infantry
followed in the rear, guarding the baggage ; it would have been
more prudent to allot them to the front division.

Marching through the afternoon, the Castilian army reached
Aljubarotta about vespers. When the enemy's line was made
out, the French of the vaward pushed forward with unwise haste
and proceeded to attack before taking the precaution of ascer-
taining that their own main body was sufficiently far forward to
co-operate in the advance. As a matter of fact, the king was
several miles to the rear, and none of his corps were near enough
to act in unison with the French. Nevertheless the marshal and
his countrymen rode briskly forward till they drew near to the
enemy, and then turned their horses loose and dismounted to
fight on foot.[3]

They advanced just in the way that the Portuguese king
had hoped : neglecting the archers and javelinmen on the
wings, they pushed on in one solid mass for the gap in the line

[1] This we get from Ayala's Chronicle, p. 232, not from Froissart.
[2] The wings are only named by Ayala ; Froissart speaks as if they had been all in
one mass. It is he also who mentions that the crossbowmen were in the rear (p. 231).
[3] The account of Lorenzo Fogaça makes the French dismount, as does Ayala ; but
Froissart's first version says that they kept their horses (p. 174).

of abattis, behind which they saw the men-at-arms arrayed. Crossing the little ravine, they flung themselves upon the hostile centre. Here they were received with a steady line of glaives and lances, while from both flanks a fierce discharge of arrows, crossbow bolts, and javelins was poured in upon them. No support came up from the main body: the French were outnumbered, and surrounded on three-sides. Hence it is not surprising that after half an hour of desperate hand-to-hand fighting they gave way: nearly half of the division were slain, and a thousand were captured; only a few hundreds escaped to bear the evil tidings to the King of Castile.

The whole encounter was over before King John had arrayed his line and proceeded to advance towards the hill of Aljubarotta. He himself was soon apprised of what had happened; his army, seeing no great back-rush of fugitives, but only isolated French knights making their way to the rear, failed to realise that the vaward-battle had been annihilated.

It was long past vespers and close to sunset when the great masses of horsemen drew near to the Portuguese position. All along the line the Castilians were protesting against the folly of fighting at such a late hour; but when their king ordered a general advance, they did not shrink from the assault. The centre dashed partly against the barricades, partly through the gap in them; the wings, which by the conformation of the ground had no good view of the enemy, got confused among ravines, orchards, and enclosures, and failed to outflank and turn the Portuguese.[1] In no part of the field did the Spaniards gain any advantage: in the centre, the only point where they were able to close, they suffered very severely from the flanking fire of arrows, bolts, and javelins. So many horses were shot down that "in forty places the ravine was passable over their heaped-up carcases." It was calculated that about five hundred Castilian knights crossed this obstacle,[2] and that the ground beyond it was such a death-trap that not one who had passed came back alive. As the dusk closed, the whole Spanish army reeled to the rear and fled in disorder; the king and the greater part of the

[1] From Lorenzo Fogaça's version in Froissart, p. 315. One of Henry's wings under Gonzalo de Guzman got right round to the rear of the enemy, but could not reach them (Ayala, p. 233).

[2] Ayala: "Los dos alas de la batalha del rey non pudieron pelear que cada una de las fallo un valle que non pudo passar" (p. 233).

fugitives reached Santarem, but the rest fled devious over the countryside and reached Estremadura by cross-roads.

The loss at Aljubarotta was very heavy: the whole vaward division perished *en masse*, for before the second combat Joao of Portugal ordered all his prisoners to be cut down (like Henry V. at Agincourt), fearing lest such a numerous body might attack him from the rear, or might at least distract too many of his men from the combat. "So perished four hundred thousand francs of ransom-money." The marshal, Regnault de Solier, the barons of Longnac, Esprés, Berneque, les Bordes, and Moriane, were the chief among the two thousand French slain. The Spaniards also suffered severely, though not in such a great proportion to their numbers: sixty barons and bannerets and twelve hundred squires and men-at-arms are said to have fallen, among whom were the Grand Masters of Santiago and Calatrava and the Count of Mayorga. Ayala names also Don Pedro, son of the Infante of Aragon, Juan lord of Aguilar, the king's cousin (son of his father's brother, Don Tello), Diego Gomez, Adelantado Mayor of Castile, Juan de Tovar, the High Admiral, Diego Gomez Sarmiento and Pero Gonsalvez Carillo, the two marshals of Castile, Pedro de Mendoza, the High Chamberlain, and many other barons of note.[1] The victors, as usual in these defensive battles, lost but a few scores: the only man of note among them who died was Martin Vaz de Mello, who was pierced right through his body by a dart cast by a Spanish genetour.

Though not discreditable to the courage of the French and Spanish knights, Aljubarotta gives us a very poor idea of their skill in war. All the blunders of Poictiers and Navarette were repeated: the vaward and main body did not co-operate; the enemy's position was not properly reconnoitred. Both corps fell blindfold into the trap which the King of Portugal had laid for them, attacking in a headlong manner the fatal gap which he had left open to allure them between the two wings of infantry armed with missiles. Instead of charging furiously down this entry, John of Castile should have employed his superior numbers in outflanking and surrounding the whole Portuguese position, and should only have closed when he had thoroughly made out the disposition of the enemy. Blind assaults are almost inevitably bound to lead to defeat—most of all blind assaults of cavalry on a front securely hedged in with abattis,

[1] Ayala, pp. 235, 236.

from behind which infantry can strike at their assailants without being themselves exposed to the danger of being ridden down.

Such was the result of the last attempt made in Western Europe to defeat the English tactics by unsupported charges of horsemen. We shall see, when we investigate the course of the second act of the Hundred Years' War, that John of Castile was hopelessly behind the times in his conception of the military art. Many years before Aljubarotta was fought, leaders of greater wisdom had discovered more effective means of meeting the system by which Edward III. and the Black Prince had won their great victories. In 1373 John of Gaunt had made his unopposed but most disastrous march through Central France, and by the end of 1374 all Aquitaine save the immediate neighbourhood of Bordeaux and Bayonne had been won back by the French. When once the generals of Charles V. had resolved no longer to attack the English in the open field, the defensive tactics of their enemies became of no avail, and a succession of petty sieges and inglorious counter-marches had put an end to the English ascendency in Southern France. All this must have been well known to the Castilian king and his auxiliaries from beyond the Pyrenees, but they showed themselves utterly unable to profit by the lesson. Their antiquated tactics and their blind plunge into the snare brought upon them a well-earned defeat.

FINIS

INDEX

Note.—Emperors, Kings, Sultans, etc., are catalogued under their personal names, not under those of their family or their realm. Dukes, Counts, and other nobles are catalogued under their personal names till the eleventh century, afterwards under the name of their chief territorial possession: *e.g.* Robert Bruce, King of Scotland, is indexed under *Robert*; Bera, Count of Barcelona, under *Bera*; but Humphrey Bohun, Earl of Hereford, under *Hereford*.

The figures in square brackets following the names of battles and sieges give the *dates* at which they took place.

Abbo, his description of the siege of Paris, 140, 147.

Acre, taken by Saracens, 262; taken by Richard I., 303; battle of [1189], 332–335; incidents of siege of [1190], 547.

Acton (*hacqueton*), use of the, 511.

Adalgis, Frankish count, defeated by Saxons, 84.

Ad Decimum, battle of [535], 29.

Adhemar Bishop of Puy, present at Dorylæum, 274; present at Antioch, 281, 282.

Adrianople, battle of [378], 13.

Aethelstan, his fleet, 113.

Aethelwulf, his wars with the Danes, 94.

Aetius, Roman general, 19, 21.

Agathias, his description of the Franks, 52.

Ailath, castle of, its importance, 255.

Alan of Brittany, Count, present at Hastings, 157.

Alaric, campaigns of, 19, 20, 44.

Albemarle, William Earl of, present at Northallerton, 387; present at Lincoln, 393.

Albigensian wars, 448.

Alboin, Lombard king, 50.

Albret, Bernard Lord of, present at Poictiers, 622; present at Navarette, 644.

Albuera, compared to Tagliacozzo, 494, 498.

Alençon, Charles Count of, his rashness at Creçy, 610, 611.

Aleppo, the Emirs of, 254.

Alexius I., Comnenus, Emperor, defeated at Dyrrhachium, 164; Turkish campaigns of, 205; his victory at Calavryta, 222, 223; his mercenaries, 225; his dealings with the Crusaders, 234, 235.

Alfred, King, his victory at Ethandune, 98; his military legislation, 109, 110; fortifies London, 111; his victory on the Lea, 112; his fleet, 112; his campaign of 893, 151.

Aljubarotta, battle of [1385], 648–652.

Alnwick, combat of [1174], 396; castle of, 532.

Alp Arslan, Sultan, his victory at Manzikert, 217.

Amadeus Count of Maurienne, his misconduct at Kazik-Bel, 244.

Amaury King of Jerusalem, his invasions of Egypt, 260.

Ammianus Marcellinus, 11, 13, 17, 18; his description of the balista, 138.

Anar, defends Damascus, 259.

Anglo-Saxons, their invasion of Britain, 63; arms and armour of the, 63, 64; military organisation of the, 64–66; their relations with the Welsh, 66, 68; use of the horse by the, 69, 70; tactics of the, 71; their resistance to the Vikings, 108–112.

Angon (Frankish spear), 52.

Angus, Gilbert Umfraville Earl of, present at Dupplin, 582, 583; at Halidon Hill, 586.

Anjou, Charles Count of, present at Mansourah, 343; invades Naples, 480, 481; victorious at Benevento, 484–486; victorious at Tagliacozzo, 492–497.

Anna Comnena, her account of Dyrrhachium, 164, 165; describes the use of Greek fire, 547.

Annibali, Tibaldo dei, present at Benevento, 483, 486.

Ansgar the Staller, at siege of London, 135; at Hastings, 163.

Antioch, Latin principality of, 257; siege of, by the Crusaders, 277, 280; battle of [1098], 280–285; fortifications of, 527, 529.

Antioch, Bohemund Prince of. *See under* Bohemund.

Antioch, Conrad of, captured at Tagliacozzo, 495.

655

PRINTED BY
MORRISON AND GIBB LIMITED, EDINBURGH.

Printed in the United States
84548LV00006B/1/A